Sir Herbert Read
was one of the most prominent writers
on twentieth-century art, whose numerous publications
include Modern Painting: A Concise History. He died in
1968. Nikos Stangos has co-authored David Hockney by
David Hockney and That's the Way I See It by Hockney; he
has edited a number of books including Concepts of
Modern Art in the World of Art.

This famous series
provides the widest available
range of illustrated books on art in all its aspects.
If you would like to receive a complete list
of titles in print please write to:
THAMES AND HUDSON
181A High Holborn, London WCIV 7QX
In the United States please write to:
THAMES AND HUDSON INC.
500 Fifth Avenue, New York, New York 10110

The Thames and Hudson Dictionary of

ART AND ARTISTS

Consulting Editor

Herbert Read

Revised, expanded and updated edition Nikos Stangos

426 illustrations

THAMES AND HUDSON

Any copy of this book issued by the publisher as a paperback is sold subject to the condition that it shall not by way of trade or otherwise be lent, resold, hired out or otherwise circulated without the publisher's prior consent in any form of binding or cover other than that in which it is published and without a similar condition including these words being imposed on a subsequent purchaser.

The major part of the material in this dictionary, especially on movements and artists active before 1945, was first published by Thames and Hudson Ltd in 1966 in the *Encyclopaedia of the Arts* whose consulting editor was Sir Herbert Read, managing editor Geoffrey Hindley and assistant editor Nathaniel Harris.

© 1966, 1985 and 1994 Thames and Hudson Ltd, London First published in Great Britain in 1985 by Thames and Hudson Ltd, London First paperback edition 1988 Revised, expanded and updated edition 1994

All Rights Reserved. No part of this publication may be reproduced or transmitted in any form or by any means, electronic or mechanical, including photocopy, recording or any other information storage and retrieval system, without prior permission in writing from the publisher.

British Library Cataloguing-in-Publication Data A catalogue record for this book is available from the British Library

ISBN 0-500-20274-5

Printed and bound in Singapore by C.S. Graphics

FOR EWORD

This dictionary provides comprehensive information on the fine arts, with entries on paintings, sculptures, drawings and prints, and the artists who have made them, throughout the world. The Thames and Hudson Dictionary of Art and Artists also covers historical styles and movements in the arts and groups of artists; in addition it contains entries on techniques, materials and terms, as well as on the major writers whose ideas have influenced the course of art and the work of artists. The aim is to be precise and specific, but without shirking the responsibility of providing, where necessary, some critical evaluation. On the whole, discursive articles on subjects such as English art, which by their very nature cannot be sufficiently detailed, are not included. One departure from this general principle is the inclusion of more general entries on cultures outside the Western world – in several of which the anonymity of the artist is a common occurrence. There are, however, entries on individual artists as well, where these are known by name and are likely to be encountered.

The majority of entries on movements and artists active before 1945 were originally written for the *Encyclopaedia of the Arts*, whose consulting editor was Sir Herbert Read, managing editor Geoffrey Hindley and assistant editor Nathaniel Harris, and was published by Thames and Hudson in 1966. Many of these entries, however, have been substantially revised and updated, and about 40 per cent more have been added. The result is that this dictionary comes right up to date. By providing extensive information on contemporary art and artists not accessible elsewhere, together with full examination of the arts of the past, on a universal scale, it is an unrivalled reference work.

This revised, updated and expanded edition of the dictionary now includes more than 2500 entries and 426 illustrations. Over 200 new entries have been added to those in the previous edition, not only to bring the dictionary up to date, but also to correct injustices in previous editions. It should perhaps be noted that the relative length of artists' entries does not necessarily imply the degree of their importance.

Extensive cross-references, indicated by asterisks (*), provide the reader with the full context in which an artist has worked.

ABBREVIATIONS

Most of the abbreviations in this dictionary are in common use or are self-evident: e.g. the name of the artist or subject which forms the headword is referred to in the text of the entry by the first letter(s) (Michelangelo becomes M.). Abbreviations such as ill. indicate various forms of the same word: illustrator, illustrated,

illustration. We have generally followed the Oxford English Dictionary in using full stops after abbreviations only where the last letter is not the last letter of the word in full. Thus: ill. (illustration, illustrator), ills (illustrations); c. (century), cs (centuries), etc.

2000	
anon.	anonymous
b.	born
C.	century
<i>C</i> .	circa
cm.	centimetre
coll.	collection
d.	died
ed.	edition, editor, etc.
fl.	floruit
Fr.	French
ft	feet
Gal.	Gallery
Ger.	German
Gr.	Greek
Inst.	Institute
It.	Italian
Jap.	Japanese

km.	kilometre
Lat.	Latin
Lib.	Library
m.	metre
ms., mss	manuscript(s)
M.O.M.A.	Museum of Modern Art, New
	York
N.G.	National Gallery, London
N.Y.	New York
R.A.	Royal Academy, London
SS	Saints
St	Saint
Tate	Tate Gallery, London
U.S.(A.)	United States (of America)
V. & A.	Victoria and Albert Museum,
	London
vol.	volume

Aaltonen Waïnö (1894–1966). Finnish sculptor and painter and a major force in modern Finnish sculpture. His work in granite is classical in line despite its monumental character. Besides a number of female torsos and portrait heads, A. executed public monuments.

Abbate Niccolo dell' (c. 1512–71). A Modenese painter who, from 1552, worked in France and was, with Primaticcio, a leader of the school of *Fontainebleau. A. was stylistically influenced by the illusionism of Mantegna and the softness of Correggio, but more important was his characteristically Mannerist treatment of landscape, as in the *Rape of Proserpine*. There are similarities in his work to Dosso Dossi and also Patenier and the Antwerp school, and A. himself introduced Mannerism in landscape into France. A major picture is *The Story of Aristaeus*.

Abbey Edwin Austin (1852–1911). U.S. oil painter, watercolourist and book ill., who worked much in Britain, becoming an R.A. in 1898. He drew ills in pen for works by Robert Herrick, Oliver Goldsmith and Shakespeare, and painted the scenes of *The Quest of the Holy Grail* on the walls of the public library, Boston, Mass.

Abbott John White (1763–1851). British amateur landscape painter. He exhibited oils regularly at the R.A.; his drawings have been admired.

Abbott Lemuel Francis (c. 1760–1803). British portrait painter, known for his portraits of Lord Nelson and the poet Cowper.

Abil(d)gaard Nicolai Abraham (1743–1809). Danish painter who studied in Italy (1772–9). His style was classical and he favoured heroic subjects. He painted little after 4 allegorical frescoes by him in the Royal Palace, Copenhagen, which he considered his best work, were burnt in 1794. Sketches of these together with many other works are preserved in the Royal Gallery, Copenhagen. B. Thorwaldsen was his pupil.

Aboriginal art. *Australian Aboriginal art

Abramtsevo Colony. A group of Russian artists drawn together in the 1870s and 1880s by the railway tycoon S. Mamontov. They included I. Levitan, V. Polenov, *Repin,

Abbate The Story of Aristaeus (detail) c. 1557

*Serov, the Vasnetsov brothers and *Vrubel. A number were members of the *Wanderers group. The colony was nationalistic in outlook and Russian folk-art and the Russo-Byzantine tradition influenced their work. They were the 1st Russian artists to work as theatrical designers, most of them working in Mamontov's 'Private Opera'.

Abstract art. Art which does not imitate or directly represent external reality: some writers restrict the term to non-figurative art, while others use it of art which is not representational though ultimately derived from reality. Various alternatives have been suggested (nonrepresentational art, non objective art, concrete art) but none has been generally accepted. 'Abstract' is frequently used as a relative term, paintings being more or less abstract in treatment. The original source of an abstract painting, e.g. a landscape or still-life, may be visible or decipherable: most Cubist painting is of this sort. Simplified or geometric shapes which have no direct reference to external reality may be used exclusively, as in *Mondrian's art. In a 3rd type of abstraction, brush-strokes,

Abstract Expressionism

the colour and textures of the material used suggest the development of the painting, as in *Pollock's work.

The idea that forms and colour in themselves can move the spectator underlies all A. a. Much 20th-c. painting and sculpture has attempted to have, like music, no representational purpose. Sources and parallels for this art have been found in ceramic decorations, decorative patterns in manuscripts and the applied arts (especially Celtic art, e.g. The Book of Kells), Mohammedan art, primitive and tribal sculpture and non-realistic elements in European painting (e.g. simplified architectural backgrounds in paintings by Fra Angelico).

20th-c. A. a. springs from Cézanne who treated some landscape motifs as geometric solids, and whose painting was much admired by the Cubists. Cubism, the 1st abstract style, had a decisive effect on other artists and groups. The independent value of colour was not emphasized by Cubism, but by other groups. Flat pattern design in pictures, used by Gauguin and the Pont-Aven painters, was taken up by the *Nabis; the *Fauves were particularly interested in colour. The 1st non-figurative painting was made by Kandinsky in 1910, but before this there were several painters in some of whose work the subject had become virtually indistinguishable, for example Hölzel and Gustave Moreau. The emotional impact of colour was also of the first importance for German *Expressionism. Cubism was followed and rivalled by *Futurism in Italy, *Vorticism in Britain, *De Stiil in the Netherlands and various forms of abstraction in Russia, including the *Rayonism of Goncharova and Larionov, *Constructivism, and the rigid geometric A. a. of Malevich (Suprematism). Abstraction of various sorts became more common in the paintings and sculptures of the 1920s, having for the most part a geometric basis: exceptionally Arp had made some chance compositions (e.g. with torn paper), and in *Surrealism there was some experiment with more informal types of abstraction. The main trend of A. a. in the 1930s was geometric, and the *Abstraction-Création group was formed in 1932 to exhibit such art. This abstract salon was succeeded after the war by Salon des Réalités Nouvelles. In abstract painting since the war informal compositions and innovations in technique have been more frequent and the main movement is *Abstract Expressionism. Sculpture during the 20th c. has been

frequently abstract, particularly in the work of several major figures such as *Arp, *Brancusi and *Calder.

Abstract Expressionism. A term 1st used in 1919 to describe certain paintings by *Kandinsky - commonly applied to U.S. nongeometric abstract art by diverse artists centred mainly in N.Y. c. 1942 and highly active and influential through the 1950s and early 1960s. The U.S. critic Robert Coates used this term in 1946 with particular reference to *De Kooning, *Pollock and their followers. It was officially recognized in the 1951 Museum of Modern Art exhibition 'Abstract Painting and Sculpture in America'. The term embraces works of diverse styles and degrees of reference to content or subject, emphasizing spontaneity of expression and individuality. The U.S. critic *Rosenberg used the term *'Action painting' (1952), while *Greenberg that of 'Americantype painting' (1952) to refer to the same general types of artistic activity which, however, began to be differentiated into two tendencies: brush painting concerned with gesture, action and texture (De Kooning, Pollock); *Color-field painting concerned with a large unified shape or area of colour (*Newman, *Rothko, *Still).

Abstraction-Création. School of non-figurative art founded in Paris in 1931 by A. Pevsner and N. Gabo, under the leadership of A. Herbin and *Vantongerloo. It has not attempted a full synthesis of the plastic arts but rather a merging of some of the techniques of painting and sculpture.

academic art. The term applies to art in a wellestablished, often realistic, tradition, showing expert command of draughtsmanship and other techniques. In the 19th c. the academies of painting became centres of opposition to new movements so that a. a. now generally has the pejorative overtones of 'conservative' and 'unimaginative'.

academies. Institutions which derive their name from Plato's Academy. In effect they originated in 15th-c. Italy, where humanist gatherings quickly attracted the official patronage, e.g. the famous Accademia Platonica founded by Cosimo I of Florence (c. 1542), which became a frequent feature of subsequent bodies. Vasari's Accademia di Disegno (1562) aimed to establish the status of artists (a frequent motive of these foundations); but

many were essentially teaching organizations. e.g. the academy of the Carracci, By 1870 over 100 academies were flourishing in Europe indicating the growing awareness of reintegrating the arts and society. Among British institutions, examples are the Royal Academy of Music (R.A.M.: 1922), the Royal College of Music (R.C.M.; 1873) and the Royal Academy of Dramatic Art (R.A.D.A.: 1904). Literary academies have sometimes functioned as arbiters of language. In this respect the Académie Française, founded by Richelieu in 1635, is pre-eminent. It has, however, been accused of undue conservatism, and has excluded many great French writers, including Molière, Balzac and Flaubert, In painting the same kind of criticism has been levelled at the British Royal Academy (R.A.; 1768; many British painters were trained in its schools) and the French Académie Royale des Beaux-Arts (founded by Louis XIV in 1648, dissolved in 1703 and reinstated in 1816 as the Académie des Beaux-Arts). The British Academy (1901) is devoted to scholarship in many fields.

Acconci Vito (1940—). U.S. artist, 1st noticed as a poet (1964–8), who then turned to *Performance, *Installation and *Action and Body art (1969) attracted by the experimentation of groups such as The Judson Church, and the conceptual framework established by such artists as *LeWitt, *Andre, R. *Morris, *Kosuth, *Weiner, D. Graham, *Oppenheim and *Burden. His most notorious work in the 1970s was Seedbed (1972) in which he lay under the floor of the gallery loudly voicing his sexual fantasies while masturbating. In the 1980s he started making constructions, e.g. Sub-Urb (1983) and furniture, e.g. Sleeping Dog Couch (1984).

Ackermann Rudolf (1764–1834). German art publ. and bookseller who opened a shop in the Strand, London, in 1795. He introduced art lithography to Britain, 1817. A. publ. various ill. magazines, e.g. Repository of Arts, Literature, Fashions, etc., topographical books, e.g. History of the University of Oxford (2 vols, 1814), The Microcosm of London (3 vols, 1808–11), and many travel books, employing artists such as *Rowlandson and A. Pugin. The illustrated annual Forget-me-not (begun 1825) was another of A.'s typographic and artistic successes.

Action and Body art. Term used of certain art manifestations of the late 1960s, making use of

the body, or direct reference to it, also involving actions by its exponents on their own bodies, or public performances calculated to shock or bore and so prompt consideration of the tedium and violence of life. Instances include patterned sun-burning, the taking of casts of limbs, e.g. B. Nauman's *From Hand to Mouth* (1967), a 12-hour lecture by *Beuys, self-mutilation, and shocking or obscene exhibitionism.

Action painting. A term first used by U.S. critic *Rosenberg to describe a method of painting widespread in the 1950s and 1960s, in which the paint is dripped, dropped or thrown on the canvas – hence the French term *Tachisme* (tache, 'stain' or 'spot'); some critics use both terms as interchangeable with *Abstract Expressionism. The term was first used about the work of *Pollock but has also been applied to European artists associated with *Tachisme*.

Adam Lambert-Sigisbert (1700–59). French Baroque sculptor, son of the sculptor Jacob-Sigisbert A. (1670–1747). In Rome (1723–33), he was strongly influenced by Bernini. His fountain *Triomphe de Neptune et d'Amphitrite* (1740) is at Versailles.

Adami Valerio (1935–). Italian painter sometimes associated with European *Pop art. His paintings, frequently of bourgeois interiors, are in flat, bold colours, with objects outlined by strong, black lines. This allows an ironic play between figurative subject matter and abstract forms.

Adams Herbert (1858–1945). U.S. sculptor who studied in Paris. A.'s work includes the tympanum of St Bartholomew's Church, N.Y. (1902).

Adam-Salomon Antony-Samuel (1818–81). French portrait photographer and sculptor. His photographs with their use of heavy *chiaroscuro effects were praised for their approximation to 17th-c. Dutch paintings.

Adler Jankel (1895–1949). Polish painter. His figure studies were influenced by Picasso and Léger. He travelled widely in Europe teaching for a time at the Düsseldorf Academy with Klee and working with *Hayter at *Atelier 17.

Aelst Willem van (1625/26–83?). Dutch stilllife painter from Delft. He was a good draughtsman and vivid colourist. A.'s still-lifes are distinguishable from those of other Dutch painters, being frequently littered with bric-àbrac of Renaissance antiquarianism.

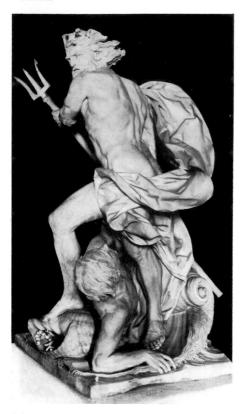

Adam Neptune Calming the Waves 1737

Aertsen (Aartsen, Aertszen, Aertsz) Pieter (Pier Lange) (1507/8–75). Dutch painter, working in Antwerp and Amsterdam, whose detailed and colourful genre and still-life paintings were highly popular and also stylistically influential on the 17th-c. Netherlands genre school. Many of his religious paintings have been destroyed.

Aesthetic movement. British literary and artistic movement of the 1880s in protest against the idea that art must serve some ulterior purpose and also against the 'philistine' taste of the period. W. *Pater was its most important member but Oscar Wilde its most vocal. The A. m. was ridiculed by *Punch* and in Gilbert and Sullivan's operetta *Patience*.

aesthetics. The study of the concepts of 'beauty' and 'art'. A. attempts to give an account of the human reaction to beauty and art, to define the words, to explain how men perceive the 'beautiful' or the 'artistic', to decide whether

the concepts have any other than a subjective meaning and to explain what happens when a man stands before a 'beautiful' sight or a work of 'art' – what kind of experiences he has and in what way he is able to 'experience' anything. Although the writings of Plato and Aristotle contain observations on the subject matter of a., the word was first used by the 18th-c. German philosopher A. G. Baumgarten. Some of the most prominent theoreticians in a. since the 19th c. include *Winckelmann, I. Kant, *Lessing, J. Schiller, G. Hegel, J. G. Herder, F. Schelling, *Ruskin, *Baudelaire, *Taine, F. Nietzsche, *Croce, *Worringer and *Gombrich.

African art. The term refers only to black African art and particularly to sculpture and carving (mostly in wood) from the vast area surrounding the Niger and Congo basins. Ancient Egyptian art and bushman painting from southern Africa are thus excluded. Distinction must be made between the courtly art (especially from *Ife and *Benin) which tended to be naturalistic and commemorative. and made in durable materials (stone, terracotta, bronze, hardwood); and the conceptual, often abstract art consisting mainly of woodcarvings (masks, ancestor figures) used during religious ceremonies. It was work of the 2nd kind which made its impact on Western artists at the beginning of the 20th c.

All the tribal artists were inspired by similar beliefs. In African 'animist' religions 'being' is regarded as vital energy and not solely as the living state. Every existing thing has a vital force or energy and by understanding and correctly approaching these forces man can use them, but in order to ensure the continuance and increase of this vital energy in the tribe and in himself he must perform religious rituals at regular intervals and on set occasions. Masks and statues are used in communication with the spirit world, in the cult of the ancestors and as protective charms in the direct exploitation of the vital energy in the world.

The artist works within a formal convention to embody in his carving some concept related to the subject and to give his carving a dynamic power, so that it can be used to enlist and generate energy. He therefore does not aim to reproduce his subject realistically nor is his 1st intention to produce 'beautiful' forms. The head of the statue is often disproportionately large owing to the belief that it is the seat of the life

force and is therefore more important than the body. Statuettes are almost always made from a single block from a tree, thus leading to elongation of the body with the arms held close to the sides, and foreshortening of the features. *Ashanti, *Bakuba, *Baluba, *Bambara, *Ba(o)ule, *Dahomey, *Dogon, *Fang, *Mende, *Nok and *Yoruba.

Afro-Cubanism. Early 20th-c. trend in Cuban music, literature and painting. It evolved from the European *avant-garde*'s interest in primitive art and the writings of the anthropologist Fernando Ortiz, notably *Los negros brujos* (1906). There were parallel movements in Puerto Rico and Haiti.

Agar Eileen (1899–1991). Born in Buenos Aires, settled in Britain 1911. Prominent among British Surrealist painters, who also made sculptures and assemblages; her work was included in the International Surrealist Exhibition, London 1936, and all other subsequent major exhibitions surveying Surrealism.

Agnolo Andrea d' *Andrea del Sarto

Agostino di Duccio (1418–81). Florentine sculptor mainly of reliefs, possibly a pupil of J. della Quercia. His earliest independent work was probably the altar (completed by 1442) in Modena cathedral. His major work is at the Tempio Malatestiano, Rimini (architect *Alberti, painter Piero della Francesca). A.'s style is essentially linear, his relief work is flat with no attempt at illusionism.

airbrushing. A method of painting by means of a fine paint or varnish spray, used primarily in commercial and graphic arts to achieve a smooth flat finish, or gradations of colour. Some Pop and Super Realist artists also use it.

Ajanta cave paintings (Hyderabad state, India). A series of wall paintings, dating from the 1st to the 7th c. AD, of which only parts now survive. They depicted scenes in the life of the Buddha and the Jataka stories of his former lives, scenes from contemporary life and animals and plants. The handling is sure and subtle, the line controlled, the colour vivid and well contrasted and the presentation, a somewhat stylized realism, ignores perspective. There are also carved pillars and sculptures.

AKhRR. *Vkhutemas

alabaster. A natural stone used for statues and ornamental carving. It is a granular form of

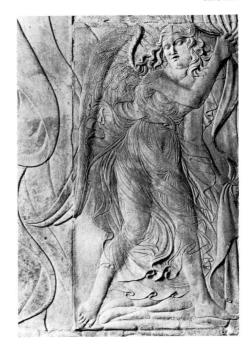

Agostino di Duccio Angel (relief from the Tempio Malatestiano, Rimini) *c.* 1447–*c.* 1454

gypsum, usually white, pink or yellowish in colour and very soft. The best sort is pure white and translucent but it can be made nearly opaque to resemble marble by heating it in almost boiling water. It was extensively used in the medieval and Renaissance periods. In the late 14th c. and 15th c. English work, particularly that of Nottingham, had a European reputation. Being soft, a allows a more delicate style of carving than is possible in stone.

Albani Francesco (1578–1660). Italian painter working at Bologna and Rome and popular with his contemporaries for graceful, if somewhat sentimental, religious and mythological paintings. He studied first under the Flemish painter *Calvaert and then at the Carracci Academy.

Albers Josef (1888–1976). German painter and designer. After an academic training in Berlin, Essen and Munich, he studied at the *Bauhaus and was later invited by Gropius to teach there. His 1st work included pictures in glass, furniture and abstracts. In 1933 he went to the U.S.A. and developed a new free abstract

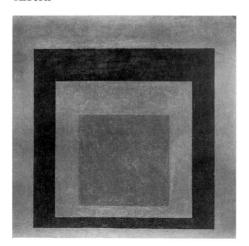

Albers Homage to the Square - Mellowed 1960

style (Étude in Red-Violet, 1935), later became interested in the manipulation of colour (his series of Variantes from 1947), and developed as the doyen of U.S. geometric abstractionists (Homage to the Square: in secret, 1962). He was always an experimental artist, his work being closely related to his practice as a teacher. In 1955 he became chairman of the Design Department at Yale Univ.

Alberti Leon Baptista (1404–72). Italian humanist and architect born in Genoa. In Florence (c. 1428) he formed friendships with *Donatello, *Ghiberti, *Robbia and *Masaccio to whom he dedicated his important treatise on painting, *Della Pittura* (1436) containing the first description of *perspective in depiction. As a great humanist, he stressed the rational and scientific nature of the arts, departing from religious symbolism or function, and urging a return to classical modes

Albertinelli Mariotto (1474–1515). Florentine painter. Close friend of, and collaborator with, Fra *Bartolommeo, whom he met in the atelier of *Rosselli. Their partnership broke up about 1512, when A. became an innkeeper. With a technique sometimes indistinguishable from Bartolommeo's A.'s best independent work is his *Visitation* (1503).

Albright Ivan Le Loraine (1897–1983). U.S. painter born in Chicago. Studied in Chicago and at National Academy of Design, N.Y. He

evolved a personal, naturalistic style outside the mainstream of modern art. Worked slowly and meticulously, drawing on experience of seamy life in Chicago where he lived.

Alcamenes (late 5th c. BC). Athenian sculptor, a pupil of Phidias. The group *Procee and Itys* is attributed to him, and he may have collaborated in the sculptures for the Parthenon.

Aldegrever Heinrich (1502–c. 1555). German engraver and painter who worked on a small scale, greatly influenced by *Dürer.

Aldobrandini Wedding, The. A 1st-c. BC Roman wall painting after a Greek original; so called after a former owner.

Alechinsky Pierre (1927—). Belgian painter; he studied painting in Brussels and engraving with *Hayter in Paris. One of the founders of the international *Cobra group (1948).

Alexander John White (1856–1915). U.S.-born painter and ill. He became a fashionable portrait painter in the 1880s. In Paris, 1890–1901, he was a friend of *Whistler and *Rodin, and was influenced by the *Art Nouveau. He executed murals at the Library of Congress, Washington, D.C. (1895–96) and the Carnegie Institute, Pittsburgh (1905–15).

Alexander mosaic (3rd c. BC) also called *The Battle of Issus*. The finest Roman mosaic known, which shows a battle between Greeks and Persians, including a combat supposedly between Alexander the Great and Darius; it may be a copy of a work by the Greek painter *Philoxenus of Eretria (c. 300 BC). Found at Pompeii.

Algardi Alessandro (1598–1654). Bolognese sculptor. After studying at the Carracci Academy he settled c. 1625 in Rome, where his friends included *Domenichino, N. *Poussin and *Sacchi. A. excelled as a portraitist, particularly in the depth of his character analysis. e.g. his Francesco Bracciolini. Although A.'s approach was classical and although he was Bernini's chief rival, his statue of Innocent X was influenced by the latter's Urban VIII and above all his tomb for Leo XI (1645/50) is the first of many to be modelled on Bernini's for Urban. From 1646 to 1653 A. was working on his relief of The Meeting of Attila and Leo I. With its modulation from the free-standing figures of the foreground to the shallow relief of the background, this was to be influential on later relief technique.

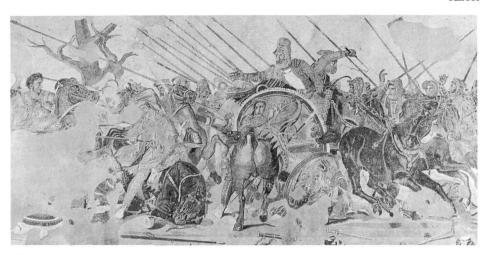

Alexander mosaic 3rd c. BC

Algarotti Count Francesco (1712–64). Italian writer and connoisseur of art and music and a friend of Voltaire and Frederick II of Prussia. In *Neutonianismo per le dame ...* (1737; trs. 1739) he popularized Newton's optical theories, and the *Saggio sopra l'opera in musica* (1736; *An Essay on the Opera*, 1767) was a protest against the elaborate machinery of the 18th–c. stage. He was a friend of *Canaletto and *Tiepolo whom he influenced.

Aliamet Jean-Jacques (1726–88). French engraver. Executed engravings after C.-J. Vernet and 17th-c. Dutch painters, particularly N. Berchem. His brother, François-Germain (1734–88), also an engraver, worked in London under Sir R. Strange.

Alken Henry (1785–1851). Best known of a family of Danish sporting artists who settled in Britain. He was a prolific painter and water-colourist of hunting, coaching and shooting scenes and produced a famous series of aquatint prints. The quality of his work declined in the 1820s.

Allan David (1744–96). Scottish genre and portrait painter. He worked in Rome (1764–77) and won a prize there for a history painting. Sometimes called the 'Scottish Hogarth', more as a measure of his fame than his style.

Allan Sir William (1782–1850). Scottish history painter admired by Walter Scott. A. and *Wilkie

were largely responsible for establishing Scottish historical genre painting.

alla prima (It. at first). Method of painting in which the colour is applied in one session and no subsequent modification is made. In oil painting any previous drawing or under-painting is obliterated so that it does not affect the final result.

allegory. A story, whether in verse or in prose, or a painting in which the literal account or presentation is intended to have, or is interpreted as having, another and parallel meaning.

Allegretto Nuzi (di Nuzio) (1315/20-73). Italian painter working at Florence. He was affected by the Sienese school as well as by the work of Giotto. A. signed many of his pictures in full, which was unusual in the 14th c.

Allori Alessandro (1535–1607). Florentine painter. Used the name Bronzino after the death of his uncle, Il *Bronzino. Studied under Bronzino and in Rome under Michelangelo. Although his drawing was rigid and his colouring cold he was popular as a painter of decorative frescoes into which he inserted portraits of prominent contemporaries. Cristofano (1577–1621), Mannerist painter, son of Alessandro. His painting united the rich colouring of the Venetian with the careful drawing of the Florentine school. His best-known painting is *Judith with the Head of*

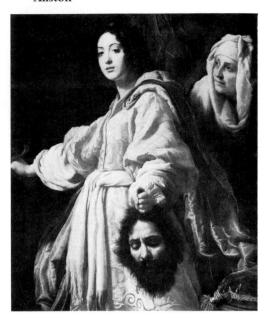

Cristofano **Allori** *Judith with the Head of Holofemes* early 17th c.

Holofernes. Judith is a portrait of his mistress Mazzafirra, while Holofernes is supposed to be a self-portrait.

Allston Washington (1779–1843). U.S. painter and writer. In Europe (1801–10, 1811–18), he studied under B. West in London and visited Paris and Rome, becoming a close friend of S. T. Coleridge, W. Irving and B. Thorwaldsen. As the 1st U.S. artist to paint romantic landscapes he was a precursor of the *Hudson River school; he also painted portraits, e.g. that of Coleridge, and large dramatic biblical and classical subjects. His *Lectures on Art* were publ. in 1850.

Alma-Tadema Sir Lawrence (1836–1912). Netherlands academic painter who settled in London (1870). He was very popular for his idealized, but accurately detailed and brilliantly coloured, scenes of Greek and Roman life.

Alsloot Denis van (d. c. 1626). Flemish painter who specialized in pageant and procession scenes.

Altamira. Limestone cave in Santander province, northern Spain, where animal paintings of the upper palaeolithic or leptolithic era were first discovered (1879). A.'s famous roof frieze of naturalistic bison is now recognized as

late Magdalenian art c. 10,000 BC belonging to the final phase of the ice age hunting cultures of Western Europe. The paintings are executed in earth colours, mostly blacks and reds, straight on to porous rock; in some cases one painting is superimposed on another. *Cave art.

Altdorfer Albrecht (c. 1480–1538), German painter and city architect and councillor of Regensburg, Bavaria. His St George is one of the first true landscape paintings in Europe. In it a mass of forest foliage soars above the tiny figures of St George and the dragon. Even in his early works, which show influences of L. Cranach and Dürer, landscape predominates, and a tour of the Danube and the Austrian Alps (c. 1511) confirmed his inclinations. An immediate result was the series of canvases, drawings and etchings of Danube landscapes (*Danube school). Other major works are Alexander's Victory, also called the Battle of Arbela (1529), and the St Florian Altar. This was eight panels depicting the life of St Florian, painted for St Florian's church, near Linz, Austria. Seven of the panels are now in colls elsewhere; the Germanisches N.-Mus., Nuremberg; the Uffizi; and a private coll.

Altichiero da Zevio (fl. 1369–84). Italian painter from Verona. His figures are reminiscent of Giotto's style but show a greater awareness of one another suggestive of later painters. There are frescoes by him in Verona and Padua including a great *Crucifixion* in the church of Sant'Antonio, Padua.

Alunno di Domenico (Disciple of Domenico, i.e. *Ghirlandaio). Name given by *Berenson to a Florentine painter and ill. (fl. late 15th—early 16th c.). His work included the predella for Ghirlandaio's Adoration of the Magi (1488) for the church of the Innocenti, Florence. Berenson later discovered a contract (1488) made for the execution of this predella between the prior of the Innocenti and a Bartolommeo di Giovanni; he accepted this as the real name of his artist but retained the name A. as more instructive.

Amasis painter. Greek potter and vase painter in the *black-figured style; his figures are lithe, vigorous and witty.

Amberger Christoph (c. 1500–c. 1561/2). German portrait painter whose work shows Venetian influence. Working in Augsburg he painted many famous people, including the Emperor Charles V (1532).

American Abstract Artists. U.S. group of painters formed in 1936, they included George L. K. Morris and Ibraham Lassaw. Their annual shows maintained a tradition of academic, if somewhat mannered, *Cubism.

Amigoni Jacopo (1675–1752). Venetian Rococo painter who worked in various European countries and during his own lifetime was very popular.

Amman Jo(b)st (1539–91). Swiss woodcut artist and painter who settled in Nuremberg (1561), where he became a prolific ill. He executed woodcut ills for S. Feyerabend's Bible (1564) and a set of 115 for a series on arts and trades.

Amman(n)ati Bartolommeo (1511–92). Florentine sculptor and architect. In Florence he carved the Neptune fountain (1563–77) in the Piazza della Signoria and built the famous Bridge of the Trinity (1567–9), destroyed in an air raid (1944), but since rebuilt, and extensions (1560–77) to the Pitti Palace. There are also buildings by A. in Rome and Lucca.

Amsler Samuel (1791–1849). Swiss engraver who worked in Munich, Germany. His work includes good reproductions of Raphael's paintings and *Triumphal March of Alexander the Great* after a sculpture by *Thorwaldsen.

Analytical Cubism. *Cubism

Anamorphosis. Term of Greek origin referring to distorted image of a subject represented in drawing or painting, which will only reveal the image in true proportion when viewed from a certain point or reflected in a curved mirror (e.g. skull in *Holbein's *Ambassadors*).

Anderson Lauric (1947—). U.S. *Performance artist, composer and *Postmodern poet. Her four-part work *United States I–IV* (1979–83), a 12-hour long work presented solo by A. of theatrical entertainment took Performance art to the wider public. In her solo Performance *Empty Places* (1989) she deals with the U.S. sense of vastness and 'the need to change, sometimes interpreted as freedom'.

Andokides. Greek vase painter in the *red-figured style.

Andre Carl (1935–). U.S. *Minimalist sculptor. In 1964–5 he exhibited 'primary structures', e.g. *Cedar Piece*, piled-up timber, 6 ft (2 m.) high, for which *Brancusi's *Endless Column* (1937–8) was 'the supreme inspiration'. From 1966 A. started his 'scatter pieces' on the floor,

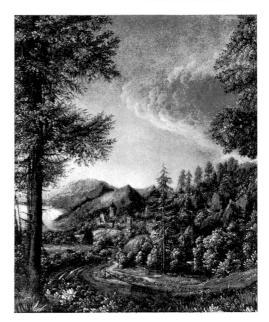

Altdorfer The Danube near Regensburg (detail) c. 1530

first using firebricks, e.g. Lever (1966), 29 ft (8.8 m.) of 137 aligned, loose bricks, and then, soon after, styrofoam bars and subsequently modular plates of copper, aluminium, steel, iron, magnesium, zinc or lead, e.g. Twelfth Copper Corner (1975) consisting of 78 plates of copper, each 19½ sq. in. (126 sq. cm.). These are his best-known works. Sometimes the flat plates are rich in colour, according to the metal used, and may be assembled as 'particles' on the floor in a checkerboard pattern of systemic units. A. defined sculpture as developing from 'form' to 'structure' and finally to 'place', i.e. the perception of the floorbound bricks or plates as sculpture depending on the site where they are presented and whether a particular sense of place is created.

Andrea del Castagno. *Castagno

Andrea del Sarto 'senza errori', 'the faultless painter' (1486–1531). Florentine painter with feeling for tone and colour characteristic of the Venetian rather than the Florentine school. Invited by Francis I to Paris (1518) he returned to Florence (1519) to his wife. His life and works were much studied and admired in the 19th c. and Browning's poem *Andrea del Sarto* was a sensitive and acceptable picture of a gifted,

Andrews

Andrea del Sarto Madonna delle Arpie (detail) 1517

irresolute and reflective man. A.'s frescoes *Birth of the Virgin* (1514) and *Madonna del Sacco* (1525), both in S. Annunziata church, Florence, are perfect examples of the High Renaissance. Other major works include *Madonna delle Arpie* (1517), classical in style, and the Holy Family was a favourite theme. Among his pupils were the Mannerists da *Pontormo and G. B. Rosso.

Andrews Michael (1928–95). British painter of complex, but traditional subjects, which he summed up as pictures of 'mysterious conventionality'. A. is best known for his series of party pictures painted after 1959, and for the series *Lights* (post–1970), as well as for his monumental landscapes of Australia.

Angelico, Fra (Giovanni da Fiesole) (c. 1387–1455). Italian painter celebrated for his frescoes in the convent of S. Marco, Florence. In 1407 he entered the Dominican convent of S. Domenico, Fiesole, near Florence, of which he was later prior (1449–52). Papal politics forced the community to leave Fiesole (1409–18) and some time after their return A. began to paint; nothing is known about his early training but he shows the influence of such international Gothic painters as *Monaco. He executed (c.

Fra Angelico Deposition c. 1436

1428-33) an altarpiece (extensively altered by di *Credi, c. 1501) and 3 frescoes (sala capitolare of the convent) for his own convent and an Annunciation for the church of S. Domenico, Cortona; these foreshadow the simplicity of his mature work. In 1433 he was commissioned to paint the 'Linaiuoli' or Linen-workers' triptych, particularly famous for the 12 angels playing on musical instruments which decorate the frame surrounding the central figures of the Virgin and Child. Two triptychs, painted after this for the churches of S. Domenico, Cortona and Perugia in the Gothic style, show that A. was attempting to break with the conventions of this form of altarpiece. In 1436 Cosimo de' Medici commissioned A. to paint 3 altarpieces including the high altar for the Dominican convent of S. Marco, Florence - Virgin and Child Enthroned with SS Cosmas and Damian (1438-40). In these and the slightly earlier Coronation of the Virgin for Fiesole the figures of saints and angels recede towards the central figure, marking a step in the development of the sacra conversazione altarpiece. A. also uses single panels instead of the triptych and completely abandons the Gothic gold background; in the S. Marco altarpiece he introduces landscape background. The predella scenes for this altarpiece from the lives of Cosmas and Damian illustrate A.'s excellence as a colourist and are his most lively narrative paintings. A. began, about this time, to supervise the painting of 50 frescoes of scenes from the life of Christ for the cells of the convent of S. Marco; he himself probably painted not more than 10. Their setting and purpose, which was not decorative but to act as an aid to meditation, were ideally suited to the direct and simple piety characteristic of A.'s painting. Those by him are the most straightforward and hence most effectively fulfil their purpose. In 1447 he was in Orvieto where he painted The Last Judgement, finished by Signorelli, and in Rome executing decorative work in the Vatican for Pope Nicholas V. Only his frescoes in the chapel of Nicholas V (1447/8) survive. In keeping with their setting these are richer and more complex than any of A.'s previous work. A. died in Rome. Much of A.'s work refers back to Giotto and he took no part in the artistic experiments and secular interests of his contemporaries, although he utilized new visual techniques such as perspective if they served the devotional purpose of his painting. *Gozzoli was his pupil.

Anguissola Sofonisba (1530s–1625). Italian painter, perhaps the best–known female artist of the 16th c., influenced, as were many of her contemporaries, by *Titian. She mainly produced portraits and self–portraits. Her pursuit of a professional career did not conflict with contemporary notions of womanhood, largely because of her noble birth, and she was hailed as a prodigal exception. A. trained for 3 years under the man who appears in her Bernadino Campi Painting Sofonisba Anguissola (late 1550s), in which she portrays herself as his subject. From 1559–80 she was court painter to the Queen of Spain.

Animal style. Used generally to refer to Germanic animal ornament from the 5th c. to the period of the *Renaissance. Based on 4th-c. provincial Roman prototypes, the forms became increasingly abstract: in the 5th c. broken up into separate, very stylized elements and linked together with obvious coherence; in the 6th c. elongated and inter-laced into rhythmic snake-like patterns. A. s. reached its greatest refinement in Scandinavia.

Annesley David (1936–). British abstract sculptor. At first influenced by *Caro, A. produces characteristic works of thin, colourfully painted, sheet steel.

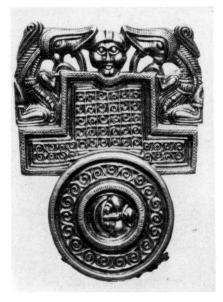

Animal style Silver nielloed brooch, 5th c.

Annigoni

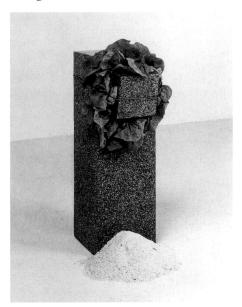

Anselmo Untitled 1968

Annigoni Pietro (1910–88). Italian painter and highly successful society portraitist, notably of British royalty.

Anselmo Giovanni (1934—). Italian artist who works with stone, metal, wood and whose concerns are energy, gravity, space, time and infinity, e.g. Verso Infinito (1969). One of the original members of the *Arte Povera group whose proponent Germano Celant said of A.'s work that it 'exalts precariousness'. From 1969 he began using words which more explicitly connected images and ideas as in *Conceptual art. In the 1980s A. created site-specific *installations.

Antelami Benedetto (12th c.). N. Italian Romanesque sculptor. He executed a relief of the *Deposition* (1178) and other work in Parma cathedral.

Antenor (late 6th c. BC). Important Greek sculptor who worked in Athens. Works attributed to A. are in the Acropolis Museum, Athens, and the pedimental sculpture of the Archaic temple of Apollo at Delphi.

anti-cerne (Fr. *cerne*, outline). The opposite of a black outline; it is a contour effected by leaving a bare strip of ground between 2 or more areas of colour.

Antonello da Messina (c. 1430–79). Sicilian painter. In Naples he saw work by Netherlandish artists and may have studied under Colantonio, whose style was based on that of J. van Eyck. He learnt Van Eyck's method of oil painting and achieved a delicate synthesis between the Northern and Italian styles. Working in Venice (1475) he passed his knowledge on to G. *Bellini, altering his manner of painting and through him exercising great influence on the development of the Venetian school. His paintings include St Sebastian, Crucifixion, Portrait of a Young Man, St Jerome in his Study and Condottiere.

Antwerp Mannerists. Group of Antwerp painters of the early 16th c. whose work is characterized by Italianate ornamentation and affected attitudes. Unconnected with later *Mannerism.

Apelles (fl. mid-4th c. Bc). Greek painter who studied near Corinth under *Pamphilos. He became court painter to Philip and Alexander the Great, whose portrait he alone was permitted to paint. His reputation rests simply on literary references since none of his paintings nor his treatise on painting survive.

Apollinaire Guillaume. The adopted name of Wilhelm Apollinaris de Kostrowitsky (1880-1918). French poet (naturalized 1914) of Polish-Italian parentage. A. went to Paris in 1898, becoming a leader of the revolutionary artistic and literary movements there. In 1908 he joined the Groupe du *Bateau-Lavoir centred upon Picasso and Braqume and the same year introduced Léger to the group. With publ. in 1913 of his poems Alcools and the essay Les Peintres cubistes (Cubist Painters in Documents of Modern Art, vol. i, ed. R. Motherwell, 1944) his importance as poet and publicist became obvious. His poetry broke with all traditions and disciplines, in subject matter, style, punctuation and typography and Les Peintres cubistes helped define the new school in painting. Works include his collected poems Calligrammes (1918) and the play Les Mamelles de Tirésias (1917) which he described as 'une drame surréaliste'. A. christened *Orphism and *Breton and Philippe Soupault adopted the term *Surrealism in homage to him.

Apollodoros (5th c. BC). Greek painter famous for panel as opposed to wall paintings and called 'skiagraphos' ('the shadow painter') because he introduced shading into his work to

achieve more naturalistic effects. He also experimented with foreshortening.

Appel Karel (1921—). Dutch painter. He travelled widely in Europe, becoming in 1948 a leader in the Dutch Reflex group which, in 1948, became the international *Cobra group. His hall-marks are violent colours and an impassioned style stemming from Van Gogh and the Expressionists.

Applebroog Ida (1929-). U.S. artist living and working in N.Y.C. Having first worked in *performance, film and sculpture, since 1974 she has emerged as one of the most serious and interesting U.S. feminist *Postmodern painters. Her cartoon-like drawings in separate panels, using ink and rhoplex on parchment-like stiff vellum, were an offshoot of *Conceptual art she uses words and pictures which appear to be, yet defy, narrative. In these, as in her large multi-panel paintings, sometimes freestanding two-sided canvases, as well as on the wall, e.g. the series 'Marginalia' (1991), A. deals with issues of power/powerlessness, alienation, 'the failure of individuals to connect', public vs. private feelings, disaffection, rejection, humiliation and what amounts to the near-breakdown of communication in our society. Her technique, using the palette knife to build up the dominant images in muted browns, reds and yellows, is contrasted to the smaller, often repetitive, scenes drawn like comic strips around the main image.

Appropriation art. The direct duplication, copying or incorporation of an image (painting, photograph, etc.) by another artist who represents it in a different context, thus completely altering its meaning and questioning notions of originality and authencity.

Apt Ulrich or Abt, the Elder. Late 15th- to early 16th-c. German painter. His works include the *Matthäus Altarpiece* and the dramatic and experimental *Lamentation over the Dead Christ*, both in Munich. The *Portrait of a Young Man*, discovered in the 19th c., was remarkably like A.'s work but showed the initials 'L.S.' on a piece of armour. A.'s best works were reattributed to 'L.S.' until it was recently shown that the initials were simply those of the armourer.

aquarelle (Fr. watercolour). A painting executed in transparent watercolour. The term is sometimes applied to delicate music.

aquatint. *Engraving technique whereby the etching plate is coated with porous resin

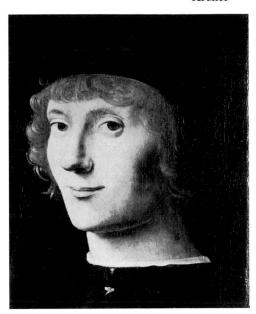

Antonello Portrait of a Young Man c. 1470

resulting in prints with granulated effects, giving impression similar to wash drawings.

Arakawa Shusaku (1936—). Japanese painter living in N.Y., best known post-1970 for his paintings of words on large canvases, which function as symbols of images.

Arawak. Aboriginal people of the Caribbean, now extinct, whose art survives in cult images of wood, stone, bone, shell and clay. Although the figures are highly stylized, details of face, torso and joints are realistically rendered. The figures were embellished with gold ornaments.

archaic. In Greek art, the period *c.* 700–480 BC, especially in sculpture, e.g. the *kouroi* and *korai* (nude youths and draped girls) from the Acropolis. Figures are stiff and formalized (Egyptian influence) gradually becoming more naturalistic. In vase painting the a. period includes Corinthian, Attic black-figure and the earliest red-figure, in architecture early Doric (e.g. Paestum) and early Ionic (e.g. 1st temple of Artemis at Ephesus).

Archer Frederic Scott (1813–57). British photographer who in 1851 invented the colodion negative, thereby replacing the daguerreotype. He was also a sculptor.

Archipenko

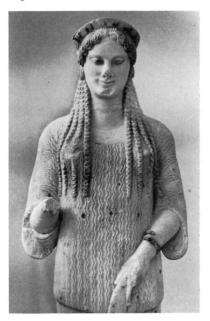

Archaic Marble Kore c. 510 BC

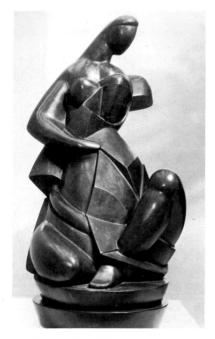

Archipenko Seated Mother 1911

Archipenko Alexander (1887–1964). Sculptor born in Kiev. He went to Paris in 1908 and soon made contact with the Cubists; his work was among the most important in the development of the new styles in 20th–c. sculpture. From essentially Cubist premises he evolved new approaches and techniques introducing (1912), for example, collage in sculpture, i.e. using wood, metal and glass, etc., on the same work. His *Boxers* (1913) is an important landmark in the assimilation by modern sculptors of the vitalist nature of primitive art.

architectonic. Term used metaphorically of a work of art with a structural pattern reminiscent of architecture in its rhythm and balance. The term is often applied to contrapuntal music where repeated themes, references and recollections of earlier material accumulate to give an effect of balance and a sense of architectural structure. The themes themselves often have a similar coherence.

Arcimboldi Giuseppe (1537–93). Milanese painter sometimes considered an ancestor of the Surrealists by virtue of his fantasy portrait heads; these are made up of fruit, vegetables, flowers, fragments of landscape, birds, animals, human bodies, tools, weapons, etc. Worked (in conventional style) at Milan cathedral and as painter to the Hapsburg court at Prague (1562–87).

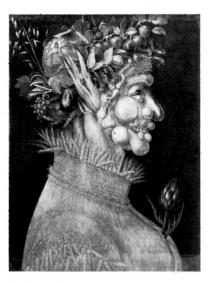

Arcimboldi Summer 1563

Ardizzone Edward Jeffrey Irving (1900–79). British artist in etching, lithography, pen drawing and watercolour. He was an official war artist (1940–5). He ill. more than 130 books, including children's books, e.g. *Tim All Alone* (1956), and an edition of Villon's poems and publ. *Diary of A War Artist* (1974).

Arentsz Arent (1585/6–before October 1635). Dutch landscape painter. Like H. Avercamp's, his landscapes are heavily populated with figure groups.

Arikha Avigdor (1929—). Israeli painter, print maker and writer on art. Born in Bukovina, he has lived and worked in Paris since 1954. A. is one of the most original and accomplished living figurative artists who 1st became known as an abstract painter. He stopped painting in 1965 and drew from life until 1973. A. has curated exhibitions and written on Poussin, Ingres, etc.

Aristides (4th c. BC). Greek painter renowned for the pathos of his figures. His most famous painting showed a dying mother in a conquered city shielding her baby from the blood on her breast.

Arman Armand Pierre (1928—). Franco-American *assemblage artist, a member of the *Nouveau réalisme group, influenced by *Klein. He worked on series like poubelles (trash

cans, displaying their contents) and accumulations (e.g. a cube 1m. cubed in volume full of toothbrushes), which are ironic statements about the detritus of the consumer society. *décollage, *Rotella, *Villeglé, *Hains and *Vostell.

armature. Metal framework used in modelling and sculpture to support the clay or other material and prevent it sagging or collapsing.

Armitage Kenneth (1916—). British sculptor. In 1956 he won a competition for a war memorial at Krefeld. He was shown in the 1963 Darmstadt exhibition 'Evidences of Anxiety in Modern Art'. A. works almost entirely in plaster cast into bronze, concentrating on achieving an effect of movement and vitality in his figures, notable in the Walking Group (1951). His works include the Figure Lying on its Side, No. 5 (1959) and Pandarus 8 (1963).

Armleder John Michael (1948—). Swiss artist known for combining pictures (of simple and random designs with references to formal abstraction) and objects (furniture, anonymous consumer articles and musical instruments) which interact in *installations, e.g. 'Furniture Sculptures' of the 1980s.

Armory Show (17 February–15 March 1913). Highly influential international exhibition of over 1100 works by modern artists held in

Arman Accumulation de Brocs 1961

Armstrong

N.Y. at the armoury of the 69th Regiment. Fauvists, Cubists and other Paris-based artists received their first proper showing in the U.S.A. and the exhibition had a major impact on U.S. art and criticism. The A. S. was organized by the Association of American Painters and Sculptors and supported by the group The *Eight. It subsequently moved to the Art Institute, Chicago.

Armstrong John (1893–1973). British painter, a member (1933) of the *Unit One group. A.'s style, partly influenced by Surrealism, includes murals and theatre designs.

Arnolfo di Cambio (c. 1232–1302). Italian sculptor and architect. Assistant to N. Pisano both on the shrine of S. Dominic in Bologna and the pulpit at Siena. His statue of Charles of Anjou (before 1277) is the 1st modern portrait statue by a known artist and the design of his wall tomb of Cardinal de Braye (the cardinal lies on a bier beneath the Madonna and Child in glory) was a model for over a c. A. was an architect of the cathedral of S. Maria del Fiore and the church of S. Croce, both Florence, and also carved the sculptural decoration on the cathedral facade

Arp Jean or Hans (1888-1966). Alsatian sculptor, graphic artist, painter and writer. He exhibited with Der *Blaue Reiter artists and contributed to Der Sturm, and his interest in poetry inspired a great deal of his graphic work. In 1915 he moved to Zürich and, together with his wife. Sophie Taeuber, started to make *collages according to the 'law of chance'. In 1916/17 he made his 1st abstract sculptures; he participated in the Dada movement and the 1st Surrealist exhibition in 1925. In addition to sculptures, reliefs (one at the Unesco building in Paris), collages and drawings, A. also designed tapestries and wrote much, both poetry and prose in French and German. His works are usually or near abstract but nevertheless identify themselves quite clearly with natural forms.

Arpino Giuseppe Cesari (called 'Chevalier d'Arpino') (1568–1640). One of the last and most conservative of Italian Mannerist painters. He designed the mosaics for the dome of St Peter's, Rome, and painted the frescoes in S. Martino, Naples (1589–91), and a series of large histories in the Conservatori Palace, Rome (1591–1636). Caravaggio was his pupil.

Arp Earth Forms 1916-17

Arroyo Eduardo (1937-). Prolific Spanish artist, based in France and Italy until Franco's death in 1975, whose politically and culturally radical targets were not only political conservatism but also new art orthodoxies. He attacked *Duchamp (Live and Let Die: The Tragic End of Marcel Duchamp, 1965) and the *Nouveau réalisme group, *Miró and *Dali. Co-founder of the Salon de la Jeune Peinture in 1963. A.'s aim was to create 'art that engages the spirit of art more than its vocabulary', a statement which characterizes all his activities. In solidarity with Cuban intellectuals, he and other members of Jeune Peinture painted a mural in homage to the Cuban Revolution and organized a 'Salle Rouge pour le Viêtnam'. In 1968 they started the Atelier Populaire at the École des Beaux-Arts, Paris, producing more than 300,000 posters. A.'s passionate commitment to radicalism informs his idiosyncratic, often autobiographical, work, which also has great formal qualities recognized widely after the 1980s.

Ars moriendi (Lat. art of dying). Title of a famous block-book of a popular devotional character printed in Germany c. 1465. The earliest British version *Ars moriendi, that is to saye the craft for to deye for the helthe of mannes sowle* was printed by Caxton c. 1491.

Art & Language. In 1968 the British artists Terry Atkinson, David Bainbridge, Michael Baldwin and Harold Hurrell founded the Art & Language Press. In 1969 they launched their magazine *Art-Language* which presented art

theory as *Conceptual art. The A. & L. group's views became influential in the U.S.A. and Europe.

Art Brut. Term coined by *Dubuffet for art made by untrained people. *Outsider art.

Arte Povera (It. impoverished art). Term coined by the Italian critic Germano Celant in 1968 to describe post-*Minimalist art produced in the late 1960s with 'humble' and commonly available materials, such as sand, wood, stones and newspaper. Some of the artists associated with A. P. were *Anselmo, *Fabro, G. Paolini and *Pistoletto.

Art Nouveau. A style of decoration and architecture current in the 1890s and early 1900s. The name derives from a gallery for interior decoration opened in Paris in 1896, called the 'Maison de l'Art Nouveau': the same style in Germany is called 'Jugendstil' after a magazine called Die Jugend (Youth) and in Italy 'Floreale' or 'Liberty' after the London store. Characteristic decorative motifs are writhing plant forms, as in the wrought-iron entrances to Paris Métro stations (by Hector Guimard). Similar forms were used both in book ills and also in the applied arts, e.g. furniture or glassware of the French artist Emile Gallé and of Louis Tiffany in the U.S.A. The best-known graphic artist is A. Beardsley, whose sinister line drawings were exceptionally well adapted to book ill. The architectural movement was widespread, leading figures being C. R. Mackintosh, and Antoni Gaudí in Barcelona, whose work has a bold fantastic style. Interior decorators include Samuel Bing (Germany), Victor Horta and Henry Van de Velde (Belgium).

Artschwager Richard (1923). U.S. painter and sculptor. While at Cornell University, Ithaca, N.Y., where he read chemistry and biology, he took painting and drawing classes. He then studied with *Ozenfant 1949–50 before temporarily turning away from painting. In N.Y. he ran a woodwork studio where he started making furniture. In the 1960s he became involved with art full time and continued to explore the theme of furniture through 3-dimensional constructions of painted or polychrome wood. A. also paints large, usually monochrome depictions of interiors, buildings and objects on celofex.

Asam Cosmas and Egid, sons of the Bavarian painter Hans Georg (1649–1711), were church

Artschwager Table with Pink Tablecloth 1964

decorators and designers in whose work S. German Baroque achieved its zenith. Cosmas Damian (1686-1739) was a painter and architect of the monastic church of Weltenburg (1717-21). In his painting illusionism is carried to its furthest extremes, e.g. his frescoes in the church of Maria Viktoria, Ingolstadt (1736), and the Alteglofsheim Palace in Brevnov (1730). His use of light colours tends to the style of Rococo. Like his brother he held high positions in S. German courts. Egid Quirin (1692-1750) was stucco-worker, sculptor and architect; his churches include the collegiate church at Rohr (1718-25) and St Johann Nepomuk (called the Asam) church, Munich (1733-c. 1750), although Cosmas may have helped in the latter. All his sculpture of any importance is designed for churches and his best works are his altarpieces, e.g. the Assumption of the Virgin at Rohr and the St George at Weltenburg. The brothers worked in such harmony that it is usually difficult to distinguish their work. They were employed to redecorate Romanesque or Gothic churches (as at Freising cathedral, 1723/4, or St Emmeram's church, Regensburg) but their masterpiece is the S. Johann Nepomuk church, Munich, where painting, sculpture, stucco and architecture serve the illusive confusion of the real and imaginary worlds (*Baroque).

Ashanti. A people of Ghana. The gold encrusted stool, former symbol of A. royalty, was the most renowned example of A. metal work. Bronze was used for ritual urns, *kuduo*, and gold weights – human or animal figurines of proverbial subjects. The disc-headed fertility dolls,

Ashcan school

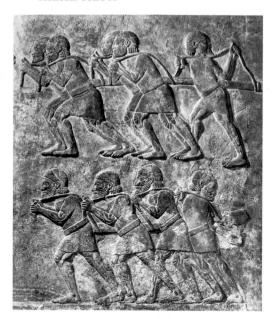

Assyrian art Slaves unloading timber (relief from the Palace of King Sargon II) 721-705 BC

akua'ba, are the best-known examples of A. wood carving.

Ashcan school. Name given in the 1930s to early 20th-c. U.S. realist painters including some members of The *Eight – Bellows and Jerome Myers – because of their preference for painting the unattractive aspects of city life.

Asselyn Jan (1610–52). Dutch painter. After visiting Rome he began to paint Italianate landscapes in the manner of Claude Lorrain, being one of the 1st in Holland to do so. His best-known, though not his most characteristic, work is *The Angry Swan*, an allegory of Dutch independence.

assemblage. A process comparable to *collage in which the art object is built up from 3-dimensional found materials. *combines and *readymades.

Assisi. Town in Perugia, Italy; the birthplace of Sextus Propertius and St Francis of A. On Monte Subasio are the Franciscan monastery and the lower and upper churches of St Francis, built 1228–53 in Gothic style. The lower contains frescoes over the high altar by Giotto, illustrating the vows of the Franciscan order, and others

attributed to Cimabue; the upper, frescoes by Giotto and pupils showing scenes from the life of St Francis. The oratory (or *Porziuncola*) of St Francis and the cell in which he died are in the church of Santa Maria degli Angeli which was built round them (1569–79; rebuilt after 1832). The basilica at A. was begun *c.* 1132.

Assyrian art. A. a. is predominantly represented by sculpture from the palaces of imperial rulers (883–612 BC). Conspicuous are colossal portal-figures of winged bulls or lions and a wealth of mural relief carvings in stone. Documentary or narrative scenes show foreign exploits of the king's armies or victory celebrations, followed by relaxation in hunting: all depicted with unparalleled stylistic vitality. Fine craftsmanship is also evident in the carved ivory enrichment of furniture, where Phoenician designs are reflected but later surpassed in grace and refinement.

atelier (Fr. studio). Used of a painter's or sculptor's studio or collectively of the pupils gathered round a master. Atelier libre (or sometimes académie) is a studio in which a model is provided but no tuition given. Famous paintings of a.s are Courbet's Atelier du peintre (1855), painted as an allegorical manifesto of Realism, and Fantin-Latour's L'Atelier des Batignolles or Hommage à Manet (1869) showing Manet with Renoir, Monet, Bazille, Zola, etc.

Atelier 17. Founded in Paris in 1927 by the British engraver S. W. Hayter for research into new graphic techniques. It became one of the most influential schools for graphic art.

Atkinson Lawrence (1873–1931). British painter, sculptor, writer and musician. Worked 1st as a painter, and later concentrated on sculpture. He was among the signatories of the *Vorticist Manifesto published in **BLAST*, No. 1, 1914.

Attiret Jean-Denis (1702–68). French painter who in the 1730s became a Jesuit and went as a missionary to China where he became court painter at Peking. His later work is in the Chinese manner.

Audubon John James (1785–1851). U.S. naturalist and artist who painted from life 435 watercolours of birds, often in action, which were reproduced in coloured aquatint by Robert Havell Jr. and publ. in London as *The Birds of America* (4 vols, 1827–38); only these prints survive. The text, written with the help of William MacGillivray, was publ. separately as

Audubon The whip-poor-will from *The Birds of America* 1827–38

Ornithological Biography (5 vols, 1831–9). A.'s paintings have considerable artistic merit although their scientific accuracy varies.

Auerbach Frank (1931–). Born in Berlin, he moved permanently to Britain in 1939. A. studied at St Martin's School of Art, London, and at the Royal College of Art. He was taught and influenced by *Bomberg who encouraged him to look back, beyond Cubism, to Cézanne. His work is modern, but in the tradition of Géricault, Delacroix, Ingres, Courbet and Daumier; he is one of the most accomplished figurative artists of his generation. His subjects are portraits of friends, and landscapes.

Augustin Jacques-Jean-Baptiste (1759–1832). French miniaturist who revived the art in France; his paintings have strong, pure colours, certainty of execution and high finish.

Australian Aboriginal art. This consists largely of paintings and carvings on rock, carvings on body ornaments and cult objects such as churingas and bull roarers, and bark paintings. Abstract styles, e.g. spiral designs, and naturalistic styles are found. Human figures and animals, such as fish, turtles and kangaroos, connected with the hunt or with totemic beliefs, are depicted. Melanesian influences through New Guinea may account for the squatting figure motifs, rich colouring and other aspects of paintings in N. Arnhem Land and N.W. Australia. The huge wondjina ancestor-skull pictures depict dark-haloed heads without mouths. Animals are shown realistically and also in 'X-ray' style, where the skeleton and organs of interest to the hunter are depicted schematically within the body outline. There is a rich oral tradition of myth, relating the ancestral time, 'The Dreaming', to the present in an unbroken continuum.

Automatism. In writing or painting, the suspension of the control of reason allowing the release of subconscious imagery. It is chiefly associated with Surrealism and defined in *Breton's Manifeste du Surréalisme (1924) as

Australian Aboriginal art Bark painting (by Mathama in traditional Arnhem Land style) *ε*. 1940

Automne, Salons d'.

'pure psychic automatism'. It was subsequently developed by the *Abstract Expressionists.

Automne, Salons d'. Opened in 1903 with an exhibition of Gauguin's works which was influential on younger artists. The Salons d'Automne was established by the *Fauve artists, as an annual exhibition by, among others, Matisse, Bonnard and Marquet.

Avant-garde (Fr. vanguard). Term applied to the group of artists, writers, etc. thought at any given time to be most 'advanced' in their techniques or subject matter.

Aved Jacques (1702–66). French portrait painter who studied in Amsterdam and unlike his French contemporaries usually painted his subjects in their normal dress and surroundings. He urged his friend *Chardin to take up portraiture and their work has sometimes been confused.

Avercamp Hendrik (1585–1634). Dutch landscape painter who specialized in winter landscapes with numerous tiny figures.

Avery Milton Clark (1893–1965). U.S. figurative artist who continued and developed Matisse's abstracting tendencies and flat colour masses. Starkness of presentation and force and clarity of images in works like *Mother and Child* (1944), *Swimmers and Sunbathers* (1945),

organized in areas of pure colour, anticipate the *Abstract Expressionists: he was greatly admired by *Gottlieb, *Hofmann and *Rothko.

Avignon school. 15th-c. French school of painting of which the leading known master was *Quarton and the outstanding work the beautiful and austere anon. *pietà. The school represents the final flowering of Avignon's 14th-c. cultural ascendency during the papal exile.

Aycock Alice (1946—). U.S. sculptor. She studied under R. *Morris and developed an interest in architecture and ancient sites (e.g. Maze, 1972) transposed to contemporary situations, e.g. The True and False Project Entitled 'The World is So Full of a Number of Things' and Project Entitled 'The Beginnings of a Complex' (both 1977). A. later studied machine forms and mechanical forces and created large-scale *installations, e.g. The Savage Sparkler (1981) and Tower of Babel (1986).

Ayrton Michael (né Gould) (1921–75). British figurative sculptor, painter, graphic artist, writer and critic. A.'s chief preoccupations were with the Greek myths of Daedalus, the Minotaur and the Delphic oracle, and the composer Berlioz. A.'s numerous books include: *Testament of Daedalus* (1962), *The Rudiments of Paradise* (1971) and *The Minos Consequence* (1974).

Aztec art. *Pre-Columbian art

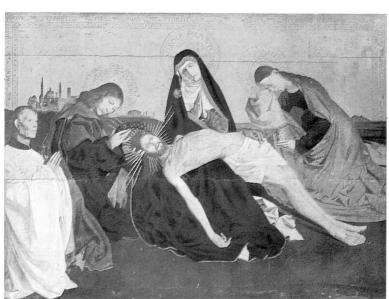

Avignon school Pietà 15th c.

\mathbf{B}

Baader Johannes (1876–1955). One of the founding members of the Berlin *Dada group. He made primarily *collages and *photomontages (e.g. *Dada Milchstrasse*, 1918–20).

Baan Jan van (1633–1702). Dutch portrait painter who visited the court of Charles II of England.

Baburen Dirck van (c. 1590–1624). Dutch painter, one of the principal members of the *Utrecht school. For a short period he worked in Rome, where he was affected by the work of Caravaggio; he was one of the first to introduce Caravaggio's *chiaroscuro* technique into the Netherlands. *Tenebrist.

Bacchiacca Francesco Ubertini (1494–1557). Florentine painter, probably a pupil of Perugino but with an eclectic style most heavily influenced by Andrea del Sarto. B. painted religious subjects and decorative panels for walls or furniture, and designed tapestries.

Baciccia (Baciccio). Nickname of Giovanni Battista Gaulli (1639–1709), one of the finest Italian Baroque portrait painters and decorators. His style was influenced by Rubens and Van Dyck. Working in Rome, where he was a friend of Bernini, he produced masterpieces of illusionist decorative work, notably the ceiling of the church of Il Gesù (1668–83).

Backer Jacob Adriaensz (1608–51). Dutch portrait painter and pupil of Rembrandt whose influence on him was strong. He was also influenced by the work of Hals.

Backhuysen Ludolf (1631–1708). Dutch painter chiefly of marine subjects, whose *Boats in a Storm* may have influenced Turner. Peter the Great of Russia took some lessons from B.

Backof(f)en Hans (d. 1519). German late Gothic sculptor, from 1505 active in Mainz. His work includes the tomb of Archbishop Uriel von Gemmingen (Mainz cathedral) and Crucifixion groups in the churchyards of St Peter's and the cathedral, Frankfurt.

Bacon Francis (1909–92). Born in Dublin of British parents, he moved to London in 1925, and soon after left Britain to live in Berlin and Paris. He settled permanently in London *c*.

Francis Bacon Pope II 1951

1928-9. After working first as an interior designer, he began to paint c. 1930 without formal training, and without much success at first. But ever since 1944 with his Three Studies for Figures at the Base of a Crucifixion, he has held the central position in British painting and world figurative art. His paintings are usually of a male or female figure set in an enclosed interior space. The scenes depicted with distorted figures in action often seem disturbing and are frequently presented in three panels, as triptychs – a format B. has virtually invented in modern painting - relating in formal rather than narrative manner. Often ideas for pictures originate in an existing visual source: X-ray photographs, Eadweard Muybridge's sequential studies of figures in motion, photographs and film stills. B.'s response to the art of the past which he admires deeply is for the paintings of Rembrandt, Velazquez and Goya (e.g. the series of screaming popes which he began in the mid-1950s based on Velazquez's portrait of Pope Innocent X, which are also related to the 'still' of the screaming nurse in Eisenstein's film

Bacon

The Battleship Potenkin, and the detail of the woman screaming in Nicolas Poussin's The Massacre of the Holy Innocents). B.'s paintings are not, however, solely about subject matter; he is a perfectionist concerning technique, seeking a balance between chance and order in the way images are built up 'accidentally' from the application of paint on canvas.

Bacon John (1740–99). British porcelain modeller and sculptor. He began working in marble in 1763 and improved the method for transferring the design of the clay model to the stone. He became a fashionable society sculptor of tombs and monuments, e.g. the Chatham monument in Westminster Abbey.

Bad art. *Neo-Expressionism

Badger Joseph (1708–65). American colonial painter. His style combines *primitive elements with the academic post-Kneller tradition of *Smibert and *Feke. His works include *The Rev. Jonathan Edwards* and *Mrs Cassius Hunt*.

Baglione Giovanni (c. 1573–1644). Italian late Mannerist painter and the author of a history of art in Rome during his lifetime, *Le vite de' pittori, scultori ed architetti* ... (1642). In spite of the hostility he expressed towards Caravaggio, his own painting c. 1600 acquired a superficial likeness to Caravaggio's. He was one of the artists commissioned by Pope Paul V to paint frescoes in the church of S. Maria Maggiore, Rome.

Baily Edward Hodges (1788–1867). British sculptor. He studied under *Flaxman. Carved reliefs on Marble Arch, London, and Nelson's statue at Trafalgar Square, as well as numerous busts.

Baj Enrico (1924—). Italian painter and maker of *assemblages incorporating *found objects, and combining humour and grotesque imagery.

Bakst Léon (1866–1924). Russian artist and stage designer. After studying in Paris (1893) he returned to St Petersburg, where with *Benois and S. Diaghilev he collaborated on the magazine Mir Iskusstva (The *World of Art). In 1909 he went to Paris and joined Diaghilev's Ballets Russes. Here his sets for the ballets Cléopâtre (1909) and above all Schéhérazade (1910) caused a sensation. B.'s designs, characterized by throbbing colours and exotic line, were the first to integrate costumes and sets into a visual unity. Other designs were for Nijinsky's ballet Le

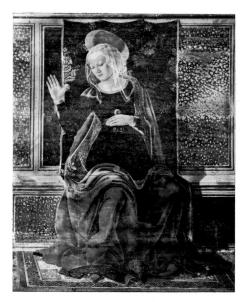

Baldovinetti *The Virgin* (detail from *Annunciation* fresco) 1460–2

Spectre de la rose (1911), G. D'Annunzio's play La Pisanella and the ballet The Sleeping Princess (1921).

Bakuba also called Bushongo. African tribal people of the Congo-Kinshasa, noted for one of the finest of African sculptural traditions. Outstanding are a series of royal portrait woodcarvings of which the most famous is that of the 16th-c. king Shamba Bolongongo.

Baldessari John (1931–). U.S. artist who makes expansive use of media imagery from photographs, videos and film, sometimes associated with *Conceptual and *Postmodern art. B. has said that he wants 'to produce images that startle one into recollection'.

Baldinucci Filippo (c. 1624–96). Florentine art historian. In the course of his studies he made a huge coll. of drawings (now in the Uffizi) and used documents more than Vasari had done. His chief work was *Notizie de' professori del disegno* ... (1681–1728), which covered the period 1260 to 1670.

Baldovinetti Alesso (c. 1425–99). Florentine painter; studied under Domenico Veneziano. His surviving masterpiece, the fresco of the *Annunciation*, S. Annunziata, Florence, shows his interest in landscape, the serenity of his figures

and the sensitivity of his colour. B. executed work in stained glass and mosaic. He influenced Ghirlandaio.

Balduccio Giovanni da (fl. 1315–49). Italian sculptor from Pisa.

Baldung (Grien) Hans (c. 1480–1545). German painter and graphic artist. He was influenced by Dürer, under whom he probably studied, and indeed in his portraits he showed a psychological insight and mastery of drawing comparable to his master's. Besides portraits he painted allegorical subjects and, like Cranach, a series of female nudes; but his fame rested on his religious paintings, and the altarpiece *The Coronation of the Virgin* (1512–16), in the cathedral at Frieburg im Breisgau, is still considered his masterpiece. His paintings are characterized by their unusual colour combinations and his woodcuts by their inventiveness, fantasy and grotesque humour. He also designed for stained glass.

Balen Hendrik van (1575–1632). Antwerp painter of small and charming landscapes,

Baldung Harmony 1529

Balla Dog on a Leash (detail) 1912

allegorical, biblical and mythological scenes. He collaborated with J. Bruegel the Younger, Momper and Vranckz. Van Dyck and Snyders were his pupils.

Balestra Antonio (1666–1740). Italian late Baroque painter, pupil of *Maratta. He worked chiefly in Venice and Verona and was influential as a teacher.

Ball Hugo (1886–1927). German painter and poet who went to Switzerland at the beginning of World War I. He was one of the founders of the *Dada movement and ed. of the 1st Dada review, *Cabaret Voltaire*. In 1917 he quarrelled with *Tzara and left the movement.

Balla Giacomo (1871–1958). Italian painter, a founder of *Futurism; one of the signatories of the Futurist Manifesto (1910). On a visit to Paris (1900) he was strongly affected by the Impressionist and Divisionist painters. B.'s Dog on a Leash (1912), as an attempt to present motion by superimposing several images, is a logical exposition of Futurism; but his pictures developed towards abstract art, increasingly resolving into abstract lines of movement and force.

Balthus full name Balthasar Klossowski de Rola (1908–). French painter of Polish descent. His early work owed much to *Bonnard and the *Nabis. Later, under the influence of Courbet and Derain, he developed a style which is naturalistic and yet modern, with occasional Surrealist overtones. Using muted colours, B. has produced remarkable landscapes, portraits and interiors with erotic scenes of adolescent girls.

Baluba

Balthus Sleeping Girl 1943

Baluba. Complex of African tribal peoples of Congo-Kinshasa. They are noted for their carvings of which the wooden ancestor figures by the sculptors of the central Hemba tribe are outstanding. Also important are stools supported by carved kneeling female figures; seated female figures holding bowls, notably examples from the N.E. village of Buli; and hemispherical *kifwebe* masks.

Bambara. W. African people, settled on the Upper Niger in the modern state of Mali, noted for their carving. The *tijiwara* ritual headdresses, used in the antelope dance, are especially prized.

Bambocciata (It. jest). A genre of painting which deals with peasant life and bawdy scenes. 17th-c. Dutch and Flemish artists were particularly given to it.

Bamboo painting. *Chinese art

Bandinelli Baccio (sometimes called 'Bartolommeo') (1493–1560). Florentine sculptor, painter and goldsmith. The much-hated rival of B. Cellini and in his own opinion the equal of Michelangelo. He executed a series of reliefs in Florence cathedral and founded 2 of the earliest *academies.

Banks Sir Thomas (1735–1805). British sculptor who went to Rome (1772–9) and was among the 1st British sculptors of Neoclassicism. His most famous works were the *Thetis* and the monument to the dead child Penelope Boothby.

Barbari Jacopo de' (c. 1450–1515/16). Venetian painter and draughtsman, perhaps of German origin, chiefly remembered as an engraver of mythological and sacred subjects. He worked for

some time in Germany and the Netherlands where he was known as 'Jacob Walch'. His work was a link between the Italian and northern schools. He is credited with instructing Dürer in the mathematical proportions of the human figure.

Barbatelli Bernardino. Bernardino *Poccetti Barbieri Giovanni Francesco. Il *Guercino

Barbizon school. Group of mid-19th-c. romantic landscape painters who, led by T. Rousseau and J.-F. Millet, settled in the village of Barbizon in the forest of Fontainebleau. In opposition to academic conventions they painted the 'paysage intime', undramatic details of the countryside or peasant life. They were influenced by 17th-c. Dutch landscapists and Constable, and were forerunners of the Impressionists. Other members of the school included N.-V. Diaz, J. Dupré and G. Daubigny.

Bark painting. Technique of Oceanic and particularly *Australian Aboriginal art. Traditional styles, both naturalistic and schematized, matched those used in rock painting, except for

Barbari Mars and Venus before 1504

Barlach Man Putting On His Coat c. 1918

the polychrome lozenge hatching of the socalled spirit pictures'. B. p. is now made on a commercial basis.

Barker Thomas (1769–1847). British landscape painter known as 'B. of Bath' (where he lived from 1793). Many of his paintings were reproduced on pottery.

Barlach Ernst (Heinrich) (1870–1938). N. German sculptor, wood-carver, draughtsman and writer associated with Expressionism. He was at the Dresden Academy (1891–5), and Paris (1895–6); in 1906 he visited Russia, in 1909 Florence. Russia shaped him: it was, for him, a land where symbol met reality. The Russian beggar symbolized and presented the truth about man; B.'s statements on human suffering, humiliation, callousness, are in terms of peasant life. The medieval associations of his work gained him a commission for sculptures at St Catherine's church, Lübeck, but the Nazi government, which destroyed many of B.'s public statues, stopped the work. Between 1898

and 1902, he ill. *Die Jugend* magazine. B.'s writings include the plays *Der tote Tag* (1912), *Die Sundflut* (1924) and his autobiography (1928).

Barlow Francis (1626?–1702). British painter of animal and sporting subjects. He ill. Mrs Aphra Behn's trs. of Aesop (1666).

Barna (da Siena) (mid-14th c.). Sienese painter influenced by Duccio and Simone Martini, and notable for his highly dramatic style. The frescoes on the life of Christ in the Collegiata at S. Gimignano are his main work; according to Vasari he was killed in a fall from the scaffolding while painting them.

Barnaba da Modena (fl. 1362–83). Italian painter of the Byzantine tradition whose work was influenced, but only slightly, by Giotto.

Barocci Federico (1526–1612). Italian Mannerist painter who worked mostly in his native town of Urbino but also in Rome and elsewhere. His style went beyond *Mannerism and influenced 18th-c. French painters.

Baronzio Giovanni (mid-14th c.). Italian painter working at Rimini although there are also frescoes of his at Ravenna and Tolentino. B. was heavily influenced by Cavallini and Giotto.

Baroque (perhaps from Portuguese barroco: a misshapen pearl). A term, at first of abuse, applied to European architecture and painting of the period approximately 1600 to 1750. B. architecture was at its height in Rome under Bernini and Borromini (c. 1630-80) and in S. Germany (c. 1700–50) under Balthazar Neumann and Fischer von Erlach. The building was planned round a series of geometrically controlled spaces - circles, squares and ellipses, within, imposed upon, adjoining one another, rhythms of convex against concave curves, exterior lines contrasted or harmonized. The actual structure forced to conform to these patterns was heavily decorated with relief and stucco-work and free-standing sculpture, which burst in upon and receded from the interior space. All the arts were enlisted and impinged on each other, painting was highly illusionistic, sculptors such as Bernini made full use of the play of light on surface and contour. The ensemble made a theatrical and emotional assault on the spectator, enmeshing him in a spatial geometry whose lines are never still, leading him from one enclave to the next, involving him in the drama depicted in the picture or relief, confusing the spatial domains

of art and reality. B. became more and more heavily ornate and gradually gave way to the lighter and more restful style of Rococo; in Spain it lapsed into the extravagances of churrigueresque, called after the architect José de Churriguera. B. art was intimately bound up with the Counter-Reformation and in particular the Jesuit order. The involvement of the spectator in the church fabric itself and the religious narratives portrayed on its walls had an intentionally evangelistic aim. Jesuit missionaries carried the style wherever they went and established it in S. America, particularly, as the dominant style in European architecture: a position it held there until the late 19th c. In music the term is used loosely of the period between Monteverdi (d. 1643) and J. S. Bach (d. 1750).

Barr Alfred Hamilton (1902–81). U.S. art historian and author who as director of M.O.M.A., 1929–43, and director of collections, 1947–67, exerted a prominent influence on the cause of international modern art. Publications include *Cubism and Abstract Art*, 1936; *What is Modern Painting?*, 1943; *Picasso; Fifty years of His Art*, 1946, and *Matisse: His Art and His Public*, 1951.

Barret the Elder, George (d. 1784). Irish landscape painter and engraver who settled in Britain in 1762 and became a foundermember of the R.A. By painting picturesque scenes on private estates he ensured his success with noble patrons. His son George B. the Younger (d. 1842) was a watercolourist of ideal landscapes.

Barry James (1741–1806). Irish history and portrait painter. Patronized by Burke, he studied in Italy and in 1782 became a professor at the R.A. He was expelled in 1799 for attacks on other members and on the memory of Reynolds, and died destitute.

Bartlett Jennifer (1941–). U.S. artist who in her most prominent work from the late 1960s used the serial structure as her main theme (e.g. Rhapsody, 1975–6, which consisted of 988 enamel-on-steel plates assembled and mounted on a wall, combining abstraction with decoration, each panel painted in a different style and with different imagery). B.'s later works show the utilization of drawing, often on a large scale, with charcoal, crayon, pencil, pen and brush, watercolour, pastel and gouache, e.g. In the Garden (1981). She painted the murals

Atlantic Ocean and Pacific Ocean (1984) for the staff dining room of Philip Johnson's AT & T headquarters in N.Y. and was given other large-scale commissions, e.g. Volvo headquarters in Sweden. B.'s most recent work has been constructions which relate to and echo paintings, placed on the floor beneath them, e.g. 'Luxembourg Gardens' series (1985).

Bartoli Taddeo. *Taddeo di Bartolo

Bartolo di Fredi (c. 1330–1410). Sienese painter, pupil of A. Lorenzetti. His best 2 fresco cycles are at S. Gimignano, one dealing with Old Testament subjects in the Collegiata (1356) and one in the church of S. Agostino on the birth and death of the Virgin (1366).

Bartolommeo Fra (1472-1517). Florentine painter and draughtsman. As student under Cosimo Rosselli he met M. Albertinelli with whom he later often collaborated. B. early inclined to mysticism and, impelled by the preaching of Savonarola, publicly burnt many of his paintings. In 1500 he entered the monastery of S. Marco. He resumed painting in 1504, becoming a close friend of Raphael. He worked in Venice (1507), then with Albertinelli in Florence (c. 1509–12); he then went to Rome. Here he was so overwhelmed by Michelangelo's and Raphael's work in the Vatican that he refused all entreaties to collaborate. B.'s work is distinguished by complex yet controlled composition and by his refined and delicate draughtsmanship and use of colour. One of his finest works is The Virgin Adoring the Child with St Joseph. Late in life he lost something of his delicacy of treatment.

Bartolommeo di Giovanni. *Alunno di Domenico

Bartolozzi Francesco (1728–1815). Italian mezzotint engraver, miniaturist and draughtsman who settled in Britain (1764) and was a foundermember of the R.A. In 1802 he became head of a school for engravers in Lisbon. Through mastery of stipple and crayon and allied techniques B. achieved great softness and luminosity of effect; this together with his elegant tenderness assured him great popularity.

Barye Antoine-Louis (1796–1875). French Romantic sculptor and painter who was the son of a goldsmith. For a time he followed his father's profession producing statuettes of wild animals. This subject interested him all his life and his treatment has the violence of the

Fra **Bartolommeo** The Virgin Adoring the Child with St Joseph late 15th c.

Romantics Delacroix, his friend, and Géricault, though it lacks the verve and panache of their work. He also produced *Napoleon Dominating History and the Arts* (1855–7), on the Pavillon de l'Horloge at the Louvre, and the equestrian statue of Napoleon at Ajaccio (1860).

Basaiti Marco (fl. 1496 1530). Venetian painter, perhaps of Greek origin, and possibly a pupil of A. Vivarini. His early style sometimes resembles that of Giovanni Bellini, but one of his best pictures, The Calling of the Sons of Zebedee, shows Vivarini's influence in the hard outlines of the figures and the unnatural lighting. The term 'Pseudo-Basaiti' was coined to describe paintings not definitely assignable to either Bellini or B., but is now considered an unwarranted invention.

Baselitz Georg (1938–). German artist, one of the leading painters of the *Neo-Expressionist movement who were intent on reviving figurative painting on a monumental scale. Since 1967 B.'s characteristic style relies on painting his images upside down.

Basket Maker. N. American, one of the Indian Anasazi group. Besides the woven containers from which the name is derived, it produced small stone sculptures of wild life. Strikingly

compact in form, they are probably the first stone carvings done in the south-west.

Baskin Leonard (1922—). U.S. figurative sculptor, print maker and teacher. He saw the artist's role as a moral one and his principal theme was the 'landscape of death' that modern man has created. Works include massive figures in stone, wood or bronze such as *The Great Dead Man* (1956). He has collaborated in an illustrative capacity with the poet Ted Hughes.

Basquiat Jean-Michel (1960-88), U.S. painter of Haitian and Puerto Rican parentage who first started making *graffiti with magic-markers on walls of buildings together with a friend, which they signed SAMO. B. also made drawings on paper, painted on T-shirts, sheet metal and other found surfaces and made *assemblages out of iunk. His work quickly became sought-after by influential critics, collectors and artists. By the early 1980s B.'s crayon-and-paint drawings on unprimed canvas, with grimacing African masklike faces and graffiti messages and texts, led to his enormous success. He collaborated with *Warhol, who had befriended him, in paintings and exhibitions. He died from a heroin overdose

ba(s)s-relief (It. *bassorilièvo*). A carved *relief projecting only slightly from its background.

Bassá Ferrer (c. 1290—after 1348). Painter of the Catalan school and 1st major painter of Spain. Until the early 20th c. the only records of him were in the criminal records of the kingdom of Aragon (for rape and other offences). The fresco series in the Franciscan convent at Predalbes (painted 1345/6) is now known to be by him. It shows that B. knew the work of the Sienese school, particularly that of *Martini.

Bassano. Family of Venetian painters working in Bassano. Jacopo (or Giacomo) da Ponte (1510/15–92) first worked under his father, the painter Francesco the Elder (1475–1539), then studied in Venice. About 1530 he returned to Bassano where some of his finest work was done. His portraits and biblical subjects are notable for their realistic landscape settings, which include animals and details of peasant life, and for their colour, influenced by Titian. The best known of his 4 sons are Francesco the Younger (1549–92) and Leandro (1557–1622) whose work closely followed that of their father. Many paintings attributed to Jacopo are the work of his sons.

Bastien-Lepage

Bassá Deposition c. 1345

Jacopo Bassano Portrait of a Bearded Man c. 1535

Bastien-Lepage Jules (1848–84). French painter remembered for his peasant genre scenes such as *The Hayfield*. Although his technique was affected by Impressionism, the sentiment of his work was in the tradition of G. Courbet and J.-F. Millet.

'Bateau Lavoir' was a tenement in Montmartre where *Picasso, Van *Dongen, André Salmon, *Gris and street traders, actors, prostitutes, etc. lived 1904–9. The Parisian avant-garde, e.g. *Apollinaire, *Braque, *Derain, *Kahnweiler, *Matisse, *Dufy, Alfred Jarry and Cocteau, met at Picasso's studio there.

Bat(t)oni Pompeo Girolamo (1708–87). Italian painter, with A. R. Mengs the leading painter in Rome in the mid-19th c. His main output was portraits of travelling foreigners (particularly Englishmen on the Grand Tour) whom he often set in front of classical monuments, but he also painted many religious, historical and mythological subjects. He was ennobled by Maria Therese for his double portrait of the emperor Joseph II and the future Leopold II at their meeting in Rome (1769).

Bauchant André (1873–1958). French 'primitive' painter commissioned by Diaghilev to design the décor for Stravinsky's *Apollon-Musagète* (1928). He was originally a gardener but began to draw while a full-time painter in the early 1920s. He first chose historical subjects but later painted genre scenes, landscapes and sensitive flower-pieces.

Baudelaire Charles-Pierre (1821-67). French poet and critic. His book of poems Les Fleurs du mal, 1857, was a landmark in introducing the modernist sensibility through its Romantic realism and freedom from conventional literary tradition. It was attacked on grounds of immorality, and in his lifetime B. did not receive the recognition he deserved. Besides his poetry, he wrote much influential criticism of literature, painting and music. He was a passionate admirer of Poe and De Quincey and trs. some of their works. B. had a Romantic view of the poet as an exceptional being born to exemplary suffering, but his verse has a density and power rarely found in his Romantic predecessors. Les Fleurs du mal can be read as a history of the human soul, oscillating between extremes of horror and delight ('l'horreur de la vie, l'extase de la vie'). B. interprets both nature and man's creation - i.e. towns and works of art - as patterns of interlocking symbols. In this he was no doubt influenced by his reading of Swedenborg, and he was one of the originators of the literary movement later to be known as *Symbolism. It has been argued that *Les Fleurs du mal* is a carefully constructed whole, and that B. intended a final version of the cycle. His work includes private diaries. (*Mon cœur mis à nu*), a vol. of prose poems, and many critical articles coll. in *Curiosités esthétiques* (publ. posth. 1868) and *L'Art romantique* (publ. posth. 1868).

Baudouin Pierre-Antoine (1723–69). French painter, pupil and follower of *Boucher.

Baudry Paul (Jacques Aimé) (1828–86). French painter known for his mural decorations, particularly those in the Opéra, Paris.

Bauhaus. A teaching institution for the arts founded, in 1919, at Weimar, Germany by Gropius. The aim was to reunify artistic disciplines and integrate them with constructional techniques. The visual arts and architecture were to be studied and applied as related activities, and any division between structural and decorative arts was denied. There were 2 parallel courses, one studying material and techniques and one studying form in the studio. A basic aim was to teach design suited to machine production and articles were produced by students as prototypes for a mass-production line. Teachers at the school included *Kandinsky. *Klee, *Feininger, *Schlemmer and Breuer, In 1925 the B. moved to Dessau where its building, by Gropius, exemplified its principles. Mies van der Rohe succeeded Gropius as director in 1928. The B. was closed in 1933 by the Nazi government. In 1937 *Moholy-Nagy became director of a new B. at Chicago and many other artists moved to the LLS A B principles have deeply influenced subsequent developments in architecture and the visual arts.

Ba(o)ule. African people of the Ivory Coast, ethnically linked with the *Ashanti. Their traditional sculpture, in hard dark woods, is finely carved and highly polished. Typical works are human figurines with delicate, introspective features, or face marks, sometimes decorated with animal figures. Painted helmet-masks and metal sculptures were also produced.

Baumeister Willi (1889–1955). German abstract painter and creator of murals. B. studied in Stuttgart under A. Hölzel; he visited Paris in 1912, 1914 and in 1924 when he met F. Léger,

Baumgarten AMERICA Invention 1988-93

and took a teaching post in Frankfurt from 1928 to 1933. B. publ. his theories of art in *Das Unbekannte in der Kunst* (1947).

Baumgarten Lothar (1944-). German artist who studied at the Düsseldorf Kunstakademie where he came into contact with *Beuvs. Since the late 1960s, he has been interested in anthropology. In his work he addresses the opposition between nature and culture, and the colonial impact on the native people and the environment in South and North American -Indian societies, e.g. Terra Incognita (1969) and El Dorado-Gran Sabana (1977-85). B. uses *installations, books and photographs as his media. Names of, for instance, the Indian populations of South America, names of indigenous animals or of North American native nations have been said 'to constitute the primary medium of his work', as in his site-specific Installation AMERICA Invention (1988-93) Guggenheim Museum, N.Y., which transformed Frank Lloyd Wright's entire spiral atrium into a single work of art with inscriptions of the names of native societies in the Americas.

Bawden

Bayeux tapestry (detail) late 11th c.

Bawden Edward (1903–90). British painter, watercolourist, ill. and designer. He studied under *Nash at the Royal College of Art where he met *Ravilious with whom he worked on murals and later formed a group of artists sometimes referred to as the Great Bardfield school.

Bayer Herbert (1900–85). Austrian-born painter and graphic artist; he trained and taught at the *Bauhaus (1921–8). His works include *photomontages, posters, e.g. for the German Werkbund Exhibition, Paris (1930), and advertising. From 1938 he worked in the U.S.A. and helped introduce Bauhaus principles.

Bayeu Francisco (1734–95). Spanish Neoclassical painter, particularly of frescoes, who worked under R. Mengs in the decoration of the Royal Palace at Madrid; he succeeded Mengs (1777) as director of the royal tapestry workshops. His brother-in-law and pupil was Goya, who painted his portrait.

Bayeux tapestry (probably late 11th c.). Not properly a tapestry but a strip of linen 231 ft (70.4 m.) long and 20 ins (50.8 cm.) deep embroidered in coloured wools. It represents events in the life of Harold of England and the Norman Conquest (1066) in a series of scenes which are supplemented by a Latin commen-

tary and decorative borders depicting, e.g. scenes from fables and everyday life. First mentioned (1476) in an inventory of Bayeux cathedral, where it was used occasionally to decorate the nave. It was probably commissioned by Odo, bishop of Bayeux, half-brother of William the Conqueror, but whether it is of Norman or Saxon design is uncertain; a totally unfounded tradition connects Mathilda, William the Conqueror's queen, with the B. t. It is the only work of its kind which survives and is now exhibited in Bayeux.

Bazille Jean-Frédéric (1841–70). Early French Impressionist painter. While a pupil of Marc Gleyre he met Renoir (with whom he shared a studio), Monet and Sisley, and through them Manet. B. painted out of doors and was interested in the correlation between flesh tints and landscape tones. He was a painter of great promise but was killed in action in the Franco-Prussian War.

Baziotes William (1912–63). U.S. *Abstract Expressionist painter of the *New York School. He was influenced by Surrealist theories on *Automatism and the subconscious; his paintings are brooding, mysterious abstract images in subtle, often muted colours. They include: Dwarf (1947); Night Landscape (1947) and Congo (1954).

Beale Charles (b. 1660). British painter and draughtsman. He was the son of Mary B. and worked as her assistant. His most individual work was a series of figure studies in red chalk which were previously attributed to his mother and resemble the work of Dutch artists such as *Metsu and *Honthorst rather than anything in contemporary English art.

Beale Mary (1632/3–99). British portrait painter in the style of Sir P. Lely and after his death in 1680 she was frequently employed to make replicas of his portraits.

Bearden Romare (1914–88). U.S. African-American painter of dazzling technical facility, who used *Cubist, *collage and *photomontage techniques late in his career, e.g. 'Projections' series (1964). Outspoken about the status of African-American artists, he wrote and lectured extensively about black artists.

Beardsley Aubrey Vincent (1872–98). British artist in black and white whose work epitomized the 'decadence' of the 1890s. His ills for J. M. Dent's ed. of *Morte d'Arthur* (1892) are strongly influenced by Burne-Jones. In 1893, work of his, showing Japanese influences, was publ. in *The Studio* (the 1st **Art Nouveau* magazine). In 1894

Bearden The Family 1948

Bazille Young Girl in a Pink Dress 1864

Beardsley The Peacock Skirt 1894

Beaumont

B. ill. Oscar Wilde's English trs. of Salome and became art ed. of The *Yellow Book, but following Wilde's fall in 1895 B. had to resign. In 1896 he became ed. of the new magazine The Savoy, in which his ills of Pope's The Rape of the Lock and of his own fragment Under the Hill appeared. In these, the stark black and white masses are broken down and the effect shows B.'s interest in 18th-c. French illustration. In 1896 began the final onset of his tuberculosis and in 1897 B. went to Mentone, where he died.

Beaumont Sir George Howland (1753–1827). British patron and amateur landscape painter. B. knew many artists and writers including Byron, Coleridge, Constable, Dr Johnson, Scott and Wordsworth. His gift of pictures (1826) to the N.G., London, was one of its major acquisitions.

Beaux-Arts, École des. The school of art in Paris which replaced the school of the Académie Royale des Beaux-Arts, suppressed during the Revolution. Most Impressionist painters were taught there but rebelled against its teaching. The school became associated with reaction, and the fact that it controlled official commissions had a stultifying effect. The school is now rather more liberal.

Beccafumi called 'II Mecarino', Domenico di Pace (c. 1485–1551). Sienese painter, took his patron's name, B., and studied under Mecarino. His masterpiece is the mosaic for S. Bernardino church, Siena. He also worked in Pisa and Genoa. His delicate early style, typical of the Sienese school, shows, in its compositional coherence, the influence of Raphael; it derived vigour and boldness from B.'s study of Michelangelo.

Becher Bernard (1931–) and Hilla (1934–). German photographers who, since 1959, have been systematically photographing archaeological-industrial buildings throughout Europe and the U.S.A. Their photographs and straightforward images of apparent anonymity and banality unintentionally acquire the stature of grand found art constructions, as well as documenting the industrial buildings themselves. They are usually exhibited in art galleries.

Beckmann Max (1884–1950). German painter, lithographer and woodcut artist and one of the greatest 20th-c. figure painters. In World War I he served in a medical corps but was released following a nervous breakdown. A teacher at

Beckmann Odysseus and Calypso 1943

Frankfurt school of art (1915–33) he was dismissed by the Nazi régime and settled in Amsterdam in 1937 moving to the U.S.A. in 1947. He is identifiable with no one school but his army experiences radically affected him and his work passed through a period of Expressionistic distortion and *New Objectivity realism, using scenes from everyday life for subjects. B. left a large series of self-portraits.

Beechey Sir William (1753–1839). British portrait painter. In 1793 he became official portrait painter to George III's queen, Charlotte.

Beer Jan de (1475–1536). Flemish painter, one of the *Antwerp Mannerist school many of whose paintings were formerly ascribed to him.

Beerbohm Sir Max (1872–1956). 'The Incomparable Max.' British satirist, caricaturist and dramatic critic; his witty drawings 1st appeared in *The Strand Magazine* (1892) and his caricatures include *The Poet's Corner* (1904) and *Rossetti and his Circle* (1922).

Beerstraten. Name of 2 Flemish landscape painters. Anthonie (fl. 1639–65) painted mostly snow scenes somewhat similar to those of H. Avercamp; Jan Abrahamsz (fl. 1622–66) used more conventional subject matter.

before all letters. In engraving, a proof taken before the plate has had the title and dedication, etc. added. Such proofs are naturally rare.

Bega Cornelis (1620–64). Dutch painter. He was the pupil of Adriaen van Ostade and painted the same kind of peasant genre scenes, but his work is far inferior.

Beggarstaff Brothers. Name used by Sir W. *Nicholson and *Pryde in their work together as poster artists.

Beham Hans Sebald (1500–50). This German etcher, engraver, painter and woodcut artist produced over 1000 book ills. His work is distinguished by force and restraint of expression as well as technical mastery whether on copper or wood. Very few of his paintings are known. His brother, Barthel (1502–40), for a time painter to the Bavarian court at Munich, in 1535 moved to Italy where he died. His paintings at Munich include the *Miracle of the Cross* (1530). He also left engravings.

Behrens Peter (1869–1940). German painter, designer and architect, the first to exploit the aesthetic possibilities of industrial architecture. From 1903 to 1907 he was director of the Düsseldorf art school, under him the leading school in Germany, and from 1907 to 1912 chief architect and design adviser to the electrical firm A.E.G.

Beijeren (Beyeren) Abraham Hendricsz van. 17th-c. Dutch still-life painter, specializing in all kinds of sea food.

Bell (Arthur Howard) Clive (1881–1964). British writer on art, husband of Vanessa B. His emphasis on aesthetic experience was through the formal qualities of a work of art; he developed the notion of *'significant form'. B. and *Fry were instrumental in securing recognition for Post-Impressionist art in Britain, especially the work of Cézanne. Works include *Art* (1914) and *Civilization* (1928).

Bell Graham (1910–43). South African-born British painter. He exhibited at the 'Objective Abstractions' exhibition (1934) and from 1937 was a member of the *Euston Road school.

Bell Larry (1939-). U.S. West Coast artist producing *Minimal art structures in glass cubes vacuum-coated with metallic compounds to yield semi-transparent, tinted panels. In works like *Memories of Mike* (1967) and

Untitled (1970) these are combined in cubes or maze-like structures.

Bell Vanessa (1879–1961). British painter and designer for the *Omega Workshops, member of the *Bloomsbury Group and the London Group; sister of Virginia Woolf. Between 1912 and 1918 she experimented with Post-Impressionist styles. She collaborated with *Grant on various decorative projects.

Bellegambe Jean (c. 1480–c. 1535). Flemish painter of altarpieces, known as 'the master of colour', working in Amiens. He was influenced by Italian painting in such works as the polyptych.

Bellini. Family of Italian painters, Jacopo and his sons Gentile and Giovanni, who created the Venetian school of the Renaissance.

Bellini Gentile (c. 1429–1507). Italian painter famous for his narrative works in the scuole (confraternities) of Venice, e.g. the Procession of the Relic of the Cross in the Piazza of San Marco (1496), and for his portraits. He was chosen to paint the Sultan Mohammed II in Constantinople (c. 1480). In his works austere draughtsmanship and architectural composition are combined with rich colouring.

Bellini Giovanni (c. 1430-1516). Pupil of his father and first collaborated with him and Gentile on the great decorative works for the scuole (Gentile *B.), now destroyed. Having no interest in classical subjects, which were becoming popular, he chose predominantly religious themes, which he treated with much of the devotional restraint of earlier painters. Nevertheless, by adopting the technique of oil glazing and gradually abandoning the linear conception of form he revolutionized Venetian painting and substantially affected the future course of European painting through his most famous pupils, Giorgione and Titian. He was slow to find his own style and never ceased to develop it. In Padua (1458-60) he was strongly influenced by Mantegna, though his work was never as sculptural or severe as Mantegna's, e.g. their respective treatments of The Agony in the Garden, both based on a sketch by Jacopo B. B.'s version has a naturalistic landscape background (one of the earliest examples of landscape painting); it illustrates his ability to create a lyrical affinity between his figures and their settings. Other early works probably done at this time include several madonnas and pietàs. These

Giovanni Bellini Doge Leonardo Loredan c. 1501

madonnas have the serenity, tenderness and individuality typical of his later work; the suffusion of light and the presentation of halflength figures are also characteristic of his style. B. returned to Venice in 1460. 4 triptychs (1460-1) for the Carità church were his 1st major undertaking and these were followed by the Altarpiece with St Vincent Ferrar (1464), for the church of SS Giovanni e Paolo, notable for the differences in style between the panels. In 1470 he was working on the decoration of the Scuola Grande di S. Marco with Gentile and visited Rimini and Pesaro. There he saw oil paintings by Rogier van der Weyden, which impressed him by their realism and tonal variations. He himself learnt the Flemish technique of oil glazing from Antonella da Messina in 1475, and his Resurrection (1475/6) was the 1st Venetian painting executed in glazes of pure oil paint. He had been using a mixture of oil and tempera in Rimini while the brushwork of the Pietà with St John is typical of that used with oil. His work gradually lost its sharp contours, expressing form by a developing richness and variety of tone and colour, e.g. the altarpiece from S. Giobbe The Virgin and Child with Saints and an Orchestra of Angels. This style was more fully exploited by

Titian. Much of B.'s time after 1497 was occupied in restoring the frescoes of the hall of the great council in the Doge's Palace, Venice, a work begun by Gentile. Among B.'s portraits is the famous Doge Leonardo Loredan (c. 1501). He painted few mythological subjects, but the best known, The Feast of the Gods (c. 1514), painted for the camerino or study of Alfonso d'Este of Ferrara, was unusual for its time in its representation of deities as ordinary people, possibly members of the court of Ferrara. Titian, who completed the decoration of the room, repainted the landscape background of this picture and made minor alterations to the figures, though retaining B.'s composition.

Bellini Jacopo (c. 1400–70). Follower of A. Pisanello and Gentile da Fabriano. His rare extant paintings show him to have been competent rather than outstanding, and his importance lies in his interest in the return to antiquity and the new scientific approach to the subjects of painting. Two valuable sketchbooks of his exist. Many of these sketches, which include figure studies for larger compositions and show an interest in landscape, architectural design and the problems of perspective, were used by his sons and his son-in-law Mantegna.

Bellmer Hans (1902–75). Polish-born artist living in Germany and, from 1938, Paris, where he joined the Surrealists. In 1933 he made *Doll*, an articulated life-size female nude which he photographed in erotic poses. Technically refined drawings and graphics, e.g. *Le Bon sens* (1964), continued B.'s obsessive exploration of the female body.

Bellori Giovanni Pietro (1615–96). Italian collector, antiquarian and writer of seminal work on art, Vite de' pittori, scultori et architetti moderni, 1672, on which he was assisted by Poussin and which is the basic source for the history of the *Baroque. In it he puts forward a rationalist Platonism and the antique as a model for value judgment. This book exercised great influence on French academic theory and the Royal Academy, and it became the theoretical foundation of *Neoclassicism as developed by *Winckelmann.

Bellotto Bernardo (1720–80). Italian landscape and townscape painter, also called Canaletto, whose nephew and pupil he was and whose style and name he adopted. In 1747 B. went to Dresden, where he became painter to the electoral court. In 1767 he settled in Warsaw,

working for the Polish king until his death. His views of Warsaw are so exact that they were used when the city was reconstructed after World War II.

Bellows George (1882–1925). U.S. painter of portraits, landscapes and urban life. He studied under Robert Henri (1865–1929). His work provided a comment on contemporary U.S. life, from which he drew his subjects with uncompromising realism. His series of 6 prize-fight paintings (1909) demonstrate his natural dashing style, which he later subjected to the theory of 'dynamic symmetry' to give a formal balance to his compositions. He turned with great success to lithography, e.g. a war series (1918), and book ill.

Bemelmans Ludwig (1898–1962). Writer, ill. and artist born in Austria; emigrated to the U.S.A. in 1914. His work is distinguished for its conscious *naïveté* and deadpan humour. His early books were for children, e.g. *Quito Express* (1938).

Benedetto da Maiano (1442–97). Florentine sculptor prominent for his reliefs which belong to the same traditions as those by *Ghiberti and *Donatello.

Benglis Lynda (1941—). U.S. artist who uses a wide range of materials (paint, wax, latex, plaster, fabric, rubber, polyurethane foam, etc.) in works which defy distinction between painting and sculpture. B. is concerned with colour (e.g. vibrant Day–Glo, fluorescent pink and blue, etc.) and large–scale organic forms in space, which she has called 'frozen gestures', e.g. 'Adhesive Products' series (1971) and *The Wave* (1984). A dedicated feminist, she has also made videos focusing on female sexuality.

Benin. City and warrior kingdom of W. Nigeria; its greatest period was apparently during the 14th–17th cs. The Portuguese reached B. in the late 15th c.; a British punitive expedition (1897) opened the Benin art treasures to Europe. These consist of naturalistic bronzes (cast by *cire perdue technique) and ivories; bronze reliefs, once decorations for the royal palace; human heads in the round, probably idealized, not actual portraits, of royalties; human and animal figures; implements. Sources and development are obscure but the surviving objects are the products of court art, probably inspired by the art of *Ife and showing slight European influences.

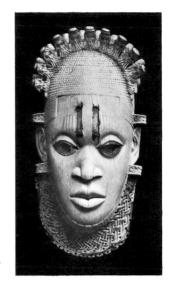

Benin Ivory pendant mask, 16th c.?

Bening. Family of 15th and 16th c. Flemish book illuminators and miniaturists.

Benois Alexandre (1870–1960). Russian painter and theatrical designer, the founder of the St Petersburg *World of Art movement. B. belonged to a very cosmopolitan and cultured family, as did most of his friends; this many-streamed culture bridged the gap isolating Russia from the rest of Europe after the 19th-c. nationalist *Wanderers. From B. came the interest in ballet, to which he introduced Diaghiley, a member of the group.

Benson Ambrosius (d. 1550). Lombard painter who settled in Bruges (1519) and painted in a Flemish style particularly reflecting the influence of *G*. *David. There are many of his pictures in Spain and he was formerly known as the 'Master of Segovia'.

Bentname. Nickname of the Dutch and Flemish painters in Rome who formed a group (also called 'Bentvueghels' – 'birds of a flock') in 1623. The centre of much scandalous behaviour, it was suppressed by the pope in 1720.

Benton Thomas Hart (1889–1975). U.S. Regionalist painter who was one of the most voluble of those protesting against European Modernism and its followers in U.S. art. *Roasting Ears* and *Cattle Loading, West Texas* (1930) are typical in portraying U.S. rural scenes. He became famous for his 1930s murals,

Benyenuto di Giovanni

e.g. at The New School for Social Research, N.Y., and for the Missouri State Capitol.

Benvenuto di Giovanni di Meo del Guasta (1436–c. 1518). Sienese painter, pupil of Vecchietta. His paintings include *Annunciation*, *Nativity* and *Assumption of the Virgin*.

Bérard Christian (1902–49). French stage designer and artist. His work, stylish and deeply evocative of period, affected both French design and fashions in the 1940s.

Berchem (Berghem) Nicolaes (1620–83). Dutch Italianate painter. He toured Italy c. 1642–5 and thereafter his best pictures were of Arcadian landscapes, delicately painted and suffused with light after the manner of *Claude Lorraine. He was sometimes employed by Van *Ruisdael and *Hobbema to animate their landscapes.

Berckheyde Gerrit (1638–98). Dutch town-scape painter, pupil of his brother Job and imitator of the style of *Saenredam. In his paintings he frequently changed the actual relative positions of the buildings to suit the pictorial composition.

Berckheyde Job (1630–93). Dutch painter of townscape. He was a more powerful colourist than his brother Gerrit.

Berenson Bernard (1865–1959). U.S. art critic, historian and art dealer; art adviser to the dealer Joseph Duveen. B.'s many works on the history and aesthetics of Italian painting, especially his *The Italian Painters of the Renaissance* (1952; first publ. as individual essays, 1894–1907), gained him a following as an expert on art and culture. Other important works are *Drawings of the Florentine Painters* (1903 and 1938) and *Aesthetics and History in the Visual Arts* (1948).

Berghe Frits van den (1883–1939). Belgian Expressionist painter and graphic artist, leader of the *Laethem-Saint-Martin group and cofounder of *Art Vivant*.

Bergognone (Borgognone) Il (Ambrogio da Fossano) (fl. 1481–d. 1523). Italian painter of the Lombard school whose use of subdued and subtle colours led Berenson to nickname him the 'Whistler of the Renaissance'. He painted an altarpiece and frescoes for the convent of the Carthusians at Pavia (1514) and frescoes in the church of S. Simpliciano, Milan.

Berlin Dada. *Dada

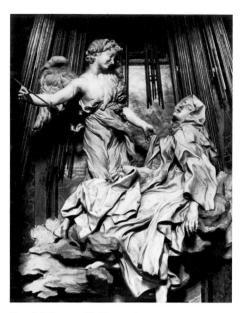

Bernini Ecstasy of St Teresa 1645-52

Bermejo Bartolomé (fl. 1474–95). Spanish painter whose work shows Flemish influences; active in and around Barcelona. His masterpiece is a *Pietà* in Barcelona cathedral.

Bernard Émile (1868–1941). French painter and critic who claimed to have been the originator of the Cloissoniste style used by Gauguin. He was a leader of the Symbolist movement in painting and in his later years worked for the revival of religious art. He was a friend and correspondent of Van Gogh and of Cézanne who wrote him the famous letter about treating nature 'by means of the cylinder, the sphere and the cone'.

Bernardino de' Conti (fl. 1490–1522). Italian painter of the school of Milan, a follower and possibly an assistant of Leonardo.

Bernini Gian Lorenzo (1598–1680). Italian sculptor and architect born at Naples; son of a Tuscan Mannerist sculptor who worked in Rome. B. was precociously skilful as a sculptor, and attracted the attention and patronage of Cardinal Scipione Borghese executing 4 groups for his garden, including *Aeneas and Anchises* (1618/19) and *Apollo and Daphne* (1622/4). During the pontificate of Urban VIII B. completed numerous large-scale commissions in and

around St Peter's: the Baldacchino (1624–33), the Barberini Palace (1625–33), the Cathedra Petri (1657–65) and his layout of the square and colonnades in front of the basilica, his grandest and subtlest architectural achievement. Also notable is his layout of the Piazza Navona and the fountain there, as well as churches (S. Andrea al Quirinale) and numerous other fountains. B. gave Rome its predominantly Baroque character.

He was a man of deep faith, and the supreme artist of the Catholic Counter-Reformation. Both as architect and sculptor he dazzled the 17th c., partly through genius and partly through skill in keeping rivals (e.g. Duquesnoy and Algardi) in the background. And this in spite of the fact that a tower which he built on the facade of St Peter's had to be rapidly demolished in 1646 when cracks appeared in the fabric of the church. In his series of portrait busts, of Cardinal Scipione Borghese (1632), Duke Francis I d'Este (1650/1), Constanza Bonarelli (c. 1635). Charles I (now lost) and many others, B. revealed both his deep insight into character and his virtuosity of technique. In 1641 he made a bust of Cardinal Richelieu after the triple portrait by Philippe de Champaigne; this was so successful that he was invited to Paris to work for the king. He did not go until 1655. The only result of this visit was his superb bust of Louis XIV. At the height of his fame B. had prophesied the decline of his reputation, a decline that lasted until the present generation. Indeed during his lifetime an equestrian statue of Louis XIV, completed in 1673, was so disliked that it was altered by Girardon in 1688 into a park ornament. B,'s sculptural style evolved partly from Michelangelo and partly from the expressiveness of Caravaggio and Annibale Carracci, whom he greatly admired. His emphasis on the unity of sculpture and its setting produced many fine tombs, in particular those of Pope Alexander VII (1671/8), with its marble draperies lifted by the skeleton figure of Death, and that of the Blessed Lodovica Albertoni (1671/4). The masterpiece of his religious sculpture, as well as the most brilliant example of his use of varied materials, is the Ecstasy of St Teresa (1645-52) in the Cornaro chapel in S. Maria della Vittoria, Rome. B.'s work freed sculpture from the classic concept of a block to be seen from one angle. The vitality of execution, as well as the restless poses of his works, at first demanded a multiple viewpoint, but this tension was often resolved into the clearcut energy and movement of such a group as Apollo and Daphne. The un-classical involvement of the spectator in his response to the vigour and emotion of such figures show how B. was the seminal genius (and largely the creator) of the Baroque style.

Berruguete Alonso (c. 1488–1561). The greatest Spanish sculptor of the 16th c. and also a painter, working mainly in Valladolid. He lived in Italy (c. 1504-c. 1517) studying above all Michelangelo's work, the influence of which is reflected in B.'s Resurrection carved in relief in alabaster for Valencia cathedral. Other major works are the altars for the monastery of La Mejorada (1526), now in Valladolid Mus., and for the church of S. Benito (1527-32), also at Valladolid, and the 36 choir stalls in wood (1539-43) for Toledo cathedral. B. was the 1st Spaniard to react strongly against the High Renaissance ideals of perfection of form. He was affected by Mannerism but used distortion or unbalanced composition to express the emotions of his mind or the agonies and ecstasies of the religious life.

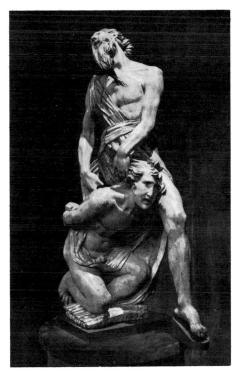

Alonso Berruguete The Sacrifice of Isaac 1526-32

Berruguete

Beuys How to Explain Pictures to a Dead Hare 1965

Berruguete Pedro (fl. 1438–1503/4). Castilian painter, father of Alonso. He worked in Avila, in Toledo cathedral and as court painter to Ferdinand and Isabella of Spain. A tradition that he studied in Urbino, Italy, is supported by the style of some of his pictures.

Bertoldo di Giovanni (c. 1420–91). Italian sculptor; pupil and assistant of Donatello. As keeper of the Medici coll. of sculpture and head of the academy, established in connection with it, he was a teacher of Michelangelo.

Bertram of Minden. *Master Bertram

Besnard (Paul) Albert (1849–1934). French painter trained under J. Brémond in the Romantic classicism of Ingres. From 1883 his work was influenced by the light and colour of the Impressionists. The intense colours of his pictures of India (1912) attracted wide attention. He also executed frescoes, pastels and etchings.

Beuckelaer Joachim (c. 1533–73). Flemish painter, most of whose career was spent as an assistant to other artists, e.g. A. Mor and possibly P. Aertsen, his uncle by marriage and also probably his master. B.'s few original pictures are mostly of market or kitchen scenes.

Beuys Joseph (1921–86). Germany's most influential post-war artist. An early interest in

natural history, country lore and mythology left evident traces in his visionary and extremely diverse work: he was a *Performance artist (How to Explain Pictures to a Dead Hare 1065 Coyote, 1974), a sculptor (Fat Corner, 1964), lecassembler of *installations gigantic scale (Tallow, 1977) and founder of Organization for Direct Democracy (1972), after becoming involved in the political arena. B. also made video art (Felt TV, 1968) and drawings. What characterized his work generally was a deep belief in the power of intuition as expressed in the parallel between the artist and the shaman; both invest simple materials with intense and potentially healing power (Show your wound, 1976).

Bewick Thomas (1753-1828). British wood engraver and book ill., best known for his animal and bird studies. He made *wood engraving a medium of fine art, designing and cutting his own blocks. He used boxwood so as to make a stronger block, and introduced techniques which greatly extended the tonal range. His work includes the engraving known as the 'Chillingham Bull', and ills for Goldsmith's poems The Traveller and The Deserted Village and R. Beilby's A General History of Quadrupeds (1790) and History of British Birds (2 vols, 1797, 1840), the 1st vol. amended, the 2nd vol. written by B. Among his best works are the numerous book tailpieces, studies of the English countryside. His autobiography, Memoirs of Thomas Bewick, by Himself, was publ. in 1862.

Beyeren Abraham Van (1620/I-90). Dutch painter who excelled in virtuoso and opulent still-lifes of fish, crustacea, banquet tables with fruit, silver and gold vessels, glass and sumptuous tablecloths.

Bicci di Lorenzo (1373–1452). Florentine painter influenced by Lorenzo Monaco, Gentile da Fabriano and Fra Angelico. Many galleries have works by him and there are frescoes in S. Francesco, Arezzo, and in several churches in Florence.

Bickerton Ashley (1959–). U.S. artist born in Barbados. From his first one-man show in N.Y., 1986, he emerged as one of the most intelligent and successful post-*Neo-Expressionist and earliest *Postmodernist U.S. artists of the younger generation. His wall-mounted boxes/containers are air-brushed with an industrial perfection and finish that gives them the look of commodity objects, affixed to the wall

Bewick The Tame Goose from History of British Birds 1797, 1840

Bingham The Trapper's Return 1845

with metal brackets that project out. The subject matter of the works, however, often contradicts or modifies the commodity status and the appearance of the pieces with layers of references to the artist's personal engagement in art and in contextual issues, e.g. Bad (1988), Good (1989) and Biofragment # 2 (1990). In Solomon Island Shark and other recent work, B. has abandoned the previous slick forms of his objects: a totemic-looking life-size rubber shark, with modifications, hangs from a rope.

Biedermeier. Critical term used of the arts in Germany and Austria between *c.* 1815 and *c.* 1850; it implies a restrained Romanticism. More broadly it is used as a synonym for 'bourgeois' or 'philistine' in describing attitudes towards the arts.

Bierstadt Albert (1830–1902). U.S. landscape painter of German extraction. After study in Europe (1853–7) he joined a surveying

Bierstadt Sunrise Yosemite Valley c. 1870

expedition of the Rocky Mountains (1858). From then on he painted large-scale pictures mostly of the Rockies and Far West, acquiring a fortune, a great reputation and decorations from several European states. His style reflects that of the German Romantics.

Bihzad Kamal Ud-Din (c. 1460–1535). The most important Persian painter of miniatures for illuminated mss, only a few of which survive.

Bijapur. *Deccani miniature painting

Bilibin Ivan (1876–1928). Russian book ill. B. belonged to The *World of Art group though his work, embedded in the 19th-c. Russian tradition, was notable for its incorporation of folk elements. In addition to his ills for Russian fairy-tales B. drew anti-Tsarist cartoons.

Bill Max (1908–1994). Swiss sculptor, painter, architect, industrial designer and art theorist strongly influenced by the ideals of the *Bauhaus. From 1951 to 1956 he was rector of the Hochschule für Gestaltung at Ulm, which he also designed. He gave support to Van Doesburg's theory of concrete art in his painting and sculpture, in written work and in the organization of exhibitions such as 'Konkrete Kunst' (1944) at Basel. In *Die mathematische Denkweise in der Kunst unserer Zeit* (1949) he advocated a new approach to artistic creativity based on mathematical concepts.

Bingham George Caleb (1811–79). U.S. painter. After a brief training at the Pennsylvania Academy of Fine Arts and travel in Europe and the U.S.A. he settled in his

biomorphic

home state of Missouri. He painted scenes from frontier life, portraits of the wealthier Missouri citizens and many political subjects. He himself held state office.

biomorphic. Term used for irregular abstract forms based on shapes found in nature, e.g. in the work of *Gorky, *Tanguy, and in *Arp's sculpture.

Birch Thomas (1779–1851). U.S. painter, one of the 1st to present the crisp luminosity of U.S. light. His series depicting naval victories over the British in the 1812 war were immensely popular through engraved reproductions.

Bird Francis (1667–1731). British monumental sculptor trained in Brussels and Rome who carved most of the statuary on St Paul's cathedral. The monument to Sir Cloudesley Shovel in Westminster Abbey, formerly ascribed to B. was, in fact, probably by Gibbons.

Birolli Renato (1906–59). Italian painter. He was a leading member of the Corrente group before World War II and a prominent anti-Fascist. During the war he produced a series of drawings entitled *Italia* 1944, protesting against the horrors of war. In 1947 he became a founder of the *Fronte nuova delle arte.

Bishop Tidying Up 1941

Bishop Isabel (1902–88). U.S. artist who, for most of her career as a highly distinguished figurative painter, depicted anonymous, urban, working-class people singularly or in groups, in outdoor settings or in the subway below Union Square in N.Y. where she had her studio. Her figures, never immobilized, are rendered in light-coloured paint and are imbued with dignity that contrasts with their mundane activities, contemporary dress and surroundings, far surpassing city genre scenes, e.g. Variations on a Theme of Walking (1979). B.'s female portraits, often nude, depict relaxed and tender relationships between women, e.g. Two Girls (1935) and Lunch Hour (1939).

Bissière Roger (1888–1964). French painter and designer, and influential teacher (1925–38) at the Académie Ranson, Paris; collaborated on the periodical *Esprit Nouveau*.

bistre. An artist's pigment brown in colour and made from charred wood. It can be used as an ink, chalk or wash and was favoured as a drawing material by Rembrandt.

bitumen. An artist's pigment, a richer brown than bistre, and made from asphaltum. It never fully dries out and, remaining chemically active, gradually damages the painting; this is noticeable in work of the 18th and 19th cs when b. was very popular.

black figure style. Style of Greek vase painting where the figures are painted in black on a red ground. It flourished from the late 7th to the late 6th c. BC; it was superseded by the *red figure style.

Blackman Charles (1928–). Australian painter. At first attracted by the Expressionist school at Melbourne, he was one of the new humanist group of younger painters who turned to city life for subject matter.

Black Mountain College North Carolina, U.S.A. Established in 1933 and directed by John Price, it soon attracted prominent artists, writers, playwrights, musicians and dancers with a multidisciplinary curriculum reminiscent of the *Bauhaus. *Albers, who had taught at the Bauhaus, provided its particular direction. In 1936 Albers invited his former Bauhaus colleague Xanti Schawinsky to expand the art faculty: visitors included Aldous Huxley, *Léger, *Feininger, etc. In 1940 B.M.C. moved to Lake Eden, N. Carolina, and from

1944 its summer school became famous and attracted experimental artists from various disciplines who collaborated in *performances, e.g. John Cage, Merce Cunningham, *De Kooning, Buckminster Fuller, *Rauschenberg, *Motherwell, etc.

Blake Peter (1932–). British artist, a noted member of the *Pop art movement. He studied at the R.C.A.; his subjects are often taken from music-hall acts, wrestling matches, etc. (*Drum*... etc.), in highly finished *trompe l'œil* style.

Blake William (1757–1827). British poet, ill., draughtsman, engraver, writer and visionary. He completed (1779) his 7-year apprenticeship as an engraver with James Basire, and engraving remained his basic livelihood. B. also studied for a brief time at the R.A. In 1782 he married Catherine Boucher, his beloved and constant companion. Friends such as the sculptor Flaxman supported the publ. of Poetical Sketches (1783) but after Songs of Innocence (1789) B. printed his own works by a process (duplicated in experiments by Ruthven Todd, S. W. Hayter and Joan Miró) of relief etching of the text and the surrounding design, printing in coloured inks often with retouching in paint. Another very successful technique was colour printing by superimposed impressions from millboard. B. lived mainly in London, but between 1800 and 1803 worked at Felpham, the estate of William Hayley, for whom B. was engraving some poems. While he was at Felpham an argument with a soldier brought B. on trial on a sedition charge, but he was acquitted. The poverty of his last years was relieved by the discipleship of such young painters as Palmer and Calvert, and commissions from another young friend, John Linnell, for B.'s engravings of Illustrations of the Book of Job (1825) and 100-odd watercolours to Dante's Divine Comedy. All B.'s work is infused with his intense imagination and visionary experiences; he claimed regular visits from heavenly emissaries. The powerful images of his engravings and paintings display his admiration of Michelangelo (e.g. in their distorted anatomy), Raphael and Dürer; but he rejected the academic traditions represented by Reynolds and the R.A. and the Venetian colourists, as at once too vague and too material. His rebellion against accepted contemporary artistic theories parallels his political radicalism and religious unorthodoxy. He rejoiced in the French and American revolutions and his spiritual

William Blake 'Ancient of Days' 1794

explorations, and his disgust with injustice and hypocrisy strengthened by his contacts with the radical circle of Paine and Godwin, are reflected in the prose satire The Marriage of Heaven and Hell (1790–3), the poem coll. Songs of Innocence and Experience (1789-94), and such poems as The French Revolution and America, a Prophecy (1793). In B.'s religious system, God is a vengeful terrible power (Urizen); Jesus the embodiment of humanity (Orc); and the virtues which derive from the human principle in its fullest and highest manifestation are Los, the male, Enitharmon, the female. B.'s works include the long poems Milton (1840-8) and Jerusalem, The Emanation of the Giant Albion (1804-20); the verse prophetic books The Everlasting Gospel (c. 1818), the Book of Thel (1789), The Song of Los and Vala or the Four Zoas (1797 - 1804).

Blakelock Ralph Albert (1847–1919). U.S. painter, self-taught. His landscapes of the American West were painted in rich dark colours, and reflected B.'s mood.

BLAST. *Vorticism

Blaue Reiter, Der (Ger. 'The Blue Rider'). A group of German Expressionist painters, led by

Blaue Vier, Die

*Marc, *Kandinsky and *Macke. Kandinsky, with a passion for blue, and Marc, enthusiastic about horses, invented the name. 2 major exhibitions were held at Munich in 1912 and 1913 with contributions from non-German artists such as *Delaunay, the *Burliuk brothers, the composer Schoenberg, *Braque, de Fresnaye, *Malevich, *Picasso and Vlaminck; the German exhibitors included *Klee. The movement also publ. the B. R. Almanac (1912) containing major essays by Marc and Kandinsky. The B. R. programme rested on Primitivism, intellectual in concept but intuitive in application, a new emphasis on child art as a source of inspiration, abstract forms and the symbolic and psychological aspects of line and colour. The group disbanded in 1914.

Blaue Vier, Die (Ger. 'The Blue Four'). From 1924, for about a decade, the painters *Kandinsky, *Jawlensky, *Klee and *Feininger exhibited their work jointly under this title in Europe and the U.S.A.

Bleckner Ross (1949–). U.S. painter. After a series of black-and-white geometric and organic-form paintings, in the 1980s he produced striped and dark 'atmosphere' works concerned with light, in the tradition of *Reinhardt, *Rothko and *Newman. These contained suggestions or memories of figurative imagery associated with death and the AIDS epidemic.

Bles Herri met de (c. 1480–after 1550). Antwerp painter of landscapes and religious pictures whose style was similar to *Patenier's; there was a fantastic element in his work, especially in his mining landscapes, e.g. *The Copper Mines*. He was probably related to Patenier and may have been identical with the Herri de Patenir recorded in the Antwerp Guild in 1535; Bles, meaning 'blaze of white hair', was possibly a nickname. In Italy he was known as 'Henrico Civetta', from the owl emblem with which he signed his pictures.

block-book. Early type of illustrated book in which both text and ills were cut from the same wood block. No existing b.-b.s can be dated before c. 1455, i.e. after the invention of movable type, and they continued into the 16th c. Although produced in large numbers in Germany and the Netherlands they included only a few titles. The best known are *Ars moriendi* and *Biblia pauperum*.

Bloemaert Abraham (1564–1651). Dutch painter of biblical and historical subjects, portraits and still-lifes. After a period of travel, including Paris (1580–3) and Amsterdam (1591–3), he settled at Utrecht, where he played an important part in founding the Utrecht school. He had a great reputation, being visited by Rubens and Elisabeth, Queen of Bohemia, and was the master of J. G. Cuyp, G. Honthorst and H. Terbrugghen. Through the Dutch 'Italianizers' he was affected by Mannerism and Caravaggio's use of *chiaroscuro*.

Bloemen Jan Frans van, called 'Orizonte' (1662–1749). Flemish painter who lived in Rome from *c.* 1681 and was influenced by G. *Poussin. He painted classical landscapes of great charm.

Bloemen Pieter van (1657–1720). Flemish genre and landscape painter, brother of Jan Frans van B. and in Rome *c.* 1674–93.

Bloom Barbara (1951-). U.S. *Installation artist who since 1974 has worked partly in Amsterdam. She creates enigmatic multi-media and multi-layered compositions which invite investigation into what she has described as 'a faked and alternate reality' in order to arrive at a 'true fiction', as in her film The Diamond Lane (1981). In her collection of essays Ghostwriter (1988) B. gives some insight into her work: 'The necessary knowledge is that of what to observe'. In her 4-room Installation Esprit de l'Escalier (Buffalo and Chicago, 1988) distinct parts are related metaphorically by the theme of ephemerality while the viewer's observations are dictated by desire. In The Reign of Narcissism (N.Y., 1990) the objects displayed in the fictional museum (e.g. busts, cameos, etc.) bear the image of the artist and true to her consistently *Postmodernist notions, the visual metaphors suggest multiple meanings.

Bloomsbury Group. Circle of intellectuals who met at the 2 houses in Bloomsbury, London, of the Stephen family (which included Virginia Woolf and V. *Bell) from c. 1907. Among them were the philosopher G. E. Moore, the economist Keynes, the artist *Grant and the writers Clive Bell, E. M. Forster, Roger Fry, Lytton Strachey and Arthur Waley.

blot drawing. Name given by A. *Cozens to his technique of developing a landscape composition out of ink blots allowed to fall at random on a sheet of paper. This method, which

Bloom The Reign of Narcissism 1990

he described in a book publ. in 1785, is an extension of Leonardo's advice to artists to study the stains on a wall or the ashes of a fire to excite inspiration.

Blue Rose Group. Group of Russian artists which succeeded The *World of Art in 1907 as the leading movement of the Russian avantgarde. They published the magazine *The Golden Fleece* (1906–7). Prominent members were *Larionov and *Goncharova.

Blume Peter (1906–92). Russian-born U.S. *Magic Realist painter whose mostly allegorical paintings combine certain Surrealist techniques (fantastic, dream imagery, free association) and social concern, e.g. *The Eternal City* (1934–7). In his earlier paintings, e.g. *Parade* (1930), he used a *Precisionist style close to *Sheeler and *Demuth.

Blythe David Gilmour (1815–65). U.S. artist. His paintings include the fine *Libby Prison* (*c.* 1863), a compassionate study of the notorious Confederate military compound in the Civil War. He also left a remarkable 9-ft (2.7-m.) wood carved figure, *Lafayette* (1847).

Boccaccino Boccaccio (fl. 1493–d. 1524/5). Italian painter. After working at Genoa, Ferrara and Venice B. settled in Cremona and his masterpiece is a series of frescoes (1510–19) of the life of the Virgin in the cathedral there; he

also did other frescoes in the cathedral. His work often shows the influence of Giovanni Bellini.

Boccioni Umberto (1882–1916). Italian *Futurist painter, sculptor and writer who studied under *Balla in Rome. Inspired by Marinetti's Futurist Manifesto (1909), B. issued the *Manifesto of Futuristic Painters* (1910). He contributed to an exhibition of Futurist art in Paris (1912) and summarized its ideals in his book *Pittura, scultura futuriste* (1914). Characteristic works are the painting *The City Rises* (1910) and the sculpture *Unique Forms of Continuity in Space* (1913).

Bochner Mel (1940—). U.S. painter of the post-*Minimalist generation. His work, making use of hybrid geometrical forms, is rationalistic in its extensive use of systems, numbers and even shape and colour. Works include: *Axiom of Exhaustion* (1971), coloured ink on masking tape on the floor; 4 paintings, *Mental Exercise Estimating: a Circle, a Centered Vertical, Corner to Corner, the Center* (1972).

Böcklin Arnold (1827–1901). Swiss Romantic painter whose early works were sentimentalized, cliché-ridden classical landscapes; his later fantastic pictures of creatures from Germanic legend and classical mythology, e.g. *Triton and Nereid* (1873/4), were ponderous rather than dramatic. Imaginative landscapes, e.g. *Isle of the Dead*

Bodegón

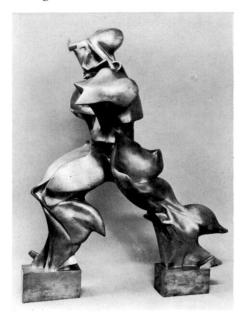

Boccioni Unique Forms of Continuity in Space 1913

(1880), following the tradition of C. D. Friedrich, have a supernatural, if theatrical, atmosphere.

Bodegón (Spanish tavern). Kitchen picture with still-life as a major feature, a genre popular in Spain in the 17th c. A famous example is Velazquez's *Old Woman Cooking Eggs*.

Body art. *Action and body art

body colour. An opaque watercolour, achieved by mixing with white and used to emphasize highlights, either in drawings on coloured paper or in watercolour paintings.

Boethus (fl. 2nd c. BC). Greek sculptor none of whose work is known to have survived, but famous for his *Child Strangling a Goose* of which Roman copies were made.

Bohemian master (*fl.* mid-14th c.). Painter working in Prague at the court of the Emperor Charles IV. By him are *The Glatz Madonna* and *Death of the Virgin*, 2 of the finest examples of International Gothic style.

Boilly Louis-Léopold (1761–1845). Popular and prolific French portrait, history and genre painter. His work includes *Triumph of Marat (c.* 1794) and *The Arrival of the Stage-Coach* (1803).

Bol Ferdinand (1616–80). Dutch painter, prior to 1640 a pupil of Rembrandt, to whom many of B.'s paintings were attributed, so well did he imitate his master. In the 1660s his work deteriorated as he pandered to popular taste and painted in a more elegant and decorative manner.

Bolgi Andrea (1605–56). Italian sculptor who worked in Bernini's studio in Rome from 1626 and executed the statue of St Helena (1629–49) in St Peter's. His style was not sufficiently vigorous to satisfy high Baroque taste and he gradually fell out of favour in Rome.

Bologna Giovanni da (Giambologna, Jean de Boulogne) (1529–1608). One of the greatest and most influential Mannerist sculptors, born at Douai and settled in Florence. His most

Bohemian master The Glatz Madonna c. 1350

important works were undertaken for the Medici family, including *Flying Mercury*, *Rape of the Sabines* and fountains in the Boboli gardens; among his other works are the early fountain of Neptune at Bologna and *Samson Slaying a Philistine*.

Bologna, school of. School of Italian painting which in the 16th and 17th cs was the centre of classicism as taught by the *Carracci Academy. Distinguished Bolognese painters include Albani, Domenichino, Guercino, Lanfranco, Reni and Sassoferrato; several of them were influential in the development of the Baroque style in Rome.

Boltanski Christian (1944—). French artist, usually of *installations, in which he makes use of 'real-life' materials such as photographs of people, memorabilia and small lamps which illuminate the photographs as if in an iconostasis. B.'s works have a documentary look of remembered history, memorials or metaphors, e.g. 29 Apparels de François C. (1972) and La Grande Réserve (1988).

Boltraffio (Beltraffio) Giovanni Antonio (1466/7–1516). Italian painter, a pupil of Leonardo da Vinci in Milan. His work includes *Virgin and Child* and *Narcissus*.

Bolus Michael (1934–). South African-born sculptor, working in Britain from 1957; he studied with *Caro (1958–62). His works include constructions of steel and aluminium in which colour emphasizes form.

bolus ground. A preparation of an artist's canvas (*oil painting). Bole is a reddish or dark brown earth; applied to the canvas as a ground or working surface, it eventually shows through the painting, producing characteristic effects.

Bombelli Sebastiano (1635–before 1716). Venetian history and portrait painter strongly influenced by Veronese. He also worked in Germany.

Bomberg David (1890–1957). Polish-born British painter and teacher (1945–53), after years of obscurity, at the Borough Polytechnic, London. B.'s large geometrical compositions, e.g. *The Mud Bath* (1914), were prominent in the *avant-garde* of the early 20th c. Later works were representational, e.g. paintings in Palestine (1923–7); from ϵ . 1929 he began to use Expressionist techniques.

Bodegón Velazquez's Old Woman Cooking Eggs (detail) 1628

Giovanni da **Bologna** Samson Slaying a Philistine c. 1565

Rombois

Boltanski Les Ombres

Bombois Camille (1883–1966). French 'primitive' painter.

Bonampak. Site, in Chiapas, S. Mexico, of wall paintings of Maya classic period of *Pre-Columbian art dated to c. AD 800. The paintings, in varied colours, among them a remarkable blue, depict religious processions, military raiding parties and the immolation of prisoners in ritual sacrifice.

Bonanno of Pisa (fl. late 12th c.). Italian sculptor and architect. He made the bronze doors of the cathedrals of Monreale and Pisa (except on the S. side destroyed and replaced). The 'Leaning Tower' of Pisa was begun under his direction.

Bone Sir Muirhead (1876–1953). Scottish draughtsman and etcher who settled in London (1901) and specialized in architectural subjects, e.g. *Demolition of St James's Hall* and *Ruins of London from St Bride's* (World War II).

Bonfigli Benedetto (fl. 1445–d. 1496). Italian painter strongly influenced by Gozzoli. He worked mainly at Perugia, where his work includes a series of frescoes in the prior's chapel in the town hall.

Bonheur Marie-Rosalie called Rosa (1822–99). French animal painter widely acclaimed in her lifetime. Her best pictures, often of horses,

combine vigorous action with accurate detail and are frequently huge, one depicting 10 lifesize horses. For her most important work, *Horse Fair* (1885) she disguised herself as a man to obtain correct 'local colour'.

Bonifazio di Pitati (1487–1553). Italian painter of the Venetian school whose paintings closely resemble those of Giorgione and Titian. Many paintings in the style of these artists have been attributed to B. but only one work signed by him survives, *Madonna and Child with Saints* (1553).

Bomberg In the Hold 1913-14

Bonington Richard Parkes (1802-28). British painter and lithographer of great talent, living and working, however, mainly in Calais. B. was a friend of *Delacroix and *Lawrence. He was awarded a gold medal at the Paris Salon in 1824 at the same time as Constable. In his work the English tradition of topographical landscape combined with the spirit of French Romanticism. His oil paintings and watercolours of marine subjects painted with a light palette and free handling are regarded as his best work. Though B. died young, he had a considerable influence over contemporary and later landscape painting, mainly in France. He was regarded as one of the first to break with the tradition of *David

Bonnard Pierre (1867–1947). French painter, lithographer and designer who studied at the École des Beaux-Arts (1888) and the Académie Julian (1889). While a student he met *Sérusier, *Vallotton, *Vuillard and the other *Nabis who first exhibited together at the Café Volpini in 1889. His early graphic work (Revue Blanche cover, 1895) combines acute and often humorous observation of a fleeting pose with an instinctive sense of design. He ill. a number of books for *Vollard including Parallèlement (1900) and the outstanding edition of Daphnis et Chloé (1902). His decorative use of silhouette reflects the widespread influence of Art Nouveau and of Japanese prints. He subscribed to the Nabis doctrine of abandoning 3dimensional modelling in favour of flat colour areas, but was never committed to the Symbolist aspect of the movement.

After 1900 he concentrated more on painting and although he still worked more from his observation than his imagination, his early wit and charm gave way to a Matisse-like monumentality of design. Mature works like La Baignoire (1925) play off the considerable surface richness of paint and colour against a simple formal strength and his acute perception of light. After 1911 he worked either at Vernon or in S. France.

Bono da Ferrara (fl. mid-15th c.). Italian painter influenced by Pisanello and Squarcione. His best surviving work is *St Jerome in a Landscape*.

Bonsignori Francesco (1455?–1519?). Italian portrait painter influenced by Mantegna. From *c.* 1490 he worked chiefly at the court of the Gonzagas in Mantua.

Bonnard Man and Woman 1900

Bonvicino Alessandro. Il *Moretto

Book of Hours. A prayer book usually illuminated, especially in the 15th c., e.g. Les Très Riches Heures du Duc de Berry and the Rohan Hours.

Bor Paulus (c. 1600–69). Dutch painter, member of the *Utrecht school and while in Rome in the 1620s a leader of the *Bentname.

Bordone Paris (1500–71). Venetian painter, a pupil of Titian, whose style he followed closely. He worked in France for King Francis I and later in Augsburg and Milan, painting portrait, religious, allegorical and mythological subjects including *Fisherman presenting the Ring of St Mark to the Doge* and *Salvator Mundi*.

Borduas Paul Émile (1905–60). Canadian *tachiste* painter, with Riopelle founder of the group Les Automatistes (1940) in Montreal and leader of the group of painters who publ. the manifesto *Refus Global* (1948).

Borglum Gutsom (1867–1941). U.S. sculptor famous for works on gigantic scale, especially

Borgognone, Il

reliefs on mountain-sides made with dynamite and pneumatic drills, e.g. the carvings on the 500-ft (152-m.) cliff at Mount Rushmore in the South Dakota Black Hills, with portraits of Washington, Jefferson, Lincoln and Roosevelt.

Borgognone, Il. G. & J. *Courtois

Borissov-Mussatov Victor (1870–1905). Russian painter. In Paris he worked in G. *Moreau's studio; *Puvis de Chavannes made a great impression on him. He returned to Russia (1899), working near Saratov painting melancholy scenes of derelict classical mansions peopled by sad, crinolined figures. A lonely figure, both as artist and man, he was influential on the *Blue Rose Group.

Borofsky Jonathan (1942–). U.S. artist of mostly multi-media *installations, often on a gigantic scale, with a strong figurative style, sometimes associated with the 'new image' painters and *Neo-Expressionism, e.g. *Dancing Clown* (1982–3), *Flying Man* (1984) and *Hammering Man* (1984–5).

Bosch Last Judgment (detail) c. 1500

Borissov-Mussatov The Reservoir 1902

Borrassá Luis (1360–1426). Spanish painter who introduced the international Gothic style, the 3rd period of Spanish Gothic painting, into Barcelona. Of his many imaginative and richly coloured altarpieces the *Altarpiece of St Clare* is a fine example.

Bosch Hieronymus, also called van Aeken (c. 1450-1516). Netherlands painter. Documentary evidence connects him at various periods between 1480 and 1516 with his birthplace Hertogenbosch (Bois-le-Duc), where he belonged to the Brotherhood of the Holy Virgin; he designed the stained-glass windows and a crucifix for the Chapel of the Brotherhood (1511-12) and was presumably a highly respected member of the community. He was referred to at his death as the 'famous artist', which is borne out by a commission in 1504 for a Last Judgment by Philip the Handsome of Burgundy. B. was a religious painter with a strong bent towards satire, pessimistic comment and great interest in everyday life. This has made his work, a unity in form and content, one of the last profound expressions of the medieval world view. Landscape plays an important part in his compositions, it sets the mood and it is seen with directness. Religious iconography is reinterpreted freely in the mood of popular prints, and the unbridled fantasy of the artist explores, not so much the world of the subconscious but every thematic variation, allusion and symbol available to his contemporaries. These were not puzzle pictures in their time, but picture books which could be read and understood. Only when the tradition

and the understanding were lost did they increasingly require interpretation of some kind, until in our own time, with the advent of Surrealism, attempts have been made to 'explain' B. by means of dream analysis. He was also referred to as a heretic by later generations. It is impossible to date and arrange his work in chronological sequence as much of his original work is now lost, many copies were made in his lifetime and even his signature forged. The Haywain and The Garden of Delights are triptychs fully authenticated and so is the table panel of the Escorial, which once belonged to Philip II as one of his intimate possessions. Other important paintings by B. are: Christ Mocked, and a portraval of the Ship of Fools, a common contemporary theme.

Boscoreale. In 1900 were discovered 1st-c. Roman murals in a villa at this site near Pompeii.

Boshier Derek (1937–). British painter and sculptor; he studied at the R.C.A., London (1958–61). B.'s early works, important in the 2nd wave of British *Pop art, employed motifs from advertising, packaging, poster hoardings and fashion.

Bosschaert Ambrosius (1573–1621). Flemish flower and still-life painter who spent most of his life in Holland and died at The Hague. B.'s works are exceptional in their subtlety of colour, their detail and finish.

Botero Fernando (1932–). Colombian artist of recognizable 'fat' figures and exaggerated forms, initially influenced by *Goya and *Velazquez, e.g. *Princess Margarita after Velázquez* (1978).

Both Andries (c. 1608–49) and Jan (c. 1618–52). Dutch painters, pupils of A. Blocmaert. Working in Venice and Rome they are reputed to have collaborated in their paintings, Jan executing the landscape backgrounds, Andries the figures, usually peasants in *bambocciata* style. Returning to the Netherlands after his brother's death, Jan became one of the leading Italianate landscapists.

bottega. This Italian word for 'shop' is used, technically, of a master artist's studio in which his assistants work under supervision.

Botticelli Sandro, born Alessandro Filipepi (c. 1445–1510). Italian painter. Born in Florence, B. lived at the time of the city's greatest intellectual and artistic flowering, which coincides

Botticelli The Birth of Venus (detail) c. 1483-4

roughly with the reign of Lorenzo the Magnificent (1449–92). He was trained or influenced by Fra Filippo *Lippi and by the two Pollaiuolo brothers. In 1470 he painted the figure Fortitude, one of 7 'Virtues', commissioned from P. Pollaiuolo. Another teacher of influence was unquestionably Verrocchio. Thus B. was prepared for his career by those masters who represented all that was most vital in Florentine painting. To this he brought a rare talent for draughtsmanship and a very unusual temperament.

19th-c. writers on art have been responsible for creating an almost legendary figure, making B. the embodiment of the Renaissance painter: in fact, he was by no means typical. The picture of B. as a lyrical painter, bringing back to life the myths of the Golden Age of Greece must also be modified. It relies on those paintings B. was commissioned to paint by patrons such as Lorenzo the Magnificent, and his cousin, Lorenzo di Pier Francesco de' Medici who set the subjects from Poliziano, Marsilio Ficino and classical authors, and who restrained B.'s natural temperament. The most famous of these paintings of classical myths are *The Birth*

Botticini

of Venus, the Primavera, Pallas Subduing a Centaur and Venus and Mars. Thoughtful, but serene, they have coloured men's ideas about classical antiquity since they were painted. With the madonnas and such large works as The Adoration of the Magi, they are the best known of B.'s works. B. probably reveals himself more fully, however, in such paintings as The Calumny of Apelles, another classical subject, where the story from Lucian is told with effects that are strained to the point of frenzy. The drawn and troubled figure of the Baptist in the St Barnabas Altarpiece is obviously close in feeling to similar figures by A. Castagno, but there is something about it which disturbs the serenity of the whole picture. Such elements are even more pronounced in the Deposition and in the same subject in the Alte Pina., Munich. We know that when Savonarola proclaimed his religious crusade against the vanities of Renaissance Florence at the end of B.'s life, B. became one of his followers. Very little is certain about his life that is not based upon Vasari, but it seems likely that in the Mystic Nativity which is dated 1500/1501, and which has an inscription referring to the Apocalypse and the 'troubles of Italy', the reconciliation between the angels and the fallen angels at the birth of Christ gives a significant clue to the divisions in B.'s own personality.

However great his inner turmoil, his life seems to have been relatively tranquil for the times. He won early recognition for his talent. Between 1481 and 1482 he was in Rome painting frescoes in the Sistine Chapel with a number of the leading painters. Vasari claims that he lost much of the reputation he had built up after this by taking time from painting to illustrate Dante. These drawings show an incredible gift for draughtmanship (Beatrice and Dante in Paradise). B. was prosperous enough by the end of the c. to be running a large workshop, but with the revolutions in painting brought about by Leonardo and Michelangelo, and his own illhealth in old age, B.'s popularity appears to have diminished. After his death he was often forged but seldom imitated.

Botticini Francesco di Giovanni (c. 1446–97). Florentine painter who imitated distinguished contemporary painters such as Verrocchio and Botticelli; critical opinion has differed considerably as to which works can be attributed to B. Definitely by him is a tabernacle (commissioned 1484) in the Mus. della Collegiata, Empoli.

Boucher Mme de Pompadour 1759

Bouchardon Edmé (1698–1762). French sculptor strongly influenced by classical sculpture during a stay in Italy. His works include the fountain in the rue de Grenelle, Paris and the *putti* on the fountain of Neptune, Versailles. His brother and pupil Jacques-Philippe (1711–53) worked at the Swedish court.

Boucher François (1703-70). French court painter and decorative artist, the truest exponent of the Rococo style. He studied under *Lemoyne and began working on engravings after Watteau. In Italy (1727-31) B. was influenced by Tiepolo. In the 1740s he obtained the patronage of Madame de Pompadour; he painted several portraits of her and through her influence became chief painter to Louis XV in 1765. His superficial but graceful, delicately coloured, frivolous and endlessly inventive variations on pastoral mythological themes were exactly attuned to the artificiality of Louis XV tastes. He also executed designs for Beauvais and Gobelins tapestries. *Fragonard was his pupil.

Boudin (Louis) Eugène (1824–98). French painter. He worked mainly in and around Deauville and Trouville and is famous for his pictures of choppy seas, windy skies and fashionable visitors. He painted out of doors and

introduced *Monet to this method. B.'s style marks the transition between that of Corot and the Impressionists; he exhibited at the 1st Impressionist exhibition (1874).

Bouguereau (Adolphe) William (1825–1905). The most revered French academic painter of his day. His harmony of composition and technical skill, as displayed in his female nudes, were superb but his subjects banal.

Bourdelle (Émile) Antoine (1861–1929). French sculptor, painter and designer, for several years Rodin's assistant. Rodin's influence can be seen in the strong lines and vigorous movement of B.'s work, e.g. *Hercules the Archer* (1909) but B. was also affected by his study of Greek and Egyptian art. His output includes frescoes and reliefs for the Théâtre des Champs-Elysées (1912), monumental work and many portrait busts.

Bourdichon Jehan (c. 1457–1521). French court painter and illuminator, a follower of J. Fouquet. Of his religious paintings and portraits only a triptych (Palazzo di Capodimonte, Naples) has been identified and his fame rests on his illuminated mss, e.g. *House of Anne of Brittany* (completed 1508). In part this follows the Gothic style of 15th-c. illuminators, but his scenes are often more naturalistic and sometimes show the marked influence of Italian paintings, particularly by Perugino; he was the 1st French artist to be influenced by the Italian Renaissance.

Bourdon Sébastien (1616–71). French painter of portraits, historical and religious subjects and landscape. In Rome (1634–7) he executed pastiches after Castiglione, P. van Laer, Claude and N. Poussin. Returning to Paris, he gained a great reputation and was one of the founders of the Paris Academy of Painting and Sculpture (1648). From 1652 to 1654 he was court painter to Queen Christina of Sweden.

Bourgeois Louise (1911—). French-born U.S. sculptor. She began her career as a painter and engraver. She turned to imaginative and highly individual carved sculpture in the late 1940s making abstract elongated forms and clustered groups of abstract shapes painted black and white. In the 1960s she turned to plaster for bronze (e.g. Labyrinthine Tower, 1963) creating anthropomorphic forms and inside-out shapes which evoke the human body, and which were subsequently worked in marble.

Bourdelle Hercules the Archer 1909

Bouts Dieric (c. 1415–75). Early Netherlands painter who united in his work the influence of the brothers Van Eyck and of Rogier van der Weyden, possibly his master. An objective painter, he was concerned with a detached observation of reality and an intellectual approach to spatial problems, to perspective and composition. This is evident in the *Eucharist* triptych where a contemporary ban queting scene is transformed by an austere geometry into the pathos of *The Last Supper*. The *Hades* panel of *The Last Judgement* triptych reveals a more tender lyricism in expression and characterization of resignation and grace.

Boyd Arthur (1920—). Australian painter, mainly self-taught, whose work is related to *Nolan's in using myths.

Boydell John (1719–1804). British engraver and printseller and publ. In 1786 he began to commission the best artists of the day, including *Reynolds, *Romney, *Fuseli and *Kauffmann, to paint pictures illustrating Shakespeare (engravings of these appeared in

Bouts The Last Supper c. 1465

Brancusi Mlle Pogany 1920

an ed. of Shakespeare publ. 1802) which he exhibited in his gal. in Pall Mall.

Boys Thomas Shotter (1803–74). British painter who studied under *Bonington in Paris. He is noted for watercolour townscapes of Paris and London and as a pioneer of chromolithography.

Braij (Bray) Jan de (d. 1697). Dutch portrait painter and architect, son and possibly pupil of Salomon (1597–1664), also a painter and architect. Jan worked in Haarlem. His best paintings are of young women or groups such as *Regentesses of the Haarlem Orphanage*.

Bramante Donato (1444–1514). Perhaps the greatest Italian architect of the High Renaissance, born near Urbino. He was a relation of Raphael and 1st trained as a painter.

When Pope Julius II demolished the thousand-year-old basilica of St Peter's, he commissioned B. to design a new one (begun in 1506). B.'s plan has been obscured by later work, though Michelangelo used as much of it as he could. What the interior would have

looked like can be seen in Raphael's painting *The School of Athens*.

Brancusi Constantin (1876-1957). One of the outstanding sculptors of the 20th c., born in Rumania and trained initially as a carpenter and stonemason. He studied sculpture at Bucharest (1898-1902) and in 1904 settled in Paris for life. Here he soon shared the interest, common among Parisian artists, in African and other primitive arts, but the most absorbing influence on him was his native folk art and oriental art. Primarily a carver of wood and stone, he worked towards expressive strength through formal simplification, and The Kiss (1908) is in some ways a sculptural counterpart to Picasso's Demoiselles D'Avignon of 1907. But, unlike Picasso, B. always retained in his carvings something of the mystic symbolism of non-European mainstream art. Le Nouveau-Né (1915) and Le Commencement du monde (1924) are universal symbols of life and fertility simple but never symmetrical or geometrical. His Endless Column (1937-8) is a turning point

in 20th-c. sculpture: B.'s influence on it is two-fold. He brought about a revival of carving and had a craftsmanlike respect for the nature of his materials; his last years were devoted to polishing the surface of earlier works, e.g. Fish (1940s). Secondly, he endowed sculpture with an almost sacred significance: his carvings are objects for contemplation. 'B.'s mission was to make us shape-conscious' (Henry Moore).

Brangwyn Sir Frank (1867–1956). British painter of murals, examples of which are to be found in the Royal Exchange, Skinner's Hall and Lloyd's Registry, London, and in Missouri State Capitol and the Rockefeller Center, N.Y. In addition to drawings, paintings and etchings he also designed pottery, furniture and textiles.

Braque Georges (1882–1963). French painter. He was born in Argenteuil. At Le Havre, from 1889, he worked as apprentice to his father, a house painter. He moved to Paris in 1900 and then studied at the free Académie Humbert (1902–4). In 1905 he was deeply impressed by the room of *Fauve paintings at the Salon d'Automne (including Matisse, Derain and B.'s friends from Le Havre, Friesz and Dufy). The landscapes that B. painted (1906–7) at Antwerp (e.g. Harbour Scene, Antwerp, 1906), L'Estaque and Le Ciotat are in freely broken strokes of strong colour. B. considered these his 1st creative works.

In 1907, like so many of his generation, he was overwhelmed by the Cézanne Memorial Exhibition at the Salon d'Automne and this revelation was followed by his meeting with Picasso and the disconcerting distortions of the Demoiselles d'Avignon. B.'s ruthlessly simplified sombre-coloured landscapes and figures, e.g. Nude (1907-8), of the next 2 years show the extent of his change of direction and prepare the way for the development of Cubism. B. is credited with the introduction into Cubist painting of typography (in Le Portugais, 1911) and of the decorator's techniques of wood-graining and marbling, but Cubism was essentially the product of a remarkable partnership with Picasso ('marriage' was Picasso's word) which was broken by the war and B.'s call up in 1914. Cubism established above all the self-sufficient existence of the work of art, independent of reality, that was implicit in Cézanne's late landscapes. In looking beyond the superficial appearance of their subjects, Picasso and B. created a precedent which has contributed in one way or

Braque Violin and Jug 1910

another to most subsequent developments in European painting and sculpture, both figurative and abstract.

Seriously injured in 1915, B. returned to Paris in 1917 where, apart from summers at Varengeville, he spent the rest of his life. His earliest post-war paintings returned to synthetic Cubism with a stronger palette; La Musicienne (1917–18).

From 1920, although still related to his Cubist experience in their formal improvisation, his paintings are less obviously disciplined. The qualities which distinguished his Cubist paintings from Picasso's – his fluent painterliness and his natural ability as a rich but subtle colourist – predominate in a work like *Guitar and Jug* (1927). The still-life remained his principal theme from the *Gueridon* series (1927–30) to the climactic *Atelier* series (1949–55) in which the scope of the still-life extends to include the studio, the artist, his model and even the painting itself. The mysterious presence of the bird in flight is gently evocative in this as in other works by B., and the

Bratby

Bronzino Lodovico Capponi c. 1550-5

mood of his whole œuvre – apart from his shortlived excursion into Surrealism in the early 1930s – is serene and harmonious.

Bratby John (1928–92). British painter of domestic interiors. B. was the most outspoken member of the short-lived New Realist group (the *'Kitchen Sink school') which emerged in London in the early 1950s as a reaction against contemporary abstraction.

Brauner Victor (1903–66). Rumanian painter working mainly in France and associated with the Surrealist movement.

Bredero Gerbrand Adriaenszoon (1585–1618). Dutch poet and, in his youth, painter. His work resembles Dutch painting in its realism and his songs describe, with a genius for characterization, the kind of low life painted by D. Teniers the Elder. His comedies include *De Spaansche Brabander* (1618). B. also wrote excellent love-poetry, observing courtly conventions of diction but distinguished by spontaneity.

Bresdin Rodolphe (1825–85). French graphic artist called 'Chien-Caillou'. He owed his nickname to Champfleury, who made him the subject of *Chien-Caillou* (1847), a story about an engraver. He led an eccentric restless life and

created a curious visionary art appreciated by Murger and Baudelaire.

Breton André (1896–1966). French poet, leader and principal theorist of Surrealism. He publ. 3 Surrealist manifestos (1924, 1930, 1934) and founded Surrealist research laboratories which employed Freudian techniques in studying the subconscious. His works include: the poetry colls *Mont de piété* (1919), *Les Pas perdus* (1924) and *Poèmes* (1948); he also wrote the partly autobiographical 'novel' *Nadja* (1928).

Brett John (1831–1902). British landscape painter who, after 1870, specialized in scenes of the Cornish coast. Under *Pre-Raphaelite influence, he aimed to achieve an exact detailed imitation of nature. *The Stone Breaker* (1858) and *Val D'Aosta* (1859) were much admired by Ruskin

Breu Jörg (c. 1480–1534). Augsburg painter and draughtsman whose subjects included portraits, altarpieces and battle scenes. He travelled in Austria, where he executed his earliest signed work, an altarpiece in the monastery of Herzogenburg; he later visited Italy. The style he developed was close to that of Burgkmair.

Brewster John (1766–1854). U.S. primitive artist. His portraits in a simple but confident style include the beautiful and poised *Sarah Prince* (c. 1801).

Bril(1) Mattheus (1550–83) and Paul (1554–1626). Flemish landscape painters who worked in Rome and received papal patronage. They developed a style between the panoramic scenes of Flemish artists and the ideal landscapes of N. *Poussin and *Claude Lorrain. Paul B.'s landscapes painted on copper exerted some influence on *Elsheimer.

Broederlam Melchior (*fl.* 1381–*c.* 1409). Painter born at Ypres. About 1385 he became painter to Philip the Bold, Duke of Burgundy, who commissioned from him 2 wings for an altar in the Carthusian monastery at Champmol (1392–9). These depict the Annunciation, the Visitation, the Presentation in the Temple and the Flight into Egypt, and are an early example of International Gothic style.

bronze. An alloy of copper and tin, harder and more suitable for casting than copper; the qualities of an ancient b. are enhanced by the *patina which develops on it. From early times the virtues of the metal were realized and both the Greek and the Chinese sculptors achieved a

standard that has never been excelled. With the fall of the Roman empire the secret of the casting of figures (*cire perdue) was largely lost but was revived at the Renaissance when working reached a new peak. Fine b.s have been found at the African centres of *Benin and *Ife.

Bronzino, II (1503–72). Florentine Mannerist painter, pupil of J. da Pontormo. B. was painter to Cosimo I de' Medici, for whom he undertook decorative works and many court portraits, e.g. those of Eleanor of Toledo and her son, and Lucrezia Panciatichi. He used fine rich colours but portrayed his sitters with unrelaxed posture and faces of inscrutable reserve. His allegorical paintings and religious subjects, which appear devoid of deep or religious feeling, show typical Mannerist figure elongation and include *Christ in Limbo* (1552) and *Venus, Cupid, Folly and Time*, remarkable for its harshly metallic flesh tones against a brilliant blue background. B. also wrote poetry.

Broodthaers Marcel (1924–76). Belgian artist whose work has at different times been associated with Neo-*Dada and *Surrealist art as well as *Pop, *Installation and *Conceptual art, using *assemblages, film, photographs, sound tapes, slides, books, words and *found objects.

Brouwer Adriaen (c. 1605–38). Flemish genre painter, mainly of low life, and landscape painter. He led a dissipated life and died of the plague at Antwerp. In his realistic, often dramatic, tavern scenes the vulgarities and rowdy emotions of the subjects are fully recorded. B. often used dark tones and thick, violent but economical brush-strokes; in his last years he painted sensitive impressionistic landscapes. B.'s genre pieces strongly influenced D. Teniers the Younger and A. van Ostade.

Brown Ford Madox (1821–93). British painter, who was born in France and studied in Antwerp, Paris and Rome, where he met *Overbeck. He settled in London, and in 1848 Rossetti became his pupil and introduced him to the *Pre-Raphaelites, who affected his work, e.g. *The Last of England* (1855), but he was never a member of the Brotherhood. He was a partner in the firm of (William) Morris, Marshall, Faulkner and Co.

Brown Frederick (1945–). U.S. African-American painter originally (early 1970s) of bold abstractions and later influenced by *De Kooning. In the 1980s B.'s work became more

explicitly figurative, specifically referring to African-American experience, e.g. Stagger Lee (1983) and Last Supper (1984). B.'s background and long-standing interest in the Blues also inspired paintings which include portraits of Blues musicians.

Bruce Patrick Henry (1880–1937). U.S. painter who worked in Paris (1907–30). He was first an adherent of Fauvism, then of Orphism, but abandoned this to make experiments in abstract structure with geometric shapes and pure colours. He finally left pure abstraction and constructed his pictures round recognizable motifs. He destroyed much of his work.

Brücke, Die (Ger. The Bridge). The 1st group of German *Expressionist painters, founded in Dresden in 1905 and formally dissolved in 1913. Associated with it were *Kirchner, the leading member, *Nolde, *Schmidt-Rottluff, *Pechstein, *Heckel and *Mueller. The artists shared a common studio, cultivated the medieval guild ideal and also canvassed 'bourgeois' support with a lay membership scheme. The B. painters were inspired by Cézanne, Gauguin, Van Gogh and Munch, and by African and Pacific art. Their work was at first characterized by flat, linear, rhythmical expression and by simplification of form and colour, and their extensive use of the woodcut especially in posters, made it an important 20th-c. medium.

Bruegel. Family of Flemish painters flourishing in the 16th and 17th cs whose most important members are listed alphabetically below. Various spellings of the name have been used such as the later 'Breugel' and 'Brueghel'. The greatest of the family, Pieter B. the Elder, was also its founder.

Bruegel (Brueghel, Breugel) Jan the Elder (1568–1625). Flemish painter, the son of P. B. the Elder; he painted flowers, landscapes and Garden of Eden subjects in a highly finished manner which won him the nickname 'Velvet B.'

Bruegel (Brueghel, Breugel) Jan the Younger (1600/02–78). Flemish painter, the close follower of his father, Jan B. the Elder. He often painted his highly finished flower studies and landscapes on copper.

Bruegel Pieter the Elder (fl. 1551–d. 1569). The last and one of the greatest of the early Netherlandish artists. B. was named after his birthplace, but there is no general agreement

Bruegel

Pieter **Breugel** the Elder *The*Massacre of the Innocents (detail) 1564

which of 3 possible villages this was. Moreover, his name is variously spelt. He signed his work Bruegel and Brueghel, while he was nicknamed 'Bruegel the Droll' or 'Peasant Bruegel', by later writers on art to distinguish him from other members of the family of painters he founded. Even the date of B.'s birth is uncertain, as are details of his training. Obviously an early influence on him was the work of Bosch (d. 1516) and it is likely B. was apprenticed to P. Coecke van Aelst, whose daughter he married in 1563. He was a master of the Antwerp Guild in 1551. Shortly afterwards B. journeyed extensively in Italy, probably as far south as Sicily, returning through the Grisons and the Tyrol. After his marriage B. moved from Antwerp to Brussels. There is much conjecture but little evidence regarding his position and attitude during the early years of the rebellion against Spanish rule, the religious controversy and the horrors of civil war. When B. died he left a family of imitators. He had established almost all the categories of later

Flemish painting and his own paintings were highly priced. Yet, despite the admiration of Rubens and the fact that most of his paintings were quickly acquired for royal colls, B.'s reputation declined until the great revival of interest in his work at the beginning of the 20th c. B. earned a living for many years with drawings engravings publ. by the humanist printseller, Hieronymus Cock. He probably painted in watercolour technique, but this work has been lost. About 40 paintings in oil and a few in tempera on linen survive. Briefly, the outstanding feature of B.'s style is its independence of Italian models at the time when most of his contemporaries in the Netherlands were already Romanists. In colour he favoured a muted palette of blue-greens, blue-greys and a wide range of browns, frequently enlivening the picture with points of clear colour, often yellow or red. He extended painting to include the countryside in all seasons, moods and weathers, following medieval Books of Hours and tapestries. He also showed much the same

sympathetic but unsentimental interest in those who worked on the land. Between the labourers and their environment B. manages to establish a wholly original relationship in visual terms, e.g. between the lean hunters and the countryside locked in winter - Hunters in the Snow; the feeling of well-being won from nature - The Corn Harvest; or a steel-cold winter's day providing the background to an act of human brutality - The Massacre of the Innocents. At times the landscape almost overpowers the activities of men, as the dramatic Alpine settings do in both The Suicide of Saul and The Conversion of St Paul, or the turbulent water in Storm at Sea. The Peasant Dance and Peasant Wedding provide 'close-ups' of the peasants' happier hours. Throughout his life B. used everyday sayings and proverbs to draw personal and highly sophisticated morals on the condition of man. The mastery he came to achieve over his vast material, observed and imagined, can nowhere be better seen than by comparing his early, over-crowded Netherlandish Proverbs with the brilliantly composed late work The Blind Leading the Blind. 2 works showing the power of his imagination at its greatest are Dulle Griet and The Triumph of Death. The 1st, a satanic landscape peopled by all the devils of medieval folk-lore, has been a stimulus to poets, painters and also film producers in the 20th c., while The Triumph of Death, with its almost mechanical destruction of human life by thousands, has appeared grimly appropriate to aspects of our times.

Bruegel (Brueghel, Breugel) Pieter the Younger (c. 1564–1638). Flemish painter, the son of Pieter B. the Elder, he imitated the fantasy subjects of his father, earning the nickname 'Hell B.'. *Snyders was his pupil and his son, Pieter B. III, was also a painter.

brushwork. The way a painter handles his brush, e.g. with thick broad strokes or short stabs at the canvas or with smooth control, has since the late Renaissance been frequently a distinguishing characteristic of individual artists' styles. Academic painters generally strive for a finish so fine that the individual brushstrokes cannot be distinguished; other painters exploit methods of putting brush to canvas, for various effects.

Brusselmans Jean (1884–1953). Belgian Expressionist painter who moved from Post-Impressionism to severe formalized compositions which linked his work with primitive Flemish painting.

Bruyn Bartholomaüs (1493–1555). German painter, chiefly of portraits of the wealthy bourgeoisie of Cologne, where he worked. His style of portraiture as exemplified in his portrait of Burgomaster Arnold von Brauweiler resembles that of *Joos van Cleve. Some of his religious paintings show the Italianate influence of Van *Scorel.

Brygos. Prominent Greek painter of the early 5th c. BC so called because 5 cups decorated by him have the potter's mark *Brygos epoisen* – 'made by Brygos'. About 170 vessels have been identified as painted by him. Stylistic characteristics are violent movement, tenseness of line in drapery folds and economy of line in depicting nude figures. His style was much imitated.

Buckley Stephen (1944—). British painter who studied under R. *Hamilton and came to prominence in the late 1960s as one of the most important abstract artists of his generation. His work is a celebration of the processes of making, constructing, shaping, framing, colouring, alluding and veiling through layers of texture. Unlike formalist abstraction works, B.'s paintings suggest, in their imagery, construction and titles, lived experience, e.g. *La Manche* (1974).

Buffalmacco Buonamico di Cristofano, called (13th–14th c.). Painter of the early Florentine school best known for his contemporary reputation as practical joker. Vasari lists many paintings by him but none can now be attributed with certainty.

Brygos Priam Ransoming Hector's Body c. 590 BC

Buffet

Buffet Bernard (1928–). French painter who trained at the École des Beaux-Arts, Paris. The expressive draughtsmanship of his early nearmonochromatic paintings has become – under the pressure of his phenomenal public success – a mannerism.

Buon Bartolommeo (c. 1374–1464). Venetian sculptor. With his father Giovanni he was responsible for the Porta della Carta, one of the last additions to the exterior of the Ducal Palace, Venice. The style is still late Gothic, though a few Renaissance motifs appear.

Buonarroti Michelangelo. *Michelangelo

Buonconsiglio Giovanni (15th–16th c.) called 'Il Marescalco'. Italian painter influenced by Antonella da Messina and Giovanni Bellini. He worked in Vicenza and Venice. His masterpiece is a *Pietà*.

Buontalenti Bernardo (1536–1608). Italian architect, sculptor and painter, a leading Mannerist. His Casino di S. Marco (now the Palazzo dei Tribunali), Florence (1574), uses such features as: a doorway decorated with stone studs; a tympanum in the form of a shell; rustication that bends inwards; a keystone transformed into a coat of arms with stone 'drapery' rising from it to support a balcony; and windows with concave sills. He also had a hand in the facades of S. Trinità, Florence, and S. Stefano de' Cavaliere, Pisa. B., who was aptly named, produced spectacles of all sorts, scenery for plays, music and firework displays, and arranged a naval battle inside the Pitti Palace.

Burchfield Charles Ephraim (1893–1967). U.S. painter of the U.S. scene. In early water-colours he evoked with Expressionistic intensity the scenes and emotions of his childhood in Salem, Ohio. He then began to work in a more objective style applied to architectural subjects. In the 1940s there appeared an element of fantasy in his paintings which links them with the work of his earlier period.

Burden Chris (1946—). U.S. *Performance artist renowned for his disturbing performances such as being crucified on the roof of a Volkswagen, or shot in the arm by a live bullet in a gallery. B.'s actions are a distillation of the violence portrayed on U.S. television and an attempt to freeze its sensationalism. B. has also been involved in site-specific sculptures

and *installations, often involving curious machines.

Buren Daniel (1938—). French artist associated with *Conceptual, *Minimal and *Installation art. He has devised a system of vertical stripes (8.7 cm. wide), sometimes varying in colour, commercially printed and applied in a variety of interiors (e.g. untitled 3-room Installation at the Ace Gallery, Los Angeles, 1989) and external site-specific locations (e.g. Deux Plateaux, 1985—6, at the Palais Royal, Paris) which determine the form of the installation.

Burgkmair Hans (1473–1531). German painter of portraits and religious subjects and woodcut designer. He studied under his father Thomas and *Schongauer and was a friend of Dürer. He was affected by Venetian painting and was one of the 1st Germans whose work showed Italian influence. He is best remembered for his striking woodcuts, e.g. the 2 series Triumph of the Emperor Maximilian I with 135 cuts and The Wise King with 327.

burin (also called 'graver'). The principal tool used by the engraver for cutting the lines on block or plate. It is, essentially, a short steel rod usually lozenge-shaped in section and cut obliquely at the end to provide a point.

Burliuk the brothers David (1882-1967) and Vladimir (188?-1917). Prominent Russian Futurists. They studied painting first in Odessa and then in Munich under Azbe. In 1907 in Moscow they came into contact with Exter, Goncharova and Larionov, with whom they organized a number of small exhibitions. In 1910 they contributed to the 1st anthology of Russian Futurist poetry; they made friends with Kandinsky, subsequently contributing to *Blaue Reiter exhibitions and Almanac. In 1911 David met Mayakovsky and encouraged him to write poetry; subsequently they together devoted themselves to writing and propaganda for the 'new art'. In 1918 David left Russia and later worked in the U.S.A. in a primitivist style.

Burne-Jones Sir Edward (1833–98). British painter and decorative artist who became a painter under the influence of D. G. Rossetti and was associated with the second, 'romantic' phase of Pre-Raphaelitism. He was strongly affected by Botticelli and Mantegna when visiting Italy in 1859 and 1862. B. lacked the vigour and social ideals of the Pre-Raphaelites; based on literary themes, chiefly from Greek

mythology, Chaucer and Malory, his mystic, romantic and unhistorical pictures represented a dream world of escape from 19th-c. industrialism. He worked in subdued tones and a linear manner which contributed to *Art Nouveau*. He made influential designs for stained glass for his friend W. *Morris, for whom he also ill. books, e.g. the Kelmscott Press *Chaucer* (1897).

burr. In *engraving, the fragments of copper left on either side of the channel cut by the *burin.

Burra Edward (1905–76). British painter and theatrical designer; member of Unit I (1933). The work of Signorelli and Goya, Grosz and the Surrealists, influenced the development of his fantastic, richly imaginative art, which also mirrored his love of Spain and Mexico. B. first specialized in scenes of the underworld, exposing the decadence and disillusionment which existed between the wars but also indulging his taste for the flamboyant and bizarre. With the Spanish Civil War and World War II his work acquired menacing and tragic overtones. He worked in watercolour, usually on a large scale.

Burri Alberto (1915–95). Italian painter. After medical studies he began painting while a prisoner of war in Texas – an experience which had a strong formative influence on his work and, in part, dictated his choice of such seemingly unpromising materials as torn sacking, rusty metal and burnt wood, e.g. *Legno Nero e Rosso* (1960).

Burroughs Margaret (1917—). U.S. African-American painter and print maker who has worked in Chicago since the 1930s (Southside Community Art Center and Du Sable Museum). B.'s travels in Africa, Mexico and what was the Soviet Union shaped her figurative work and commitment to the social responsibility of art. Also distinguished children's book ill., teacher and museum administrator.

Burton Scott (1939–89). U.S. sculptor who studied under *Hofmann. Early in his career he was a *Performance artist; his first Performance was Eighteen Pieces (1971), containing elements anticipating his later work for which he is best known: *found' body movements and props, e.g. chairs. He first showed his sculptures in an exhibition in 1975, 'Two Chair Pieces' (N.Y.). B.'s 'furniture' sculptures were rendered in *Purist and *De Stijl styles, in granite and lava rock, e.g. his 'Rock Chairs' series (1980) in which only the two right-angle smooth surfaces, for sitting, and the base are cut

Burne-Jones Pygmalion and the Image (detail) series 1869-79

into the stone which is otherwise left in its natural state. His 'furniture' is not, however, just a purely formal and utilitarian exercise, but suffused with references to the human figure and it also functions as a metaphor for moral issues, especially in his numerous and expansive publicly sited works.

Busch Wilhelm (1832–1908). German graphic humorist and landscape and portrait painter best known for his rhymed picture stories, in particular *Max und Moritz* (1865; *Max and Moritz*, 1874) which remains popular. His paper *Fliegende Blätter* from 1871 expressed an essentially pessimistic view of life.

Bushman painting. The Bushmen are a nomad people of the Kalahari Desert, S. Africa. Their rock and cave paintings and engravings, at some 1500 sites in Namibia and S. Africa,

Bushnell

Byzantine art Mosaic of the Empress Theodora and her suite (S. Vitale, Ravenna) *c.* 547

depict human and animal figures (often in hunting scenes) in a vigorous, lifelike style reminiscent of prehistoric European art and Saharan rock painting. The B. have a rich oral tradition of mythology.

Bushnell John (c. 1630–1701). British sculptor. He travelled in France and Italy where he executed the huge tomb (1660s) of Alvise Mocenigo in the church of the Mendicanti, Venice. Having returned to London, he gained many commissions because of his Baroque style (a novelty in Britain) but his work is uneven in quality, often badly designed and tentatively expressed.

Bushongo. *Bakuba

bust. A sculpture portrait representing the head and upper portion of the torso.

Butinone Bernardino (fl. 1484–1507). Italian painter, who worked in Treviglio and Milan. B. was early influenced by Mantegna, later by Vincenzo Foppa, but his work retains traces of Lombard Gothic. In collaboration with *Zenale he painted frescoes in S. Pietro in Gessate, Milan (c. 1489–93) and an altarpiece at Treviglio. Other work includes a triptych (1484).

Butler Reg(inald) (1913–81). British sculptor trained as an architect. He began to make sculpture in 1944 and held his 1st 1-man exhibition in 1949. He held a Gregory Fellowship at Leeds

Univ. (1950–3) and in 1953 won the major prize in the Unknown Political Prisoner international competition. His earlier figure groups, e.g. *Boy and Girl* (1950) were linear constructions, but he later evolved more vulnerable figures, often delicately balanced, like *Girl* (1956–7), or trapped within an angular network of lines.

Buytewech Willem Pietersz (c. 1585–c. 1625). Dutch genre painter and one of the few significant landscape etchers before Rembrandt.

Bylert Jan van (1603–71). Dutch painter, a pupil of A. Bloemaert. He began painting in the Caravaggesque style of the Utrecht school, but after 1630 his style changed and his pictures became lighter and prettier.

Byzantine art. Art produced in and under the influence of the E. Roman or B. empire; this is conveniently dated from the founding of Constantinople in AD 330 to its conquest by the Turks in AD 1453. Examples of B. a. survive in Ravenna in Italy, the Balkans, S. Russia and other areas which once belonged to the empire, as well as in Asia Minor proper. B. artists produced wall paintings, illuminated mss, panel paintings and above all *mosaics. The brilliant shining colours of these last, their conventions of iconography and powerful mystical religiosity embody the best and most characteristic of B. a., which enjoyed its golden ages in the 6th to 7th cs and 9th to 12th cs, and in the

13th c. – a renaissance marked by an increased realism of treatment. The impact of B. a. on medieval European art was of great importance and is especially clear in the work of 13th- and 14th-c. Italian painters.

The 2 most important elements in Byzantine architecture were the Roman brick vault and the dome, which probably originated in Persia. Byzantine architects fused these with the use of mosaic as developed in early Christian art into a powerful highly individual style which found its most magnificent expression in the church of S. Sophia.

C

Cabaret Voltaire. Founded by H. *Ball for avant-garde artists and writers, it opened on 5 March 1916 in the Meierei Café in Zürich. *Arp, *Janco, *Tzara and other Dadaists gathered and launched the *Dada movement.

cabinet picture. Small easel painting. The minor Netherlands painters specialized in this type of picture.

Cadmus Paul (1904—). U.S. painter, also highly accomplished draughtsman and print maker, of contemporary life and social interaction. His *The Fleet's In!* (1934) was controversial due to its depiction of sailors and women carousing in an uninhibited sexual manner. This atmosphere permeates much of his work. Satire and *Social Realism were also characteristic of his subsequent *Sailors and Floosies* (1938). His subject matter means, however, that his remarkable technique, in the tradition of Renaissance painting and drawing, which he self-consciously emulates, is sometimes overlooked.

Cage John (1912–92). U.S. composer and artist, greatly influential in the worlds of music, dance and the visual arts. His artworks include unorthodox musical scores, prints based on Thoreau's *Journals* and Joyce's *Finnegan's Wake*, and a *multiple, *Not Wanting to Say Anything about Marcel* (1969). C. also produced 'edible drawings'.

Caillebotte Gustave (1848–94). French Impressionist painter and an early collector of Impressionist paintings. He bequeathed his coll.

Caldecott The Fox jumped over the Parson's Gate 1883

to the Musée du Luxembourg and it is now in the Musée d'Impressionnisme (Paris).

Caldara Polidoro. *Polidoro da Caravaggio

Caldecott Randolph (1846–86). British ill. and painter best known for his picture-books for children which were among the first to make use of colour wood engravings.

Calder Alexander (1898–1976). U.S. artist who first trained as an engineer. In Paris in the 1930s he was influenced by the work of Mondrian and Miró and broke new ground with his wire figure sculptures; these 'stabiles'

Calder Black Crescent 1960

Calle Cash Machine 1991

gave place to C.'s new concept in sculpture, the mobile. C.'s mobiles, sometimes several feet from extremity to extremity, are carefully balanced constructions of metal plates, rods and wires which are activated by either air currents, mechanical means or the push of a hand. With their continually changing configurations they provide a new medium for the artist of space. C. also produced book ills and stage sets.

Calderon Philip (Hermogenes) (1833–98). British painter. He established himself with narrative pictures, e.g. the Pre-Raphaelitesque *Broken Vows* (1857), became a successful portraitist and ran the R.A. school.

Caliari Paolo. *Veronese

Calle Sophie (1953–). French artist whose work consists of paired photographs and texts that document real-life situations. C.'s voyeuristic activity engages her in close detective-like surveillance in her search for and experience of histories of people who are observed knowingly or unknowingly. In *The Sleepers* (1979) 24 people were individually invited to sleep in her bed over a period of 8 days while she constantly observed and photographed them. In *Suite vénetienne* (1980), C. in disguise, secretly

followed a man (to whom she had been introduced once) from Paris to Venice: a narrative of a one-sided relationship emerges as he remains unaware that he is being watched. In *The Blind* (1986) a number of people born blind are photographed and asked to describe their ideas of beauty. In *Autobiographical Stories* (1988) the artist's 'prying eye' turns in on herself.

calligraphy. This has been classified as a fine art in China since the 4th c. AD. The brush is used both for writing and painting, and the written word is a visual ideogram and not, as in the West, the equivalent of a sound by phonetic symbols. While brush-strokes in China must be life-containing and spontaneous, their execution and appreciation are bound by strict rules. Each character must distribute its ink-intensities and lines in a rectangular field of its own: it is both an abstract composition and part of the sentence's flow. The aesthetic concentration on brushstrokes has recently been taken up as a style in painting by modern Western painters, such as *Kline, Michaux and *Tobey, under direct Japanese influence.

Callimachus (fl. 5th c. BC). Greek sculptor and architect to whom was ascribed (doubtless unhistorically) the invention of the Corinthian capital. He is said to have been inspired by seeing an acanthus plant growing through a basket.

Callot Jacques (1592–1635). French etcher, one of the masters of this technique who made it a respectable medium in its own right. He spent about 10 years in Rome and Florence but from 1622 worked mainly in Nancy. He drew court figures, etc., but is most famous for *Les Grandes Misères de la Guerre* (1633) illustrating the horrifying brutalities of the 30 Years War. His use of etching rather than line engraving enabled him to make extensive use of aerial perspective.

Callow William (1812–1908). British painter. He studied in France and later toured Europe (1838–40). C. is best known for his water-colours – landscapes, townscapes and sea pieces.

Cals Adolphe-Félix (1810–80). French genre and landscape painter whose work gives a sympathetic, slightly melancholy portrayal of peasant life. In 1879 he exhibited with the Impressionists.

Canaletto Grand Canal, Venice c. 1753

Calvaert Dionisio or Denis (c. 1545–1619). Flemish painter of landscape and religious subjects who went to Italy in his early 20s. After studying in Bologna and Rome he opened an academy in Bologna which preceded that of the *Carracci; *Albani, *Domenichino and *Reni were among the pupils. His work was eclectic, but popular for its brilliant colours and sensitive brushwork.

Calvert Edward (1799–1883). British engraver and painter, one of S. Palmer's circle in the mid-1820s. The poetic and imaginative vision found in C.'s early engravings, much influenced by W. Blake, rapidly declined. Feeble later paintings expressed his ideal of Hellenic paganism.

Camden Town Group, The. Inspired by *Sickert and formed in 1911 by British painters who introduced *Post-Impressionism into Britain, this group, which later merged with the London Group, included *Gore and *Gilman.

camera obscura ('dark') and lucida ('light'). Devices using light to throw an image of a landscape, portrait, etc., on to paper; the artist can then copy or trace it. The c.o. (in which an inverted image is thrown through a small opening on to a surface in a darkened room) uses an optical principle which makes

photography possible. The c.l. uses a prism to throw an image on to a drawing surface.

Campagnola Giulio (c. 1482–1510). Italian engraver, trained under *Mantegna, whose Dürer copies established the latter's reputation in Italy. His adopted son Domenico (1500–after 1552) was a painter several of whose works have been mis-attributed to Titian.

Campendonk Heinrich (1889–1957). German painter, woodcut artist and designer of stained glass; member of Der *Blaue Reiter group.

Campin Robert. *Master of Flémalle

Canaletto Bernardo Bellotto Bernardo *Bellotto

Canaletto. Name adopted by Giovanni Antonio Canal(e) (1697–1768), Italian painter of the Venetian school. Trained by his father and by Pannini in Rome, C. became the painter of Venice, its canals, the Rialto, the Riva dei Schiavoni, the Salute. His pictures were sold to tourists, including Englishmen on the Grand Tour, with whom he became so popular that he placed most of his business through Joseph Smith, later British consul in Venice. In 1746 C. was in London, and for the next 10 or so years he painted English scenes, but he appears to have been less in demand when he came to this market than he was in

Canova Pauline Bonaparte Borghese as Venus 1807

Venice. C. gives his studies of buildings, sky and water a shimmering effect and the rapid, stylized drawings of small figures in landscapes and town scenes were to influence artists and illustrators in every part of Europe to the present day. The Royal Colls contain much of his best work, both of the Venetian and the English period.

Cano Alonso (1601–67). Spanish court painter, architect and sculptor called, on account of his versatility, the 'Michelangelo of Spain'. Like Velazquez he studied under *Pacheco. He painted portraits and religious subjects in soft golden brownish tones but often with hard contours. There is an excellent portrait of C. by Velazquez.

Canova Antonio (1757–1822). Italian sculptor, the most celebrated exponent of Neoclassicism in sculpture. In Rome he executed monuments of Popes Clement XIII (1787–92; St Peter's) and Clement XIV (1782–7; SS Apostoli) and in Vienna the tomb of the Archduchess Maria Christina (completed 1805). Other work included *Pauline Bonaparte Borghese as Venus*

(1807) and the charming Amor and Psyche (1793); C. also executed 2 huge nudes of the Emperor Napoleon, one of which was captured by Wellington.

Cantarini Simone called 'Simone da Pesaro' or 'Il Pesarese' (1612–48). Italian painter of portraits and religious subjects in the style of G. Reni.

Capelle Jan van de (1624–79). Dutch marine painter, follower of De *Vlieger. Being a man of some means, he painted for pleasure and appears to have been self-taught. His works are notable for greyish brown tones, high-billowing clouds and reflected sunlight. He also painted winter scenes.

Capogrossi Giuseppe (1900–72). Italian painter who turned from a representational style to abstraction in 1950.

capriccio (It. caprice). Term used to refer to invented, collage-like or fantasy pictures, the most remarkable examples being *Los caprichos* of Goya. Canaletto, Guardi and Pannini also did paintings and etchings of imaginary townscapes or combined different details and viewpoints in one picture.

Caracciolo Giovanni Battista called 'Battistello' (1578–1635). Neapolitan painter whose Caravaggesque style strongly influenced 17th-c. Neapolitan painting.

Caravaggio. The name taken from his birthplace by Michelangelo Merisi or Amerighi (1571-1610), an Italian painter. He was trained in Milan by an undistinguished Mannerist. By 1593 he was in Rome working for other painters, very poor and already appearing in police records as a bravo. In about 1596 his fortunes changed dramatically. Some of his paintings were bought by the influential Cardinal del Monte and he was commissioned to paint a series of large religious paintings for the Contarelli chapel, S. Luigi de' Francesi. Previous to this C. has painted some of the 1st true still-lifes, notably The Basket of Fruit, a series of paintings of a model as 'Bacchus', The Musical Party and a masterly double halfportrait of a man and woman entitled The Fortune Teller, which obviously owes something to Giorgione in subject and composition, though the lighting and feeling reveal a quite new and original talent.

For the Contarelli chapel C. painted an altarpiece, St Matthew and an Angel, and 2 large

canvases for the side walls, The Calling of St Matthew and The Martyrdom of St Matthew. These pictures caused a sensation. The 'St Matthew' (original destroyed 1945) of the was considered vulgar sacrilegious by the clergy and C. painted the 2nd version, still in the church. Other major works of the period are The Conversion of St Paul, The Martyrdom of St Paul for S. Maria del Popolo, The Supper at Emmaus, The Death of the Virgin and The Deposition of Christ. At the height of his success C. killed a companion in a brawl and had to flee Rome. The last years of his life consisted of short periods of asylum, spent painting, at Naples, in Malta and Sicily. Each period ended in a brawl and renewed flight. Wounded in Palermo he reached Porto Ercole where he died. Although recent scholarship has modified C.'s reputation as a revolutionary, he remains one of the true innovators. He declared early in his career that he had rejected the Renaissance search for the ideal and would study no teacher but nature. His method of painting directly from the model and his choice of models from low life. presented just as they were even in his large religious works, were both complete breaks with tradition. However, to consider him a realist before his time is to miss his other innovation: a heightening of dramatic effect by the use of lighting that was always contrived and often highly artificial showing his emphatic sense of chiaroscuro. Attacked by many, his works were protected by powerful patrons during his life and after his death. The imitation of his work inspired a school of painting in Spain, the Caravaggisti, and led to the art of Velazquez. In N. Europe he had even more followers; the most directly affected were De *La Tour in France and *Honthorst in Holland and Rembrandt learned much from him.

Carducci (Carducho) Bartolommeo (Bartolomé) (1560–1610). Italian painter of religious subjects who settled in Spain and was one of the first to work in a Baroque style there.

Carducci (Carducho) Vincenzo (Vincente) (1568–1638). Italian Baroque painter, chiefly of religious subjects, who accompanied his brother Bartolommeo to Spain and settled there. In 1633 he publ. *Diálogos de ... la pintura ...* which gives an account of contemporary Spanish and Italian painters and illustrates the tensions which existed between Mannerist and Baroque aims.

Caravaggio Bacchus c. 1591

Caresme (Jacques-) Philippe (1734–96). French painter of scenes from classical mythology; pupil of C.-A. Coypel.

Cariani Giovanni Busi, called (fl. early 16th c.). Italian painter of the Venetian school. He was a pupil of Giovanni Bellini but had a varied style chiefly derived from Palma Vecchio, Giorgione and Titian. He retained an individual boldness of style in his portraiture.

caricature. The representation of a person's characteristic features or attitudes in an exaggerated manner so as to produce a ludicrous effect; in frequent use as an instrument of social and political satire. The grotesque figures found in medieval sculpture and the physiognomical studies of Leonardo da Vinci are among the predecessors of the c., which was developed as we know it by the Carracci; the word 'c.' first appears in Italian writings of the 17th c. Apart from its use in the Press of the 19th (e.g. Gillray) and 20th cs, its exponents have included Daumier, Goya, Grosz and Hogarth.

Carlevaris Luca (1665–1731). Italian painter and etcher who lived in Venice from 1679 and painted scenes of the city for foreign visitors. In this he was a precursor of Canaletto and Guardi, though he maintained a greater interest in figure groups.

Carpaccio Two Venetian Ladies (detail) c. 1515?

Carlsund Otto Gustaf (1897–1948). Swedish painter who pioneered *avant-garde* painting in Sweden. Through contact with Mondrian he was converted to Neo-plasticism. In 1930 he joined Van Doesburg's Art Concret group.

Caro Sir Anthony (1924—). The leading British sculptor of the post-H. *Moore generation; C. read engineering before studying sculpture (1947–52). He assisted Moore (1951–3), later producing bronze figures showing his influence. Following a visit to the U.S.A. (1959) C. began creating formal abstract, yet expressive structures in painted sheets and welded metal, and small-scale table sculptures for which he is best known. Subsequently figurative and decorative elements entered his work, as well as references to the grand sculptural traditions of the West, from Classicism to *Baroque, and of India.

Carolingian Renaissance. Name given to the revival of scholarship and the arts under the Frankish emperor, Charlemagne (d. 814). The revival of education, promoted by the founding of schools throughout the empire, sprang from the return to Latin literature and scholarship directed at Charlemagne's court at Aachen by the Anglo-Saxon scholar, Alcuin. A major achievement of the C. R. was the copying of classical mss and the development of the strongly formed and clear minuscule script. In architecture the C. R. marked the return, in Europe, to large-scale building; works such as the cathedral at Aachen led to the development of the *Romanesque style.

Carpaccio Vittore (c. 1460-c. 1525). Italian painter of the Venetian school, trained in the style of the Vivarini and the Bellini, C.'s bestknown work is the cycle of paintings The Legend of St Ursula. A story-teller of great imagination, C. related the incidents of the legend against the background of an idealized version of the Venice he knew. Thus the enchanting Dream of St Ursula shows the bedroom of a Venetian noblewoman. Similarly in The Vision of St Augustine the artist depicts the grandiose study of some Renaissance scholar-churchman. C. has always been a popular painter and there has been considerable critical interest in his work in recent years. His range of subjects and feeling is shown by such works as Two Venetian Ladies, the St George cycle of paintings, Preparations for the Entombment of Christ, The Presentation of Christ in the Temple, Meditation on the Passion of Christ.

Carpeaux Jean-Baptiste (1827–75). French sculptor who used a realistic approach in opposition to pseudo-classicism. His best work is found in the model for a monument to Watteau (c. 1863) and the group *The Dance* for the Paris Opéra (1869).

Carr Emily (1871–1945). Canadian painter, notably of Indian villages and of stylized totemic figures. She was also a writer.

Carrà Carlo (1881–1966). Leading Italian *Futurist painter who signed the *Manifesto of Futurist Painters* (1910). After World War I he followed De *Chirico's 'metaphysical' style. From 1921 he produced peaceful, more naturalistic work influenced by Giotto.

Carracci. 3 Italian artists from Bologna: Lodovico and his cousins, the brothers

Annibale Carracci Flight into Egypt c. 1604

Agostino and Annibale, who was the major artist of the 3. In 1585 the C. founded an academy in Bologna to teach painting and to revive the canons of classical art as it was then understood. All 3 of the C. painted in Bologna. In 1595 Annibale (1560–1609) was summoned to Rome to paint the decorations of the Palazzo Farnese. His most accomplished work is the Galleria Farnese of the Palace. This ambitious fresco cycle of subjects taken from classical mythology, such as The Triumph of Bacchus and Ariadne, at once established Annibale's fame. The frescoes were compared with those of Raphael and Michelangelo in the Vatican. In the Galleria Farnese, and in small works such as the delightful Flight into Egypt, Annibale created the ideal classical landscape, chosen by many later artists, including N. Poussin. Other important paintings Annibale are Domine, Quo Vadis? and the unusual composition Butcher's Shop. Agostino (1557-1602) assisted his brother at the Palazzo Farnese. His chief work is The Last Communion of St Jerome. He was an important art theorist and a notable engraver. Lodovico (1555–1619) continued the Academy when his cousins left for Rome. His own paintings are chiefly large altarpieces, e.g. The Madonna of the Bargellini. Domenichino and Guido Reni were among the many pupils of the C.

Carreño de Miranda Juan (1614–85). Spanish painter who worked in the style of Rubens and Velazquez. He painted frescoes in the cathedral of Toledo, mythological subjects and portraits. In 1669 he became court painter to Charles II.

Carriera Rosalba (1675–1757). Venetian pastellist, sister-in-law of G. A. Pellegrini; one of the first to work in pastel. She achieved European popularity as a portraitist. In Paris during 1720–1 she introduced pastel technique, revealed its possibilities to M.-Q. de Latour and kept an interesting journal of her visit, *Diario* ... (1865).

Carrière Eugène (1849–1906). French painter of romantic portraits and pictures of mother-hood.

Carrington Dora (1893–1932). British painter and engraver, a member of the *Bloomsbury Group through which she turned to decorative work emulating V. *Bell and *Grant.

Carrington Leonora (1917—). British painter and writer living and working in Mexico and the U.S.A. In the 1930s and early '40s she was closely associated with the *Surrealists. In 1942 she settled in Mexico and came into contact with a lively group of artists including *Varo, with whom she could identify. Her work of the late '30s is on themes of childhood, with magical elements, e.g. Self-Portrait (c. 1938), Celtic mythology, e.g. The House Opposite (c. 1947) and alchemical transformations, e.g. Again the Gemini Are in the Orchard (1947). Her narrative paintings of figures and animals, often in outdoor scenes, are hermetic allegories created in Early Renaissance technique and manner, although

Leonora Carrington Self-Portrait c. 1938

they are constructed in a highly personal style. Her books include the autobiographical *Down Below, The House of Fear – Notes from Down Below* and *The Seventh Horse and other Tales.*

Carrucci Jacopo. Jacopo *Pontormo

Carstens Asmus Jakob (1754–98). German painter and sculptor who settled in Rome and modelled his style on the works of classical antiquity and Michelangelo. Few of his completed paintings survive; it is chiefly cartoons for large-scale unexecuted mythological murals which remain. He made very limited use of colour, and the strength of his work lies in its power of draughtsmanship and intensity of feeling.

cartellino (It. label). Scroll or piece of paper painted either on the background of a picture or on a ledge in the foreground. It is used for the artist's signature or sometimes for a motto or inscription. Examples occur in the paintings of Giovanni Bellini and Antonello da Messina.

cartoon. The term has 2 well-defined meanings. Originally it was used for a full-scale and detailed preparatory drawing or painting for a tapestry, painting or fresco; famous examples are the c.s by Raphael (7 in the V. & A.,

London) for tapestries originally intended for the Sistine Chapel and now in the Vatican, and c.s by Leonardo da Vinci on the *Madonna and Child with St Anne*.

The term c. is now generally used, in a 2nd meaning, of a satirical drawing with a specific point, usually political.

cartouche. Originally a form of ornamentation in the shape of a scroll, such as a volute of an Ionic capital, it was later adapted in engraving and sculpture as a ground for titles and armorial bearings, and in this form is usually oval with a scrolled frame.

Cassandre. Pseud. of Adolphe Mouron (1901–68), Ukrainian-born French artist noted for poster designs. These included Étoile du Nord (1927) for Pullman and a 1930s advertisement, for Nicolas wines, related to *Orphism and pre-figuring *Op art.

Cassatt Mary (1844–1926). U.S.-born painter of the French Impressionist school. She studied in Paris, where she settled and became a disciple of Degas. Her finest paintings were studies of mother and child, scrupulously firm and unsentimental, e.g. *The Bath, Mother and Child*, and her studies of everyday life in dry

point and aquatint have recently received recognition. *Young Woman Sewing* is a fine example of her work in oil. She made an exquisite series of colour prints under Japanese influence.

Castagno Andrea del (*c*. 1423–*c*. 1457). Florentine painter whose style shows clearly the influence of Masaccio, but which borrows sculptural qualities from Donatello, with whom C. had a close emotional affinity. He is 1st heard of as the painter of a cautionary or propaganda picture showing the bodies of rebels hung in chains. This work gave C. the reputation of pursuing realism to the point of violence. Few of his paintings survive, but the Assumption of the Virgin in Berlin is a fine work. C.'s masterpiece is undoubtedly his Last Supper, a fresco of great intellectual and emotional intensity. By keeping alive and vital the harsh preoccupation with figure drawing and tactile values of the early painters and sculptors of Florence, C.'s work was of great importance to the later Florentines, Signorelli, Leonardo da Vinci and, above all, Michelangelo.

Castiglione Giovanni Benedetto called 'Il Grechetto' (c. 1610–65). Genoese painter of genre and monumental religious and mythological subjects in Baroque style and usually including animals; from 1648 court painter at Mantua. Also an etcher, he followed the Netherlandish school, particularly Rembrandt. He is the 1st artist known to have used monotype. He evolved a lively sketching technique in oil paint on paper.

Cassatt Lady at the Tea-Table 1885

Castagno Boccaccio c. 1450?

Castiglione Giuseppe (1698–1768). Italian Jesuit missionary and painter who settled in China (c. 1730). C. studied Chinese painting and developed a style which combined Oriental and Western techniques. His paintings were popular in France at a time when Oriental art was especially fashionable (*Chinoiserie). Many of C.'s paintings have survived.

casting. *bronze, *cire perdu

Catena Vincenzo di Biagio called (c. 1475–1531). Italian painter of the Venetian school, his early work, e.g. Virgin and Child, closely resembling that of Giovanni Bellini and Cima. Later he was more strongly influenced by Giorgione, Titian and Palma Vecchio. An inscription on the back of Giorgione's Laura refers to C. as a 'colleague' of his; Virgin and

Catlett

Child with Kneeling Warrior, once attributed to Giorgione, is now attributed to C. Also by C. is the portrait of Doge Andrea Gritti previously attributed to Titian.

Catlett Elizabeth (1915—). U.S. sculptor, painter and print maker living in Mexico. Her work represents the struggles of African-Americans. Regarded as one of Mexico's most celebrated artists, it is C.'s African-American consciousness and activism that inspires her work.

Catlin George (1796–1872). U.S. traveller and painter of Indian tribal life. He publ. *Manners ... of the North American Indians* (1841) with some 300 engravings and painted some 470 canvases, many of them full-length portraits of chiefs.

Caulfield Patrick (1936—). British painter; studied at Chelsea School of Art (1956—60), and at the R.C.A. (1960—3) at the same time as *Boshier, *Hockney, A. *Jones, *Kitaj, P. *Phillips. His work is figurative but formally rigorous, using familiar imagery which is subject to cool, spare, sophisticated treatment in the tradition of J. Gris and F. Léger.

Cavallini Pietro (fl. 1273–1308). Italian painter who worked in Rome and, at about the same time as Cimabue, began to move away from stereotyped Byzantine forms towards naturalism. There are mosaics (1291) by him in S.

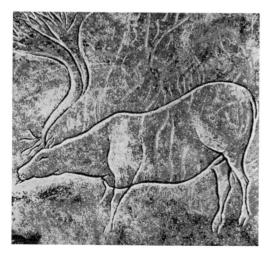

Cave art Engraved deer from Altamira c. 15/12,000 BC

Catlett Singing Head 1980

Maria in Trastevere, Rome, and fragments of a fresco, *The Last Judgement*, in S. Cecilia, Rome.

Cavallino Bernardo (1616–56). Neapolitan painter of religious subjects who worked in an individual style both graceful and sophisticated. His figures were slightly elongated, his colour combinations unusual and his background landscapes approached the romanticism of Salvator Rosa.

Cavazzola Paolo Morando called (1486–1522). Veronese painter of portraits and religious subjects. He was a pupil of D. Morone but became increasingly influenced by Raphael.

Cave art of the upper palaeolithic era was discovered in 1879 in the Spanish cavern of Altamira, where the roof is painted with polychrome bison. Archaeologists accepted these as prehistoric only after the discovery in 1894 of engravings and paintings in the previously sealed cave of La Mouthe, in the Dordogne. Discoveries have multiplied ever since in limestone areas N. and S. of the Pyrenees. In contrast to upper palaeolithic sculpture on limestone overhangs, the pictorial art is in caverns away from daylight. Beasts of the chase are depicted naturalistically (oxen, horses, reindeer, bison, etc., less commonly mammoth) in

various techniques, engraving, drawing in black or coloured outline, and painting (chiefly reds and ochres). Engraving and pigment are frequently combined, and images were often suggested by the shape of the rock. Crude composition occurs, though images are mostly superimposed. This C. a. was ritual, beyond which its purposes are disputed, recent opinion holding that myths were frequently depicted. The artists were homo sapiens whose migrations into a sub-glacial Europe began c. 30,000 BC. The art spans about 18,000 years, the developed polychrome naturalism belonging to the millennia before 12,000 BC when the retreat of the glaciers brought the hunting cultures to an end.

Cellini Benvenuto (1500-71). Florentine goldsmith, sculptor, medallist and adventurer whose boastful and entertaining autobiography (written 1558-62; publ. 1728; trs. 1771) is an invaluable record of life in Renaissance Italy. Commissioned by emperors, kings, popes and princes, he was renowned throughout Italy. His famous gold salt-cellar for Francis I is a typically florid piece, superbly executed. His work in coins, medals and medallions includes the famous gold Leda and the Swan. His large bronze sculpture of Perseus Holding the Head of Medusa is an intense early Mannerist work. Among lost bronzes are a pair of doorways and a huge statue of Mars.

Celtic art. The art produced by Celtic peoples in Western Europe from ϵ . 450 BC to ϵ . AD 650, notable for its use of asymmetrical and curvilinear abstract ornament, often combined with zoomorphic decoration. It falls into two main phases: an earlier, which was produced on the continent and often called the La Tène style (to the beginning of the 1st ϵ AD), and a later, confined to Britain and Ireland, from ϵ . AD 150, and often showing signs of contact with Roman art. Jewellery, wood carving, pottery and metalwork are some of the most typical products of C. a.

Cennini Cennino (late 14th—early 15th c.). Italian painter, none of whose works is known, and author of the artist's handbook *Libro dell'* arte (c. 1390), important for its information about the techniques of the school of Giotto, which C. derived through A. Gaddi, a pupil of T. Gaddi who was a pupil of Giotto.

Cephisodotus. Name of 2 Greek sculptors (I) (fl. early 4th c. BC) probably the father of

Cellini Perseus Holding the Head of Medusa 1545–54

Praxiteles A copy of his Irene Bearing the Infant Plutus is in the Glyptothek Museum, Munich, and one of Dionysus in the B.M., London; (2) (fl. late 4th c.) the son of Praxiteles. No complete work of his survives but among the work he is known to have executed was a statue of Menander in the Theatre at Athens.

Cerano, Il. Giovanni Battista *Crespi

César full name César Baldaccini (1921–98). French sculptor of mainly figurative work: *assemblages adding up to figures made with found and discarded iron scraps and machine parts (e.g. *La maison de Davotte*, 1960). C. was one of the members of the *Nouveau réalisme group founded in Paris in 1960 by the critic

Céspedes

Pierre Restany and *Klein. *décollage, *Rotella, *Villeglé, *Hains and *Vostell.

Céspedes Pablo de (1538–1608). Spanish Mannerist painter, sculptor, architect, poet and priest who spent over 15 years in Italy. He became a friend and pupil of the Zuccaro brothers and was strongly influenced by Raphael and Michelangelo; the latter is celebrated in C.'s didactic poem *Poema de la pintura*. His altarpiece *The Last Supper* in Cordova cathedral is a good example.

Cézanne Paul (1839-1906). French painter born in Aix-en-Provence the son of a well-todo banker. He studied in the same school as Zola, and formed a close friendship which had a decisive effect on the course of C.'s life. Destined by his father to study law he was eventually, at the age of 22, allowed to devote himself entirely to painting; a yearly allowance from his father enabled him to work without distraction for the next 23 years until his father's death, when he became a man of means. His 1st visit to Paris proved disappointing and he returned to Aix as a clerk in his father's office, but in 1862 C. was in Paris again for a decisive stay. He worked hard, and with Zola became involved in the revolutionary creative ferment directed against the bourgeoisie and academism. Yet he submitted work for the Salon and applied for admission to the École des Beaux-Arts, Paris, He failed in both. For the rest of his life he regularly sent paintings to the Salon. In 1882 he succeeded in having a portrait accepted as the result of friendly intervention. He exhibited in the Salon des Refusés of 1863. In 1886 he married his mistress; they had had a son in 1872. About this time C. worked with his friend Camille Pissarro, taking part in the 1st Impressionist exhibition of 1874. Chocquet, a collector. became his friend and patron. Again he showed with the Impressionists in 1877, then refused to take part in any more exhibitions and retired to the south. His friendship with Zola was broken off in 1886 and later he also broke with Chocquet. He withdrew more and more, but his fame was growing and he was becoming an almost legendary figure. In 1895 the dealer Vollard gave him a 1-man show consisting of 150 canvases, and in the same year 2 of his paintings entered the Luxembourg Mus. as part of the Caillebotte bequest. He was invited to show in Brussels and with the Vienna and Berlin *Sezession. In 1901 Maurice Denis

Cézanne Self-portrait c. 1873-4

exhibited his painting *Homage to Cézanne* and the 1904 Salon d'Automne showed his paintings in a separate room. A large retrospective Cézanne exhibition was organized in the 1906 Salon d'Automne.

C.'s development divides into a number of phases. From 1862 to 1870 was a time of fervent research, study devoted to the museums absorbing influences of Courbet, Zurbarán, Poussin, Manet and the sculptor Puget. C. was striving for a realism, searching for exactitude in revolt against the banality of the bourgeois Salons and the official Academy. His paintings tended to be clumsy, coarse in texture, painted with a palette-knife, turbulent almost brutal: greys, browns, earth colour and heavy black shadows with occasional flashes of brilliant colour. Characteristic of this period is a portrait, painted in 1866, of his father reading a newspaper and the Still-life with black clock. Both are monumental, showing an interest in architectural composition and a sense of plasticity.

C. retired to l'Estaque during the 1870 Paris Commune and here, in close contact with the landscape, his sensibility developed. When he joined Pissarro at Pontoise in 1872 a radical change was inevitable. The former heaviness slowly gave way to a more controlled and subtle surface, his palette lightened with the increased use of primary colours, their division

and related tones. C. acknowledged Pissarro as his master, but he also influenced Pissarro, though to a lesser extent. Both painters preserved their identity.

La Maison du Pendu shown at the 1st Impressionist exhibition (1874) typified this new palette. The realization of this change was of necessity slow and painful as increasingly colour and a colour-tone hierarchy became his dominant sensation and means of expression. A false note meant a fresh start - hence the deliberate brush-stroke, the incessant work in front of the model requiring countless sittings, immense effort, patience and genius to maintain and nourish the intensity of emotion. From 1880 onwards this research is intensified in his portraits, self-portraits, still-lifes, landscapes and in compositions such as the Card Players (1890-2) where the subject is interpreted in the classical tradition of Poussin. C. used watercolour for its heightened purity and brilliance, especially during his last years when his strong feeling for nature was surest. He was now an heir to the great colourists of the past, from the Venetians to Delacroix and he expressed volume and light in his own way by a system of superimposed glazes of pure colour and tone relations, where each colour temperature corresponded to a mood both of the physical world and of the world of painting. Thus he achieved a synthesis of reality and abstraction as in his Bathers (1900-6) and showed the way to the developments of the 20th c., first fully expressed by the painters of Cubism.

Chadwick Lynn (1914—). British sculptor. He started making mobiles in 1945. In the early 1950s he emerged as one of the leading figures of a group of young British artists whose linear constructions were in direct contrast to Moore's monumental style.

Chagall Marc (1887–1985). Russian artist of a devout Jewish family, born in Vitebsk. He went to St Petersburg in 1907 where he entered a minor art school, at the same time working as a sign painter; throughout his work a foundation of Russian art and the sign painter's technique was evident. He went (1910) to Paris where he came in contact with the Cubists; his work began to show Cubist influence (e.g. Homage to Apollinaire, 1911–12) but subjects generally remain of life in Vitebsk. In 1914 he returned home and contributed to Larionov's exhibitions and the *Knave of

Chagall Self-portrait with Seven Fingers (detail) 1912

Diamonds group. He was drawn back to his Jewish heritage, expressed now with a deep sense of pathos, as in The Praying Jew (1914). His marriage resulted in a series of exuberant paintings of lovers, e.g. Birthday (1915-23). After the Revolution, in 1918, C. was appointed director of the Vitebsk art school, which became a centre of avant-garde ideas, but was soon ousted by *Malevich and left for Moscow. From 1919 to 1922 he worked as theatrical designer for the Jewish State Theatre, executing murals there. In 1922 he went to Berlin, executing Mein leben etchings for *Vollard who then invited him to Paris (ills for Gogol's Dead Souls). In 1925-6 he completed a set of ills for an ed. of La Fontaine's Fables and held a 1-man show in N.Y. In 1930 his autobiography, Ma Vie, was publ., and C. began to prepare ills for the Bible, travelling to the Middle East. He went to the U.S.A. in 1941, producing the décor for Massine's ballet Aleko (1942) and Bolm's Firebird (1945) both for the Ballet Theater. He returned to France after the war. Of later work, his designs for stained-glass windows should be mentioned, and his paintings for the ceilings of the Paris Opéra.

Chalukya

Chalukya. Style of S. central medieval Indian sculpture and architecture which fl. under the C. dynasty. Architecture includes the early Ladkhan temple (ϵ . 450 AD), the 'Durga' temple (ϵ . 550) at Aihole and the 4 rock-cut shrines of Badami (begun 578). Sculptures include the majestic figure of Vishnu in Cave III, Badami (ϵ . 580), and some fragmentary wall painting also survives.

Chamberlain John (1927–). U.S. *assemblage sculptor. In the late 1950s he began a series made from polychromed crushed automobile parts, e.g. *Johnnybird* (1959) and *Mr Press* (1961).

Champaigne Jean-Baptiste de (1631–81). Painter, nephew of P. de C. and his assistant. He was born in Brussels, moved to Paris in 1643 and took French nationality in 1655.

Champaigne Philippe de (1602–74). Painter of portraits and religious subjects, born in Brussels and trained as a landscapist there. In 1621 he moved to Paris and with N. Poussin assisted on decorations for the Luxembourg Palace. In 1628 he was appointed painter to Marie de' Medici and was patronized by Louis XIII and Cardinal Richelieu. For the latter he painted frescoes in the dome of the Sorbonne church, a full-length portrait (1635) and a triple portrait as a model for Bernini's bust. During this period his portraits, though more sculptural, resembled Van Dyck's and his religious

Chardin Self-portrait 1771

paintings, e.g. Adoration of the Shepherds (c. 1630), showed the influence of Rubens's Baroque, though much restrained. His most original work was produced after c. 1647 when he began to associate with the Jansenists of Port-Royal. Under the influence of the harsh, puritanical doctrines of this Catholic sect his tendency to coldness and restraint was accentuated and all Baroque contrapposto eliminated. his work achieving a beauty new in French art founded on extreme simplicity and austerity. Outstanding examples of this period are his half-length Portrait of an Unknown Man (1650) and the picture Ex Voto, 1662 painted in thanks for the wonderful healing of his daughter, a nun at Port-Royal.

Champfleury. The pseud. of Jules Hussar of Fleury (1828–89). French writer and art historian. He applied the term Realist to his own fiction and was a great supporter of *Courbet, opposing idealizing traditional religious and classical subjects. His critical study, *Le Réalisme* (1857), was one of the 1st studies of the movement. He wrote many books on the movement. He wrote many books of the movements, caricature and popular art, including *Histoire de la caricature antique* (1865–90). His novels include *Souffrances de professeur Delteil* (1853; *Naughty Boys, or the Sufferings of Mr Delteil*, 1855).

Chan Chan. Ancient city near Trujillo, Peru, capital of the Chimu empire (*c.* 1000–1466). The ruins include great step-pyramids, terraced houses and stone cisterns. The adobe walls are decorated with lively, repeating-pattern reliefs of plant, animal and bird motifs.

Chandler Winthrop (1747–90). American colonial primitive painter. His works include portraits of his parents and the *Rev. Ebenezer Devotion*.

Chantrey Sir Francis (Legatt) (1781–1841). British Neoclassic portrait sculptor and, in his youth, painter, renowned for his tender portrayal of children. He left his fortune to the R.A. mainly for the purchase of 'works of Fine Art ... executed in Great Britain' to be known as the Chantrey Bequest (purchases now in the Tate).

Chao Meng-fu (1254–1322). Chinese court painter under the *Yüan dynasty and a master calligrapher. He was renowned for studies of horses and for landscapes which were a model for all subsequent scholar-painters (*wen-jen).

charcoal. Sticks of charred wood, usually willow. There is literary evidence that c. was used as a drawing medium by the Greeks, but extant drawings date only from c. 1500. It is very soft and needs to be 'fixed' if used on paper. In general it is unsuitable for detailed work but lends itself to the bold statement; it is widely used for compositional sketches because it is so easily rubbed off that corrections can be made indefinitely. It is often used in conjunction with white chalk on toned paper.

Chardin Jean-Baptiste-Siméon (1699-1779). French painter, master of still-life and genre. The son of a court craftsman, he was trained in the Rococo tradition of P.-I. Cazes and Noël-Nicolas Covpel and worked as a restorer of the Vanloo decorations at Fontainebleau. Despite this. his early work was mistaken by contemporaries for that of the Dutch masters of stilllife. His modest nature, individual style and choice of subjects from everyday middle-class life retarded his success in the age of Boucher and Fragonard, but he was elected a member of the French Academy in 1728, while his genre subjects were made popular by engravers. When the court art of the 18th c, went out of favour the reputation of C. rose. The simplicity of his composition, his single figures of kitchen-maids at work and children absorbed in their games, had an influence upon the painters of everyday life in the 19th c. Manet was greatly influenced by the unstressed brilliance of C.'s still-life painting, as Courbet had been before him

Charlet Nicolas-Toussaint (1792–1845). French graphic artist and painter, a pupil of A.-J. Gros and friend of Géricault. His paintings depicted romanticized episodes of the Napoleonic era; more successful were his litho graphs and woodcuts illustrating informal incidents of life in Napoleon's army.

Charonton Enguerrand. *Quarton

Chase William Merritt (1849–1916). U.S. portrait, landscape, genre and still-life painter. He went to Munich in 1872 and worked under F. Wagner and K. von Piloty; after returning to the U.S.A. he gained a great reputation as a teacher.

Chassériau Theodore (1819–56). French historical and portrait painter and engraver. C. was born in the French West Indies; he studied in Paris and Rome, chiefly under Ingres, but

Chassériau Chaste Susanna 1839

was later influenced by *Delacroix and the Romantics, particularly in his use of colour and his choice of subjects. In the *Chaste Susanna* this combination of firm drawing with Romantic feeling can be seen. C. painted murals for a number of churches and in the Palais D'Orsay and fashionably romanticized versions of African life; he engraved several sets of ills to Shakespeare.

Chatelain (Chatelin, Chatelaine) Jean-Baptiste-Claude (1710 71). British draughtsman and engraver of French Huguenot origin. He specialized in landscapes and was one of the first to exploit the Lake District; his drawings have sometimes been attributed to Gainsborough. He executed engravings after Claude Lorrain, G. Poussin, Rembrandt, S. Ricci and others.

Chéret Jules (1836–1932). French colour lithographer, a pioneer of the *poster, e.g. the series for the Circus Rancy in the mid-1860s. 'La Chérette', the happy, vivacious girl of his posters, was the toast of the 1880s and 1890s. His flat interlocking shapes and use of colour are reflected in such works as Seurat's Le Cirque.

Chia Sandro (1946—). Italian painter, one of the new figurative, *Neo-Expressionist artists

chiaroscuro

who came to prominence in the late 1970s along with the Germans *Baselitz and *Kiefer and the American *Schnabel.

chiaroscuro (It. light-dark). In painting this refers to the use of strong contrasts of light and shade for dramatic impact, as in the paintings of Caravaggio and Rembrandt.

Chicago Judy (1939-). U.S. controversial feminist artist (organizer of the 1st Feminist Art Program in the U.S.A. in 1970). Her most famous work is the *Installation, The Dinner Party (1974-9), 'a symbolic history of women's achievements and struggles', executed by about 400 women working as ceramicists, needleworkers, china painters, etc. It represents 39 successful women with place settings at the triangular-shaped table, with ceramic plates on an embroidered runner, set on a porcelain floor of triangles painted in gold with the names of 999 'supporting' women. In 1980-5 she created The Birth Project, consisting of 100 pieces and 85 exhibition units, using various needlework techniques. C. and her husband have been working on a complex project on the Holocaust since 1987.

Chillida Eduardo (1924-). Spanish Basque sculptor, also known for his drawings, collages and prints. Internationally C. is considered to be one of the most distinguished sculptors of his generation. His highly individual abstract work evolves partly out of the grand traditions of *Cubism and *Constructivism, but also has affinities with his background. His sculptures in iron, steel, stone, alabaster and concrete are controlled and contemplative, evoking natural forces. C. has received many honours including the Gran Premio Internazionale di Scultura at the Venice Biennale (1958), the Kandinsky Prize (1960), the Carnegie Prize for sculpture at the Pittsburgh International (1964) and the Andrew W. Mellon Prize (shared with *De Kooning) in 1978. His work is in most of the important public and private collections in the world, including his Desde Dentro (1954) which was bought by the Guggenheim Museum, N.Y., Abesti Gogora V (1966) in the Museum of Fine Arts, Houston, Alrededor del Vacio IV (1968) at the Kunstmuseum. Basle and a later version (1970) at the World Bank, Washington. There have been numerous important exhibitions of C.'s work, most notably a major retrospective was mounted at the Guggenheim Museum, N.Y. (1980) and another

retrospective in the entire Martin-Gropius-Bau, Berlin (1991).

Chinese art. Carvings and ritual bronze figures and vessels survive from the Shang, Chou and Ch'in dynasties (c. 1500-206 BC). The 1st great flowering of C. a. was during the *Han dynasty (206 BC-AD 220). Chinese Buddhist art achieved an individual classic style under the *Six Dynasties (3rd-6th cs). The Six Principles of the 6th-c. Hsieh Ho laid the foundations of all C. a. By the principle of ch'i yun (vital spirit), the artist must be in consonance with the cosmic spirit. Hsieh Ho then deals with the brush-stroke. basic to all Chinese painterly techniques; fidelity to reality, colour; design; and the duty to copy and so perpetuate ancient models. Under the *T'ang dynasty Buddhist painting and sculpture reached a peak; the scholar-painter (*wen-jen) Wang Wei, a southern T'ang painter, worked in monochrome landscape painting. The classical style of the *Sung dynasty (960-1279) continued its brilliant evolution under Yüan. *Ming art tended to be backward looking. *Tung Ch'i-ch'ang enunciated his theory of the two schools of landscape painting: the 'northern' (i.e. courtly academic, *T'ang) and the 'southern' (i.e. scholarly). The latter, supposedly originating with Wang Wei, was superior since it expressed the individual cultured man's understanding of universal moral law revealed in nature. The *Ch'ing period (1644-1912) produced much fine minor work. The classical landscape style, in ink and colour on silk, was much influenced by *calligraphy and verses were often incorporated in the design. Bamboo painting was considered a virtuoso vehicle for the calligraphic brush-stroke.

Ching. The Manchu dynasty of China (1644-1912). Some court artists, traditionally the academics of *Chinese art, studied European techniques of shading and perspective. In reaction scholar-painters (*wen-jen), e.g. the 17th-c. 'Four Wangs', turned to a delicate but strict academicism. The 'Early C. Individualists' e.g. Chu Ta (1625-c. 1705), K'un ts'an (c. 1610-c. 1670) and Shih-t'ao (1641-c. 1717), among the most original figures in Chinese art, aimed at a truly Chinese nonacademic style. Other groups were the 'Eight Masters of Nanking' and the 18th-c. 'Eccentrics of Yangchou'. The reigns of the emperors K'ang Hsi (1662-1722) and Ch'ien Lung (1736-95) were remarkable for the high technical achievement and the last decadent flourish of traditional

Chinese porcelain, lacquer furniture and the minor arts, including a revived use of jade for highly ornamented and intricately carved cups, brush-pots, snuff-bottles and the like. During this period Chinese exports of porcelain and furniture flooded into Europe.

Chinoiserie. European imitation of Chinese, or sometimes nondescript oriental forms and designs. It was popular throughout Europe from about 1670, but is associated especially with the Rococo movement. The motifs were applied to architecture, room decoration, both pictorial and sculptural, porcelain (itself a direct imitation of the Chinese), silver and furniture.

Chirico Giorgio de (1888–1974). Italian painter born in Greece where he studied painting in Athens. *Böcklin and *Klinger influenced him during studies in Munich, and 15th-c. painting during a stay in Italy. C. worked in Paris (1911-15) and came into close contact with the avant-garde movement and the poet *Apollinaire. He was then painting, in what he later called his *'metaphysical' style, pictures of strange pseudo-classical buildings, shown in exaggerated perspective framing empty squares and dreamy sculpture. This dream-like quality was increased by the juxtaposition of unexpected objects in an incongruous setting painted with calm objectivity. His 2nd *'Surrealist' phase was characterized by mannequins, mechanical drawing instruments and strange haunted interiors. The work of this period is considered among the highest points of pictorial modernism. From 1929 his work took an entirely new turn, developing into a mannered naturalism and after 1933 he openly repudiated the modern movement.

Chodowiecki Daniel Nicholas (1726–1801). Polish-born painter, engraver, ill. and miniaturist who worked in Germany from 1743. For his valuable pictures of German middle-class life and manners he was known as the 'German Hogarth' but disclaimed the title.

Chola. S.E. Indian dynasty (c. 850–1267 AD). It conquered Bengal (1023) and established colonies in Sumatra. Early C. sculpture shows *Pallava influence; the Rajarajeshvara temple (c. 1000) at the C. capital of Tanjore, Tamilnadu, and the Shiva temple at Gangaikondacholapuram, near Kumbakonam, Tamilnadu (c. 1025) carry stone sculpture in the classical C. style. Magnificent *cire perdue bronzes include the famous Shiva Nataraja ('Lord of the Dance').

De Chirico Melancholy and Mystery of a Street 1914

Christo full name Christo Javacheff (1935–). U.S. artist born in Bulgaria who made his mark by wrapping public buildings and landscapes. Wrapped Coast, Little Bay, Australia (1969) draped I million sq. ft (9300 sq. m.) of coastline in plastic sheeting. Running Fence, completed in 1976 in California, was described by C. as '40 kilometres of diaphanous white fabric running over the hills, emerging from the sea and disappearing into the sea again.' In his extraordinary homage to Monet, Surrounded Islands, Biscayne Bay, Greater Miami, Florida (1980-3), 6 million sq. ft (560,000 sq. m.) of pink and shiny polypropylene fabric was used around II small islands, transforming them into waterlilies. The work was seen for 2 weeks in May 1983. The Umbrellas, Japan–USA (1984-91) literally linked the two countries by the simultaneous erection of an enormous number of blue and vellow umbrellas. All C.'s *installations are time-based and site-specific and are planned over several years. The documentation of the complex preparatory planning stages, of fund raising and of political, environmental and bureaucratic procedures with the drawings and collages, etc. are all that

Christus

remains of these temporarily installed works which after their brief realization are subsequently only memories.

Christus Petrus (c. 1400–72?). Early Netherlands painter. He was made a master at Bruges in 1444. He may have been a pupil or assistant of Jan van Eyck, and all his pictures have been confused with the greater master's at some time. It is still not clear whether C. visited Italy and was thus responsible for transmitting the style and technical achievements of the best northern painting to Antonello da Messina and other Italian painters. The delightful *Portrait of a Lady* by C. is a major work of the Netherlands school.

Church Frederick Edwin (1826–1900). U.S. landscape painter in the Romantic tradition of the *Hudson River school; a pupil of T. Cole.

Churriguera. Family of Spanish architects and sculptors, originally from Catalonia but settling in Madrid c. 1670. Its earliest members were stucco artists and makers of altarpieces. José Benito (1665-1725) was the first to turn to architecture. He built the town, palace and church of Nuevo Baztán, and many altarpieces, one of them over 90 ft (27.5 m.) high. His brother Joaquín (1674–1724) did an extravagant design for the dome of Salamanca cathedral, with barley-sugar columns and shell-niches (it was dismantled in 1755). The 3rd, most talented, brother, Alberto (1676–1750), laid out the Plaza Mayor at Salamanca, designed S. Sebastian, Salamanca, and parts of other churches, including the cathedral. The family continued to be important in the next generation and gave its name - 'Churrigueresque' - to the whole middle phase of Spanish Baroque (c. 1700-60). This is characterized by the fantastically lavish use of relief ornament, stucco, gilding and sculpture. The style lasted longest, and was taken to its greatest extremes, in Spanish Mexico.

Cibber Caius Gabriel (1630–1700). Danish sculptor who settled in Britain; father of Colley C. He worked in a smoothly modelled, tentatively Baroque style, e.g. his relief for The Monument, London (1674), and the Sackville tomb, Withyham church, Sussex (1677). His most famous and vigorous sculptures were the figures *Melancholy* and *Raving Madness* (c. 1680) for the Bethlehem Hospital.

Cicéri Pierre-Luc-Charles (1782–1868). French decorative painter and chief designer of sets

Christus Portrait of a Lady c. 1450

and costumes at the Paris Opéra. His extravagant Romanticism set an example which influenced theatrical design in France until the end of the Second Empire. He introduced gas lighting to the Opéra in 1822. His son Eugène (1813–90) was a Romantic landscape painter and lithographer.

Cignani Carlo (1628–1719). Late Baroque painter of the Bolognese school; pupil of F. Albani. In his active atelier he upheld the academic traditions established by the Carracci Academy.

Cimabue (c. 1240–1302?). Florentine painter. C.'s reputation as the 1st artist of the Italian Renaissance rests upon his mention by Dante in a famous passage, which, literally trs., states that 'C. believed he held the field in painting, but now the cry goes out for Giotto so that the fame of the former is obscured.' Tradition may be right in calling C. the teacher of Giotto. He was also believed by Vasari and others to be the painter of the *Rucellai Madonna* now given by most authorities to Duccio. However, in spite of difficulties of attribution which may never be resolved, it seems certain that C., or another Tuscan artist, was responsible for the all-

important break with the rigid conventions of painting in Byzantine art, giving greater scope to the natural, as opposed to the conventional and stylized form, and in choosing from a far wider range of subjects. C. is known to have been in Rome in 1272 and is documented to have been working on the mosaic figure of St John in the apse of Pisa cathedral in 1302. No attributions except for the St John are certain, but C. was probably the painter of the very damaged frescoes in the choir of the upper church and of the Madonna Enthroned with Four Angels and St Francis in the lower church at Assisi. The superb Crucifix, a second Crucifix, the large Madonna and Child Enthroned and a few other works are given to C. on the grounds of style and the authority of tradition which dates back almost to his own lifetime.

Cima da Conegliano Giovanni Battista (1459/60–1517/18). Venetian painter strongly influenced by Giovanni Bellini. His many works include a *Virgin and Child*.

Cione Andrea di. Andrea *Orcagna

Cipriani Giovanni Battista (1727–85). Italian painter and draughtsman, the 1st exponent in Britain of an elegant, superficial Neoclassicism. Meeting Sir W. Chambers and J. Wilton in Rome, he returned (1755) with them to Britain, settled there and became the leading history and decorative painter; as a decorator he was an early exponent of the Adam style.

cire perdue (Fr. lost wax). A very ancient technique of casting in bronze. The sculptor first makes a plaster core, roughly the shape of the finished work and pierced with iron rods; on this he models, in wax, the details of the sculpture. Next the wax surface is coated with a liquid clay which is left to harden. There is now an outer mould (pierced with vents) and an inner core, held together by rods and 'sandwiching' the thin wax 'outline' of the projected work. The wax is melted and molten bronze poured in its place. Mould and core are removed. The method was used in ancient Greece and Rome and revived in the Renaissance; it was also used by the *Benin sculptors.

Ciurlionis Mikalojus (1875–1911). Lithuanian composer and later painter of quasi-abstract works given musical titles, e.g. *Sonata of the Stars*. From 1906 until his death he worked in St Petersburg where he exhibited with The *World of Art group.

Cimabue Madonna and Child Enthroned (detail) c. 1280

Claesz Pieter (1597/8–1661). Dutch still-life painter. From a few commonplace objects standing on part of a sideboard or table lie created an uncommon, almost mystical harmony between each of these objects and a plain background. He used brownish tones occasionally enlivened by a brighter colour.

Claude Lorrain originally named Claude Gellée (1600–82). French landscape painter and draughtsman. Little is known about his personal life. He went to Rome as a youth, and is thought to have earned his living as a pastry-cook before returning to Paris in 1625. He lived in Rome from 1627, devoted to his work and famous for his picturesque landscape compositions. To prevent forgeries he recorded his paintings in a portfolio of drawings, the Liber Veritatis, in the coll. of the Duke of Devonshire since c. 1770, publ. in mezzotint in 1777. C. was a passionate observer of light and

Clemente

Claude Landscape with the Angel Appearing to Hagar 1668

atmospheric changes, and he made numerous line and brush drawings of dawn and dusk, working out of doors. Many of these studies are now in the Print Room of the B.M., London. Compared with the landscapes of N. *Poussin, his contemporary, C.'s work is more sensual and atmospheric and his drawings retain the spontaneity of an impression. He painted many large compositions - biblical, mythological, religious and pastoral subjects, views of Rome and sea views which have made him famous and influential. C. was a stimulus and inspiration to the great landscape painters of the 17th-19th cs, Hubert Robert, Watteau, Wilson and Turner, who painted his Dido Building Carthage in emulation of C.

Clemente Francesco (1952–). Italian figurative, *Neo-Expressionist artist who, along with *Chia, *Kiefer, *Schnabel, etc. came to prominence in the late 1970s.

Cleve Joos van. *Joos van Cleve

cliché-verre. Type of print invented by Corot, combining photographic and graphic techniques. A design was scratched on a sheet of glass which had been covered with black paint or albumen and made opaque through exposure to the sun; this was then used as a

negative and printed on sensitized paper. The technique was also used by Daubigny, Delacroix, Millet and Rousseau.

Clodion Claude Michel called (1738–1814). French sculptor, in Rome (1762–71). He produced many statuettes of pastoral figures but his sensual manner fell out of favour in the period following the Revolution; he then turned to monumental sculpture.

cloisonnism (derived from *cloisonné*). Technique used by the French Symbolist painters, notably *Gauguin. It is characterized by flat colour areas and heavy outlines. *Bernard claimed to have been its originator, though this was denied by Gauguin.

Close Chuck (1940–). U.S. artist of portraits – heads from photographs – sometimes associated with *Pop art and a pioneer of *Photo Realism, but also related to *Minimalist aesthetics through the use of grid points.

Clouet François (c. 1510–72). French court portrait painter, miniaturist and draughtsman, son of Jean C. His work, e.g. portrait of the apothecary Pierre Zuthe (1562) shows Florentine influence. His drawings were more meticulous and his paintings more brilliant and

Close Self Portrait 1968

François Clouet Francis I after 1541

more elaborate than his father's and he acquired a great contemporary reputation.

Clouet Jean (c. 1485–1540/41). Flemish portrait painter, miniaturist and draughtsman; father of François C. He worked at the court of Francis I of France. His paintings show earlier Flemish influence but his drawings in black or red chalk have the solid modelling of form typical of the Italian Renaissance.

Cobra. An international art group (founded 1948) named from the 1st letters of the cities Copenhagen, Brussels and Amsterdam. The best-known participants were *Alechinsky, *Appel and *Jorn, who aimed to revive *Expressionism. The group was co-ordinated by Christian Dotremont and was dissolved in 1951. It held an exhibition at the Stedelijk Museum, Amsterdam, in 1949; animals and insect life treated in a free abstract style showed the artists' admiration for pre-historic, primitive and unsophisticated art.

Cochin. Family of French artists. They included Nicolas (1610–86), an engraver in the style of J. Callot, his brother Noël (1622–95), a painter and engraver who settled in Venice, Charles-Nicolas the Elder (1688–1754), an engraver after contemporary French masters

such as Chardin, Lancret and Watteau, and his son and pupil Charles-Nicolas the Younger (1715–90), famous as an engraver of vignettes, frontispieces and scenes of court festivities executed from his own drawings. He visited Italy in 1749 and in 1755 publ. Supplication aux orfèvres which initiated the reaction against Rocco organization

Codde Pieter (1599–1678). Dutch genre painter of small but spirited drinking scenes and conversation pieces. He completed *The Marksmen* by Hals.

Coello Alonso Sánchez (1531/2–88). Spanish court portrait painter, pupil of *Mor. His figures are stiff and melancholy but elaborate details of dress are given meticulous care, e.g. *Portrait of a Young Man*.

Coello Claudio (1642–93). Late Baroque Spanish painter, influenced by J. de Carreño and the last important representative of the Madrid school. Of his huge decorative works his masterpiece is *La sagrada forma* (1685–90), a religious and historical picture with portraits of Charles II and his court, composed to give the illusion of being a continuation of the sacristy.

Cohen Harold (1928–87) and Bernard (1933–). British artists. H. taught mathematics, designed and made furniture, was deeply involved in scientific problems and techniques relating to art, and produced computer art and programs for machine-made drawings. He lived most of the time in the U.S.A. B. was one of the leading British artists associated with the Pop movement. By the late 1960s he had developed his own highly distinct non-figurative idiom in paintings and drawings of linear, serpentine forms which then led him to patchwork-like paintings of great complexity and vivid colour effects.

Coldstream Sir William (1908–87). British painter, teacher, administrator in art education, head of the Slade School of A. 1949–75. C. cofounded (1938) the *Euston Road school together with *Pasmore. He exhibited with the *New English Art Club and the *London Group of which he became a member in 1934. His portraits, landscapes and still-lifes are formally constructed in an austere style.

Cole Thomas (1801–48). British-born U.S. landscape painter, a founder of the *Hudson River school. C. considered his allegorical and religious pictures his best work but these have

Cole View of the White Mountains

been far less influential or lastingly popular than his Romantic landscapes of the Hudson Valley.

collage. Composition made up of various materials – cardboard, string, fabric, newspaper cuttings, photographs, etc. – pasted to a canvas or board and sometimes combined with painting or drawing. It was a technique used by the Cubists, Dadaists and Surrealists. Matisse and others used a similar technique, called *papier collé*, which involved the pasting not of found material, but of cut–outs of paper in different flat colours.

Collingwood Robin George (1889–1943). British philosopher and historian. C.'s aesthetic theories were strongly influenced by *Croce. *The Principles of Art* (1938) emphasizes the communicative function of art, which generates the emotions necessary to a healthy social life. C. also wrote a study of the development of his thought, *An Autobiography* (1939).

Collins Cecil (1908–89). British painter and print maker. C.'s work is mystical and symbolic, often concerned with archetypal images and figures, e.g. the Fool.

Collins Charles Allston (1828–73). British painter and author, brother of Wilkie C. He was strongly influenced by Pre-Raphaelite ideals.

Collins William (1788–1847). British painter of landscapes and anecdotal pictures. C. was a follower and friend of *Wilkie and father of C.A.C. and the writer W.W.C. His paintings

were mediocre but such works as *The Sale of the Pet Lamb* (1812) achieved huge popularity.

Collinson James (1825?–81). British painter, an original member of the *Pre-Raphaelite Brotherhood; he painted *An Incident in the Life of St Elizabeth of Hungary* (1851) according to their ideals. The breaking of his engagement to Christina Rossetti was the occasion of many of her saddest and most exquisite poems.

Color-field painting. Term used primarily with reference to some *Abstract Expressionist U.S. artists of the 1950s to differentiate them from the *Action painters (e.g. *De Kooning, *Klein, *Pollock). Color-field painters (e.g. *Gottlieb, *Motherwell, *Newman, *Reinhardt, *Rothko, *Still) were concerned with the abstract image which was constituted by a unified colour shape or large area.

Colossi of Memnon Thebes (c. 1400 BC). 2 colossal seated statues of Amenophis III believed by classical historians to represent the mythical king, Memnon. Carved from quartz and orginally c. 68 ft (21 m.) high, the figures flanked the gateway of the Pharaoh's mortuary temple. Before restoration, that on the north emitted a musical note at sunrise and was consequently known as the 'singing Memnon'.

Colossus of Rhodes. Bronze statue (105 ft/32 m. high) of Helios, the sun god, by Chares of Lindos, erected by the harbour at Rhodes, *ε.* 280 BC, and one of the 7 wonders of the ancient world. It was overthrown by an earthquake in 225 BC. The remains were not removed until AD 656.

Colville Alex (1920—). Canadian painter. After World War II (in which he served as war artist) he developed a characteristic style formally organized and extremely realistic in subject and treatment.

combines. Term used by *Rauschenberg with reference to flat or, usually, 3-dimensional found objects which are incorporated, collage-like, into a painting.

'Company' paintings. Pictures of European-Indian style and subject matter, done (late 18th–19th cs) by N. Indian artists for officers of the British East India Company.

composition. The formal arrangement of a painting or work of graphic art; also a piece of music or writing, or the act of writing or composing.

Conca Sebastiano (1680–1764). Italian decorative painter in Baroque style who studied in Naples under F. Solimena. From 1706 he was in Rome, his work there including the ceiling fresco *Crowning of St Cecilia* (1725). In 1751 he returned to Naples.

Conceptual art. Art form and theory evolved in the later 1960s, the logical development from *Minimal art. It questions the whole idea of 'art', e.g. whether it has reference outside itself, and especially the validity of the traditional art object, and uses concepts as its 'material'. Since physical form is not essential in the presentation of concepts, and as a concept is usually the starting point of a work of art, conceptual artists propose that traditional media and physical manifestations (objects) are unnecessary. Ideas and information are thereby presented as, and conveyed by, written proposals, photographs, documents, charts, maps, film and video, and above all by language itself. The U.S. artists *Huebler, *Kosuth and *Weiner, and the British based *Art & Language group have been the main exponents.

Concrete art (Ger. konkrete Kunst; Fr. art concret). Artistic term introduced by Van *Doesburg in 1930 in preference to 'abstract art'. According to *Bill, its greatest propagandist, it 'refers to those works that have developed through their own, innate means and laws' and are therefore autonomous, i.e. not dependent on a process of abstraction.

Conder Charles (1868–1909). British painter and lithographer. After government work in

Australia he studied art in Paris. He produced delicate, elusive pastoral designs, influenced by Watteau and oriental art, sometimes executed on white silk and often for fans. In 1901 he settled in London.

Coninxloo Gillis van (1544–1607). Flemish landscape painter and engraver who settled in Amsterdam in 1595. His work marks a transition in landscape painting from the stylization of the early work of P. Bril and J. de Momper to the realism of the 17th-c. Dutch landscapists. J. Bruegel and Rubens were among those he influenced.

Constable John (1776–1837). British landscape painter. Born at East Bergholt, Suffolk, the son of a miller. C. worked for a time in his father's windmills, which he said later taught him to study 'the natural history of the skies'. He was encouraged in drawing by a village amateur and copied from Girtin and Claude. In 1705 he came to London determined to be a painter. and in 1799 entered the R.A. as a student. He grew impatient of the Italianate landscape painting of the time, which was still under the spell of Wilson, and in 1802 he returned to Suffolk, writing the famous letter in which he says: 'there is room enough for a natural painture [sic]'. Apart from discouraging periods in London painting portraits C. now gave his time wholly to teaching himself how to reproduce every effect of changing light and weather in the skies and the river meadows of the Stour. The work of these years was little known or appreciated until 1888 when over 300 drawings and paintings were given to the nation by C.'s daughter. This superb coll., now at the V. & A., contains sketches for many of his major paintings in oil, as well as cloud studies, flower pieces and large watercolours such as the Study of a Tree. 'Lights - dews - breezes - blooms - and freshness' could be used to sum up the impression they give. But if the results were lyrical, the study behind them was hard, slow and not materially rewarding. Gradually C. evolved an infinitely subtle modulation of greens and a strict, though hidden, sense of composition. Recognition of his genius was almost equally slow. Although he continued to exhibit large paintings at the R.A. almost every vear, it was 1819 before he became an Associate and 1829 before he was an Academician. In contrast to this, his exhibition of the Hay Wain at the Paris Salon in 1824 won him a gold medal and caused great excitement among

Constructivism

Constable Brighton Beach, Colliers 1824

French painters. Delacroix, it is said, repainted his Massacre of Chios on seeing it. C.'s influence on the French *Barbizon school of landscape painters is undisputed and his paintings of ships and harbours, such as the brilliant sketch in oil, Brighton Beach, Colliers or the large work, Marine Parade and Chain Pier, Brighton, were obviously a formative influence on Boudin. In Britain, despite continuing French enthusiasm, C. suffered from comparison with Turner and from the unfavourable opinion of Ruskin. C.'s art seemed, curiously enough, too easy and too ordinary when contrasted with that of the Pre-Raphaelites and Turner.

Constructivism. An aesthetic which arose in Russia based on the Futurist cult of the machine and first expressed in the 'Relief Constructions' of 1913-17 by *Tatlin. Its ideas became crystallized and assumed the importance of a movement in 1921/2 when there was a split between Muscovite abstract painters, some opting for the principle of 'pure' art and others for utilitarian and propaganda work. The latter group became known as 'Constructivists' or 'artist-engineers'. In their attempt to overcome the isolation of the artist from society, they entered the fields of industrial design (Tatlin, *Rodchenko, *Popova, *Lissitzky), the theatre and film (Meyerhold, Eisenstein) architecture (Melnikov, Ginzburg, Golossov, the 3 Vesnin brothers). Apart from

Tatlin's unrealized Monument to the 3rd International of 1919/20, Constructivist buildings include Lenin's mausoleum by Shchusev and the Izvestia building by Barkhin, both in Moscow. Constructivist principles produced the 1st examples of the 'new typography' (Lissitzky) and pioneer work in poster and exhibition design (Soviet Pavilion of the International Press Exhibition, Cologne, 1930 designed by Lissitzky). Through *Kandinsky, *Gabo and *Moholy-Nagy Constructivist ideas had a basic influence on the creation of the 'international functionalist style' of architecture and industrial design in W. Europe in the 1920s, chiefly propagated by the *Bauhaus.

continuous representation. A painting which represents on the same canvas various consecutive elements in a story; the type was sometimes used by medieval and early Renaissance artists.

contour. In a painting or drawing, the line defining a shape. A line in this sense can suggest, by modulation in thickness and intensity, spatial relationships and textures, and thus is not simply an outline.

contraposto. Italian term used also in English to describe a posture of the human body, in a painting or sculpture, in which the upper torso is twisted on the same axis as the legs but in a different plane.

Samuel **Cooper** The Duchess of Cleveland

conversation piece. A type of group portrait, common in the 18th c., often of a family depicted in the setting of their library or garden. The sitters are normally engaged in some everyday occupation. There are a few 20th-c. examples such as Orpen's *Homage to Manet*. To use the term of an object so

unusual as to be likely to provoke conversation is a recent and unconnected idea.

Cooper Alexander (*fl.* 1630–60). British painter and brothers of S.C. He was trained by his uncle J. Hoskins and worked mainly on the Continent.

Cooper Samuel (1609–73). British miniaturist whose portraits have a high place, both as historical records and as works of art. He was trained by his uncle, J. Hoskins, miniaturist at the court of Charles I. According to Horace Walpole, C. 'first gave the strength and freedom of oil to the miniature'. His skill appears to have been limited to painting the faces of his subjects. Some of his best work is at the V. & A., London, but there is a fine, unfinished portrait from life of Oliver Cromwell in the coll. of the Duke of Buccleuch.

Copley John Singleton (1738–1815). U.S. painter. From 1774 he lived first in Italy, then in Britain, where he was greatly influenced by *Reynolds and *West. Having won a reputation as a portrait painter, he embarked on large historical paintings, e.g. *Death of Major Pierson* (1783) in which C. paints himself as a child fleeing with his family from the battle. This expansion of a small incident to the proportions of a panorama was copied in both French and English 19th-c. painting.

Copley Death of Major Pierson 1783

Coppo di Marcovaldo

Coppo di Marcovaldo (1225–74). Florentine painter in the Byzantine style.

Coptic art. The art of a Christianized community of Egypt, converted c. 2nd c. AD; it fused late Egyptian, *Hellenistic and Byzantine styles. Funerary sculptures are stiffly posed; wall painting uses bold, flat colour areas, and depicts decorative animal and plant forms and primitive human figures with staring whites of the eyes and heavy eyebrows. Numerous C. textiles survive in similar style. Important buildings are the Red and White Monasteries at Sohag (c. 440) and the 11th- and 12th-c. churches of Old Cairo. Early 3-aisled basilicatype buildings evolved to a characteristic C. type of cellular structure of numerous chapels and cells.

Coques Gonzales (1614–84). Flemish portrait and genre painter known as the 'little Van Dyck' because he adapted Van Dyck's stately manner to small-size pictures, often conversation pieces.

Corbusier. *Le Corbusier

Corinth Lovis (1858–1925). German painter. C. studied at Königsberg Academy (1876–80) and the Académie Julian, Paris (1884–5). He became one of the leaders of German Impressionism, joining the Munich *Sezession; but his late style – e.g. his paintings of the Walchensee – comes close to *Expressionism, developing from his interest in dramatic scenes and facial expression using *impasto, and very free brushwork.

Corneille (Cornelis van Beverloo) (1922–). Belgian artist, a member of Reflex group and a founder of the international *Cobra group.

Corneille de Lyon (fl. 1534–74). Dutch portrait painter working at Lyons. The few surviving works attributed to him are similar in style to the portraits of F. Clouet.

Cornelisz Cornelis (Cornelis van Haarlem) (1562–1638). Dutch Mannerist painter of portraits and biblical and mythological subjects; a pupil of P. Aertsen.

Cornelisz Jakob (Jakob van Oostsanen) (d. before 1533). Dutch painter who worked in Amsterdam and is sometimes known as 'C. van Amsterdam'. He was an early representative of the Dutch school; to a hard style reminiscent of late Gothic he added ornamental features.

Corot Woman with a Pearl c. 1869

Cornelisz Lucas (1495–1552). Dutch portrait painter and court painter to Henry VIII of Britain.

Cornelius Peter von (1783–1867). German painter, for a time a member of the *Nazarene group before settling in Munich, where he did much work, notably large-scale frescoes.

Cornell Joseph (1903–72). U.S. *assemblage artist. His 3-dimensional 'collages' of everyday objects enclosed in heavy picture-frame boxes, glass and sometimes mirrors, suggest a remote private world, surreal in time and space. Works include *Medici Slot Machine* (1942) and the *Eclipse Series* (early 1960s).

Corot (Jean-Baptiste) Camille (1796–1875). French painter of landscape and portraits. Trained in the classical tradition of French landscape, founded chiefly on Poussin, C. went to Italy in 1825, and returned there many times. There are 3 distinct styles in his painting. His early classical landscapes, painted in rich panels of colour, often in the full glare of an Italian noon, e.g. View of the Colosseum, influenced Cézanne and other Post-Impressionists in their composition by tonal contrasts instead of strict drawing. In the 2nd style are the soft and silvery woodland scenes painted from the 1850s to his death, e.g. Ville d'Avray. Finally he painted a few portraits and studies of women, e.g. Woman with

a Pearl. The last are of a very high quality and have recently won recognition.

Correggio born Antonio Allegri (c. 1494-1534). Italian painter called after his birthplace in Emilia. C. worked all his life in the district around Parma, yet he seems to have been aware to a remarkable degree of the innovations in painting in Rome, Florence and Venice. He was probably the pupil of F. Bianchi Ferrari, but an early visit to Mantua brought him under the influence of L. Costa and Mantegna. Soon, however, the revolutionary style of Leonardo had softened C.'s painting. He combined this softness, a sort of 'golden haze', which is characteristic of all his major work, with a strong sense of modelling and a delight in rendering flesh tones. Unlike most N. Italian painters of the time, he did not simply surrender himself to the style of Leonardo: instead of Leonardo's creation of an unearthly beauty, C.'s subjects, however idealized, are sensual and very much of this earth. There is no evidence that C. was ever in Rome, but he was certainly informed of Michelangelo's frescoes in the Sistine Chapel and those of Raphael in the Vatican Stanze. Qualities of all 3 of the leading painters of the High Renaissance are reflected in C.'s madonnas. Equally popular were his mythological subjects, e.g. Mercury Instructing Cupid Before Venus. Today, he is chiefly considered important for the boldness of his imagination. C. was one of the 1st major artists to experiment with the dramatic effects of artificial lighting, e.g. Agony in the Garden, in which the figure of Christ alone lights the dark garden, and in Holy Night, in which the light comes from the Christ-child in the crib. C. is also seen as the vital link between the early experiments in illusionist painting of Mantegna at Mantua and the Baroque painters of ceilings. In Ganymede C. successfully depicts the figure of the shepherd carried into space by the bird of Jove. In his frescoes in the Camera di S. Paolo, Parma, or in the cupola of S. Giovanni Evangelista, Parma, figures flying freely in space are seen from below, and in the Assumption a vision of a mass ascent into Heaven is rendered for the spectator in visually convincing terms.

Cortona Pietro da. *Pietro da Cortona

Cosimo Piero di. *Piero di Cosimo

Cossa Francesco del (c. 1435–c. 1477). Ferrarese painter, possibly a pupil of C. Tura

Correggio Assumption (detail) 1526-30

but influenced by Mantegna and Squarcione; some of his work, e.g. Autumn, follows Piero della Francesca. His masterly frescoes *The Months* (c. 1470) for the Palazzo di Schifanoia, Ferrara, depict, in a detailed style, fanciful scenes of court activities.

Costa Lorenzo (1459/60 1535). Italian painter of the school of *Ferrara. With F. Francia he worked for the Bentivoglio family in Bologna painting portraits and religious subjects. In 1507 he succeeded Mantegna as court painter at Mantua.

costruzione legittima. An early form of *perspective used in the 1st half of the 15th c.; it used only 1 vanishing point and produced a certain amount of distortion.

Cosway Richard (1740–1821). Fashionable British miniaturist, portrait painter, picture dealer and eccentric, a friend of the Prince Regent. He revived the art of portrait miniatures and extended the use of ivory as a ground.

Cotman Greta Bridge 1810

His delicate, elegant, superbly executed work forms a complement to the artificiality of his age. One of his finest portraits is that of Mrs Fitzherbert. His wife Maria (fl. 1820) was an etcher and book ill.

Cotán Juan Sánchez (1561–1627). Spanish stilllife painter whose compositions created an esoteric relationship between a few simple objects painted with great naturalism and 3dimensional solidity. C.'s work, like that of his contemporary De *Zurbarán, was influenced by the still-life of Caravaggio.

Cotes Francis (1726–70). British portrait painter and pastellist; a founder-member of the R.A. His early oils were influenced by pastel technique but in the late 1750s he imitated Reynolds's style. His oil portrait of the artist Paul Sandby (1759) is one of the best examples of his work. His brother Samuel (1734–1818) was a miniaturist.

Cotman John Sell (1782–1842). British painter and engraver of the *Norwich school and 1st professor of drawing at King's College, London. His austere early watercolours, landscapes often painted in broad washes of a minimum number of colours: yellows, greens, browns and blues, are now highly prized. C. visited Normandy in 1817–18 and 1820. He made many engravings of buildings there and in Britain ill. books on antiquities.

Courbet (Jean-Désiré-) Gustave (1819–77). The leading French Realist painter of his time,

C. was controversial both as an artist and as a public figure. Born at Ornans, Franche-Comté, he studied at Besancon and Paris, but was scornful of tuition and largely self-taught. He first took his subjects from life in the artists' studios in Paris and from the countryside around Ornans. In 1850 C.'s Burial at Ornans caused a sensation at the Salon. This enormous painting, containing over 30 life-size figures, was attacked on the alleged grounds that it presented the clergy as cynical and the peasants as brutalized. C. had intended it as a sincere, but not conventionally idealized, group portrait of the villagers with whom he had grown up. Seascapes, landscapes, flower paintings, studies of animals, nudes and a few large-scale genre paintings followed. All were savagely criticized. C. responded with an arrogant and angry wit which became celebrated. Many of the nudes are splendidly coloured - perhaps only Titian could have equalled the contrasts C. achieves between the tones of a fur or of a girl's hair against the tones of her flesh. The winter landscapes, e.g. Rocks at Ornans, have a rough and earthy texture which makes them at the same time realistic and evocative.

In 1855 and 1867 C. withdrew from the Salon and held his own exhibition in the grounds, an action which was to set a precedent followed by the Impressionists. In 1871 he sided with the Commune, was made director of Museums and organized the destruction of the Napoleonic column in the Place Vendôme. For these activities he was later imprisoned and heavily fined. He died in exile in Switzerland.

By rejecting the ideals of both the Neoclassical and the Romantic schools and by choosing such subjects as the everyday life of the poor, C. prepared the way for artists as diverse as Millet and Degas. The independence of his behaviour and scorn of academic training had a lasting influence on the artists of Paris.

Courtauld Samuel (1867–1947). British collector and patron of Impressionist and Post-Impressionist painting whose important collection was presented to the University of London (the Courtauld Institute Galleries). C. endowed the Courtauld Institute of Art in the University of London, the most important British arthistorical institution.

Courtois (Cortese) Guillaume (Guglielmo) (1628–79) called 'Il Borgognone'. French Baroque painter. He went to Italy with his brother J.C. and studied in Rome under Pietro da Cortona. *Martyrdom of St Andrew*, over the high altar of S. Andrea al Quirinale, is an example of his work in Roman churches.

Courtois (Cortese) Jacques (Giacomo) (1621–75) called 'Il Borgognone'. French painter who worked in Italy, specializing in battle scenes which rivalled those of Salvator Rosa. Towards the end of his life he became a Jesuit and painted religious subjects for the churches of the order.

Cousin Jean the Elder (c. 1490–1560/1). French painter and designer. Working in Sens he designed the stained-glass window of St Eutropius (1536) for the cathedral and painted (probably) there the 1st great French nude, *Eva prima Pandora*. He designed the tapestries of the life of St Mammès (begun 1543) for Langres cathedral.

Cousin Jean the Younger (c. 1522–c. 1594). French painter, influenced by Mannerism and best known for *The Last Judgement*. He was also a miniaturist, engraver, goldsmith, book ill. and designer for stained glass.

Coustou Guillaume (1677–1746). French sculptor, nephew and pupil of A. Coysevox and brother of the Baroque sculptor Nicolas C. (1658–1733). The Baroque style exercised slight influence on Guillaume's work, which had a classic restraint. He is best known for his *Horses* made for the park at Marly and now at the entrance to the Champs-Élysées, Paris. His son Guillaume (1716–77) was also a sculptor

Courbet L'Atelier du peintre (detail) 1855

whose work included statues of Mars and Venus for the Sans Souci Palace at Potsdam.

Couture Thomas (1815–79). French portrait, historical and genre painter. His small commedia dell'arte paintings are popular, while the paintings on classical themes, such as the celebrated Romans of the Decadence (1847) and A Roman Feast have at times lost their appeal. *Manet was C.'s pupil for 6 years and undoubtedly learnt much from his strong, free brushwork and bold contrasts, shown especially in the sketches and a few fine landscapes.

Cox David (1783–1859). British painter in watercolours and oils. His *A Treatise on Landscape Painting and Effect in Water-colours* (1814) and other writings had an influence on artists throughout the 19th c. His own work became very free and broad in style and some of the effects he achieved look forward to the French Impressionists, e.g. *By-road with Gipsy Tent*.

Coxcie (Coxie) Michiel van (1499–1592). Flemish painter and engraver of religious subjects in the Raphaelesque style adopted after he visited Italy with his master B. van Orley. For Philip II of Spain he copied the Van Eycks' altarpiece *The Adoration of the Lamb*.

Couture A Roman Feast (detail) 1846

Coypel Antoine (1661–1722). French painter and designer for Gobelins tapestries; son of N.C. He produced 2 of the most unequivocally Baroque decorations of his age in France, the ceiling of the great gallery, Palais Royal, Paris (1702), and the ceiling of the chapel at Versailles (1708/9), the latter based on Baciccia's ceiling for the church of Il Gesù, Rome. His son Charles-Antoine (1694–1752) was also a painter.

Coypel Noël (1628–1707). French decorative painter, strongly influenced by Poussin, designer for Gobelins tapestries and for several years director of the French Academy at

John **Cozens** Valley of the Eisah near Brixen in the Tyrol c. 1776?

Rome. His son Noël-Nicolas (1690–1734), a mediocre but popular painter of religious and mythological subjects, was a teacher of *Chardin.

Coysevox Antoine (1640–1720). French Baroque sculptor at the court of Louis XIV, famous for his expressive portrait busts and his decorations at Versailles for the Galerie des Glaces, Salon de la Guerre and Escalier des Ambassadeurs. C.'s statues there, in Girardon's classical manner in which he was trained, are uninspired.

Cozens Alexander (c. 1717–86). One of the earliest British landscapists in watercolours; he was born in Russia and settled in Britain in 1746. He wrote several books; best known is A New Method of Assisting the Invention in Drawing Original Compositions of Landscape (1785) describing his method of composing landscapes out of accidental ink blots (*blot drawing).

Cozens John Robert (1752–99). British landscapist in watercolours, pupil of his father Alexander. Constable described him as 'the greatest genius that ever touched landscape'. C. visited Italy via Switzerland in 1776 and again in 1782. The muted tones and generalized handling of his subjects show them to be expressions of poetic feeling rather than topographical records, and as such they influenced Turner, Girtin and other British landscape painters.

Cragg Tony (1949-). British sculptor living and working in Germany. In the early 1980s, along with *Deacon, *Woodrow, *Mach and *Wentworth, he was at the forefront of a new wave of prominent British sculptors of the post-*Caro, *King, *Flanagan and *Long generation. In works like Britain Seen from the North (1981) he assembled found fragments of industrial waste. Often he used plastic, e.g. Riot (1987) and arranged the material by colour and mounted it on the wall. Since then his work has evolved through creating everyday objects via other, often traditional, techniques in materials such as marble, glass, bronze, wood, stone and cast iron. Recently C.'s work has taken on a more explicitly poetic and visionary tone, e.g. Angels and Other Antibodies (1992). In 1988 he won the prestigious Turner Prize.

Craig-Martin Michael (1941–). Born in Ireland and brought up in the U.S.A., he has been living and working mainly in Britain since

Cragg African Culture Myth 1984

1966. Artist, highly articulate and perceptive writer, and teacher of wide influence, his work is informed by his U.S. art education at Yale Univ. where *Albers's legacy was still dominant after his departure. At Yale other contemporaries included R. *Serra. *Close. *Marden. N. *Graves. *Bartlett and *Borofsky. His sculptures, paintings, wall drawings and installations reflect not only a sharp critical intelligence of modern and contemporary art, but contain oblique allusions to intellectual, conceptual and moral issues which are juxtaposed to their cool, anonymous commodity looking surface. He has written: 'I have tried to strip away everything inessential, to touch the line between art and the world, meaning and no meaning, feeling and no feeling. Using objects and imagery as neutral as possible. I have tried to make an art as charged as possible. Through extreme clarity and explicitness, I have tried to confirm mystery and depth. The closer a work of art brings me to the crisis of experience, the more inclusive its significance.'

Cranach Lucas, the Elder (1472–1553). German painter, engraver and book ill. named after his birthplace. One of the most important of German artists, his training is obscure but his father was probably a painter. He travelled about the German states as an itinerant painter.

In 1505 he was at Wittenberg and by 1508 he had become court painter to the Electors of Saxony, a position he held under 3 successive Electors. He was ennobled, served as burgomaster and ran a large workshop which combined a studio, an apothecary shop and a printing and bookselling establishment. He became a personal friend of Luther and many of his woodcuts were designed to promote the Protestant cause. C.'s sons, Hans (d. 1537) and Lucas the Younger (1515-86), continued his workshop and his work is thus often hard to identify. Religious paintings, particularly madonnas depicted in landscapes, often with birds and animals in the foreground, survive to show the same love of detail as those of the *Danube school, e.g. Madonna and Child. His portraits, e.g. those of Luther, Duke Henry of Saxony and his Duchess are important documents of the time and some are among the 1st full-length portraits. C.'s rather awkward and self-conscious nudes are well known. One of the most natural and graceful of them is the Eve in Adam and Eve. Another painting which shows C.'s very individual, almost whimsical

Cranach Charity 1550?

Crivelli The Annunciation 1486

talent is the *Judgement of Paris* in which Paris, shown as an elderly warrior in full armour, presents the apple to one of a group of C.'s nudes.

Crane Walter (1845–1915). British painter, textile and wallpaper designer and ill. of children's books, a descendant of the *Pre-Raphaelites. He was associated with *Burne-Jones and W. *Morris. Baby's Opera (1877), which is typical of his style of delicate line and pastel colours, was done for the publisher Edmund Evans who had commissioned him and *Greenaway for a series of children's books.

craquelure. The fine cracks on an old painting produced by movement and shrinkage in the paint surface, the ground and the varnish. Different grounds and paint surfaces give characteristic patterns, slightly varied according to the age of the painting and the skill of the painter.

Crawford Thomas (1814–57). U.S. sculptor. His official commissions included: the colossal mourning *Indian Warrior*, *Armed Freedom*, on

the dome of the Capitol, Washington, and the Washington Memorial, Richmond, Va.

Credi Lorenzo di (c. 1459–1537). Italian painter of the Florentine school and a fellow pupil of Leonardo da Vinci under Verrocchio. His style, which changed little, was formed by both these masters; his work shows the best professional manner of Florentine painting at the period. The *Noli me Tangere* is a typical work.

Cresilas (5th c. BC). Cretan sculptor who with Phidias and Polycleitus took part in a competition to produce figures of Amazons for the Temple of Artemis at Ephesus. Various copies of C.'s *Wounded Amazon* exist. There are also copies of his idealized portrait of Pericles.

Crespi Giovanni Battista called 'Il Cerano' (c. 1557–1633). Italian painter, sculptor and architect of the *Lombard school. He was head of the Milanese Academy from 1620; Guercino was his pupil.

Crespi Giuseppe Maria (1665–1747). Bolognese painter of religious subjects, portraits and genre who broke from the academic affectations of the Bolognese school. In deep tones and with heavy *chiaroscuro* he treated his subjects in naturalistic, even prosaic, terms, e.g. his pictures *The Seven Sacraments*. His son Luigi (1709–79) was a painter and the continuator of C. C. Malvasia's lives of the Bolognese painters.

Crivelli Carlo (c. 1430-95). Italian painter of the Venetian school. Although trained, probably by the Vivarini in Venice, C. worked all his life outside the developing Venetian tradition, living in Ancona, Ascoli and other towns of the Marches where altarpieces painted by C., his relatives and pupils are still to be found. His style shows many diverse influences. In his use of swags of fruit and other classical motifs he follows the Paduan painters, but his decorative handling of gold and the stiffly posed figures belong to the conventions of the International Gothic style which was already out of fashion. C. was a highly original artist who combined such different elements within a hard, flowing, highly decorative style of draughtsmanship, matched only perhaps by Botticelli. 2 small Madonna and Child panels combine this mastery of decoration with a simple and direct piety. On a grander scale the Demidoff Altarpiece and

the Madonna and Child retain the same grace and feeling with a greater impression of power. The Annunciation (1486) is a rare and outstanding work in which all the unusual talents of this artist reach their culmination.

Croce Benedetto (1866-1952). Italian critic and philosopher of aesthetics and politician; he became minister of education in 1920 but retired from public office to oppose the Fascist régime. In the restored democratic system he was leader of the Liberal party until 1947. In 1903 he founded La Critica, a bi-monthly review of literature, history and philosophy, contributing to it until his death. C.'s aesthetic, propounded in L'Estetica (1902; 1909; vol. i of La Filosofia dello spirito), regards art as an intuition revealed by the artist with the tools of ink. stone, paint, etc. The work of art is the image which exists in the artist's mind before its mechanical reproduction. C. considered his aesthetic theory to cover expression of all kinds; his thinking greatly influenced the British philosopher *Collingwood.

Crome John, called 'Old Crome' (1768–1821). British painter of landscape in oil and watercolour. C. was born in Norwich and was

Crome Marlingford Grove

Cruikshank Oliver Introduced to the Respectable Old Gentleman 1838

a founder of the Norwich Society of Artists. The influence of Dutch landscape painters (*Hobbema and *Ruisdael in particular) is obvious; so is his close study of Gainsborough and R. *Wilson when he was a copyist, but a powerful imagination informs his richly coloured, formally composed yet romantically emotional compositions, e.g. *Moonrise on the Yare, Mousehold Heath near Norwich.* His son John Bernay C. (1794–1842) was also a landscape painter of the *Norwich school.

Cross Henri-Edmond (1856–1910). French painter, an exponent of *Divisionism which he used with greater freedom than *Signac or *Seurat. His brilliant colours influenced the Fauves.

Cruikshank George (1792–1878). British comic artist whose individual style showed traces of Gillray's influence. He first became widely known with his caricatures of the leading figures in the scandal of Queen Caroline's trial. His later satirical drawings attacked, among other things, the savage criminal code of his time, the slave trade, patronage and the evils of drink. His ills to Dickens (*Sketches by Boz, Oliver Twist*) are well known, but perhaps the works which best matched his own flair for the grotesque were the trs of fairy-tales by the Grimm brothers.

Csontváry Tivadar Mihály Kosztka called (1853–1919). Hungarian painter of imaginative

works inspired by landscape and religious themes.

Cubism. The 1st abstract art style of the 20th c. named by the art critic Louis Vauxcelles, who took up a remark of Matisse's about *Braque's little cubes. The major period of the style is from 1907 to 1914, and the originators were *Picasso and Braque, who worked closely together. Various divisions of C. into periods have been suggested: the names 'analytic', 'hermetic' and 'synthetic' are in general use: but the term 'analytic' does not adequately describe the earliest Cubist works, which are influenced by Iberian and African art as in the Demoiselles d'Avignon by Picasso (1907), so that some critics have suggested 'pre-Cubist' or 'proto-Cubist' for this phase.

If such works are seen as the prelude to C.. the 1st truly Cubist works are those in which objects, landscapes and people are represented as many-sided (or many-faceted) solids. Cézanne's later work was a catalyst for this painting, and was known to Cubists from the important showing of his work after his death in 1905; his advice to *Bernard to 'deal with nature by means of the cylinder, the sphere and the cone' was taken as a justification of Cubist experiments. Woman with a Guitar by Picasso is a clear example of this phase of C. Braque and Picasso then turned to a flatter type of abstraction, in which the allover pattern becomes more important, and the objects represented are largely or wholly indecipherable (hermetic C). At this period colour was almost wholly absent from their work, which is mainly monochromatic, grey, blue or brown and white. Colour reappeared in the final phase of C., called 'synthetic', from its combination of abstraction with real materials. Many other artists worked in the Cubist style, which replaced Fauvism as the leading artistic movement in Paris from about 1909. The most significant contributions were made by *Gris and *Léger, but there were many others including *Gleizes and *Metzinger (who publ. a book on C.), *Derain, *Friesz, De la Fresnaye and *Marcoussis. Cubist sculptors included *Archipenko and *Laurens, C. was represented in the Salon d'Automne, and a group was formed called the Section d'Or: in this the Villon brothers, *Villon, *Duchamp-Villon and *Duchamp, are the major figures. This activity in Paris had far-reaching effects, stimulating the Futurist movement in Italy, the

Vorticists in Britain, and having some effect on Expressionist art in Germany: it was also an important precedent for other movements with abstract aims such as those in Russia (*Constructivism, *Suprematism) and the Netherlands (*De Stijl). C. developed in Paris in 2 main ways, towards a decorative style, in which the subjects are treated geometrically but remain clearly recognizable, or towards a greater degree of abstraction as in *Delaunay's rhythmic paintings of coloured segments and circles (*Orphism).

C. has continued to have an important influence on 20th-c. art. An attempt was made by *Ozenfant and the architect *Le Corbusier to return to a simpler purified C., but by 1920 C. was already too much a part of the general artistic vocabulary to be restricted to this Purism. Cubist ideas and techniques continue to be used up to the present, particularly *collage invented in the synthetic period.

Cubist-Realism (also known as 'Precisionism'). Style of U.S. painting of the 1920s and 1930s which effected a compromise between Cubism and straight representational painting. Its chief exponents were *Demuth and *Sheeler. While their subject matter – urban or industrial architecture – remained recognizable it was schematized into a formal geometrized design executed with hard-edged precision. *Magic Realism.

Cubo-futurism. *Futurism

Currier and Ives prints. Series of hand-coloured lithographs publ. in N.Y. depicting all aspects of the U.S. scene in the 2nd half of the 19th c. Nathaniel C. (1813–88) began the series in 1835 and took J(ames) Merritt I. (1824–95) into partnership in 1857.

Curry John Steuart (1897–1946). U.S. regionalist painter who depicted in narrative style scenes of Kansas life.

Cuyp Aelbert (1620–91). Dutch painter influenced by earlier Dutch landscape painters, in particular Van Goyen. There is a strong element in his work of Italianate Dutch painters, such as Jan Both, especially in his handling of light. He painted portraits, still-lifes, seascapes, landscapes and town scenes, but is best known for studies of animals in the mellow light of a summer evening. C.'s work was greatly admired by British collectors and by British landscape painters of the early 19th c.

Cycladic Life-size figure (Mother-goddess?) 2500/2000 BC

Cycladic. Term applied to vases and (notably) the marble idols found in the Cyclades, a group of islands in the Aegean, and evidence for what appears to have been a flourishing culture between 2600 and 1100 BC.

\mathbf{D}

Dada. Artistic movement started in Zürich in 1916 by a group, mostly painters and poets, who went to Switzerland to take refuge from World War I and who gathered at the *Cabaret Voltaire, a 'literary nightclub' organized by *Ball. Other members included Emmy Hennings, H. *Richter and Richard

Daddi The Martyrdom of St Stephen (detail) early 14th c.

Huelsenbeck from Germany, *Arp from Alsace, *Janco and *Tzara from Rumania. Under *Picabia's influence, Tzara emerged by 1918 as D.'s chief spokesman and wrote the Dada Manifesto (1918). D. works are nihilistic gestures and provocations. Tzara, encouraged by *Breton and other members of the Parisian Littérature group (L. Aragon, Philippe Soupault and others), went to Paris in 1920 to launch the movement which prepared the way for *Surrealism. In the meantime, other Dadaists moved to other European centres: Arp joined M. *Ernst and Johannes Baargeld in Cologne in 1919, but it was primarily in Berlin, after the war, that D. became identified with political radicalism. The Berlin Club D. included among its members *Baader. *Grosz. *Hausmann, *Heartfield, Wieland Herzfelde, *IIöch and Huelsenbeck. *Schwitters, although rejected by the Berlin group, became associated with Arp and Picabia's branch of Dadaism. D. in Paris collapsed in 1922; most members of the French group formed the Surrealist group in 1924 when Breton published the 1st Surrealist Manifesto.

Daddi Bernardo (c. 1290–c. 1349). Italian painter and leading artist in the generation which followed G10tto in Florence. His muchdamaged frescoes, *The Martyrdom of St Laurence* and *The Martyrdom of St Stephen*, are very close to Giotto in style. Later D. was greatly influenced by Sienese painting, particularly by that of the Lorenzetti brothers, and by French and Italian sculpture. These influences can be traced

Dahl

in a major work, the polyptych altarpiece of S. Pancrazio. Other important works are *The Virgin and Child with Eight Angels* and *St Paul and Worshippers*.

Dahl Michael (1656/9–1743). Swedish portrait painter who settled in London in 1688, becoming painter to Queen Anne and the rival of Sir G. Kneller. His work is less pretentious than Kneller's and his colours softer; it is marred by uneasy poses and lack of psychological insight.

Dahomey. W. African republic, formerly a powerful kingdom under the Abomey kings but occupied as a French colony in the 1870s. Outstanding examples of Abomey courtly art include a remarkable wrought-iron, over-life-size figure, thought to be Gu, the god of war and iron. By 19th-c. Fon tribal craftsmen, it was made by *assemblage technique. D. non-courtly art was dominated by *Yoruba wood carvings.

daibutsu (Jap. great Buddha). Colossal statues of the Buddha. The 8th-c. bronze d. at Nara, frequently restored, is 53 ft (16.2 m.) high. The most famous d., the great mid-13th-c. bronze Buddha at Kamakura, is 37 ft (11.3 m.) high.

Dalem Cornelis van (c. 1535–75). Flemish landscape painter; Bartholomeus Spranger was his pupil. Little of his work has survived; it includes *Landscape with Farm* (1564).

Dali Salvador (1904–89). Spanish painter, designer of jewellery, etc. and stage-sets, book ill. and writer, notorious for his extravagant and eccentric statements about himself. He joined the Surrealist movement in Paris in 1929 making

Dali The Persistence of Memory 1931

the Surrealist films *Le Chien Andalou* (1929) and *L'Age d'or* (1931) with L. Buñuel and painting such works as *The Persistence of Memory* (1931) and *Premonition of Civil War* (1936). His paintings, which he has called 'hand-painted dream photographs', are characterized by minute detail, virtuoso technique, ingenuity and showmanship together with elements of Freudian dream symbolism. His religious paintings include *Christ of St John of the Cross* (1951). Later works include ills for *Alice's Adventures in Wonderland* (1969). His publs include *Diary of a Genius* (trs. 1966) and his *Unspeakable Confessions* ... (trs. 1976).

Dalmau Luis (d. 1460). Spanish painter who worked at the court of Aragon and helped to extend the influence of Flemish painting in Spain. In 1431 D. was sent on a mission to Bruges and probably there learnt to follow Van Eyck's style, evident in his great work *Virgin and Councillors* (1445).

Dalou Jules (1838–1902). French sculptor. Such works as *French Peasant Woman* (1873) showed a *Realism similar to that of *Courbet's paintings. For his monumental *Triumph of the Republic* (1879–99) D. adopted a style approaching the *Baroque. He worked (1871–80) in Britain.

Dalwood Hubert (1924–76). British sculptor at first of modelled and cast works, then of constructions in metals and fibreglass. He held important academic positions and was awarded 1st prize for sculpture, Venice Biennale, 1962.

Danby Francis (1793–1861). Irish painter who worked in England and Geneva. His early work, small landscapes, e.g. *Blaise Castle Woods* (c. 1822), has a charming verity but Turner's influence encouraged him to an aerial romanticism of sunsets and seascapes. For a while he painted dramatic apocalyptic subjects, e.g. *The Opening of the Sixth Seal* (1826).

Daniell William (1769–1837). British landscape painter and engraver. With his uncle Thomas (1749–1840), also a landscape painter, he travelled to India (1784) and together they produced *Oriental Scenery* (1808), 6 vols of aquatints. William D.'s most remarkable plates illustrate *A Voyage around Great Britain* (1814–25) – text by Richard Ayton – a monumental coll. of Romantic landscape themes.

Dan(c)kerts or **Dankers** Hendrik (1630?–1680?). Dutch landscape painter and portrait engraver; he visited Italy (1653) and lived in Britain from 1668 to 1679. He painted views of

Daumier For the Defence (detail)

famous places for Charles II and some large classical landscapes in the style of Claude Lorrain.

Danti Vincenzo (1530–76). Perugian sculptor strongly influenced by Michelangelo. He executed a statue of Pope Julius III (1555) in the cathedral, Perugia, but later worked in the Baptistery, Florence, where he completed Sansovino's *Baptism of Christ* and produced his greatest work, *The Decollation of St John the Baptist*.

Danube school. Name used to describe the developments in landscape painting which took place in the Danube region in the early 16th c. The artists working there, who included Altdorfer, Huber and Lucas Cranach (as a young man), introduced a romantic awareness of landscape as an expressive adjunct to human action. They also produced a large number of pure landscape drawings.

D'Arcangelo Allan (1930–). U.S. artist, noted in the mid-1960s for his *Pop art paintings of highways.

Daret Jacques (c. 1403–c. 1468). Early Netherlands painter trained by the *Master of Flémalle. Rogier van der Weyden was probably a fellow-pupil. 2 parts of an altarpiece, the *Nativity with the Annunciation to the Shepherds* and the *Adoration of the Kings*, are fine and typical examples of his work.

Daubigny Charles-François (1817–78). French landscape painter associated with the Barbizon school. D. painted chiefly in the Île-de-France, but travelled in Italy, Spain, Britain and Holland.

Typical of his work are The Lock at Optevoz and River Scene with Ducks

Daumier Honoré (-Victorin) (1808-79). French painter, caricaturist, graphic artist and sculptor Trained in Paris and attracted to lithography. D. made his living from 1830 with cartoons in the satirical journals La Caricature and Le Charivari. He lampooned the government (being imprisoned in 1832 for his attack on King Louis-Philippe), the bourgeoisie in the Robert Macaire series and the legal profession. From about 1848 D. attempted to establish himself as a serious painter in oils, but he was hampered by his fame as a left-wing cartoonist, his dependence on his fellow-painters for most of his subjects and his refusal to give his works the finish then considered necessary. A brief period of success under the Third Republic was followed by neglect, poverty and near-blindness. Since his death he has been recognized as a pioneer, chiefly of Expressionism, e.g. The Painter before his Easel, a master draughtsman, e.g. We want Barabbas!, a major graphic artist and a sculptor of vigour and expressiveness. In his sketches and oil paintings of Don Quixote and Sancho Panza D. created a great modern reinterpretation of Cervantes's characters, e.g. Don Ouixote and Sancho Panza.

Davey Grenville (1961—). British sculptor whose work is distinguished by its being paradoxically neither abstract nor representational—although in his sculptures (on the wall or on the floor) there are references to everyday, *readymade objects and they have their look, they are not representations of them, e.g. *Grey Seal* (1987).

David Gerard (c. 1460-1523). Netherlands painter who succeeded Memlinc as the most important painter of the school. Born in Oudewater, D. was admitted to the painters' guild in Bruges in 1484. He was influenced by earlier Netherlands masters, in particular Van Evck and Van der Goes, but his work shows close relationship with the painting of Geertgen tot Sint Jans and the miniaturists of Bruges. He was commissioned by the town of Bruges to paint a number of works, including 2 pictures to warn officials of the stern retribution for corruption and injustice – The Judgement of Cambyses and The Flaying of Sisamnes - a Last Judgement and Virgin with Child and Angels. Other important works are The Baptism of Christ, The Marriage at Cana, 2 landscapes, and The Virgin and Child with

Gerard **David** The Baptism of Christ (detail) begun 1502

Jacques-Louis David The Death of Marat 1793

Saints and Donor, the most serene and successful *sacra conversazione painted in N. Europe.

David Jacques-Louis (1748–1825). French painter, the leading figure of Neoclassical painting. Trained in the Rococo tradition of Boucher by J.-M. Vien, D. repudiated this

training with his Oath of the Horatii, shown in Rome and Paris in 1784 and immediately recognized as a landmark in painting. Its colouring was lucid and cool, its drawing strong, simple and severe. In its theme it advocated a return from the diversions of a pleasureloving aristocracy to the traditionally austere virtues of the early Roman republic. D. became virtual dictator of the arts in France from the outbreak of the Revolution to the fall of Napoleon; few men have exercised such power over the art and taste of their period. His subjects - allegory, history and mythology and his search for an ideal beauty based on the supposed canons of classical sculpture were to become the hall-marks of academic art during the 19th c. D. celebrated the victories and extolled the martyrs of the Revolution, e.g. The Death of Marat; in Return of the Sons of Brutus the theme of republican virtue recurs. D. was himself a deputy and was briefly imprisoned after the fall of Robespierre (1794); from his cell he painted the View of the Luxembourg Gardens, a small masterpiece of landscape painting, wholly romantic and warmly evocative in feeling. His portraits too, are far from austere, e.g. of M. Seriziat and Mme Seriziat, and of the famous beauty and conversationalist Mme Récamier (1800). Later he became the painteradvocate of Napoleon, e.g. The Coronation of Napoleon and his work was fundamental in the creation of the Empire style.

David Pierre-Jean, known as 'David d'Angers' (1788–1856). French Neoclassic sculptor. He executed the monument to Condé at Versailles, the Gutenberg monument, Strasbourg, the busts and medallions.

Davie Alan (1920–). Scottish painter, jewellery designer and jazz musician. The first young British abstractionist to win international reputation after World War II. His large, vigorous abstract paintings, e.g. Seascape Erotic (1955), often have more in common with *Pollock and the *Cobra group paintings than most British abstract painting of the 1950s.

Davies Arthur Bowen (1862–1928). U.S. painter of romanticized landscapes with whimsical, elongated figures, e.g. *Crescendo* (1910). He was a member of The *Eight. He supported new trends and artistic independence and took a leading part in organizing the *Armory Show. After it he worked for a time in a modified Cubist style.

Davis Gene. *Washington Color Painters

Davis Stuart (1894–1964). U.S. painter and graphic artist. His early work was in the realist tradition of Robert Henri, under whom he studied in N.Y., however he subsequently submitted to Cubist influences, in particular that of Léger. The turning-point in his career came in 1927, when he began to experiment with still-life abstractions in his *Eggbeater* series. Since the late 1930s, he reduced subjects to a flat, brightly coloured, abstract pattern, often incorporating a descriptive or evocative word.

Deacon Richard (1949–). British sculptor, one of the most accomplished of the same generation as *Cragg who, along with other sculptors, ushered in a new wave of artists of great diversity and dynamicism in British art. D.'s works are abstract and yet they encompass a wide range of references and evoke numerous associations with the world of appearances. Made of readily available materials, such as laminated plywood, they directly expose the means and processes of fabricating forms, often in sensuous curves, e.g. Blind, Deaf and Dumb A (1985). In the late 1980s the linear, lyrical quality of his earlier laminated wood sculptures gave way to assertive, bulky forms, e.g. Struck Dumb (1988), Kiss and Tell and Host (both 1989), in which the component parts, be they timber, plywood, steel, bolts or binding glue are openly declared.

De Andrea John (1941–). U.S. *Hyper-Realist sculptor of figures cast from life which, through the perfection of his models, appear to be idealized as in classical sculpture, e.g. Seated Man and Woman (1981). Sometimes the figures re enact 3-dimensional, realist scenes from works such as *Manet's Le Déjeuner sur l'herbe or Allegory: After Courbet (1988).

Debucourt Philibert-Louis (1755–1832). French painter and graphic artist, caricaturist of manners.

Decadence. A term applied to any period of artistic or moral decline. It has also a specific and not necessarily pejorative meaning in connection with the late 19th-c. movement originating in France and characterized by emphasis on the isolated role of the artist, hostility to bourgeois society, a taste for the morbid and perverse, and a belief in the superiority of the artificial to the natural. This was a development of some of the attitudes of *Romanticism, first exemplified by *Baudelaire's Les Fleurs du mal. It

Davis Lucky Strike 1921

reached its full development in the last 2 decades of the 19th c., reacting against *Naturalism; Huysmans's À Rebours became the virtual textbook of the movement and a magazine, Le Décadent, was publ. briefly (1886). In Britain D. was at its height in the 1890s; representative figures were Oscar Wilde and *Beardsley.

decalcomania. A Surrealist technique for generating images: ink or paint is applied on to a piece of paper which is then either folded or transferred to another piece of paper by pressing the two together. The artist then would elaborate what the resulting accidental 'image' suggests to him as in blot drawing.

Decamps Alexandre (Gabriel) (1803–60). French painter, lithographer, caricaturist and book ill. His travels in Turkey, which antedated those of Delacroix in Morocco, gave him material for successful exotic landscapes and genre paintings.

Deccani miniature painting

Degas Women Ironing (detail) c. 1884

Deccani miniature painting. Art of the Islamic states of Ahmadnagar, Golkonda and Bijapur, central Deccan, India. The earliest known is a life of the ruler of Ahmadnagar (late 1560s); some of the finest, e.g. *Ragamala, was for Ibraham Adil Shah II of Bijapur (1580–1626). *Mughal miniature painting, Hindu, Persian and European art affected D. m. p.

Decker Joseph (1853–1924). German-born U.S. painter who specialized in still-lifes, but also painted landscapes, portraits and genre scenes. His remarkable close-up pictures of fruit (1880s) were probably influenced by photography. Later influences came from *Chardin and *Innes.

décollage (Fr. unsticking). The opposite of *collage: the peeling away, usually of found images, i.e. posters, resulting in the accidental creation of new images and surface effects.

Deconstruction. *Postmodernism

découpage. The process of cutting designs out of paper and applying them to a surface to make a *collage or papier collé.

Degas (Hilaire Germain) Edgar (1834–1917). French painter, draughtsman, sculptor and graphic artist, the son of a rich banker and a Creole mother. After a typical bourgeois education he studied law, but in 1855 went to the École des Beaux-Arts in Paris, then to Naples and Rome. In 1861 he was back in Paris, where

he painted portraits and compositions in a severely classical style, later turning to the painting of dancers, the races, town life and portraits in an environment, which established his reputation. Though not in agreement with Impressionist theory he allied himself with the movement from its beginning in protest against sterile academic theory and practice, and exhibited with the Impressionist painters until 1886. His life was marred by hypochondria increasing with old age, and with his eyesight failing towards the end of his life, he shunned all society.

D. discovered and appropriated the new environment of 19th-c. industrial man - the townscape, the street, the interiors of the places of entertainment and work of all social classes. He observed the behaviour of the female and male human animal against these settings with analytical detachment, biting wit and an unfailing eye for the typical. For this purpose he made use of photography, the store of knowledge accumulated in museums, the technical knowledge of craftsmen and the visual discoveries of the Impressionist painters. He strove after perfection in every possible way, for he believed that given sensibility the mastery of the technical means was decisive. He experimented therefore with graphic media, perfected the art of pastel, made monotypes and etchings and modelled in clay and wax in order to understand better the movements of his dancers and racehorses. These studies, which were never intended for exhibition, were cast in bronze after his death and thus preserved. He never painted on the spot, but composed only after much observation, many studies and a most intimate knowledge of the subject, relying on a prodigious visual memory. The vision of eternal truth in fleeting reality was D.'s characteristic contribution. There is a gradual development from the early composition of the Young Spartans (1860) with its cool colours, to the new science of colour and movement in the Washerwomen (1879), the Miss Lola, the series of ballet dancers, drawings, paintings and pastels of women at their toilette, washing themselves and dressing, and especially in the near-abstract monotypes.

Degen. Niklaus *Manuel

Degenerate art (Ger. *Entartete Kunst*). The term of official denigration in Nazi Germany for the work of *avant-garde* artists such as

*Beckmann, *Chagall, *Corinth, *Dix, *Feininger, *Grosz, *Kandinsky, *Klee, *Kokoschka, *Marc and *Modersohn-Becker. Their works were held up for public contempt in an exhibition which opened in Munich, and public galleries were stripped of all 'degenerate' exhibits.

Deineka Alexander (1899–1969). One of the 1st generation of Soviet painters. He was trained in Kharkov art school and then the Moscow *Vkhutemas, chiefly by *Constructivists. His early work of a monumental character can be compared to Eisenstein's film methods in its use of photomontage techniques. Teaching in Moscow from 1928, he was one of the most influential painters in the U.S.S.R.

De Kooning Willem (1904–97). Dutch painter, influenced by *De Stijl and Flemish Expressionists, who moved to the U.S.A. (1926) where he worked as a decorator. He worked on the *W.P.A. art project (1935) and joined the N.Y. Group of *Abstract Expressionist painters, becoming a leading member. His painting has its roots in *Gorky's Surrealism and he often uses open allusions to reality which may be the starting-point or may accidentally occur during the painting's execution. His best-known series,

De Kooning Women 1952

Delacroix Women of Algiers (detail) 1834

the Women (1952) was the first sign of the 'new figuration' in N.Y. painting. Its violent imagery and technique caused a sensation. It was followed by a series of landscapes and a return c. 1963 to the theme of woman, now painted in flamboyant, almost satiric style.

Delacroix (Ferdinand Victor) Eugène (1798-1863). Leading French Romantic painter, draughtsman, lithographer, writer and art critic. It is possible that he was a natural son of Talleyrand. After studies with Guérin, a follower of David, he worked at the Ecole des Beaux-Arts, Paris, for a while, In 1821, when D. was in financial difficulties, he was helped by his friend Géricault, whose work he greatly admired. D. became known from 1822 with his painting Dante and Virgil in the Inferno, shown in the Salon. During a visit to Britain in 1825 D. met Lawrence and Wilkie. In 1831 he was awarded the Légion d'honneur and during the following year visited Morocco and Spain, a journey which proved to be crucial for the further development of his work. In 1833 a commission to decorate a salon in the Palais Bourbon was the beginning of a period of very intense work and a number of public

Delaney

Delaunay The Eiffel Tower 1909–10

commissions on a large scale, which established D. State honours followed and in 1857, after 7 rejections, he was at last elected a member of the French Institute. He was frequently ill now, but his monumental work increased and he employed about 30 assistants. His last great work, paintings for the church of St-Sulpice, occupied him until 1861.

D. used the works of his contemporaries Constable, Géricault, Gros and of the past masters, Michelangelo, Poussin, Rubens and others, as sources from which he took what he needed. He applied the same approach to his study of nature and to reality as a whole. He made use of literature for his subjects, of science in his studies of colour relationships, of photography in his study of form, and of lithography in his graphic work. He saw painting as a bridge between painter and spectator, and colour as its most important element. He was original in the realization of related - as against local - colour, and in the use of complementaries and of simultaneous contrast, but it is wrong to see D. as a colourist only. His concern for form and composition increased, and towards the end he achieved a synthesis of these elements. His use of broken colour and the freedom of his brushwork was decisive in the formation of the later Realist and Impressionist painting. D. is best known today for his Massacre of Chios (1824) and the Death of Sardanapalus

(1827), and also for Liberty Leading the People (1830). He is also celebrated for his paintings of Morocco in the Louvre, such as the Women of Algiers (1834), his compositions of animal subjects and many watercolours. His religious paintings, e.g. the Pietà (1848), are less known; so are his mural paintings, mainly because of lack of access. His journals (1823–54) and critical writings are valuable as historical documents and as works in their own right.

Delaney Beauford (1901–79). U.S. African-American painter who, from 1935, lived in Paris for more than 30 years where he became closely associated with other African-American artists and writers including James Baldwin and Richard Wright. He was called the 'dean of American Negro painters living abroad'. In the 1940s he often painted street scenes and interiors in thick *impasto. His work became increasingly non-representational. It has been said that the 3 forces which contributed to his style were 'the techniques of Van *Gogh, the colour of the Fauves, and the design principles of *Abstract Expressionism'.

Delaroche Paul (properly Hippolyte) (1797–1856). French painter of historical subjects of romantic or sentimental interest derived from works by Sir Walter Scott, Shakespeare and others. Pictures painted with extreme naturalism such as *Children of Edward* (the Princes in the Tower), 1830, were popular and widely used in history textbooks.

Delaunay Robert (1885–1941). French painter and the originator of *Orphism, which extended the Cubist practice of fragmentation into the field of colour. He started painting c. 1904. His works of 1905-7 are painted in a brilliantly coloured *Divisionist technique. In 1907, under the influence of Cézanne, his palette was temporarily subdued, and during his military service (1908) he began his study of optics. He met *Léger in 1909, and their sombre-coloured paintings pursued a parallel search for structural organization. In the Saint-Severin and The Eiffel Tower series (1909-10) he returned to his highly coloured palette and by 1912, in the Fenêtre Simultané paintings, he had isolated pure colour areas from the motif. In Orphist paintings, D. writes, 'the breaking up of form by light creates coloured planes; these are the structure for description but a pretext'. He saw Orphism as a logical development of Impressionism and Neo-Impressionism, but his transition to pure abstraction was probably inspired by *Kupka (c. 1911–12). D. was visited in 1912 by Marc, Macke and Klee, who later trs. his essay *On Light*. His influence upon the *Blaue Reiter group was considerable and by 1914 he was probably the most influential artist in Paris. His later work, like Léger's, attempted to reconcile his innovations with more traditional forms.

Delaunay-Terk Sonia (née Terk) (1885–1979). Russian painter who settled in Paris (1905), married *Delaunay (1910) and with him was a pioneer of abstract painting (*Orphism). After World War I she concentrated on textile and fashion design but returned to painting in the late 1930s. She exhibited regularly from the early 1950s and held retrospectives in Paris (1967) and Lisbon (1972). She designed costumes and décor for Stravinsky's ballet *Dances Concertantes* (1968).

Delvaux Laurent (1695–1778). Flemish Baroque sculptor whose style showed leanings towards classicism. He worked in Britain and Italy before settling in the Low Countries, where he was sculptor to the Emperor Charles VI and later to Charles, Duke of Lorraine. The pulpit (1745) in Ghent cathedral is one of the best examples of his work.

Delvaux Paul (1897-1994). Belgian painter, leading member of Belgian *Surrealist movement since 1935, although he was never an official member of the Surrealist group. He studied first architecture, then painting at the Brussels Académie Royale des Beaux-Arts, and in his early work followed the Expressionists Permeke and De Smet. In the 1930s he came under the influence of Magritte, De Chirico and the Surrealists, though never wholeheartedly adhering to their programme. In characteristic works such as Venus Asleep (1944), The Hands (1941) and Le Corte (1963), he places female nudes, juxtaposed with clothed figures, in incongruous architectural settings, imbuing the whole with the mysterious, disquieting inconsequentiality of a dream, reminiscent of De Chirico's 'metaphysical' painting.

De Maistre (Le) Roy (Levenson Laurent Joseph) (1894–1968). Australian-born painter of French descent who settled in London in 1936. His best-known paintings – religious subjects such as the *Pietà* (1950) – are in a heavily formalized naturalistic style, deeply indebted to Cubism.

Paul Delvaux The Hands 1941

De Maria Walter (1935–). U.S. artist of *Earth and *Minimal art, who works both in and out of doors, which reflects his persuasion that 'the invisible is real'. In The New York Earth Room (a 1977 version of a 1968 work), moist earth, 2 ft (0.6 m.) deep, fills up the entire exhibition space. In perhaps his most famous work, Lightning Field (1971-7), located on a high plateau in the desert in New Mexico, 400 stainless steel poles are arranged in a rectangular grid array (16 poles wide by 25 poles long) spaced 220 ft (67 m.) apart, with an average pole height of 20 ft, 7 in. (6.3 m.). The poles rise to form an even plane and when a storm cloud 'senses' the polished steel 'high energy bars' lightning strikes them with thunderbolts. Vertical Earth Kilometer (1977) consists of a brass rod, I km.-long, sunk into the earth with only its top visible.

Demuth Charles (1883–1935). U.S. painter, with *Sheeler the most important exponent of Cubist-Realism (or Precisionism), and also an ill. His preferred subject matter was colonial and industrial architecture, which he treated with exceptional clarity and delicacy of line and colour. His early paintings, many in watercolour, included vaudeville subjects and flower pieces. *Magic Realism.

Denis Maurice (1870–1943). French painter who followed various styles. He was a leader of the *Nabis and made the famous statement 'A picture – before being a horse, a nude or an anecdotal subject – is essentially a flat surface covered with colours arranged in a certain order.' His picture *Homage to Cézanne* (1900)

Denny

Demuth Lancaster 1921

Denis Homage to Cézanne (detail) 1900

shows members of the Nabis admiring a still-life by Cézanne. He painted decorative murals and biblical subjects in modern settings.

Denny Robyn (1930–). British painter. After studying in Paris (1950) and London he developed a style influenced by *Rothko and painted large canvases of *Hard-edge geometrical shapes.

Derain André (1880–1954). French painter, who studied at the Académie Carrière. D. was

one of the most original of the *Fauve painters, working at first with *Vlaminck at Chatou and then at Collioure with *Matisse. The Pool of London (1906) shows him using a Neo-Impressionist technique with a freedom inspired by Matisse. Between 1906 and 1909 he was working along parallel lines to *Braque and *Picasso, whom he had met, and even preceded them in his fusion of African and Cézannesque forms, e.g. Baigneuses (1906); but he never wholly responded to *Cubism and after about 1919 withdrew from the avant-garde.

Desiderio 'Monsù' (*fl.* early 17th c.). 'Painter' of architectural fantasies, recently discovered to be in fact 2 painters from Lorraine, Didier Barra and Francesco de Nome, who worked in the same studio. Paintings by D. include *An Explosion in a Church* and *St Augustine*.

Desiderio da Settignano (c. 1430–c. 1464). Florentine sculptor. Born into a family of stonemasons and carvers, D. was greatly influenced by Donatello, of whom he may have been a pupil. Many of D.'s studies of the Madonna and Child and busts of Florentine women and children have an unsentimental grace and great beauty, e.g. Bust of a Woman. His 2 major works are the tomb of the humanist scholar Carlo Marsuppini and the Tabernacle of the Sacrament.

Desmarées Georg (1697–1776). Swedish portrait painter, a pupil of G. B. Piazetta in Venice. He worked chiefly in Munich in a Rococo style.

Desnoyer François (1894–?). French landscape and figure painter whose style is an attempt to combine the structural qualities of Cubism with a Fauvist approach to colour.

Desnoyers Auguste Gaspard Louis Boucher (1779–1857). French engraver. D. made a famous engraving of Raphael's *Belle Jardinière*; he worked for Napoleon.

Despiau Charles (1874–1946). French sculptor who worked as *Rodin's assistant and for a time followed his style. D.'s characteristic work was more weighty and controlled, and closer to that of *Maillol.

Desportes Alexandre-François (1661–1743). French painter renowned for his hunting scenes and tapestry designs. He also painted portraits.

De Stijl. A group of artists, among them the Dutch abstract painter *Mondrian, who took the name from a magazine ed. by Van *Doesburg, painter and theoretician, from 1917.

Derain Portrait of Matisse 1905

De S. advocated the use in art of basic forms, particularly cubes, verticals and horizontals: in an essay entitled *Neo-Plasticism* (1920), Mondrian suggested that such an abstract art best expresses spiritual values. Architects such as Rietveld and J. J. Oud were connected with the group, which became international with the adherence of artists like H. *Richter, *Lissitzky and *Brancusi. De S. ideas influenced the *Bauhaus (where Van Doesburg lectured) and geometric abstract art of the 1930s. The group liad split up by Van Doesburg's death in 1931.

Deutsch. Niklaus *Manuel

Deutscher Werkbund. German organization founded in 1907 to promote progressive ideas and better-quality design in architecture and in industry.

Devis Arthur (1711–87). British painter of small portraits and conversation pieces of the provincial gentry; he flourished until the 1760s when he was ousted by *Zoffany. His style was essentially primitive and the naïvety, stylization and tranquillity of his work gave it great charm. D. was 'discovered' in the 1930s along with his son Arthur William (1763–1822) and his brother Anthony (1729–1816).

De Wint Peter (1784–1849). British landscape painter in oil and watercolour, influenced by Girtin and Varley. De W. used a technique of broad washes, enlivening his blocks of sober colour with subtle variations of light. A good example of his work is *Landscape near Gloucester in 1840*.

Diamante Fra (1430–*c*. 1498). Italian painter, pupil of Fra Filippo Lippi and his assistant on the frescoes in Prato and Spoleto cathedrals. Filippo's son Filippino was left in his care.

Diana Benedetto (c. 1460–1525). Venetian painter in the manner of Giorgione.

diaper-work. A simple pattern based on small geometric or floral forms repeated uniformly over a surface. It is found in textiles, manuscripts, murals and panel painting, metalwork, sculpture and architectural detail, especially in the Middle Ages.

Diaz (de la Peña) Narcisse Virgile (1808–76). French painter of Spanish descent. As a landscape painter he was taught by T. *Rousseau and belonged to the *Barbizon school. He also painted mythological figure groups.

Dibbets Jan (1941–). Dutch *Conceptual artist who uses series of aligned colour photographs to depict landscapes by 'correcting' or modifying the way humans, the camera and nature itself interact and thus challenge both the 'reality' of the photograph and that of seeing with the naked eye, e.g. *Dutch Mountain*, *Big Sca 1 'A'* (1971). D. has used similar modificiations of seeing in videos, e.g. *Horizon I – Sea* (1970).

Dickinson Edwin (1891–1978). Distinguished and original U.S. figurative painter in a romantic and theatrical idiom, combining figures and studio props in extravagant, imaginary scenes, e.g. *Composition with Still Life* (1933–7).

Didot. Firm of French printers founded (1713) by François D. (1689–1757). His son François Ambrose (1730–1804) completed the development of the system of standard type measure (now called after him) originated by S.-P. Fournier. His younger son Firmin (1764–1836), one of the great type-cutters, was responsible for the introduction of the 'modern' type-face with its distinctive strictness and regularity of line; he also devised the 1st completely successful stereotype process (c. 1795). With his brother Pierre (1761–1853) he produced many fine books.

Diebenkorn

Diebenkorn City Scape 1 1963

Diebenkorn Richard (1922–93). U.S. painter. He studied (1946) at the California School of Fine Arts. He achieved recognition as an abstract painter but in 1955 turned to a figurative style becoming one of the few artists of his generation to carry on the figurative tradition in U.S. art with vigour and imagination. His example inspired younger Californian artists to return to representationalism.

Dine Jim (1935—). U.S. artist. In the late 1950s and 1960s he collaborated in *Happenings with *Oldenburg and produced *Pop art works and objects. From the early 1970s D.'s oil paintings, prints (perhaps his most successful work, usually sensitive and simple depictions of tools, robes, etc.) and drawings became increasingly figurative. He collaborated with writers, e.g. series of lithographs with R. Padgett (1970).

diorama. A large-scale scenic representation, parts of which are translucent, displayed in a special building which allows for lighting effects by means of which the picture can be animated.

diptych. Two-panelled paintings (often a portrait facing the portrayal of a saint) hinged together and thus a free-standing unit when opened out. Several survive from the late Middle Ages.

Direct art. Name given by a group of Austrian artists active in the 1960s, among them Hermann Nitsch and Otto Mühl, to sexual, sado-masochistic *performances.

distemper. A painting medium of powder colours mixed in water used since classical times for interior decoration. It is impermanent but was occasionally used by Renaissance artists for *cartoons.

Divisionism. An alternative term for the techniques of *Neo-Impressionism.

Dix Otto (1891–1969). German painter and graphic artist best known for his paintings and etchings of protest based on his experience of World War I. He became famous with a portfolio of etchings publ. in 1917. His early paintings resemble the primitive style of the Douanier Rousseau, but he later adopted the principles of the *New Objectivity and like *Grosz exposed the corruption of post-war Germany with biting satire; the Hitler era brought persecution to D. After the war he painted mainly religious subjects.

Dobell William (1899–1970). Australian painter, among the earliest to achieve wide recognition. D. was not as openly nationalistic as many of his younger contemporaries; he lived in London from 1929 to 1939, and his

Dix Self-portrait 1931

cruel realistic portraits owe as much to Hogarth and Rembrandt as to contemporary national or international movements.

Dobson Frank (1886–1963). British sculptor and painter, highly regarded in the 1920s and 1930s.

Dobson William (1611–46). British painter, best known for his portraits of Royalist officers. D.'s robust style is quite unlike that of Van Dyck, his great contemporary. The full-length portrait *James Compton, 3rd Earl of Northampton* has been called 'the best thing of its kind painted by an Englishman before Hogarth'. Another fine example is *Endymion Porter*.

Doesburg Theo van (real name C. E. M. Küpper) (1883–1931). Dutch painter, writer on art, poet; leader of the movement *De Stijl and founder of its journal. In 1916 he began to collaborate with the architects J. P. Oud and J. Wils and in 1923 with C. van Eesteren in applying the principles of De Stijl to building and interior decoration; in 1922 he taught at the *Bauhaus, Weimar. In the same year he publicized Dadaism in the Netherlands and under the pseud. 'I. K. Bonset' ed. the Dada periodical *Mecano*. In 1930 he ed. a pamphlet entitled *Art Concret* introducing this term as an alternative to 'abstract art'.

Dogon. W. African people settled in the great bend of the River Niger. Their outstanding sculpture is represented by: free-standing ancestor figures in a spindly style; softwood masks, in bold simplified forms; and decorative high-relief ancestor figures in cubistic forms, found, e.g. on granary doors. The masks may be pierced with iron hooks to counteract the life force in the wood. D. granaries are tall tubular structures of great elegance. The D. territory yields hoards of ancient cult carvings, often encrusted with sacrificial matter, called telem.

Dokoupil Jiri Georg (1954–). Czech-born painter and sculptor resident mostly in Germany. His prolific production consists of works which are compulsively eclectic in style, but *Expressionist in character. D. also uses subjects from mass culture, e.g. *Frotee Bilder* (1984), but unashamedly shifts to whatever mode might suit the commercial gallery system.

Dolci Carlo (Carlino) (1616–86). Florentine painter whose work exemplifies one aspect of the decline of Baroque painting. The tenderness and piety affected by his languorous, softly

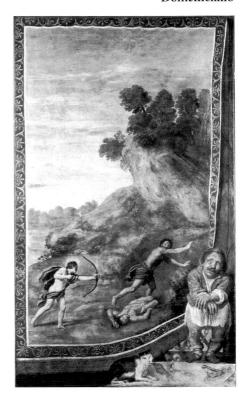

Domenichino Apollo Killing Cyclops 17th c.

modelled half-length madonnas and female saints were popular with his contemporaries but have since appeared sentimental.

Domela (Nieuwenhuis) César (1900–92). Dutch painter in the *Constructivist tradition. D. first exhibited non figurative work with the Novembergruppe, Berlin, in 1923; in 1925 he joined the De Stijl group after contact with *Mondrian and Van *Doesburg in Paris, where he settled, 1933. In 1946 he founded the Research Centre. His works include coloured relief constructions composed of various contrasting materials.

Domenichino Domenico Zampieri called (1581–1641). Bolognese painter, pupil and assistant of the Carracci. He worked in Rome, becoming the leading exponent of the Bolognese school there; in 1630 he moved to Naples. His frescoes in Rome included *Scourging of St Andrew* (1608) and *Scenes from the life of St Cecilia* (1615–17); the latter marked the peak of

Domenico di Bartolo

Domenico Veneziano Head of a Beardless Saint

classicism in his painting. A tendency towards the Baroque in his work in S. Andrea della Valle, Rome (1624–8), was further developed in his frescoes (1630–41) in Naples cathedral.

Domenico di Bartolo (Domenico Ghezzi) (c. 1400–c. 1445). Sienese painter, pupil of Taddeo di Bartolo.

Domenico Veneziano (d. 1461). Italian painter of the Florentine school (although he was probably born in Venice: his work shows a stronger sense of colour than that of most of his Florentine contemporaries). He is known to have been in Perugia in 1438 and in Florence between 1439 and 1445. The story in Vasari of D.V.'s murder by Castagno is disproved by the fact that he died after Castagno. D.V.'s work has recently been critically revalued and his influence traced in the painting of Piero della Francesca. D.V.'s surviving masterpiece is the signed St Lucy Altarpiece, consisting of the central panel, Madonna and Child with Four Saints, 2 very fine predella panels, The Miracle of St Zenobius and Annunciation, and the panels St John in the Wilderness and St Francis Receiving the Stigmata and The Martyrdom of St Lucy.

Dominguez Oscar (1906–58). Spanish Surrealist painter and sculptor, living in Paris from 1934. He evolved *decalcomania, his own style of *Automatism in painting; later works introduced technological imagery. His sculptures used *readymades.

Donatello (c. 1386–1466). Italian sculptor of the Florentine school. Probably no artist so shaped the whole artistic expression of the Italian Renaissance. In himself he found the whole range of that expression, from the lyrical joy of the dancing cherubs, or putti, to the high tragedy and the extremes of religious passion given daring expression in works such as the Magdalen. At the same time, in the bronze David, St George and the Gattamelata, D. demonstrates that enormous confidence in himself and his destiny which marks the man of the Renaissance.

Little is known about D.'s life. He was trained as a goldsmith and in other crafts, entered the workshop of L. Ghiberti at 17 and was probably taught to carve marble by Nanni di Banco, with whom he collaborated on figures for Or San Michele. His earliest work is probably the marble *David*. D. is first mentioned in records of artists working on Florence cathedral in 1406 and he executed commissions for the cathedral throughout his life. In this early period he became a friend of Brunelleschi. Critics now believe the traditional account of a trip to Rome taken by D. and Brunelleschi together, but differ

Donatello
David 1431-3

on the date. Classical motifs and conceptions become important in the work of both artists from the 1420s. Other of D.'s major works include: the figures for Or San Michele, Florence, which include St George and the plaque St George Slaying the Dragon, important because it creates a scene in depth for the 1st time and the illusion of perspective in carved relief; the figures for the cathedral; the wall tombs executed with Michelozzo, such as the tomb of the Antipope John XXIII; the Crucifix; the carvings on the Siena font, including the scene Herod's Feast; Judith and Holofernes; the important panel in low relief, Ascension; the bronze David, the singing gallery or Cantoria of Florence cathedral, and in Padua, the equestrian statue Gattamelata and the high altar of the Santo; finally the influential and enormously powerful carving in wood, the Magdalen.

D.'s influence is traceable in the work of every Florence artist, notably the painters Masaccio and Castagna, Botticelli to some extent, and, to the greatest degree of all, Michelangelo. The Paduan artists under Mantegna and even the Venetians drew upon the enormous technical and spiritual wealth inherent in his work. Almost all later schools have made use of some aspects of D.'s work, e.g. the putti in the Rococo period, the 'rediscovery' of D.'s values in sculpture by Rodin and the way in which emotional tension is reproduced in much contemporary sculpture.

Donati Enrico (1909–). Italian painter. In the 1930s he lived in Paris where he was associated with *Breton and other Surrealists. He settled in the U.S.A. in 1940 and developed an Abstract Expressionist style.

Dongen Kees van (1877–1968). Dutch painter who settled in Paris in 1897. He joined the *Fauves in 1905 and became an important member of the group; he also exhibited with Die *Brücke. After World War I he was successful as a society portraitist of wit and sophistication.

Doré Gustave (1832–83). French graphic artist, painter and sculptor. He visited London for a period, and for a time there was a Doré Gallery there exhibiting his ambitious but now thought unsuccessful oil paintings. D.'s best work results from the unrestrained outpouring of his fantastic imagination and gift for the grotesque; it includes ills for Dante's *Divine Comedy* and Cervantes's *Don Quixote* and plates in *London*, publ. by Blanchard Jerrold.

Dosso Circe and her Lovers in a Landscape (detail) c. 1525

Dosso Dossi. The name used by Giovanni di Lutero (d. 1542), Italian painter of Ferrara, greatly influenced by Giorgione, Titian and Raphael, but a strongly individual painter. He borrows the theme of Giorgione's pastoral in his best-known picture, *Circe and Her Lovers in a Landscape*, but replaces the poetic evocation with a sense of drama and worldly splendour. There is a second, very fine version in the N.G., Washington, in which the lovers have been turned into animals by the enchantress. Both D. and his brother Battista (d. c. 1548) were employed as painters, designers and craftsmen at the Ferrarese court. D. painted a number of warriors in armour at this time.

Dou Gerard or Gerrit (1613–75). Dutch painter of portraits and genre, and the founder of the fijnschilders ('fine-painters'). D. was first apprenticed to his father, an engraver on glass, then became a pupil or companion of the young Rembrandt. After Rembrandt left Leyden, c. 1631, D. became the city's leading painter. Close to Rembrandt's style is A Hermit. D.'s highly finished scenes, often of dramatically lit interiors with figures, e.g. The Young Mother, were very popular and had a lasting influence even outside Holland. Among D.'s pupils were F. van Mieris the Elder, G. Metsu and G. Schalcken.

Doughty

Dove Moon 1935

Doughty Thomas (1793–1856). U.S. Romantic landscapist of the *Hudson River school. Carefully observed sky effects and silvery grey tones characterize his paintings.

Douglas Aaron (1899–1979). U.S. painter and teacher, one of the leaders of the 'Negro Renaissance' period who, from the mid-1920s, defined a modern, black approach to art, e.g. *Aspiration* (1936).

Dove Arthur G(arfield) (1880–1946). U.S. painter and, in his youth, commercial ill. He began experiments in abstraction after a visit to Paris (1907/8) and was a pioneer of abstract painting in the U.S.A. His paintings as exemplified in *Rise of the Full Moon* (1937) recognizably relate to natural forms.

Downing Tom. *Washington Color Painters

Downman John (1750–1824). British painter, notably of small-scale portraits in crayon tinted with watercolour; pupil of Benjamin West.

Doyle Richard (1824–83). British draughtsman and ill. His vigorous gift for grotesque comedy appears in the famous cover for *Punch*, drawn for

the first issue (1841), also in his ills for Ruskin and Dickens and his comic social histories, Ye Manners and Customs of Ye Englishe, drawn from ye Quick and The Foreign Tour of Brown, Jones and Robinson, for which he was admired by the Pre-Raphaelites.

drapery. In sculpture, painting and drawing the representation of the folds in a garment. Artists have used d. as an important expressive medium and different schools and periods render it in a characteristic style. Hence it is a valuable guide to the art historian in identifying and classifying a work of art. Leonardo da Vinci, Dürer and Grünewald are among the artists to have made fine studies of d.

drawing. In the Western tradition the instruments used for d. have normally been charcoal, chalk, pen or pencil (however, watercolours are sometimes classified as drawing); d.s can be merely preparatory studies for a painting or work of sculpture, or independent works entire in themselves. The importance of d. in the visual arts has been much debated since the 16th c. and contrasted with the importance of colour. Florentine art, Poussin and Ingres are ranged against the Venetians, Rubens and Delacroix. In Chinese and Japanese art there is no distinction between painting and drawing, as the only instrument used is a brush, normally with ink.

Doyle Cover for Punch 1841

Duccio Maestà 1308-11

drip painting. A technique in which the paint is dripped on to the canvas which is usually laid on the floor. It was used frequently by the *Abstract Expressionists especially *Pollock.

Driskell David C. (1913—). U.S. African-American painter and influential teacher who worked with a number of important Nigerian artists when he taught at the Institute of African Studies at the University of Ife, W. Nigeria. In his semi-abstract work he makes use of African imagery.

Droeshout Martin (fl. 1620–51). British portrait engraver of Flemish parentage. His copper plate engraving of Shakespeare prefixed to the 1st folio (1623) and commissioned by Shakespeare's friends and eds, Heminge and Condell, is one of the 2 authenticated portraits of the poet. It was probably taken from a portrait now lost.

Drouais François-Hubert (1727–75). French society portraitist, especially of women and children in a graceful, if over-facile, Rococo style. He was a favourite with Mme de Pompadour and Mme Du Barry.

Drouais Jean-Germain (1763–88). French Neoclassical painter, son of the above and pupil and assistant of J.-L. *David, by whom he was influenced. In 1784 he gained the *Grand Prix de Rome* and very soon after he went with David to Rome to study at the Rome Academy and also to assist David in his *The Oath of the Horatii*.

D.'s first painting to be displayed in Rome as a Grand Prix winner was the Dying Athlete (1785), also called Wounded Warrior. It was followed by Marius at Minturnae (1786), Philoctetes on Lemnos (1787) and Cairs Gracchus (unfinished 1788). He died of smallpox. Further to and beyond David's influence, D. absorbed the example of Poussin and the ideas about classicism of *Winckelmann and *Lessing.

dry point. *engraving

Drysdale Russell (1912–81). British-born painter who emigrated to Australia and achieved a substantial reputation. He applied semi-abstract and Surrealistic techniques to depict Australian landscapes.

Dubuffet Jean (1901–85). French painter and print maker. His works, imbued with the spirit of l'Art Brut, created an irrational, primitive world, and varied textural surfaces produced by experimenting with sand, cement, tar, lacquer, etc., gave to his work a supra-pictorial existence. In 1954 he exhibited sculptures which he called *Little Statues of Precarious Life*, made from ephemeral and cast-off materials such as newspaper, worn-out sponge and string. In the late 1960s D. became increasingly occupied with sculpture.

Duccio di Buoninsegna (c. 1260–c. 1319). Italian painter, the creator of the Sienese school as Giotto was that of the Florentine school. D.'s

Duchamp

break with the conventions of Byzantine painting was far less revolutionary than Giotto's, and the great success with which he filled many of the old forms with the new spirit, combined with his superlative colour sense, his feeling for composition, and the dramatic rendering of familiar religious scenes, meant that those Sienese painters who followed him were often content to remain detached from the search for more natural forms of representation which was being pursued in Florence and elsewhere.

The documents of D.'s life tell of his frequent clashes with the government of his city. Despite this he was trusted with important commissions and rose to a position of power, wealth and influence. It may have been during a period of exile from Siena that he executed the earliest picture attributed to him. Most critics now agree that the famous *Rucellai Madonna* is the painting D. was commissioned to paint for the Chapter of Sta Maria Novella in 1285. While the figure of the Madonna remains a type of Byzantine art, the graceful angels and the Child are alive with the new spirit.

The work which displays every quality of D.'s greatness is unquestionably the *Maestà* which D. was commissioned to paint in 1308 and which, according to tradition, was carried to the cathedral with rejoicing in 1311. Apart from the *Maestà* itself, there are some 44 panels on the front and back of the altarpiece representing scenes from the Bible and the lives of the saints; 10 of these panels are now separated. Among these are the outstanding *Calling of the Apostles Peter and Andrew and Annunciation*

Duchamp Marcel (1887–1968). French painter, brother of Jacques Villon and Raymond Duchamp-Villon. He studied part-time at the Académie Julian, Paris, while working as a librarian at the Bibliothèque Ste-Geneviève. He abandoned painting in the 1920s but contributed to Surrealist exhibitions in 1938 and 1947. His 1st paintings (1911-12), influenced by the Cubists, analysed the movement of form in space. Nude Descending a Staircase No. 1 (1911) and No. 2 (1912) inspired, like contemporary Futurist painting, by chronophotography, attempted to create an autonomous equivalent to the moving figure, and he originally intended that the construction The Bride stripped bare by her Bachelors, even should actually move. The 2nd version of the Nude Descending was rejected from a 1912 Cubist exhibition and became the most notorious exhibit at the famous *Armory Show

Duchamp Nude Descending a Staircase No. 2 1912

(1913). The exhibition of his *readymades, e.g. Bicycle Wheel (1913), Bottle Rack (1914), In Advance of the Broken Arm (1915), Comb (1916), Fountain (1917), etc. foreshadowed the polemical 'anti-art' character of Dada. He was, with Picabia, the leader of the New York Dada and Surrealist movement – he moved permanently to the U.S.A. in 1913. D. exerted the greatest influence on the post-Abstract Expressionist generation of U.S. artists like *Rauschenberg and *Johns and determined to a large extent, and for a long period, the course of the most visible U.S. art. He remained throughout his life a legendary figure. The Bride stripped bare by her Bachelors, even occupied him between 1915 and 1923. From 1946 to 1966, when he was supposed to have stopped making art and seemed interested only in chess, he was secretly engaged in Etant donnés: 1. La Chute d'eau/2. Le Gaz d'éclairage, a 3-dimensional mixed-media assemblage which is viewed through two peepholes in an old Spanish wooden door. The scene revealed is of a sun-lit landscape with a waterfall and in

the foreground the realistic form of a female nude. This work is probably related to *The Bride* ... It is perhaps the most mysterious and certainly the most intriguing work of art in the 20th c.

Duchamp-Villon Raymond (1876–1918). French sculptor, brother of Gaston (known as Jacques Villon) and Marcel Duchamp. He took up sculpture in 1898 after studying medicine and was first influenced by Rodin. In 1910 he joined the Cubists. Cubist sculpture reached its apogee in his *Horse* (1914), a masterly synthesis of organic and mechanical elements.

Dufresne Charles (1896–1938). French painter and designer who combined the stylistic influences of Fauvism and Cubism with romantic subject matter. A visit to Algeria (1910–12) stimulated his interest in exotic subjects – *Patio à Alger* (1913). Among his last works were murals for the Palais de Chaillot (1937) and the École de Pharmacie (1938), Paris.

Dufresne Jacques (1922–). French sculptor, son of the above and pupil of *Laurens; he works in a variety of materials, producing severe figures full of tension.

Dufy Raoul (1877–1953). French painter, born in Le Havre, where he met *Braque and Friesz. He studied at the École des Beaux-Arts, Paris. Under *Matisse's influence he produced Fauve paintings around 1905 with strong colour areas and an intermittent heavy black contour – e.g. *La Plage de Ste-Adresse* (1904). Cubism and the influence of Cézanne prompted a monumental

Duchamp-Villon Horse 1914

Dufy Les Trois Baigneuses 1919

sense of form as in *Les Trois Baigneuses* (1919), but after 1920 D.'s paintings of racecourses, regattas and casinos were conceived, like his remarkable textiles, as a tapestry of clear colours. His brother Jean (1888–1964) was also a painter, mainly in watercolour.

Dughet Gaspard. Gaspard *Poussin

Dujardin Karel (1622–78). Dutch painter of Italianate landscapes with animals or figures, genre pieces and portraits. He was a pupil of N. Berchem and twice visited Italy.

Dulac Edmund (1882–1953). French-born British ill., watercolour painter, portraitist and designer. Some of the best known of his fantastic, intricate ills are the watercolours for *The Arabian Nights, The Rubáiyát of Omar Khayyám, Sinbad the Sailor, The Tempest* and many books of fairy-tales.

Dumoustier (Dumonstier). Large family of French artists working in the 16th–17th cs.

Duncanson

Duncanson Robert Scott (1821–72). U.S. African–American painter who first travelled in Europe in 1853 financed by an abolitionist organization. On a subsequent trip to England and Scotland he was especially attracted to the work of *Claude Lorrain and *Turner. D. painted portraits, landscapes, still-lifes and murals, including a series of 12 murals for Belmont, residence of Nicholas Longworth (abolitionist and political leader), with landscapes painted in *trompe l'wil. His highly accomplished classical landscapes include Loch Long (1867) and at least two paintings of Pompeii (1855 and 1871).

Dupré Jules (1811–89). French landscape painter, one of the leading members of the *Barbizon school. He visited Britain in 1831 and was greatly impressed by Constable, though his own work gave a more romanticized and introspective interpretation of nature.

Duquesnoy François (1594–1643) called 'Il Fiammingo'. Flemish sculptor who settled in Rome. His major works are the marble statues *St Andrew* and *St Susanna*. In his own time he was renowned for his *putti. He represented the classical tradition in the age of Bernini's Baroque.

Durand Asher Brown (1796–1886). U.S. land-scape painter, founder, with T. Cole, of the *Hudson River school. He abandoned a successful career as an engraver to become a painter, first of portraits and biblical and anecdotal subjects, later of quiet, Romantic landscapes.

Dürer Albrecht (1471–1528). German painter, engraver, designer of woodcuts and major art theorist. D. was born in Nuremberg and trained 1st under his father, a goldsmith. He was apprenticed (1486-90) to M. Wolgemut, in whose workshop he became familiar with the best work of contemporary German artists and with the recent technical advances in engraving and drawing for woodcuts. D. soon began to provide ills himself for his godfather, the printer A. Koberger. In 1490 he went on the 1st journeys that were so to affect his art. visiting Colmar, Basel and Strassburg. He was in Nuremberg for his marriage in 1496, but left in the autumn of that year for Italy. On this visit and during the longer stay of 1505-7, D. made a profound study of Italian painting at the very moment when it was being changed by the revolutionary ideas of Leonardo da Vinci and others. He also studied the whole intellectual background of the Italian Renaissance, the

Dürer Self-portrait 1500

writings of the humanists and, in particular, Mantegna's attempts to re-create in engravings and paintings the classical canon of art. D. was thus able to make his own personal synthesis of the arts of the north and south, a synthesis which was to have immense importance to European art. From 1495, when D. established his workshop in Nuremberg, his success and reputation increased rapidly. Until 1499 he was engaged chiefly on engravings and designs for his books of woodcuts. Comparatively easy to reproduce in large numbers and to transport, this work made him more widely known than any but the almost legendary Italians. He was encouraged by an enthusiastic patron, the Elector of Saxony, and he became the friend of many of the chief figures of the Reformation. Though he never broke with Catholicism, D. was deeply involved in the religious controversy until his death. In 1512 he was made court painter to the Emperor Maximilian. This honour was confirmed by Charles V, and when D. visited the Netherlands in 1520 he was widely fêted. In his last years he planned and partly composed a thesis on the theoretical basis of the arts.

To mention only his greatest works: The Madonna of the Rose Garlands and The Adoration of the Trinity were painted almost in

competition with the Italians. His portraits are of great interest, particularly the series of selfportraits: that of 1403, of 1408, of 1500 and of 1522. Probably his major work in oils is the late Four Anostles, However, D.'s greatest single achievement and one which established him as supreme among graphic artists is his book of woodcuts. The Apocalypse (1498). Other series of woodcuts are: The Great Passion. The Life of the Virgin and The Lesser Passion. Single woodcuts of outstanding quality are: The Last Supper and The Men's Bath House. Of his engravings the series The Engraved Passion, and the single plates: Adam and Eve. Melancholia, Knight, Death and the Devil, The Prodigal Son, St Jerome in his Study and St Eustace are the finest in quality. D.'s smallest sketches are often masterpieces of draughtsmanship and feeling, e.g. Crowned Death on a Thin Horse, charcoal. His watercolours of places (often scenes done on his travels), people, animals and plants are evidence of his desire to record the world around him with the greatest precision, yet with no surrender of the passion of an artist before the objectivity of the scientist.

Dusart Cornelis (1660–1704). Dutch genre painter and engraver, pupil and close friend of A. van Ostade, whose style he followed. On Van Ostade's death D. inherited his pictures and completed a number of them.

Düsseldorf school. U.S. painters who studied at Düsseldorf and exhibited at the Düsseldorf Gal., N.Y. (1849–61); notably *Bierstadt, *Bingham and E. *Johnson. The paintings were polished and realistic in style, sentimental and anecdotal in mood

Duveneck Frank (1848–1919). U.S. painter who was trained in Munich, 1870–3, and was influenced by *Leibl. He spent 1875–88 again in Europe: in Munich he had his own painting class that attracted several U.S. painters. D. introduced anti-academic styles in the U.S.A. in the late 1870s.

Duyster Willem Cornelisz (1598/9–1635). Dutch genre painter who specialized in social gatherings of officers, etc., e.g. *Players at Tric-Trac* and *Soldiers Quarrelling*.

Dyce William (1806–64). Scottish painter. Early sympathy with the *Nazarenes encountered by him in Rome (1827) made him welcome the *Pre-Raphaelites. Though his frescoes in the House of Lords and elsewhere lack inspiration,

his *Pegwell Bay* is an admirable piece of mid-toth-c. Realism.

Dyck Sir Anthony Van (1500-1641). Flemish painter chiefly famous for portraits of the English aristocracy, though he also painted a number of large religious, allegorical and mythological subjects. D. was trained in Antwerp by H. van Balen and became the chief assistant of Rubens. He was in Britain for some months in 1620-1, then embarked on a prolonged tour of Italy, where he spent periods at Venice. Genoa and Rome, executing portraits and commissions for churches. He painted for a further period in Antwerp before he settled in Britain in 1631 as court painter. Typical of his rich but refined and elegant portrait style, which flattered almost all his sitters with a look of distinction and intelligence, are Philippe le Roy, Frans Snyders, Charles I and the more ambitious Charles I in Hunting Dress. This style set a pattern, especially for British portrait painters, for at least 200 years. Larger works include The Crucifixion of St Peter, Samson and Delilah, Rinaldo and Armida and Amarillis and Mirtille

Dyck Charles I in Hunting Dress (detail) c. 1635

E

Eakins Thomas (1844–1916). U.S. painter and photographer. Trained as a painter in Paris and influenced by Manet, E. became one of the major American Realists, e.g. his studies of surgeons operating. His paintings include brilliantly composed sculling pictures, e.g. The Biglen Brothers Turning the Stake. E. revolutionized U.S. art teaching, insisting on drawing from the nude and sound anatomical knowledge. As a photographer he continued Muybridge's experiments in the photography of motion, improving on them by using I camera to produce a series of images on a single plate rather than a number of cameras producing single images. E.'s composite plates inspired Duchamp's famous painting Nude Descending a Staircase.

Earle Ralph (1751–1801). Self-taught, itinerant U.S. portraitist and, for his battle scenes of Lexington and Concord (1775), believed to be the earliest historical painter in America. He worked for a time in London, replacing the attractive untutored stiffness of his early pictures with the smoother style of fashionable English portraiture.

Earth art. Trend which emerged in the late 1960s and early 1970s. Works were the result of the preoccupation with natural processes: often monumental and realized with the aid of earthmoving equipment, they were created in remote locations, e.g. *Smithson's Spiral Jetty of boulders, 1500 ft (457 m.) long, in Great Salt Lake, Utah (1970). Such works were concerned with the notion of 'sites and non-sites' and geology. Works were often presented in photographs (often taken from the air because of the scale of the work), sometimes juxtaposed with piles of material selected from the site of the work. *Long.

earth colours. Pigments such as yellow and red ochres, raw sienna, raw umber and terre verte which are found in their natural state in the earth. Ochres in particular were used in prehistoric cave painting. They are among the most permanent and least expensive colours.

East Sir Alfred (1849–1913). British landscape painter and watercolourist. His idealized romantic scenes are painted in a style indebted to the *Barbizon school.

Eakins Masked Woman Seated c. 1886

Easter Island. *Oceanic art

Eastlake Sir Charles Lock (1793–1865). British painter, writer on art and administrator. As keeper (1843–7) and 1st director (1855–65) of the N.G., London, he devoted energy, scholarship and taste to building up one of the greatest colls of Italian art, particularly the work of the so-called 'primitives'. E.'s early landscapes deserve attention.

Eclecticism. Loosely definable as the drawing on many styles by an artist, more specifically the practice of selecting the best from various styles in an attempt to create a style of greater perfection. The term used to be applied to the work of the Carracci who were believed (wrongly) to have deliberately formulated such a programme.

École de Paris (Fr. School of Paris). Term used to describe the modernist artists, many of them from other countries, who were centred in Paris during approximately the first forty years of the 20th c. They included *Bonnard, *Chagall, *Matisse, *Miró, *Modigliani and *Mondrian.

Ecological art. Art which first appeared c. 1968 and which is concerned with natural processes, as in the work of artists *Sonfist and *Haacke.

Edmondson Crucifixion 1932-7

écorché figure (Fr. flayed). Term used to describe human or animal figure drawing or engraving, practised widely since *c.* 16th c., displaying the muscles of the body.

Edmondson William (1882–1951). U.S. African-American sculptor, the 1st to have a one-man exhibition at M.O.M.A., N.Y. (1937). A religious convert to the United Primitive Baptist Church in Nashville, Tennessee, he said he started making tombstones and sculptures at God's command. E. depicted human and animal figures, and angels inspired by biblical texts. The Crucifixion of Christ is a frequent subject in his numerous limestone carvings, e.g. Crucifixion (c. 1932–7).

Edo. Period of Japanese history (1616–1868) ruled by the Tokugawa shogunate, secured in 1615 by T. Ieyasu (1542–1616), from its capital Edo (modern Tokyo). In the arts sculpture stagnated except in netsuke carving. The new graphic art of ukiyo-e (*Japanese prints) produced popular masterpieces. Painting was represented by the courtly school of *Kano Tanyu at Edo; the Tosa school; Ogata Korin (1658–1716), working in a revived *yamato-e tradition of great decorative splendour; and the 18th-c. nanga school. Based on Chinese ideals (*wen-jen) and on Zen Buddhist principles, this

admired self-expression above academic expertise.

Eeckhout Gerbrand van den (1621–74). Dutch painter of portraits, religious subjects and genre, a favourite pupil of Rembrandt and a close imitator of his style, e.g. Officers of the Amsterdam Coopers' Guild. About 1665 he began to paint genre scenes in the style of *Ter Borch.

Egg Augustus Leopold (1816–63). British painter of anecdotal subjects whose popularity revived in the mid-20th-c. vogue for Victoriana. He was a friend of Dickens and travelled with him to Italy.

Eggeling Viking (1880–1925). Swedish painter and pioneer of avant-garde films. In 1915 he met Arp in Paris, moved to Switzerland and joined the *Dada movement. In Germany he and H. Richter experimented with abstract picture strips which formed the bases for *Symphonie diagonale* (1921), an early abstract film.

Ehrenstahl David Klo(c)ker von (1629–98). German portrait painter known as the 'father of Swedish painting'. He was in Italy (1654–8) but worked mainly at the Swedish court, introducing a style of portrait with allegorical figures and *putti.

Edo Matsuura Byobu (detail of screen) early 17th c.

Eight, The. Group of 8 U.S. painters – Henri, Luks, Sloan, Glackens, Shinn (previously the Philadelphia Realists), joined by Prendergast, Lawson, Davies – formed in 1907 as a gesture of protest against the National Academy. Stylistically the members differed considerably and they exhibited together only once (N.Y., 1908); they were, however, united in seeking independence of the Academy and supporting progressive trends in art; and they played a vital role in organizing the *Armory Show and in founding the Society of Independent Artists (1917).

Elementarism. A successor to the Neoplasticism promoted by the Dutch artists connected with De Stijl, this new movement was announced by Van *Doesburg in a manifesto published in the magazine *De Stijl* in 1926. Forms were still to be right-angled, as in Neo-plasticism, but inclined planes could now be used.

Elsheimer Adam (1578–1610). German painter, trained chiefly in Italy. He specialized in small highly finished works, often painted on copper. The landscape is given great importance and E. experiments with effects of lighting. In one example of a scene he painted many times, *Flight into Egypt*, half the picture is lit by moonlight, half by the light from a bonfire.

emblems. Books of e.s were not uncommon in the 17th c. They consisted of short poems, etc., based on passages of Scripture and with quotations from the fathers of the Church and were decorated with engravings. A well-known example was publ. by Francis Quarles.

encaustic wax. A technique of painting in which the *medium for the powdered colour is hot wax; the method was used in classical antiquity and revived in the 20th c., e.g. *Johns.

engraving. The term covers many techniques for multiplying prints, either of a picture designed by the engraver himself for the medium, or of a reproduction of a work in another medium by another artist. Correctly e. refers only to *intaglio techniques. All these involve a metal plate, usually copper, on which the ink is held in furrows and crevices cut or bitten by acid into its surface: a print is obtained by rolling the plate, covered by a sheet of dampened paper, through a press; so that the

paper is forced into the engraved markings, thus picking up the ink.

LINE ENGRAVING. A copper plate is polished and often covered with chalk. The main contours of the picture are marked in the chalk and the lines cut in the copper with a shaver or burin; graduated tones can be obtained by hatching. Line e. achieved its greatest expressiveness in the N. schools, especially in the work of Dürer. Later it was used mainly for making reproductions.

DRY POINT. A steel stylus is used on a copper plate; but whereas in line e. the burr of copper is polished away, in dry point it is left. In printing, the ink caught in this burr gives a characteristic 'bloom' to the line. This technique is often used with etching, notably in Rembrandt's work.

ETCHING. The plate is covered with a thin resinous film impervious to acid. The artist draws on this ground with a needle, exposing lines on the copper which are bitten away when the plate is dipped in acid. Since shallow lines will hold less ink than deep ones, graduations of tone can be obtained by briefly immersing the plate for the faintest lines, 'stopping' these out and immersing for longer and longer periods as the darker lines are drawn in. 'stopping out' each successive set of lines when they have been etched. Tonal gradations in etching are far more subtle than those possible in line engraving. Aerial *perspective is one effect thus obtainable. Developed in the early 16th c., etching was first fully explored by *Callot; its greatest exponent was Rembrandt. In soft ground etching the artist draws on to the ground (mixed with tallow) with a pencil through a sheet of paper; parts of the ground cling to the paper and the final picture from the plate has a grainy texture.

MEZZOTINT. Unlike line e. or etching, mezzotint (invented in the mid-17th c.) works with tones rather than lines; it was thus suitable, and in the 18th c. widely used, to reproduce paintings. A curved file or 'rocker' is rocked over the plate to give a uniformly burred surface like sandpaper. This, when inked, would print as a solid black. By scraping off the burr to a greater or lesser extent or by burnishing it away entirely, the amount of ink carried by different areas can be controlled and gradations of tone or highlight (the burnished areas will carry no ink) obtained.

AQUATINT. A tone process (invented by *Leprince) which uses acid as in etching. The

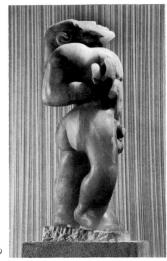

Epstein Adam 1938–9

plate is covered with a porous ground which allows the acid to bite away a fine mesh of tiny dots. The artist first stops out the white areas of the picture, immerses the plate briefly for the next lightest tone, stops out these areas in turn and repeats the process for the successively darker tones. Unlike the mczzotint, the aquatint is incapable of fine modulations of tone, each tone being uniform and bounded by an abrupt contour.

SUGAR AQUATINT is a linear technique combined with aquatint tone. The design is brushed on to the copper with a black ink or gouache dissolved in sugar-water, and the plate is covered with a ground and dipped in warm water. The sugar mixture dissolves, leaving the plate exposed where the drawing was. A second ground is laid and the plate bitten as for an ordinary aquatint.

Ensor James (1860–1949). Belgian painter and engraver, born in Ostend of an British father and a Flemish mother. E. studied at the Brussels Academy, but otherwise seldom left Ostend. Neglected by all but a few writers such as Verhaeren and Maeterlinck, E. was awarded later recognition in the 1920s and created a baron in 1930. Today he is considered a major pioneer of both Expressionism and Abstract Expressionism. E. began by painting sombre interiors, portraits, landscapes and seascapes (*The Rower*) as well as a few superb still-life studies. About 1883 his palette changed to

lighter, brilliantly contrasted colours. This very Flemish choice of colour can first be seen in a variation in a self-portrait by Rubens, Portrait of the Artist in a Flowered Hat. Of E.'s engravings of this period, one of the greatest is The Cathedral (1886). The macabre carnival paintings of fighting skeletons and masked revellers, with the echoes of the Dance of Death, Bosch, Bruegel the Elder, Callot, Goya and Magnasco, now made their appearance. The most celebrated of these, Christ's Entry into Brussels, was rejected in 1889 after a scandal by Les XX, an avant-garde group which E. had helped to found. E. continued to paint until 1939; his later work is less fierce in character, e.g. Coup de lumière (1935).

Environmental art. Term used from the late 1950s for works of art which are three-dimensional environments, i.e. which the spectator can enter, e.g. *Kienholz.

Epstein Sir Jacob (1880–1959). U.S.-born portrait and monumental sculptor who settled in London in 1905. His fame and notoriety were established with the 18 figures in semirelief carved for the British Medical Association Building in the Strand. Many sculptures of his early and middle period were rejected by the general public as ugly and attacked by the criticise either for the deliberate distortion of the human figure or on formal grounds: the *Risen Christ* (1919) showed Christ as a Jew, and the influence of primitive art is apparent in the *Ecce*

Max Ernst Woman, Grey and Blue 1924

Homo (1934–5) and the alabaster Adam (1938–9), a barbaric and energy-charged figure. The 3 major religious commissions of E.'s last years, the Madonna and Child (1951–2), the Christ in Majesty (1953–7) and the St Michael and the Devil (1955–7) were more traditional compositions. His bronze portrait heads of children and of great contemporaries are notable.

Erbslöh Adolf (1881–1947). German *Expressionist painter, a member of the New Artists' Federation (1909) led by Kandinsky. He disapproved of the increasing tendency towards abstraction in Kandinsky's work and was partly responsible for bringing about his resignation from the Federation in 1911.

Erhart Gregor (d. 1540). German sculptor in wood and stone, trained in late Gothic style but subsequently influenced by the Renaissance. Most famous are his painful figures on the high altar of the Klosterkirche, Blaubeuren; other works include the *Frauenstein Madonna* and *La Belle Allemande*, a figure of Mary Magdalene.

Ernst Jimmy Ulrich (1920–84). German-born *Abstract Expressionist painter who settled in the U.S.A. in 1938; son of Max E.

Ernst Max (1891–1976). German painter who first studied philosophy at Bonn (1909–14). Untrained as an artist, he visited Paris in 1913 and met Macke, Delaunay and – more significantly – Apollinaire and Arp. After the war he founded the Cologne *Dada group in 1919. By this time he had seen the work of De Chirico,

Klee, Picasso and the Zürich Dadaists, and his paintings combined found objects (pieces of wood, wallpaper, etc.) with painted objects into a fantasy imagery whose disturbing ambiguity was emphasized by the titles – *The Little Tear Gland that says Tic Tac* (1920). His oneman exhibition in Paris in 1920 was acclaimed by the *Surrealists. His invention of 'frottage' paralleled the automatic writing of *Breton and Eluard in eliminating the conscious creative role of the artist, e.g. *Histoire Naturelle* (publ. Paris 1926).

The painting and sculpture which now make him regarded as one of the major influential figures of international Surrealism depend either on the irrational juxtaposition of unrelated elements, e.g. Of this Men shall know Nothing (1923) or on a more imaginative nightmare improvisation of organic forms (The Horde, 1927). E. spent the war years in the U.S.A., later settling in France. In 1961 he publ. An Informal Life of Max Ernst.

Erri Agnolo and Bartolommeo (fl. after 1540). Italian painters who worked in Modena.

Eskimo. Name commonly applied to a group of Arctic tribal peoples occupying the area from N.E. Siberia to Labrador and Newfoundland. They have a powerful oral tradition of myths and legends and a sculptural tradition stretching back more than 2000 years to the stone carvings of the Old Bering Sea culture. This was maintained up to the early decades of the 20th c. with outstanding miniature carvings in wood, bone, walrus ivory and antler, depicting

animal figures with vigorous economy of line. In recent decades the bulk of E. art has degenerated into tourist 'airport' art.

Estense Baldassare (d. 1504). Ferrarese painter, the natural son of Niccolo d'Este III, Duke of Ferrara. The only signed work by him disappeared in the 19th c., but a number of other pictures in a severe, intellectual style are believed to be his, e.g. Family Group.

etching. *engraving

Etty William (1787–1849). British painter best remembered for his studies of the nude, e.g. *The Bather.*

Euphronios (6th–5th c. BC). Greek potter and vase painter in the *red figure style whose drawing showed a new interest in anatomical structure

Euston Road school. A group of British artists, led by *Coldstream, *Gowing, C. Rogers and *Pasmore who conducted a school

Eskimo Soapstone carving (by Thorsen Frederikshaab) *c.* 1930

Eworth Sir John Luttrell Saved from Drowning 1550

(1938 9) of painting and drawing in London in which artists worked alongside their students. Realistic townscapes, landscapes and interiors were painted in opposition to the abstract and Surrealist painting current in Britain.

Eutychides (4th–3rd c. BC). Greek sculptor, pupil of Lysippus and famous for his statue of Tyche (Fortune), tutelary goddess of Antioch in Syria, showing her seated on a cliff with the river god Orontes at her feet. There is a Roman copy in the Vatican.

Everdingen Allart van (1621–75). Dutch landscape painter who visited Scandinavia (1640–4). His pictures of rough, romantic mountain scenery were the first of their kind in Holland and affected the later work of Van *Ruisdael.

Everdingen Cesar Boetius van (d. 1678). Dutch painter of portraits and mythological subjects in a highly finished Caravaggesque manner. He was the brother of Allart van E.

Eworth Hans, or Jan Euworts, Flemish painter who worked chiefly in Britain (c. 1545–74). He painted portraits or flattered his patrons by including them in elaborate allegories close in style to the school of Fontainebleau, e.g. *Queen Elizabeth puts the Goddess to Flight*. A mysterious and evocative work is *Sir John Luttrell Saved from Drowning*.

Exekias (6th c. BC). Greek potter and famous vase painter in the *black figure style whose masterpiece is an amphora now in the Vatican showing Achilles and Ajax.

Expressionism. Term used to describe works of art in which reality is distorted in order to express the artists' emotions or inner vision, e.g. in painting, emotional impact is heightened by deliberate use of strong colours, distortion of form, etc. In this sense, the paintings of El Greco and Grünewald are sometimes called Expressionist, though the term is usually restricted to artists of the last 100 years. Thus Van Gogh in painting and Strindberg in drama are regarded as the forerunners of modern E.

An overtly Expressionist movement developed in the German theatre after World War I (Kaiser, Toller) and there are Expressionist elements in the work of, e.g., Brecht, O'Casey and O'Neill; in other branches of literature there has been no avowed Expressionist movement, though similar effects have frequently been sought (e.g. by Kafka).

The most conscious Expressionist movements, however, have been in the visual arts, notably Die *Brücke and *Blaue Reiter groups in Germany. *Munch's influence was strong in Germany; his work had been shown in exhibitions and admired since the 1890s. Other important Expressionist painters are O. Kokoschka, C. Soutine, G. Rouault and M. Beckmann (his later allegorical works). O.

Zadkine and E. Barlach are important Expressionist sculptors. A group of Expressionist painters formed round C. Permeke at Laethem-Saint-Martin in the Netherlands, including G. de Smet, F. van der Berghe and F. Masereel. In France the work of Édouard Georg, F. Gruber, Gromaire and B. Buffet is also described as Expressionist.

The term E. is sometimes used of architecture, e.g. of the work of P. Behrens and Eric Mendelsohn (the Einstein Tower at Potsdam, 1920), and of the picturesque Goetheanum built by Rudolf Steiner. There was much contact between architects and other artists after World War I, especially in the *Novembergruppe.

Exter Alexandra (1884–1949). Russian Futurist and abstract painter; she emigrated to Paris in 1924. She is important chiefly as a theatrical designer for Tairov, director of the Kamerny Theatre in Moscow; famous productions were for Salome (1917) and Romeo and Juliet (1921).

Eyck Jan van (c. 1390–1441) and Hubert or Hubrecht (d. 1426). Early Netherlands painters. The great altarpiece of the cathedral of St Bavon, Ghent (*The Adoration of the Lamb*), bears an inscription stating that the work was begun by Hubert van Eyck and completed by Jan. This inscription has been a stumbling-block to scholars ever since. A number of attempts have been made to separate the work of the 2 brothers, but none has been universally

Jan van Eyck Man in a Red Turban (detail) 1433

accepted. Hubert's name appears only on the Ghent altarpiece, while signed and dated works by Jan are numerous.

Despite these difficulties of attribution, Jan emerges as unquestionably the greatest artist of the early Netherlands school. He was probably born at Maaseyck near Maastricht. From 1422 to 1424 he was in the service of John of Bavaria, Count of Holland. On the count's death he joined the court of Duke Philip the Good of Burgundy at Lille, acting as his envoy on missions to Spain (1426) and to Portugal (1428). From 1430 he lived at Bruges. Thereafter there is evidence of his increasing wealth and importance as a court painter, diplomat and city official of Bruges.

The earliest works attributed to Jan are the miniatures identified in 1902 as the *Turin-Milan Book of Hours*.

The Eycks' clarity and realism were revered and sometimes imitated, but they proved too difficult for most painters to follow and there was an inevitable reaction against such work. Although the tradition that one or other of the brothers was the inventor of oil paint has been disproved, their mastery of the technique and the improvements they introduced undoubtedly changed the whole nature of the medium. Jan's pupil, Petrus Christus, may have been responsible for teaching the secrets of the technique to Λntonello da Messina and the Italians.

Jan executed a number of large commissions for donors who presented them to churches. Among these are The Virgin of Chancellor Rolin, Virgin and Child and the Canon van der Paele, Virgin and Child with Saints and a Carthusian. Similar subjects are The Virgin and Child in a Church, The Annunciation and the Virgin and Child, a triptych. Among his portraits are the early Tymotheos, The Painter's wife, Margaret, Man in a Red Turban and Cardinal Niccolo Albergati. Perhaps the best known of his paintings is the The Marriage of Giovanni(?) Arnolfini and Giovanna Cenami(?), which is, at the same time, a double-portrait of great psychological insight, a meticulously rendered interior and one of the 1st genre paintings. The greatest aspect of Jan's genius was in depicting such a scene with the utmost clarity and naturalism and yet creating from apparently mundane subjects a mystery so rich that it has eluded all analysis.

Fabritius Self-portrait (detail)

Fabritius Carel. Name used by Carel Pietersz (1622–54), Dutch painter, killed in the explosion of the powder-magazine at Delft, which probably also destroyed many of his paintings. The few surviving pictures show him to have been technically very accomplished. He was the pupil of Rembrandt and the master of Vermeer. One of his most interesting paintings is the small View of Delft in which the unique planned perspective shows F.'s interest in creating optical illusions. Other works are: Man in a Fur Cap, the strong Self-portrait and the popular Goldfinch.

Fabro Luciano (1936—). Italian artist of the *Arte Povera circle who was influenced in certain respects by *Manzoni, *Klein and, closer at hand, L. *Fontana. His objects and *installations operate as metaphors. As with other European artists with post-*Minimalist tendencies after the late 1960s, F.'s work is suggestive of theoretical concerns, ideological disillusionment and memories of the collective imagination, as in the 'Italia' series (1968–75), e.g. Golden Italy (1971), Cristo-Buddha-Zaratustra (1981) and La Dialettica (1985).

Fairweather

Fabro Golden Italy 1971

Fairweather Ian (1890–1974). Scottish-born Australian abstract painter.

Falconet Étienne-Maurice (1716–91). French sculptor. He was a pupil of *Lemoyne and director of sculpture at Sèvres (1757–66). For Sèvres biscuitware he produced many graceful Rococo models. His masterpiece was a monumental equestrian statue of Peter the Great in the Baroque tradition.

Falk Robert (1886–1958). Russian painter and a founder of the Muscovite *Knave of Diamonds group. Cézanne was the most important influence on F., although during the 1920s he gradually evolved a more personal vision and technique. Still-life, portrait and landscape subjects predominate. As a teacher in Moscow he was important to less academic young artists.

Fang. A populous complex of African tribal peoples living in the region of the Northern Gabon; their carvers and sculptors are considered among the finest in Africa. They are especially noted for mortuary heads and figures, possibly representing primeval ancestors, given a dark finish and carved in a powerfully geometric style.

Fantastic Realism. The work of a group of Austrian artists, among them Erich Bramer,

Ernst Fuchs and Rudolph Hausner, who came together in the 1940s. It combines Surrealism with elements borrowed from late medieval fantastic art and 19th-c. academicism.

Fantin-Latour Ignace-Henri-Jean-Théodore (1836–1904). French painter, especially of flowers and a few large group portraits. F.-L. studied under his father and under Courbet. In his *Homage to Manet* (1899) and *Homage to Delacroix* (1864) he included many of the leading artists of his day and he repeated this formula for group portraits of writers and musicians. F.-L. was friendly with a number of the most advanced contemporary artists. Of his many studies of flowers *Bouquet of Dahlias* is typical.

Farington Joseph (1747–1821). British land-scape and topographical draughtsman. He became an influential member of the R.A. (elected 1785) and his *Diary* (publ. 1922–8) provides one of the chief sources for our knowledge of English painting and the R.A. in the late 18th–early 19th cs.

Fauvism. A style of painting in which colours are the all-important theme of the work. The art critic Louis Vauxcelles described a room at the 1905 Salon d'Automne in which a sculpture in a classical style by Albert Marque was surrounded by paintings of *Matisse, Derain and others as 'Donatello parmi les fauves' (i.e. 'Donatello among the beasts'). A Divisionist style gave way to flat patterns and free, bold handling of colour (influenced by the work of Van Gogh). The most important members of the group were Matisse (the leader), *Derain, Van *Dongen, *Dufy, *Friesz, *Marquet, *Vlaminck and for a short time *Braque: *Rouault, friendly with the group, worked in a markedly different style. F. gave way to *Cubism after a few years.

Fayum, Faiyum, portraits. Fayum, a region of Upper Egypt. Portrait paintings found on the faces of mummies in Roman cemeteries in Ancient Egypt, dating from the 1st c. BC to the 3rd c. AD. The medium can be either tempera or *encaustic. Bold but remarkably naturalistic in style, the paintings seem most usually to have been made during the subjects' lifetimes.

Federal Art Project. *W.P.A.

Fedorovich Sophie (1893–1953). Russian artist who in 1920 came to Britain where she created décor for many ballets.

Fedotov Pavel Andreyevich (1815–53). Russian satirical genre painter who depicted the manners of the urban bourgeoisie and the army. His satire now appears harmless and so discreet as to be hardly noticeable, but it nevertheless received official censure. His choice of commonplace subjects broke with contemporary idealist theories.

Feininger Lyonel (1871–1956). Painter, born in N.Y. of German-American parents. All the early influences upon him were subsequently reflected in the subjects of his paintings: music, tov making, Manhattan skyscrapers, trains, bridges and ships. F. studied music in Berlin, then became a cartoonist, first for German, later for French and U.S. journals. In Paris he came into contact with the work of *Delaunav and the *Cubists. From 1913 he made Germany his home, associating himself with the *Blaue Reiter group under F. Marc, and later teaching at the *Bauhaus in Weimar and Dessau. In 1024. F. joined W. Kandinsky, P. Klee and A. von Jawlensky in Die *Blaue Vier ('The Blue Four'). Named among the 'degenerate' artists by Hitler's government, F. returned to the U.S.A., where his teaching, writings and last watercolours were influential on the birth of *Abstract Expressionist painting.

Feke Robert (fl. 1741–50). Colonial American portrait painter who worked mainly in Philadelphia and Boston and was possibly taught by the British painter Smibert. Strong characterization and an emphasis on elaborate dress give distinction to his rather stereotyped poses.

Ferguson William Gouw (1632/3–90?). Scottish still-life painter who worked in the Netherlands and England; his paintings have sometimes been confused with those of Jan Weenix and other Dutch artists.

Fernández (Hernández) Gregorio (1576–1636). Leading Spanish Baroque sculptor of religious subjects in painted wood; he worked in Valladolid. Many of his most expressive sculptures, e.g. *Pietà* (1617) and *St Veronica*, are life-size figures (*pasos*) designed to be carried in Holy Week processions. He also carved the high altar of Plasencia cathedral (1624–34).

Ferrara, school of. School of Italian painting which flourished in the 2nd half of the 15th c. and is represented by Tura, Cossa, Ercole de' Roberti and Costa. Its marked austerity of style

Feininger Grützturm 1928

derived from the influence of Piero della Francesca and Mantegna.

Ferrari Gaudenzio (d. 1546). Italian painter of the Lombard school. His major works, dramatic and overcrowded with figures, are frescoes in several chapels on the Sacro Monte, Varallo; a screen depicting scenes from the life of Christ, an altarpiece and frescoes in S. Cristoforo, Vercelli; and the *Choir of Angels* in the dome of S. Maria dei Miracoli, Saromuo.

Ferri Ciro (1634–89). Roman Baroque painter. He was the principal follower of Pietro da Cortona and on the death of the latter completed his frescoes in the Pitti Palace, Florence. F.'s own work includes an altarpiece for S. Ambrogio, Rome, biblical frescoes in S. Maria Maggiore, Bergamo, and frescoes of the seasons in the Villa Falconieri, Frascati.

fête champêtre. French term used to describe a type of painting in which a group of townspeople is depicted relaxing in rural surroundings. Giorgione's *Concert Champêtre* is an example.

fête galante. French term used to describe a French 18th-c. genre of painting in which members of the court amuse themselves in love making, dancing and music in a park, garden or rural setting. It is a particular form of the *fête champêtre and was practised most notably by *Watteau but also by J.-B.-J. Pater, Lancret

and others. The term was first used in 1717 when Watteau was admitted to the French Academy and described as a painter of f.s g.s.

Fet(t)i Domenico (1589–1623). Italian painter, trained in Rome. He was court painter at Mantua (1613–21) but settled in Venice in 1622. Characteristic works such as *The Good Samaritan* are richly coloured, broadly executed cabinet pictures of biblical subjects as genre. In these he was influenced by A. Elsheimer, Rubens and the Venetian school.

Feuerbach Anselm (1829–80). German painter of classical subjects and portraits whose painting marked the end of German academic classicism. He was influenced by *Couture in Paris and spent many years in Italy. His best work, e.g. the portrait Nanna (1861) and Orpheus and Eurydice (1869) is majestic and controlled, his inferior work sombre and artificial.

Field Erastus Salisbury (1805–1900). U.S. primitive artist, noted for his remarkable architectural fantasy, *Historical Monument of the American Republic* (c. 1876).

Fielding (Anthony Vandyke) Copley (1787–1855). British landscapist and marine painter in watercolours and oils. He studied with J. *Varley and received the 1824 Paris Salon gold medal. His paintings, now sought by collectors, were praised by Ruskin for their vigour and freshness.

Figuration libre. *Neo-Expressionism

Filarete Antonio (1400–69). Italian architect, sculptor and writer living in Milan. F. drew up vast schemes for palaces and ideal cities to be laid out according to elaborate astrological rules. His *Trattato d'architettura* (1460–4) was called by Vasari 'perhaps the most stupid book that was ever written'. He did, however, design the Ospedale Maggiore, Milan (1457) – intended as a mere fragment of an enormous edifice, never built – which shows a mixture of Gothic and Renaissance motifs, and his writings had an influence on the centrally planned church.

Fildes Sir Luke (1843–1927). British painter and book ill., e.g. of Dickens' *Edwin Drood*. He made his name with *Applicants for Admission to a Casualty Ward* (1874); similar compassionately realistic documentaries followed but F.'s social success rested on his portraits.

Filonov Pavel (1883–1941). Russian painter and graphic artist with a very individual style and

vision in some ways reminiscent of Klee and the Surrealists. He was associated with the Russian *Futurist movement from the outset and designed the scenery for Mayakovsky's 1st play; F. also ill. a number of booklets of Futurist poetry. In 1925 he founded a school of analytical painting in Leningrad, dissolved in 1928, like all such private institutions in the U.S.S.R.

fin de siècle (Fr. end of century). Used adjectivally of works, styles, etc. (particularly those of the late 19th-c. decadence) having some or all of the supposed characteristics of 'the end of an era' – elaborateness, artificiality, weariness, perversity.

fine manner. One of 2 classifications used by scholars of Florentine engravings of the 2nd half of the 15th c.; the engravings are classified according to whether the line is generally fine (fine manner) or bold (broad manner).

Finlay Ian Hamilton (1925—). British artist, poet and writer who has been making concrete poetry since 1963 consisting of words often made in three-dimensional materials and placed in landscapes and seascapes. Since 1967 F. has been creating Stonypath, a garden in Scotland.

Finson or Finsonius, Ludovicus (Louis) (d. 1617). Netherlands painter of portraits and religious subjects. He visited Italy, where he worked under Caravaggio, and later painted a number of altarpieces in Provence. His style combined elements from Caravaggio with Mannerism, and influenced Provençal artists.

Fischl Eric (1948–). U.S. Neo-figurative painter, who rose to great international prominence in the late 1970s. Depicted U.S. suburbia in large-scale narratives of leisure, voyeurism and sexuality, often charged with hidden violence, e.g. *Bad Boy* (1981) and *Digging Children* (1982).

Flanagan Barry (1941—). British sculptor who has emerged since the 1960s as one of the most interesting, original and distinguished contemporary sculptors. He studied at St Martin's School of Art 1964—6, at the time when *Caro and *King were teaching there. Initially F. made abstract work with a variety of materials — cloth, rope, sand, polystyrene, light and glass — some of which were *Environmental installations. F. also made films, drawings, etchings and furniture. From the 1970s he started working in metals, stone, clay and marble: his 'anarchic wit' became even more pronounced in this work; he also began making discreet references to

traditional carving and modelling in mysterious, fossil-like sculptures, or references to prehistoric and Celtic iconography. In the late 1970s and early 1980s F. finally turned to explicit but idiosyncratic figurative sculpture often cast in bronze, of hares, helmets and horses.

Flannagan John Bernard (1895–1942). U.S. sculptor and painter. His figures have a rough unfinished texture and are usually of animal subjects. Later works included bronze castings, drawings and watercolours.

Flatman Thomas (1637–88). British poet and gifted painter of miniatures, the best being that of Charles II and 2 self-portraits. F.'s poetry was esteemed by his contemporaries; his *A Thought of Death* influencing Pope's *The Dying Christian to his Soul*.

Flavin Dan (1933–96). U.S. *Minimal light (neon) artist. He used white and coloured fluorescent light fittings arranged sometimes vertically on walls, in free-standing 'barrier structures', and across corners to dissolve and re-modulate space, while always enveloping the spectator and forcing him to redefine his relationship to the enclosing space.

Flaxman John (1755–1826). British Neoclassical sculptor and draughtsman who began his career as a designer of cameos and classical friezes for Josiah Wedgwood. Working in Rome (1787–94) he won a European reputation with his famous line drawings illustrating Homer, Dante and the tragedies of Aeschylus. F.'s largest sculptural commission was the memorial to Lord Mansfield, but he did many other portrait busts, bas-reliefs and monumental groups of great technical accomplishment. F. was a friend of *Blake.

Flegel Georg (1563–1638). German painter, 1st of landscapes, later of prosaic still-life subjects in subdued tones. He was influenced by Flemish painting.

Fleischmann Adolf Richard (1902–90). German abstract painter. He was 1st interested in Expressionism and Cubism but in the late 1930s turned to pure abstraction.

Flinck Govert (1615–60). German portrait and subject painter who settled in Amsterdam. He was a pupil of Rembrandt and until the early 1640s a close imitator of his master; later he followed the more fashionable style of B. van der Helst. F. painted a portrait of Rembrandt in 1639.

Flaxman Memorial to Lord Mansfield, 1801

Flint Sir William Russell (1880–1969). British society watercolourist, known for his Spanish gypsy subjects.

Florence, school of. The history of modern European painting is dated from the work of the Florentine artist Giotto (d. 1337) but the great period of Florence as a centre of the arts was the 15th and 16th cs. In the work of such painters as Fra Angelico, Botticelli, Leonardo da Vinci, Michelangelo and Raphael the school reached its apogee. The Florentine preoccupation with form and line may be contrasted with the later Venetian emphasis on colour.

Floris Cornelis (Cornelis de Vriendt) (1514–75). Flemish architect and sculptor who exercised an important influence on the development of Renaissance architecture in the Netherlands. After travelling in Italy he publ. an influential book of engravings of florid adaptations of Roman grotesque ornamentation. His masterpiece, Antwerp town hall (begun 1561), combined Flemish gable and Italian Renaissance palace facade, and set a new style of public building.

Floris

Floris Frans (Frans de Vriendt) (1516–70). Flemish painter, the brother of C.F.; he worked in Antwerp. He visited Italy (c. 1542–6) and was an influential exponent of Italian Mannerism in the Netherlands.

Fluxus. Name taken by an international art movement founded in 1962 to unite members of the extreme *avant-garde* in Europe and later in the U.S.A. The group had no stylistic identity, but its activities were in many respects a revival of the spirit of *Dada.

Fontainebleau France. A royal palace of Francis I begun in 1528 and added to for the next 200 years. The Cour du Cheval Blanc and Cour d'Honneur (including the Porte Dorée) are by G. Lebreton. The Galerie François I (1533–40) introduces the so-called 'F. style' of interior decoration, a combination of sculpture, metalwork, painting, stucco and woodwork. It was evolved by the Italian artists Niccolò dell' Abbate, Primaticcio and Rosso, who worked for Francis I from c. 1530 to c. 1560. This 1st School of Fontainebleau introduced Mannerism to France. A decorative revival under Henry IV, known as the '2nd school of F.', was less important.

Fontana Lavinia (1522–1614). Bolognese painter of portraits and, less successfully, of religious subjects; daughter of the Mannerist painter Prospero F. (1512–97), a pupil of Vasari. She settled in Rome, where her portraiture became fashionable among the leading families.

Fontana Lucio (1899–1968). Argentineborn Italian artist. Associated (1930s) with *Abstraction-Création he launched *spazialismo* with his 'White manifesto' (1946). It combined *Dada with *Concrete art principles and deeply influenced younger Italian artists. F. worked in sculpture – e.g. neon light structure (1952) – pottery and painting, slashing canvases and crevassing clay and metal in later works.

Foppa Vincenzo (c. 1427–1515/16). Italian painter, the leading artist of the Milanese school before Leonardo da Vinci visited Milan. He was probably trained by the Paduans and was influenced both by Mantegna and the Bellini. Among his works are *The Adoration of the Kings, St Francis Receiving the Stigmata* and a Madonna and Child.

Forain Jean-Louis (1852–1931). French painter, caricaturist and graphic artist. F. contributed ills of Parisian life to journals for many years. He chose similar subjects to Degas and Toulouse-

Lautrec, but his wit is more sardonic and often at the expense of his models. Later he concentrated on oil painting, e.g. *The Court of Justice*.

foreshortening. In painting and drawing perspective applied to single objects or figures to create the illusion of projection and depth. F. is 1st found in Greek vase painting (c. 500 BC) but was not developed until the Renaissance, e.g. *Dead Christ* by Mantegna; it was fully exploited during the Baroque period, e.g. *sotto in sù* illusionism.

form. Term used in the arts for (1) an accepted framework of expression, e.g. the sonnet f. in literature and sonata f. in music; and (2) the structural qualities of a work, e.g. the harmonious proportioning of the various parts and their arrangement in order to create tension and bring about climaxes.

Fortuny y Carbo Mariano (1838–74). Spanish painter of history and genre. F. first attracted notice with his paintings of the Moroccan campaigns of General Prim, e.g. *Battle of Wad-ras*. Later he worked in Rome on large canvases, rich in incident and detail, which sold for record prices, e.g. *The Spanish Marriage*.

Foster Myles Birket (1825–99). British painter and book ill., e.g. of Longfellow. He produced a very large number of extremely popular drawings and watercolours (and, for a period, oil paintings), almost always of rustic life.

found object (Fr. *objet trouvé*). The *Surrealists held that any object could become a work of art if chosen by an artist. *Duchamp exhibited a bottle-rack as a sculptural object, but f.o.s are more commonly natural forms such as shells, tree roots and pebbles, altered or added to by the artist ('objets trouvés assistés). *readymade.

Fouquet Jean (c. 1425–c. 1480). French painter. F. was born in Tours and probably trained in Paris. He travelled in Italy and brought many of the achievements of Italian painting back to France on his return to Tours in 1448. F. was painter to the French kings and probably the major French artist of the 15th c. Only the miniatures in a copy of the Antiquités judaïques are documented, but other attributed works include: the Melun Diptych, the portraits Charles VII and Jouvenel des Ursins and the monumental Pietà.

Fragonard Jean-Honoré (1732–1806). French Rococo painter who studied under *Chardin,

Fragonard The Swing 1767

Boucher and Van Loo, then in Italy. There he was influenced by the painting of Tiepolo and Murillo. A large historical painting won him immediate fame, but he abandoned the grand manner to paint the familiar lovers in gardens, e.g. *The Swing*, and the incidents of clandestine love-affairs, e.g. *The Stolen Kiss*. Some of his finest works are the rapid drawings he made with pencil, sepia and *bistre wash, or red chalk, 2 examples of these are *The Bed* and *Villa d'Este*.

Francesco di Giorgio Martini (1439–1501/2). Sienese painter, sculptor, architect and engineer. There are a few paintings by F. but after 1477 he devoted himself to other work. This included a great chain of fortifications for the duke of Urbino, the church of S. Maria delle Grazie al Calcinaio at Cortona, a series of bronze reliefs, most famous of which is the *Deposition* in S. Maria del Carmine, Venice, and four bronze *Angels* for Siena cathedral. He also wrote a technical treatise on architecture, *Trattato d'architettura* (publ. 1841).

Francia Francesco (Francesco Raibolini) (ε. 1450–1517/18). Bolognese goldsmith and from 1486 painter in an eclectic style derived mainly from Perugino and L. Costa; until 1507 he worked in partnership with the latter. An altarpiece *The Virgin with St Anne* with a *Pietà* in the lunette is probably his best-known painting.

Franciabigio Francesco di Cristofano called (c. 1482–1525). Florentine painter influenced by Andrea del Sarto, with whom he collaborated on frescoes in the church of the Annunziata, Florence, and elsewhere, and by Raphael, to whom his *Madonna del Pozzo* was once attributed. F.'s portraits, e.g. *Knight of Rhodes*, are his most distinctive works.

Francis Sam (1923–94). U.S. *Tachiste painter who settled in Paris in 1950. His interest in painting began when he was in hospital, wounded in World War II; he produced his 1st abstract work in 1947, influenced by late work of Monet and oriental, especially Japanese art. His work is lyrical and has delicate sense of colour and feeling for paint. He has also done murals for the K.-halle, Basel (1956–8) and the Sofu School of Flower Arrangement, Tokyo (1957).

Francken (Franck) a family of Flemish painters extending from Nicholas F. (c. 1525–96) to Constantinus F. (1661–1717). Probably the most talented was Frans F. the Younger (1581–1642) who painted altarpieces and small, somewhat crowded scenes with a Mannerist emphasis on lighting and eccentric detail, e.g. *The Jews Having Crossed the Red Sea*.

Frankenthaler Helen (1928—). U.S. *Abstract Expressionist painter. *Pollock was a major early influence. In the early 1950s F. evolved an individual style of lyrical abstraction, using washes and stains of thin pigments on unprepared canvas to produce diaphanous textures merging with it. *Mountains and Sea* (1952) influenced the 'stain' paintings of *Louis and *Noland. Later works in stronger colours and forms include *Flood* (1967), synthetic polymer paint on canvas.

Freilicher Jane (1924–). U.S. representational, realist painter prominent for her landscapes, cityscapes, interiors and still-lifes – often combined. In her work she has developed her own highly personal idiom through absorbing *Post-Impressionist and *Abstract Expressionist influences. Eschewing art fashions, F.'s quiet and assured paintings, e.g. Parts of the World (1988) give 'unalloyed aesthetic pleasure'.

Fréminet Martin (1567–1619). French painter of the 2nd school of *Fontainebleau who spent about 15 years in Italy and was strongly affected by the Mannerism of the Chevalier d'Arpino. In 1603 Henry IV recalled him to

French

France, where his works included decorations for the Trinité chapel, Fontainebleau (begun 1608).

French Daniel Chester (1850–1931). U.S. sculptor; self-taught, he became with A. Saint Gaudens the principal academic sculptor of his age. F.'s most famous piece is the statue of *Lincoln* (1915) in the Lincoln Memorial, Washington, D.C.

fresco. Properly, the technique of wall painting on unset plaster. In true or *buon f.* layers of limeplaster are applied; while the final layer (*intonaco*) is still wet the painter applies his colours so that they become integrated with the wall. This technique, perfected in Renaissance Italy, produces very durable works in suitable climatic conditions; the most famous example is the ceiling of the Sistine Chapel by Michelangelo. In *f. secco*, painted on lime-plaster which has set, flaking tends to occur and the range of colours is restricted; but it produces light colours and delicate tones which made it a popular technique in the Rococo period.

Freud Lucian (1922—). Berlin-born British painter, grandson of Sigmund Freud. His earlier work until the late 1950s was painted with a hard, linear realism, consisting mostly of portraits, but also paintings showing a mysterious relationship between plants and human beings, which are Surrealist in character. His work since about 1952 is primarily portraits and nudes painted with extraordinary expressive subtlety. He is considered one of the few modern innovators in the representational tradition.

Freundlich Otto (1878–1943). German painter, sculptor and graphic artist living in Paris from 1909; he took part in abstractionist experiments. He exhibited with the *Cubists and the *Novembergruppe in Berlin and was a member of the Cercle et Carré at *Abstraction-Création groups.

Friedrich Caspar David (1774–1840). Leading German Romantic landscape painter and engraver who studied in Copenhagen (1794–8) and settled in Dresden. His characteristic subjects, depicted in a sharply delineated style, were Gothic ruins, stark contorted trees, bleak seascapes and mountain crags often seen under mysterious lighting effects and peopled with lonely figures, insignificant before nature. Wellknown examples are Abbey Graveyard under Snow, Capuchin Friar by the Sea and Wreck of the 'Hope'.

Friedrich Cross in the Mountains (detail) 1808

Friesz Othon (1879–1949). French *Post-Impressionist painter and designer, friend of R. Dufy and Matisse and for a time a member of the Fauves.

Frink Elizabeth (1930–93). British sculptor of monumental archaic figures, horses and other animals, associated in the 1960s with British sculptors, such as *Chadwick and *Butler. Her work was hugely popular, esp. in Britain, largely because of its conventionality.

Frith William Powell (1819–1909). British painter of anecdotal subjects, so popular when 1st exhibited at the R.A. that they required special railings for protection; best known is *Derby Day* (1858). Although possessed of formidable technical skill he sacrificed the overall effect of his pictures to various independent incidents and human 'types'.

Fritsch Katharina (1956—). German artist who came to prominence in the 1980s. Her artefacts, often in series, and *installations look readymade, as if industrially manufactured, although their original impulses are highly personal and have been described as 'prototypes of massproduced goods' bringing into question the difference between original and copy. F.'s Installation *Tischgesellschaft* (1988) is a long table down the length of which, facing each other, black-and-white polyester casts of the same man are repeated at measured intervals.

Froben Johann (1460–1527). German painter and publ. who as the successor to J. Amerbach (d. 1513) at the Amerbach Press, Basel, played a major part in German humanism. His books were fine works of art and, in conjunction with Erasmus, editorial adviser to the firm, important contributions to the new scholarship. F.'s publs incuded an ed. of St Jerome and Erasmus's ed. of the Greek New Testament (1516).

Froment Nicholas (15th c.). Provençal painter who worked in Italy and at the court of René of Anjou. There are 2 documented works, both triptychs but stylistically far apart – the awkwardly realistic Raising of Lazarus (1461) and the symbolical and more accomplished Burning Bush (1475/6).

Fromentin Eugène (1820–76). French 'oriental' painter who followed P. Marilhat and Delacroix. He is, however, remembered for his discerning criticism of Dutch and Flemish painting, Les Maîtres d'autrefois (1876; The Masters of Past Time, 1913). He also wrote a nostalgic autobiographical novel, Dominique (1862; 1932), and 2 books describing N. Africa.

Fronte nuovo delle arte. Movement in Italian art founded after World War II by painters and sculptors who recognized the need for Italian artists to free themselves from tradition and come to terms with modern movements elsewhere in Europe. The group (originally the Nuova Secessione Artistica) broke up after exhibiting in Milan (1947) and at the Venice Biennale (1948) because of the disparate opinions of its members, who included both Realists and Abstractionists.

Frost Terry (1915—). British painter working mainly in oils and watercolours. He studied in St Ives and London, where his work received lasting influences from his contact with *Pasmore.

frottage. Transferring a relief design on to paper by placing the paper over the design and rubbing the paper with charcoal or crayon, etc. Brass rubbings are taken in this way, but the technique received its French name when it was introduced into painting by M. *Ernst.

Frueauf the Elder, Rueland (1440/50–1507). German painter of altarpieces in a severe Gothic style. He worked in Salzburg and Passau. His son Rueland the Younger was also a painter, of the *Danube school.

Fry Roger Eliot (1866–1934). British painter and critic, originally an expert on the masters of the Italian Renaissance but after seeing work by Cézanne in 1906 a powerful propagandist for art of the period and organizer (1910) of the 1st exhibition of Post-Impressionist paintings in Britain. In insisting that this revolutionary art be assessed on colour and form alone he followed in the tradition of late 19th–c. aestheticism. His articles and lectures were collected in *Vision and Design* (1920) and *Transformations* (1926). *Omega Workshops.

Füger Friedrich Heinrich (1751–1818). German portrait painter, often in miniature. From 1776 to 1783 he lived in Italy, then settled in Vienna. His style was influenced by late Baroque and English portraiture given subtlety by the use of *sfumato* effects.

Fujiwara. Alternative name for the later *Heian period of Japanese history (late 9th-late 12th c.). It was dominated politically by the F. clan and culturally by the exquisite courtly arts of the capital, Heian-kyo. Esoteric religious sects (Early Heian) lost ground to the more accessible Amida Buddhism. Painting portraved the divinity surrounded by Bodhisattyas in brilliant colours and harmonized tones. From the exclusively Chinese style, kara-e, the court Painting Academy (founded 886) developed to a Japanese style, yamato-e. Its chief themes were popular life, e.g. the satirical 12th-c. Animal Scrolls and ills for courtly poems and novels, notably a 12th-c. series for Murasaki's Tale of Genii. The heavy style of Early Heian wood sculpture yielded to a gentle dignity and sinuous line, e.g. the masterly Amida by Jocho (d. 1057). His school developed the yosekitsukuri technique, assembling a statue from separately carved blocks to form a thin outer shell and hollow space inside. Later 12th-c. sculptures, generally polychromed, developed more life-like realism.

Fuller Isaac (d. 1672). British painter of murals and portraits. He studied under F. Perrier in France and worked in Oxford and London, leading an increasingly dissolute life. His decorative works are now lost but his portraits, particularly the raffish *Self-portrait* (1670), have great dash and bravura.

Funk art. Term used to describe (usually) U.S. art which makes use of unlikely materials and combines painting and sculpture, sometimes in *Environmental art pieces, e.g. *Kienholz.

Fuseli The Death of Oedipus 1784

Furini Francesco (c. 1600–46). Florentine painter of biblical and mythological subjects heavy with female nudes, and of single half-length nudes in oppressive bluish tones with strong *sfumato*. In the 1630s he became a priest and devoted himself to religious works in the manner of G. Reni.

Furniss Harry (1845–1925). Anglo-Irish caricaturist, ill. and writer. He settled in London (1873) and drew for various illustrated magazines. He ill. the complete works of Dickens (1910) and Thackeray (1911).

Fuseli Henry (1741–1825). Swiss-born painter, engraver, draughtsman of great power and penetrating art critic, associated with the English school. After studying art in Berlin and Rome, where he copied Michelangelo, F. settled in London. *The Nightmare*, based on a painting by Reynolds won him early fame and his eccentric style, combining Italian Mannerism with German elements, had both a vogue and an influence in Britain; as professor of painting at the R.A. he taught many leading early 19th-c. British artists. He made the celebrated remark that his friend Blake was 'good to steal from'.

Futurism. Italian artistic and literary movement. The 1st Futurist Manifesto was publ. in *Le Figaro*, in 1909 by the poet and dramatist Marinetti. In 1910 3 manifestoes were publ. including the painters' 'Technical Manifesto'. F.

celebrated the machine (proclaiming the racingcar more beautiful than the Victory of Samothrace). rejected the art of the past and advocated the destruction of museums. F. paintings represented figures and objects in motion; poetry employed 'industrial' imagery and a grammar and vocabulary deliberately distorted in the interests of onomatopoeia. Artists concerned included *Boccioni, *Carlo, *Carrà, *Russolo and *Balla; writers, Soffici and Papini; architects, Sant'Elia. Cinema was acclaimed as an ideal means of expression but a Futurist cinema as such never developed, despite its influence on the early Soviet films of Dziga-Vertov, Eisenstein and Kozintsey, After World War I F. became associated with Fascism. It had several off-shoots, e.g. R. Delaunay's simultanéisme, which was also related to Cubism. More specifically a marriage of these 2 movements was Russian Cubo-futurism, represented in, e.g. Malevich's painting and the poems of Khlebnikov, Mayakovsky and Pasternak. It also influenced such painters as M. Duchamp and F. Léger.

Fyt Jan (1611–61). Flemish painter of still-life, especially trophies of the hunt, and a few outstanding flower paintings. Trained by F. Snyders, he probably painted some of the animals in paintings by Jordaens and Rubens. Typical of his rich colour and technical brilliance is Still-life with Pageboy and Parrot.

G

Gabo Naum (né Pevsner) (1890–1977). Painter of Russian origin trained as an engineer in Munich before turning to the creation of abstract constructions. The first of these was *Bust* (1915), a Cubist-influenced work executed in planes of wood. In 1917 he returned to Russia with his elder brother, the painter *Pevsner, and settled in Moscow, becoming associated with the local *avant-garde* led by *Malevich and *Tatlin. In 1920 the Pevsners issued their 'Realist Manifesto', which declared against the functionalism of Tatlin and *Rodchenko's *Constructivism; a year later they left Russia, finding the artistic climate unsympathetic, for Berlin. G. continued to develop his ideas in

constructions made of glass, plastics and metals, after Berlin, in Paris, then Britain and, from 1939, in the U.S.A. Later works included an 80 ft (24.4 m.) sculpture for the Bykenkorf Building, Rotterdam (1957). Among his publs is Of Divers Arts (1962).

Gaddi. A family of Italian artists who sustained the style of Giotto for 2 generations in Florence. Taddeo G. (d. 1366) was probably an assistant to Giotto. His own best-known work is the fresco cycle *Life of the Virgin*. His sons, Agnolo and Giovanni, were working in the Vatican in 1369. Agnolo painted the fresco cycles *The True Cross* and *Life of the Virgin* as well as a number of panels, e.g. *Coronation of the Virgin*.

Gainsborough Thomas (1727–88). British painter of landscape and portraits. Born at Sudbury, Suffolk, G. was trained in London. His early style was formed by a study of the figures in Watteau and other French Rococo painters while working for the engraver Gravelot, combined with the influence of the Dutch masters of landscape, especially J. van Ruisdael and J. Wynants.

G. returned to Suffolk and painted some of his finest work (c. 1750–9), including the combination of a double portrait and a landscape, Mr and Mrs Andrews, and the large landscape Cornard Wood (or Gainsborough's Forest). In 1759 G. was astute enough to move to Bath, where he soon came to the notice of the fashionable world. When his reputation spread to London he moved there in 1774. In a few years he disputed with Reynolds the enormous profit and prestige of being the leading portrait painter in Britain and even in Europe. Though a founder-member of the R.A., G. later withdrew and exhibited his

Gabo Linear Construction c. 1920-1

paintings in his own home, Schomberg House, Pall Mall. His success continued to his death and his rival, Reynolds, did much to confirm his fame. In his later portraits G. borrowed from Van Dyck, e.g. *The Blue Boy*. He was most successful in painting women of obvious spirit and animation, e.g. *Countess Howe*, such sympathetic studies as the newly married couple in *The Morning Walk*, and the delightfully informal sketches of his 2 daughters.

G. preferred to paint idealized landscapes and what Reynolds called his 'fancy pictures'. His strange lighting was his own, but Rubens was an

Gainsborough Mr and Mrs Andrews c. 1750

Galgario

Gaudier-Brzeska Birds Erect 1914

influence on his later work. The feathery brushwork, lyrical style and rich sense of colour can be seen in many galleries. A masterpiece is *The Harvest Wagon. Two Shepherd Boys with Dogs Fighting* is a good example of the 'fancy pictures' and shows the late influence of Murillo. Many of G.'s oil sketches and drawings are of an unusually high quality: *Housemaid*, and *Mrs Gainsborough Going to Church*.

G. had a lasting influence on British painting, but his only direct follower was his nephew, Gainsborough Dupont (c. 1754–97), who worked in his studio, completed many of his late portraits and was a skilful imitator of his style.

Galgario Fra Vittore del (Giuseppe Ghislandi) (1655–1743). One of the most important Italian portrait painters of the late Baroque period. After studying in Venice under S. Bombelli he worked mainly in Bergamo. His paintings combine the richness of Venetian colouring with a directness derived from G. Moroni.

Gallego Fernando (fl. 1466–1507). Spanish painter who worked in and around Salamanca. His style, especially reminiscent of R. van der

Weyden, and his use of oils, show him to have been under the Flemish influence strong in Spanish art at the time. There are altarpieces by G. in Zamora cathedral and the Prado.

Gallego Francisco (*fl.* late 15th c.). Spanish painter under Flemish influence, possibly father of Fernando G. The latter's work and his own are not easily distinguishable.

Gandhara. N.W. region of the Kushan empire on the Upper Indus, Pakistan, noted for its Greco-Buddhist sculpture of the early cs AD. Greek influence came from neighbouring Bactria. Buddha is shown as a young Apollonian type with eastern features; he has a straight nose, fleshy face, lengthened ear lobes and evenly waved hair gathered in a top knot. The G. style spread E. to China (The *Six Dynasties).

Garofalo, II. Benvenuto Tisi (1481–1559). Ferrarese painter of religious and mythological subjects, the last representative of the school of Ferrara. In Ferrara he studied under B. Boccaccino and worked with Dosso Dossi; in Rome he met Raphael. The successive influence of these artists is apparent in his work, much of which is in Ferrara

Gaudier-Brzeska Henri (1891-1915). Sculptor and draughtsman; born in France but associated with the English school. Although only 23 when killed in action, G.-B. had already achieved an astonishing maturity as an artist. From 1911 he lived in Britain, working by day as a clerk, encouraged by his companion Sophia Brzeska (whose name he adopted), and a few sympathetic patrons. In 1913 he identified himself briefly with the *Vorticists. Such works as The Dancer, Horace Brodzsky and Birds Erect explore the potentialities of modern sculpture, representational, Cubist and abstract; while G.-B.'s drawings, especially the superb outline drawings of nudes, birds and animals, are now highly valued.

Gauguin Paul (1848–1903). French painter, sculptor and graphic artist. With Van Gogh and *Bernard, G. was the creator of a new conception of painting, and his work was a formative influence on 20th-c. art. Like Van Gogh's, his life has become almost a modern legend. Born in Paris but brought up chiefly in Peru, he served 1st in the French merchant marine, then became a successful stockbroker in Paris, painting in his spare time. He exhibited with the Impressionists (1880–6), and the 1st evidence of great original

Gauguin Nevermore 1897

talent was Study of the Nude (1880). In 1883 he gave up his job to paint full-time with disastrous financial consequences. After an attempt to support his family in Denmark, he left them, dividing his time between painting in Brittany and a number of jobs, such as bill-sticking in Paris and working as a navvy on the Panama Canal. At Pont-Aven, Brittany, in 1888 he met Bernard with whom he evolved a muchsimplified, non-naturalistic style of painting with emphasis on decorative line and the use of flat bright colour. Based on many models (ills in children's books and Japanese colour prints among them), the new style was called 'Synthetism'. A masterpiece of the period is Jacob Wrestling with the Angel. Late in 1888 came the disastrous visit to Van *Gogh at Arles. In 1889-90 he was painting at Pont-Aven and Le Pouldu, Brittany. In 1891 he left Europe for Tahiti. The remainder of his life was spent in the South Seas, except for an unsuccessful attempt to sell his paintings in France (1893–5). When G. died in poverty at Atuana, Marquesas Islands, he left behind not only many paintings, including The White Horse, Mango Blossoms, Where Do We Come From ... and Nevermore, but also carvings, woodcuts, watercolours, lithographs and ceramics; while his writings, chiefly journals and letters, are also of interest. The most important of these are Noa-Noa and Avant et après.

Gaulli Giovanni Battista *Baciccia

Gavarni Paul. Pseud. of Sulpice-Guillaume Chevalier (1804–66). One of the leading French graphic artists of the 19th c., satirist, ill., also wood engraver and lithographer. His contributions to *Le Charivari* and other papers illustrated the absurdity of the human comedy with elegance and good humour. His visits to London (1847, 1849 52) opened his eyes to vice and poverty, and an increasing bitterness and disillusionment appeared in his work. *Masques et visages* (1852), which includes the series *Les Propos de Thomas Vireloque*, is typical of this period. His own apt captions give additional point to his drawings.

Geddes Andrew (1783–1844). Scottish portrait painter and etcher, friend of *Wilkie. His best-known painting, which shows the strong influence of Rembrandt on his work, is his portrait of his mother, of which he also made an etching.

G(h)eeraerts the Elder, Marcus (1510?–90?). Flemish painter of historical and religious subjects who came to Britain with his son in 1568.

G(h)eeraerts the Younger, Marcus (1561–1635). Flemish portrait painter who settled in Britain; son of the above. Paintings in a variety of styles are attributed to him; probably he collaborated with the other Flemish artists in Britain, J. de Critz and I. Oliver, in producing the costume portraits of the late Elizabethan and Jacobean periods.

Geertgen tot Sint Jans (c. 1465–c. 1495). Early Netherlandish painter. Born in Leyden and a pupil of Van *Ouwater, G. is poorly documented. 2 works, Lamentation Over the Dead Christ and Julian the Apostate Orders the Bones of

Gentile Adoration of the Magi 1423

St John the Baptist to be Burnt, are almost certainly his and his curiously effective, if naïve, style and smooth egg-shaped heads (probably influenced by wood carving) have been traced in a number of works including the harrowing Man of Sorrows and the Nativity, a small brilliantly lit night scene of mystical intensity.

Gelder Aert de (1645–1727). Dutch painter of biblical subjects and portraits, a pupil of S. van Hoogstraten and in the 1660s of Rembrandt, whose style he followed closely. His work was unfashionable during his lifetime but was later sought after when thought to be by Rembrandt.

Gelée Claude. *Claude Lorraine

Genga Girolamo (c. 1476–c. 1551). Italian painter and architect who worked mainly for the court at Urbino. He studied under Signorelli and assisted him on the frescoes in Orvieto cathedral. He softened his style under the influence of Perugino and Raphael and later came close to Mannerism. He designed the church of S. Giovanni Battista, Pesaro (1543).

genre (Fr. type, kind). The painting of the life of ordinary people, first found as an independent subject of paintings in Dutch 17th-c. art. Religious art and paintings of ceremonial occasions are not g. although details in such works may be so called. G. paintings are more common in N. European art than in Italy; they were

frequent in the 19th c. but the term is not used for pictures telling a story or with identifiable persons.

Gentile da Fabriano (c. 1370–1427). Italian painter working in Florence; there his refined decorative sense acted as a counterbalance to the pursuit of representation. G.'s 2 great paintings are *Adoration of the Magi*, a masterpiece of the International Gothic school, and the exquisite *Flight into Egypt*; other works include the early *Madonna and Child.*

Gentileschi Artemisia (1593–1651). Italian painter, daughter of O.G. She worked mainly in Naples in a strongly Caravaggesque style.

Gentileschi Orazio (1563–1647?). Italian Caravaggesque painter; from 1576 in Rome and from 1626 court painter to Charles I of England. His painting was emotionally gentler and his palette eventually lighter than Caravaggio's, though the latter's naturalism remained the major influence on G.'s work.

Gérard François, baron (1770–1837). French Neoclassical painter of portraits and historical subjects, painter to both Napoleon and Louis XVIII. He was a pupil of J.-L. *David but softened and sweetened his master's style so that he stands closer to J.-B. Regnault. Portraits such as *Jean-Baptiste Isabey and his Daughter* and *Madame Récamier* are superficial but charming.

Artemisia Gentileschi Susanna and the Elders 1610

Orazio Gentileschi Lutenist c. 1626

Gerhaert Nicolaus (d. 1473). German Gothic sculptor in a markedly naturalistic style. He worked in Baden-Baden, Constance, Strassburg, Trier, Vienna and Wiener Neustadt. Works attributed to him include the tomb of Archbishop Jacob von Sierck, *Crucifixion* and the tomb of the Emperor Frederick III.

Géricault Théodore (1791-1824). French painter, graphic artist and sculptor of great promise and originality who strongly influenced his close friend *Delacroix and French 19th-c. painting as a whole. G. was the pupil of the fashionable painters *Vernet and *Guérin; he studied at the Louvre, visited Italy and later Britain, but the example of *Legros, painter of contemporary subject matter, decided the course of his development. His restlessness, excitement and disappointments found expression in his turbulent paintings and often morbid subject matter. His most famous composition The Raft of the 'Medusa' (1819) was based on the experiences of survivors from an actual shipwreck and is painted with a compelling realism based on the study of corpses and sickness. The painting was intended to shock, and to protest; inevitably it caused a scandal. G. became a leader of French Romantic painting. His interest in racing and riding is obvious from his paintings and lithographs of horses, where animal life achieves a symbolic power. In these paintings he was influenced by the popular British sporting print and by the British painter J. Ward. His portraits of the insane, e.g. The Mad Woman (1822-3), are extraordinary documents revealing G.'s psychology and insight.

Gérard Madame Récamier 1805

Géricault The Mad Woman 1822-3

Germ, The. The magazine of the *Pre-Raphaelites. Its ed. was W. M. Rossetti and included contributions in prose and verse from D. G. Rossetti and other members of the 'brotherhood'. Only 4 numbers were issued between January and April 1851.

Gerolamo dai Libri (c. 1474–1555). Veronese painter. The development of his style owed most to Mantegna but also something to Moroni and other Veronese painters. His works include *Madonna and Child with St Anne* and *St Anne with Virgin and Saints*.

Gérôme Jean-Léon (1824–1904). Facile French academic painter and sculptor, pupil of *David and an exponent of a prettified Davidian classicism. In some of his work he followed the vogue for oriental subjects.

Gertler Mark (1891–1939). British-Jewish painter, an early member of the *London Group (1915). His best works depict life in London E. End Jewish communities. Other pictures include nudes and still-lifes, some influenced by *Post-Impressionism.

gesso. A form of plaster used as a ground for modelling or painting; it has a brilliantly white, smooth-textured surface. Frequently used on furniture in low relief, and gilded.

Gestural painting. A general term for the work of leading U.S. *Abstract Expressionists,

and also that of European artists working in the same vein: the marks on the canvas are considered to be the record of the artist's characteristic physical gestures and therefore express not only his emotions at the time when the painting was made, but also his whole personality. *calligraphic painting.

Ghiberti Lorenzo (c. 1378-1455). Italian sculptor, goldsmith, architect and writer on art of the Florentine school. Trained as a goldsmith, G. won the commission for the making of a pair of bronze doors for the Baptistery, Florence, in 1402, when he was about 24. His winning panel, Sacrifice of Isaac, can be compared with that of his older competitor, Brunelleschi, at the Bargello, Florence. Most of G.'s life was spent making the 28 panels for these doors (1404-24) and those of the even more celebrated Gates of Paradise, a 2nd pair also for the Baptistery (1430-47). His 3 large bronze figures for Or San Michele, Florence, St John the Baptist, St Matthew and St Stephen, were technically and artistically more ambitious than anything attempted before and won G. a wide reputation. To the famous baptismal font in Siena he contributed 2 panels in relief. The Baptist before Herod and Baptism of Christ. His large workshop was the training school of a whole generation of Florentine artists: Donatello, Michelozzo and Uccello were among his pupils. Despite this, every commission undertaken bears the unmistakable mark of his own very individual talent. Furthermore, G. was a leading citizen of Florence. He was also a humanist and scholar. the friend of such men as Leonardo Bruni. His own work shows study of the International

Gérôme The Cock Fight (detail) 1847

Gothic style, the masters of Sienese painting and classical bas-reliefs. His learning and taste are reflected again in his writings on art, the 3 books of his *Commentarii*. Traditionally, it was *Michelangelo who said that the 2nd pair of G.'s Baptistery doors were worthy to stand as the Gates of Paradise.

Ghirlandaio Domenico (1449-94). Italian painter of the Florentine school. Trained as a goldsmith by his father, G. later won a reputation chiefly as a fresco painter, creating a serene style which reflects the full development of Florentine painting before Leonardo da Vinci. His earliest known works are the frescoes above the Vespucci altar, Ognissanti, Florence. Later, for the same church, he painted St Jerome and a Last Supper warm with the mellow light of a Tuscan evening. In 1481-2 G. was in Rome painting 2 frescoes for the Sistine Chapel, the survivor of which, The Calling of the Apostles Peter and Andrew, shows G.'s habit of including portraits of people he knew among the witnesses to a religious scene. Again, in the frescoes of the Sassetti chapel (S. Trinità, Florence) he includes portraits of members of the Medici, Sassetti and Spini families. Other works by G. are Visitation, Birth of the Virgin and other frescoes, and Madonna and Saints. G.'s workshop assistants included his brother Davide (1452-1525). His son Ridolfo (1483-1561) was a minor Florentine painter. More important, Michelangelo was a pupil and learned from G. the technique of fresco painting.

Ghiberti Self-portrait on *The Gates of Paradise* 1430–47

Ghirlandaio Old Man and his Grandson

Ghislandi Giuseppe. Fra Vittore del *Galgario

Giacometti Alberto (1901–66). Swiss sculptor and painter; father Giovanni (1868–1933) and 2nd cousin Augusto (1877–1947) were painters. G. studied at the Geneva School of Arts and Crafts (1919) and under Bourdelle in Paris (1922–5) where (apart from the war years) he thereafter lived. G.'s early works, e.g. *Two figures* (1926), have an elemental, primitive force; later, more Surrealist constructions like

Giacometti Man Pointing

Giambologna

The Palace at 4 a.m. (1933) already have the attenuation which increasingly became the feature of the human figures he produced from c. 1940. The fraility of these strange, desolate matchstick-men (e.g. the group City Square, 1949) is emphasized by the heavy bases on which they are usually placed; the spatial relationships created, quite different from the monumental quality of traditional sculpture, have had great influence on contemporary work. G. painted a series of meticulously observed portraits, notably a 5-year study of Isabel Lambert and Portrait of Jean Genet (1955).

Giambologna. Giovanni da *Bologna

Giambono Michele Giovanni Bono called (fl. 1420–62). Venetian painter influenced by the International Gothic style of Gentile de Fabriano and Pisanello. His best-known authenticated work is his *Madonna* in the Palazzo Venezia, Rome.

Gibbons Grinling (1648–1721). British wood carver. He enjoyed royal patronage under Charles II and George I and also worked under Wren. G.'s ornamental carving is of exquisite finesse and delicacy; his preferred subjects were fruit, flowers, lace motifs, etc. Examples of his work are at Windsor, St Paul's, London, and many country-houses, most notably Petworth, where there is a magnificent room by him.

Gibson John (1790–1866). British Neoclassical sculptor who went to Rome in 1817 and settled there, only returning to Britain in 1844 and 1850 to execute royal commissions. He worked under *Canova and *Thorwaldsen and ranked next to them in importance. In later works he revived the Greek practice of tinting marble, as in his *Tinted Venus*.

Gifford Sanford R. (1823–80). U.S. painter primarily of landscapes, who was influenced by *Cole.

Gilbert Alfred (1854–1934). British sculptor whose work is a delightful amalgamation of his inventions and mastery of new techniques of bronze casting, showing great sensitivity to materials, colour and texture. He constantly reworked and re-interpreted images, figures, motifs and themes as in *Kiss of Victory* (1878–81), *Victory* (1887), *Eros* (1891–2) and *Icarus* (1884 and 1889).

Gilbert Sir John (1817–97). British draughtsman, ill. and painter known as 'the Scott of

painting' because of his choice and romantic treatment of historical and chivalric themes. He worked for *The Illustrated London News* (1842–72) and ill. an ed. of Shakespeare (1856–60).

Gilbert and George (Gilbert Proesch, Italian, b. 1943; George Passmore, British, b. 1942). In 1969 G. & G. created their first 'singing sculpture' while still students at St Martin's School of Art, London. Hands and faces painted gold and wearing staid business suits, they moved marionette-like on a table in a work that came to be known as Underneath the Arches, after the Flannagan and Allen song played on a cassette tape-recorder beneath the table. Refusing to separate life from art, their activities as living sculpture from their activities at home in the East End of London, G. & G. have achieved great international prominence working in various media as living sculpture, in large pastoral drawings, in small photographic pieces, books or genteel poems, and recently in their film, The World of Gilbert and George, and in many-panelled large, 14 x 36 ft (4 x 11 m.) polychrome tinted mono photographs. Their use of their own persons as art material suggests an affinity with artists such as *Manzoni or *Klein

gilding. The process by which another metal is covered with a thin layer of gold. Traditionally silver was the most common metal to be gilded, but base metals are also used extensively. The old method of g. was by a mercury distillation process, but in the 19th c. electrolysis provided a safer, cheaper though less efficient method.

Gill Eric (Rowland) (1882–1940). British sculptor, wood engraver and typographer. G. was deeply religious (he became a Catholic in 1913) and held views of the artist-craftsman and the social place of the arts similar to those of William Morris. G.'s simple yet strong line was best adapted to bas-relief, e.g. the Stations of the Cross in Westminster cathedral (1913–18), and its grandest and perhaps most lasting expression is in the chiselled elegance of his Perpetua and Gill Sans-serif type-faces. His writings include: Christianity and Art (1927) and Work and Property (1937).

Gilliam Sam (1933–). U.S. African-American *Color-field painter who came to prominence in the late 1960s and early '70s with stained, unsupported canvases draped or suspended

Giorgione Sleeping Venus c. 1508

from walls and ceilings. In the '70s he began making geometric collages influenced by the music of John Coltrane and Miles Davis. Later in the '80s G.'s painting technique changed from staining to an *impasto of layers of acrylic paint and gels, into which are cut geometric shapes reminiscent of African-American patchwork quilts; this phase led to series of textured paintings which also incorporate metal forms.

Gillot Claude (1673–1722). French decorative and genre painter and draughtsman of the Rococo period. He was director of costumes and decoration at the Paris Opéra and the 1st French painter to produce commedia dell'arte scenes. Watteau and Lancret were his pupils.

Gillray James (1757–1815). British engraver and caricaturist, best known for his cartoons of the Napoleonic Wars period. He exploited the same vein of satire as Hogarth, but was far more personal in his attack. Even at their most scurrilous, his drawings are composed with skill and wit, e.g. *A Voluptuary*, lampooning the greed of the Prince Regent.

Gilman Harold (1876–1919). British painter of portraits, interiors and landscapes, member of the *Camden Town Group and 1st president of the *London Group. He was originally associated with Sickert but later fell under the influence of the Post-Impressionists, e.g. *Mrs Mounter*.

Gilpin Sawrey (1733–1807). British painter of animals, particularly horses, sporting scenes and (less successfully) historical subjects. He was a considerable draughtsman and his horse paintings were ancestral to French Romantic painting.

Ginner Charles (1878–1952). French-born British painter. A founder-member of the *Camden Town Group (1911), he defined its style as Neo-realism. G. also admired Van Gogh and other *Post-Impressionists.

Giordano Luca (1632–1705). Neapolitan painter, pupil of Ribera and Pietro da Cortona and remarkable for his facility and eclecticism. He helped to change the character of Neapolitan art, previously dominated by Ribera, by introducing a Baroque style and lighter treatment. His prodigious output included the ballroom ceiling, Palazzo Riccardi, Florence (1682), and ceilings in the Escorial, Madrid (1692).

Giorgione, born Giorgio, or Zorzi, da Castelfranco (c. 1477–1510), Italian painter of the Venetian school. Despite his great influence on painting and a reputation which has lasted without fluctuating for 400 years, little is known of his life and few paintings are certainly by him. His master was Giovanni Bellini. In 1508 he was a colleague of Catena, in 1507–8 he was painting at the Doge's Palace, Venice.

Giotteschi

Girardon Apollo Tended by Nymphs begun 1666

In 1508 there was a dispute over the frescoes he was painting on the outside of the Fondaco dei Tedeschi, Venice. Titian was also engaged on this commission. Most authorities are agreed that G. was the more original genius of the 2 and that Titian bore G.'s influence for the rest of his life, but this cannot be proved on evidence – almost nothing remains of the frescoes.

Although G. painted commissions for churches such as the Castelfranco Madonna, it was the small paintings in oil he painted for private collectors which are G.'s great innovation in art. These are neither portraits, nor recognizable subjects from myth or history. Indeed, it is almost impossible to determine what is happening in The Tempest, though a profoundly evocative mood is created and, instead of resenting the fact that there is no obvious subject, the imagination is gratified by being freed. However quietly accomplished by G., this was a revolutionary new conception of what a painting should be. Such paintings found patrons; they were highly prized before G.'s early death (probably of plague), and works left unfinished in his studio were completed by other artists: Sleeping Venus by Titian and Three Philosophers by Sebastiano del Piombo. Other major works attributed include: Adoration of the Magi, Judith, Laura, Shepherd with Pipe and Fête champêtre.

Giotteschi. Name given to the followers of Giotto. They included Bernardo Daddi, Giottino, Maso di Banco and Taddeo Gaddi but many works in Giotto's style are anon.

Giottino. Florentine painter of the mid-14th c. A somewhat shadowy figure, probably a pupil of Giotto, perhaps identical with a Giotto di Maestro Stefano. The work generally attributed to him is the *S. Remigio Deposition*.

Giotto di Bondone (c. 1266-1337). Italian painter and architect. The significance of G.'s original vision of the natural world and his genius in communicating it were proclaimed by Boccaccio, Dante and Petrarch in the 14th c. and G. has been celebrated ever since as the true founder of Florentine painting and an initiator of Western art. The outline of his life can only be put forward tentatively. By tradition he was the pupil of Cimabue, working with his master both in Florence and Rome. Then or later he was undoubtedly in contact with the work of the Roman painter P. Cavallini and the sculptor Arnolfo di Cambio, which paralleled the break Cimabue had made with the conventions of Byzantine art in Italy. G.'s earliest work may have been connected with the mosaics of the Baptistery, Florence. He was almost certainly painting at Assisi by about 1290. In 1300 he was probably employed in Rome and soon after in Florence. The famous frescoes of the Arena, or

Scrovegni chapel, Padua, occupied him during the 1st decade of the 14th c. Either in 1300, or, more likely, in about 1313, G. designed the Navicella, 'Ship of the Church', mosaic in St Peter's, Rome. During the 2nd decade of the 14th c. he painted the Cappella di S. Maddalena at Assisi, the frescoes of S. Antonio and the Palazzo della Ragione, Padua, and works in Rimini. In the 3rd decade much of his time was spent in Florence, where among other undertakings he painted the frescoes of S. Croce. Subsequently he painted in both Naples and Milan, but in 1334 he was present to be nominated architect of Florence cathedral and the city fortifications. Later that year he began the Campanile, which still bears his name, but which was considerably altered from his plan.

G. consolidated the break others had made with Byzantine art, but his real achievements were those of a narrator of genius and a master draughtsman. The last enabled him to create the illusion of texture, weight, expression and, above all, depth in his paintings. Thus his scenes are visually convincing What is more, he was able to give expression to complex human emotions in a way that is both subtle and tellingly simple. G.'s influence, paramount for a generation after he died, later surrendered to others, only to be revived by artists, chiefly Florentine, who were interested in draughtsmanship as a means of expressing reality. Michelangelo admired and made copies of his work.

Of G.'s works, the frescoes attributed to him in the upper and lower churches, Assisi, have been frequently challenged. The St Francis cycle in the upper church is almost certainly his, though the later frescoes were probably painted to his design by assistants. Crucifixion, Lamentation and Joachim's Dream are among the most outstanding scenes depicted in the Scrovegni chapel, Padua. Among his panel pictures the most important is unquestionably the Ognissanti Madonna; while other works generally attributed to him are Crucifix and Dormition of the Virgin.

Giovanni da Bologna. *Bologna

Giovanni da Milano (fl. mid-14th c.). Italian painter, follower of Taddeo Gaddi. He worked in Florence and Rome. There are frescoes by him in the Rinuccini chapel, S. Croce, Florence.

Giovanni di Paolo or Giovanni dal Poggio (c. 1403–82/3). Italian painter of the Sienese school. G.'s paintings must have appeared old-

fashioned even in his own day, but his strong narrative sense makes strangely effective such imaginative and brightly coloured works as *A Paradise* and versions of scenes from the life of St John the Baptist.

Girardon François (1628–1715). French sculptor, famous exponent of classicism who worked for Louis XIV at Versailles. His most famous sculptures there are *Apollo Tended by Nymphs* (begun 1666; original grouping altered) in the grotto of Thetis, and *Rape of Persephone* (begun 1677) in the gardens. His other work includes the monument to Richelieu (1675–7).

Girodet de Roucy-Trioson, Anne-Louis (1767–1824). French painter, ill. and poet; pupil of David. His painting *The Burial of Atala* (1808), based on a novel by Chateaubriand, is a notable early expression of French Romanticism in theme and presentation although it retains the balanced composition and smooth technique of the classical school.

Girtin Thomas (1775–1802). British painter. Together with *Turner, G. revolutionized watercolour technique, chiefly by abandoning the use of underpainting for a much freer style in which colours were applied directly on to semi absorbent paper. G. travelled all over Britain painting and on a visit to Paris painted street scenes, etc. which show the variety and richness of the effects that could be achieved in the new technique. G. did much to raise British landscape painting in watercolour from topographical drawing to a fine art. Among his best paintings are Kirkstall Abbey and The White House.

Girodet The Burial of Atala 1808

Gislebertus

Giulio Romano Fresco in the Sala di Psiche (Palazzo del Tè, Mantua) 1527-31

Gislebertus. French sculptor who signed his name under the tympanum of Autun cathedral, Burgundy (1120–30), and was presumably the master in charge of the whole sculptural programme. The tympanum shows the Last Judgement, the capitals inside the church episodes from the life of Christ, allegories and parables. They are among the masterpieces of Romanesque art, ranging from horrific images of damnation and terror to the sensuous charm of the well-known *Eve.*

Giuliano da Maiano (1432–90). Florentine architect and sculptor; from 1477 master architect for Florence cathedral. His masterpiece was the cathedral at Faenza (completed 1486). He built the Fina chapel, Collegiata, S. Gimignano in collaboration with his brother Benedetto Da Maiano (1442–97), sculptor and architect of the Palazzo Strozzi, Florence.

Giulio Romano (Giulio Pippi) (1492 or 1499–1546). Italian Mannerist painter and architect, a pupil of Raphael, whom he assisted in the Vatican Stanze and Loggie. He continued Raphael's later style, but with harsher colours, greater distortions and more violent composition; he also did a famous series of pornographic engravings. In 1524 he went to Mantua in the service of the duke and turned mainly to architecture. There he built the Palazzo del Tè

(1526–34), his masterpiece and the prime example of Mannerist architecture: orthodox classical motifs are wilfully misused, rhythms irregular, keystones dropped, columns left rough as if from the quarry, etc. The impression of instability is epitomized in the Sala dei Giganti (also painted by G.R.), where the architecture of the room appears to be on the point of collapsing; the illusionistic frescoes *The Fall of the Titans* covering the whole room from floor to ceiling, showed a melodramatic exaggeration of Raphael's style.

Glackens William James (1870–1938). U.S. painter (in an Impressionist style influenced by Renoir) and also ill.; member of The *Eight.

Glarner Fritz (1899–1972). Swiss painter, the leading exponent of *Neo-plasticism in the U.S.A. where he settled in 1936.

Glasgow school. A term confusingly applied to two quite different groups of late 19th- and early 20th-c. Scottish painters: I. The group led by William Yorke Macgregor, and also including John Lavery and David Cameron, which was influenced by the more decorative aspects of French *Impressionism; 2. The group led by the architect C. R. Mackintosh which produced a distinctive Scottish version of *Art Nouveau.

glass print. *cliché-verre

Gleizes Albert (1881–1953). French painter; deeply impressed by a painting by Le Fauconnier, he abandoned his early Impressionist manner in 1910 and came in contact with other *Cubist painters. He was influenced by Léger and later by Gris, but paintings such as *Harvesters* (1912) reveal a limited conservative understanding of Cubism. He exhibited with the main Cubist group in 1911 and 1912 and his attempt to revive the group after the war suggests a need to belong to a corporate movement. Du cubisme (1912) by G. and Metzinger was an attempt to clarify its history and principles.

Gleyre (Marc) Gabriel-Charles (1808–74). Swiss history and genre painter who settled in Paris, took over the studio of Delaroche and is remembered for having taught there Bazille, Monet, Renoir, Sisley and Whistler among others. Though academic himself he acknowledged the talents of these younger artists.

glyptic. Term meaning 'carved', used in sculpture to describe the method of working in

which the form is carved directly from wood, stone, etc. instead of being built up in wax or clay prior to casting.

Gobelins. A firm of Paris tapestry weavers, transformed by Louis XIV and Colbert in 1662 into the Manufacture Royale des Meubles de la Couronne with the twofold aim of supplying the royal palaces with furnishings and building up a state manufacture of luxury articles to prevent the need for foreign imports. The presiding genius was Charles Le Brun the painter, who provided designs for all kinds of furnishings and controlled the factory in the greatest detail to ensure the highest standards of workmanship. Not only tapestries were produced, but also furniture, sculpture, works in gold and silver, carriages and architectural details. even door-locks.

Gober Robert (1954—). U.S. artist of simulated objects (sinks, urinals and baby cribs) and *installations. The objects recall *Minimal art, but in fact are always slightly altered everyday *readymades. The installations, like the objects, are redolent with deep poetic feeling and ambiguity of meaning, with dream-like 'narratives' which are also disturbing and threatening, e.g. Male and Female Genital Wallpaper, Wedding Gown and Hanging Man/Sleeping Man (all 1989). G.'s major untitled Installation was displayed at the Dia Center for the Arts, N.Y., in 1992.

Gober Untitled 1991

Goes Portinari triptych (right wing) 1475

Goeneutte Norbert (1854–94). French painter, engraver and lithographer; friend of Manet and Renoir. He specialized in Paris street scenes, and was admired by his contemporaries for his remarkable and subtle draughtsmanship, his keen observation and satirical humour.

Goes Hugo van der (c. 1440–82). Early Netherlands painter and, after Van Eyck, the most gifted artist of the school; probably born in Ghent. He entered the artists' guild there in 1467 and was dean in 1474. Shortly afterwards he became a lay brother at the monastery of Roode Clooster near Brussels and from this time he was subject to increasing attacks of depression and mental instability. He contin-

Van Gogh Self-portrait with Ear Cut Off 1889

ued to paint until about 1481. His greatest work is unquestionably the large triptych commissioned by the Florentine merchant Portinari in 1475. Taken to Florence, this masterpiece had a considerable influence on Florentine painting, e.g. in the later work of Ghirlandaio. Among other important works are Adoration of the Shepherds, Adoration of the Kings, Fall of Adam, Lamentation, Virgin and St Anne, the 2 large organ shutters at Holyrood Palace, Edinburgh, Crucifixion and the almost mystically intense Death of the Virgin. G.'s only true follower was the *Master of Moulins.

Goethe Johann Wolfgang von (1749–1832). German poet, writer and polymath, the major influence on German Romanticism and European Romantic poetry and art. G. is best known for his epistolary novel *The Sorrous of Young Werther* (1774; 2nd version 1787) and the verse drama *Faust* (1808; 1823; 1832; 1838). At 1st G. identified art with nature and maintained the Romantic notion of individuality and genius. He later turned to the classicism of the Renaissance and developed the idea of 'beauty' as the symbolic expression of the inner laws of nature, as exemplified in the art of antiquity, and apprehended intuitively. He wrote extensively on art, c.g. *Über Kunst und Altertum*

(1816-32), including a treatise on colour theory, Zur Farbenlehre.

Gogh Vincent van (1853-90). An artist whose work is one of the formative influences of 20th-c. art and whose life has become almost a legend. The son of a Dutch parson, he was employed by a firm of art dealers in The Hague, London and Paris. Afterwards he became in turn a schoolmaster in Britain, a missionary to the miners in the Borinage, Belgium, and finally, in 1880, an artist. Van G. was virtually self-taught, though he received some technical advice in oil and watercolour painting from a cousin, the artist A. Mauve. In 1886 he left Holland for Paris, where he lived with his brother Theo, one of the few art dealers encouraging such artists as Bernard, Degas, Gauguin. Seurat and Toulouse-Lautrec. Impressed by the work and personalities of these painters, Van G. conceived the idea of founding a 'Studio of the South' at Arles as a working community for progressive artists. He himself went to Arles early in 1888, but the only other painter he persuaded to join him was Gauguin, who visited him at the end of 1888. A violent guarrel between the 2 precipitated the first of Van G.'s periodic attacks of madness in which he cut off part of his ear. 2 years later, at Auvers-sur-Oise, he shot himself. He had sold I picture during his lifetime.

Early work of Van G.'s Dutch period is heavy, rich but subdued in colour, with a few fine effects. The Potato Eaters is typical. After his contact with other painters in Paris, with Japanese prints and the work of such original colourists as Delacroix and A. Monticelli, Van G.'s style changed radically to the brilliant colour and frenzied, thick brushwork of his Arles period. Among hundreds of paintings of the last two and a half years are: Comfield and Cypress Trees, Starry Night, La Mousmé, Sunflowers and Self-portrait. His watercolours (e.g. Fishing Boats at Santeo Maries) and drawings are of equal intensity and value, while the letters he wrote to his brother Theo are important literary and human documents in their own right.

Golden Fleece, The. A monthly magazine, printed in Moscow, running from 1906 to 1909, ed. and publ. by the wealthy painter Nikolai Ryabushinsky. Chiefly an art magazine, profusely illustrated, it also publ. poetry and literature of the late Symbolist school. It sponsored 2 historic Franco-Russian art

exhibitions in Moscow in 1908 and 1909 which introduced the French Fauves and 1st brought together the Moscow and Paris *avant-garde* painters.

golden section, golden mean. The name given in art to the mathematical relationship between 3 points in a straight line (see diagram) in which the ratio AC: BC equals the ratio BC: AB.

This relationship was invested with an almost mystical significance by some Renaissance theorists and used extensively by certain painters, above all Piero della Francesca.

Golkonda. *Deccani miniature painting

Goltzius Hendrick (1558–1617). Dutch engraver and, from 1600, painter influenced by Italian Mannerism. He worked in Haarlem and was the 1st engraver to exploit all the tonal possibilities of line engraving. Although his work lost some of the characteristics of the medium it achieved something of the subtle gradations of oil painting and exercised great influence on the growth of reproduction engraving.

Golub Leon (Albert) (1922—). U.S. figurative painter, co-founder of School of Chicago Art after World War II. His paintings (e.g. the series 'Mercenaries' and 'Interrogations', begun in

1976) often have a harsh and violent narrative content reflecting existential and political concerns and, from 1955, his strong opposition to *Abstract Expressionism. G.'s large-scale works are characterized by their surfaces which are built up of successive layers of lacquer. He has often exhibited together with his wife *Spero.

Gombrich Sir Ernst (Hans Josef) (1909—). Viennese-born British art historian. He studied in Vienna and at the Warburg Institute, London (1936). From 1949 until his retirement in 1976, he was Director of the Warburg Institute and Professor of the History of Classical Tradition, University of London. His best-known and highly influential books are *The Story of Art* (1950), *Art and Illusion* (1960), *Meditations on a Hobby Horse* (1963) and *Norm and Form* (1966).

Gonçalves Nuno (c. 1438–81). Portuguese painter rediscovered in the 20th c. and regarded as the founder of the Portuguese school. He is known to have been active as court painter to Alfonso V. c. 1450–72; the only work attributed to him with certainty is the polyptych for the convent of St Vincent, Lisbon (c. 1465–7), 6 panels which depict the whole of Portuguese society crowded about King Alfonso and Henry the Navigator as they pray to St Vincent. G. was a master of colour and of composition. The modelling of his figures is sculpturesque and their heads are painted with a sharp insight which anticipates the psychological portrait.

Golub Interrogations I 1980-1

Gorky The Betrothal 1947

Goncharova Natalia (1881–1962). Russian painter and theatrical designer who studied under the sculptor Trubetskoy in Moscow where she met *Larionov, the major influence in her work as well as a life-long companion. A preoccupation with icon painting and national folk-art characterizes her best-known work such as designs for Diaghilev's Le Coq d'Or, Les Noces and Firebird. Before leaving Moscow for Paris in 1915, she was well known in Russia as a Futurist and Rayonnist painter.

Goncourt the brothers Edmond de (1822–96) and Jules de (1830–70). French writers who worked in collaboration until the younger died of syphilis. Edmond cherished the memory of Jules, continued the diary they had begun in collaboration and left money for the founding of the Académie G. and the Prix G., by which they were to be jointly commemorated. Well-to-do, self-absorbed bourgeois, they looked upon themselves as exceptional, sensitive creatures with a literary and artistic mission. They helped to create a fashion in 18th-c. French furniture and paintings and in Japanese art. Their

extremely detailed books on the social and artistic life of the 18th c. are still read. They applied the same technique of close documentation and mannered writing, which they called 'l'écriture artiste', to the lurid contemporary social subjects they dealt with in their novels, and so were pioneers of Realism and Naturalism: Germinie Lacerteux (1864; Germinie Lacerteux, 1887) and Madame Gervaisais (1869). Now their chief claim to fame is the Journal des Goncourt (complete text, 22 vols 1956–8; The Journal of the de Goncourts (extracts) 1915). Its accounts of the conversation of Daudet, Flaubert, Gautier, Saint-Beuve, Turgenev, Zola, etc. are absorbing though often malicious.

Gonzalèz Eva (1849–83). French Impressionist painter, pupil and close follower of Manet who painted a famous portrait of her.

González Julio (1876–1942). Spanish sculptor, who lived in Paris from 1900. He began his career as a painter but found his métier as a sculptor in iron, making use of new industrial processes, and inspired by Cubism and a desire to create forms based on the natural limitations

of the material. In his abstract and realistic work alike, observed nature was the source of his ideas

Gore Frederick Spencer (1878–1914). British painter of landscapes, ballet and music-hall scenes and interiors, closely associated with *Gilman and 1st president of the *Camden Town Group. He first worked in France and was strongly influenced by Impressionist painting through his friendship with L. *Pissarro; he later followed the Post-Impressionists.

Gorky Arshile (1904–48). Armenian-born U.S. painter who settled in the U.S.A. in 1920. He met S. *Davis in N.Y., c. 1929, and *De Kooning in 1933. His early pictures derived from Cézanne and Picasso. A series of family portraits were true to life but also showed the germ of G.'s highly individual style: images flat on the surface of the canvas, pre-figuring later De Kooning and G.'s own later flat, *biomorphic works, which were released from use of Surrealist automatism. G. had the greatest influence on subsequent developments in U.S. art and he anticipated and pioneered *Abstract Expressionism.

Gossaert Jan. *Mabuse

Gothic. General term applied to the style in the arts of the high Middle Ages; it was coined contemptuously in the 17th c., the Goths being among the barbarian ancestors of medieval Europe. In architecture it is applied to the style developed in the Île de France in the 12th c. (Suger) characterized by the pointed arch, soaring piers, elaborate vaults, extensive use of glass and increasingly intricate tracery. Rib-vaults and pointed arches are found in Romanesque, but their fusion, with the added element of the flying buttress, produced G., a new style in architecture. The emphasis was on dynamic line rather than on weight and mass, as in Romanesque, and the more elegant working out of engineering problems combined with the new spirit of religious mysticism and aspiration produced an ever stronger emphasis on vertical and height, evidenced in spires and flèches. Extensive use was made of sculpture and stained glass as decorative features. The style spread to Britain, where it developed the 3 periods of Early English, decorated and perpendicular, and somewhat later Germany. Spanish G. was deeply influenced by French, though a distinct national style evolved in the 15th and 16th cs. Italy remained outside

the mainstream (e.g. Siena cathedral; Frari, Venice). In Britain the gradual 18th-c. renewal of interest in all things 'Gothick' led eventually to the Gothic revival of the 19th c. and the Neo-Gothic style in architecture. *International G. is a term used in painting.

Gottlieb Adolph (1903–74). U.S. *Abstract Expressionist painter, with *Rothko and others a founder of the *Ten Group, N.Y. (1935). Early in the 1940s, under the influence of primitive art, he invented the 'pictograph', the compartmental arrangement of symbolic calligraphic motifs. Later he concentrated on exploring the relationship between 2 contrasted shapes and produced a series of 'burst' paintings. His decorative works include murals for the Post Office, Yerington, Nevada (1939), and tapestries for the Synagogue, Millburn, New Jersey (1951).

Götz Karl Otto (1914–). German painter of expressionistic abstractions. He exhibited with the *Cobra group.

gouache. Watercolour paint made opaque by the addition of white. Effects similar to those of oil paint can be obtained with g. but it has the defects of lightening in colour as it dries and cracking if used thickly. It was used by the medieval ms. illuminators and later by many continental artists. In Britain it was less popular than transparent watercolour but was used by Sandby. It has been revived by 20th-c. painters and designers. In less good quality it is known as poster colour.

Goujon Jean (fl. 1540–62). The greatest French sculptor of the mid-16th c. who worked first in Rouen, then in Paris. He was influenced by the Mannerism of Parmigianino, G. B. Rosso and Cellini but gave the style a personal interpretation derived from classical sculpture. He executed relief decoration for the rood-screen of St Germain l'Auxerrois, Paris, and the Fontaine des Innocents, Paris, and decorative work for the Louvre (spoilt by 19th-c. restoration).

Gowing Sir Lawrence (1918–91). British painter, writer on art and teacher. He studied painting with *Coldstream at the *Euston Road school (1938) at the time when *Pasmore and *Moynihan also taught there, and formed close friendships with G. *Bell and *Stokes by whom he was influenced. He painted portraits, land-scapes and figures. His important and highly

Goya The Third of May (Executions) 1814–15

stylistic writing includes publs on Renoir, Vermeer, Turner, Cézanne, Matisse and L. Freud.

Goya y Lucientes, Francisco José de (1746-1828). Spanish painter and graphic artist. Born at Fuendetodos, by 1760 G. was apprenticed in Saragossa to José Luzán, an artist who studied under Neapolitan masters. Francisco Bayeu, a former pupil of Luzán, had won fame in Madrid as assistant to the royal painter A. R. Mengs, and G. followed Bayeu, became his pupil and married his sister in 1773. Meanwhile, in 1771. G. had made a visit (which is rich in legend if not in facts) to Italy and he painted commissions for churches in the vicinity of Saragossa at the end of the same year. He settled in Madrid in 1775 and in 1776 was commissioned to paint cartoons for the royal tapestry works. At first G. followed conventional subjects, the court pastorals that relied on French and German Rococo models and the painting of Tiepolo and the Neapolitans. Soon, however, his own painting became noticeably freer and he introduced scenes observed from Spanish life, e.g. Stilt Walkers, Blind Guitarist. In the course of his work he was admitted to the Royal Colls where he engraved copies of Velazquez. Stimulated by Velazquez and by mezzotints after Gainsborough and Reynolds, he began to paint portraits.

The 1780s record his increasing fame and an amazing variety of activity. In 1782 he portrayed the powerful minister Floridablanca; in 1786 he painted *Charles III Hunting*. He had many commissions from the Church including

the 2 St Francis Borgia scenes for Valencia cathedral. Among small works he did for his own pleasure is the remarkable view of Madrid, Fiesta of San Isidero. In 1780 he had submitted his Crucifixion to the academy of San Fernando, being elected a member unanimously and appointed deputy director in 1785. At the court he was progressively pintor del rey (1786), pintor de cámara (1789), and primer pintor de cámara (1799). A change in his style is noticeable after his illness in 1792, which left him deaf. The portraits show greater insight, e.g. Dr Peral, and almost cruel objectivity in the famous Charles IV and Family. G.'s attachment to the duchess of Alba is celebrated in 2 fine portraits. He castigated the follies of the court, superstition and the vanity of women in Los caprichos, his engravings of 1796-8. In the same period he painted the Maja Clothed and Maja Unclothed. His religious paintings are revolutionarily free in technique, but obviously profoundly felt, e.g. Betrayal of Christ and the frescoes of S. Antonio de la Florida, Madrid. Subsequently G. chronicled the horrors of Napoleonic occupation in The Second of May (Uprising) and The Third of May (Executions) as well as in the engravings Disasters of War and his drawings. After the restoration of the reactionary Ferdinand VII, G. retired to the outskirts of Madrid. The decorations in his own house, called during his lifetime the House of the Deaf Man, now removed to the Prado, remain among the strangest and most original paintings ever painted both in subject and technique. They include Witches' Sabbath, Saturn Devouring

his Child and Fantastic Vision. In a self-chosen exile in France G. continued to paint, engrave and practise lithography with undiminished vigour until his death. Milkmaid of Bordeaux, one of his last works, has a frenzied brushwork which looks forward to the effects of the Post-Impressionists. G. was the favourite of French writers such as Baudelaire. Artists of almost every major school have been influenced by his work in painting and the graphic arts from Delacroix and Géricault, Manet and Daumier to Käthe Kollwitz and Picasso.

Goyen Jan van (1596–1659). Dutch painter and father-in-law and teacher of Jan Steen. With Pieter de Molijn and S. van Ruysdael G. established the early school of Dutch naturalistic landscape painting. He executed a great number of paintings. Those of the middle period are often so austere in colour as to be almost monochrome, and they were once thought to have faded. His best-known works are views of the towns of Holland, of which View of Dordrecht is a good example with its wide sky and low horizon, the bustle of human life confined to the bottom quarter of the painting.

Gozzoli Benozzo. Name adopted by Benozzo di Lese (c. 1421–97). Florentine painter. Best known for the *Procession of the Magi* frescoes in the Medici-Riccardi Palace, Florence, G. was an assistant to both L. Ghiberti and Fra Angelico before painting frescoes and altarpieces in a number of towns, including Rome, San Gimignano and Pisa. Λ typical altarpiece is *The Virgin with Saints*.

Graf Urs (c. 1485–1527/8). Swiss draughtsman, engraver, painter, goldsmith and mercenary soldier. From 1509 he worked in Basel and is famous for his drawings, influenced by Baldung and *Dürer, often depicting military genre scenes. Only 1 painting, *War* (c. 1515), can definitely be ascribed to him.

Graff Anton (1736–1813). Swiss portrait painter who worked in Dresden. He abandoned the idealized portraiture of the Rococo period and specialized in half-length portraits with naturalistic poses and subdued tones, e.g. his picture of the painter Daniel Chodowiecki (c. 1800).

graffiti. From the Italian graffito for 'scratched', a decorating technique of scratching through one layer of wall plaster or the 'slip' of pottery to reveal a contrasting colour beneath. Also,

drawings or words scratched on walls etc. in public places. In the 1980s graffiti became a widespread art practised by younger artists who then came to prominence, e.g. *Basquiat and *Haring, but prior to this in the 1950s *Twombly's distinctive art style had already been inspired by graffiti he saw in Rome.

Graham Robert (1938–). U.S. sculptor of the human figure. Originally his small-scale figures were in wax and enclosed within Plexiglas domes. Later G. produced figures in action, cast in bronze, viewed simultaneously from different angles. His sculptures are coloured with oil paints.

Granacci Francesco (1477–1543). Florentine painter. Although most heavily influenced by his master Ghirlandaio, he sometimes modified his style towards Michelangelo, sometimes towards Lorenzo di Credi or Fra Bartolommeo. This changeability has made his paintings difficult to identify.

Grandville Jean-Ignace-Isidore Gérard called (1803–47). French graphic artist whose fantastic imagination and satirical humour make him an important figure in 19th-c. graphic art. Besides political cartoons he produced *Les Métamorphoses du jour* (1828), *Une Autre monde* (1844) and ills to *Robinson Crusoe* and La Fontaine's *Fables*.

Grant Duncan (1885–1978). British landscape, portrait and decorative painter and designer, member of the *Bloomsbury Group and the *London Group and closely associated with *Fry, V. *Bell and the *Omega Workshops. He was among the 1st British artists to be influenced by the Post-Impressionists.

graphic arts. The collective term for the pictorial arts outside paintings, e.g. engraving, lithography, silk screen, etc.

Grassi Anton (1755–1807). Viennese sculptor. He did much work at the palace of Schönbrunn, Vienna, but his finest pieces were porcelain figures in a Rococo and later a more classical style.

Gravelot Hubert (François) (né H.-F. Bourguignon) (1699–1773). French draughtsman, book ill. and engraver who brought the style of *Watteau to Britain. He worked for several years in London, where Gainsborough studied under him. His work is light and delicate and often on a very small scale.

Nancy Graves Trap 1985

Graves Morris (1910—). U.S. painter, a mystic and visionary whose use of symbolism links his work with Surrealism. An isolated and introspective painter, he evolved a very personal imagery derived from nature and wildlife, and a calligraphic style influenced by *Tobey's 'white writing' technique. G.'s works include numerous series of paintings on a single theme, e.g. the notable *Inner Eye* series (1941).

Graves Nancy (1940-95). U.S. sculptor, painter, print and film maker, and stage-set designer of exceptional inventiveness. Her work in whatever form and medium is fundamentally inspired by nature. Her breakthrough came in 1968 with a number of freestanding sculptures of doublehumped, Bactrian camels made of wood, steel, burlap, polyurethane, animal skin, wax and oil paint. In 1970 other works quickly followed such as *assemblages of freestanding and hanging skeletal parts (e.g. Vertebral Column with Skull and Eyes, 1970), bone and fossil floor pieces and a hanging sculpture in 38 parts, Totem. In the following 5 years she turned to painting sea animals and maps ('Camouflage' series) and from 1978 she started making sculptures in bronze (e.g. Cantilever, 1983). G. also worked with fantastical and exuberant polychrome, making freestanding constructions, and equally inventive paintings.

Gray Henry Peters (1819–77). U.S. academic painter who made several visits to Italy and was influenced by the Venetian school. From 1869 to 1871 he was president of the National Academy, N.Y.

Greaves Walter (1846–1930). British painter. Originally a Thames boatman but taught to paint by *Whistler in return for rowing him on the river. G. chose his subjects from the Thames and often followed Whistler's style though *Hammersmith Bridge on Boat Race Day (c.* 1862), one of the best British pictures of its period, has a directness and precision unlike anything of Whistler's.

Greco, El i.e. 'The Greek'. Domenikos Theotokopoulos (1541–1614). Spanish painter born in Crete. G. was trained as a painter of icons in the Byzantine tradition. About 1560 he went to Venice (Crete was a Venetian colony) and became a pupil of Titian, then to Rome with an introduction to Cardinal Farnese from Giulio Clovio, of whom he painted a portrait. He attracted some attention and had pupils but *c.* 1570 moved to Toledo, where he lived until his death.

There are 3 main phases in his development. The pictures from the 1st phase (1570–80) show Venetian influence and especially Titian's: line drawing disappears, the use of colour is unlimited and the purely pictorial dominates (compare Titian's *Golgotha* with G.'s). G.'s dramatic use of light and shade and his portrait style indicate Tintoretto's influence as well as that of Veronese, Bassano and perhaps Correggio. *The Holy Trinity* (1577–8) belongs to this period.

The 2nd phase (1580-1604) combines some Byzantine features (especially plastic forms) with a growing sense of rhythm and movement; it includes The Martyrdom of St Maurice (1580), commissioned by Philip II in 1580 but not accepted, and Golgotha (1590). The Burial of Count Orgaz (1586), a legendary theme, shows St Augustine and St Stephen lowering the body into the grave. The canvas is filled with figures, some of them portraits, and contrasts vet unifies the human and heavenly worlds, the austerity and solemnity of the lower part of the painting and the radiance of the Holy Ghost in the upper. The eye is led upwards to the figure of Christ, who is beseeched by John the Baptist to receive the count's soul. This spiritual exaltation is typical of G.; another example is The Despoiling of Christ (1583). The best of the

El Greco The Burial of Count Orgaz 1586

portraits painted in this period is the Cardinal Don Fernando Niño de Guevara (1598).

From about 1590 G. concentrated increasingly on portraying inner beauty and in the last phase achieved complete inward expression. From 1604 the rhythm and the simplicity of form and colour increase. The combination of Byzantine influence with rhythm, movement, intensity of expression obtained through elongation and distortion of form, use of light and unusual colour (the blues and lemons), convey the exaltation and radiance of the Holy Ghost. The latter paintings include the *Vision of St John the Divine* (1610–14) and the *View of Toledo* (1608). The latter is no mere landscape: it is a vision in which nature has overcome man.

Works include: St Martin and the Beggar (1597–9); Resurrection of Christ (1597–1604); Assumption of the Virgin Mary (1608–13); and Adoration of the Shepherds (1612–14).

Greco Emilio (1913–). Italian sculptor; he studied at the academy in Palermo coming to the fore only after World War II.

Greenaway Kate (1846–1901). British artist and writer and close friend of *Ruskin, famous as an ill. of children's books, chiefly her own works. Her characters, oddly costumed in early 19th-c. style, started a fashion in children's clothes.

Greenberg Clement (1909–94). Leading U.S. art critic who was instrumental in bringing to attention *Abstract Expressionism, esp. the works of *Louis, *Newman, *Pollock, the *Post-painterly abstractionists and the British sculptor *Caro. He has published extensively in art magazines and a collection of his essays, *Art and Culture* (1965).

Greene Balcomb (1904–91). U.S. painter and teacher. He was a geometric abstractionist, e.g. murals for the New York World Fair (1939), until the early 1940s when he began to react against pure abstraction. He turned to semi-abstract studies of landscape and the human figure in which form is made vague and ambiguous by the interpenetration of light.

Greenhill

Greenhill John (c. 1644–76). British portrait painter, pupil of Sir P. Lely. In his late work G. began to break from Lely's influence and paintings such as *Naval Officer* have a solidity and reserve which anticipates the next generation of British painters.

Greenough Horatio (1805–52). U.S. Neoclassic sculptor whose working life was spent in Italy. His seated half-nude of Washington as Zeus (1833–43) is the 1st important example of U.S. monumental sculpture. His writings, which expound an early functionalist theory of beauty, include *Aesthetics in Washington* (1851).

Greuze Jean-Baptiste (1725–1805). French painter who became famous with the appearance of his *Father of the Family Reading the Bible* at the Paris Salon in 1755. Praised by Diderot and other moral philosophers, his large-scale genre subjects usually had a moral lesson to tell, as in *Return from the Wineshop*. They were made famous from Britain to Russia through engravings. However, it is his portraits, particularly of children (*Boy with Lesson Book*), which are preferred today. His art had declined even before the outbreak of the Revolution, which ruined him.

Greenough Washington 1833-43

Greuze Boy with Lesson Book c. 1757

Grignion (Grignon) the Elder, Charles (1717–1810). British engraver of French parentage; uncle of C. G. the Younger. He studied under H. Gravelot and in Paris under J.-P. Le Bas. He engraved the plates for various publications including H. Walpole's *Anecdotes of Painting in England* and was employed by Hogarth.

Grignion the Younger, Charles (1754–1804). British history and portrait painter, nephew of C. G. the Elder. He studied under G. B. Cipriani and at the R.A. In 1782 he settled in Rome.

Gris Juan (originally José Gonzalez) (1887– 1927). Spanish painter, sculptor and draughtsman. G. studied in Madrid, and settled in 1906 in Paris, where he became *Picasso's friend and one of the avant-garde. His development was slow. He earned a living as an ill. but continued to paint, and exhibited from 1912. His work was noticed by the art dealer *Kahnweiler, who placed him under contract. G. as a result was able to devote himself entirely to painting and became a leading *Cubist, e.g. Portrait of Picasso (1912). He remained faithful to the Cubist aesthetic; his work developed from simplified, precise forms based on the world of objects (e.g. La Place Ravignan, Still Life in Front of an Open Window, 1915) to the monumental compositions of 1916-19, a flat coloured architecture. From this time he

Gris Still-life with Newspaper 1914

experimented with polychrome sculpture, inspired by *Lipchitz. His last period expressed his increasing preoccupation with colour, e.g. *Guitar with sheet of music* (1926). G. regarded himself as a classical painter; for him a painting was a self-contained creation and within its context he used objects to express ideas.

grisaille. Monochrome painting in greys sometimes used as an underpainting or to imitate sculptural features as in the paintings of early Netherlandish artists such as D. Bouts or J. van Eyck. Also a type of stained-glass painting of which the most famous example is the 'Five Sisters' window in York Minster.

Gromaire Marcel (1892–1971). French painter in a heavy Expressionist style which he developed after World War I. He made his reputation with *La Guerre* (1925). He produced notable engravings and with Lurçat played an important part in reviving the art of tapestry in France.

Grooms Red (1937—). U.S. artist and sculptor whose exuberant *assemblages, *Environments and *Happenings are about urban U.S. and particularly N.Y. life. He writes, 'there is a proletarian feeling about my work. That type of energy and subject matter excite me a lot. And I've always felt a kinship to commercial people.' In 1975–6 he was involved in setting up the Ruckus Construction Company who

worked on a project 're-creating' the whole of Manhattan, using different materials, a popular work of kitsch and humour.

Gros Antoine-Jean (1771–1835). French painter whose earlier work exerted a powerful influence on the development of Romanticism in France. His training by J.-L. *David and intellectual assent to classicism eventually stifled his temperamental bias towards Romanticism, and after David's death (1825) he took over the leadership of the outmoded classical school, produced unsatisfactory paintings and committed suicide. Among his important works are Napoleon Visiting the Plague-stricken at Jaffa (1804) and The Battle of Aboukir (1806).

Grosz George (1893–1959). German *Expressionist painter and graphic artist best known for his pen and ink drawings satirizing the German nation during and after World War I; in 1933 he settled in the U.S.A. His own experiences of the war in the German army, as a civilian in Berlin (1916–17) and in a military asylum, made a searing impression. A founding member of the Berlin *Dada group, he was also part of the *New Objectivity movement. In his work he exposed with merciless and horrifying precision the officials and profiteers who lived off the war and, after it, the vice, the political chaos and the complacency of the bourgeoisie.

Gros Napoleon at Arcoli (detail) 1796

Grünewald *Temptation of St Anthony* (detail, from the Isenheim altarpiece) *c.* 1515

grotesque. Originally derived from the mural decoration of excavated classical grottoes. These consisted of panels where fantastic shapes of human beings, animals, etc. were joined together by flowers, garlands and arabesques into a symmetrical design covering the wall or ceiling. Very popular in the 16th c. The term came to be applied to distorted exaggerations, humorous or horrifying, in various art forms, especially sculpture.

ground. Term used in (1) painting, of the foundation surface of white oil paint or gesso laid down on the canvas or panel to receive the painting; (2) music, for a repeated figure played in the bass and serving as a support for variations above it; (3) embroidery, of the basic overall background over which the pattern is worked.

Groupe de Recherche d'Art Visuel (GRAV). A group of artists founded in Paris in 1960. Their approach to art was quasiscientific, and concerned with the qualities of colour, light and movement. The group owed much to *Constructivism, and in its own turn made an important contribution to the development of *Kinetic art. The artists associated with it were Garcia-Rossi, *Le Parc, Morellet, Sobrino, Stein and Yvaral.

Group of Seven. Group of Canadian landscape painters influential and controversial in the 1920s and 1930s; they stressed design and colour, and aimed to produce decorative but specifically Canadian landscapes. The group was founded in 1919 by Lawren Harris, F. H. Varley, Arthur Lismer, Franz Johnston, A. Y. Jackson, J. E. H. MacDonald and F. Carmichael.

group portrait. Term applied to the painting of a family or other group of real people, as opposed to mythological, historical, religious and other paintings in which a number of people appear. Such portraits were often commissioned and were a great challenge to the artist, who had to give each sitter equal importance while producing a work of art. The genre flourished in 17th-c. Holland; its famous exponents include Rembrandt and Hals.

Gruber Francis (1912–48). French realist painter whose work has affinities with Expressionism.

Grünewald Mathias or Mathis Gothart Nithart called (c. 1475–1528). German painter, born in Würzburg, Bavaria. G. was trained in Alsace in the style of Schongauer, and travelled through Germany, living in Isenheim, Seligenstadt, Aschaffenburg and Mainz, where he was court painter to the Elector. He died in Halle, where he painted a series of pictures in the cathedral for the Elector of Mainz. G.'s masterpiece is the set of 10 paintings for the Isenheim altar (finished c. 1515; now at the Mus. Unterlinden, Colmar). They were intended to be seen in 3 groups which changed as panels were opened and shut: 2 scenes from the life of St Anthony flanking the carved centre-piece (c. 1505, by Backoffen) of St Anthony enthroned with SS Augustine and Jerome; the Annunciation, Concert of Angels, Virgin and Child and Resurrection; and the Crucifixion, St Anthony and St Sebastian (supposedly a self-portrait). Below these was the Pietà which disclosed the carved Christ and Apostles of the predella (also by Backoffen).

The spirit of the Renaissance is remote from G.'s work, but he imbued the medieval German art to which he adhered with an entirely original personal vision expressed in the distorted, tortured forms and strange colouring of the Crucifixions. His range is enormous, encompassing the horrifying Crucifixion and serene Virgin and Child of the Isenheim

altar. The Karlsruhe Crucifixion - the greenish, blood-spattered body of Christ, its deformed limbs, where even the nails pinning the clawlike hands, the crown of thorns and the draperies are painted in the same tortured manner - is utterly different from the Madonna who stands in a beautiful garden, fresh and tender. The Mocking of Christ is filled with large figures caught in frenzied movement. Christ, his eyes covered, is gripped by the hair by his assailant, whose fist is poised ready to strike; another, holding Christ's bonds, is about to lash him with the knotted end of a rope. The figure of Christ in this painting, abused and defiled, directly contrasts with that in the Resurrection, in which Christ ascends suffused with a golden celestial light. G. also painted The Meeting of St Erasmus and St Maurice which formed part of the Halle commission.

Guardi Francesco (1712-93). Venetian landscape painter and draughtsman, brother-in-law of *Tiepolo and son of a painter. His son Giacomo (1764-1835) carried on his workshop. G.'s development was slow and his early paintings lacked originality since he was mainly concerned with satisfying the popular demand for small religious and genre paintings. He absorbed the influence of his contemporaries *Canaletto and *Longhi but evolved a new type of landscape painting, which became very popular. He can be ranked with Constable, Turner and the painters of Barbizon as a pioneer of a new approach to landscape for his subjective use of light and atmosphere expressed with a nervous, calligraphic touch. In his maturity he portrayed Venetian social life brilliantly and accurately. He recorded the excitement of the Ascent in a Balloon and the ceremonial of the Doge embarking on the Bucintoro.

Guercino, II ('the squint eyed') Giovanni Francesco Barbieri called (1591–1666). Italian painter. He was born at Cento near Ferrara and worked there for much of his life; he also worked in Rome (1621–3) and Bologna (from 1642). The Carracci, Caravaggio and the Venetian school were important influences on his development. Between 1616 and 1621 in a number of notable altarpieces he evolved a colouristic, painterly style which culminated in Aurora. This fine illusionistic painting was the model for many later Baroque ceiling paintings and makes an interesting comparison with Reni's more restrained treatment of the same

Guardi Courtyard in Venice 1770s

subject (1613) in the Palazzo Rospigliosi, Rome. In *Burial and Reception into Heaven of St Petronilla*, also painted in Rome, G. abandoned the vigorous treatment of *Aurora* in favour of Annibale Carracci's type of classicism. The power and originality of his work steadily declined as he became involved in the Counter-Reformation under the influence of which he painted uninspired pietistic altarpieces, many of them in the manner of his rival Reni. On the death of Reni, G. took over his workshop in Bologna. The Royal Library, Windsor, has the best coll. of G.'s very fine drawings.

Guérin Pierre-Narcisse (1774–1833). French painter, pupil of J.-N. Regnault. As an exponent of Neoclassicism he alternated between the styles of J.-L. David and Regnault but in either case produced work of extreme banality. Géricault and Delacroix studied under him.

Guido da Siena (13th c.). Italian painter, the founder of the Sienese school. A signed *Madonna in Majesty* (Palazzo Pubblico, Siena) is dated 1221 but there is controversy among art historians as to whether in fact it does not come from the 1260s or 1270s like other works in a similar style.

Guillaumin

Il Guercino Night

Guillaumin Armand (1841–1927). French Impressionist painter. He was a friend of C. Pissarro and Cézanne and exhibited at the 1st (1874), and most subsequent, Impressionist exhibitions. Pale violet and orange predominate in his landscapes.

Günther Franz Ignaz (1725–75). Bavarian sculptor whose painted wood sculptures of religious subjects are among the greatest works of the Rococo period. Best known of these are *The Annunciation* (1764) and his last surviving work, the *Pietà* (1774), which has great depth of feeling.

Gupta. N. Indian empire of the 4th-6th cs AD, at its peak under Chandra Gupta II (c. 380-414). Music and Sanskrit literature (Kalidasa) achieved a golden age. G. Buddhist sculpture, e.g. the red sandstone standing Buddha from Mathura, reached a pinnacle of refinement at Sarnath, notably the 'wet Buddhas' so-named from their sheer, clinging draperies. The G. balance between stylistic simplicity and decoration, physical refinement and massiveness, influenced subsequent Buddhist art in S.E. Asia. Fine G. Hindu sculptures are at the rock-cut shrine of Uday-agari, Bhopal, and in the reliefs on the Dashavatara temple at Deogarh, both in N. central India. G. Buddhist painting survives in works of remarkable grace and realism at Ajanta.

Guston Philip (1913–80). Born in Canada of Russian-Jewish emigré parents, moved to

California 1919. He met *Pollock 1927. Initially adhering to the tradition of the Italian Renaissance, he became acquainted with the artists of the Mexican mural movement in 1932 and visited the studios of *Orozco and *Siqueiros, later becoming involved in mural projects, in association with De Kooning, Gorky and Pollock. In the late 1940s G. turned to lyrical abstract painting and his disciples dubbed his work 'Abstract Impressionism'. In the 1970s he returned to figurative paintings of cartoon-like simplicity of line and socially conscious subject matter. These works, usually on a large scale, were of great importance to the younger generation of neo-figurative artists.

Guttuso Renato (1912–87). Italian *Social Realist painter. Co-founder of 'Fronte Nuovo delle Arte', also member of the Communist party. The vigour of his style and imagination transcended his polemical approach to subject matter.

Guys Constantin (1802–92). French draughtsman and ill. famous for his vivacious sketches of British and French society – manners and changing fashions, carriages and military

Günther Pietà (detail) 1774

occasions, courtesans and dandies. This 'modernity' was commended by Baudelaire in his appreciation of G.'s work, *Peintre de la vie moderne (Le Figaro*, 1863; *The Painter of Victorian Life*, 1930). G. was reporter-illustrator for *The Illustrated London News* during the Crimean War.

H

Haacke Hans (1936-). German-American artist. In his 'real-time systems' H. combines materials, styles and words taken from the everyday capitalist experience - politics, social issues, corporate industry and advertising - in works that critique such experience and its relation to art (e.g. Creating Consent, 1981, which exposes Mobil Oil's expenditure on advertising). His work has been directed against art institutions, and their links with industries, such as the Guggenheim and the Metropolitan Museums, N.Y., the public relations company Saatchi and Saatchi, ex-President Reagan, ex-Prime Minister Thatcher and others. His notorious Manet Project (1974) used Manet's Bunch of Asparagus as a centrepiece surrounded by an exposé of all the collectors who had acquired it at different times, including its last owner who was the founder of a museum in Cologne, aiming in this, as in other works, to expose and discredit the image of the world which art may unwittingly promote and whose interests it may serve.

Haberle John (1856–1933). U.S. painter who, like *Peto, specialized in *trompe l'æil still-lifes for which he is best known

Hague school. A group of *Realist artists who worked in Holland between 1860 and 1900, reviving many of the traditions of 17th-c. Dutch landscape and architectural painters. The group included Bosboom, Joseph Israels, Mauve and the Maris brothers.

Haida. North American Indian people of the *North-west Coast group, centred in the Queen Charlotte Islands of British Columbia. They are noted for a tradition of powerful wood carvers whose finest work was in the totemic house and grave poles (totem poles).

Hains Raymond (1926–). French *Nouveau réaliste artist and photographer who worked

Haacke Germania 1993

closely with *Villeglé and *Rotella. He pioneered the *décollage technique of found and torn poster abstracts in 1949, which he termed affiches lacérées, e.g. Cet homme est dangereux (1957). *Vostell.

Halley Peter (1953–). U.S. painter and chief theorist of Neo-Geo (*'Neo'). Despite the abstract look of his strongly coloured paintings, 11. denies that they are abstracts. Their geometric imagery refers, on the one hand, to such modernist artists as *Albers, but also, metaphorically, to the cell-like isolation of individuals in the urban world, as well as to electronic circuitry, comics and the mapping of underground networks.

Hallstatt. Site in Austria which has given its name to the 1st W. European Iron Age culture; the H. period produced a geometrical art less interesting than that of the subsequent *La Tène period.

Hals Dirck or Dirk (1591–1656). Dutch painter. His painting is close in style to that of his brother, the more famous F. H. His best-known works

Frans Hals Women Governors of the Haarlem Almshouse 1664

are convivial gatherings such as A Party of Young Men and Women at Table.

Hals Frans (1580/5-1666). Dutch portrait painter. H. lived all his life in Haarlem. He probably studied under K. van Mander and may have visited Rubens in Antwerp (1616). He must have won a considerable reputation as a portrait painter prior to 1616, when he was commissioned to paint The Banquet of the Haarlem Civic Guard, Archers of St George. In this work H. confidently solves the enormous problems of composition involved in a group portrait where no figure can be subordinate. Other militia portraits were commissioned for the same mess in 1627, 1633 and 1639, while H.'s fame had spread to Amsterdam, whose Civic Guard he was invited to paint in 1633, a picture he left unfinished. Married, with numerous children, one an imbecile, another a delinquent, H. was in continuous financial difficulty. He gave lessons and among his pupils were probably Brouwer, Leyster, Molenaer and Wouwerman. In 1641 H. painted The Governors of St Elizabeth Hospital. In 1644 the entrance fee of the Haarlem Guild was waived to allow H. to become a member. In 1664, in return for a small grant of money and fuel from the city, H. painted 2 of his most masterful and technically bold group portraits, Men ... and Women Governors of the Haarlem Almshouse. Of his single portraits, perhaps the best known is the one called The Laughing Cavalier. Among

others which show the brilliance of his brushwork and which capture the spontaneity of gesture he was famous for, are Gipsy Girl, Elderly Woman, Hille Bobbe, or The Witch of Haarlem and Young Couple in a Landscape. H. was an important influence on Manet.

Hamilton Ann (1956-). U.S. *Installation and *Environmental artist. In a statement (with her frequent collaborator, artist Kathryn Clark) it is said that 'making site-related work - work that is ephemeral and constituted of organic materials - is part of retracing the path toward art that is among the living, and therefore among the dying'. Her usually temporary works are immensely evocative, poetic metaphors of innocence, collective memory and loss. H. uses birds, animals, people, objects, honey, wax and any other animate or inanimate material that may serve in realizing her vision, e.g. Privations and Excesses (1989) where 750,000 pennies are arranged in overlapping patterns, imbedded in a layer of honey spread over the floor. Also, The Savage Garden and View - in collaboration with Kathryn Clark - (both 1991) and Parallel Lines and Accounting (both 1992).

Hamilton Gavin (1723–98). Scottish Neoclassical history and portrait painter and antiquary. After studying in Rome he worked as a portrait painter in Britain (c. 1752–4), then settled in Rome. There he became an important member of the Neoclassical school centred round A. R. Mengs and J. J. Winckelmann.

Richard Hamilton Portrait of Hugh Gaitskell 1964

Hamilton Richard (1922-). British artist. He studied at the R.A. Schools (1938) but his art training was interrupted by the war when he was trained as engineering draughtsman. He taught for 14 years, first at the Central School of Arts and Crafts, London, and then at the University of Newcastle-upon-Tyne. H. was largely responsible for the radical developments which transformed British art in the 1950s and 1960s: his seminal role in the birth of *Pop art is acknowledged internationally. Although best known as a painter and maker of prints, his influence has been exercised also through teaching, writing, and through a number of exhibitions, e.g. 'Growth and Form' (1951), 'Man, Machine and Motion' (1955) and 'This is Tomorrow' (1956). His publications include Collected Words (1953-82).

Hammons David (1943—). African-American artist who articulates the African-American experience of inner-city life through *assemblages and *installations in which he juxtaposes objects signifying African culture with *found waste, e.g. discarded food, packaging, etc. His House of the Future (1991), an Installation for the 'Places with a Past' exhibition at Charleston, South Carolina, became an educational centre devoted to African-American culture. Constructed from materials found in the area, it evokes the living conditions of black people in the South, while alluding to the prosperity of the white community.

Han. Chinese dynasty (206 BC–AD 220), a period of imperial expansion and Confucianist orthodoxy modified by the introduction of Buddhism (c. 1st c. AD). Fine bronze, lacquer and jade objects survive but of the great wall paintings which decorated the palaces only a few tomb paintings are left – notably at Liao-yang, S. Manchuria and Wang-tu, Hopei province. The style is naturalistic and vigorous with affinities to *calligraphy. Funerary sculptures includes the 1st Chinese monumental stone carving, e.g. at the tomb of General Ho Ch'u-ping (d. 117 BC), Hsing-p'ing, Shensi and magnificent small bronzes, notably the famous Horse Poised on a Swallow, from a tomb at Lei-t'ai, Kansu.

Hanson Duane (1925–96). U.S. *Super-Realist sculptor of life-size and life-like figures of ordinary Americans, made with plastic materials (reinforced polyester resin and fibreglass) which result in extraordinary and disconcerting verisimilitude. The subjects and types chosen may express a critical attitude towards the social types they represent (e.g. *Tourists*, 1970) or the society that produces them.

Hans von Tübingen (d. 1462). Austrian painter trained in France and Burgundy and active from 1433 in Wiener-Neustadt.

Happening. An apparently impromptu situation, performance, event or series of events sometimes contrived to generate participation by onlookers. The H. was developed in the late 1950s and early 1960s in the U.S.A. Random responses from the spectator—performers are often part of the H. whose purpose is to rupture the barriers between 'art' and 'life'. *Kaprow's 18 Happenings in 6 Parts, Reuben Gal., N.Y. (1959) and *Oldenburg's Store Days (1962) are typical early examples. H.'s were mounted in Europe and Japan.

Hard-edge painting. A term coined in 1958 by the Los Angeles art critic Jules Lansner to describe the work of local artists using cleanly defined forms and flat colour. By extension, any modern abstract painting with these characteristics.

Haring Keith (1958–90). U.S. artist whose *graffiti-like drawings of children, dogs, UFOs and AIDS-inspired images made him one of the art celebrities of the 1980s. He also painted and sculpted, and designed stage-sets, murals, record covers and logos. As the critic Germano Celant has observed, H. 'had the singular ability to

Haring Ignorance = Fear 1989

depict the complexity of the present with both its sublime and horrifying aspects as well as its marvelous and monstrous forms.'

Harnett William Michael (1848–92). Irish-born U.S. still-life painter, a virtuoso exponent of *trompe l'œil illusionism. Interest in his work was revived by the Surrealists.

Harper William (1873–1910). African-American artist born in Canada. He studied at the Art Institute of Chicago and in Paris and was considered one of the most gifted black artists at the turn of the century. His paintings of French landscapes (e.g. Landscape with Poplars (Afternoon at Montigny), c. 1898) show the influence of the *Barbizon school.

Harpignies Henri-Joseph (1819–1916). French landscape painter, a follower of *Corot.

Hartigan Grace (1922—). U.S. *Abstract Expressionist painter influenced by *De Kooning. She made her 1st abstract paintings in 1948; after a period of figurative work (1952—5) in which she painted *Grand Street Brides* (1954) she returned to abstraction but her compositions almost always relate to her environment.

Hartley Marsden (1877–1943). U.S. painter and poet, best remembered for his paintings of his native state, Maine, e.g. Camden Hills From Baker's Island, Penobscot Bay, though his extensive travels in Mexico, the West Indies, France and Germany also inspired many works, e.g. Portrait of a German Officer, or Painting No. 5 1914.

Hartung Hans (1904–89). German-born painter of the school of *Paris where he settled in 1935. H. experimented with abstract drawings as early as 1922. In the 1930s he explored variants of Cubism and Surrealism. In the 1940s he developed a style of free linearism over colour fields which he subsequently developed.

Harunobu Suzuki (c. 1725–70). The great 18th–c. master of the Japanese colour print. His main themes were girlhood and scenes from everyday life, and he endowed these commonplace subjects with a grace and beauty far excelling anything in the Japanese tradition before or after his time.

Hassam Childe (1859–1935). U.S. painter and graphic artist. After studying in Boston he went to Paris, where he was strongly influenced by the technique and high colour range of the Impressionists. He was one of the 1st U.S. artists to adopt Impressionism and also to paint the N.Y. scene.

hatching. To create the effect of tone or shadow by a series of parallel lines or, in the case of Cross-Hatching, of parallel lines crossed by others.

Hausmann Raoul (1886–1971). Austrianborn Dadaist, one of the co-founders – with *Grosz, *Heartfield, Huelsenbeck and others – of the 'Club Dada' in Berlin in 1918, one of the signatories of the Berlin Dada Manifesto (1918) and editor of the magazine *Der Dada*. H. developed first, along with other Berlin Dadaists, the method of *photomontage. H. wrote: 'seized with an innovatory zeal, I also needed a name for this technique, and in agreement with Grosz, Heartfield, Baader, and Höch, we decided to call these works *photomontages*. This

Harunobu Mother and Child with Bird

term translates our aversion at playing the artist, and, thinking of ourselves as engineers ... we meant to construct, to assemble our works.' H. also edited the *Dada Almanach* (1920) and was one of the key participants at the Berlin Dada Fair in June 1920.

Hayden Henri (1883–1970). Polish-born painter who settled in Paris in 1907. His interest in Cézanne and a meeting with Gris and Delaunay in 1916 led him to work as a Cubist, but in 1922 he turned to a more traditional style.

Hayden Palmer (1890–1973). African-American artist who, after studying at the Cooper Union School of Art in N.Y. and at the Boothbay Art Colony in Maine, received the coveted Harmon Foundation award which enabled him to go to France in 1927. In Paris he enrolled at the École des Beaux-Arts and soon after successfully exhibited his works associated with the final years of the Harlem Renaissance. After returning to N.Y. in 1932, he worked on the U.S. Treasury Art Project and the *W.P.A. In 1944 he began a series, Ballad of John Henry (until 1954), on the life of the legendary African-American folk hero.

Haydon Benjamin Robert (1768–1846). British historical painter and writer, a friend of Wordsworth and Keats. His attempts to paint in the grand manner were not successful and he committed suicide after imprisonment for debt. Chairing the Member is an example of his style. In his clear-eyed and vivid Autobiography and Memoirs (1853) H. discusses art patronage and chronicles the art world of his time.

Hayman Francis (1708–76). British painter and book ill., founder-member of the R.A. He was best known for his decorative paintings at Vauxhall Gardens, London. He also painted portraits and small portrait groups which influenced the young Gainsborough. H.'s work shows French influence, possibly through contact with H. Gravelot.

Hayter Stanley (William) (1901–88). British graphic artist responsible for giving a new impetus to engraving techniques, widely extending their field of reference by his imaginative use of mixed techniques. In Paris he founded (1927) the influential experimental workshop *Atelier 17.

Head Tim (1946–). British artist who studied with R. *Hamilton at the Univ. of Newcastle-

Heartfield Justicia 30 November 1933

upon-Tyne (1965–9) and on the Advance Sculpture course run by *Flanagan at St Martin's School of Art (1969–70). In his work he employs a variety of media and forms: *installations, using mirrors and light, projections, printed and painted serial imagery, and patterned pictures, e.g. the Installations Displacements (1975), Appearance/Apparition (1977), Dislocations (1977) and Present (1978); wall paintings of bar codes in Techno-prison (1990); Cibachrome photographs of combined *found objects as in State of the Art (1984) and Erasers (1985); and paintings, e.g. Cow Mutations (1986) and Deep Freeze (1987).

Heade Martin Johnson (1819–1904). U.S. painter, one of the principal figures of *Luminism. His landscapes include the dramatic coast scene *Approaching Storm* (c. 1860).

Heartfield John (Helmut Herzfelde) (1891–1968). German pioneer of *photomontage and a founder of Berlin *Dada in the 1910s. In Britain from 1938, he settled in E. Germany in 1950. A Communist, H. fought relentlessly against Nazism, capitalism and war, in renowned satirical montages.

Heckel Erich (1883–1970). German *Expressionist painter and graphic artist, with Kirchner

and Schmidt-Rottluff founder of Die *Brücke. The brooding introspection of his work up to 1920 gradually diminished and he turned away from Expressionism, developing a more decorative style and a lyrical sensitivity to landscape. He produced important woodcuts such as *The Crouching One* (1914) which conveys his tragic sense of man's isolation.

Heda Willem Claesz (1594–1682). Dutch stilllife painter who worked in Haarlem in the manner of P. Claesz. H.'s son Gerrit Willemsz worked in the same style.

Heem Jan Davidsz de (1606–83/4). Dutch still-life painter, as was his father, David de H. (1570–1632). He worked mainly in Antwerp but also in Leyden and Utrecht. He specialized in elaborate flower pieces influenced by those of D. Seghers but used a lighter range of colours. He had many pupils and imitators including his son Cornelis (1613–95).

Heemskerck Maerten Jacobsz van (1498–1574). Dutch painter of portraits and religious subjects, pupil of J. van Scorel, from whom he learned an Italianate style which he further established in Rome (1532–5). There he made sketches which give important information about the appearance of classical monuments in the 16th c.

Heian. Period in Japanese history (784–1185) when the capital was Heian-kyo (now Kyoto). Japanese art of Early H. known as Konin and Jogan (784-897) was shaped by the esoteric Tendai and Shingon sects derived from Chinese Buddhism and introduced respectively by the monks Saicho and Kukai (d. 835). Painters, generally monks, produced involved, though often finely drawn, mandalas, portraits of Buddhist saints and portrayals of elemental divinities, often in violent colours. Shingon (the True Word sect), an occult branch of Buddhism, encouraged heavily symbolic sculptures, generally in unpainted wood. Later H. (897–1185) is commonly called the *Fujiwara period.

Heizer Michael (1944–). U.S. artist who, like *Smithson, often works on a vast scale (*Complex One/City*, 1972–6). A leading *Earth work artist, H. creates 'negative objects' which are rarely documented. In *Double Negative* he excavated 40,000 tons of earth and rock in 2 sq. miles of desert.

Held Al (1928–). U.S. painter; he studied in N.Y. and Paris. He moved from *Abstract Expressionist canvases in the 1950s to simplified forms and monumental scale. Works like *Ivan the Terrible* (1961) and *B/W XVI* (1968), both acrylic on canvas, are abstract compositions built from schematic geometric forms.

Hélion Jean (1904–87). French painter. He collaborated with Van *Doesburg on the pamphlet *Art Concret* and was a member of the *Abstraction-Création group. He spent several years in the U.S.A. After working under the influence of the Cubists and Mondrian he reverted to representational painting.

Hellenistic. Dating from the time of Alexander the Great's successors (c. 323–c. 50 BC). Such art was produced in a variety of styles, from the baroque to the archaistic, throughout the territories Alexander had conquered, from Egypt to the borders of India.

Helst Bartholomeus van der (1613–70). Dutch portrait painter who worked in Amsterdam and replaced Rembrandt in popular estimation. Although not in the class of Rembrandt or Hals, both of whom influenced his work, H. produced well-composed portrait groups, e.g. *Banquet of the Civil Guard*, 1648.

Henri Robert (1865–1929). U.S. Realist painter who studied at Pennsylvania Academy of Fine Arts and in Paris, and in the 1890s founded the group called 'Philadelphia Realists', later The *Eight; an organizer of the *Armory Show. He was an important and stimulating teacher, encouraging his pupils to seek inspiration in the contemporary scene. Some of his essays and classroom notes were publ. as *The Art Spirit* (1923).

Hepworth Barbara (1903–75). British sculptor. Born at Wakefield, Yorkshire, H. was taught modelling at Leeds Art School and carving, chiefly in Italy. Early works such as *Doves* (stone, 1929) already give an impression of monumental power in repose, close in spirit to Egyptian art. Her work became more abstract and was allied to that of H. *Moore and the painting of her 2nd husband, B. *Nicholson (marriage dissolved). In 1933 she joined the *Abstraction-Création group, Paris, and met Mondrian. She was a member of the Circle Group, London (1935), and joined in the group publ. *Circle* (1937). Her work won far wider recognition after World War II. She was

Hepworth Two Figures 1954-5

awarded the C.B.E. in 1958 and foreign awards include the International grand prix, São Paulo Biennale, 1959. Her drawings include those of surgeons and operating theatres (exhibited in 1947). She also designed sets and costumes, notably for Tippett's opera *The Midsummer Marriage* (1955). Later sculpture experimented in new substances, including sheet-metal, wire and bronze. There was a gain in power without loss of the early nobility, subtlety or flawless rendering of surfaces. Late works include *Icon*, in mahogany, and *Meridian*, a 14-ft (4.2 m.) work in bronze.

Herbin Auguste (1882–1960). French painter in a formal abstract style. He settled in Paris in 1901 and came under Cubist influence before turning to abstraction. He was co-ed. with *Vantongerloo of the magazine *Abstraction-Création. He invented a pictorial alphabet on which he based his compositions, e.g. Composition on the Word 'Rose' (1947) and by means of which he invested forms and colours with verbal symbolism. He explained his alphabet and his colour theories, in part derived from Goethe's, in L'art non-figuratif, non-objectif (1949).

Hering Loy (c. 1485–c. 1554). German sculptor of the Renaissance whose major work is the over-life-size seated figure of St Willibald in Eichstätt cathedral.

Herkomer Sir Hubert von (1849–1914). German-born British painter, opera composer and stage and film-set designer. His paintings include portraits, e.g. of Wagner and Ruskin, and social documentary scenes, e.g. *Hard Times* (1885) and *On Strike* (1891).

Heron Patrick (1920—). British painter. From 1958 he worked regularly in Cornwall, associated with the younger generation of the *St Ives artists. His work is mainly of semi-abstract forms rendered in strong—predominantly red—colours, reminiscent of the late *Matisse *papiers collés, e.g. Manganese in Deep Violet, 1967. In 1955 he published a collection of critical writings, The Changing Forms of Art.

Herrara Francisco the Elder (d. 1656). Spanish painter of religious and genre subjects treated with coarse realism. He worked in Seville and Madrid and from 1611 to 1612 was master of Velazquez. The vigour and free brushwork of his style at its best is seen in *St Basil Dictating his Rule* (1639).

Herrara Francisco the Younger (1622–85). Spanish painter, son of F. H. the Elder and from 1672 court painter and architect at Madrid. He went to Rome to escape his father's brutal treatment and there became famous for still-life paintings. On returning to Spain in 1656 he turned to portraits and religious subjects, imitating contemporary Italian styles.

Herring John Frederick, Sr (1795–1865). British painter. Helped by patrons he rose from stable lad and coach painter to become a successful artist. His coaching and racing pictures are highly valued; his farmyard scenes were imitated by John Frederick (d. 1907) his son.

Hesdin Jacquemart de (d. c. 1410). French miniaturist of Flemish origin. He worked for John, Duke of Berry, decorating several Books of Hours, the most famous being the *Belles Heures*. Subtlety of colour and use of borders with birds and foliage characterize his work. His representation of architecture suggests Sienese influence.

Hesse Untitled ('Three Nets') 1966

Hesse Eva (1936–70). German-born U.S. painter and sculptor, associated with *Bochner, *LeWitt and *Smithson. She did ladder-like structures and loops (*Hang-Up*, 1965–6).

Hesselius Gustavus (1682–1755). Swedishborn American colonial artist who settled in

Philadelphia in 1712. He painted competent portraits and the mythological *Bacchus and Ariadne*.

Heyden Jan van der (1637–1712). Dutch painter and engineer, 1 of the earliest townscape painters in Holland and the first in Amsterdam. He also worked in Cologne. Though very detailed, his views cannot be considered topographically accurate.

Hicks Edward (1780–1849). The greatest of the itinerant, self-taught American folk artists or 'primitives', famous for his versions of *The Peaceable Kingdom* illustrating Isaiah II, with W. Penn signing his treaty with the Indians shown in the background.

Highmore Joseph (1692–1780). British painter of portraits and conversation pieces but more famous for his lively paintings illustrating Richardson's *Pamela*, which compare superficially with Hogarth's *Marriage à la Mode* series. H.'s work, however, lacks the moral and social implications of Hogarth's and has a greater daintiness of execution with French influence.

Hildebrand Adolf von (1847–1921). German sculptor who, like his friend H. von Marees, aimed at a timeless classical purity of form. He publ. his theories on art in *Das Problem der Form* ... (1893; *The Problem of Form* ..., 1907) which influenced Heinrich Wölfflin and the development of art criticism. The Wittelsbach and

Gary Hill Tall Ships 1992

Hubertus fountains in Munich are among his best works.

Hill Anthony (1930–). British abstract artist. He moved from free abstraction to more formal Constructivist works reminiscent of *De Stijl. He is best known for relief constructions made from Plexiglas, aluminium, etc.

Hill David Octavius (1802–70). Scots painter and photographer who collaborated with Robert Adamson in early photographic work, using the paper negative process called calotype. The 2 men enjoyed wide success and by the 1850s their calotyped portraits and views were being favourably compared with Rembrandt etchings.

Hill Gary (1951—). U.S. video artist of international importance. His *Postmodern concerns with perception and language are informed by cybernetics, communications theory, video technology, *Performance and *Conceptual art, and poetry in the U.S.A. since the early 1960s. In his works complex video installations are combined with language, in spoken and written texts, which often allude to French thinkers, like M. Blanchot and J. Derrida, in an interplay between word and image, e.g. Inasmuch as It Is Always Already Taking Place (1990), I Believe It is an Image in Light of the Other (1991–2), Tall Ships (1992), Between 1 & 0 and Learning Curve (both 1993).

Hilliard Nicholas (ι. 1547–1619). The 1st native-born artist of the English school whose work and life are reliably documented. The son

Hilliard Young Man among Roses c. 1587

of an Exeter goldsmith, H. held a warrant as a goldsmith from Queen Elizabeth. His best-known works, however, are miniature portraits of very high quality, invaluable also as lively historical records, e.g. Queen Elizabeth. His style is close to French court art and he visited France in 1577–8. Among his best portraits are Alice Hilliard and Young Man among Roses. The latter closely parallels in visual terms the symbolism of the love-story of H.'s friend Sir Philip Sidney. H. also wrote a treatise on miniature painting entitled The Arte of Limning; *Oliver was his pupil.

Hilton Roger (1911–75). British painter. From 1957 – and permanently from 1965 – he worked in Cornwall, associated with the *St Ives group of artists, doing semi-abstract paintings, e.g. *June* (1953).

Hiroshige Ando Tokitaro called (1797–1858). Japanese artist of the Ukiyo-e school, one of the great masters of the coloured woodcut. He adapted block printing to landscape subjects

Hiroshige Shower on the Ohashi Bridge near Ataka 1857

history painting

being best known for his poetical prints of the Yedo (Tokyo) district and the old high road to Kyoto. His work exerted a powerful influence on the Impressionists and other 10th-c. European artists.

history painting. Alberti, in the 15th c., used the word *istoria* to describe any subject picture with more than 1 figure. In the 17th c., h. p. had come to mean pictures with subjects taken from the histories, that is poetry, history (especially of antiquity) and religion; it was held to be the highest form of art. In the 18th c. Reynolds stated 'a history painter paints man in general: a portrait painter, a particular man, and consequently a defective model'. Scenes of contemporary history in modern dress were only slowly accepted at the beginning of the 19th c.

Hitchcock George (1850–1913). U.S. Impressionist painter who lived most of his life in Holland specializing in Dutch genre subjects.

Hitchens Ivon (1893–1979). British painter. Studied at the St John's Wood School of Art and at the R.A. schools. He belonged to the *London Group and the *Seven and Five Group. He lived most of his life in the heart of the Sussex countryside, and his paintings are concerned with communicating the poetic beauty of his environment. His main influence is Matisse, and whilst his work borders on abstraction, he never divorces himself completely from natural forms.

Hobbema Meindert (1638-1709). Dutch painter of landscape. A period of activity while he was the pupil and friend of J. van Ruisdael ended when H. became an excise officer in 1668. He painted few works after this, but The Avenue. Middelharnis, one of the most popular of all Dutch naturalistic landscapes, is an exception, and is now dated 1689. Neglected and poorly paid in his lifetime, H. was the favourite of English landscape painters and collectors of the 18th and early 19th cs. His quiet scenes lack the dramatic qualities of Ruisdael's. All detail is subordinated to the overall effect. The contrast in colour between the red of a tile roof and greygreen foliage is very typical. Of the many variations of the same subject, The Mill is a fine example.

Höch Hannah (1889–1978). German artist, a member of the Berlin Club *Dada and one of the originators of *photomontage, along with

Höch Dada-Dance 1922

*Hausmann, *Grosz, *Heartfield and *Baader. Her photomontages, e.g. *Cut with the Cake Knife* (c. 1919), are often larger than those of the others and differ in composition. H. used photographs, scraps of text, images of machinery, and assembled heads and bodies – often including portraits of friends and photographs of herself, e.g. *Da-Dandy* (1919).

Hockney David (1937-). British artist who, more than any other British painter of his generation, has enjoyed great international and popular success from the early 1960s. H. studied at the R.C.A., London (1959-62) where he met *Kitaj who influenced him to turn to figurative painting and unashamed use of literary sources. Already while at R.C.A., H. achieved distinction as an engraver with the major series of 16 etchings The Rake's Progress (1961-3) which combined Hogarth's narrative, from his series of the same name, and H.'s experience from his 1st visit to N.Y. He exhibited at the Young Contemporaries (Whitechapel Art Gal., 1962) 4 paintings under the general title Demonstrations of Versatility, painted in different styles and emulating the example of Picasso who was to become the major influence on H.'s development. During 1963-7 he settled in California

which resulted in paintings of Californian subjects, culminating with A Bigger Splash (1967), and an ever-increasing tendency towards naturalism. This was briefly interrupted by a 2nd series of etchings. Illustrations for Fourteen Poems from C. P. Cavafy (1966) and his 1st stage designs for Alfred Jarry's Ubu Roi (Royal Court Theatre, 1966). From 1968 to 1971 he painted a number of double portraits including Mr and Mrs Clark and Percy (1970-1), while in 1969 he executed another series of etchings. Six Fairy Tales from the Brothers Grimm, H. has always drawn profusely: a book, Travels with Pen, Pencil and Ink. was published in 1978. From 1975 he designed frequently for the stage: Stravinsky's The Rake's Progress (Glyndebourne 1975). Mozart's The Magic Flute (Glyndebourne 1978) and 2 triple bills at the N.Y. Metropolitan Opera House (L'Enfant et les sortilèges, Parade and Les Mamelles de Tirésias, 1980-1, and Le Sacre du printemps, Le Rossignol and Oedipus Rex, 1982). Also Tristan und Isolde (1987), Turandot (1991) and Die Frau ohne Schatten (1992). H. has often used photography and since 1980 he has experimented with new technology, using it in complex, Cubist-like photomontages, e.g. Grand Canyon Looking North (1982) and Jardin de Luxembourg, Paris (1985). His work has also been influenced by faxes and xeroxes, e.g. Hotel by the Sea, Tennis and Breakfast with Stanley in Malibu (all 1989). H.'s most recent paintings include Where Now? followed by his group called 'Some Very New Paintings' (all 1992).

Hodgkin Sir Howard (1932—). British painter. II. followed an independent course from the mainstream art movements of the 1960s and 1970s; he has developed his own vocabulary, painting with careful and prolonged deliberation the memory of daily life encounters with friends. H.'s paintings defy distinction between figurative and abstract art, and are intimate, in the tradition of *Vuillard and *Matisse; at times they recall Indian art on which he is an expert. His works, regardless of scale, invite the viewer to enter their theatrical space and are intense and brilliant in colour, and highly physical.

Hodgkins Frances (1870–1947). New Zealand painter whose best work was done in water-colour. From 1900 she lived in Britain and France. Her early work was Impressionist but after World War I she evolved a poetic personal style of landscape and still-life painting which grew increasingly closer to abstraction.

Hockney Henry Geldzahler and Christopher Scott

Hodler Ferdinand (1853–1918). Swiss painter, a precursor of *Expressionism. Deliberately rejecting Impressionism, he developed a precise and expressive linear style which relates to the German Jugendstil movement. He painted landscapes, portraits and large-scale historical and mythological subjects, but his fame rests on his symbolical works such as *Night*, *Disillusioned Souls* and *Towards the Infinite*. The combination of realism and mysticism in these paintings gives him a solitary place among the artists of his time.

Hofer Karl (1878–1955). German *Expressionist painter. He spent several years in Paris and Rome before World War I. His work was condemned as 'degenerate' by the Nazis and he was forced to give up teaching; he was later president of the Berlin Academy (1945–55).

Hofmann Hans (1880–1966). German painter and teacher who settled in the U.S.A. in 1931. He was a friend of Matisse, Delaunay, Braque and Picasso in Paris before World War I. In 1915 he opened an art school in Munich and in 1933 another in N.Y. which powerfully influenced the development of contemporary U.S. painting. His work was representational in the *Expressionist tradition until the early 1940s when he began to develop an exuberant abstract style.

Hogarth William (1697–1764). British painter, engraver and caricaturist whose innovations in art and genius in depicting the English national character give him an importance even beyond his great talent as an artist. H. was trained as an engraver on plate. He studied painting at the rudimentary academies then open in London but undoubtedly profited more from his study

Hohokam

Hogarth Scene 4 (detail) from *Marriage à la Mode* 1745

of European paintings from engravings and his incredible visual memory. Later he apprenticed himself to Sir James Thornhill, marrying Thornhill's daughter in 1729 and inheriting from him the academy which was to be a forerunner of the R.A. H. won an early reputation for small groups and conversation pieces, e.g. Assembly at Wanstead House, and for brilliantly captured dramatic scenes, such as the many versions of The Beggar's Opera. In 1731 he won a far wider fame with the first of his story-series of paintings, The Harlot's Progress. This form was quite new, certainly to secular painting. The series combined the appeal of the street ballad with that of a play, having a strong plot, allusions to contemporaries and a moral none could miss. So popular were the engravings made from this series that H. was forced to defend himself by promoting a Copyright Act before issuing the later series: The Rake's Progress, Marriage à la Mode and The Industrious and Idle Apprentice. Similar in style are the 4 electioneering paintings and the famous O the Roast Beef of Old England. H. campaigned vigorously in his engravings against cruelty, the drinking of crude spirit and the domination of English taste by foreign artists. He undoubtedly suffered as a painter from the prejudice against native-born artists and from his own popularity as a propagandist and caricaturist. In 1753 H. publ. The Analysis of Beauty. This was in part a polemic against uncritical appreciation in the arts and in part a serious contribution to aesthetics, describing a 'line of beauty' supposed to be present in all works of visual art. His history paintings, Pool of Bethesda and The Good Samaritan were ignored, his Sigismunda was abused; even the originals of his famous engravings often remained unsold or were sold for very little. More important, H.'s unusual talent as a portrait painter went unrewarded. Fine examples are Captain Coram, Graham Children, William Jones, Self-portrait with Pug, The Artist's Servants, a masterly study of contrasting character, and the vigorous, charming and technically fascinating Shrimp Girl.

Hohokam. Pre-historic N. American Indian culture, centred on the Gila and Salt rivers, Arizona; it *fl. c.* 400–1400 AD. Its colourful products include remarkable polychrome pottery, animal carvings in stone and quartzite (related in style to Anasazi sculptures) and *cire perdue copper castings.

Hokusai Katsushika (Nakajima Tet-Sujiro) (1760–1849). Extraordinarily prolific Japanese painter and graphic artist, to Europeans the most famous exponent of the colour print, which had great influence on Western painting. He produced his greatest work between 1818–30, *The Wave* being perhaps his best-known print.

Holbein Hans the Younger (1497/8-1543). German artist. H.'s father, Hans H., the Elder, had a large workshop in Augsburg. When this was disbanded, H. and his brother Ambrosius apprenticed themselves to a painter in Basel. H. soon won a wide reputation for his work undertaken for the Basel book printers. Besides designs for wood blocks, he was already painting portraits and commissions for churches. In his larger works a certain awkwardness and overcrowding is noticeable. In 1517 H. visited Lucerne and may have entered N. Italy. Returning to Basel, he married and quickly became a citizen of importance. At this period his fame was spread throughout Europe by the ills to the Luther Bible (1522) and the woodcuts of the famous Alphabet of Death and Dance of Death. Despite this success, H. was driven by

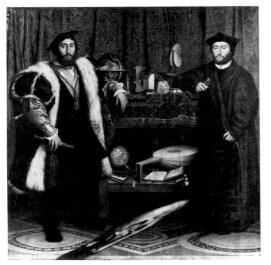

Holzer Selection from The 'Survival' series 1986

Holbein The Ambassadors 1533

doubts of his financial future during the disturbed conditions of the Reformation to seek work in Britain. During his 1st visit in 1526 he was patronized by the circle of Sir Thomas More. He went back to Basel for a period, but was in Britain once more in 1532. His patrons of the 1st visit were disgraced or dead. H. first painted the German merchants of the steelyard and was then introduced to the king. Until his death H. was employed by Henry VIII in a wide assortment of tasks, ranging from designing court costumes, silverware, jewellery and triumphal arches to painting the actual and prospective brides of the monarch. Outstanding among H.'s portraits are the superb Christina of Denmark, George Gisze, The Artist's Wife and 2 Children, Anne of Cleves and his 'showpiece' the double portrait, The Ambassadors. H. made many drawings for portraits and those of the court ladies are among the masterpieces of portrait drawing. Of H.'s other work, his miniature painting is important for itself, e.g. Mrs Pemberton, and for its influence on British miniature painting. H.'s outstanding early works for churches are the Dead Christ and the Madonnas of Solothurn and Darmstadt.

Hollar Wenceslaus (1607–77). Draughtsman and engraver born in Prague; worked in Britain from 1636. His output was enormous and covered a wide range of subjects. His topographical views of London before the Great Fire of 1666 and his works on costume, *Ornatus Muliebris*

Anglicanus (1640) and Theatrum Mulierum (1643), are of considerable historical interest.

Holzer Jenny (1950—). U.S. artist whose work consists of aphorisms and exhortations in signs (electronic, printed or inscribed in stone, etc.) which often appear in public spaces — like the electronic signboard in Times Square in N.Y. H.'s messages or 'Truisms' (1977—9) strongly reflect political, feminist and environmental issues (e.g. 'MONEY CREATES TASTE'), as do her 'Inflamatory Essays' (1979–82) and the 'Living' series (1980—2) which make use of longer texts. The 'Survival' series (1986) consists of 10–ft (3 m.) Unex signs and also anonymous stickers of messages placed on parking meters and public telephones, 1st in N.Y. and then

Hokusai The Wave c. 1820

Homer

in various European cities. Another series, 'Lament' (1987-90), made use of light-emitting diode (LED) signs and corresponding inscriptions engraved on sarcophagi, e.g. '... THE NEW DISEASE CAME. I LEARN THAT TIME DOES NOT HEAL. I DO NOT WANT TO STOP KNOWING ALL MY FACTS.' The major exhibition of her work at the Guggenheim Museum, N.Y. (1989-90), made use of the entire rotonda for which she programmed hundreds of texts into the 535-ftlong electronic message board on the rotonda's spiral, while at entrance level a number of granite benches had messages inscribed on them. In 1990 she became the first woman to represent the U.S.A. in the Venice Biennale.

Homer Winslow (1836–1910). U.S. painter, pictorial journalist and ill. He covered the Civil War for *Harper's Weekly* and achieved recognition as a painter with *Prisoners from the Front* (1866). Between 1867 and 1880 his subjects were broadly treated rural genre scenes, e.g. *Gloucester Farm* (1874) but after a visit to Britain (1881–2) he returned to violent realistic paintings connected with the sea, e.g. *The Life Line* (1884). Later he adopted an Impressionistic watercolour technique.

Hondecoeter Melchior D' (1636–95). Dutch painter notable for his pictures of birds. He studied under his father Gijsbert Gillisz (1604–53), an animal painter, and his uncle J. B. Weenix, and worked at The Hague and Amsterdam.

Hone Nathaniel (1718–84). Irish-born portrait miniaturist in enamel and watercolour who worked in Britain; founder-member of the R.A.

Homer Gloucester Farm (detail) 1874

From 1750 to 1752 he studied in Italy and subsequently painted some large-scale portraits in oils. He satirized Reynolds in a painting entitled *The Conjurer* (rejected R.A., 1775).

Honthorst Gerard or Gerrit van (1590–1656). Dutch painter, trained in Utrecht, but in Rome by about 1610. H. was very popular in Italy, where he was known as 'Gherardo delle Notti' because of his dramatically lit night scenes after Caravaggio (*Christ before the High Priest*). H. was largely responsible for bringing the innovations of Caravaggio to Holland on his return there in 1620. Enjoying an international reputation, he was invited to the English court in 1628 (*Charles I and Henrietta Maria with the Liberal Arts*) and to the Danish court in 1635. As Dutch court painter he painted the Baroque decorations at Huisten-Bosch.

Hoogh or Hooch Pieter de (1629–after 1683). Dutch painter, the contemporary of N. Maes and Vermeer of Delft and, like them, a recorder of scenes of middle-class life. H. is first recorded as 'painter and footman' in the household of a rich merchant. After 1654 he lived in Delft and his art declined when he moved to Amsterdam, c. 1663, and tried to portray a higher stratum of society. Like Vermeer, he was interested in optics and the fall of light. His colour harmonies are simple and very effective. Among his best works are: Courtyard in Delft, Woman Peeling Apples, The Pantry and The Linen Cupboard.

Hoogstraten Samuel van (1627–78). Dutch painter of portraits, genre and religious subjects and architectural fantasies. He studied under Rembrandt in Amsterdam. He was famous for his experiments with *trompe l'æil and perspective illusionism, e.g. his peepshow box.

Hopper Edward (1882–1967). U.S. painter. He was a student of *Henri and showed at the *Armory Show. In the late 1930s he emerged as a major realist painter of the U.S. scene, developing a personal, severe style of depiction and going against the current of European influence and abstraction. His work is formally sharp with harsh contrasts of light and shadow, and despite its figurative content is essentially modernist in spirit, which accounts for his reputation as a master of 20th-c. U.S. art.

Hoppner John (1758–1810). Portrait painter born in Britain of German parentage. He gained sufficient contemporary popularity to rank as Lawrence's chief rival, although his style was

Horn Rebel Moon 1991

based almost entirely on borrowings from other artists including Reynolds, Romney and later Lawrence.

Horlor Joseph (fl. 1834–66). British painter of landscapes and coastal subjects, particularly in the English West Country and Wales. His works enjoyed a collectors' vogue from the late 1960s.

Horn Rebecca (1944—). German sculptor, *Installation, *Performance, *action and video artist, and film maker in whose work 'themes of human vulnerability, emotional fragility, and desire pervade the narrative that binds each of her separate productions.' In her sculptures, installations and films the body interacts

Hoogh Courtyard in Delft 1658

ritualistically with the environment and becomes transformed, e.g. the large-scale Performance *Head Extension* (1972), which she also filmed, and the film *Berlin Exercises: Dreaming Under Water* (1974–5). In *Overflowing Blood Machine* (1970) the body and the machine merge, illustrating the common theme in II.'s work. She has

HopperEarly Sunday
Morning 1930

Hornebolte

also frequently used animal imagery in such works as Unicorn (1970), Kiss of the Rhinoceros (1989) and Drunken Beetle (1991-3). H.'s films and performances, using sculptural and *Kinetic devices, are often autobiographical narratives and memory fantasies which combine *Bauhaus. *Constructivist and *Kinetic references, creating an individual poetic discourse, e.g. a collaboration with *Kounellis (1986) in Vienna's Theater am Steinhof, the site of an insane asylum, The Concert in Reverse (1987), a site-specific Installation at Münster, and the film Buster's Bedroom (1991). In 1993 a major retrospective of H.'s work was held at the Solomon R. Guggenheim Mus., N.Y., which included a temporary, site-specific Installation, Paradiso, in the museum's rotunda and the lobby, and Inferno, in the Guggenheim Museum, SoHo. Called The Inferno-Paradiso Switch, it alluded to Dante's Divine Comedy.

Hornebolte Lucas (c. 1490/5–1544). Born in Ghent, he and his family settled in Britain in 1525. They were the leading exponents of the Ghent-Bruges school of illuminators. H. was a court painter under Henry VIII for almost 20 years; also painted portrait miniatures and taught Holbein. He is considered to be the founding father of the British miniature. 23 extant miniatures are attributed to H., and they are mostly portraits painted ad vivum with no preliminary drawing, a feature that was to be the essence of the British *limning tradition.

Hoskins John (c. 1595–1665). British portrait miniaturist. His early style derives from Hilliard. He became famous for miniature copies of Van *Dyck's portraits.

Houbracken Arnold (1660–1719). Dutch painter remembered as the author of *Du groote Schouburgh* ... (1718–21), an important source of information about 17th-c. Dutch and Flemish painters despite its inaccuracies. His son Jacobus (1698–1780) was a portrait engraver.

Houckgeest Gerard (c. 1600–61). Dutch painter who worked in Delft. He specialized in church interiors.

Houdon Jean-Antoine (1741–1828). French sculptor who studied under J.-B. Pigalle and J.-B. Lemoyne and worked in Rome from 1764 to 1768; there he came under the influence of J. J. *Winckelmann and his circle. For some time he followed the style of late Baroque sculpture but gradually adopted the colder manner of

Neoclassicism. His best and most numerous works are portraits, which include busts of Diderot, Rousseau, Voltaire and George Washington.

Hours, Book of. *Book of Hours

Hovenden Thomas (1840–95). Irish-born U.S. painter of the *Pont-Aven school. H. painted historical and genre subjects, often large-scale, colourful and sentimental pictures of Breton peasants and of Americans from the Civil War period.

Hoyland John (1934—). British painter. After studies at Sheffield College of Art (1951–6) and the Royal Academy Schools (1956–60), his work became oriented towards U.S. *Colorfield painting following the 1956 Tate Gal. exhibition 'Modern Art in the USA'. From 1964 he made frequent visits to the U.S.A., often for extended periods, working and teaching. He met *Frankenthaler, *Louis, *Motherwell, *Noland, *Olitski and the critic *Greenberg who introduced him to the work of *Hofinann which had great impact. H. has been the most prominent British Color-field painter, often using thick impasto and brilliant colours, predominantly red and green.

Hoysala. Medieval Indian dynasty of Mysore (c. 1110–1327). The Keshava temple at Somnathpur (late 13th c.) is characteristic of H. architecture with star-shaped plan, fine filigree sculptural decoration and flat roofs. Other classic sites are at Belur and Halebid. H. sculpture includes a renowned *stele* (stone slab) of the elephant-headed Hindu god Ganesha and sculptures of the sun god Surya and of Durga.

Hsia Kuei (fl. 1180–1230). Chinese landscape painter, with *Ma Yuan originator of the classic S. *Sung style. H. K.'s style is generally vigorous using stabbing brush-strokes to produce bold, atmospheric effects.

Huaxte. Mexican *Pre-Columbian culture *fl.* AD 900–1519. The H. produced large limestone sculptures and pottery decorated with black designs on a cream base.

Huber Wolf (c. 1490–1553). German painter, draughtsman and woodcut artist who, after Altdorfer, was the most important member of the *Danube school. He worked in Regensburg and Passau. Few paintings by him are known and it is in his woodcuts and drawings that his lyrical approach to landscape can best be seen.

Hudson Thomas (1701–79). British portraitpainter, son-in-law and pupil of J. Richardson the Elder and master of Reynolds. His sound, conventional work was popular before the rise of Reynolds.

Hudson River school. Name loosely applied to a number of 19th-c. U.S. Romantic land-scape painters who worked mainly, though not exclusively, in the vicinity of the Catskill Mountains and the Hudson River. They were never an organized group but shared a sense of wonderment at the grandeur of the newly discovered U.S. landscape. Painstaking attention to detail is a common feature of their style. *Bierstadt, *Church, *Cole and *Doughty are among the many representatives of the school.

Huebler Douglas (1924—). U.S. *Conceptual artist who, since 1971, has been working on a series which aims to photograph 'everyone alive'. *Variable Piece 28*, 1970, consists of 23 photographs of a child and H.'s statement. 'I painted till 1961. ... As the painting had become an "object", I went "off the wall" and began making constructions. ...'

Huet Jean-Baptiste (1745–1811). French painter (of animal and pastoral subjects) and engraver, pupil of J.-B. Leprince. He designed for Gobelins and Beauvais tapestries, following the style of Boucher.

Huet Paul (1803–69). French Romantic landscape painter and engraver, influenced by Delacroix, Constable and Bonington.

Hughes Arthur (1832–1915). British painter of the later phase of *Pre-Raphaelitism. His best-known paintings date from the 1850s and include *April Love* and *The Eve of St Agnes* (both

1856). H. also completed book ills for Christina Rossetti's *Sing Song* (1872); he died a recluse.

Huguet Jaime (fl. 1448–87). Spanish painter of the Catalan school who worked in Barcelona. Not only were his paintings influential in Spain but, through exporting altarpieces to Sardinia, he was responsible for the development of a Catalan school there. His figures are elongated and sumptuously clothed with rather similar lean sad features. Extensive use of gold paint also characterizes his work.

Hundertwasser Fritz (1928–). Austrian painter who studied at Academy of Fine Arts, Vienna. At 1st influenced by Surrealism, H. developed a more abstract style, but his pictures usually include figurative references, in the tradition of Klimt and the painters of the Sezession.

Hunt Richard (1935—). African-American sculptor and print maker whose early influences include *Gonzáles and who studied at the Art Institute of Chicago. Highly distinguished as one of the U.S.A.'s major *abstract sculptors of welded metal, steel, aluminium, copper and bronze. His work — including major public commissions, e.g. Freedmen's Column, at Howard University, Washington — although abstract, suggests organic and figurative forms.

Hunt William Holman (1827–1910). British painter who, with D. G. Rossetti and J. E. Millais, founded the *Pre-Raphaelite Brotherhood and alone remained faithful to its principles. He visited Palestine to obtain the correct settings for *The Scapegoat* (1856). H. painted the famous *The Light of the World* (1854). His unpretentious portraits and small landscapes have considerable realistic force.

Holman Hunt The Scapegoat 1856

Hunt

Hunt William Morris (1824–79). U.S. painter. At first associated with the *Düsseldorf school, he then went to France where he worked with the *Barbizon painters. From the mid-1850s he popularized their style in the U.S.A.

Huysum Jan van (1682–1749). Dutch flower painter who imitated nature with unequalled virtuosity; he worked in Amsterdam. He used a higher range of tones in his elaborate compositions than any Dutch flower painter before him and was responsible for introducing light backgrounds. He had many imitators, above all his brother Jacob (1687–1740) who, working in Britain from *c.* 1721, marketed Jan's work as his own. Their father Justus (1659–1716) was also a flower painter.

Hyper Realism. *Super Realism

Hypnerotomachia Poliphili. One of the world's most remarkable books; written (1467) by F. Colonna. The 1st ed., using F. Griffo's 3rd roman fount, was printed in 1499 by Aldus Manutius in Venice, with 200 woodcuts by an unknown artist, and is in itself the most famous illustrated incunabulum. It is an obscure allegorical narrative, written in a mixture of languages including Italian, Greek, Latin and Hebrew, and telling of a dream journey through the realms of Art and Free Will. The numerous detailed architectural descriptions are partly fantasy and partly derived from a knowledge of classical architecture. Colonna particularly delighted in the descriptions of ruins and decay, symbols of the impermanence of human life. These imaginary monuments were an endless source of themes to Renaissance painters, sculptors and engravers.

I

icon (Gr. image). Religious picture used as an object of worship and often portraying the Virgin and Child. The term is particularly used of pictures of the Byzantine school and later of the Russian school. Russian i.s show clear derivation from Byzantine art and maintained a stylized convention of composition and posture. The works of such artists as *Rublev and his school, to which is ascribed the *Old Testament*

Icon The Virgin of Vladimir (Byzantine) 13th c.

Trinity, show the range of emotional and artistic expression possible in this form. In later Russian i.s the painted figure was often surrounded by a halo of precious metals and stones. An iconostasis in a Greek Orthodox church is a screen covered with i.s, usually between the congregation and the altar.

iconography. Art historical term describing the investigation of ideas and subject matter in art, associated with the method used by *Panofsky, *Saxl and *Warburg.

iconology. Term used by *Panofsky for the investigation of general meaning of works of art in their historical and cultural contexts.

Ife. A town in W. Nigeria, traditionally the spiritual centre of the Yoruba people, where a number of very beautiful terracotta heads and remarkable brass heads have been discovered since the beginning of the 20th c. These have been tentatively dated to the 12th to 14th cs. I. art is naturalistic and reveals an extremely high standard of accomplishment. It has therefore been compared with Greek statuary, but there is no evidence that it was not completely indigenous. The art of brass-casting was probably passed on to the people of *Benin in the 14th c.

illumination. The decoration of mss, one of the most common forms of medieval visual art:

because of its monastic origins, usually of religious texts. The practice extends from heavy decorations of initial letters and inter-woven margin patterns (as in Celtic examples) to miniatures and full-page ills, often of a formal and grandiose kind (as in Byzantine mss). Rich colours are a common feature, in particular a luxurious use of gold and silver. I. survived the advent of printing for some time and only died out with the rise of printed illustration in the 16th c. Well-known examples are: The *Book of Hours, The Book of Kells, The Lindisfarne Gospels, The Luttrell Psalter and Les Très Riches Heures du Duc de Berry.

Illusionism. Term used in painiting of a style which exploits all the technical procedures of perspective, etc., not merely to represent 3-dimensional space in 2 dimensions but rather to give the impression that the pictorial space is an extension of the real space; sculptured 3-dimensional figures are often integrated into paintings to heighten the fusion of real and artistic space. The term is especially used of Baroque art.

imago pietatis (Lat. image of piety). Representation, especially in the late Middle Ages, of the dead Christ standing in his grave, sometimes supported by other figures. Emblems of the Passion are often included to stress the redemptive significance of his suffering.

impasto. In oil painting, thick heavy application of paint. Where the stockes of the brush or palette-knife are very pronounced, causing the paint to stand up in relief, the term loaded i. is used.

Impressionism. The major movement in 19thc. art. The name comes from a painting exhibited by C. Monet in 1874, catalogued as Impression Sunrise. The word was used as a label for the whole group of artists who exhibited as the 'Society of Painters, Etchers and Engravers'. It has been said that I. was not a style but a moment in time. Nevertheless, the term is applied most frequently to paintings where the artist has aimed to capture the visual impression made by a scene, usually of a landscape, and not make a 'factual' report on it; Impressionist painters are characteristically absorbed by the play of light on a scene. In a sense an Impressionist picture is the sketch as opposed to the finished picture; in Monet's own words 'a spontaneous work rather than a calculated one'.

The 1st Impressionist exhibition was in 1874, but Impressionist works had been seen in the Salon des Refusés in 1863. The 1860s were the formative years in which the possibilities of working in the open air, using a light palette, and close analysis of the actual colours in landscape were explored. Monet, Renoir and Sisley were students together and formed the most close-knit group. In the 1870s the group experienced much opposition, and their exhibitions were generally unsuccessful. The Impressionist painters were divided as to who should exhibit, Degas arguing that work by conventional painters would make the exhibitions more accessible to the general public. Manet never exhibited with the Impressionists although his work strongly influenced them. Their interest in the effects of light on landscape was not at first acceptable, nor was the time of day they chose to paint – clear sunny afternoons, as opposed to scenes of twilight or early morning. In the 1880s these subjects had become more general, and the movement achieved slow recognition and success. But I. became less coherent and less of a common style: Monet continued to analyse his visual perceptions with extreme care, and Sisley continued to paint landscapes; but Renoir turned to a style which stressed line, became accepted as a portraitist, and began to paint many important figure paintings, especially nudes. C. Pissarro came under the influence of Seurat's *Divisionist theory, and exhibited works in this style from 1886, the year of the last Impressionist exhibition, at which Seurat and Signac also showed work. Other Impressionists include J.-F. Bazille, G. Caillebotte, M. Cassatt and B. Morisot.

I. became widely accepted as an artistic style from the late 1890s, spreading through Europe. No sculptor was directly associated with the movement, but both Degas and Renoir did sculpture (Renoir at the end of his life working through an assistant). Rodin has been called Impressionist because of the interest he took in the effects of light on his sculpture, and Medardo Rosso's evocative technique has caused his work to be so called.

Indépendants Salon des. *Salon

Independent Group. Group of British artists, architects and art critics (among them R. *Hamilton and *Paolozzi) who met for discussion at the I.C.A. (Institute of Contemporary Arts) in London in the middle and late 1950s. The I. G. was responsible for

Indiana

the birth of British *Pop art, with its romanticization of U.S. mass-culture.

Indiana Robert (1928—). U.S. painter associated with 1950s N.Y. *Hard-edge, New Realist painting and 1960s U.S. *Pop art. His work reflects the influence of *Demuth and advertising techniques, and includes the 20 ft (6.1 m.) *EAT Sign*, 1964 New York World Fair; *LOVE* paintings and sculpture (1966).

Ingres Jean-Auguste-Dominique (1780–1867). French painter and draughtsman. After the Academy of Toulouse he entered the studio of *David in 1797, and later the École des Beaux-Arts, Paris. In the Salon of 1806 his portrait of Napoleon I on the Imperial Throne created a stir and received adverse criticism which he had to suffer from critics most of his life. During a difficult period after the downfall of his patrons, the Bonaparte family, portrait drawings became the main source of income and he lived in Italy for a time. He returned to Paris, was elected to the Academy (1825) and was able to open a successful atelier; by the 1840s he was a celebrated public figure and eventually became a Senator. I. was the painter of an ideal reality. He sought to reconcile a searching truth (expressed in the silhouette, relief-like modelling, purity of line and perfection in craftsmanship, strongly influenced by the Italian schools and David), with

Ingres La Grande Baigneuse 1808

the inescapable Romanticism of his time. His most famous paintings are *La Grande Baigneuse* (1808), *La Grande Odalisque* (1819) and *Le Bain Turc* (1864). Though he had many pupils he had no significant followers until Degas reinterpreted his classical draughtsmanship.

Inkhuk. *Vkhutemas

Innes James Dickson (1887–1914). Welsh landscape painter, pupil of Wilson Steer at the Slade School, London, and friend of Augustus John; exhibitor at the N.E.A.C. From 1910 when he painted *The Waterfall* his work began to show a Post-Impressionistic sense of design and intensity of colour.

Inness George (1825–94). U.S. landscape painter who made several visits to Europe where he studied the paintings of Corot and the *Barbizon school. His work showed a gradual loosening of his early attachment to the *Hudson River school in favour of these European influences.

Installation art. Multi-media, multi-dimensional and multi-form works which are created temporarily for a particular space or site either outdoors or indoors - in a museum or gallery (*Environmental art). Installations only exist as long as they are installed, but they can be recreated in different sites. The works are perceived 'in time' as they cannot be looked at like traditional art objects, but are experienced in time and space, and are interactive with the viewer. Although installations have as long a history as modern art, with pioneering works by *Duchamp, *Schwitters and other *Futurist, *Dada and *Surrealist artists, it is especially since the 1960s that I. a. has been more prominent (e.g. *Beuys) with many of the most important younger artists turning to this form post-1980. Increasingly, galleries and large exhibitions in museums include, or are wholly devoted to, installations, e.g. the Venice Biennale, the annual Documenta exhibition in Kassel. Germany and the Carnegie International in Pittsburgh, Pennsylvania, U.S.A. Artists who have created prominent works include *Acconci, *Baumgarten, *Bloom, *Boltanski, *Buren, *Christo, *De Maria, *Gober, A. *Hamilton, *Holzer, *Kabakov, *Kosuth, *Kounellis, *Kruger and *Turrell. *Happenings and *Performance art.

intaglio. Method of printing in which the design is incised on to a copper or zinc plate;

the block is inked and the surface cleaned so that the ink is retained only in the incised lines. Block and paper are then passed through a copper-plate press and the paper picks up the design as the heavy rollers force it into the incisions in the block. *engraving.

intarsia. A type of marquetry popular in Italy during the 15th and 16th cs. Both Florence and Venice were renowned for i. depicting, notably, architectural perspectives and still-lifes. Uccello and Piero della Francesca are known to have made designs for use by *intarsiatori*, the practitioners of the craft.

International Gothic. Sophisticated late Gothic style of painting which spread through Europe in the late 14th and 15th cs. It is a decorative linear style with its origins in French Gothic art, particularly ms. illumination, and is characterized by refined and elegant figures, graceful curves of drapery, jewel-like colour and naturalistic detail. Examples include Melchior Broederlam's Dijon altarpiece, which owes a good deal to the Sienese influence of Simone Martini, who worked at Avignon; also from Burgundy is the ms. Les Très Riches Heures ... by the *Limbourg brothers. In Italy I. G., which was highly developed in the work of Gentile da Fabriano and Pisanello, existed simultaneously with Masaccio's new realism. The style also flourished in Germany, Bohemia and Spain. A variant on I. G. found in German painting and sculpture is known as the soft style characterized by softly flowing drapery and a sweetness of sentiment which found particular expression in the representation of the Madonna and Child (Schöne Madonnen).

Intimism. Term invented to describe the type of painting of domestic interiors executed by *Bonnard and *Vuillard.

Ipousteguy Jean (1920—). French sculptor and graphic artist. He is noted particularly for his 'sculptural landscapes' in concrete, e.g. *Alexander in Front of Ecbatana* (1965).

Isabey Jean-Baptiste (1767–1855). French portrait painter and miniaturist; pupil of *David. His son Louis-Gabriel-Eugène 1. (1803–86) was a painter and engraver whose romantic landscapes and seascapes connect him with the *Barbizon school.

Isenbran(d)t Adriaen (d. 1551). Painter of the early Netherlandish school who worked at

Bruges; follower of G. *David. The altarpiece Our Lady of Seven Sorrows is the chief work attributed to him but he is better known for small panels such as The Rest on the Flight and The Magdalen in a Landscape.

Islamic art reflects the powerful influence of the Islamic faith and is essentially a religious art. Decoration is a fundamental element that has been tirelessly and ingeniously elaborated upon since the founding of the Moslem religion in the 7th c. AD which forbade the portraval of living creatures. After the death of Mohammed (632), the Umayvad family ruled the Islamic empire (c. 650-c. 730) which contained Egypt, Syria, Persia and Mesopotamia, and the Islamic civilization was founded. Craftsmen from these lands combined their skills but their differing traditions produced an architecture of a somewhat eclectic style that only developed and established its form during the rule of the Abbasid family (c. 730-c. 700). Under this new dynasty there was considerable creative and intellectual advancement: the distinctive elements of I. a. began to emerge such as the decorative arabesque and rosette motifs which, among others, later influenced Renaissance art: Moslem craftsmen excelled in

Islamic art The Angel Gabriel (illuminated ms.)

architecture using such designs to emphasize structural beauty, most notably in the unique character of the mosque. A tradition of highquality pottery and porcelain also developed and was influenced particularly by Chinese porcelain which reached Persia via the trade routes. Elements of many other cultures influenced the development of I. a. chiefly: Mesopotamian and Persian, Mughal, Turkish and Egyptian. Islam also became established in N. India from c. 700 and it was under the Mughal rulers that Moslem art in this region reached its peak. The Tai Mahal is perhaps the best-known example of Islamic architecture in India. During the 15th and 16th cs the Ottoman Turks ruled over the majority of the Islamic world which incl. Greece, the Balkans, Egypt and Syria, Mesopotamia and most of N. Africa. The enlightened rulers of these empires encouraged artistic development to such an extent that the period is considered one of the greatest in I. a. Both design and the harmonious use of colour flourished and were used to great effect in pottery and especially in the weaving of fine fabric, particularly carpets. The earliest Islamic paintings date from c. 1500. a tradition cultivated by the Mughal rulers and strongly influenced by Persian miniature techniques. Typical paintings of the genre depict court and hunting scenes, and use varied and brilliant colour combined with a technical perfection. *Mesopotamian art.

Israëls Jozef (1824–1911). Dutch painter of Jewish parentage who worked at The Hague and was known as 'the Dutch Millet'. He painted the poverty-stricken peasantry, particularly fishermen, with compassionate realism.

Itten Johannes (1888–1967). Swiss painter and teacher of the art of colour. I. began to study under Adolph Hölzell in Stuttgart, 1913, later moving to Vienna where he ran his own school for several years. In 1919 he joined the staff of the Weimar *Bauhaus where he formed an association with *Albers, *Klee and *Kandinsky. Many of the theories formulated by I. during his long teaching career were published in *The Art of Color* (1961) which still remains one of the most important textbooks on colour.

Ivanov Alexander Andreyevich (1806–58). Russian painter mostly of religious subjects, influenced by the *Nazarenes in Rome where he spent most of his life. His main work, other than drawings, is *Christ's First Appearance to the People* (1833–55).

ivory. The elephant or walrus tusk has been used for carving since palaeolithic times. It is one of the most durable of all materials and lends itself to a variety of techniques, relief, entire carvings and to the most subtle and intricate interweaving of shapes. It has been employed equally for ornamentation and use at all times, and there exist boxes, brooches, chessmen, combs, pendants, as well as statuettes, altarpieces, etc.

Although most naturally lending itself to miniature work i. has been used for the colossal chryselephantine (gold and ivory) cult statues in Greece, the most famous of which were those of the Zeus at Olympia and the statue of Athena by Phidias in the Parthenon on the Athens Acropolis. It was also used as a decoration for large objects, notably, e.g. the throne of Archbishop Maximian at Ravenna.

Ivories were the predominant form of Byzantine sculpture and the dispersal of Byzantine ivories in W. Europe was an important vehicle of cultural influence; Carolingian and Romanesque work produced further outstanding examples in the medium. The high period of medieval Europe an i. carving was during the 9th—11th cs; superb pieces from other cultures include the carvings from African centres such as *Benin and *Ife.

J

Jack of Diamonds. *Knave of Diamonds

Jackson A(lexander) Y(oung) (1882–1974). Canadian painter, one of the *Group of Seven.

Jacob Max (1876–1944). French poet and artist, a friend of *Apollinaire and *Picasso in the early days of *Cubism.

Jacquemart de Hesdin. *Hesdin

jade. Properly the term refers only to nephrite, a silicate of lime and magnesia, but it is more often extended to include jadeite, a silicate of sodium and aluminium, and further to any stone that resembles nephrite in its hardness, translucency and colouring (light green, bluish, white and even ochre). It is a stone laboriously difficult to work, but its tactile and visual beauty have recommended it since prehistory to the

Chinese, Maori and pre-Columbian American cultures; the archaic Chinese products – ritual implements, emblems of rank, ornaments and small figures in the round – are best known. The Chinese *Ch'ing dynasty produced fine examples.

Jaenisch Hans (1907—). German painter and sculptor. He represents animal and human figures in an archaic-symbolic style in which there is a quality of sly humour.

Jain miniature painting. School of art in Gujarat, W. India, ill. Jain religious scriptures. Flat colours were used against red or (from c. 1500) blue grounds; faces were shown in profile but with both eyes. Painting was on palm leaf up to c. 1350, paper after c. 1400. Persian art and *Mughal miniature painting were influential.

Jamesone George (d. 1644). Scottish portrait painter by tradition supposed to have studied under Rubens. He worked in Edinburgh in a style similar to that of C. Johnson in England.

Janco Marcel (1895–?). Rumanian painter, member of the Zürich Dada group and propagandist of contemporary art in Rumania in the 1920s and 1930s. He settled in Israel and was founder of the artists' village Ein Hod.

Janssens van Nuyssen Abraham (d. 1632). Antwerp painter of religious, mythological and allegorical subjects in an Italianate style close to Bolognese classicism, e.g. *Scaldis and Antwerpia* (1600). His later work was influenced by Rubens.

Japanese art. The earliest Japanese sculptures are the haniwa tomb figurines (c. 4th-7th cs). Buddhism, formative in subsequent J. a., was introduced in the 6th c. (Asuka). Chinese influence dominated and continued during the Nara and Early *Heian periods (7th-9th cs) but during the *Fujiwara age Chinese-style painting (kara-e) was joined by the still derivative but more colourful Japanese style (yamato-e) and the Japanese technique of jointed sculpture, yosekitsukuri. In 1192 the administrative capital was moved to Kamakura (300 miles (480 km.) from imperial Kyoto). Zen Buddhism influenced the arts increasingly, notably in the monochrome ink painting (sumi e) in part derived from the Chinese *wen-jen style. The restrained style of the *Muromachi period was supplanted in the late 16th-c. *Momoyama age by gorgeous colours often embellished with cut gold leaf (kirikane). The court style of the Tokugawa shogunate (1616-1868), set by the *Kano

school, was less vigorous than the popular *Japanese prints. Japanese landscapes and narrative are generally on room screens or sliding panels, hanging scrolls (*kakemono*) or scrolls designed to be unrolled as the narrative progresses (*makimono*).

Japanese prints. Probably influenced by the Chinese 'stone prints', certain early 18th-c. Japanese artists began producing brightly coloured wood-block prints on city life and actors and scenes from the *kabuki* theatre. Considered ephemeral and vulgar they were called *ukiyo-e*, 'pictures of the floating (fleeting) world'. However, prints by *Harunobu, *Hiroshige, *Hokusai and *Utamaro had considerable influence on late 19th-c. European art.

Iawlensky Alexei von (1864-1941). Russian painter, trained at a military school in Moscow; he studied at St Petersburg Academy (1889) and then in Munich (1896) under Azbe as a fellowstudent of *Kandinsky. While in France during 1905 he was deeply impressed by Matisse's free use of colour. In 1909 he joined Kandinsky's New Artists' Association in Munich. His early work (1911-14) reveals a Kandinsky-inspired interest in the expression of feeling through brilliant colour and violent execution, but in his mature work, e.g. Head (1935), forms are controlled with a Cubist sense of structure and the image has a deeper icon-like mysticism. He exhibited with Feininger, Kandinsky and Klee (Der *Blaue Vier in 1924), but mostly worked in isolation at Wiesbaden, where he died.

Jenney Neil (1945–). U.S. sculptor and painter associated with *Postmodern representational work which strongly echoes political, social and environmental concerns. In the 1970s J. looked back to the U.S. tradition of 19th-c. Realist painters, esp. to the *Hudson River school, e.g. The Modern Era (1971–2). His work became more overtly concerned with the destruction of landscape, e.g. Acid Story (1983–4) and Venus from the North (1987).

Jode the Elder, Pieter de (c. 1570–1634). Flemish engraver, pupil of H. Goltzius. His son Pieter the Younger (1606–after 1674), also an engraver, worked in Britain reproducing paintings by Rubens and Van Dyck.

John Augustus Edwin (1878–1961). Welshborn painter and draughtsman. J.'s brilliant gifts as a draughtsman attracted attention when he was a student; he also corresponded to the

Augustus John Madame Suggia (detail) c. 1923

popular idea of the artist as a Bohemian; in his youth he lived with gypsies and led an unconventional life. He owed much to the study of the old masters and to 19th-c. French painters, but established a style of his own, striking and spontaneous if not deep. Paintings of his wife

Gwen John Self-portrait c. 1900

Dorelia, the *Madame Suggia* (c. 1923) and the portrait of Bernard Shaw (c. 1914) assure him a place amongst British portrait painters.

John Gwen (1876–1939). Welsh-born painter. She studied at the Slade School, where she was influenced by Ambrose McEvoy, then in Paris, where she settled from 1898, working in Whistler's studio and later in close friendship with Rodin and the poet Rilke. She became a Catholic, and associate of Jacques Maritain. J. developed in almost complete isolation a sheltered and refined art. Self-portrait (c. 1900) and the later Portrait of a Nun are sensitive to an extreme in their response to character and their subtle tonal relationships.

Johns Jasper (1930-). Leading U.S. painter, sculptor and print maker. In the 1950s associated with *Rauschenberg and U.S. *Pop art but always using the rich painterly techniques of *Abstract Expressionism. J. at 1st used ordinary objects in his paintings or cast as sculptures, e.g. Flag (1955), Target with Plaster Casts (1955). His paintings, usually made in encaustic and oil, are collaged and built up in relief. The representation of subject matter such as flags, numbers, targets, maps of the U.S.A., colour and number charts is cool and objective, yet personal, ironic and ambiguous e.g. Gray Numbers, 1958. In the late 1950s and '60s his works became increasingly freer and he eventually reduced recognizable representation in many works but without lapsing into abstraction, e.g. According to what (1964) and Harlem Light (1967). These works often incorporated found objects (rulers, brooms, brushes, etc.) as well as stencilled letters and body prints. From 1972 on J.'s work developed even further in this direction with paintings which do not make any use of recognizable subject matter and yet convey a quality of representation unlike most abstract art, e.g. Scent (1973-4) and Weeping Women (1975). Since about 1974, J.'s work has taken a new turn becoming interestingly enriched through complex allusions to the work of Grünewald, Munch, Cézanne, Picasso, Duchamp, etc., and to images from his own earlier paintings. J. has also worked extensively in silk-screens and lithographs.

Johnson or Janssens Cornelius (1593–1661). Portrait painter of Flemish parentage born in London, where he worked until 1643, when he left for Holland. His popularity waned after Van Dyck's arrival in Britain in 1632 and his

style, previously very similar to that of D. Mytens, increasingly showed the influence of Van Dyck. In Holland his work deteriorated.

Johnson (Jonathan) Eastman (1824–1906). U.S. genre and portrait painter. He studied in Düsseldorf and worked for some years in Holland before returning to the U.S.A. in 1855. He was a successful portraitist but is best known for his American genre scenes, e.g. Corn Husking in Nantucket. He painted Indian and Frontier life in Wisconsin and the life of the blacks in the Southern states.

Johnson Joshua (fl. 1795–1825). The first professional African-American portrait painter to be documented, although his background and attribution of works are disputed. J. was self-taught and worked in Baltimore.

Johnson Ray (1927–95). U.S. artist, best known since the early 1950s for his 'mailart' and *collages. J. is one of the most original artists of U.S. *Pop art, using letters, postcards, photographs and portraits of 'high' and 'low' culture personalities like Elvis Presley, Mondrian, Virginia Woolf and Shirley Temple. His work is both playful and surprising, fusing life and art, and raising questions about both.

Johnson Sargent (1887–1967). African-American sculptor and print maker active on the

Johns Target with Plaster Casts 1955

West Coast of the U.S.A. His most productive period was in the 1930s when he used a wide variety of materials, including copper, for his masks derived from *Ife and *Benin sculptures. He executed a number of *W.P.A. projects. His large figures of Incas on llamas (8-ft (2.43 m.) high) were made for the Treasure Island, San Francisco.

Iohnson William H. (1901-70). African-American artist considered today to be one of the most important of his generation. He travelled extensively and absorbed in his oils, watercolours, drawings, prints and ceramics elements from the diverse cultures of N.Y., North Africa and Europe. His style ranged from the self-consciously naive to academicism. *Impressionism, *Fauvism, German *Expressionism and *Cubism. Married to Holcha Krake a Danish artist, he lived for several years in Denmark, before and after his wife's death. From 1945 he painted a series of social, historical and political narrative panels depicting African-American imagery. Soon after these were exhibited with great success in Copenhagen, he became mentally ill. He spent the last 23 years of his life in obscurity, in a mental hospital on Long Island.

Jones Allen (1937—). British artist prominent in early 1960s *Pop art, his subjects generally coming from 1940s U.S. culture. His sometimes commercial technique includes use of acrylic paints. Banal sexy images of intense, even '3–D.' reality, highlight J.'s preoccupation with the dichotomy between the realism of picture details and the unreality of picture space.

Jones David (1895–1974). Anglo-Welsh writer and painter. His reputation is based largely on *In Parenthesis* (1937), on his experiences as an infantryman in World War I, and *The Anathemata* (1952), an epic poem on the Christian concept of sacrifice and the Catholic belief in its re-enactment in the Mass.

Jones Lois Mailou (1905—). African-American painter, ill., textile designer and teacher. Born in Boston, she received her initial education in art at the Boston School of the Museum of Fine Arts which, however, turned down her application for a graduate assistantship in 1927 on racial grounds. In 1937 she went to study in Paris and has returned frequently since. After 1st working in North Carolina, she joined the faculty of Fine Arts, Howard University, Washington, where she became associated with

Jongkind

Lois Mailou Jones Les Fétiches 1938

the Harmon Foundation. She remained there until her retirement. As an artist J. was one of the 1st African-American women painters to depict African imagery, e.g. *Les Fétiches* (1938). Her output ranges prolifically from her African-inspired works of the early 1930s to landscapes, cityscapes and figures (1937–51). Since 1960 she has depicted Haitian scenes and returned to African themes. In 1973 the 1st major retrospective of J.'s work was held.

Jongkind Johan Barthold (1819–91). Dutch land- and seascape painter and engraver who worked mainly in France and was a leading pioneer of Impressionism and *plein air painting. He was interested in capturing the transitory effects of light and preceded Monet in depicting the same scene under different atmospheric conditions.

Joos van Cleve (Joose van der Beke) (c. 1480–1540). Flemish painter identified with the Master of the Death of the Virgin. He worked in Antwerp and for Francis I in France, painting portraits and religious subjects. The dispassionate realism of his portraits owes something to the influence of Quentin Massys, but wide stylistic differences are apparent in his work as a whole.

Joos van Gent (Joose van Wassenhove) called 'Justus of Ghent' (fl. 1460–80). Flemish painter

influenced by Bouts and Van der Weyden, and active in Antwerp and Ghent before going to work at the court at Urbino. His works include Adoration of the Magi, Crucifixion and Last Supper.

Jordaens Jacob (1593–1678). Flemish painter working in Antwerp. He collaborated with Rubens on at least 2 pictures and was greatly influenced by him. His paint is thicker, however, and his robust sense of *joie de vivre* often becomes outright vulgarity, e.g. *The Wife of Candaules*. His portrait style at its best is seen in *Man and his Wife*.

Jorn Asger (1914–73). Danish painter and writer, a forerunner of *Action painting in Europe, a founder of the *Cobra group and a contributor to the Exhibition of Experimental Art, Amsterdam (1949). Between 1957 and 1961 J. was an important member of the international Situationist movement.

Josephson Ernst (1851–1906). Swedish painter, a distinguished portraitist and colourist who led the Swedish artists in Paris at the end of the 19th c. in their dissent against Swedish academic art.

Jouvenet Jean-Baptiste (1644–1717). French decorative painter, pupil of *Lebrun. He decorated the Hall of Mars at Versailles.

Juan de Flandes (fl. 1496–c. 1519). Artist of the Spanish school and painter to Queen Isabella of Castile, though probably born in the Netherlands. J.'s sensitive style is close to that of H. van der Goes and the Burgundian miniaturists, e.g. *Pietà* and *Portrait of Joanna the Mad*.

Judd Donald (1928–94). U.S. minimalist 'structure-maker' and leading theorist of *Minimal art. He, however, did not call himself a minimalist, but an empiricist. In the late '50s and early '60s his writings advocated rigorously new art and his belief that representational art was finished and that painting was 'finished', e.g. his article 'Specific Objects' (1965) which brusquely dismissed 2-dimensional painting as subject to 'the problem of illusionism', arguing that the artist must work in the 'real space' of the 3rd dimension and that the art object was autonomous. J.'s cubic, rectilinear, freestanding works of the late '60s redefined the nature of sculpture alongside other minimalists including *Flavin, *Andre and F. *Morris. He used metals, e.g. galvanized iron or aluminium, and Plexiglas (sometimes painted in strong colours)

in open structures which explored the relationships between space, scale and materials. These compositions were factory-made, fabricated by others and often determined according to mathematical progressions – this is apparent in the way in which his works were modular and serial repeating at identical intervals arrangements of identical units. He upheld the idea that such 'primary structures' were essentially different from *Constructivism in that they achieved a wholeness through the repetition of identical units in absolute symmetry. His views naturally led to *Conceptual art, but J. insisted that 'art is something you look at'. In the late '80s he founded the Chinati Foundation with Dia.

Jugendstil. German term for *Art Nouveau.

Junk sculpture. A variety of *assemblage made by such artists as *Chamberlain from the late 1950s, out of discarded industrial items and the detritus of modern consumer culture.

K

Kabakov Ilya (1933-). Russian artist who emerged during the Soviet regime as one of the most imaginative, powerful and sophisticated 'dissident' or 'unofficial' artists freed from the *Socialist realism of Soviet art. K. was partly influenced by the freedom shown in theatrical productions, such as those by Y. Lubimov at the Taganka Theatre, and the work of film directors such as A. Tarkovsky, and by *Conceptual and *Installation art in the West. K.'s art, whether he has used oil paint or text-and-found objects in his paintings and installations, is based on autobiographical and specifically Russian experiences and is unique to him in style and atmosphere. As in fiction or poetry language is an important element in K.'s work – invented characters are created and their consciousness, often through speech, becomes the central focus of the work. In the Installation The Man Who Flew into Space from His Apartment (one of several tableaux in a work called Ten Characters, 1981-8), a cluttered room is reconstructed with objects in disorder, with technical diagrams of trajectories on the walls and a model with an aerial view of a town. The central object is a home-made slingshot over the bed, below a hole

in the ceiling. In My Mother's Life (1989-90), a narrow passage re-creates the corridor of a shabby Soviet apartment block. Black-and-white scenic photographs, taken by his uncle, hang densely in large frames on the walls with texts written by his mother attached to them which contradict the idyllic landscapes of the photographs. For the Berlin exhibition 'The Finite Nature of Freedom' (1990), which commemorated the fall of the Berlin Wall, K.'s Two Walls of Fear was installed on the site of the former Wall. Two parallel walls made of wooden planks formed a narrow passage and at the top of them debris collected in the pre-war heart of Berlin and texts written in Russian, German and English were hung from wires.

Kahlo Frida (1910–54). Mexican artist. Self-taught after a crippling accident at the age of 15 which left her in agonizing pain for life. Her icon-like paintings, e.g. *The Two Fridas* (1939) and *Tree of Hope* (1946), are all autobiographical – suggestive of a disturbing psychology – and have startling symbolic imagery. Today they are among the best-loved works of the 20th c. K. married *Rivera in 1929 (they were divorced in 1939) and was 'discovered' by *Breton in

Kahlo The Broken Column 1944

Kahnweiler

1938 who adopted her as a *Surrealist contrary to her own insistence that she was a Mexican Realist painter who depicted her own life. It has been written that 'the duality of [her] life — an exterior persona constantly reinvented with ornament, costume, and a captivating personality, and an interior image nourished on the pain of her crippled body — invest her painting with a haunting complexity. The traditions of Mexican popular art and Mayan history, incredible suffering and brilliant invention, mingle with a sophisticated knowledge of European literature and painting.' (Whitney Chadwick, Women Artists and the Surrealist Movement, 1991.)

Kahnweiler Daniel-Henry (1884-1979). German-born French art dealer, collector, writer and art publisher who, as one of the major gallery owners of the 20th c., is a key figure to modern art. His 1st gallery opened in 1907 when he bought works by the completely unknown artists *Derain and *Vlaminck at the Salon des Indépendants, and by Van *Dongen and *Braque. In the same year he met *Picasso, in 1908 *Gris and in 1910 *Léger. 1912-14 he contracted the 4 great Cubists: Braque, Gris, Léger and Picasso. K. was one of the earliest supporters of *Cubism and its most effective spokesman (not least through his Der Weg zum Kubismus, 1914-20). He wrote the major monograph on J. Gris (1943), and was also an important art publisher, the 1st to publ. the writings of *Apollinaire, *Jacob, *Masson, among more than 40 titles.

Kakemono. *Japanese art

Kakiemon Sakaida (1596–1666). Japanese painter and potter at Arita, originator of Kakiemon style decoration. Milk-white porcelain with a flawless glaze is decorated in rich overglaze orange-red, greens and blues with sparse, asymmetric motifs of flowering plants and birds; e.g. the notable 'quail pattern'. The style, probably perfected by K.'s sons, was much imitated in Europe.

Kalf Willem (1622–93). Dutch still-life painter who worked mainly in Amsterdam. His faïence bowls and vases, glasses, gold and silver vessels, fruit and shells are painted with taste and economy in warm, luminous colours which shine out from a dark background.

Kamakura. Period of Japanese history (12th–14th cs) named after K. the capital (from 1192)

Kamakura Chigo Daishi (detail) late 13th c.

of Minamotono Yoritomo after the *Fujiwara period; the imperial court remained at Kyoto. Nara buildings and sculpture were restored but K. was dominated by the ideals of the samurai, Zen Buddhism and the popular cult of Amida Buddhism. The colossal bronze daibutsu of Amida Buddha at K. (1252) is in the style of Kaikei; the other leading K. sculpture is Unkei (1142–1212) whose wood statue of the priest Muchaku is a masterpiece of realism. Amida painters depicted the torments of hell and the benignity of Amida. Zen inspired *sumi-e painting and portraiture which aimed to convey the living presence of Zen masters.

Kandinsky Vassily (1866–1944). Russian painter, born in Moscow, generally considered the pioneer of abstract painting. His 1st work to be so described was a watercolour of 1910; however, all representational elements disappeared from his work only in the 1920s. K. was trained as a lawyer and took up painting when he was 30, studying the art 1st in Munich. His early work was related to the Russian Symbolists and the Sezession groups. In 1906 he went to Paris for a year and exhibited at the current Salons. On his return to Munich his work began to reflect the ideas of the French *Nabis

Kandinsky With the Black Arch 1913

and *Fauves and became related to the Die *Brücke group; from the beginning the city of Moscow, Russian icon painting and folk-art strongly influenced him, providing a link with the Moscow avant-garde. By 1909 K. was painting landscapes called *Improvisations* which reflect a growing detachment from nature. In 1910 he painted his 1st abstract works, making contact with the Muscovite avant-garde, who invited him to exhibit at the 1st *Knave of Diamonds Exhibition. His On the Spiritual in Art was publ. in 1912. In 1911 he was a co-founder of the *Blaue Reiter. In 1912 K. had his 1st one-man show at the Berlin Sturm Gallery and publ. 2 plays Yellow Tone and Violet, which reflect his interest in relations between colour and music: he also became interested in the German Romantic philosophers, Rudolf Steiner and occultism. With the Bolshevik Revolution he was drawn into administrative work in the art field. In 1920 he drew up a programme for a new teaching system in art schools, but its Symbolist philosophy was rejected by the *Constructivists and was put into practice only after he had left Russia and joined the *Bauhaus school in Weimar (1922). In 1920 K. began to paint again, introducing geometrical forms which became strictly abstract, reminiscent of *Suprematist and Constructivist work; such forms remained typical throughout his Bauhaus period up to 1933, when he moved to France and came under the influence of Miró, his forms becoming more fluid and Surrealist. While at the Bauhaus he wrote Point and Line to Surface (1926), which deals with the nature of form.

Kangra. N. Indian *Rajput court; under Raja Sansar Chand (1775–1823) the outstanding centre of late *Pahari painting. Works depict court ladies, e.g. *The Swing* (c. 1810) and the loves of Krishna and Radha, the most beautiful of the *gopis* (herdswomen).

Kano. Family and school of Japanese artists which fused Chinese ink painting techniques with local Japanese decorative idioms. K. Motonobu (c. 1476-1559) evolved a characteristic style of hard outline and bold designs. Many of his highly prized screen paintings are in temples at Kyoto. K. Eitoku (1543-90), his grandson, produced screen paintings for *Muromachi lords in a free and vigorous style using brilliant colours on a gold-leaf ground; he had many followers. K. Tanyu (1602-74), Eitoku's grandson, one of Japan's most versatile artists, revived the family tradition. Official painter (from 1621) of the *Tokugawa government, he provided decorative screens for palaces and castles in Edo and Kyoto.

Kapoor Anish (1954-). Born in India, he moved to Britain in 1972. He came to promi nence in the early 1980s, one of a number of diverse new British sculptors including *Cragg and *Deacon to enjoy international recognition. His brightly coloured works with powdered pigment dropped on them, and often surrounding them on the floor, are, as well as his subsequent sculptures, evocative metaphors which deal with issues of content and form, representation, spirituality and creativity. In 1990 he represented Britain at the Venice Biennale with works including Void Field (1989), 20 roughly hewn stones each incised with a small circular aperture and Madonna (1990), a large wall-hung 'void' of intense blue.

Kaprow Allan (1927—). U.S. artist and theorist, pioneer of *Happenings. In 1958 he proposed that artists 'abandon craftsmanship and permanence' for 'perishable media', foreshadowing U.S. *Junk art. Study with the composer J. Cage (1956–8) shaped K.'s views on chance and spectator participation in art events. His works include assemblages and constructions; 18 Happenings in 6 Parts (1959); Yard (1961), random heaps of car tyres; and the book Assemblage, Environments, and Happenings (1966).

Kara-e. *Japanese art

Karli Maharashtra State, India. Site of rock-cut Buddhist caves and a *chaitya*-hall (vaulted

Kashmiri art

preaching hall) (Andhra period, 1st—early 2nd cs). The octagonal aisle pillars have elaborately carved capitals of royal figures and kneeling elephants; the entrance vestibule has relief carvings of serene erotic couples (mithuna) in archaic style. The Buddha images were added later.

Kashmiri art. The art of Kashmir and neighbouring Himachal reached its zenith in the 8th c. Ad. K. temples are square, built of massive stone blocks with trilobate blind windows and pointed roofs; e.g. Avantipura, Marttanda and Naranag. Tantric symbolism is evident in both Hindu and Buddhist art. Superb bronzes and stone sculptures are based on post-*Gupta N. Indian styles.

Katz Alex (1927—). U.S. figurative painter. He studied at The Cooper Union Art School, N.Y. In the 1950s he was among the 1st artists of his generation to abandon the gestural painting of the *Abstract Expressionists and, anticipating *Pop art, to turn to billboard-like figurative art, characteristically on a vast scale. His paintings are cool, flat, smooth and mechanized (e.g. Cocktail Party, 1965).

Kauffmann Angelica (1741–1807). Swiss Rococo decorative and portrait painter. She worked in Britain from 1766 to 1781, becoming the friend of Joshua Reynolds and a foundermember of the R.A.; she worked in conjunction with R. Adam on many interiors. Her work became widely known through engravings by Bartolozzi and was also a favourite source of motifs for porcelain factories.

Kauffmann Roundel c. 1779

Katz The Red Smile 1963

Kawara On (1933-). Japanese *Conceptual artist living in N.Y. since 1965. He has been engaged in 'date paintings' since 1966 which merely record the dates when they were made in white letters and numbers on small monochrome canvases. Also in 1966 he started another series, I Read, made up of newspaper clippings assembled in loose-leaf binders. K. began two other series in 1969, I Went and I Met, which record his daily movements and names of people he met. His postcard series (1969-79) consists of mailing a postcard of where he has stayed to friends every day. A similar series consisted of telegrams sent daily informing the recipient, 'I Am Still Alive'. He has been producing a monumental work in progress, One Million Years, in volumes which record the dates for one million years and in audiotapes of a man's voice reading the dates, for an installation (N.Y., 1992).

Keene Charles Samuel (1823–91). British draughtsman, etcher, painter and engraver. K. is one of the most fascinating draughtsmen of the 19th-c. English school and is mentioned admiringly in Pissarro's letters; as a painter he produced a masterly self-portrait.

Keirincx Alexander (1600–52). Flemish landscape painter and engraver who settled in Amsterdam and specialized in forest scenes. From 1640 to 1641 he worked in Britain where he was known as 'Carings'.

Kelley Mike (1954–). U.S. artist who staged *performances in the late 1970s, e.g. Spirit Voices (1978). His *installations challenge accepted definitions of 'culture' and debunk emblems of nostalgia and sentimentality, e.g. Lumpenprole (1991). He uses stuffed animals, garbage, excrement and other detritus, and *found objects

which he collects and displays. The Wages of Sin/More Love Hours Than Can Ever Be Repaid (1987) is made up of wax candles on a base and stuffed animals and afghans on canvas. In 1993 a retrospective of K.'s work was held at the Whitney Museum of American Art, N.Y.

Kells Book of (c. 800; Trinity College, Dublin). Elaborately illuminated copy of the Gospels written in Latin, long one of the treasures of the Columban monastery of Kells in Ireland. The work of monks from Iona, it is the masterpiece of the Celtic school of illumination.

Kelly Ellsworth (1923—). U.S. *Hard-edge painter, he studied in Paris 1948—54. *Arp, *Miró and *Matisse affected K.'s early paintings. Later works employed joined canvas panels and shaped canvases painted in bold monotonal areas, e.g. Red, Blue, Green, Yellow (1965), Red, Yellow (1968) and Two Panels: Black with Red Bar (1971). He also made sculptures of painted aluminium sheets.

Kelly Mary (1941–). U.S. feminist artist living and working in N.Y. and London. Post Partum Document (1973–9) – 165 units in 6 sections – challenges the assumption that motherhood is an instinctive experience. In this work, K. uses *found objects and incorporates the language of psychoanalysis, linguistics, archaeology and science to chronicle her relationship with her son – with one stage famously represented by stained nappies in mounted Plexiglas boxes – and his passage into a phallocentric order with which she engages, and subverts: 'Such work is scriptovisual precisely because feminine

Mike Kelley Untitled (Double Take exhibition)

Page from The Book of Kells (detail) c. 800

discourse is trying to articulate the unsaid, the "feminine", the negative signification'. In Gloria Patri (1992) – mixed media which incorporate inscribed pseudo-military aluminium trophies juxtaposed with textual fragments – K. transposes her exploration of the 'feminine' to the 'masculine', focusing on crises of male identity against a background of stereotypical machismo.

Kensett John Frederick (1816–72). U.S. painter greatly admired for his landscapes. In 1840 he went to Europe and worked in Paris making copies of *Claude Lorrain, and also visited London and Rome. He returned to N.Y. in 1848. He established the Artists' Fund Society in 1865 and was a founding trustee of the Metropolitan Museum of Art in 1870. A metropolitan Museum of Art in 1870. A second–generation *Hudson River school painter, K. excelled with his expansive shoreline views, e.g. the series of 38 paintings of Long Island Sound which he produced in the year of his death.

Kessel Jan van (1626–79). Flemish still-life painter famous for his minutely detailed miniatures of butterflies and insects. He worked in Antwerp.

Kessel Johan van (1641/2–80). Dutch landscape painter, pupil and follower of J. van Ruisdael. He painted mountain scenes with rushing water and panoramic views. **Ketel** Cornelis (1548–1616). Dutch painter, mainly of portraits but also of historical and allegorical subjects. He worked in Gouda and Amsterdam and for a time in Britain. His style of portraiture was close to that of H. Eworth with slightly stronger characterization.

key. The predominant tone and colour values in a painting if light are said to be in a 'high k.', if dark in a 'low k.'.

Key Adriaen Thomasz (ε. 1544–ε. 1590). Flemish portrait painter, nephew and pupil of Willem K. (d. 1568), a portrait and history painter, pupil of Lambert Lombard.

Key Marco Indians. Prehistoric North American Indian culture. The name comes from a site in Florida where, in the 1890s, a large number of superb, realistic animal wood carvings were discovered.

Keyser Hendrick de (1565–1621). Dutch sculptor and architect for the city of Amsterdam. There his work includes the Zuiderkerk and the Westerkerk and the Erasmus monument. He also executed the tomb of William the Silent at Delft. His sons Pieter (1595–1676), Willem (1603–after 1674) and Hendrick (1613–65) were sculptors.

Keyser Thomas de (1596/7–1667). Dutch portrait painter, son of H. de K. He worked in Amsterdam and based his style on that of N. Eliasz and later of Rembrandt. He painted small-size group and equestrian portraits, e.g. *Pieter Schout on Horseback*.

Khmer. Medieval S.E. Asian empire (roughly modern Cambodia and Laos) of the late 6th—mid-15th cs. Indian Buddhist and Hindu culture shaped K. arts and literature (Sanskrit was the literary language). Architecture developed from brick-built tower sanctuaries decorated with sculptures to the Angkor golden age (late 9th—early 13th cs).

Kiefer Anselm (1945—). German painter. After studying with *Beuys (1970—2) he started a series, *Panelled Rooms*, of bare and ominous interiors. His work attempts to come to terms with his country's past. His *Resumptio* and *Scorched Earth* (both 1974) are enormous threatening symbolic landscapes, painted expressionistically and incorporating twigs, straw and grass. He is one of the most prominent artists to have revived Expressionist painting in the mid—to late 1970s.

Kienholz Edward (1927–94). U.S. *assemblage artist, noted for a series of *Funk art life-sized tableaux. Bizarre, sick or horrifying, they are essentially moralizing comments on sordid aspects of U.S. society. They include: Roxy's (1961); Back Seat Dodge-38 (1964), a mordant comment on 'Lovers' Lane' type romance; and the terrifying The State Hospital (1966).

Kinetic art. Art involving movement, either real or apparent; the term originated in the 1920s. Movement in sculpture was proposed by the Futurist *Boccioni and the idea was developed by Duchamp, Gabo and Pevsner, Moholy-Nagy and A. Kemeny, who advocated a 'dynamic-constructive art form'. In the 1950s artists such as *Schoffer began producing Kinetic sculpture; subsequent groups include Gruppo N. (1959) and EAT (1966). Kinetic sensations in painting are achieved by optical effects and the use of lights. *Op art.

King Philip (1934—). British sculptor and teacher, he studied with *Caro and was an assistant of H. *Moore (1958–9). He worked initially in clay and plaster. From 1960 making abstract work in fibreglass and metal. Since the late 1960s he has been using wood and slate. His works are often abstract enclosed forms in which colour is an essential sculptural element.

Kirchner Ernst Ludwig (1880–1938). German *Expressionist painter. He studied architecture at Dresden (1901-5) where he met Heckel and Schmidt-Rottluff, co-founders in 1905 of Die *Brücke. Led by K. and inspired by Gauguin, Munch, Van Gogh and above all by primitive art, Die Brücke was the first manifestation of German Expressionism – superficially similar to Parisian *Fauvism, but deliberately more violently and directly expressive of human emotions. The intensity of their art and philosophy, deeply rooted in Nietzsche, is a parallel to the Italian *Futurists' fervent belief in a new world. The Artist and his Model (1907) is a typical example of K.'s deployment of pure colour - brilliant oranges and pinks juxtaposed producing a jarring visual sensation. In his woodcuts the same effect is achieved by the crudeness of his harsh outlines, partly inspired by his admiration of German primitive art but with exaggerated distortions. He moved to Berlin in 1911, joined Nolde's Neue Sezession and was associated with Der Sturm circles. His work became more aggressively angular and sombre coloured: the Five Women in the Street

Kirchner Painters of the Brücke Group 1925

(1913) are stark, primitive images of the modern city. He suffered a nervous breakdown during World War I and convalesced (1917) at Davos, where he continued to live. His late landscapes are more serene, profound formalizations at their purest (1921–5) and then becoming abstract in 1928. His art was suppressed as 'degenerate' by the Nazis (1937) and he committed suicide in 1938.

Kirikane. *Japanese art

Kisling Moïse (1891–1953). Polish born painter of the school of *Paris. He settled in Paris in 1910 and joined the Bateau Lavoir group, then the circle round Modigliani.

Kitaj R.B. (1932–). U.S. painter and print maker working mostly in Britain. K. studied at the Vienna Akademie der Bildenden Künste, 1951–4, and at the Oxford Ruskin School of Drawing and Fine Art, 1957–9, with a grant under the G.I. Bill. In 1960 he entered the R.C.A., London, where he met *Hockney with whom he formed a close friendship which had a great mutual influence. K.'s work is essentially figurative and rich in literary and other intellectual associations and references. His style draws on the figurative tradition of Western art

from the Renaissance to the present, especially on late 19th-c. and early 20th-c. painting, notably that of *Degas and *Matisse; his work usually combines figure drawing and landscape, e.g. The Autumn of Central Paris (After Walter Benjamin) (1972–4) and If Not, Not (1975–6). He also draws extensively – it has been said (Time magazine) that 'he draws better than almost anyone else alive' – and works in pastels often on a large scale.

Kitchen Sink. Term applied to the work of various British playwrights (Angry Young Men) after the success of J. Osborne's Look Back in Anger (1956), in which working-class locales and values contrasted with prevailing middle-class conventions. Also applied to the work of British Social Realist painters, e.g. *Bratby.

Klee Paul (1879–1940). Painter born near Berne, Switzerland. He studied in Munich (1898–1900) under Knirr and Stuck, visited Italy (1901) and then returned to Berne (1902–6). Most of his early work was in black and white graphic media: the precision of his draughtsmanship and the recurrent Expressionist fantasy element (e.g. *Inventions* etchings, 1903–5) link him with the N. European tradition. K. settled in Munich in 1906 and in 1911 made contact with the *Blaue Reiter artists (Kandinsky, Marc, Macke) and

Kitaj The Jew, Etc. 1976

Klee A Young Lady's Adventure 1922

contributed to their exhibition in 1912. In 1912 also he visited Paris, met *Delaunay and trs. his essay Sur la lumière. The accumulation of his contacts with the colouristic paintings of the Blaue Reiter, and with Delaunay's *Orphism, and finally his experience of Tunis, which he visited with Macke in 1914, resulted in K.'s release from his early monochromatic discipline. He now felt ready to paint and his watercolours of 1914–16 are subtle arrangements of glowing translucent colour areas. During the war he served in the army (1916–18) and was deeply distressed by the deaths of Macke (1914) and Marc (1916).

From 1920 to 1931 he taught at the *Bauhaus, Weimar and Dessau. His *Pedagogical Sketchbook* was publ. in 1925 as a Bauhausbuch. The principle of his art and his influential teaching is best expressed in his own metaphor of the tree whose trunk is the artist. The pattern of growth of the roots is the pattern of nature (the artist's source of forms and ideas); this pattern is reflected in the growth of

the branches and blossoms, but in this final flowering (which is the work of art) nature has been transformed by the richness of the artist's imaginative instincts. Improvisation plays an important part: the work of art is allowed, like a doodle, to follow its own evolution, subconsciously guided by the artist rather than consciously controlled. These ideas, disciplined by a rare self-knowledge and humility, which lie behind so many later developments, have made him a very influential thinker in art; the persistent quality of his prolific and varied œuvre, exquisitely sensitive in line, colour and texture and often laced with fantasy and humour, has made him one of the c.'s most original artists. A Young Lady's Adventure (1922) shows his subtle colour, fluid line and uninhibited wit, but it is difficult to appreciate the character of his art without experiencing its full range. He left the Bauhaus (c. 1931) and held a professorship at Düsseldorf until 1933, when he was expelled by the Nazis. 102 of his works were confiscated from German museums during the Nazi régime, 17 of which were incl. in the notorious exhibition Degenerate Art (Munich, 1937).

Klein Yves (1928–62). Influential French artistic iconoclast and innovator. His 'exhibition' (1958) of the bare walls of a Paris gallery rejected every painterly convention. In *Anthropometries* (1958–60) nude models daubed in blue (the preeminent 'cosmic' colour) imprinted themselves on canvas, to musical accompaniment.

Kleitias (early 6th c. BC). Greek vase painter. Only 5 works signed by him have survived but these are in a lively style, showing marked originality.

Klimt Gustav (1862–1918). Austrian painter and designer associated with the *Symbolist and *Jugendstil movements and a leading member of the Vienna *Sezession (1898–1903). He devoted much of his time to architectural decoration (e.g. *The Kiss*, mosaic for Palais Stoclet, Brussels, built by Josef Hoffmann) and considerably influenced the decorative arts in Austria. His paintings are often large allegorical canvases and portraits of women which combine linear construction and rich colours.

Kline Franz (1910–62). U.S. *Abstract Expressionist painter whose stark and startling black-and-white compositions on a huge scale made him one of the most powerful exponents of the large black-and-white gesture painting.

Kline Untitled drawing (ink and oil) 1955

Only rarely using colour, K. produced variations, which never became a formula. He started by painting rather traditional figurative pictures. After spending most of the 1930s in Britain, he returned to the U.S.A. and settled in N.Y. At this time the change in scale and drama in his

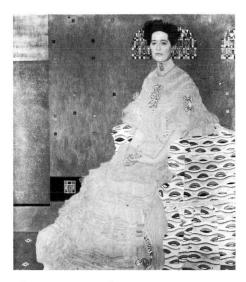

Klimt Mme Fritsa Riedler 1906

work and the development of a highly personal, abstract, gestural style made him a heroic figure. Between them, *De Kooning and K. did much to invent the rhetoric of Abstract Expressionism.

Klinger Max (1857–1920). German painter, sculptor and print maker; from 1883 he worked in Paris, Berlin and Rome settling in Leipzig (1893). His works include monumental paintings on history and legend, polychrome sculptures and graphics. Among these, sensitive etchings on macabre, fantastic, surreal or symbolic themes affected later artists such as De *Chirico and *Dix.

Kliun (Kliunkov) Ivan Vasilievich (1873–1942). Russian artist. He met *Malevich in 1907, and co-founded the Moscow Salon in 1910. He supported *Suprematism and took part in the 1st Russian Futurist exhibition (1915) as well as in all the major *avant-garde* exhibitions in 1915–17. He became professor of paintings at *Vkhutemas (1918–21). From the 1920s he turned gradually to *Purist and figurative work.

Klutsis Gustav Gustavovich (1895–1944). Russian artist, book, poster and architectural designer. He studied at the *Vkhutemas, under *Malevich and *Pevsner, where he was eventually appointed professor in the Department of Architecture and head of its Colour Study Group (1924–30). He experimented with new applications of photography in conjunction with painting and graphic art, in the Productivist group which included *Rodchenko, *Stepanova, etc. and was influential in developing *photomontage techniques for posters. His abstract painting, like that of *Lissitzky's, is distinct within the *Suprematism of the 1920s.

Knapton George (1698–1778). British portrait painter and pastellist, pupil of J. Richardson the Elder. He was a founder-member of the Society of Dilettanti and as an official painter to the Society executed portraits of the members. F. Cotes was his pupil.

Knaths Karl (1891–1971). U.S. Expressionist painter in a post-Cubist idiom.

Knave of Diamonds. Group of young Russian Paris-orientated artists who rebelled against the Moscow Art School in 1909. Headed by *Larionov, they organized their 1st exhibition of the newest Franco-Russian art in 1910, including works by *Malevich, *Goncharova, etc.; exhibitions continued to be held in Moscow under this name up to 1922 though after the first, Larionov left the group, which

Kneller

then became synonymous with painters of the Russian Paris school such as Falk, Konchalovsky, Lentulov, Mashkov, and with the Russian Futurists.

Kneller Sir Godfrey (1649?-1723). Painter born (Kniller) in Lübeck, but usually associated with the English school. He studied in Amsterdam under F. Bol and, possibly, Rembrandt and was influenced by C. Maratta and other Italian portrait painters during a period in Italy. In 1674 he settled in Britain, where he rapidly became the leading portrait painter. K. was knighted in 1692 and was the 1st painter to become an English baronet (in 1715). He founded the 1st English Academy of Painting in 1711, K.'s success made it necessary for him to establish a workshop; the standard of his painting declined and he often fell back on the conventional poses of Lely. Among his best works are the 42 portraits known as the Kit Cat series, while an unusually fine example is The Chinese Convert.

Knight Dame Laura (1887–1970). British painter of circus and ballet subjects.

Kokoschka Oskar (1886–1980). Austrian painter who studied (1905-8) in Vienna, a vital centre of new intellectual currents: Freud. Schoenberg, Kraus, Max Dvořák and Adolph Loos were there and the last three became his friends and patrons. In 1910 he went to Berlin to work on Herwarth Walden's magazine Der Sturm. His early graphic work was intensely personal, using a Klimt-like curvilinear calligraphy as an Expressionist vehicle, but the majority of his early paintings were the portraits which constitute his major achievement. Auguste Forel (1910) is typical in its concentration on head and hands, taut draughtsmanship and in the tattoolike incisions in the painted surface. The tone of his early work is depressed and cynical and his disgust with reality was heightened by the war. He was injured in 1915. He taught at Dresden Academy (1919-24) and then travelled in Europe, Africa and the Near East. He became a British subject in 1947 and a C.B.E. in 1959. The intense wiry complexity of his style disappeared into the solid impasto of Woman in Blue (1919), but his real release from reality came with the landscapes: the same panoramic world landscapes that Altdorfer, Bruegel and Turner painted (e.g. Polperro, Cornwall, 1939/40). They have a baroque sense of infinite space and elemental force that is also present in the Prometheus Triptych (1950). K.'s writings include a play on the Czech humanist Comenius.

Kokoschka Egon Wellesz 1911-12

Kolbe Georg (1877–1947). German sculptor influenced by Rodin. In the best of his figures, e.g. *Dancer* (1912), he achieved a remarkable rhythmic beauty lost in the 1930s when he produced 'heroic' works conforming to Nazi ideals.

Kollwitz Käthe (1867–1945). German graphic artist, sculptor and draughtsman. Her experiences as a doctor's wife in a poor district of Berlin during and after World War I resulted in her best-known work-drawings, lithographs and engravings, chiefly of the sufferings of women and children. Examples of her engravings include: 6 subjects from Gerhart Hauptmann's

Kollwitz Killed in Action 1921

play *The Weavers* (exhibited 1898), *Peasants War* cycle (1902–8), and *Run Over* (1910); the posters – *Never Again War!*, *Bread*, *Children Starving* (all 1924); the woodcuts – *War* cycle (1922–3); the lithographs – *Death* cycle (finished 1936); and the sculptures – *Father* and *Mother* (1931).

Konenkov Sergey (1874–1971). One of the best-known Russian sculptors; he spent many years in the U.S.A. before returning again to Moscow after World War II. Many of his more familiar works are executed in wood or plaster such as his bust of Paganini. Of the generation of *Vrubel and the *Symbolists, K. later came to work in a more classical tradition.

Koninck Philips (1619–88). Dutch painter, probably a pupil of Rembrandt. His portraits and genre subjects in the manner of Brouwer are undistinguished but he is justly famous for his panoramic views, e.g. *Landscape in Gelderland*. His drawings have been confused with those of Rembrandt, as have those of Salomon K. (1609–56), a distant relative, painter of genre and biblical subjects in a Rembrandtesque style.

Konrad von Soest (late 14th–15th c.). German painter in the soft style active in Dortmund from 1394. A signed polyptych in Niederwildungen parish church is his major work.

Koons Jeff (1955–). U.S. artist who came to prominence with celebrity-like status in the mid-1080s with the exhibition of consumer items such as whisky flasks and vacuum cleaners. In his Banality series (1988) popular kitsch icons were re-created with great care and expertise by traditional craftsmen operating under his instructions, e.g. The Pink Panther, Popples and Michael Jackson with a white face. Since 1989, K. has worked with Ilona Staller (La Cicciolina), who became his wife, in a series of explicitly erotic sculptures, paintings and posters all relating to their continuing project, Made in Heaven. In these works notions such as purity, sentiment and pornography become deliberately confused. In his selfpromotional appearances, interviews and writings, K. is a brilliant performer whose apparent sincerity and intelligence defy comparisons with *Warhol or easy dismissal. The questions raised by K. about art practice in the 1990s challenge many assumptions, pretensions and received ideas about authenticity, originality and other value-loaded criteria.

Koons Bourgeois Bust - Jeff and Ilona 1991

Korean art. Chinese influence, marked during the *Han dynasty (206 BC-AD 220), was always important. Major early works are 4th-7th-c. murals from tombs of the N. kingdom of Koguryo and Buddhist sculptures from the S.W. Paekche kingdom which influenced Japanese sculpture. *T'ang influence dominated the 'Great Silla' period which united Korea (668-918), e.g. magnificent mid-8th-c. Buddhist sculptures and reliefs. During the Koryo period (918-1392), Confucianism inspired a tradition of artist savants (*wen-jen), e.g. Kang Hui-an (1419-65). *Chinese art principles inspired painting; Chinese poetry provided themes and Chinese *Sung fantasy landscape painting subject matter. Chong Son (1676-1760) returned to Korean landscape for inspiration. Artist literateurs did elegant, calligraphic studies of bamboo, orchid, plum blossom or chrysanthemum. Official portraiture was largely stereotyped though skilful.

Kossoff Leon (1926—). British figurative painter. Taught by *Bomberg and influenced by *Expressionism, he developed a style of thickly applied paint and fluid forms; industrial London

Kosuth

scenes and figures are most frequently his subjects. His black-and-white drawings are often on a large scale and are among the most accomplished contemporary figure drawings.

Kosuth Joseph (1945-). Influential U.S. *Conceptual artist whose 10 'Investigations' in the 1970s reflected the impact of the philosopher Ludwig Wittgenstein's linguistic and epistemological theories. The manifesto, Art After Philosophy (1969), advocated the dematerialization of the art object; it was first published as an introduction to an exhibition, 'Conceptual Art and Conceptual Aspects' and proclaimed that 'Art is the definition of art'. K.'s 'Investigations' were exhibited in a variety of forms: wall panels with inscribed definitions of art terms, texts of linguistic philosophy and theory, art magazines and words in neon. In 1970 he was the U.S. ed. of Art-Language, the magazine published by *Art & Language. and in 1975-6 co-founder of the art-political magazine, Fox. In 1988 he mounted a highly controversial *Installation at the Brooklyn Museum, The Play of the Unmentionable, which reflected his opposition to censorship in the arts. In it works from the permanent collection of the museum, which at various times had been considered politically or sexually objectionable. were juxtaposed with statements about art and its role

Kounellis Jannis (1936-). Greek-born artist who moved to Rome in 1956, associated with the Italian *Arte Povera group in the late 1960s and with the process-related works of L. *Fontana, *Burri and *Manzoni. In the late 1960s he started creating evocative *installations and *performances, e.g. 12 horses tethered to the walls of the Galleria L'Attico (1969). Another notable work of the same year was Porta Murata, a doorway filled with stone rubble. and then in 1970 Woman with Blanket, Flame and Motivo Africano. In the late 1970s K. started introducing in his work references to European history - cast fragments of classical sculpture and Byzantine motifs - and to early 20th-c, art. In the mid-1980s he made a series of 'Accumulations', fragments of objects, casts, clothes. stones, etc. mounted on large sheet metal, displayed on walls, like paintings. He has also continued making site-specific installations using burlap sacks, wooden barriers, shelves, wax, charcoal, wool, etc. in works with a mysterious, suggestive power - evocations of a longed-for historical and cultural continuity.

Kraft Adam (d. 1509). German late Gothic sculptor in stone. Almost all his work is in Nuremberg including his masterpiece, the 62-ft (18.9-m.) high tabernacle in the church of St Lawrence, and the Schreyer monument, St Sebald's church.

Kounellis H.C.W.W. 1991

Krasner Lee (1908–84). U.S. *Abstract Expressionist painter, married to *Pollock (1945). She studied at Cooper Union, Art Students League and National Academy of Design. In 1934 she worked for *W.P.A. and in 1935 she became assistant on W.P.A. Federal Art Project Mural Division. In 1937–40 she had further studies with *Hofmann. Her work is powerful with strong figurative overtones (e.g. *Three in Two*, 1956; *Spring Memory*, 1959).

Krieghoff Cornelius (c. 1812–72). German– or Dutch-born Canadian painter; from the 1840s he painted colourful landscapes and anecdotal scenes, mainly of French-Canadian life in Ouebec.

Kruger Barbara (1945–). U.S. *Postmodernist artist and writer, of primarily black-and-white *photomontages which carry messages challenging and deconstructing sexual stereotyping and domination, and the usually unchallenged assumption that images are neutral in terms of meaning, e.g. Untitled ('Your gaze hits the side of my face') and Untitled ('You construct intricate rituals which allow you to touch the skin of other men') (both 1981).

Kruger Untitled ('Your gaze hits the side of my face')

Ku K'ai-chi Admonitions of the Instructress to the Court Ladies (copy of 4th-c. original)

Kubin Alfred (1877–1959). Austrian painter and graphic artist associated with the *Blaue Reiter group. His choice of subject matter particularly in his graphic work of the early 1900s was grotesque, even repulsive. He wrote and ill. a Surrealistic novel *Die andere Seite* (1909) which led him to concentrate on book ill., e.g. works by d'Aurevilly, Dostoyevsky, Nerval and Poe.

Ku K'ai-chi (c. 344–406). The 1st great Chinese artist and a renowned calligrapher. Copies of 3 works by him survive, e.g. the 12th-c. *Sung version of *The Nymph of the Lo River*, and the Admonitions of the Instructress to the Court Ladies.

Kulmbach Hans Süss von (c. 1480–1522). German painter, pupil of Jacopo de' Barbari and follower of Dürer. He worked in Nuremberg and probably for a time in Cracow, Poland. His works include the Tucher altarpiece designed by Dürer in St Sebald's church, Nuremberg, altarpieces in churches in Cracow, *Adoration of the Magi*, and portraits.

Kuniyoshi Yasuo (1893–1955). Japanese born U.S. painter. His early work combined fantasy with covert humour in a way which recalls Chagall. In the 1930s he turned to figure studies, chiefly of languorous women sensitively drawn and coloured, showing the influence of Pascin, whom he met in Paris.

Kupetzky

Kupetzky Johann (1667–1740). Portrait painter of Czech origin who lived for many years in Italy, then worked as court painter at Vienna and finally settled in Nuremberg.

Kupka Frantisek (1871–1957). Czech painter who arrived in Paris (1894) via the academies of Prague and Vienna. He is historically important for the paintings he made ϵ . 1910. These reveal the emancipation of pure colour areas from any descriptive role and are among the first abstract paintings in Paris, probably preceding and inspiring the similar developments in Delaunay's painting. From 1931 he was connected with the *Abstraction-Création group in Paris.

Kushan. N. Indian empire at its height in the 1st—2nd cs AD, stretching from Afghanistan to the upper Ganges and its tributaries. It was a formative period in Buddhist, Jain and Hindu sculpture. The chief centres were *Gandhara, Mathura on the upper Jumna river, and Bamiyan, Surkh Kotal, Hadda and Fondukistan, all in Afghanistan.

Kusnetsov Pavel (1878–1968). Soviet painter, a founder-member of the *Blue Rose group and with Saryan its most distinguished artist. His most characteristic works depict the Kirghiz people and countryside, such as *Mirage in the Steppes* (1912) painted in a Symbolist blue-green palette; in later years his colours became brilliant and his subjects less exotic.

Kusnetsov Holiday c. 1906

L

Lachaise Gaston (1882–1935). French sculptor who emigrated to the U.S.A. in 1906. He is known chiefly for his imposing female nudes of exaggerated but balanced proportions. Famous examples are his versions of *Standing Woman* (1912–27, 1932).

Laer Pieter van (nicknamed 'Bamboccio', It. bonny baby) (d. 1642). Dutch painter who spent most of his working life in Rome specializing in the scenes of low life which influenced many Dutch artists. *Bambocciata.

Laethem-Saint-Martin. Belgian village with which 2 groups of 20th-c. artists have been associated. The first was a Symbolist group led by Valerius de Saedeleer (1867–1947) and Gustaaf van de Woestijne (1881–1947), the second and more important an Expressionist group represented by Van den *Berghe, *Permeke and De *Smet.

La Farge John (1835–1910). U.S. painter, designer and writer on art; of French parentage. He studied in Paris under T. Couture and visited Britain, coming under the influence of the Pre-Raphaelites. Back in the U.S.A. he concentrated on mural decoration and stained-glass work.

La Fresnaye Roger de (1885–1925). French painter, studied in Paris at the Académie Julian (1903), the École des Beaux-Arts and the Académie Ranson (1908), where he met *Denis and *Sérusier. Their influence was succeeded by Cézanne's, which prepared him for *Cubism. He exhibited with the other Cubist painters in 1911 and at the Section d'Or of 1912, without ever really subscribing to Cubist principles. In paintings such as *La Conquête de l'air* (1913) he adopted the superficial manner of Cubism – particularly its structural clarity – to suit traditional requirements. A very accomplished painter, he was the 1st 'academic' in the new idiom.

Laguerre Louis (1663–1721). French painter who worked under C. Lebrun before settling in Britain as assistant to A. Verrio. He executed decorative work at several of Britain's greatest houses.

La Hire (Hyre) Laurent de (1606–56). French painter of religious subjects and landscape. The Caravaggesque style of his work up to 1640 probably derived from Vouet as he did not himself visit Italy; in his later work he followed Poussin.

Lam Wifredo (1902–82). Cuban painter influenced by Picasso and Surrealism, and based on African sculpture and folk-art. His work evokes the savage world of the jungle and the primitive mythology of Cuba. He made use of the theme of metamorphosis as in *Jungles* (1943).

Lancret Nicholas (1690–1743). French painter of fêtes galantes and *commedia dell'arte* scenes; an imitator of Watteau, with whom he studied under Gillot.

Land art. *Earth art

Landseer Sir Edwin (1802–73). British artist, immensely popular in the 19th c. and early 20th c. He invented, or at any rate, popularized, the animal, heroic or domestic, embodying popular virtues, e.g. the dog of *The Old Shepherd's Chief Mourner*, the stag of *The Monarch of the Glen*. L. modelled the lions for the base of Nelson's Column in Trafalgar Square (1867).

Lane Fitz Hugh (1804–65). U.S. marine painter, a leading figure of *Luminism. His works include *Owl's Head, Penobscot Bay* (1862).

Lanfranco Giovanni (1582–1647). Italian Baroque painter, pupil of Agostino Carracci and influenced by the ceiling paintings of Correggio. He worked in Rome and Naples and decorated the domes and apses of many churches with illusionistic paintings, a famous example being the dome of S. Andrea del Valle, Rome (1625–8).

Langley Batty (1696–1751). Pioneer of British landscape gardening. In 1740 he started a school of architectural drawing, undertaking to design 'Grottos, Cascades, Caves, Temples, Pavilions and other Rural Buildings of Pleasure'. He produced over 20 books of engravings and instructions on building and landscaping which had widespread influence on taste. He helped to popularize Gothic architecture as an exotic style, though his attempt to classify it in 5 'orders' was a failure.

Lanier Nicholas (1588–1666). British musician and painter of French descent; Charles I's agent in Italy for the purchase of paintings. He composed music for masques by Ben Johnson, singing the masque *Lovers made Men* (1617) in Italian recitative style and designing the set. He also left a self-portrait.

Landseer The Monarch of the Glen (detail) 1851

Lanyon Peter (1918–64). British painter. He studied at the Penzance and *Euston Road art schools. He was one of the artists who worked at *St Ives. Cornwall.

Laocoön (c. 50 BC). Highly naturalistic and emotional late Hellenistic marble group of the

Laocoon c. 50 BC

Lapicque

Rhodian school. The Trojan priest L. was killed with his sons for offending the gods. Found in Nero's palace on the Esquiline in 1506, the statue profoundly influenced Michelangelo. *Laokoon* (1766) is the title of a treatise on art by *Lessing in which he attacked the Neoclassical views of the tragic and the beautiful which *Winckelmann considered that the statue of the Laocoön embodied.

Lapicque Charles (1898–1988). French painter. In his early work in the 1920s and 1930s he alternated between abstract and representational styles but later combined these elements in his vivacious compositions.

Largillière (Largillierre) Nicolas de (1656–1746). French Rococo portrait painter. He studied in Antwerp, then worked in London as assistant to P. Lely. In 1682 he went to Paris, where he became the favourite painter of the wealthy bourgeoisie. He brought a new freedom and fluency to French portraiture.

Larionov Mikhail (1881-1964). Russian painter trained in Moscow where he met *Goncharova. He was a prolific worker and a highly energetic personality who soon attracted a nucleus of Muscovite painters round him with whom he organized exhibitions such as the Golden Fleece, the 1st *Knave of Diamonds show, and in 1913 publ. his Rayonnist Manifesto which laid the foundations of abstract art in Russia. L. is important in Russian art history for his creative absorption of contemporary (1905-8) French ideas in painting; for his subsequent synthesis of these ideas with national folk-arts, e.g., in his Soldier series (1908-11); and for his Rayonnist work (1910-14), much of it abstract and among the first of such modern work, although not basically a system of non-representational composition. After 1914 he left Russia to work as a designer for Diaghilev's Ballets Russes, and from then lived in Paris.

Laroon the Elder, Marcellus (1653–1702). Dutch painter and engraver who settled in Britain and worked as an assistant to *Kneller.

Laroon the Younger, Marcellus (1679–1772). British painter and mezzotint engraver, actor and soldier, son of L. the Elder. He is best known for his conversation pieces similar in type to those of his friend Hogarth but painted in an unusual agitated style. There is an element of caricature in much of his work.

Larionov Soldier at the Hairdresser 1908-11

Lascaux. Prehistoric caves in the Dordogne accidentally discovered in 1940 and containing paintings of bulls, horses, deer, etc. executed by Cro-Magnon men in the Aurignacian period of the upper paleolithic era (c. 20,000 BC). The growth of a fungus which endangered the paintings — evidently caused by increased humidity—led to the sealing off of the caves. *Cave art.

Lascaux Head of a bull (cave painting) *c.* 20,000 BC

Lastman Pieter Pietersz (1583–1633). Dutch painter of religious, mythological and historical subjects, and engraver who worked in Amsterdam. He visited Italy, where he was influenced by Caravaggio's use of *chiaroscuro*. Rembrandt and Jan Lievens were his pupils.

La Tène. A site in E. Switzerland which has given its name to a style of Celtic art and a culture centred upon it and expanding throughout Central Europe and into Britain; it flourished in the last 5 cs BC. Its characteristic motifs are stylized and sinuous animal and plant forms; the style became increasingly abstract, especially in the art of Celtic Britain.

La Tour Georges de (1593–1652). French artist born at Vic in Lorraine. La T. lived all his life in the province, working at Lunéville from 1620. Despite this isolation, he won recognition and rewards. In 1623 the duke of Lorraine became his patron. In 1638 King Louis XIII, accepting his *St Sebastian Tended by St Irene*, found it 'in such perfect taste that His Majesty had all the other pictures removed from his chamber and kept there only La T.'s'. This makes it curious that the artist was forgotten

until his rediscovery in 1915. It has been claimed that his preference for scenes lit dramatically by a single artificial light shows the influence of Caravaggio or G. Honthorst, but this may have been an original discovery. Original, certainly, is the austere but rich and wonderfully effective colouring – red, yellow and a full range of browns. There is considerable affinity in drawing between La T. and the *Master of Moulins. Outstanding examples of his work are: Job Taunted by his Wife, St Joseph's Dream, The Newborn and Magdalene with the Lamp.

Latour Maurice-Quentin de (1704–88). French portraitist in pastel, one of the great masters of that medium, appointed painter to Louis XV in 1750. His work shows a degree of individual characterization outstanding in the portraiture of the Rococo period.

Laurencin Marie (1885–1956). French painter, designer and ill. Although she was a friend of avant-garde painters and poets in Paris her work was unaffected by modern movements. The grace and sensitivity of her paintings of young girls derive in part from her study of Persian miniatures and Rococo art.

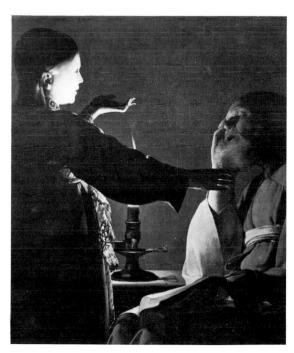

Georges de La Tour St Joseph's Dream

Laurens Siren 1937

Laurens Henri (1885–1954). French sculptor and graphic artist, one of the leading *Cubist sculptors. His work at that time dealt with the structural correlation of geometric forms and his use of contrasting materials provided a sculptural parallel to collage. His polychrome sculptures in sheet-iron of 1914 anticipated Constructivist ideas. From 1930 he concentrated on the female figure as a basis for his work but remained preoccupied with the interplay of forms, organic instead of geometric. In much of his sculpture and graphic work he reinterpreted themes from Greek mythology.

Lawrence Jacob (1917—). Perhaps the most popular 20th-c. African-American artist—a popularity he felt once to be at the expense of fellow black artists—who paints colourful, stylized figurative scenes of African-American life. L. was predominantly influenced by black artists, among them the African-American sculptor Augusta Savage (1892—1962). His best-known work is a series entitled *The Migration of the Negro* (1940—1) which represents, through 60 panels connected by descriptions, design and colour, the mass-migration of over a million

African-Americans to northern industrial towns from the South. He painted *Captain Skinner* (1944) after serving in the U.S. coast-guard in 1943, but returned to his political and cultural concerns after the war, e.g. *Struggle – The History of the American People* (1953–5 in 30 panels).

Lawrence Sir Thomas (1769–1830). British painter. At 22 his Miss Farren made him the rival of Reynolds, whose portrait style he followed, adding a bravura of his own. An unfinished portrait, Wilberforce, shows the quality beneath the glittering surface. Sarah Moulton Barrett is one of the most vivacious of his popular studies of children. Among the many men of the day he painted, his portraits The Duke of Wellington and George IV as Prince Regent are outstanding examples.

Lawson Ernest (1873–1939). U.S. painter of rural and urban landscapes in an impressionistic style. He was a member of The *Eight and one of the sponsors of the Armory Show (1913).

lay figure. Wooden figure with jointed limbs, and often life-size, used to establish a pose or carry drapery. It is said to have been invented by Fra Bartolommeo.

Lear Edward (1812–88). British poet and artist. He produced delicate and proficient drawings and watercolour landscapes of his travels through the countries on the Mediterranean and in India. He was regarded highly enough to be drawing master to Queen Victoria. In his nonsense drawings and poems (Book of Nonsense, 1846; Nonsense Songs, 1871; More Nonsense, 1872; Laughable Lyrics, 1877; Nonsense Songs and Stories, 1895) he found relief in the mannered idealism of his age in line and verse at once timelessly direct and a parody of Victorianism.

Le Bas Jacques-Philippe (1707–83). French *Rococo designer and engraver.

Lebrun Charles (1619–90). French painter, a student under Vouet and also in Rome, where he was influenced by Poussin. L.'s elegant and decorative classicism is thin-blooded, but as chief painter to the king (from 1662) and director of the Gobelins factory (from 1663), under the patronage of Colbert, he controlled the arts in France into the 1680s. He was also a founder and later director of the Royal Academy of Painting and Sculpture. His works include much of the decoration at Versailles.

Leck Bart van der (1876–1958). Dutch painter and designer strongly influenced by *Mondrian and associated with Van *Doesburg in the 1st issue of *De Stijl*.

Le Corbusier originally named Charles-Edouard Jeanneret (1887–1965). One of the greatest modern architects. He was born in Switzerland. In addition to being an architect, Le C. was a propagandist for architecture, a founder of the C.I.A.M. and author of many books, the most influential *Vers une architecture* (1923). He was also a painter of some note, and in 1917 founded *Purism, with *Ozenfant; they publ. the influential magazine *L'Esprit Nouveau*.

Leech John (1817–64). British ill. and caricaturist, best known for his contributions to *Punch* (from 1841); his book ills included Dickens's *Christmas Books*, and Barham's *Ingoldsby Legends*. L. also made ills for the sporting novels of R. Surtees, incl. *Jorrocks's Jaunts and Jollities* (1838) and *Handley Cross* (1843).

LEF. *Vkhutemas

Léger Fernand (1881–1955). French painter, trained initially as an architectural designer. He studied in various Paris studios between 1903 and 1907 when, like many others, he discovered Cézanne. For the next 7 years, reacting against the diffuseness of his early Neo-Impressionist manner, he worked towards a concentrated structural strength in his painting. His early

Sir Thomas Lawrence Miss Farren (detail) 1791

Léger The City 1919

Legros

*Cubist paintings (nicknamed 'tubist') differed from the mainstream in their volumetric solidity, in their deep space and in a *Futurist 'tendency towards the dynamic'. With his friend Delaunay he was one of the most influential Cubist painters: Mondrian greatly admired him and the transitional works (c. 1911-12) of Malevich seem to derive directly from paintings such as Nus dans un paysage (1909-11). By 1912 (La Femme en Bleu) he was nearing abstraction. He attributed his post-war abandonment of his path to his wartime discoveries first of the working man and second of the beauty of machinery. His major works are of contemporary subjects, simple in their black contours and bold colour areas and endowing the ordinary man with a 19th-c. monumentality, e.g. Les Loisins (1948-9). His contact with *De Stijl circles in the 1930s did not diminish his deep respect for the figurative tradition. He also collaborated on a film, Le Ballet mécanique (1923-4) with Man Ray, and designed for stained glass, mosaics, ceramics and the stage.

Legros Alphonse (1837–1911). French painter and etcher. He was associated with the early Impressionists and was a friend of Whistler, who persuaded him to come to Britain, where he settled. He was Slade professor at Univ. College, London (1876–92).

Lehmbruck Wilhelm (1881–1919). German sculptor. After living in Paris (1910–14) he returned to Germany at the beginning of World War I; shocked by his experiences as a nurse in

Lehmbruck
Kneeling Woman

a military hospital he committed suicide. His early work was influenced by *Maillol. In 1911 with *Kneeling Woman* he began to create the slender, melancholy, expressionistic type of figure characteristic of his maturity.

Leibl Wilhelm (1844–1900). German portrait, genre and subject painter, the most important representative of 19th-c. German Realism. He was a painter of intensity and power, frequently taking peasant life as his subject, e.g. *Three Women in Church*.

Leighton Frederic, Lord (1830–96). British painter and sculptor, the leading exponent of the sentimental classicism and idealism of the late Victorian era, in opposition to the *Pre-Raphaelites. He was brought up and studied on the Continent but settled in London in 1860. He became president of the R.A. (1878), and was the 1st painter to receive a peerage (1896). His house, Leighton House, at Holland Park, London, is now a museum.

Lely Sir Peter, born Pieter van der Faes (1618-80). Portrait painter, probably born and certainly trained in Holland, but chiefly associated with the English school. L. arrived in Britain c. 1641 where, in spite of early hesitation in style, some competition from native-born painters and the Civil War, he became the chief portrait painter after Van Dyck's death. The Children of Charles I (1647) is close in style to Van Dyck. Oliver Cromwell (1651) is more confident. At the Restoration L. was appointed principal painter to Charles II. Numerous commissions necessitated setting up a workshop. This grew larger and L.'s control diminished, as did the standard of paintings bearing his name. Of high quality: The Capel Sisters, Painter and Family, Lady Byron and the famous Admirals. Already showing the decline of L.'s art are the equally famous Beauties.

Le Moyne (Lemoyne) Françoise (1688–1737). French decorative painter. He was an admirer of the work of Pietro da Cortona and one of the last French artists to follow the Baroque decorative tradition. He was employed at Versailles, where he painted his masterpiece, the ceiling of the Salon d'Hercule.

Lemoyne Jean-Baptiste (1704–78). French sculptor to Louis XV, pupil of his father Jean-Louis L. and R. Le Lorrain. His finest monumental works for the king were destroyed during the Revolution and his reputation rests

Leibl Three Women in Church 1882

Le Nain the brothers Antoine (1588–1648), Louis (1593–1648) and Mathieu (1607–77). French painters, rediscovered in the 19th c. Details of their lives are still obscure, but it is known that in 1648 they were members of the Academy. It is difficult to differentiate between them. Recent research has sought to establish Louis as the most significant; his pictures of peasants in their surroundings are painted with realism and formal strengths, and show the influence of Velazquez. The *Family Portrait* is a good example. Antoine worked mainly on a small scale and Mathieu produced more polished and pleasing paintings of cavaliers and genre.

Lenbach Franz von (1836–1904). German popular portrait painter, e.g. his numerous portraits of Bismarck.

Leighton The Garden of the Hesperides 1892

Louis Le Nain Family Portrait (detail) c. 1640

Lely Painter and Family (detail) c. 1658

Leonardo da Vinci

Leonardo da Vinci (1452-1519). Florentine painter, sculptor and draughtsman, a universal genius who was architect, town planner, inventor, scientist, writer and musician. L. was the natural son of the notary at Vinci, then under Florentine rule. His extraordinary gifts were soon apparent and he was apprenticed (c. 1470) to Andrea Verrocchio, leading Florentine artist. His fellow-apprentices were Lorenzo di Credi and Botticelli. Little is known about this period except that L. came under the patronage of Lorenzo de' Medici and in 1472 became a master, a member of the Guild of St Luke. In 1482 he entered the service of Lodovico Sforza, Duke of Milan, where he was active as court painter, sculptor, architect and military engineer until the fall of Sforza in 1499, when the French armies occupied Milan. L. fled to Mantua, then to Venice, where he was employed as a military engineer. In 1500 he went to Florence, 2 years later joined Cesare Borgia in his campaigns, but on Borgia's defeat returned to Florence, where he remained until 1508. The Mona Lisa was painted in Florence between 1503 and 1506. In 1508 L. was recalled to Milan by the French governor of the city, Charles d'Amboise, and for 5 years was occupied with scientific studies and plans for the construction of a canal. With his pupil and assistant, Francesco Melzi, he travelled to the Vatican in 1513 to seek the favour of the Medici Pope Leo X, but left disappointed in 1517 to join the court of the French king, Francis I. In Rome L. was surrounded by intrigue; in France, however, he was greatly appreciated and admired. He lived at the royal château de Cloux, near Amboise, until his death.

L. left few authentic paintings. The Angel kneeling at the extreme left in Verrocchio's Baptism of Christ is believed to be his work. He assisted Verrocchio on a number of paintings, and this has led to a great deal of controversy over their authorship. The Annunciation (c. 1474) is attributed to L. on account of the mysterious landscape and the scientific rendering of depth; 2 Madonnas, now much restored, are also attributed to this period. In 1481 L. undertook a painting, the Adoration, for the monks of San Donato at Scopeto, but left it unfinished. The composition was significant for its grouping of figures, their expressive gestures and its chiaroscuro effect (also a characteristic of the unfinished St Jerome). During 1483 L. worked on the painting the Virgin of the Rocks; the version at the Louvre is considered to be

Leonardo Virgin of the Rocks before 1483

earlier and of greater artistic value. He painted a number of portraits of court ladies during his stay in Milan; the Lady with the Ermine was probably the duke's mistress. It is a masterly rendering of form and a profound psychological study. The Last Supper, painted 1495-8 for the refectory of the monastery of S. Maria delle Grazie, Milan, has, though now carefully restored, been much damaged and overpainted; moreover, because of L.'s experiment in this picture with oil paint, the wall surface was already affected by 1517. The spectator is drawn to participate in the action: Christ and the Apostles are sitting at a table which seems to stand as an extension of the refectory itself. In the Mona Lisa (1503) L. expressed with consummate skill his feeling for the mystery of existence. The forms are precise yet melting, fused into each other with subtle tonal transitions, the *sfumato perfected by L. and exploited by his followers. The cartoon of the Battle of Anghiari, painted at the same time in Florence, is now lost; several copies, including one by

Rubens, have survived. When L. moved to France, he took with him the Mona Lisa, John the Baptist, and the Virgin and Child with St Anne. No authentic sculpture by L. is known. In Milan he made a model of an equestrian monument, the Sforza, but it was destroyed by French soldiers (1499) before it could be cast in bronze: it is known only by surviving drawings. Numerous landscape drawings and studies of heads and nude figures survive: many form part of his notes and scientific studies. L.'s draughtsmanship has never been equalled. His notebooks, written backwards and unknown to his contemporaries, contained profound scientific observations on proportion, perspective, optics, anatomy, geology and such inventions as cannons, tanks, a diving-suit and flying machines. His celebrated Treatise on Painting. which has survived in a fairly accurate copy by another hand, circulated widely in the 16th c. L. greatly influenced his contemporaries, Correggio, Giorgione, Raphael and del Sarto, with his compositions and use of light. He influenced Rubens and foreshadowed the chiaroscura of Rembrandt

Leoni Leone (1509–90). Italian sculptor and goldsmith, mainly of portraits many of which are in Spain, e.g. *Charles V*.

Le Parc Julio (1928—). Argentinian artist who settled in Paris in 1958. He founded the Groupe de Recherche d'Art Visuel based in the Galerie Denis René where *Op and *Kinetic artists were shown. His Op(tical) work is concerned with perception, light, movement and illusion (e.g. Continuel Lumière Formes en Contorsion, 1966).

Lépine Stanislas-Victor-Edmond (Édouard) (1835–92). French painter who with L.-E. Boudin and J. B. Jongkind was a forerunner of Impressionism. He was a pupil of J.-B. Corot.

Leprince Jean-Baptiste (1734–81). French painter and engraver, inventor of the aquatint process of *engraving.

Leslie Charles Robert (1794–1859). British painter of U.S. parentage who specialized in small paintings illustrating scenes from literature. He is remembered as author of *Memoirs of John Constable*, R.A. (1843), an important biography largely composed of extracts from Constable's correspondence.

Lessing Gotthold Ephraim (1729–81). German scholar and writer on art, whose essay, *Laokoon

(1766), became extremely influential.

Le Sueur Eustache (1616–55). French painter of religious and mythological subjects, pupil of S. Vouet, who strongly influenced his early work. He subsequently followed Poussin's classicism, evident in his 22 paintings *The Life of St Bruno* (1645–8) for the Charterhouse, Paris. In his late work he became a dull imitator of Raphael.

Le Sueur Hubert. French sculptor of the early 17th c., from 1629 in Britain, where he did much mediocre work for Charles I.

Leutze Emanuel Gottlieb (1816–68). Germanborn history painter who worked and settled in the U.S.A. His most famous painting was *Washington Crossing the Delaware* (1851).

Levine Jack (1915–). U.S. Expressionist painter, reminiscent of G. Grosz, whose work is devoted to social themes. The savage satire of *The Feast of Pure Reason* (1937) was moderated in later paintings by a more tolerant attitude towards humanity.

Levine Sherrie (1947–). U.S. *Postmodern artist who since the early 1980s has risen to prominence with her *appropriation works –

Sherrie Levine After Fernard Leger 1984

Levitan

watercolour and graphite copies from printed reproductions of photographs and paintings by modern masters, e.g. *Mondrian, *Malevich, Walker Evans, Edward Weston, etc. Using the originals she appropriated as *readymades, L. challenged received ideas of originality, drawing attention to relations between power, gender and creativity, consumerism and commodity value, the social sources and uses of art. In 1985 she ended direct appropriation and started painting abstracts.

Levitan Isaac (1860–1900). Among the earliest painters of Russian landscape. A member of the *Abramtsevo Colony, he contributed designs for some of the earliest productions of Mamontov's 'Private Opera'. At the Moscow College he was an influential professor among the future avant-garde, e.g. Falk, Kusnetsov, Larionov and Tatlin.

Lewis Edmonia (c. 1843–?1911). African-American *Neoclassical sculptor (originally named Wildfire by her Chippewa Indian mother, among whose tribe she grew up after being orphaned at 4). With the help of her brothers and several abolitionists, L. attended Oberlin College, Ohio. However, she was forbidden to graduate, having been accused, although acquitted, of poisoning her roommates. After moving to Boston, patrons there enabled her to visit Italy in 1865. She settled permanently in Rome and was taken up by a group of women artists – attracted to Italy by

Edmonia **Lewis** Old Indian Arrowmaker and his Daughter 1872

the quality of the marble, the attendant craftsmanship and the abundance of Classical sculpture - which centred around the U.S. sculptor Harriet Hosmer (1830–1908). Hosmer, who was concerned mainly with the struggle of women against patriarchal constraints, encouraged L. to explore power conflicts. L. focused on the African-American revolt against slavery. with women as objects of both racial and sexual oppression. Forever Free (1867) is a sculpture of a woman and a man freed on the morning of Lincoln's proclamation in 1863. Yet in their supplication to liberty they remain vestiges of enslavement with the manacles that linger on her foot and his wrist. The subsequent marginalization of freedwomen in the U.S.A. after abolition (both within their own community and beyond) gives this work an ambiguous irony which is made stronger by L.'s only intermittent and mainly promotional return visits to the U.S.A., although she faced, perhaps personally less iniquitous, racism in Rome's view of her as a 'novelty'. Hagar in the Wilderness (1868) and Old Indian Arrowmaker and his Daughter (1872) are her best-known works, the former - that of the biblical Egyptian slave - a female allegory of black oppression in the U.S.A. and the latter a direct evocation of her native U.S. ancestry.

Lewis Frederick Christian (1779–1856). British engraver and landscape painter. His brother George Robert L. (1782–1871) was a portrait and landscape painter, e.g. *View in Herefordshire: Harvest.*

Lewis John Frederick (1805–76). British painter of oriental subjects, son of F. C. L. The brilliant colour and minute detail of his paintings attracted the admiration of Ruskin and anticipated the Pre-Raphaelites.

Lewis (Percy) Wyndham (1884–1957). British writer and painter. After founding the Rebel Art Centre (1913) and *Vorticism, editing the 2 violently polemical numbers of the magazine BLAST (1914, 1915) and war service, L. emerged as the most powerful and one of the most imaginative figures in English art, revered by some artists, increasingly rejected by cultural and social orthodoxy. L.'s novels and critical writings were radical and ruthless attacks on contemporary art and society. He despised the 'average' intellect, and in art held to the 'great ideals of structure and formal significance'; Impressionism, in his view, marked the decay of Realism and neither Cubism. Futurism nor

Wyndham Lewis Surrender of Barcelona 1936

abstract art was the true way out of the impasse of 20th-c. art. Art, he believed, was the science of the outside of things, and his own paintings and his drawings have a precise, tense, controlled line and a steely angularity of form and surface. His writings include: the novels Tarr (1918); The Apes of God (1930), on the superficialities and pretensions of 1920s society; Revenge for Love (1937); and The Human Age, a trilogy -The Childermass (1928), Monstre Gai and Malign Fiesta (both 1955): the critical work Time and Western Man (1927) and the autobiographical Blasting and Bombardiering (1937). His paintings include: famous portraits of T. S. Eliot (1938 and 1949), Ezra Pound (1938) and Edith Sitwell (1923-35); Surrender of Barcelona (1936); and Mud Clinic (1937). He also produced graphic work.

LeWitt Sol (1928–). U.S. Minimalist artist, author of 'Paragraphs on *Conceptual Art' (*Artforum*, 1967). L., like *Judd, has made modular and serial constructions, open modular cubes which derive from logical propositions and operations (49 3-Part Variations, 1967–70). In his drawings, geometrical patterns are derived from sets of instructions or are reinterpretations of mathematical calculations of points, lines and planes (10,000 Lines 3" Long, 1972); concepts like

'towards' or 'between' are worked out in relation to the wall on which a drawing is executed usually by assistants from sets of instructions.

Leyden Lucas van. *Lucas van Leyden

Leyster Judith (1609–60). Dutch genre and portrait painter, wife of the painter Jan Molenaer

Lhote André (1885–1962). French painter and influential teacher and writer on art. His admiration for the work of Cézanne led him to join the Cubists, and in 1912 he exhibited with the Section d'Or group. His later work in a modified Cubist style became academic.

Liberman Alexander (1912—). Russian-born U.S. *Hard-edge abstract painter whose work developed against the current of *Abstract Expressionism and *Action painting of the late 1950s in N.Y. In his paintings, as in those by e.g. *Kelly and *Reinhardt, no distinction is made between foreground and background and the design and image — often achieved by staining unprimed canvas — are sharp and fresh.

Lichtenstein Roy (1923–97). U.S. painter and sculptor, one of the main exponents of U.S. *Pop art. Like *Wesselmann, *Rosenquist and

Lichtenstein Serigraph 1965

Liebermann

*Warhol, his subjects are often banal objects (golf ball, hamburger, hot dog) of modern commercial industrial U.S.A. and mass media, enlarged comic strips, showing printing with dots, talk balloons and exclamations (Whaam, 1963), parodies of famous paintings (Cézanne, Mondrian, Picasso, the Abstract Expressionists) and formalized landscapes. L.'s pictures are usually on a large scale, often painted in acrylic paint, using limited, flat colours and hard, precise drawing in a neutral, deadpan manner.

Liebermann Max (1847–1935). German painter and etcher. L. studied in Amsterdam, where he was influenced by the Realism of J. Israëls, and in Paris, where he came into contact with Munkácsy, Courbet and the painters of the *Barbizon school. In 1873 he worked in Barbizon, then from 1884 in Berlin as an accomplished master of Naturalism, opposed to the theatrical school of Böcklin. His paintings of this period were dark and heavy, but from the 1890s the influence of Manet and the French Impressionists increased; he was elected president of the Berlin Sezession in 1898. Famous and highly productive, L. became the most important German Impressionist.

Lievensz (Lievens) Jan (1607–74). Dutch painter of portraits and religious, allegorical and genre subjects, pupil of Lastman. He worked for a time in Leyden with Rembrandt and in a very similar style. By 1635 he had moved to Antwerp, where his portraiture was influenced by Van Dyck, and his other work to a lesser extent by Rubens and Brouwer. *Raising of Lazarus* is a fine example of his work. His son Jan Andrea (1644–80) was a portrait painter.

Ligon Glenn (1960-). African-American painter who transforms specific cultural experiences into wider explorations of race and identity, focusing on the power of language to define, dictate and marginalize. In Dreambooks (1990), L. draws on 'lexicons' once popular among the African-American community which offer ambiguous textual interpretations - 'readings' - of dreams, providing corresponding numbers, which were intended as a guide to gamblers. Profiles (1990) was prompted by the beating and rape of a white woman in Central Park, N.Y., in 1988, an event that focused the negative feelings of the media and many white New Yorkers towards black and hispanic men.

Limburg The Month of May from Les Très Riches Heures 1411–16

Limb(o)urg de, the brothers Paul (Pol), Jean (Hennequin) and Herman (Hermant). Artists born in Flanders, probably the nephews of the painter J. Malouel. The brothers first entered the service of the dukes of Burgundy. From 1411 they worked for the duke of Berry, succeeding J. de Hesdin. Paul, the greatest, was chiefly responsible for Les Très Riches Heures du Duc de Berry. This illuminated book of hours, one of the masterpieces of the *International Gothic style, is a superb evocation of the age of chivalry and courtly love painted in its last years. The landscape backgrounds, especially of the calendar, are justly famous. All 3 artists were dead by 1416.

limning (from illumination). Word meaning originally manuscript illumination and, from the 16th c. onwards, the painting of miniature portraits.

Lindisfarne Gospels (c. 700; B. M.). Copy of the Vulgate written, and probably illuminated, by Eadfrith, Bishop of Lindisfarne. The illuminations are a masterpiece of the Celtic style with the exception of 4 full-page miniatures of the Evangelists based on early Christian models. An interlinear Anglo-Saxon gloss was added about 950. It is also known as the *Book of St Cuthbert* or the *Durham Book*.

Lindner Richard (1901–78). German-born painter, he emigrated to the U.S.A. in 1941. L.

evolved a mannered fetishistic style appropriate to subjects which evoke N.Y. life.

Lindsay Norman (1879–1969). Australian artist, known mainly for his ills of Petronius, Rabelais and Villon, and also the poetry of Kenneth Mackenzie

Linnell John (1792–1882). British artist, friend and benefactor of Blake and father-in-law of Palmer. He painted portraits, miniatures on ivory, landscapes and religious subjects. His best works are the early portraits and landscapes, e.g. *Kensington Sand Quarry*.

linocut. Form of relief printing similar in technique to the woodcut. Lino, invented in the mid-19th c., is easier to work than wood and is therefore often used when the durability of the block is not an important consideration. It is suited to bold, simplified rather than naturalistic effects

Liotard Jean-Étienne (1702–89). Swiss pastellist and miniaturist who specialized in society and genre portraits, a fine example of the latter being *Chocolate Girl*. He spent 5 years in Constantinople and on his return continued to wear Turkish dress and a beard, which earned him the nickname 'The Turk' and brought him

publicity and patronage all over Europe. He painted several portraits of himself thus attired; also famous is his portrait of himself as an old man (1773).

Linchitz Jacques (1801–1973). Lithuanian-born sculptor who first studied architecture; he settled in Paris (1000), studying at the École des Beaux-Arts and then at the Académie Iulian. He lived in N.Y. from 1941. His 1st 1-man show was held in 1020. In Paris he met *Archipenko. *Gris and *Picasso, and his work from 1915 to about 1925 is Cubist in character. Figures and heads are reduced to a simple block-like structure, whose flat planes are sometimes coloured (Man with Guitar, 1947). In the late 1920s his work underwent a change in form and content. The structural angularity gave way to a looser spatial play and the disciplined formal analysis was abandoned for a free use of evocative natural forms. The idol-like Figure (1926-30) shows his affinity to the Parisian Surrealism of the 1930s, while Chant des voyelles (1931) or the International Prometheus made for the Exhibition (Paris, 1937) illustrate the concern of his mature style to appeal to the spectator through direct association with natural forms and emotions. He executed several important commissions while in N.Y.

Lindisfarne Gospels Illuminated initial c. 700

Lipchitz Chant des voyelles 1931

Filippino **Lippi** Madonna and Child with St Dominic and St Jerome c. 1485

Lippi Filippino (c. 1457–1504). Florentine painter, the son of Fra Filippo L. and almost certainly the pupil of Botticelli. His finest work is The Vision of St Bernard. Madonna and Child with St Dominic and St Jerome and Portrait of a Young Man are also representative of the graceful style of Florentine painting before the revolution of Leonardo da Vinci. Early frescoes by L. are found beside those of Masaccio and Masolino in the Brancacci chapel, Carmine church, Florence. More important, and showing L.'s interest in classical art, are the cycle in the Strozzi chapel, S. Maria Novella, Florence. In his last years he worked in Rome, where he painted many panel pictures and the frescoes of the Caraffa chapel, S. Maria sopra Minerva.

Lippi Fra Filippo (c. 1406–69). Florentine painter. L. was received into a religious order as a child. He was certainly influenced by Masaccio, who painted his frescoes in the Carmine at the time when L. was growing up there. His 1st important work is the *Tarquinia Madonna*. His *Barbadori Altarpiece* shows an almost complete movement away from Masaccio. Its composition is complicated and makes much of decorative elements, and the whole spirit is one of grace and refinement. At Prato L. painted his most important cycle of

frescoes. Of special interest are the 2 scenes St Stephen's Funeral and The Feast of Herod. In Prato he eloped with a nun; their son was the painter Filippino Lippi. Among many later paintings in which L.'s special grace is best seen are Madonna and Child and Madonna Adoring the Child in a Wood. The fresco cycle at Spoleto cathedral was unfinished at his death and was completed by others.

Lismer Arthur (1885–1969). British-born Canadian painter, one of the *Group of Seven.

Liss (Lys) Johann (Jan) (d. 1629) nicknamed 'Pan'. German painter of genre, biblical and mythological subjects who went to Italy (c. 1619) after being trained in the Netherlands. He settled in Venice and with Feti brought new vigour to Venetian painting of the early 17th c.

Lissitzky El (Lazar) (1890–1941). Russian pioneer of modern design in the fields of typography and exhibition design in the 1920s; he also transmitted Russian ideas to W. Europe. In 1919 he met *Malevich in Vitebsk; painted his 1st abstract paintings of startling originality which he called *Prouns*. His *Story of Two Squares* (1920) is considered the 1st example of modern typographical design; in 1921 he helped to organize and design the Russian exhibition in

Lissitzky Proun 99 1919

Fra Filippo **Lippi** Barbadori Altarpiece before 1437

Berlin. Group G which he founded in Berlin in 1920, fusing *Suprematist and *Constructivist ideas, made contact with *De Stijl, leading architects and, through the other foundermember *Moholy-Nagy, with the *Bauhaus.

lithography. A surface printing technique, invented (1798) by A. Senefelder, which depends on the fact that grease and water do not mix. The design is drawn with a greasy chalk on the 'stone' (originally a porous limestone, now always zinc plate), which is then wetted. The water runs off the chalked areas and the greasy ink will take on these areas but not on the damp stone. At first used simply for reproductions, l. developed into an independent art and was used by many 19th-c. artists notably *Daumier. Colour l. was developed early but was pioneered as an art form by *Toulouse-Lautrec.

local colour. Term used in painting of the actual colour of an object in natural diffused light. Shadows or strong neighbouring colours may modify local colour.

Lochner Stefan. 15th-c. German painter mainly active in Cologne. He acted as a link between later Gothic and Early Renaissance painting. He assimilated the tradition of the harsh S. German and the courtly, lyrical Cologne schools. *The Virgin of the Rose Garden* combines charm with

geometry; and his most famous work, the altarpiece in Cologne cathedral, combines the decorative with a monumental realism, influenced by Flemish art.

Lockey Rowland (c. 1565–1616). British miniaturist, designer and goldsmith, apprenticed to *Hilliard.

Lomazzo Giovanni Paolo (1538–1600). Italian painter and influential art theoretician (*Trattato dell' Arte de la Pittura*, 1584, and *Idea del Tempio della Pittura*, 1590) whose writing was influenced by Neo-platonism and who expressed the precepts of late *Mannerism.

Lombard Lambert (1506–66). Flemish painter and architect who went to Rome in 1537 and on his return was influential as a Romanist. His pupils included Frans Floris and Goltzius.

Lombardo Pietro (c. 1433–1515). Venetian sculptor and architect of prominence, largely responsible, among other work, for the design and interior sculptures of S. Maria dei Miracoli in Venice. He often worked with his sons Tullio and Antonio who also distinguished themselves as architects and sculptors in Venice and the Veneto area.

London Group. An exhibiting society founded in 1913 in opposition to the *New English Art Club, which was held to have

Long

become conventional and academic. H. Gilman was the 1st president, and both the *Camden Town painters and the *Vorticists exhibited. Between the wars V. *Bell, *Fry, *Grant and *Nash were among the exhibitors; in the postwar period such figurative painters as *Bomberg and Cliff Holden.

Long Richard (1945-). British artist. He began making geometric forms in the landscape in 1966 (circles of paper on grass, cut turf in a lawn, e.g. Turf Circle, 1966). He works exclusively with natural materials in the landscape, or in a gallery space, the former being works that become integral parts of the landscape (e.g. Stones in Morocco - A Six Day Walk in the Atlas Mountains, 1979) and which are realized on long solitary, ritualized walks (walking in circles, in lines, spirals or zigzags), many in remote and uninhabited parts of the world, e.g. a stone line in the Himalayas, a stone circle in the Andes. etc. These works are documented by photographs, e.g. Footstone, a 126-mile (203-km) walk across England from the Irish Sea coast to the North Sea coast, placing five piles of stones along the way.

Longhi Alessandro (1733–1813). Italian portrait painter and engraver, son of Pietro L., best known for his *Compendio delle Vite de' Pittori Veneziani* ... (1762), an account of the lives of

Pietro **Longhi** Exhibition of a Rhinoceros at Venice (detail) 1751

Ambrogio **Lorenzetti** Good Government in the City (detail) 1338-40

contemporary Venetian painters and an important source-book for the period.

Longhi Pietro Falca called (1702–85). Venetian painter of the Rococo period famous for his delicate, slightly ironical paintings and sketches of Venetian life and manners. He was a pupil of G. M. Crespi at Bologna. He became a member of the Academy of Venice in 1766.

Longo Robert (1953–). U.S. artist associated with a group who arrived in N.Y. from Buffalo in 1977, among whom were Charlie Clough, Nancy Dwyer, *Sherman and Michael Zwack. L. has created works in several media on contemporary urban situations (e.g. *Now Everybody*, 1982–3); these works complement his *performances.

Lorenzetti the brothers Ambrogio and Pietro. 14th-c. Sienese painters, probably pupils of Duccio; both almost certainly died in the plague of 1384. Both were greatly influenced by Giotto, their works leaning towards narrative rather than decorative qualities. Important paintings by Pietro include the altarpiece of the Carmine church (1329) and The Birth of the Virgin. Of his frescoes in the lower church of St Francis, Assisi, the 2 outstanding subjects are Madonna and Child and Descent from the Cross. In both frescoes everything else is subordinated to the creation of emotional intensity; in

Pietro Lorenzetti Madonna and Child (detail) 1329

the *Descent* pain has distorted the figure of Christ but has not robbed it of grandeur. Ambrogio's best-known works are the frescoes on the theme *Good and Bad Government* in the town hall, Siena. Here he displays an imaginative genius for ordering the elements of a townscape or a landscape. Other important panel paintings by Ambrogio are: 4 scenes from the Legend of S. Nicholas of Bari, *Presentation in the Temple*, a polyptych altarpiece and *St Catherine of Alexandria*.

Lorenzo di Credi. Lorenzo di *Credi

lost wax. *cire perdue

Lotto Lorenzo (c. 1480-1556). Venetian painter. L. trained probably under A. Vivarini in Venice, though most of his working life was spent in towns outside Venice - Treviso, Recanati, Rome (c. 1508), Bergamo (1513-28), Ancona and Loreto, where he died as a lay brother in a religious order. Although influenced at different periods by Giovanni Bellini, Titian and Palma Vecchio, L. remained a strongly individual painter. His frescoes in and near Bergamo and his altarpieces in towns where he worked are often marred by stylistic idiosyncrasies. However, his own unusual personality often gives him a rare insight into the personalities of his sitters when he turns to portraits, e.g. Man on a Terrace, the superbly alive Youth Before a White Damask Curtain, and Andrea Odoni. The St Jerome in the Wilderness and St Nicholas of Bari in Glory are outstanding for their landscape backgrounds, while the intarsias of S. Maria Maggiore, Bergamo, are notable for their rare decorative sense and draughtsmanship, e.g. Vision of Elijah, Paintings such as The Annunciation and Christ Taking Leave of His Mother are close in style to Mannerism.

Louis Morris (1912–62). U.S. painter who, with a group of Washington artists that included *Noland, was one of the most accomplished U.S. artists to have emerged in the 1950s, and was central to the development of *Color-field painting, deriving from *Frankenthaler's

Lotto Andrea Odoni 1527

Lowry

method of colour-staining raw canvas. L. was in the tradition of painting of *Motherwell, *Newman, *Pollock, *Reinhardt and *Still and was close to the influential critic *Greenberg. His first stain-painting was made in 1954. He applied liquid paint to unstretched canvas, allowing it to flow down, but rarely to the bottom edge of the canvas, achieving an effect of colour veils in brilliant, curving colour shapes. In his later work L. used long, parallel strips of colour, their edges overlapping.

Lowry L(awrence) S(tephen) (1887–1976). British painter. His characteristic subject was industrial N. England. The paintings, with strangely expressive matchstick figures, are in a *faux-naif* 2-dimensional style.

lubok. 17th–c. Russian woodcut similar to the British chapbooks; at 1st religious, then political in subject, or often simply a means of circulating songs and dances among the peasants. The l. had a considerable influence in forming *Larionov's and *Goncharova's 'primitivist' style (1908–12) so noticeable, e.g. in Goncharova's designs for *Firebird*.

Lucas van Leyden (c. 1494-1533). Early Netherlandish painter and engraver. Taught by his father and C. Engelbrechtsz, L. was a celebrated engraver by the age of 15. Among his engravings, often valued second only to those of Dürer, are Ecce Homo and Mohammed and the Monk. He met Dürer in the Netherlands in 1521 and travelled in the Netherlands with Mabuse in 1527. Like Dürer, L. was very interested in bold technical experiments, perspective, detailed studies from nature, and character, if not oddity, in human beings. His colour is bright, his composition is restless, while serene and lovingly painted landscapes provide relief in such paintings as Last Judgement, The Adoration of the Kings. Healing of the Blind Man and The Worship of the Golden Calf.

Luini Bernardino (c. 1481–1532). Italian painter of the Milanese school, one of the most popular. His personal idiom was fresh and lighthearted but after a series of frescoes in this style he turned to imitating Leonardo. This brought him success but deadened a delightful artistic talent.

Luks George (1867–1933). U.S. painter of low urban life, member of The *Eight and of the *Ashcan School of Social Realism.

Luminism. Term used to describe certain U.S. 19th-c. landscape painters, e.g. *Lane, *Heade and *Kensett in certain of his works, as Lake George, 1869. Luminists painted small, intimate and quietist landscapes and 'waterscapes' whose horizontality imitated the format of vast panoramas, probably drawing on the Dutch tradition. In L. landscapes the sense of monumentality is accomplished through scale, not size, by emphasizing the horizon and reducing the size of the objects, trees, rocks, etc. Landscapes are painted with sharp realism transcended by the effect of clear yet atmospheric light which bathes the scene - often expanses of water - with sublime luminosity. In keeping with the American transcendentalist tradition of R. W. Emerson and H. D. Thoreau, a L. landscape aims to draw in the spectator, submerging and uniting him with nature.

Lundquist Evert (1904—). Swedish painter. At 1st a follower of *Munch, from early 1930s exerted considerable influence on Swedish painters, but was not recognized as his country's leading artist until 1950s. His work is characterized by thick, rich impasto.

Lundstrøm Vilhelm (1893–1950). Danish Cubist painter and collagist whose work derives from Picasso and Archipenko.

Lüpertz Markus (1941—). German painter, sculptor and print maker, a contemporary of *Baselitz, *Penck and *Kiefer, associated, despite his denials, with *Neo-Expressionism and the 1980s wave of new figuration in Germany. In fact, L.'s prolific work is in virtually all modernist styles: *Surrealist, *Cubist and *Abstract Expressionist, e.g. both his series of 'Style Paintings' (started in 1977 and continuing through the 1980s) and of 'Alice in Wonderland' (1980–1).

Lurçat Jean (1892–1966). French painter and important tapestry designer largely responsible for reviving the art of tapestry in France and associated with the Aubusson works.

Luttrell Psalter (c. 1340). Illuminated Psalter executed for Sir Geoffrey Luttrell of Irnham, Lincolnshire, who is portrayed in one of its miniatures with his wife and daughter-in-law. Though artistically it represents the East Anglian school in its decadence, its tinted marginal ills, which include scenes of contemporary life and labour, are of great value to the historian.

Lysippus (*fl.* late 4th c.). Greek sculptor of the early Hellenistic period, official sculptor to Alexander the Great. His works combined idealization with movement and pathos.

M

Mabuse also called Jan Gossaert (1470/80-c. 1533). Early Netherlands artist, born probably at Maubeuge, Hainault, and a master of the Antwerp Guild in 1503. In 1508 he visited Rome and from this date Italian elements appear in his work, which had been close to that of G. David before this. Neptune and Amphitrite shows M.'s humanist interest in antique sculpture, the nude and classical architecture following the journey. It also shows a close study of Dürer's Adam and Eve. All M.'s work has a fine and carefully calculated finish. In the outstanding early work The Adoration of the Kings this has been described as 'an enamel-like purity'. Among other paintings are: Adam and Eve and Portrait of the Children of Christian II of Denmark, and Danaë.

Macchiaioli (It. macchia: stain, blot). A group of Italian painters working in Florence ε. 1855–65. They rebelled against the prevailing academic style. Influenced by Corot and Courbet, and in some ways anticipating the techniques of French Impressionism, they used short brush-strokes and dots of paint to build up an image. Among the most prominent were Giovanni Fattori and Telemaco Signorini.

McCollum Allan (1944-). U.S. artist, best known for his 'Perfect Vehicles' series, e.g. Five Perfect Vehicles (1985-7) - identical vase-like objects cast in plaster and painted in different colours which look mass-produced. As such his work can be defined as being between *Pop, rigorous *Minimalism and Neo-*Conceptualism. The themes M. explores play on the ambivalence between the uniformity of the mass-produced and the authenticity and uniqueness expected of an art work. His Surrogate Paintings (1978-82) and Plaster Surrogates (1982 to the present) are echoed in the salon-like dense presentation of small separate works, as in the series 'Individual Works' in which he has produced over 25,000 unique, hand-sized sculptures since 1987, and in other series like 'Perpetual Photographs' and 'Drawings'.

MacDonald J(ames) E(dward) J(arvey) (1873–1932). British-born Canadian painter, one of the *Group of Seven.

McEvoy Arthur Ambrose (1878–1927). British painter, influenced by Gainsborough, who became successful near the end of his life as a portrait painter.

McEwen Jean Albert (1923–). Canadian painter, president of the 'Association des Artistes Nonfiguratifs de Montréal'.

McGarrell James (1930–). U.S. painter of figurative paintings. His eerie, erotic compositions sometimes recall F. Bacon and R. B. Kitaj.

MacIver Loren (1909—). U.S. painter, I of the U.S.A.'s best-known women artists and virtually untrained, who has produced atmospheric, refined and unusual art. Besides figurative, abstract and symbolic works, she has painted a number of sympathetic portraits of friends; she moves freely and with a constant sense of poetry from precise realism to a sophisticated abstraction.

Macke Auguste (1887–1914). German painter. He studied at Düsseldorf Academy (1904–6) and under *Corinth in Berlin (1907–8). He visited Paris, admiring Seurat and Matisse for their free use of colour. He was a founder-member in 1911 of the *Blaue Reiter group, Munich, with *Kandinsky and *Marc. His visit to Delaunay in Paris (1912) with Marc, and his trip to Tunis (1914) with Klee were the conclusive factors in the emergence of his personal colouristic style. Landscape with Cows and Camel (1914) is characteristic in its radiant crystalline colour areas.

McKnight-Kauffer Edward (1890–1954). U.S. graphic artist and designer; he produced the 1st advertisement in a Cubist style but also worked as a designer for the stage, e.g. Bliss's ballet *Checkmate*.

Maclisc Daniel (1806–70). Irish-born artist who became one of the leading Victorian painters of grandiose historical subjects. 2 frescoes, *The Death of Nelson* and *The Meeting of Blücher and Wellington*, are in the House of Lords. M. was also noted for portraits of famous contemporaries which appeared in *Fraser's Magazine*.

Madurai

Madurai Tamilnadu, S. India. Capital of the medieval Pandya kingdom whose art and architecture, e.g. the rock-cut shrine at Kalugumalai, derives from ★Chola styles. The Nayak dynasty (c. 1550−1743) transformed it into a temple city with mandapa halls of elaborately sculptured columns and lofty gopurams (huge gateway towers) covered in tiers of sculpture.

Maerten van Veen. Name by which Van *Heemskerck is sometimes known.

Maes (Maas) Nicolaes (1632–93). Dutch portrait and genre painter who studied under Rembrandt; best known for his intimate domestic scenes. A visit to Antwerp in 1670 led to a change in style and the production of fashionable and suave portraits in the Flemish manner.

maestà (It. majesty). Short name given to paintings of the Madonna and Child enthroned in majesty with saints and angels in adoration.

Magic Realism or 'Sharp-Focus Realism'. A style of primarily U.S. painting which combines simple, sharply defined Precisionist compositions of machine-like clarity with decorative and illustrative Cubism (*Cubist-Realism). It has occasionally fantastic or symbolic overtones. *Sheeler, Preston Dickinson and *Blume are sometimes described as M. Realists.

Magnasco Alessandro (1667–1749). Italian painter in the manner of Salvator Rosa, of monks, gypsies, etc. in wild stormy landscapes.

Magnelli Alberto (1888–1971). Italian non-figurative painter working in Paris. Joined by Kandinsky in 1932, he became one of the chief abstract painters in Paris in the 1930s.

Magritte René (1898-1967). Belgian Surrealist painter. His early work (c. 1920) was influenced by *Futurism and *Cubism. In 1925 he founded, with the Belgian poet and collagist E. L. T. Messens, the reviews Oesophage and Marie which launched Belgian *Surrealism. From that year, and under the influence of De *Chirico's vision which showed him 'the ascendancy of poetry over painting', M. developed his personal style: literal paintings of precise, illusionistic images encapsulating poetic ideas, which transcend formal concerns and which suggest the mysterious and unknown presence, or action, of more than what can be seen, e.g. The Menaced Assassin (1926) which incorporates all the features of M.'s subsequent painting: perplexing narrative,

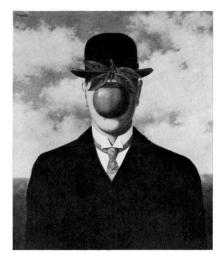

Magritte La grande guerre 1964

suggesting the extraordinary by means of the ordinary, distortion of scales, an erotic quality. the unexpected, mysterious and unfamiliar. In 1927 M. went to Paris for 3 years and joined other Surrealists, before settling in Brussels for the rest of his life. M.'s 'magic realism', applied to different themes, changed little throughout his career, e.g. The Treachery (or Perfidy) of Images (1928-9), which aims to subvert identity, The Human Condition I (1933), which introduces the theme of real space vs. painted spatial illusionism (trompe l'œil), Threatening Weather (1928) and The Ladder of Fire I (1933), The Castle of the Pyrenees (1959), and Delusions of Grandeur (1961). M.'s paintings did not receive wide attention until after World War II. The retrospective exhibition of his work at M.O.M.A., N.Y., in 1965, and subsequent large-scale retrospectives in London and Paris, however, confirmed him as one of the most important Surrealist artists and perhaps the most widely popular modernist painter of the 20th c. M.'s characteristic style has since exerted a wide influence, also on posters, advertising and graphic design.

Mahabalipuram or Mamallapuram, Tamilnadu, India. Coastal site near Madras of rock-carved Hindu sculpture and temples for the *Pallava king Narasimha Varman I (d. 688). The reliefs, in a developed, elegant post-Andhra style, include the *Descent of the Ganges*. On the beach are 5 small rock-cut temples, called *Raths* ('chariots [of the gods]'), profusely adorned with

sculptures, and the early 8th-c. granite-built shore temple of Shiva.

Maillol Aristide (1861–1944). French sculptor. He studied painting and sculpture at the École des Beaux-Arts, Paris (1882-6). He was associated with the Nabis as a painter and tapestry designer and did not concentrate solely on sculpture until c. 1897, when his sight was failing. His early works (wood carvings and terracotta statuettes) provided the basis of his later sculpture, most of which was cast in bronze. He was influenced at first by *Rodin (the 2 men shared a mutual respect), but his mature treatment of the figure, strengthened by a visit to Greece in 1906, has a sensuality which is closer to classical art than to Rodin's expressive and sometimes erotic Romanticism. M.'s whole œuvre is built round the female nude. His most original work (c. 1898-1910) is important for its renewed respect for mass after the fluid surface richness of Rodin and the Impressionist sculpture of artists like M. *Rosso. Torso (1906) is typical in its massive simplicity of closed form with a strong sense of a contained dynamic energy. After 1910 his work was relatively uninventive and ranges from the prosaic stylization of his Memorial to Cézanne (1912-25) to the rather theatrical quality of symbolic figures such as Air and River (1939-43).

Mainardi Sebastiano di Bartolo (c. 1460–1513). Italian painter, follower and assistant of Domenico Ghirlandaio, who worked chiefly on altarpieces and frescoes. His 1st dated work is at the Collegiata, San Gimignano; but he later worked mainly in Florence. The early influence of Verrocchio was later superseded by that of Filippino Lippi.

Makart Hans (1840–84). Austrian history painter of huge decorative canvases; student of *Piloty.

Makimono. *Japanese art

Malbone Edward Greene (1777–1807). U.S. portrait painter especially noted as a miniaturist. He studied under Samuel King in Boston, and worked in Boston, N.Y., Philadelphia and Charleston.

Malerisch (Ger. painterly). The art historian *Wölfflin gave a particular meaning to this term by using it to characterize the type of painting which expresses form in terms of colour and tone (e.g. Rembrandt and Titian) as opposed to line (e.g. Botticelli).

Maillol Torso 1906

Malevich Kasimir (1878–1935). Russian painter born in Kiev, coming to Moscow about 1905 and working for the next few years in a private studio run by Roerich. From 1908 to 1910 M.'s work underwent rapid development under the impact of French Post-Impressionism (The *Golden Fleece) and came to the notice of *Larionov, who invited him to contribute to the 1st *Knave of Diamonds Exhibition. For the next 2 years he associated closely with Larionov and *Goncharova, sharing their interest in national folk-art as well as continuing his enthusiasm for the work of Cezanne, Matisse, Picasso and Van Gogh. Intimate with Russian Futurist poets, e.g. Mayakovsky and Khlebnikov, M. designed scenery and costumes for Victory over the Sun, produced in St Petersburg (1913), one of the back-cloths being an abstract black-andwhite square. According to M., this production launched *Suprematism. During the next 2 years he painted a series of Surrealist and 'nonsense Realist' works, e.g. An Englishman in Moscow. In 1915 he exhibited 36 abstract canvases, including the famous Black Square. In this later period of Suprematism (1917-18), e.g. Sensation of the Space of the Universe, soft amorphous forms combined with geometric; 2 series dominated, those using a cross form and a White on White series such as the painting of a white square on a white ground in 1918. After this M.

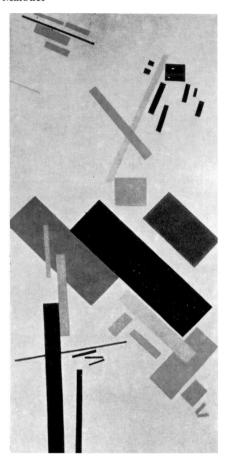

Malevich House under Construction 1914-15

ceased to paint except as illustration to theories expounded in a series of pamphlets and small books. His 1st idealized architectural drawings (1915–16) developed into 3-dimensional plaster sculptures, *Architectonicas*; during the 1920s M. was influential as a teacher in Vitebsk and Moscow and from 1922 in Leningrad.

Malouel Jean (d. 1419?). Flemish artist and court painter (from 1397) to Philip the Bold and John the Fearless, dukes of Burgundy. He was commissioned to paint 5 altarpieces for the Chartreuse of Champmol in 1398 and was one of the earliest panel painters of N. Europe.

Mamallapuram. *Mahabalipuram

Mamontov Savva Ivanovich. Muscovite merchant and railway tycoon who during the

1870s and 1880s gathered round himself on his estate at *Abramtsevo the most prominent painters of the Wanderers group. In 1883 he opened his 'Private Opera' in Moscow where he introduced the music of Rimsky Korsakov, Borodin and Mussorgsky to the Russian public and where Chaliapin made his début. These productions were also revolutionary in their use of painters as stage designers, a tradition continued directly by Diaghilev. Stanislavsky was a cousin of M.

Man Ray (1890–1976). U.S. painter, photographer, film maker; one of the founders of the New York *Dada movement and long associated with *Surrealism, though by temperament an eclectic. In the 1920s and 1930s he worked in Paris, mainly as a photographer: he and *Moholy-Nagy explored the principles of space and motion in a type of photography that bypassed the camera and concerned itself with forms produced directly on the photographic printing paper. He wrote an autobiography, Self Portrait (1963).

Mander Karel van (1548–1606). Dutch painter, poet and art historian, in Rome from 1574 to 1577. His early work is a mixture of Flemish and Italian Mannerist styles, but he later tended to greater realism. He founded the Academy of Painting at Haarlem. His history of art, *Het Schilderboeck* (1604), was modelled on Vasari's work, and also contained an introduction on the techniques of painting.

Manessier Alfred (1911–93). French painter, a leading member of the post-war École de Paris. In the 1930s he moved through *Cubist and *Surrealist styles, evolving his own lyrical, abstract idiom. His works include a tapestry for the Dominican convent at Sulchoir, with *Laurens, a tapestry for the National Center of Art, Ottawa, and stained-glass designs.

Manet Édouard (1832–83). French painter born in Paris. He studied at the École des Beaux-Arts (1850–6) under Couture. His *Spanish Guitar Player* (1860) was awarded an honourable mention at the 1861 Salon, his only real public success. He continued to cherish official recognition, believing the Salon to be the 'real field of battle' and was reluctant to link his name with younger revolutionaries. In the 1860s, however, he was himself the main object of controversy and ridicule. The barrage of hostility which greeted *Le Déjeuner sur l'herbe* (1861–3) at the famous Salon des Refusés of 1863 was followed

in 1865 by the scandalized outcry against Olympia (1863-5). From the start M. had followed the advice of Baudelaire and Courbet to paint modern life. The main public objection was that reality was not adequately disguised: the unabashed nakedness of the female figures was offensive to a public that could approve open eroticism in the right classical garb. In fact M. was little concerned with subject matter; he used highly respectable traditional compositions taken from Giorgione, Raphael and Titian on which to base his scenes of modern life. His primary interest was in the organization of the picture surface. Olympia is flooded with a strong frontal light producing simple tonal contrasts and flattening form and space.

The chief formative influence on M.'s style was that of Spanish art; already fervently Hispanophile, he visited Spain in 1865 and declared Velazquez 'the painter of painters'. The figure of M.'s Le Fifre (1866) is isolated against a nondescript grey ground, and his early ideas crystallized in the maturity of Le Balcon (1868) and Le Déjeuner à l'Atelier (1868), with a fluid directness of execution and a cool grey/green palette that owe much to Velazquez. He admired the same painterly facility in Frans Hals while visiting Holland in 1872.

During the 1870s at Argenteuil lie came under the influence of the Impressionists. Although often linked with them by his contemporaries (he was congratulated for 2 Monet seascapes in 1865, much to his dismay), he is really important with Courbet as their predecessor: in the steadfast integrity of his stand

against official disapproval, in his lack of concern for subject matter in painting and in the establishment of the artist's complete freedom in handling colours and tone. He never exhibited with the Impressionists and during the 1870s continued to paint highly composed studio pictures (*In the Conservatory* 1879). His last important work, *Le Bar aux Folies-Bergères* (1882), returned to his ideas of the 1860s.

He was appointed Chevalier de la Légion d'Honneur in 1882, but he died bitter and cynical about this late recognition. A large memorial exhibition was held at the École des Beaux-Arts, bastion of officialdom, in 1884.

Manfredi Bartolommeo (c. 1580–c. 1620). Italian painter, born near Mantua, who worked in Rome (1610–19). His paintings were influenced by, and are sometimes mistaken for, those of Caravaggio. M. influenced the Utrecht school. He later adopted Mannerism and painted religious subjects in a genre idiom.

Mangold Robert (1937–). U.S. artist. His paintings are of spaces and silences, introspective works in which M. aims at 'a simple, direct statement which should affect the viewer quietly but forcefully'.

Mannerism. Any affectation of style, but used more specifically of Italian painting, sculpture and architecture of the period between the High Renaissance and the Baroque period. Architecturally it differs from Renaissance in its deliberate contradiction of classical rules (e.g. regarding the use of orders), aiming at discord instead of harmony and strain instead of repose;

Manet Olympia 1863-5

Mantegna

and from Baroque in not fusing all its elements into unified, dynamic patterns, but producing effects of ambiguity and discomfort rather than energy and confidence. It is first fully realized in Michelangelo's Vestibule of the Laurentian Library (1523) and characterizes most of the works of Giulio Romano, Ammanati, Ligorio, Buontalenti and Vignola. Similar qualities appear in French and British architecture slightly later. M. painting is also characterized by a search for novelty and excitement leading to capriciously elongated figures on complicated *contraposto, asymmetrical composition with huge discrepancies in scale, and harsh colour. Michelangelo, Tintoretto and El Greco are the great creative exponents of M., but the style is best exemplified in the paintings of such artists as Parmigianino, Rosso and Pontormo; other Mannerist painters and sculptors include Daniele da Volterra, Niccolò dell'Abbate, Bronzino, Cellini and Giovanni da Bologna.

Mantegna Andrea (c. 1431–1506). Northern Italian painter and engraver. M. appears to have been both the apprentice and the adopted son of the antiquarian and painter F. Squarcione, for 6 years in Padua, before freeing himself in a lawsuit. Squarcione's studies of antiquity, the humanistic influences of Padua Univ. and the masterpieces resulting from Donatello's 10-year stay in the city were each important in the formation of M.'s art. He painted *The Assumption*,

4 Scenes from the Life of St James and The Martyrdom of St Christopher in the Ovetari chapel, Eremitani church, Padua (1448-59). All but the last of these important frescoes were destroyed during World War II. In them, and in such paintings as the St Zeno Altarpiece and St Sebastian, M.'s debt to Donatello is obvious: not only are the monumental qualities of sculpture reproduced but even the surface often appears to be made of metal or stone. Classical motifs are actually distracting in the St Sebastian, and M. attempts to reproduce the effect of a Roman bas-relief in paint on canvas in such monochrome works as Judith with the Head of Holofernes. In predella panels, e.g. the superb Crucifixion, the figures are less sculptural, though the landscape is ordered with the same rigour. M. married the daughter of Jacopo Bellini in 1453, and the strengthening of his connection with the Venetians is illustrated by The Agony in the Garden, a painting based on a drawing by Bellini. In 1460 M. became court painter to the Gonzaga family, and in their palace at Mantua painted frescoes of incidents in the lives of his patrons. Most important is the ceiling of the Camera degli Sposi. An illusion of an opened roof above the spectator's head is created, with a blue sky and a circle of figures gazing down into the room. This is the first use of such effects and it was to lead directly to Correggio and the Baroque masters' exploitation of illusionistic perspective.

Mantegna The Agony in the Garden c. 1465

At the Gonzaga court M. formed a coll. of classical works of art which was the envy of the Pope. He also executed the fine engravings on classical subjects, such as Battle of the Sea Gods and Death of Orpheus, which were to influence Dürer and other graphic artists. For the Gonzagas he painted The Triumphs of Caesar. One of his last works was the magnificent Dead Christ.

Manuel Niklaus (1484-1530). Swiss painter and poet and statesman; formerly sometimes wrongly called N. M. Deutsch on the basis of his monogram N.M.D.: the 'D' is now thought to stand for the surname 'Degen'. As a member of the Inner Council of Berne, M. had an important influence on the debates on religious reform, having already made a name with plays attacking ecclesiastical abuses. As a painter M. was obviously affected by the work of Dürer and Baldung Grien; but his richly coloured pictures of biblical and mythological subjects frequently have dramatic effects of lighting and mood of landscape peculiar to him. His paintings include: The Execution of John the Baptist and the Judgement of Paris.

Manzoni Piero (1933–63). Italian artist, until 1956 working figuratively in a traditional style; his work then changed abruptly and radically. Many works are entitled *Achrome*, made of polystyrene pellets in various shapes and forms. In 1960 he made *Artist's Breath*, a balloon on a wooden base. With the Gruppo Nucleare he signed the 'Manifesto against style' in 1957.

Manzù Giacomo (1908–91). Leading Italian sculptor. Much of his work is religious. It includes: doors for St Peter's, Rome, and for Salzburg cathedral; some 50 seated or standing figures of cardinals; and *Madonna and Child.* M. obviously owes a debt to Rodin, and some of his free-standing sculptures have affinities with Marini. M. also did a series of young girl nudes and has done stage designs.

Mapplethorpe Robert (1946–89). U.S. photographer noted for his black-and-white flower studies, nudes, self-portraits, and portraits of artists and celebrities, as well as for his controversial S & M depictions. His work, unlike that of many other contemporary photographers who deal with issues of sexuality, has acquired the status of high art.

maquette. In sculpture a small preliminary model in wax or clay.

Maratta or Maratti Carlo (1625–1713). Italian Baroque decorative artist and portrait painter who studied in Rome. His work was influenced by that of Correggio and Guido Reni. Examples of his fresco work are in S. Giovanni in Fonte and S. Giuseppe dei Falegnani, Rome.

Marc Franz (1880-1916). German *Expressionist painter born in Munich; he studied philosophy and theology at the University and then painting at the Academy. He was one of the founders of the *Blaue Reiter group in Munich in 1911. He was killed at Verdun. Working in close association with *Kandinsky, M. explored the expressive values of colour. This preoccupation with colour was partly inspired by the *Orphist paintings of *Delaunay, whom he visited in Paris with Macke in 1912, and probably also by Goethe's Farbenlehre. Although he remained a painter of animals, paintings like Tiger (1912) are primarily expressive through their simple planes of colour; and in Fighting Forms (1914) he was nearing a point of abstract expressionism.

Marcantonio Raimondi (1480–1534). Italian engraver; his most important works are engravings reproducing paintings by Raphael and his school, an art which he was the first to practise.

Marcks Gerhard (1889–1967). German sculptor; his work has been almost exclusively on the theme of the nude figure, in the tradition of Barlach and Lehmbruck. He taught at the *Bauhaus (1920–5), where he ran the pottery studio.

Marcoussis Louis (Markhous) (1883–1941). Polish painter who went to Paris in 1903 and was associated with the *Cubists from 1907. He made no original contribution to Cubism, but of the group which exhibited together in 1911 and 1912, he seems to have most fully understood Picasso and Braque, e.g. Nature morte au damier (1912).

Marden Brice (1938—). U.S. painter whose work evolved from *Abstract Expressionism to seemingly *minimalist simplicity, although redolent of personal expression, with an increasing focus on colour. M.'s admiration for *Zurbarán, *Newman and *Johns is reflected in his particular attention to medium, colour and facture. His use of hot beeswax mixed with turpentine and pigment makes layers of colours deeper and more evocative, and creates a sense

Marées

of space. In his single-panel paintings of the 1960s, mainly monochrome grey, he left the bottom edge of the canvas unpainted allowing drips and smears to run down, disclosing the process of the painting's evolution. In the 1970s he painted multi-panel-and-colour works, e.g. Seasons (1974-5) and a 5-panel 'Annunciation' series (1977) which has been called 'one of the most important works of religious art in the twentieth century'. Thira (1980) is an 18-panel, multi-coloured triptych in which he uses for the first time horizontal panels on top of vertical ones which are suggestive of doors and windows. His remarkable large-scale drawings on paper with black ink are composed of dense parallel and intersecting lines.

Marées Hans von (1837–87). German painter who studied in Berlin but later worked in Munich and, after 1865, in Rome. He specialized in frescoes and large landscapes, and his work influenced that of *Böcklin and *Beckmann.

Margarito of Arezzo. Italian painter sometimes identified with Margaritone of Magnano. According to Vasari he lived from 1236 to 1316. He painted in a rigid, linear 'Romanesque' style, producing many paintings of St Francis.

Maria Walter de (1935—). U.S. artist. In the early 1960s he produced *Minimal art and (1961) a proposal for an *Earth art piece, Art Yard, the digging of a hole in the ground. His Mile-Long Drawing (1968) consisted of 2 milelong parallel lines chalked in the Nevada desert.

Marin John (1870–1953). U.S. painter and engraver, M.'s watercolours and engravings of buildings in Europe (1905–9, 1910–11) and the skyscrapers of N.Y. were made known in the U.S.A. by *Stieglitz. Later, scenes of Maine, e.g. Maine Islands (1922), and New Mexico made M. the leading U.S. watercolour painter. He worked in a free style reminiscent of *Kandinsky, but with a strong and usually obvious element of construction – probably a legacy of his early training as an architect. In his last years he painted many of the same land-scapes in oil.

Marinetti Filippo Tommaso (1876–1944). Italian poet (writing in French and Italian) and novelist, remembered as the founder of *Futurism: he publ. its 1st manifesto in 1909.

Marini Marino (1901–66). Considered by some as the leading Italian sculptor since Boccioni and

Rosso. He studied painting and sculpture at the Florence Academy and then sculpture in Paris (1928). His œuvre includes paintings and prints in several media, and some of his sculpture is itself painted. His principal theme has been that of the horse and rider.

Marinus van Reymerswaele (c. 1493–after 1567). Flemish painter influenced by contemporary German styles and that of Quinten Massys; he painted portraits of bankers, businessmen and grasping excisemen; his work was known in Italy and Spain.

Marisol Escobar (1930-). Venezuelan sculptor, painter and graphic artist who lives and works in N.Y. Initially associated with *Pop art in the 1950s, her work has been seen as highly individualized, often combining social and political comment with images of her own striking features. M. is influenced by native American art which she has alluded to throughout her career. Her large wooden sculptures of well-known U.S. figures, e.g. the Kennedys and John Wayne are often painted and in *assemblages with *found objects and plaster casts, which challenge expectations of dimension. M. subsequently distanced herself from political comment, while her search for identity remains a constant in her work, e.g. projections of her face on to finely carved mahogany figures of fish.

Marmion Simon (d. 1489). Franco-Flemish illuminator and panel painter who worked in Amiens, Valenciennes and Tournai, and for Philip the Good, Duke of Burgundy. His principal work was a 22-panel altarpiece for St Omer abbey.

Marquet Pierre-Albert (1875–1947). French painter who studied under G. *Moreau. He subsequently became associated with the Fauvists and with *Matisse, with whom he went to Morocco in 1913. M. later frequently returned there to paint.

Marsh Reginald (1898–1954). U.S. painter of city scenes who worked on newspapers and studied under K. H. Miller. His etchings of N.Y. life verge on caricature.

Marshall Benjamin (1767–1835). British painter of sporting subjects, above all horseracing.

Martin. The 3 brothers of this name, Robert Wallace (1843–1923), Walter (1859–1912) and Edwin (1860–1915), working together from 1873 were an important factor in the British artist potter movement. Their best-known,

though not their best works, are the grotesque face and bird jugs and vases mainly by Wallace.

Martin Agnes (1912–). U.S. artist. Although painting for several years she did not hold her first solo show until 1958, and she won increasing critical acclaim in the early 1960s with her all-over grid paintings, pencilled on monochrome oil or acrylic grounds on large square canvases. Illusion, texture, delicacy and quiet strength characterize her exquisite paintings and drawings.

Martin Homer Dodge (1836–97). U.S. land-scape painter who was largely self-taught. He came under the influence of Impressionism, partly through W. Hart, and this led to a break with the literal manner of the *Hudson River school. Travels in France (1881–6) confirmed this stylistic preference.

Martin John (1789–1854). British Romantic painter of visionary and apocalyptic landscape and other subjects; he also painted heroic or Old Testament subjects, with hundreds of figures often in fantastic architectural settings.

Martin Kenneth (1905–84). British painter and sculptor. His best-known works are wire mobiles, e.g. the bronze and steel *Mobile Spiral* (1956), which describe 'fields of force' in their movement. M. also painted landscapes and Gonatructivist abstracts

Martineau Robert Braithwaite (1826–69). British genre and portrait painter, pupil of Holman Hunt.

Martini Simone (c. 1284–1344). Sienese painter, the pupil of Duccio, M. drew upon Duccio's colour harmonies while pursuing his own experiments in using line for decorative purposes, so that his later works become almost abstract compositions. By 1315 he was sufficiently well thought of to be commissioned to paint a Maestà for the town hall of Siena. This work makes obvious M.'s debt to Duccio, but it also shows his knowledge of the sculpture of the Pisani and of the use of line in Sienese art. He was brought in direct contact with the court art and literature of France when he was summoned to the French kingdom of Naples by Robert of Anjou in 1317 to paint St Louis of Toulouse Crowning the King. In 1320 he was painting in Pisa and Orvieto. By 1328 he was in Siena to paint the famous portrait of Guidoriccio da Fogliano reviewing his battlelines on horseback, and other frescoes in the town hall. He was in Florence in 1333, working

John Martin Sadak in Search of the Waters of Oblivion

Martini Maestà (detail) 1315

Masaccio

with his brother-in-law *Memmi. Both artists signed the *Annunciation*, which is one of the masterpieces of Sienese painting. In 1339 M. was at the court of the Papacy at Avignon. Here he became the close friend of Petrarch; he is known to have painted Petrarch's Laura, but this portrait has been lost. 'Surely my friend Simone was once in paradise', Petrarch said, and it was M.'s conception of the earthly paradise as the scene of courtly love that was to influence the artists of the *International Gothic style throughout Europe.

Masaccio. The nickname of Tommaso di Giovanni (1401–28?). Florentine painter, one of the great innovators of European art: the revolution he brought about in painting was recognized by his contemporaries even within the short span of his own lifetime. Little is known of his early years and his nickname, variously interpreted as 'naughty Tom', 'clumsy Tom' or 'hulking Tom' gives little clue. Vasari simply maintains that he was impractical in everyday affairs. M. became a member of the Florentine Guild in 1422, which leaves a period of some 6 years in which he was to accomplish his revolution, before setting out for Rome never to be heard of again. *Masolino

Masaccio Crucifixion 1426-7

is said to have taught him, but if this is so, the roles of master and pupil were to be reversed almost at once. What is certain is that M. was profoundly influenced by those elements of Giotto's art that had been retained and exploited better by the sculptor Donatello and the architect Brunelleschi, than by any contemporary Florentine painter. M. took up Giotto's search for a way of expressing the more exalted human emotions through figures in action in terms of painting. Where the painters of the *International Gothic style allowed line to flow. to proliferate, to become pure decoration. M. tightened it almost to breaking-point. His style is austere. His drawing of the human figure achieves an incredible degree of realism, the illusion of weight and modelling, with the sparest of means. Yet from reality he chooses only what human presence or the Divine Spirit can make noble. The Pisan polyptych altarpiece, one of his earliest works, has been divided and scattered; they survive separately as: Madonna and Child, Crucifixion, Adoration of the Magi and Beheading of the Baptist. A similar work on panel is the Madonna and Child with St Anne and Five Angels. The fresco The Trinity is undoubtedly the most successful and moving rendering of this subject. But M.'s fame, both as an artist and as the teacher of a whole group of Florentine painters, rests with the frescoes of the Brancacci chapel, S. Maria del Carmine, Florence. Masolino and, later, Filippino *Lippi also painted subjects on this chapel; a third of the scheme was destroyed by fire, and some difficulty of attribution remains. Generally accepted as being by M. are: The Tribute Money, Explusion from Paradise, St Peter and St John healing the Sick by letting their Shadows fall on them, St Peter and St John distributing Alms, The Raising of the King's Son (most) and St Paul visiting St Peter in Prison (part).

Masereel Frans (1889–1972). Belgian painter who studied in Ghent, London and Paris, where he finally settled, illustrating books and painting Parisian street scenes and shore scenes at Boulogne. He is known in particular for his Expressionist stories in woodcut.

Masip or Macip Juan Vicente (c. 1490–1550). Spanish painter working in Valencia, painting in the style of Raphael. His son (c. 1523–79) and pupil (of the same name) studied Raphael, Michelangelo and Leonardo and later painted passionate religious pictures in a dramatic Mannerist style.

Maso di Banco (fl. mid-14th c.). Italian painter and one of the greatest of Giotti's followers; he is sometimes confused with Giottino. The only works which can be ascribed to him with certainty are the fresco cycle *St Sylvester and the Emperor Constantine* in S. Croce, Florence.

Masolino (c. 1383–c. 1432). Florentine painter trained in the *International Gothic style, perhaps by Ghiberti, e.g. Madonna. He was influenced by Masaccio, a much younger man, when working with him on frescoes in the Brancacci chapel, S. Maria del Carmine, Florence. He was in Hungary (1425–7) and later worked in Eripoli, Todi and Rome.

Masson André (1896–1987). French *Surrealist painter. He quarrelled with *Breton in the late 1920s and developed a form of calligraphic Surrealism which probably had some influence on the *Abstract Expressionist movement in the U.S.A.

Massys Quinten (1465/6–1530), also spelt 'Quentin' and 'Matsys' or 'Metsys'. Early Netherlandish painter born in Louvain but made a master of the Antwerp Guild in 1519. M.'s style carries the Netherlands search for refinement and spiritual sensitivity to an extreme in his religious work and his portraits; his painting had a considerable influence, especially among the Italianate painters of the Netherlands. His range of subjects is large. An outstanding early painting is the central panel of the St Anne

Massys St Anne Altarpiece (central panel) 1509

Altarpiece. Portraits of scholars at their work such as Erasmus anticipate a favourite subject of Holbein. In his Virgin and Child, Rest on the Flight into Egypt and other studies of the Holy Family there is a profound melancholy. The caricature drawings and the faces of the crowd in Ecce Homo provide the reverse side of the refinement. Genre paintings such as Money-changer and his Wife are in the tradition of Van Eyck and Petrus Christus. Late, highly finished panels such as The Temptation of St Anthony were often the result of a collaboration with *Patenier. Finally, the exceptional painting in tempera on linen, The Virgin and Child with St Barbara (?) and St Catherine gives evidence of Italian influences, particularly of Raphael and Leonardo da Vinci.

Master Bertram. German artist working at Hamburg 1367–87. His workshop produced an altarpiece for St Peter's, Hamburg, now in the Kunsthalle.

Master Francke (d. after 1424). Painter who worked in Hamburg; information about his activities is slight. Owing to the influence of French illuminated mss evident in his work he is believed to have been in Paris. His painting shows an advance on that of the slightly older Hamburg artist Master Bertram, in its composition, brilliance of colour, observation of life and expressiveness coupled with restraint. Most famous are his *St Thomas Altar* (1424), on Thomas à Becket, including the gentle *Nativity* panel, and 2 versions of the *Man of Sorrows*.

Master of Flémalle. Early Netherlandish painter, now generally accepted to have been the same artist as both the Master of Mérode and Robert Campin (c. 1380–1444). Campin worked in Tournai, becoming a citizen in 1423. Despite being 'mildly persecuted' for political activity and 'living in concubinage' his reputation remained high. J. Daret and Rogier van der Weyden were his pupils. No major works were known before the association of his name with works attributed to the Master of Flémalle, which include: Nativity, The Werl altarpiece, Miracle of the Rod and Betrothal of the Virgin, Portrait of a Man, Virgin and Child before a Firescreen and Madonna in Glory. Attributed to the Master of Mérode is the important triptych now in the Metropolitan Museum. As controversial as the artist's identity is the question of his precedence in relation to Jan van Eyck. His naturalism of style shows a quite different feeling to Van Eyck's but is hardly less revolutionary. He was probably the inventor of the painted

Master of Flémalle Annunciation (St Mérode Altarpiece) c. 1427

statues in grisaille on the backs of the wing panels of altarpieces and of distant views of townscapes seen through windows.

Master of Moulins (fl. c. 1483–c. 1500) also known as the 'Master of the Bourbons', or 'Maître aux Anges'. French painter, influenced by Netherlandish artists, especially H. van der Goes, but with a very individual and graceful style which can be seen at its best in the altarpiece, Moulins cathedral. Works include: Nativity, St Mary Magdalene and Female Donor, The Annunciation, and Charlemagne and the Meeting at the Gopdeu Gate.

Master of St Giles. French or Netherlandish artist who worked for the French court in Lyons, Paris and the Loire Valley in the last years of the 15th c. He is named after 2 panels, St Giles and the Hind and The Mass of St Giles. 2 panels with incidents from the life of St Remi are also attributed.

Master of the Aix Annunciation. The painter of an altarpiece, *Annunciation*, for the Eglise des Prêcheurs, Aix-en-Provence, c. 1445. The artist was probably French, though influenced by Van Eyck's *Adoration of the Lamb* and the Master of Flémalle. The Rijksmus. panel, an outstanding still-life study of books and papers, may also show the link in style between Netherlands and Neapolitan painters.

Master of the Death of the Virgin. A painter of the early 16th c. usually identified with *Joos van Cleve.

Master of the Duke of Bedford. French artist, working in Paris during the English occupation, who executed a breviary for the English Regent and *The Bedford Hours* (1423).

Master of the Female Half-Lengths. Early Netherlandish artist active about 1530 in Antwerp, who often painted young girls playing musical instruments or reading. His graceful, rather mannered style is close to that of *Massys, e.g. Three Girls Playing Instruments.

Master of the Housebook. Late 15th-c. German or Dutch artist called after the *Hausbuch* at Schloss Wolfegg. This contains many drawings depicting contemporary life; and the numerous engravings attributed to this master, important early examples of the technique, have similar subjects.

Master of the Legend of the Magdalen. Early Netherlandish painter active at the beginning of the 16th c. at Brussels. He followed Rogier van der Weyden and others. Works include the *Annunciation* triptych and *St Mary Magdalen Preaching*.

Master of the Life of the Virgin. German painter active in Cologne c. 1463–80. His serene style, showing Netherlands influences, is seen best in the beautiful *Annunciation* from the altarpiece which gave him his name. Other important works: *The Presentation in the Temple* and a triptych including *The Crucifixion*.

Master of the Rohan Book of Hours. French artist active c. 1420, named after Les

Grandes Heures du Duc de Rohan. M. had a predilection for Last Judgement themes, suffering, violence and death, often rendered in almost Expressionist terms.

Master of the St Lucy Legend. Early Netherlandish painter, active in Bruges c. 1480–90, named after Scenes from the Life of St Lucy. Other attributed works include St Catherine and Madonna with Magdalen and Virgins. Gérard David and others were influenced by the master's quality of elegance in painting the female saints, the richness of their costume and brilliance of landscape detail.

Master of the St Ursula Legend. Early Netherlandish artist working at Bruges at the end of the 15th c., a close follower in style of Rogier van der Weyden and Memlinc, who painted the 4 Scenes from The St Ursula Legend.

Master of the Virgo inter Virgines. Early Netherlandish artist, probably working in Delft at the end of the 15th c., who painted the Madonna and Child Surrounded by Four Holy Women.

Master of Třeboň or Wittingau. Bohemian Gothic painter whose masterpiece is *The Resurrection*, a panel from the parts of an altarpiece painted c. 1380 for a church in Třeboň, or Wittingau, now in Czechoslovakia.

Mataré Ewald (1887–1965). German sculptor who started his career as a painter, studying under *Corinth.

Matisse Henri (1869–1954). French painter. Until the advent of *Cubism, he was the most influential painter in Paris, if not in Europe, and he remains one of the most important artists of the c. His emancipation of colour has an historical importance comparable to Cubism's role in releasing form from representation, and his Notes d'un peintre (1908) stated clearly for the 1st time several principles that lie behind later developments in 20th-c. painting. He first studied law in Paris and worked as a lawyer's clerk at St-Quentin. He started to draw and paint c. 1890 and in 1892 studied in Paris, first under *Bouguereau at the Académie Julian and then (1893-8) in Moreau's studio at the École des Beaux-Arts, where Marquet became his close friend and he met Rouault, Manguin and other future *Fauves. His early independent works painted in Brittany (1896-8) were restrained objective interiors and still-lifes, reflecting his admiration for Chardin. In the late 1890s, under

Matisse Madame Matisse 1905

the influence of Impressionism and Neo-Impressionism, he began to paint in heightened colour, but dissatisfied with Divisionism, he turned to Cézanne. Although poor at the time, he purchased from Vollard in 1899 the small Cézanne Bathers which later 'sustained me spiritually in the critical moments of my career as an artist'. Working at the Académie Carrière (c. 1800-1000) where he met Derain, and later in a studio at Quai St-Michel, M. concentrated until 1904 on structural strength in his painting. Académie Bleu (c. 1900) shows the transition from brilliant colour to crudely simple draughtsmanship and solidly modelled form. Significantly he made his 1st sculpture at this time: sculpture continued throughout his career to be an extension of his painting. The experimental phase ended when in 1904, working at St-Tropez, the renewed contact with the brilliant Neo-Impressionist palette proved the springboard to *Fauvism. M.'s leadership was recognized and in his major works of the period, Luxe, calme et volupté (1905) and Joie de vivre (1905 6) the fundamental character of his whole œuvre was emerging.

M. was concerned with an expressive art, with a seriousness of purpose comparable to the German *Expressionists (whom he influenced) but totally different from them in mood and

Matsys

technique. In his art primitive forms are assimilated without their disturbing violence, e.g. Portrait of Madame Matisse (1913), and his treatment of colour and line never loses sight of their artistic, pictorial values. The difference is fully apparent in his belief that 'only one who is able to order his emotions systematically is an artist'. He wrote in his Notes d'un peintre (1908): 'What I dream of is an art of balance, purity and serenity, devoid of troubling or depressing subject-matter ... which might be ... like an appeasing influence, a mental soother, something like a good armchair in which to rest from physical fatigue.'

He worked in brilliant colour at Collioure (1905) with Derain and each painted a portrait of the other. Although his palette was somewhat subdued during the 1910s, e.g. Pond at Trivaux (c. 1916) or Painter and his Model (1916), he was as little touched by Cubism as Picasso was by Fauvism. He was deeply impressed by an exhibition of Near Eastern art in Munich (1910) and visited Morocco. His love of oriental fabrics and ceramics is reflected in the exotic decorative details and character of the great Odalisques of 1920-5. From 1917 he lived at Nice, with a visit to the U.S.A. and Tahiti in 1930-1. He worked on the chapel at Vence (1949-51); his other late works include the remarkable collages of cutout, gouache-coloured paper shapes arranged in terms of expressive abstract rhythms, e.g. l'Escargot (1953).

Matsys Quinten. *Massys

Matta Echaurren Roberto Sebastian Antonio (1912–). Chilean-born painter who studied architecture under Le Corbusier, from 1934, but joined the *Surrealists in 1937 and began painting, contributing his own brand of organic abstractionism which has sexual and science-fiction overtones

Matteo di Giovanni (fl. c. 1435–95). Sienese artist who worked in association with Giovanni di Pietro at Siena and Piero della Francesca at Borgo San Sepolcro. M. was influenced by Vecchietta and, later, by the Pollaiuolo brothers. Among many works, *The Assumption of the Virgin* is notable for the great beauty of the painting of the Virgin herself.

Matveev Alexandr (1878–1960). Russian sculptor of Saratov, like his close friend and hero Borissov–Mussatov; one of M.'s best-known works is his memorial (1910) to this artist. He began as an architect but soon took to sculpture.

He worked in *Mamontov's ceramic factory for some years. After a visit to Paris in 1906 he became the only sculptor in the *Blue Rose group. For many years he was an influential teacher both in Leningrad and in Moscow. Many of his portraits are of young girls and boys, executed in a mood and technique little changed since his first mature works of the Blue Rose period.

Maulbertsch Franz Anton (1724–96). The most important of the Austrian Baroque decorative painters. He worked in Vienna, throughout Austria, Hungary and Czechoslovakia, and also at the Residenz in Dresden.

Maurya. The first great N. Indian imperial dynasty (c. 320–c. 200 BC). The emperor Ashoka (c. 264–227) adopted Buddhism. Cave sanctuaries were hewn out of rocks and hills, e.g. the Barabar hills, and excellent animal sculpture (e.g. 4 addorsed lions and a bull) on columns erected throughout the empire. The style shows influence from *Hellenistic Iran. Massive sculptures of *yakshas* (nature spirits) survive as do fine terracotta portrait figures.

Mauve Anton (1838–88). Dutch painter in oil and watercolour. The muted colours and atmospheric effects in his landscape subjects show affinities with Corot, Daubigny and Millet. He was an important member of the Dutch 'Barbizon' school.

Maya art. *Pre-Columbian art

Mayakovsky Vladimir Vladimirovich (1893–1930). Soviet poet and playwright. He studied painting and in 1912 joined the Cubo-futurists. After the October Revolution he worked devotedly for the Bolsheviks, designing and writing the texts of thousands of posters, writing poems and film-scripts and making speeches for Red victory in the Civil War. At this time he was virtually the official poet of Communism, a position he began to lose as Futurism became less acceptable to the régime, but regained after his suicide.

Ma Yuan (fl. 1190–1230). Chinese landscape painter, with *Hsia Kuei originator of the classic S. *Sung style; of the two, M.Y. is generally calmer and more precise. Characteristic works depict diagonal composition of a figure in one corner under a gnarled tree, looking meditatively out on a misty expanse.

Mazo Juan Batista del (c. 1612-67). Spanish painter, pupil and son-in-law of Velazquez,

whose portraits strongly influenced him. His copy of Velazquez's *Infanta* is in Vienna, together with the original.

Medici Lorenzo de' ('The Magnificent') (1449–92). Ruler of Florence, politician and poet and one of the greatest art patrons of the Italian Renaissance. Other members of the M. family, notably Lorenzo's father, Cosimo (1389–1464), and his son Giuliano (1479–1516), who became Pope Leo X, were also important art patrons.

Medina Sir John (1655/60–1711). Portrait painter of Spanish origin who settled and worked in Scotland after 1688. He also illustrated Milton's *Paradise Lost*.

medium. (1) The liquid or vehicle (linseed oil, gum arabic, etc.) used to bind powdered pigments to render them usable as paint. (2) The liquid or vehicle (water, turps, etc.) used to thin prepared paint to render it more workable. The word is also used (3) in the more general sense of the technical means by which a work is executed (pastel, charcoal, pen and ink, fresco, etc.).

Meegeren Henricus Anthonius van, called Han (1889–1947). Dutch painter and renowned forger of Vermeers and Dc Hooghs, notably the magnificent *Christ at Emmaus* (1937) supposedly by Vermeer. He successfully deceived art experts and was only caught on his own confession in 1945 when he was arrested as an enemy collaborator for being involved in the sale of an old master – in fact one of his own forgeries – to Goering.

Meidner Ludwig (1884–1966). German lithographer and painter. M. was initially influenced by Impressionism but turned to an extreme Expressionism which contained a strong vein of social criticism.

Meissonier Jean-Louis-Ernest (1815–91). French painter, sculptor, lithographer and etcher, pupil of L. Cogniet, whose large historical canvases of the Napoleonic campaign were very popular at the time.

Meléndez Luis Eugenio (1716–80). Spanish painter, son and pupil of Francisco M. (1682– ϵ . 1752). His work included portraits and still-lifes.

Melozzo da Forli (1438–94). Italian painter who worked in Rome from 1476. Work includes frescoes and commissions for the

Papacy; much other work is dubiously attributed to him.

Melzi Francesco (1493–c. 1570). Italian painter, pupil and friend of Leonardo da Vinci, working with him in Rome, Bologna and, in 1515, in France. His style is very close to that of his master, e.g. *Portrait of a Young Woman*.

Memlinc or Memling Hans (c. 1433-94). Painter, born at Seligenstadt near Frankfurtam-Main but trained in the early Netherlands tradition, probably by Rogier van der Weyden. M. worked in Bruges, where he became a leading citizen. His talent, unoriginal but otherwise of a high order, is contrasted unfavourably at present with that of D. Bouts and Rogier van der Weyden, from whom he frequently borrows. This may be in retribution for his over-valuation in the 19th c. M.'s painting shows little development and he repeats himself, e.g. in the composition of The Mystical Marriage of St Catherine and the triptych painted for Sir John Donne of Kidwelly. His portraits combine extreme sensibility with a serene self-confidence, e.g. Tommaso Portinari and Maria, Wife of Tommaso Portinari. Other important examples of his paintings are: The Passion of Christ, The 7 Joys of the Virgin, the panels of The Shrine of St Ursula depicting the St Ursula legend, Adoration of the Magi, the diptych Descent from the Cross and Holy Women and St John.

Memlinc The Mystical Marriage of St Catherine (detail) 1479

Memmi

Memmi Lippo (documented 1317–47). Sienese painter, the pupil and brother-in-law of *Martini. His signature appears with Martini's on the *Annunciation* and the Saints on each side are attributed to him. He painted frescoes at S. Gimignano and designed the graceful bell-tower of the Torre del Mangia, Siena. One of his finest pictures is *Madonna and Child*.

Mende. African tribal people of Sierra Leone. Their art is noted for the carvings, such as slender female figures and the awesome Bundu (Sande) helmets, made for the women's secret societies.

Mengs Anton Raphael (1728–79). German painter and writer on art. Most of his life M. worked in Rome or as court painter in Spain. First influenced by Correggio, he belonged to the *Neoclassicist circle of *Winckelmann and became the most famous of the early Neoclassical painters. M. was much sought after as a painter of religious and historical compositions and as a portrait painter. A characteristic example of his later, dry and colourless manner is the ceiling painting, the *Pamassus* (1761), for the Villa Albani, Rome.

Menzel Adolf van (1815–1905). German painter of historical and military subjects, chiefly known for paintings of scenes in the life of Frederick the Great, in particular the military campaigns. M. also glorified the achievements of Bismarck and William I.

Merz Mario (1925—). Italian artist, frequently related to *Beuys. He has made many igloos, constructed with clay, glass, stones, asphalt or metal (*Black Igloo*, 1967). He uses his painting as part of his works and installations (*A Board with Legs Becomes a Table*, 1974).

Mesdag Hendrik Wilhelm (1831–1915). Dutch marine painter. At first M. was a banker, but turned to painting in 1866, studying under *Alma-Tadema in Brussels. He soon became very popular, more for his subject matter than for his questionable technical standards.

Mesopotamian art. Primary elements of Mesopotamian art and architecture are already perceptible in the late 4th millennium BC among the ancestors or immediate predecessors of the Sumerians. Religious buildings of sun-dried brick show sophisticated planning and ingenious wall ornament. Sculpture is limited in scale by shortage of stone or wood, but the mythical imagery of seal engraving initiates conventions still observed 25 centuries

Mesopotamian art Relief of a harp-player (Babylon)

later. Under the dynastic rulers of Sumer (c. 2900-2100 BC), pretentious palaces appear and shrines occupy the summits of staged towers known as ziggurats. Small votive statues, animated by coloured inlay, develop characteristics of a style distinctively Mesopotamian. while new metallurgical skills are applied to the use of gold or silver. These, together with other semi-precious materials, are imported from abroad. Superb craftsmanship creates composite art-objects for religious dedication or tomb furniture. Relief carving in stone, mainly of documentary interest in Sumerian times, is refined under Semitic influence from Akkad and, in the 2nd millennium, supplemented by mural paintings. It is not until the 6th c. BC that M. architecture attains its ultimate aggrandizement. In Nebuchadnezzar's Babylon – a fortified city covering almost 500 acres - the facades of great buildings and a 'Procession Street' between them, are ornamented with brilliant designs in glazed brickwork. Elsewhere, the imperishable symbols of Mesopotamian tradition are still in evidence. *Islamic art.

Meštrović Ivan (1883–1962). Yugoslav sculptor. He studied at the Vienna Academy, became a friend of Rodin in Paris (1907–8) and during World War I visited Rome, Geneva and London, rapidly earning a considerable European reputation.

Metaphysical painting (It. pittura metafisica). Term used of the work of the Italian painters De *Chirico and *Carrà between about 1910 and 1920. Their use of dream imagery in architectural fantasies and the juxtaposition of incongruous elements foreshadowed certain aspects of *Surrealism.

Metsu Gabriel (1629–67). Dutch painter, probably the pupil of G. Dou, though later influenced by Rembrandt. He worked in Leyden and Amsterdam. His genre studies of middle-class life are painted with great care and unusually genuine feeling for the subject, e.g. *The Sick Child.*

Metzinger Jean (1883–1956). French painter of the school of *Paris. Born in Nantes, he studied in Paris where he was influenced by Neo-Impressionism and then by *Cubism. M. publ. Du Cubisme with A. Gleizes in 1912.

Meulen Adam Franz van der (1632–90). Flemish painter of genre and landscape pictures. He was related to *Lebrun and became court painter to Louis XIV.

Meunier Constantin (1831–1905). Belgian painter and sculptor. After a period of religious then impressionistic paintings, he turned to sculpture, carving figures of labourers in a 'heroic' manner.

Meyer Felix (1653–1713). Swiss painter and engraver noted for his rapidity of execution, mainly of Swiss landscapes and pastoral scenes.

Meyer-Amden Otto (1885–1933). Swiss painter and lithographer who studied under Hölzel in Stuttgart from 1909 to 1912. He formed a circle of artists, some of whom (Baumeister and Pellegrini) were of more importance than himself.

mezzotint. A form of *engraving.

Michaux Henri (1899–1984). Belgian poet and prose writer; also a painter and graphic artist producing strange and frightening forms (he often worked under the influence of mescalin). His teeming ink-blots conjured up visions, such as mescalin induces, of a universe in microcosm.

Michel Georges (1763–1843). French landscape painter, the pupil of Taunay; he became known as 'the Ruisdael of Montmartre' and most of his subjects were scenes in and around Paris. M. was a forerunner of the *Barbizon school.

Michelangelo **Buonarroti** (1475–1564). Florentine sculptor, painter, poet and architect. M. was born at Caprese where his father was the chief Florentine official. He was trained in Florence, first in the technique of fresco painting by D. Ghirlandaio; then under the patronage of Lorenzo the Magnificent, in the Medici school. Here he became a sculptor. Here too, his mind was formed by the companionship of the Neo-platonic philosophers, artists, poets and men of letters Lorenzo had drawn to his household. M.'s own genius was recognized and encouraged from the beginning. After the death of his patron he went to Bologna and then to Rome, where, at 23, he began the Pietà of St Peter's. On his return to Florence M. carved the large marble David for the city. Among other works of this period are the Bruges Madonna, the painting Holy Family, or Doni Tondo, and the large cartoon or design for a fresco, The Battle of Cascina, done in competition with Leonardo da Vinci. This important work was destroyed, but not before the studies of the nude in violent action had influenced many artists in a way that led ultimately to *Mannerism. In 1505 M. was recalled to Rome by Pope Julius II and ordered to design and

Michelangelo Creation of Adam (detail from Sistine Chapel ceiling) 1508–12

Michelangelo Pietà (St Peter's, Rome) c. 1498

execute the tomb which would glorify the Pope after death. Only 1 of the 40 large figures originally envisaged was ever completed, Moses. 2 unfinished but wonderfully realized figures of captives or slaves are in the Louvre. M. quarrelled with the Pope and fled from Rome; he was later reconciled with him and returned in 1508, not to complete the tomb, but to decorate the whole of the ceiling of the Sistine Chapel in the Vatican with frescoes. This enormous undertaking took him over 4 years, working virtually single-handed. His attempt to return to sculpture and the Julian tomb was again frustrated by the successor of Julius II, the Medici Pope Leo X, who ordered him to provide a facade for the unfinished church of S. Lorenzo, Florence, Although this project was abandoned in 1520, M. remained in Florence working for the Medici, chiefly on the chapel which was to contain the family tombs, the Medici chapel, and the Laurentian library, both attached to S. Lorenzo. The city rose against the Medici in 1527 and M. was divided between his loyalty to his patrons and his Republican sympathies. He took an active part in the defence of Florence as engineer in charge of fortifications, but when the Medici recaptured the town, M. was forgiven. He returned to his work in the Medici chapel, completing the tombs of Giuliano and Lorenzo de' Medici, with the symbolic figures Day and

Night, Dawn and Evening, before he was again recalled to Rome in 1534 to paint his 2nd great fresco, the Last Judgement, which covers the whole area of the altar wall of the Sistine Chapel. In Rome he met Vittoria Colonna, a chief influence on his later years. 2 further frescoes, Conversion of St Paul and Crucifixion of St Peter were painted (1542-50). The tomb of Julius II, much reduced in scale, was completed at S. Pietro in Vincoli (1545). In 1546 M. was appointed architect-in-chief of St Peter's and architect for the new plan and building of the Roman Capitol. Despite all this, designing the dome of St Peter's, supervising the actual building of the church and work on other architectural projects, M. executed 3 of his most profoundly imagined sculptures at this time, Pietà, the Palestrina Pietà and the Rondanini Pietà. Many of his finest sonnets were also written in these last years.

Probably no artist has ever exerted a greater influence than M. To his contemporaries he was 'The Divine M.', and though the greatness of the man was apparent and recognized, the creative power within him inspired an awe in worldly popes, scholars and soldiers, so that they spoke of his 'terribilità'. His friend *Vasari made the achievement of M. the culmination of that gathering splendour in the arts that had begun with Giotto. For over 400 years the frescoes of the Sistine Chapel have been studied by painters, their patrons and all who judged the art of their own times. ('Until you have seen the Sistine Chapel, you can have no adequate conception of what man is capable of accomplishing', Goethe wrote.) M.'s influence as a poet might have been equally great if his sonnets had not had to wait until 1863 before they were publ. in their original form. The mutilated and bowdlerized version publ. in 1623 by M.'s great-nephew had little value and aroused interest chiefly as a curiosity. It is often difficult to grasp the total meaning of the sonnets but M.'s genius is as clear in such sonnets as Giunto è già'l corso della vita mia (title given by J. A. Symonds, On the Brink of Death) as it is in those last Pietàs in which the struggle in search of meaning almost destroys meaning.

Michelozzo Michelozzi (1396–1472). Italian highly influential architect and sculptor from Florence. He worked with *Ghiberti and *Donatello and designed for Cosimo de' Medici the Rucellai Palace considered to be the most important palace of the quattrocento.

Middendorf Helmut (1953—). German *Neo-Expressionist artist (Bad art) influenced by *Lüpertz and subsequently aligned with the Berlin figurative artists Rainer Fetting and Salomé called 'Young Fauves'. M. often painted city life, e.g. Man with Fire (1985).

Miereveld Michiel van (1567–1641). Dutch portrait painter working in Delft and The Hague, and portrait painter to the House of Orange. Charles I tried to attract him to England in 1625. His numerous portraits are frequently small and restrained in style.

Mieris the Elder, Franz van (1635–81). Dutch portrait painter and engraver, born at Leyden, notable for his handling of colour and for his treatment of silks, satins and jewellery. He was reputed to have painted on a gold base.

Mignard Pierre (1612–95). French painter. He studied under *Boucher and then went to Rome where he became popular, producing Madonnas, called 'Mignardes'. He returned to France and from 1658 onwards began painting court portraits, including that of Cardinal Mazarin. After long and uneasy rivalry he succeeded *Lebrun as first court painter in 1690.

Milan, school of. 15th–16th-c. school of Italian painting brought into prominence by Vincenzo Foppa but subsequently dominated by Leonardo (in Milan 1483–99) and his followers, e.g. Boltraffio and *Luini.

Millais Sir John Everett (1829–96). Leading Victorian artist and a founder of the *Pre-Raphaelite Brotherhood in 1848. His friendship with *Ruskin ended with M.'s marriage to Ruskin's former wife. Growing away from Ruskin's ideas and those of the Pre-Raphaelite Brotherhood, he became the greatest academic painter of his day, and was president of the R.A. His youthful work *Christ in the House of His Parents* (1850) caused a scandal by its realistic treatment of the Holy Family.

Millares Manolo (1926—). Spanish painter. He Ist experimented in a Surrealist manner and with 'magical abstractions'. Ed. of art review, *Aqueros*. He became the founder-member of 'El Passo' group (1955). His torn and slashed canvases are painted in funeral blacks and blood colours.

Milles Carl (1875–1955). Swedish sculptor. He studied in Paris (1897) and was subsequently very much influenced by the work of Rodin. His work is well represented in fountains and on

Millais Christ in the House of His Parents 1850

public buildings in Stockholm, and also in the U.S.A. where he had a considerable reputation.

Millet Jean-François (1814–75). French painter, etcher and draughtsman. He studied in great poverty in Paris, absorbing the lessons of Flemish painting and of French classicism, above all Poussin. He created his most significant work at *Barbizon after 1848. His best-known work, *The Angelus* (1858–9), expresses his smypathy for the peasant's simplicity and devotion in the face of nature. M. reconciled classicism with Realism in direct impressions from nature; his work inspired Van Gogh and contemporary social realists.

Millet The Angelus 1858-9

Ming Ming Emperor

Milne David (Bruce) (1882–1953). Canadian painter of landscapes, notably of Ontario, working in an impressionistic style.

Milow Keith (1945–). British artist living in the U.S.A. He came to prominence, one of the most important of his generation, in the 1970s with works that are often a 'cross between painting and sculpture' and contain *Contructivist and architectural references, e.g. an extensive series of 'crosses', made over c. the last 20 years, which relate both to *Malevich and to the stylized form of the human figure. Wall reliefs refer to, and are often of, hybrid monuments, faced with oxidized lead over wood, which yields a painterly and subtly coloured surface, e.g. Justice (1986-7). M.'s work has been increasingly suffused with references to architectural Graeco-Roman classicism, lettering and links to the grand cultural traditions of the West and, more recently, of Britain.

Mimbres. *Mogollon

Ming. Chinese dynasty (1368–1644). Most court art was an uninspired revival of pre-Mongol (*Yüan) academic styles. The talented scholar-painters (*wen-jen) of the Wu school, by contrast, included Shen Chou (1427–1509),

inspired by the *Yüan masters Huang Kungwang and Ni Tsan, as well as N. *Sung art, and his pupil Wen Cheng-ming (1470–1559). Other gifted painters were T'ang Yin (1479-1523). the still popular Ch'in Ying (fl. 1520-40) and the theorist *Tung Ch' i-ch' ang. M. sculptors revived T'ang styles with vigorous independence. In porcelain, cobalt glazing was taken up and fully developed in the famous blue-andwhite wares; porcelain was refined to a purity and hardness never since achieved and, based on the factories of Ching-te-chen (kaolin), its manufacture became a major industry. The export trade was developed from the 16th c. through Portuguese, Spanish and Dutch merchantadventurers. Decorative glaze and underglaze painted porcelain was a specifically M. technique. This and all M. porcelain, and the blanc-de-chine ceramic figures especially from the Wan-li period (1573-1616), were to stimulate the growth of such European wares as Meissen and Wedgwood. Blue was only one of the many new M. glaze colours, used either in monochrome or polychrome; perhaps the most well known are the polychrome enamel wares. The use of enamel in Chinese ceramics was probably borrowed from Chinese cloisonné metalwork. M. is also famous for its carved red and layered lacquer vessels and furniture.

miniature. Term originally applied to the art of ms. illumination but later used of paintings, usually portraits, executed on a very small scale. The earliest miniaturists or *limners (16th c.) continued to use the materials of the illuminators, painting in gouache on vellum or card. In the 18th c. it became usual to paint in transparent watercolour on ivory, though some mss were painted in oils on metal. In the mid-19th c. the art began to decline. Famous miniaturists include Hilliard, *Oliver, Cooper, Cosway (in Britain), J. and F. Clouet, Petitot and Jean-Baptiste Isabey (in France), Fuger (in Germany).

Minimal art. Although not a defined movement or style, a number of U.S. artists in the 1960s reacted against the values that had been exalted by the previous generation of the *Abstract Expressionists – self-expression, subjectivity, emotionalism and gestural brushstrokes. Those who became the leading practioners of 'ABC' or M. a. were *Judd, *Flavin, *Andre, R. *Morris and, in the early stages of his work, F. *Stella. With the exception of Stella, they were concerned in constructing 3-dimensional objects. They shared

with *Mondrian the belief that a work of art should be completely conceived in the mind before its excecution. In M. a. the mind imposes a rational order, conceptual rigour, clarity, literalness and simplicity, indifferent to received moral, social and philosophical values, preoccupied with ideas comparable to those of mathematics. Like all strictly rational attempts, however, an unintended aura of calm beauty emanates from the purity of M. a. works. Rectangular, cubic and modular 3-dimensional forms are purged of all intended metaphor and meaning. Equality of component parts, repetition, often neutral surfaces, emphasize the modular state of M. a. objects with their serial potential as an extendable, open-ended grid. As Morris claimed, 'the notion that work is an irreversible process ending in a static icon-object no longer has much relevance...' In 1961 Andre began stacking and piling beams and soon after introduced a new element of horizontality in sculptures that hug the ground, e.g. Lever (1966) consisting of 137 unjoined commercial fire bricks that extend along the floor for 34.5 ft (10.5 m.), '... putting Brancusi's Endless Column on the ground instead of in the air.' M. a. aimed to achieve a new interpretation of the goals of sculpture and Judd and Morris were its main polemicists, publishing numerous articles defining the new aesthetic and dictating the terms on which they wished their work to be apprehended. They redefined the traditional conventions of painting and especially sculpture by removing spatial illusionism through the elimination of figure-ground relationships. Actual space thus became more powerful and specific than depicted space. Judd called the resulting works 'specific objects', originally Plexiglas boxes with metal sides. These were assembled, consisting of identical and interchangeable units laid out in a repetitive manner, the module always seving as the ordering principle. M. a. became one of the most uncompromising and pervasive aesthetics in the 1960s and '70s, its influence extending to poetry, dance and music as in the compositions of Philip Glass and Steve Reich.

Minoan culture. Bronze age culture of Crete, conventionally divided into Early M., 3000–2000 BC, Middle M., 2000–1600 BC and Late M., 1600–1100 BC. The most famous sites are the Palace of Minos at Knossos and Phaestos. M. c. is also noted for exquisite jewellery, fine pottery, notably the vigorous and spontaneous

Minoan culture *Priest King* (reconstructed, from Knossos) 1600/1100 BC

marine style of c. 1500–c. 1450 BC, bronze, ivory and terracotta sculptures, seal engravings and Late M. wall paintings in an elegant and refined court style.

Mino da Fiesole (1430/31-84). A leading Florentine sculptor of his period. His work shows an interest in classical models but also imagination and technical mastery, notably in his fine portrait bust of Niccolò Strozzi (1454).

Miralda Antoni (1942—). Spanish artist renowned for his edible art — ornate, brilliantly coloured cake sculptures on a monumental scale which highlight the association of food with ritual and ceremony, e.g. *L'anniversaire de l'amour* (1969). Sometimes his food sculptures become part of an event, e.g. *Diner en quatre couleurs* (1970) where 400 participants in ceremonial costume were served red, blue, yellow and green food, and *Moveable Feast* (1974) in Manhattan.

Mir Iskusstva. The *World of Art

Miró Joan (1893–1983). Spanish painter who trained (1907–15) in Barcelona at the School of Fine Art and the Academy Cali. As a student

Mississippi culture

Miró *Harlequinade* 1924–5

he had a great admiration for Catalan art, popular arts and the extreme Art Nouveau forms of Gaudi's architecture. His early painting passed through Cézannesque and *Fauve phases. He was in Portugal with *Delaunay during World War I and in 1920 settled in Paris, where he met and was influenced by his compatriots *Picasso and *Gris. During the 1920s he became closely associated with the *Surrealists and contributed to all their important exhibitions. His freely invented calligraphy of highly coloured forms earned from *Breton the description 'the most Surrealist of us all'; the decorative complexity of Harlequinade (1924-5) gave way in the 1930s to a simpler use of expressive colours and symbols which influenced Kandinsky and probably Picasso. Back in Barcelona from 1940, he continued to paint highly personal subjective images, e.g. Women, Bird by Moonlight (1949), but nevertheless remained a very influential figure, particularly for U.S. artists like *Gorky and *Calder. His public commissions include the 2 ceramic-tile walls, The Sun and The Moon (1955-8, UNESCO, Paris) which won the 1958 Guggenheim International Award. Later works include a mural for the Fondation Maeght, St Paul, France (1968).

Mississippi culture. *Mound builders

Mitchell Joan (1926–). U.S. painter who was among the 2nd generation of *Abstract

Expressionists who developed under the influence of *De Kooning.

mixed media. Term used to describe 20th-c. works of art which combine different types of materials, or different art forms (also called multimedia and intermedia).

Mixtec. Mexican *Pre-Columbian culture which fl. from c. AD 900; apparently successors of the *Zapotec. The M. produced brilliant metalwork, mosaic and ms. illumination. Other work includes fine pottery and stone and bone carvings. M. art influenced the Aztecs.

mobile. A form of sculpture invented in the early 1930s by *Calder; m.s consist of a number of objects of various shapes suspended on wire rods in such a way that they move in continuously changing relationships when placed in a current of air. By creating movement in space m.s get away from the traditionally static nature of sculpture. *Kinetic sculpture.

Mochi Francesco (1580–1654). Italian sculptor, strongly influenced by Florentine styles, who worked in Florence, Rome and Piacenza. Among numerous equestrian statues is that of Alessandro Farnese at Piacenza. His religious works include the *Annunciation* group and *St Veronica*.

Mochica. *Pre-Columbian coastal empire of Peru (c. 1st c.-9th c. AD) followed by the

Chimu. Its architectural monuments, built of adobe brick, include temples, e.g. Huaca del Sol, pyramid-type structures and aqueducts. M. ceramics include stirrup jars, painted with lifelike scenes of everyday life, and moulded portrait pots.

modelling. (1) In sculpture to build up form in clay or other plastic material; the opposite of carving. (2) In painting to give an appearance of 3-dimensional solidity on a 2-dimensional surface, used particularly with reference to the human figure. (3) Posing as a subject for an artist.

modello. Small version of a large painting executed by the artist for his patron's approval. Unlike a sketch, a m. is often highly finished.

Modersohn-Becker Paula (1876–1907). German painter, and a friend of the poet Rilke. Her painting is *Expressionist in the sense that she was primarily concerned with the expression of personal feeling; but the mood of her work is predominantly a gentle poetic Romanticism without strident colour or harsh distortion. Her Self-portrait (1907), the best known of several, shows simple form and restrained colour used to create a feminine tenderness of expression.

Modigliani Amedeo (1884–1920). Italian painter, sculptor and draughtsman; born in Leghorn, of Jewish descent. M. studied in Venice and Florence and arrived in Paris in 1906. Without associating himself with any particular group or movement, M. took what he wanted from the paintings of Toulouse-Lautrec, Cézanne, African sculpture, the Fauves, Cubism and other experimental work of Picasso and Braque. More decisive was his meeting with Brancusi; and between 1910 and 1913 it was

Modigliani Seated Girl c. 1917

sculpture that absorbed him. Forced to give this up because the dust thrown off by the chisel damaged his lungs, already weakened by disease, M. applied many sculptural effects in his portraits and nudes, particularly the characteristic elongation of the head, the long raised ridge of the nose and the long neck. The legend of his life as a Montparnasse eccentric – handsome, poor, proud, amorous and drugged or drunk – was cultivated by his literary friends, especially after his genuinely tragic death at 35. The legend ignores his intense concentration on his painting in his last years. Outstanding examples of his paintings are: Jacques Lipchitz and his Wife, Nude on a Cushion, Bride and Groom, The Little Peasant.

Mogollon. Tradition of North American Indian art centred in S.E. Arizona and S.W. New Mexico. The principal cultures were the M. proper, dating from *c.* 300 BC and the Mimbres AD 1000–1300. Also called the Mimbreños, these were masters of ceramic decoration, polychrome and black-and-white.

Mogul art. *Mughal art

Moholy-Nagy László (1895–1946). Hungarian sculptor, painter, designer and photographer. He trained in law but by 1920 was working in Berlin with *Lissitzky; his originality was soon recognized by Gropius, who appointed him to run the metalworkshop at the *Bauliaus. He was again in Berlin (1928–32), a member of the *Abstraction-Création group in Paris (1932-6); in London (1935-7) and finally Chicago, where he directed a New Bauhaus (1938-46). His transparent Space Modulators are influenced by N. Gabo. Like him, M.-N. was concerned with the dynamic relationships of forms in space. His teaching at the Bauhaus (1922-8) also concentrated upon the use in art of 20th-c. materials and techniques (including photography - in which he experimented with the technical possibilities to produce the montage, double exposure and photogram - and the cinema and telephone). These are the themes of his Von Material zu Architektur (1929, as a Bauhaus Book; The New Vision, 1939).

Molenaer Jan Miense (c. 1610–68). Dutch painter of genre and historical subjects. Both he and his wife, Judith Leyster (married 1636) were probably pupils of *Hals whose work theirs resembled closely in subject and style. M. had a particular fondness for genre pieces involving musical scenes.

Molvig

Molvig Jon (1923–70). Australian painter. His work, notably the series *Ballad of the Dead Stockman*, holds a central position in contemporary Australian art.

Momoyama. A period in Japanese history (1573–1614) named after the castle-palace near Kyoto, of Toyotomi Hideyoshi (d. 1598), who with Tokugawa Ieyasu (d. 1616) dominated the period. Japanese art swung decisively from the restrained elegance of *Muromachi art. The castle-palaces of the feudal lords (*daimyo*) had flaring roof lines of wooden stories on massive stone plinths. The interiors were luxuriously decorated with huge screens and sliding panels painted in strong, thick colours, against a ground of gold leaf, notably by *Kano Eitoku and Kano Sanraku (1559–1635), his adopted son.

Momper Joos de (1564–1635). Flemish painter. He painted Alpine landscapes (he travelled in Italy and Switzerland) and also scenes around Antwerp. *The Miraculous Deliverance of the Emperor Maximilian* is at Antwerp.

Monaco Lorenzo, i.e. 'Lorenzo the Monk', Piero di Giovanni called (c. 1370/72–c. 1425). Italian painter and illuminator of the Florentine school. He moved from Siena to Florence, where he entered the monastery of S. Maria degli Angeli, a famous centre of ms. illumination. His style of painting as seen in *Coronation of the Virgin*, derived from the tradition of Giotto

Mondrian Composition with Red, Yellow and Blue 1921

Momoyama Peonies (sliding screen) early 17th c.

and the Sienese school; however, a late painting, *Adoration of the Magi*, is one of the earliest examples of the *International Gothic style in Florence.

Monamy Peter (1689–1749). Self-taught British marine painter, influenced by the work of Willem van der Velde. He painted an historical piece, *The Embarkation of Charles II at Scheveningen*, 1660 amongst others, and was also employed on the decorations at Vauxhall Gardens. M. found his subjects to a large extent in shipping on the Thames.

Mondrian Piet (1872–1944). Dutch painter; he studied at the Amsterdam Academy. His earliest works, sombre-coloured landscapes, are patently in the Dutch tradition. During the years 1907-10 the landscape became more heavily stylized and expressively brilliant in colour, with echoes of Munch as well as Matisse, e.g. the series of Church Tower paintings (c. 1909). In 1909 he moved to Paris and the experience of *Cubism was the turning-point in his evolution. His colouristic Expressionist tendencies were suppressed and he submitted his formalizations to a rigorous linear discipline. In a series such as the Still-life with Ginger-pot paintings (1912) the motif is analysed in terms of linear and planear relationships which became, progressively, more important than the motif itself. The debt to Cubism is emphasized by the shallow space illusion and by the familiar blue/grey or

ochre monochromatic palette. He returned to Holland in 1014 and by 1017 realized that the perfect expressive harmony that he sought was hindered by starting from a given motif - 'The emotion of beauty is always obstructed by the appearance of the "object"; therefore the object must be eliminated from the picture.' His Compositions (1914–17) comprise simple flat rectangles of colour, their austerity heightened (c. 1916) by the use of primary colours only. The final evolution of his mature style was in eliminating the depth-suggesting spaces between the rectangles: from c. 1917 on the coloured shapes are divided by a flat grid of black lines. His mature œuvre using only the primary colours and non-colours (black, white and sometimes grey), consists of a series of refined variations. e.g. Broadway Boogie-Woogie (1942-3).

M.'s importance lies in his development of 'pure' abstraction — he called his art Neoplasticism — in which the shapes, lines and colours have their own absolute, autonomous values and relationships, divorced from any associative role whatsoever. He was a member of the Dutch Theosophical Society from 1909 and it is clear from his writings in the *De Stijl journal (founded in 1917 with Van der Leck and Van Doesburg) and in his pamphlet Néoplasticisme (1920), that M., inspired by the Dutch philosopher Schoenmaekers, saw his art as an expression of a perfect universal harmony, to whose creation he was contributing.

Monet Claude (1840–1926). French painter. He was born in Paris but educated at Le Havre where, in 1858, he met Boudin who encouraged him to paint nature on the spot. At the Atelier Suisse in Paris in 1859 he met Pissarro and Cézanne and after military service in Algiers (1862) returned to Paris to study under Gleyre. A fellow-student of Renoir, Sisley and Bazille (1862-4), he painted with them at Chailly, near Fontainebleau. He was the least satisfied with Glevre's teaching and learnt more from Jongkind and Boudin; and working with them at Honfleur (1864), he began to paint the landscape in terms of its atmospheric appearance. His paintings of the Seine estuary - very well received at the 1865 Salon - already revealed the extraordinarily acute judgment of tonal values that prompted Cézanne to call him 'only an eye, but my God what an eye'. Around 1865/6 he tried to rework the theme of Manet's Le Déjeuner sur l'Herbe without its studio artificiality. The projected large painting was

Monet Rouen Cathedral 1894

probably never completed; but the study, dated 1866, in Moscow, is a remarkably complete attempt to represent figures in a glade with the sunlight filtering on to them through the leaves. This was to become a recurrent Impressionist theme. In the late 1860s M. and Renoir worked in a partnership of mutual advantage and pro duced the 1st pure Impressionist paintings. In La Grenouillère (1869) he began to break up local colour into strokes of pure colour and in The Magpie (c. 1870) - an evenly toned snowscape – the pale blue of the shadow vibrantly complements the touches of yellow flecked across the snow's surface. Impression Sunrise (1872) which earned the group their derisive name suggests a debt to Constable's empirical directness and to Turner's atmospheric generalizations (M. was in London in 1871). He contributed to 5 of the 8 Impressionist exhibitions and suffered as much as Pissarro and Sisley from hostility and lack of patronage. Working mainly at Argenteuil with Manet, Morisot, Renoir and Sisley during the 1870s, M. remained dedicated to the study of light and its changing effect on nature. In 1876 he began the

Monnier

first of his series of paintings on a single subject - the Gare St Lazare (1876-8) was followed by the Haystacks (1890-2), Poplars (1890-2), and Rouen Cathedral (1892-4). Their object was to observe the transformation of the motif under changing light and atmosphere, but they almost incidentally led to the surface richness of colour and paint of his late style which has earned comparison with Abstract Expressionism. The 1880s were prolific years, but years of continued poverty and depression until in 1889 he had his 1st big public success at an exhibition shared with Rodin. In 1883 he settled at Giverny where - apart from visits to London (1891, 1899, 1903) and Venice (1908–9) – he spent the rest of his life. There he created an astonishing garden elaborately arranged with plants and flowers of different colours. The late water-lily paintings (Nymphéas) painted in the water gardens ('outdoor studios') which he built there, were still responses to his eye, but – increasingly subjective - they embody a larger, cosmic sense of nature. He presented the vast canvases in the Musée de l'Orangerie, Paris, to the state in 1921 as his contribution to the restoring of the spirit of peace. The canvases surround and submerge the spectator. M., who said he 'feared the dark more than death', died blind. Perhaps the most astonishing of the late paintings were given by M.'s son Michel as a bequest to the Musée Marmottan in 1966, including 12 of the Nymphéas and 7 Ponts japonais. These works anticipate in many ways *Abstract Expressionism.

Monnier Henri Bonaventure (1805–77). French caricaturist who created the famous character of Joseph Prud'homme in his *Scènes populaires* (1830).

Monnoyer Jean-Baptiste (1634–99). The outstanding Flemish flower painter of the age; he worked mainly in France, at the Trianon and at Marly. In England in 1685 he painted decorative flower pieces for Montagu House, Hampton Court, Windsor Castle and Kensington Palace.

monotype. In art, the painting of a picture in oils on a metal plate from which one unique print is taken. Castiglione and Degas experimented with the medium (which produces characteristic textures), as did several contemporary artists.

Monro Thomas (1759–1833). British amateur painter in watercolour, but known mainly as the enlightened patron of Cotman, Cozens, Girtin,

Turner and De Wint. His London home became a meeting-place and unofficial academy for watercolour painters.

montage (Fr. mounting). A design, not necessarily intended as an art work, made by sticking one material over another, and the process of creating such designs. The term is used in filmmaking for cutting and piecing together images or sequences when a film is edited. *collage, *photomontage.

Montagna Bartolommeo (c. 1450–1523). Italian painter of frescoes and religious subjects, e.g. the frescoes in the oratory of S. Biagio, Verona (1493–6). His work is mainly confined to N. Italy. He was assisted by his son Benedetto.

Montanez Juan Martínez (1568–1649). Spanish sculptor whose work is best represented in Seville. His sculptures are chiefly religious works, and include crucifixes, statuary and altarpieces.

Monticelli Adolphe (1824–86). French painter of figures, portraits and still-lifes. Popular and patronized by Napoleon III, he moved to Marseilles on the fall of the Second Empire in 1871. His style changed and he continued to work in Marseilles and shunned the life of a fashionable painter.

Moore Albert Joseph (1841–92). British painter, son of William Moore, mural and decorative painter. M. exhibited at the R.A. but was never an Academician.

Moore Henry (1898–1986). British sculptor. M. studied at Leeds College of Art (1919-21) and at the Royal College of Art, London (1921-5), where he was a fellow-student of Barbara Hepworth. The 1st major contemporary British sculptor of international standing, M. exerted a considerable influence on succeeding generations, although this was to some extent superseded by the rise of British Constructivism in the 1950s. 3 main influences dominated his work from the beginning: first primitive and archaic arts (encouraged by reading Roger Fry's Vision and Design, and by the precedent of Epstein, who admired and encouraged his early work); secondly the contemporary work of Brancusi and Picasso (M. made several visits to Paris from 1923); and thirdly his visit to Italy (1925) on a scholarship, where he discovered Giotto and Masaccio but was little interested in the 'perfection' of Renaissance art. In 1928 M.

Henry Moore King and Queen 1952-3

had his 1st one-man exhibition and his 1st public commission - the North Wind relief on the London Transport Executive Building, St James's. Around 1927-9 he made his first reclining figure, the theme which was to be central to his whole œuvre. In treating the figure he was never concerned with its superficial appearance, but with creating an elemental living image. The hollows in Reclining Figure (1930), for example, reveal space contained within a volume and are at the same time womb-like fertility symbols. There are also subconscious analogies to landscape - hillsides, caverns, etc. - in many of his figures. Brancusi, he said, made him 'shape-conscious', but M.'s shapes at their most abstract retain a vital sense of organic growth, often in an ambiguous part-animal, part-vegetable metamorphosis. All of his prewar work was characterized by his truth to the nature of his materials (carving allowed him this closeness of contact), full 3-dimensionality and an unidealized urgent sense of energy and vitality. In 1933 M. was a founder-member of Unit One with Nash, Hepworth and Nicholson. His work in the 1930s ranged from strange Surrealist metamorphoses influenced by Tanguy and Picasso, to his most abstract works - the String Figures of 1937-40, inspired by Gabo and Nicholson; the Helmet Head (1939-40) was the 1st of his ideas on a theme of forms-withinforms. The Shelter drawings of the London Underground which he made as a war artist (1940-3) pursue this interest with the small figures enclosed within the throat of the tunnel.

There is also an expressive element of pathos in these wartime drawings, which in general abandon Surrealism for a naturalism full of feeling for humanity. Since the war he continued to work on the reclining figure theme—the figure often divided into 2 or 3 monumental pieces. The general development of his post-war sculpture, much of it in bronze, was towards an overpowering dominance of mood and a massive sense of scale. The domesticity of his Madonna and Child (1943–4) gave way to the primeval cult character of the King and Queen (1952–3) and the early Surrealist organisms to the pantheistic, totem-like Glenkiln Cross (1955–6).

Mor Antonio (c. 1519–c. 1575). Netherlandish portrait painter, also called 'Moro or Anthonis Mor van Dashorst'; trained by Jan van Scorel in Utrecht and later court painter to Philip II of Spain, with whom he may have come to Britain in 1554. M. combines great skill in painting costume with a sharp if diplomatic eye for character in his sitter, e.g. Sir Thomas Gresham and the very fine Queen Mary I of England.

Morales Luis de (c. 1509–86). Spanish painter, devoted almost exclusively to religious subjects, especially of the head of Christ crowned with thorns. His style was based on a fusion of those of Leonardo da Vinci and Michelangelo. M. often painted on wood and copper.

Morandi Giorgio (1890–1964). Italian painter. In 1918 he joined the *Metaphysical school of painters (Pittura Metafisica) and subsequently the Novecento group. He then followed a solitary path with the single-mindedness of a Chardin or Cézanne. He specialized in subtle,

Morandi Still-life 1946

Moreau

simplified groups of still-life objects – bottles, jugs, candlesticks, paper roses – which have great serenity. M. is one of the few major figures of 20th-c. representational art. He was also an accomplished engraver.

Moreau Gustave (1826–98). French painter who studied under F.-E. Picot. A painter in the academic tradition, he favoured large, involved biblical or classical subjects, painted in great detail. Most celebrated of M.'s works is the Salomé described by Huysmans in his novel À Rebours; it was admired by the novelist for its *'decadence' of mood. M.'s views on the use of colour and his valuable teaching at the École des Beaux-Arts, Paris, had some influence on Surrealism, and stimulated his outstanding pupils, Matisse and Rouault, and several of the lesser Fauve painters.

Moreau Louis (1740–1806). French painter of landscapes in the Île-de-France, in watercolour and oil. His work combines precise observation with a certain spontaneous freshness. His work found great official favour under the governments of the Revolution and Empire.

Gustave Moreau Salomé 1876

Morellet François (1926—). French artist of influential early *Op and *Kinetic works combining scientific and aesthetic principles in terms of visual perception. Associated with the *Groupe de Recherche d'Art Visuel, of which he was a founder-member, and with the Nouvelle Tendance. M. has said that his main aim in his work is to reduce arbitrariness and to limit his 'artist's' sensibility.

Morelli Giovanni (1816–91). Italian art critic who formulated systematic criteria for making attributions of works of art to artists by codifying 'minor' details (hands, ears, noses, etc.), his theory being that, by the close study of such, attribution can be made beyond doubt. M.'s theory is now regarded with scepticism.

Moretto Alessandro Bonvicino ('Moretto of Brescia') (c. 1498–1554). Italian painter and pupil of Ferramola, with whom Moretto decorated the choir of Brescia cathedral (1518). Influenced by Titian and Raphael, he was one of the chief Renaissance painters of N. Italy, and is noted for his preference for silvery or yellowy greys. *Moroni was his pupil. He is credited with introducing the full-length portrait into Italy.

Morisot Berthe (1841–95). French painter who studied at the École des Beaux-Arts, Paris (1856–9) and then from 1860 under Corot. She exhibited in 7 of the 8 Impressionist exhibitions and her sensitive *Impressionism influenced Manet, her brother-in-law, during the 1870s. The Cradle (1873) was shown in the 1st Impressionist exhibition (1874).

Morland George (1763–1804). British painter who rose quickly to fame, but was soon encumbered with debts and died in squalor. His rustic scenes, usually depicting idealized village life, were popularized by a Morland Gallery and by engravings; they created a new public for such pictures. His popular legacy was divided between those who took up his genre subjects, such as Sir D. Wilkie, and the generations of British sporting and animal painters who followed such works as *Shooting Sea Fowl* and *Inside of a Stable*.

Morley Malcolm (1931–). British artist who lives in N.Y. Known after the mid-1960s as the leading Photo-Realist (*Super Realism). Post-1970–1 he became a *Neo-Expressionist with vivid, colourful and vivacious works which make frequent references to *Delacroix, Van

*Gogh, *Monet, *De Kooning and other late 19th-c. and early 20th-c. masters, combining a variety of visual references, techniques and styles, e.g. Day Fishing at Heraklion (1983).

Morone Francesco (1471–1529). Italian fresco painter. He painted religious works and frescoes for the churches of Verona and also an altarpiece for S. Maria dell'Organa.

Moroni Giovanni Battista (c. 1525–78). Italian painter, pupil of *Moretto and much influenced by Lotto. Apart from a number of uninteresting religious pictures, he painted astonishing portraits of ordinary people, combining German and Dutch Realism with the technical skill of the Venetian school. In his day he was the rival of Titian in reputation.

Morosov Ivan (1871–1921). One of the great Muscovite merchant patrons (who had an influence on the development of modern art in Russia) and among the 1st to buy Post-Impressionist French painting in Russia. His coll. of 135 works (acquired 1905–14) is now divided between the Pushkin Mus. (Moscow) and the Hermitage (Leningrad). Cézanne, Gauguin, Monet and Renoir predominate with specially commissioned panels by Bonnard, Denis and Vuillard.

Morrice James W(ilson) (1864–1924). Canadian painter. Most of M.'s life was spent in France,

Morisot The Cradle 1873

Moroni Portrait of a Tailor c. 1550

though on visits he painted Quebec landscapes. He was primarily a colourist and was heavily influenced by Matisse.

Morris Robert (1931—). U.S. artist, working first in San Francisco and from 1961 in N.Y.; his work has ranged from mixed media works to *Performance art. In the mid-1960s he was noted for large-scale *Minimalist sculptures built from industrial materials. Among M.'s other projects were performances with Yvonne Rainer, permutation pieces, changed every few days during their exhibition, anti-form sculpture and *Process art.

Morris William (1834–96). British writer, designer, craftsman and Socialist. At Oxford (1853–5) he met Burne-Jones; in 1859 M. married and commissioned the building of the famous Red House, Bexley Heath, from P. Webb. From 1876 M. became increasingly involved in political activities, although he continued to publ. poetry, lecture on politics, and take up and master new crafts until his death. M., like Ruskin, who strongly influenced his ideas, was appalled by the deadening effect of

Morrow

industrialism; he believed that art derived from the workman's pleasure in his 'daily necessary work' and that decoration, the beginning of art, was the expression of this pleasure; the 1st move towards a rebirth of art must be to raise the condition of the workers. Thus M.'s political and artistic convictions were closely interwoven. This craft theory of art, which was coupled with an admiration for the Middle Ages, together with his contempt for 19th-c. English art, led M. to the founding of 'The Firm' to design and manufacture wallpapers and furniture for the Red House; besides M. the designers were Burne-Jones, Rossetti, Ford Madox Brown and Webb. Originally a private venture, 'The Firm' continued in production for the commercial market. The arts and crafts movement was the development of M.'s work. His concern that the artist-designer should understand craft processes and 'honour' his material is reflected in the principles of the *Bauhaus.

Morrow George (1869–1955). Irish caricaturist and ill. who was one of the principal humorists in *Punch* between the World Wars.

Morse Samuel F. G. (1791–1872). U.S. painter who studied painting in London under *Allston and *West. After 1833 he abandoned painting, invented the telegraph and pursued mechanical inventions and politics.

Mosaic Centre of Roman hunting mosaic (Lillebone)

Mortimer John Hamilton (1741–79). British painter of portraits, religious and historical subjects, and pupil of Reynolds. For an 18th-c. painter his choice of historical subjects, e.g. King John Granting Magna Carta, was unusual.

mosaic. A design composed of coloured squares of clay, glass, marble or wood embedded in walls, floors or ceilings, either inset in small squares or covering a large area. Both pictorial and abstract designs are found. The Romans were the most extensive users of m. and the early Christians continued the tradition, which survived into the early Middle Ages, and which under the Byzantine empire was raised to an unsurpassed level.

Moser Lucas. German 15th-c. painter whose only known work is the *Magdalen Altar* (1431) at Tiefenbronn, near Pforzheim, in Swabia. Stylistically, this altarpiece is a German counterpart to the work of Van Eyck or Campin.

Moses Grandma (Anna Mary Robertson) (1860–1961). U.S. primitive painter (*primitives). She took to painting in her old age and rapidly gained widespread attention.

Moskowitz Robert (1935-). U.S. *abstract artist whose work explores notions of absence and presence. This was most manifest in 1962 when he produced a series of window shades stretched and stuck on to monochrome canvases: through the concealment suggested by the 'drawn' shade, it points to the imagined space beyond. M. has spoken of the meditative process of making art, which he took to an extreme from the early '60s until the mid-70s, in a series of paintings based on a diagram of a corner of a room which he had found in a D.I.Y. book. Although he has continued to work from the idea of a single, isolated image (he once said, 'Most of the images I use have been so stamped on my brain that they are almost abstract') in the '70s he introduced more colour and figurative imagery into his increasingly iconic work. Cadillac/Chopsticks (1976) is a study of East/West divergences through the seemingly moving car and static chopsticks, Swimmer (1978) suggests ambiguously the possibility of 'drowning' in N.Y. and Flatiron (For Lilly) (1978), a black-on-black re-presentation of the N.Y. skyscraper, has been seen as a metaphor for death. The combination of a single image and a highly wrought surface emphasizes the relationship between meaning and process, e.g. Thinker (1982), based on Rodin's sculpture.

Moss Marlow (1890–1958). British abstract painter and sculptor. She was a member of the *Abstraction-Création group in Paris and was a close follower of Mondrian in the 1920s.

Mostaert Jan (c. 1475–c. 1555). Dutch painter from Haarlem probably identifiable with the Master of Oultremont; he probably worked for the Regent of the Netherlands. He travelled in Italy and painted court portraits and religious subjects. A large number of works by other hands have been attributed to him.

Motherwell Robert (1915-91). U.S. painter, the youngest of the artists originally associated with *Abstract Expressionism. His early training was in art history and aesthetics. He studied painting with the Chilean Surrealist *Matta in Mexico in 1941, when he adopted Surrealist psychic automatism. 1st 1-man show was at Peggy Guggenheim's gallery 'The Art of this Century' (1944). Soon after he became famous with his series known as Elegies to the Spanish Republic: horizontal paintings with black vertical Arp-like forms, alternately large and small, also reminiscent of late Matisse cutouts. He taught at Black Mountain College, North Carolina (from 1945) and Hunter College, N.Y. (1951-8). A leading art theorist, M. was the ed. of Documents of Modern Art, The Dada Painters and Poets and, with A. Reinhardt, Modern Artists in America

Motley Archibald Jr (1891–1980). Painter of African-American city life, best known for his use of bright, incandescent colours depicting vivacious 'jazzy' scenes. Like contemporary artists *Hayden and *Douglas, M. was in search of a consummate pictorial style representational of African culture without idealizing it and its people.

Mound Builders. Prehistoric North American cultures of the S.E. states. The name derives from a series of massive earth structures at sites in Ohio, Mississippi, Arkansas and Alabama; archaeologists distinguish between the Hopewell and Adena cultures of Ohio and the Mississippi culture. The structures are of various types: conical funerary mounds; flat topped, terraced or stepped mounds; and linear mounds outlining animal shapes. Archaeological finds include stone sculptures, among the finest in pre-Columbian North America, and carvings such as pipes in animal shapes.

Mount William Sidney (1807–68). U.S. painter of genre scenes of U.S. manners whose work

was influenced by Dutch and Flemish genre painting. In 1830, with *Rustic Dance*, his career as a successful painter was established and his pictures of life on Long Island attained great popularity. M. experimented with painting methods, pigments and brushes, and his sensitivity of composition and lighting established him as an artist of influence on the younger generation of U.S. artists.

Moynihan Rodrigo (1910–91). British painter born in the Canary Islands of a Spanish mother. He studied in N.Y., Rome and London, at the Slade School together with, among others, *Coldstream. A member of the *London Group and the Objective Abstraction Group, and closely associated with the *Euston Road school, he became professor of painting at the Royal College of Art (1948–57) and a Royal Academician (1954). He is a notable portrait painter, but has also done remarkable large portrait-groups, e.g. *The Staff of the Royal College of Art* (1949–50), and still-lifes, as well as abstract work.

Mozarabic. Term applied to the Christian communities and the mixed style produced by Christian artists working under and for the Moorish rulers of Spain (8th–15th cs).

Mucha Alphonse or Alphonso Mario (1860–1939). Czech-born *Art Nouveau graphic artist and designer. He trained and worked in Munich, Vienna and Paris where (1894) he became associated with the actress Sarah Bernhardt. He designed jewellery, furniture, wallpaper panels and a series of now celebrated *posters.

Mueller Otto (1874–1930). German painter and graphic artist, one of the members of Die *Brücke from 1907 to 1913, and from 1919 a teacher at the Breslau Academy. He painted subjects mainly of women bathing or grazing horses; Expressionist in manner, he was influenced by Gauguin.

Mughal miniature painting. Art of the Muslim Mughal empire of India. Its first masterpieces (1549–c. 1564) are the 1400 large ms. ills for the fantastic narrative Hamza Mama by 2 Persian artists and Indian assistants. Their polished Indo-Persian style evolved a vigorous, detailed realism. This reached maturity in the atelier established by Emperor Akbar (1556–1605); here European techniques also were fluently adapted. M. m. p. includes ills for

Müller

Mughal Escaping Elephant c. 1800

histories of the emperors and brilliant royal portraits, some in formalized profile with a nimbus, notably Jahangir (1605–27). Decline began under Shah Jahan (1627–58) accelerated under Aurangzeb (1658–1707), many artists moving to *Rajput and *Deccani courts. There was a brief revival under Muhammad Shah (1719–48). The M. artist painted on burnished paper and the finished picture, often embellished with gold leaf, was also burnished.

Müller Friedrich (1749–1825). German writer and painter. He wrote prose 'idylls' in the style

Munch The Scream 1893

of Gessner, a dramatized version of the Faust legend and the powerful *Golo und Genoveva* (1775–81; publ. 1811), indebted to Goethe's *Götz von Berlichingen*.

Muller William James (1812–45). British water-colour painter noted for his fresh and direct style of work. M. travelled in Italy, Greece and the Near East. His subject matter was mainly land-scapes or architecture. He was influenced by *Constable and *Cox.

Mulready William (1786–1863). Irish-born landscape and genre painter; with Morland he was the leading genre painter in Britain in the early 19th c., following the popular manner and subject matter of Wilkie. Later works show some technical anticipations of the Pre-Raphaelites.

multiples. Works of art – usually 3-dimensional – which are produced in limited editions.

Multscher Hans (c. 1400–before 1467). German sculptor and painter working mainly in Ulm, where he produced a number of carvings. The *Wurzach Altar* (1437), the only picture known to be by him, exhibits a realism nearer to contemporary Flemish than German painting.

Munch Edvard (1863-1944). Norwegian painter. He studied at Oslo (1880-2). His early work is influenced by the social realism of his friend Christian Krohg. His work became widely known through periodicals in Paris and Berlin (1895–1905, his most creative period) and was one of the main artistic sources of German *Expressionism. He returned to Norway (1909) after a nervous breakdown and painted the mural decorations for Oslo Univ. (1909-10), several portraits, and reworked some earlier themes. He was condemned as 'degenerate' by the Nazis. The Sick Child (1885-6) was inspired by his sister's death from tuberculosis and shows the neurotic Expressionism with which he intensified images from reality. His mature paintings and prints were concerned with the expression of his feelings in face of reality rather than representing the appearance of reality. In Paris (1889-92) he gained confidence in his developing ideas from Van Gogh's art and from the current Symbolist movement (Gauguin, Mallarmé, Moreau, Redon) and was impressed by the brilliant colours of Neo-Impressionism. In his most characteristic work, The Scream (1893), he builds up rhythms of colour and

swirling lines – as Van Gogh had done in his self-portraits – to a pitch of hysterical intensity.

Munkácsy Mihály von (1844–1909). Hungarian subject and portrait painter, strongly influenced by Courbet. In 1872 he settled in Paris, where he enjoyed a formidable reputation in his lifetime. His paintings include *The Last Day in the Life of a Condemned Prisoner*.

Munnings Sir Alfred (1878–1959). British painter of horses and country life and president of the R.A. (1944). M. was noted for his facile handling of paint, and also for his virulent attacks on most forms of modern art.

Münter Gabriele (1877–1962). German painter and engraver, at one time married to *Kandinsky. Her style was initially influenced by the Impressionists, but after 1908 by the *Expressionists; she contributed to the *Blaue Reiter and Der *Sturm Munich exhibitions.

Mural painting. Painting on a wall, either directly on to the surface, as a fresco, or on a panel which is mounted in a permanent position; a type of architectural decoration which can either exploit the flat character of a wall or create the effect of a new area of space.

Murillo Bartolomé Esteban (1618–82). Spanish painter. Highly esteemed in his own time, M. was the 1st president of the Seville Academy (1660). A lesser artist than his contemporary Velazquez, he perfected popular genre paintings and sentimental biblical themes painted in the prevailing bombastic and polished mode of the Spanish Counter-Reformation; his beggar boys, fruit-sellers, Madonnas and saints are presented with shallow feeling. The Beggar Boys Throwing Dice and Madonna are among his best and most sincere paintings.

Muromachi or Ashikaga. Period in Japanese history, mid-14th-16th c., presided over by the Ashikaga *shoguns* at their palace in the Muromachi quarter of Kyoto. The court's mannered elegance was reflected in Nōh drama and the tea ceremony imbued with the restrained cult of Zen Buddhism, which inspired a school of monochrome ink painters, notably *Sesshu (1420–1506) and Sesson (1504–89), both influenced by Chinese S. *Sung masters. Important court painters included Noami (1397–1494), Geiami (1431–85) and Soami (d. 1525).

Murphy Gerald (1888–1964). U.S. painter. He settled in France 1921–9 and formed close

friendships with Picasso, Léger, Stravinsky, Scott Fitzgerald, Dos Passos, Hemingway and other U.S. expatriates and creative personalities. Taught painting by *Goncharova, his few works (he stopped in 1929) are immaculately and flatly painted, geometrically organized abstract arrangements to which he accommodated precisely painted ordinary objects – a razor, a pen, the mechanism of a watch, e.g. Razor (1924) and Watch (1924–5). The layout of the pictures and the pictorial space, e.g. Wasp and Pear (1929), are related to *Cubism, *Purism and Precisionism, as well as to Léger's work of the mid-20s and S. *Davis; they anticipate *Pop art.

Murray Elizabeth (1940–). U.S. painter and print maker who studied at the Art Institute of Chicago. Its renowned art collection had a great impact on her development as a painter. From the early 1970s M. started widely exhibiting large canvases which post-1980 were shaped in irregular, organic-looking and interlocking shapes, e.g. *The Hunger Artist* (1987). Her highly original work denies pat distinctions between the figurative and the abstract, making imaginative use of both, and combines shape, colour and representation to convey depth of feeling.

Murillo Beggar Boys Throwing Dice c. 1670-5

Music (Zoran) Antonio (1909—). Italian painter deeply influenced by the Venetian landscape (e.g. *Barques de Palestrina*, 1956) and Byzantine art.

Mycenaean culture. Greek culture named from its principal site of Mycenae. M. c. *fl.* c. 1600–c. 1200 BC; it was indebted to *Minoan culture.

Myron (fl. 480–440 BC). Greek sculptor, a pupil of Hageladas of Argos. Working in the Athens of Pericles, he was noted for the exact proportions and the sense of movement in his figures, mainly of athletes and wrestlers. Among his works was the *Discobolos*. Many spurious works were subsequently attributed to him.

Mytens Daniel (c. 1590–before 1648). Dutch portrait painter, probably a pupil of Miereveld, who became court painter to James I of England (1614) and subsequently to Charles I. One of the best portrait painters of the time, he lost in rivalry to Van Dyck and returned to The Hague in 1635. His style was influenced by Rubens, then by Van Dyck.

N

Nabis, the (Hebrew, the prophets). A group of artists who exhibited together from 1891 to 1900, of whom the best known are *Vuillard and *Bonnard; Ranson, K.-X. Roussel and Maillol were other members. The style they had in common was partly derived from Gauguin's flat pattern compositions done in Brittany; *Denis wrote several articles which outlined N. ideas. Lithography was especially congenial as a medium and well used in book illustration, posters and theatre decoration.

Nadelman Elie (1882–1946). Warsaw-born U.S. sculptor; he settled in N.Y., 1914. During the 1920s he produced numerous marble portrait busts of society personalities; these, and figures of dancers and circus performers, are generally in a simplified, primitivistic style.

Nanni di Banco (c. 1385/90–1421). Florentine sculptor who like Donatello returned to classical models. He and Donatello executed companion figures, very similar in style, of *Prophets* in

Florence cathedral. N.'s other work includes the statues *Quattro Santi Coronati* for Or San Michele and *Assumption of the Virgin* above the Porta della Mandorla, Florence cathedral.

Nanteuil Robert (1623–78). One of the most important of French portrait engravers. His engravings, which show remarkable powers of characterization and masterly linear modelling, were based on his own drawings from life, mainly in pastel. He also engraved portraits by Champaigne. His influence gained engravers the privileges accorded by the government to artists as opposed to craftsmen.

Naples, school of. 17th-c. Italo-Spanish school of painting characterized by pictures of torture and martyrdom in a *Tenebrist style derived from Caravaggio, exemplified in the work of Ribera.

Narrative painting. Type of painting which flourished in the 19th c.; it relies on anecdotal subject matter to create interest. The title is an important part of the whole: Last Day in the Old Home by Martineau and 'And When Did You Last See Your Father?' by William Frederick Yeames are examples.

Nash Paul (1889–1946). British painter, mainly of landscapes, in oils and watercolour. He studied at the Slade School (1910-11); his early works were influenced by Rossetti, but his reputation was made as an official war artist (1917-18). N. then continued to paint landscapes in a formalized, decorative manner. In the 1930s he fell under the influence of *Surrealism and in 1933 was one of the founders of the *Unit One group. During World War II he was again an official war artist, painting aircraft, reverting to landscapes and symbolic pictures of an intense and mystical quality in the years before his death. He was also a distinguished photographer. An incomplete autobiography, Outline, was publ. in 1949. His brother, John (1893-1977), also a painter of landscapes, shows affinities of style, but his formalized shapes remain closer to naturalistic forms and he specialized more in botanical subjects.

Nasmyth Peter (also known as Patrick) (1787–1831). British landscape painter, known as 'the English Hobema'. He was one of the founders of the Society of British Artists (1824).

Nast Thomas (1840–1902). German-born painter who lived in the U.S.A. from 1846. He began his career by illustrated work in news-

papers and, after fighting in the Civil War, specialized in political cartoons, becoming the father of U.S. caricature and cartoon work

Nattier Jean-Marc (1685–1766). French painter of historical subjects, noted particularly for his delicate portraits of young ladies and for starting the vogue for classical and mythological trappings in portraiture. As a fashionable portraitist he painted members of the Russian and French Royal Houses. His pictures were delicate and fragile in feeling, with a fondness for bluish colouring.

Naturalism. Late 19th-c. French literary movement led by Emile Zola whose writings, also on art, exerted considerable influence. In art the term signifies the depiction of subject matter with uncompromising fidelity and in deliberate defiance of conventional distinctions between 'high' and 'low', 'seemly' and 'unseemly', and 'ugly' and 'beautiful'.

Nauman Bruce (1941-). U.S. artist whose work, in a rich variety of types, forms, styles and media (e.g. sculpture, neon, film, video, performance and environments), defies simplistic categorization. Yet N.'s personal and reflective vision results in an œuvre of total, complex and convincing coherence, carrying perceptual and philosophical, especially ethical, social, political and sexual meaning. These ideas are often presented with deliberate ambiguity and in binary form, e.g. From Hand to Mouth (1967), a wax cast of mouth, shoulder, arm and hand, or Eat/Death (1972), a neon piece of the two words where EAT is in yellow and DEATH in blue (the first word contained within the second, placed one on top of the other and lighting up alternately) and the large figurative neon piece Welcome Shaking Hands (1985) in which the two naked male figures facing each other appear alternately standing and shaking hands, with erect or limp penises. As N. re-examines and modifies ideas constantly in his work, it is only by looking at it in terms of ideas rather than of chronology that its cohesiveness is revealed. In Window or Wall Sign (1967) the neon spiral contains the text: 'The true artist helps the world by revealing mystic truths'. In 100 Live and Die (1984) contradictory commands in neon are arranged below and alongside each other in 4 rows, e.g. 'live and die', 'live and live', 'die and die', 'die and live', 'fuck and die', 'fuck and live', etc. Several of N.'s early sculptures are related to the body – a persistent theme in all his work. He

Nauman Hanged Man 1985

uses its poses and limitations, or its volume and traces, as either container or contained, e.g. the 2 *Untitled* (1965 and 1967) and *Six Inches of My Knee Extended to Six Feet* (1967), which in later works are modified into tunnels, underground passages and chambers, e.g. *House Divided* (1983) and *Room With My Soul Lest Out/Room That Does Not Care* (1984).

Nazarenes. A group of German artists who formed a brotherhood of painters, the Lukashriider (Brotherhood of St Luke), in Vienna in 1809. The following year *Overbeck and *Pforr were joined by *Cornelius at the monastery of Isidoro outside Rome. The intention of these artists was to revise German religious art after the examples of Dürer, Michelangelo, Perugino and the young Raphael.

N.E.A.C. *New English Art Club

Neagle John (1796–1865). U.S. portrait painter who spent most of his professional career in Philadelphia. *Stuart and *Sully were the major influences on his work.

Neefs (Neeffs or Nefs) Peter (c. 1578–1656/61). Flemish painter of architectural subjects, probably the pupil of Van Steenwyck. He painted many pictures of Antwerp churches

and added the architectural detail to the paintings of other contemporary artists. His son, Pieter (1620–after 1675), painted the same subjects in the same idiom, which has led to confusion in attribution.

Neel Alice (1900-84). U.S. figurative painter who was one of the most remarkable of her generation. Her often densely textured, realist portraits are honest and uncompromising depictions of people. They show penetrating psychological insight and are given *Expressionist interpretations. N. also painted still-lifes and interiors. Although associated with the *W.P.A. in the 1930s, along with *Bishop, *Nevelson and *Krasner, her work was little appreciated until the 1960s, as with much figurative art, when she re-emerged at the forefront of the U.S. *Realist tradition. A retrospective of N.'s work at the Whitney Museum of American Art, N.Y., in 1974 established her position. Her political sympathies and realist style of painting earned her a major exhibition in 1981 at the Artists' Union in Moscow. It has been said that 'the personal images in A.N.'s work not only reflect her life, they also provide metaphors related to politics, economics and philosophies of contemporary American life.' (Patricia Hills, Alice Neel, N.Y., 1983.) Her work has sometimes been compared to *Pearlstein, but only because they both painted portraits of the same members of the Manhattan intellectual world, as their styles, although both described as realists, are fundamentally different.

Neer Aert van der (1603/4-77). Dutch landscape painter, influenced by the works of

Neel Andy Warhol 1970

Camphuysen and Avercamp. He became a painter late in life; his later work was mainly of landscapes under snow, under strong atmospheric conditions or with dramatic lighting.

Neer Eglon Hendrik van der (1634–1703). Dutch painter chiefly of genre subjects, son of A. van der N. His work is similar to that of *Metsu and *Ochtervelt.

Nefertiti (c. 1360 BC). Brightly coloured limestone portrait bust of Queen Nefertiti, the wife of the Egyptian king Akhenaton. It was found in the workshop of the sculptor Thutmose in Akhenaton's new royal city of Tel-el-Amarna by the German expedition of 1912–14, and is in the naturalistic Tel-el-Amarna style.

'Neo'. Prefix meaning new. When placed before the name of a past art style or movement it indicates a subsequent manifestation and at least partial revival of the style's look, e.g. *Neoclassicism. Especially since the 1970s, 'Neo' has indicated the *Postmodern indifference to art styles and the free recycling of the look of previous movements, but with different meaning and intent, e.g. Neo-Geo indicating the revival of the style of a work which would originally have been described as a Geometric Abstraction.

Neoclassicism. In painting the name given to the late 18th- and early 10th-c, revival of classical motifs, subjects and decorations. Its inspiration came from the excavations at Herculaneum and Pompeii (begun 1748) and the publ. writing of the German archaeologist *Winckelmann. In Britain the sculptor *Flaxman, Wedgwood's Etrurian ware, and the Adam style of interior decoration were all inspired by the revival; in Rome the sculptors *Canova and *Thorwaldsen were the great exponents of N.; and in France, where it became associated with the Revolution, the painters J.-L. *David, G.-J. *Drouais and *Girodet, the latter both pupils of David. In architecture N. developed in the 17th c. in Italy and spread to France, Britain and Russia (18th c.). Its characteristic features are the use of the orders (columns or pilasters), pediments, entablatures, friezes and classical ornamental motifs. Architects include Juvarra, Vanvitelli, Mansart, Gibbs and Nash.

Neo-Expressionism. Term used with reference to the Expressionist art revival in Germany, the U.S.A. and Italy in the late 1970s and early

1980s, as practised by artists such as *Baselitz, *Kiefer and *Polke, in Germany, *Chia, *Clemente and Mimmo Paladino, in Italy and Cuchi, *Fischl, *Salle and *Schnabel, in the U.S.A. Also referred to as 'Bad' art and New Image Painting.

Neo-Impressionism. A late 19th-c. style of painting also known as Pointillism or Divisionism, associated above all with Seurat but also practised by Camille Pissarro, Signac, Cross and, in some of their works, Van Gogh, Toulouse-Lautrec, and even Matisse. Instead of mixing pigments on the palette the artist applied pure colours, in small dots or dashes (hence Pointillism); seen at the right distance the fragmented areas of vivid colour dots produced the effect of colour areas more subtle and rich than could be achieved by conventional techniques.

Neo-plasticism. (Fr. néo-plasticisme, from the Du. nieuwe-beelding; new-forming). Theory of art propounded by *Mondrian which influenced his painting, and that of disciples such as Van *Doesburg (1912–18). Its precepts were that art was to be entirely abstract; that only right angles in the horizontal and vertical position were to be used, and that the colours were to be simple primaries, supplemented with white, black and grey. *De Stijl.

Neroccio di Bartolommeo Landi (1447–1500). Italian painter and sculptor of the Sienese school, the pupil of Vecchietta. He worked for a time with his brother-in-law, Francesco di Giorgio. His paintings are religious or devotional, in the tradition of Simone Martini.

Nesfield William Andrews (1793–1881). British landscape painter and landscape gardener who worked on the layout of St James's Park, London, and Kew Gardens, Surrey.

Netscher Caspar (1639–84). Dutch genre and portrait painter, pupil of G. Terborch. He made a trip to France (1659) before settling at The Hague, where he joined the painters' guild and taught.

Neue Sachlichkeit, Die. *New Objectivity

Neue Sezession. *Sezession

Nevelson Louise (1900–88). Russian-born U.S. sculptor. From early affinities with *Constructivism and *Surrealism, she developed a unique personal idiom of wooden relief-like assemblages. Her characteristic works of the 1960s were large wooden structures, often occupying

a whole wall, consisting of many compartments filled with carefully arranged found objects, usually sawn fragments of furniture or woodwork from old houses. These were then painted in flat, uniform colours, black or, later, white or gold. She also made similar structures, on a smaller scale, in aluminium and lucite, e.g. *Transparent Sculpture VI* (1967–8).

Nevinson Christopher Richard Wynne (1889–1946). British painter, who became associated with W. *Lewis and *Vorticism, under the influence of *Futurism. With *Marinetti, he published in 1914 *Vital English Art*.

New English Art Club. Exhibiting society founded in 1886 as a protest against the R.A., by artists interested in reviving Naturalism. *Sickert and *Steer were among the original members, and they later became the *Camden Town Group. The Club's position as the leading progressive art exhibition was lost to the *London Group, founded in 1913.

Newman Barnett (1905–70). U.S. painter, a founder of N.Y. *Abstract Expressionism. He shared the group's interest in mythological themes, e.g. Pagan Void (1946). His 1st paintings of vertical elements, which characterize his

Newman Fifth Station 1962

New Objectivity

mature work, were started in 1946. The work which best expressed his formal, spatial and mystical preoccupations of that period was Onement I (1948). Later vast canvases of saturated colour fields, inflected with vertical stripes or 'zips' with fragmented edges, present majestic colour-spatial experiences which create the impression of an opening in the picture plane. N. had a profound influence on younger painters of the 1960s. Examples include Vir Heroicus Sublimis (1951), Stations of the Cross (1965–6) and Jericho (1969).

New Objectivity (Ger. neue sachlichkeit). Term coined in 1923 by G. F. Hartlaub, director of the Kunsthalle, Mannheim, to describe the paintings of *Beckmann, *Dix and *Grosz. The term *'magic realism' was also used to describe the work of these artists. Clear, detailed, highly realistic, sometimes grotesque, satirical paintings and drawings, which express disillusionment and are a form of social realism, are characteristic of these artists, who reacted against the violent distortion of other Expressionists. An exhibition under this name was held in 1925.

New Realism. Name sometimes applied to the work of *Social Realist painters.

New York school. The heterogeneous group of predominantly abstract painters who were centred in N.Y. after 1940. The powerful and original work, which came to dominate con-

Ben Nicholson White Relief 1935

temporary art internationally, was also called *Abstract Expressionism and *Action painting.

Niccolò di Liberatore (Niccolò da Foligno) (c. 1425/30–1502). Minor Italian painter of the Umbrian school. His work was influenced by Benozzo Gozzoli and later by Carlo Crivelli and the Vivarini.

Nicholson Ben (1894–1982). British painter, son of Sir William N. He spent one term at the Slade (1911) and then travelled (1911-18) in France, Italy, Spain and the U.S.A. In the 1920s he began to paint seriously in an experimental manner reflecting *Cubism (he first saw a Picasso in 1921), Christopher Wood, and the Cornish primitive A. *Wallis (whom he discovered with Wood in 1928). A naïve pictorial freedom of scale is fused with great textural sensitivity in the grained and scratched paint surface (e.g. Bistro II, 1932). He married *Hepworth in 1930, was a founder-member of *Unit One (with Nash, Moore and Hepworth) in 1933 and edited Circle with Gabo in 1937. During the 1930s he emerged as the major pioneer in British abstract painting. Through his objective analysis of the still-life he evolved an art of pure formal and colour relationships. In his Notes on Abstract Art (1941) he compares these relationships with musical harmonies and states his aim to create from them an equivalent to reality. Whether his 'equivalents' were figurative or abstract was irrelevant. His meeting with Mondrian (Paris, 1934) probably inspired the confident austerity of his first abstract reliefs - e.g. White Relief (1935).

Nicholson Sir William (1872–1949). British painter of portraits, landscapes and particularly of still-lifes. He studied in Paris at the Académie Julian. With his brother-in-law James Pryde, he revolutionized poster design, under the pseud. 'The Beggarstaff Brothers'. He was also noted for woodcuts of well-known late Victorian characters.

Nicias (Nikias) (fl. 348–308 BC). Athenian painter, the pupil of Antidotus. His work was praised by Praxiteles.

Nielsen Kay (Rasmus) (1886–1957). Danish book ill. After the Beardsley-influenced *The Book of Death* (1911), the delicate, suggestive watercolours of *In Powder and Crinoline* (1913) and the decorative yet immediate *East of the Sun and West of the Moon* (1914) include some of N.'s finest ills.

Noguchi Isamu (1904–89). U.S. sculptor. He studied with *Borglum and *Brancusi whose assistant he became in 1927. He was also influenced by *Calder, *Giacometti, *Miró and *Picasso in his Surrealist phase. In the 1930s N. was, with Calder, the most advanced sculptor working in the U.S.A.

Nok. Ancient culture of Central and N. Nigeria. Archaeological sites have yielded terracotta heads of which the earliest have been dated to the 2nd half of the 1st millennium BC. Among later art styles those of *Benin and *Ife are closest to N.

Nolan Sidney (1917–92). Australian painter. N. started painting in 1937. His early work was influenced by Klee and Moholy-Nagy; it was later enriched by Australian aboriginal art. N. spent his army service (from 1942) in remote parts of Australia. In 1950 he came to Europe, where his outback mythologies and folk-histories (Ned Kelly, 1945–7; Burke and Wills, 1948) were well received. He continued to work on Australian themes – Kelly (1954–5), Mrs Fraser (1957) – as well as others (e.g. Leda, 1960).

Noland Kenneth (1924-). U.S. artist, one of the *Washington Color Painters; his works are concerned above all with the relationship between colour and structure. In the 1950s and early 1060s, influenced by *Frankenthaler, he and *Louis produced 'stain' paintings. Targetlike images of chromatic brilliance, set in bare canvas, e.g. Cantabile (1962), were followed by chevron motifs - Golden Days (1964) - later applied on lozenge-shaped canvases. In the late 1960s N. produced long narrow canvases covered in brilliant horizontal stripes, e.g. Graded Exposure (1967), with its graded strata, and Via Blues (1967). With such works as China Blue (1971) he moved to Mondrian-like but colourful geometric abstractions.

Nolde Emil (1867–1956). German *Expressionist painter. N. studied at Flensburg (1884–8), Karlsruhe (1889), and with Hölzel at Dachau (1889). He moved to Munich c. 1900 and was an invited member of the *Brücke group (1906–8). In Berlin (1910) he founded the revolutionary Neue *Sezession and was associated with the *Blaue Reiter, but remained a solitary individual in his work.

His art had a strong folk-art background: he was only able to give all his time to painting through the financial success of his coloured postcards (painted c. 1896–8) of peasant

mythologies (mountain spirits, trolls, goblins, etc.); and this element of primitive imagery remained the basis of his work. His early admiration for Rembrandt, Goya and Daumier was replaced c. 1905 by the influence of Van Gogh, Munch and Ensor (whom he met in 1911). His major religious paintings (c. 1909–15) were interspersed with paintings such as the Candle Dancers (1912) which in their emotional violence of colour and paint typify the sensual anti-intellectual character of Expressionism in its purest form.

Nollekens Joseph (1737–1823). The greatest British sculptor of the later 18th c. He studied and worked in Rome from 1759 to 1770. Returning to Britain, he became a R.A. (1772) and, under George III's patronage, rapidly became renowned for portrait busts.

Non-figurative. Abstract art in which no figures or recognizable motifs appear. It is a moot point whether geometric figures (triangles, circles) are figurative: the term usually refers to paintings in which not even these appear.

Noort Adam van (1562–1641). Flemish painter of portraits and historical subjects. Dull and conservative in style, he was unimportant except as the teacher of Rubens, Jordaens and Van Balen.

Nootka. North American Indian people of the *North-west Coast group, centred on Vancouver Island. The masterpiece of N. art is a painting on wood, some 10 st (3 m.) long, depicting the myth of the abduction of the Killer Whale by the Lightning Snake and the Thunder Bird.

Northcote James (1746–1831). British painter, art critic and poet. He was the pupil of Reynolds, whose biography he wrote in 1813. N.'s output in portraits was prodigious; he also painted scenes from Shakespeare for John Boydell.

Northern school. *Chinese art

North-west Coast Indians. Collective term for a group of American Indian peoples living in a coastal and island zone stretching from S. Alaska to Washington. Their ancient artistic tradition, of which the earliest examples are carvings in stone, is noted for painted wood carvings – masks, ceremonial rattles and whistles, totemic structures and decorated utensils. They also built wooden houses and vast ocean–going canoes. Principal members of the group are: the

Norwich school

*Haida, Kwakiutl, *Nootka and Tlingit. The N. C. I. are also famous for the *potlatch*, a ceremonial connected with status, which involved the competitive distribution of wealth, generally blankets, and sometimes the destruction, or sinking at sea, of immensely treasured 'coppers', shield-like objects made of copper. As an economic mechanism the *potlatch* redistributed surplus wealth and gave it a social function.

Norwich school. English regional school of landscape painting, the only local school in English art history which is comparable with the earlier Italian schools. Its leaders were *Crome and *Cotman, and it flourished from 1803 (when Crome founded the Norwich Society of Artists) until *c.* 1830. Minor artists included J. B. Crome (1794–1842), J. S. Stannard (1797–1830), G. Vincent (1796–1831).

Nouveau réalisme (Fr. New Realism). Term coined by the French art critic Pierre Restany in a manifesto published in 1960. He used it to characterize a group of French artists, among them *Tinguely, *Klein and *Arman, who were rejecting the free abstraction of the period in order to make use of existing objects, particularly found material from the urban environment. *assemblage, *décollage, *Rotella, *Villeglé, *Hains and *Vostell.

Novecento Italiano. An association of Italian artists founded in 1922. Its aim was to revive the large-scale figurative 'Neoclassical' composition, and to some extent it became associated with Fascism.

Novembergruppe. A movement, formed in Berlin in 1918, of Expressionist artists, writers and architects, the leaders being M. Pechstein and César Klein, who were soon joined by the Berlin *Dadaists. Their aim was the unity of the arts, architecture and city planning in the socialist state. They sponsored publications, composers, radio broadcasts and abstract film experiments (1920 and 1921 by Viking Eggeling and H. Richter). Many of their aims were incorporated into the programme of the Weimar *Bauhaus.

Nuraghic culture. Bronze age culture of Sardinia (1500–1100 BC), so named from the fortified towers (*nuraghi*) of the period. N. c. is particularly noted for primitive and stylized bronze statuettes.

objet trouvé. *found object

Oceanic art. The term refers to the *primitive art of the island populations of the Pacific. 3 main areas are distinguished: Melanesia (New Guinea and surrounding islands), Micronesia (islands to the N. of Melanesia), and Polynesia (the triangle formed by the Hawaiian Islands, New Zealand and Easter Island).

The art objects include ancestor figures, canoe-prow ornaments, ceremonial shields and clubs, masks, decorated human skulls, stone carvings, carved stools and other cult objects and artefacts. Besides wood and stone, the materials used include shells, wicker, feathers, cane, fibre, bamboo, rattan and bark cloth. As distinct from *African art, various materials are often used in combination, and may be painted in bright pigments, the surfaces with stylized designs of the human face or figure. The range of styles among such widely scattered peoples is enormous, though many groups reveal related art motifs. Among the most famous examples of O. a. are the giant stone ancestor-cult figures of Easter Island, the convoluted designs of Maori wood carvings and the vast production of carved drums, masks, stools and shields of the Sepik river area on the N. coast of New Guinea.

Ochtervelt Jacob (1634–82). Dutch genre and portrait painter, the pupil of Berchem. He was influenced by Metsu and Terborch, and above all by Pieter de Hooch, and therefore by Vermeer. He worked in Rotterdam but spent his later years in Amsterdam. 2 of his betterknown works are *A Woman Standing at a Harpsichord* and *A Woman Playing a Virginal*.

O'Connor James (1792–1841). Irish landscape painter who moved to London in 1813 and later settled there. Trained as an engraver, he tried, unsuccessfully, to make a living as a landscape painter. His style is modelled largely on that of R. *Wilson.

oil painting. An increasingly important technique in European painting since the late 15th c. O. p. in one form or another had been known since antiquity for coarse work such as house painting, but the technique was immensely refined in early 15th-c. Flanders, the improved medium being gradually taken up

by Italian painters. Powdered colours, mixed with a fine oil (usually linseed) until the resulting paint is sufficiently viscous, are applied to a prepared ground – usually stretched canvas with an overall coating in a neutral pigment. The technique at its most elaborate, as in the work of the old masters, involved a careful application of colours building up from dark to lighter tones and relying on extensive technical knowledge of the interaction between the various pigments – the various chemicals involved can act on one another and, if not carefully applied, can over a period of time damage the layers of paint above and next to them. Colours can be laid down with the intention that they should show through upper layers to a certain extent, while coloured transparent glazes can be applied for further gradations of tone. Apart from the immense tonal subtlety of the medium, surface texture can also be varied by *impasto and *brushwork.

O'Keeffe Georgia (1887–1986). U.S. painter and wife of *Stieglitz; she was one of the prominent figures in the 1920s U.S. reaction against avant-garde European ideas and movement towards a romantic, naturalistic art. Her own painting, however – 'magical realism' – has Surrealist undertones. The exotic colour and form of plants and flowers are heightened by taking them out of their natural context. Later works include the 24-ft wide (7.3-m.) Sky Above Clouds IV (1965).

Oldenburg Claes (1929—). Swedish-born U.S. artist; he came to prominence as one of the major figures of U.S. art of the 1960s associated with *Pop. Early works in the style of *Abstract Expressionism gave place to 'total environments'

O'Keeffe Ram's Skull with Brown Leaves 1936

(The Street, 1960), *Happenings (Store Days, 1962) and *Performance art and eventually to soft sculptures of commonplace, vastly enlarged objects made out of canvas, kapok or vinyl – Floor-Burger (1962), Soft Light Switches (1964), etc. – and monuments, e.g. Lipstick on Caterpillar Tracks (1969).

Olitski Jules (1922–). Russian-born U.S. painter and teacher. His canvases of the 1950s were in thick impasto; in those of the 1960s there is a decisive change with sprayed, stained-canvas, *Color-field paintings of large forms and clear colours (e.g. High A Yellow, 1967). O.'s atmospheric and luminous paintings emphasize the flatness of the picture surface and the edges of the canvas. *Post-painterly abstraction.

Oldenburg Bedroom Ensemble 1963

Oliver Unknown Man c. 1590-5

Oliver Isaac (d. 1617). British miniaturist of French Huguenot parentage. He studied under *Hilliard and became his master's principal rival, developing a style of portraiture less linear than Hilliard's. He painted Elizabeth I and Mary, Queen of Scots, and worked at the court of James I. A visit to Venice in 1596 stimulated him to paint religious and classical subjects. His son Peter (c. 1594–1647) was also a miniaturist.

Olmec. *Pre-Columbian Mexican culture, fl. c. 800–400 BC; the principal O. site is at La Venta on the Gulf Coast. Archaeological finds include carved altars, plaques, jade figurines and massive stone heads.

Omega Workshops. Founded by Roger Fry in 1913; several painters including *Grant and V. *Bell took part. Furniture, fabrics and pottery were designed and decorated in the workshops following current fashions in painting among the *Bloomsbury Group and issued anonymously with the Greek letter omega as sole mark; the actual construction, weaving, etc. of their products was done by craftsmen. The O.W. were not financially successful and closed in 1920.

Op(tical) art. Term which gained currency in the 1960s for a style of abstract painting deriving from the work of such painters as *Albers and *Vasarély. O. a. concerns itself with purely visual sensations, relying for its effects upon optical illusions; often canvases are a mass of small shapes, lines or vivid colours constantly shifting under the eye. The best works are black-and-white. Some of the most inventive works are by B. *Riley.

Opie John (1761–1807). British painter. In 1781 he was introduced to London as the self-taught 'Cornish Wonder' by J. Wolcot (Peter Pindar). He excelled in portraits and in genre scenes in which he made notable use of *chiaroscuro* effects. The quality of his work declined as he became increasingly fashionable. His wife Amelia (1769–1853) was author of numerous popular, moralizing domestic novels.

Oppenheim Meret (1913–85). *Surrealist artist widely known for her *Objet* (1936): a cup, saucer and spoon covered in fur, which has come to be seen as the archetypal Surrealist object.

Opsomer Isidore (1878–1967). Belgian painter, pupil of A. de Vriendt. His main work was in portraiture and scenes in Antwerp. His studio at the Institut Supérieur des Beaux-Arts was one of the leading influences in Belgian art.

Orcagna Andrea (Andrea di Cione) (c. 1308–c. 1368). Florentine painter, sculptor and architect in a traditional Gothic idiom. His only certain painting, the Strozzi altarpiece in S. Maria Novella, Florence, rejects many of Giotto's innovations (definition of space, solidity, etc.), returning to a more hieratic, less humanist religious idiom. His tabernacle in Or San Michele, Florence, is a riot of crockets, gables and finials. As an architect he was also traditional: the Loggia dei Lanzi, Florence (attributed to him on Vasari's authority) is still wholly Italian Gothic in spite of its round arches. His brothers Nardo (fl. 1343–65) and Jacopo (fl. 1365–98) were both painters.

Orchardson Sir William Quiller (1832–1910). Scottish subject and portrait painter known principally for his picture *Napoleon on Board the 'Bellerophon'*.

Ordóñez Bartolomé (fl. c. 1515–20). Spanish sculptor who was influenced by High Renaissance sculptors in Italy where he often worked. He executed reliefs for the Barcelona cathedral

and several tombs (e.g. in the royal chapel at Granada).

Orley Barnaert van (c. 1490–1541). Belgian painter who also designed tapestries. He was influenced by Italian art and was employed as a court painter by Margaret of Austria and Mary of Hungary.

Orozco José Clemente (1883-1949). Mexican painter, trained as an architect, who turned to painting in 1909. At first working in watercolours (e.g. Mexico in Revolution, 1916), he later became a leading fresco painter, much in demand for decorating public buildings in Mexico and the U.S.A. In 1923-4 he executed the famous murals for the National Preparatory School in Mexico where he also did a 2nd series in 1926-7. From 1927 O. worked continuously in the U.S.A. where he had important commissions, notably at Dartmouth College in Hanover, New Hampshire (Modern Migration of the Spirit, 1932-4). *Pollock became attracted to O.'s work as well as to that of the other 2 important contemporary Mexican muralists,

Orozco The Caudillo Zapata 1930

*Rivera and *Siqueiros. O.'s subject matter tended to social realism, but it was treated in a decorative, formalized and rhythmic manner. In this sense O. gave a new aspect to the Revolutionary epic style initiated by Rivera.

Orpen Sir William Newenham Montague (1878–1931). Irish painter, a founder of and exhibitor at the *New English Art Club. He painted portraits of great technical virtuosity, interiors and conversation pieces of historical interest, including the famous *Homage to Manet* (1909) with Sickert, Wilson Steer, George Moore and others grouped in front of Manet's portrait of Eva Gonzalès.

Orphism. A tendency of abstract art in Paris c. 1911–14. In 1912 Apollinaire called the Cubist painting of *Delaunay 'Orphic', linking it with that of Léger, Picabia, Duchamp and some works of Picasso and F. Kupka. The name has only stayed with the painting of Delaunay and his wife Sonia Terk Delaunay, who experimented with colour circles, segments and rhythms in a style called 'simultaneity'. 2 U.S. painters, MacDonald-Wright and Morgan Russell, stressed colour in a similar way (*Synchromism).

Ostade Adriaen van (1610–84). Dutch painter working in Haarlem, perhaps the pupil of Frans Hals or of Salomon van Ruysdael. His genre pictures of peasant, country and tavern life were highly popular. He was closely associated in his work with A. Brouwer. O. later in life produced watercolours, etchings and religious paintings.

Ottoman art. *Islamic art

Oudry Jean-Baptiste (1686–1755). French painter, ill. and tapestry designer, and also director of the Beauvais tapestry works. He began as a still-life and portrait painter but after being commissioned to paint Louis XV's pack of hounds turned to painting animals, hunting scenes and landscapes. He ill. La Fontaine's *Fables*.

Oulton Thérèse (1953–). British abstract painter. Her meticulous, layered application of paint (*impasto) in deep and rich colours characterizes her works, which appear both dense and transparent, alluding to the molecular makeup of matter. Despite their apparent abstractness, O. intends her paintings to work as metaphors with references to traditional pictorial language, hinting at representational art, but confounding any single obvious reading, e.g. Spinner (1986),

Outsider art

Lachrimæ (1987), Vanitas (1989) and the 'Abstract with Memories' series (1991).

Outsider art. Art made by artists who are either not specifically trained as such by defined standards, accepted members of the art establishment or of the same racial, cultural and social background as those who become professionally empowered to define art within a society. At various times art not conforming to such definitions and made by people marginalized by such societies — women, ethnic minorities, peasants, children and the insane — has been designated as O. a. *Primitive art and *primitives.

Ouwater Albert van (mid 15th c.). Dutch painter who worked at Haarlem. Very little is known about him and his reputation rests on the one painting definitely attributable to him, *The Raising of Lazarus*. *Geertgen tot Sint Jans was his pupil.

Overbeck Johann Friedrich (1789–1869). German painter. After studying in Vienna, he went to Rome (1810) and became well known after an exhibition of work there in 1819. He founded, in Rome, the German *Nazarene

Overbeck Madonna and Child 1825

Ozenfant Still-life 1920

movement with *Cornelius, *Pforr and others. His subjects were mainly historical and religious.

Ozenfant Amédée (1886–1966). French painter and one of the theorists of the school of *Paris. He was a pupil of *Segonzac. A leading exponent of *Purism, he collaborated in writings with *Le Corbusier; in 1920–5 they co-published *L'Esprit nouveau*. He founded the Académie Ozenfant (1930) in Paris, but subsequently went to live in N.Y. in 1938.

P

Paalen Wolfgang (1905–59). Viennese-born Surrealist painter. He studied in Paris, but later lived and worked in Mexico.

Pacheco Francisco (1564–1654). Spanish painter, writer and poet. Studied painting under Luis Fernandez and became a leading artist in Seville. He worked for several religious establishments and among his pupils was Velazquez. From 1623 to 1625 he lived in Madrid but then returned to Seville and abandoned painting for literature.

Pacher Michael (c. 1435–98). Tyrolese painter and sculptor. P. was a highly influential original painter who, under the influence of Mantegna, achieved a new spatial clarity in his essentially German style; his work, however, remained for long unknown outside the Tyrol. P.'s best-

known work is the St Wolfgang altarpiece in the Salzkammergut. The carved and painted central panel and the frame are by his hand, providing proof of his remarkable mastery of form. The frame, still Gothic in style, forms a part of painted compositions which themselves are in the Renaissance spirit of scientific perspective and objective observation.

Padovanino, **II** (Alessandro Varotari) (1588–1648). Italian painter in the style of Titian.

Padua, school of. School of Italian painting which became important in the 15th c. under Squarcione and through his pupils Mantegna, Tura and Crivelli powerfully influenced the Ferrarese and Venetian schools.

Page William (1811–85). U.S. painter of portraits, landscapes, historical and genre subjects. The pupil of Herring and Morse, P. lived in Italy (1849–60). His works include portraits of J. G. Adams, John Quincy and General Winfield Scott.

Pahari painting. Art of *Rajput courts (c. 1650–c. 1820) in the Himalayan foothills of the Punjab. A mature style of flat, bold, intense colour and strong profiles is 1st found at Basohli. Other important centres were Bilaspur, Guler, Jammu, *Kangra and Mandi. *Mughal miniature painting was influential but Hindu folk-style predominates.

Paik Nam June (1932—). Korean-American composer, and *Performance and video artist. In 1958 he met *Cage in Germany which resulted in performance works called 'action concerts', e.g. Étude for Pianoforte (1960). In the early 1960s he became associated with *Fluxus and took part in the first 'official' Fluxus festival

Paik V-MATRIX with Beuys' voice am Seibu 1983-8

Pacher Expulsion of the Money-changers from the Temple (detail from St Wolfgang) 1471–81

in Wiesbaden in 1962. P. then began using television as an art medium, and in 1963 exhibited at the first international video art show at the Galeric Bruce Kurtz in Wuppertal. In 1964 he moved to N.Y. He made Cello Sonato No. 1 for Adults Only (1965) with the cellist Charlotte Moorman, which became notorious because in the work she undresses while playing J. S. Bach; in TV Cello (1969) she plays a 'cello' made of TV monitors. In 1970 P. and the Japanese engineer Suya Abe invented a video synthesizer which could mix, polarize and distort images from several video and TV sources, e.g. Global Groove (1973). Obsessed with television as a medium, he installs TV sets in different ways: hanging them in rows from the ceiling, lying them on the floor and stacking them like building blocks, etc., e.g. V-yramid (1982). P. has also used disembowelled old TV cabinets filled with fish, drawings or video cameras, e.g. The Elements (1991).

Painterly. *Malerisch

Pajou Augustin (1730–1809). French sculptor, and pupil of *Lemoyne. He spent some years working in Rome and was a regular exhibitor at the Paris Salon until 1802. Greatly favoured by the French court, he decorated the church

Paladino

of St Louis (Versailles) and the chapel of the Palais-Bourbon.

Paladino Mimmo (1948—). Italian painter, sculptor, draughtsman and print maker associated with the *Trans-avantgarde movement in the 1980s. His consistently figurative paintings fuse styles and imagery, the past and the present, allusions of myth and ritual, primitivist animism and symbolism, e.g. *The Caves at Naples* (1983). From 1983 his canvases have included depictions of sculpted objects, expressionless masks and heads, and animal skulls, e.g. the group of 12 paintings entitled *Il Respiro della Bellezza* (1991). He has also made numerous large-scale bronze sculptures with a polychrome patina, sculptures in wood and a series of totem figures in limestone.

Pala-Sena. Cultural period in Bengal under the Buddhist Pala dynasty (c. 760–1142) and the 12th-c. Hindu Senas. Stone sculpture greatly elaborated the *Gupta style. Nalanda (Kanauj) was an important centre for Buddhist *cire perdue bronze statuary. The Tantric aspect of Hinduism and Buddhism is apparent in the symbolism of P.-S. art.

palette. Flat thin board on which a painter lays and mixes his colours. By derivation used of an artist's choice of particular colours as a characteristic of his style.

Palma Vecchio A Blonde Woman (detail) c. 1520

Pallava. S.E. Indian dynasty (c. 300–888). Its chief artistic glories are the medieval temples at *Mahabalipuram and the early 8th-c. Kailasanatha temple at Kanchipuram (Conjeeveram, Tamilnadu). Exquisite P. bronzes foreshadow *Chola achievements.

Palma Jacopo (called 'Il Giovane') (1544–1628). Italian painter of the Venetian school, concerned mainly with historical subjects. Rising rapidly in reputation, he became a great rival to Tintoretto; in later years his work declined in quality. He worked in the Doge's Palace and in the churches of Venice and also under the patronage of the duke of Urbino.

Palma Jacopo (Vecchio) (c. 1480–1528). Italian painter of the Venetian school, a native of Serimalta, near Bergamo. P. V. may have studied with Titian and Giorgione under Giovanni Bellini. His reputation was established by 1520, when he painted the altarpiece for the church of S. Antonio. This painting and an Adoration of the Magi of 1525 are his only datable works. Although his contemporary reputation was great, he does not appear to have been commissioned to paint in the public buildings of Venice to any extent. P. V. was noted for his ample modelling and figures, especially for a female type of generous proportions and blonde beauty (probably copied by Titian). Many of his works are Sacre Conversazioni. P. V. was influenced by Giorgione and Titian and in turn influenced many painters, including Moretto and Romanino.

Palmer Samuel (1805–81). British painter. Very precocious, he exhibited at the R.A. from 1820 onwards. He became friendly with J. Linnell (his future father-in-law) who introduced P. to J. Varley and, in 1824, to W. Blake. This meeting was decisive; P. was overwhelmed by Blake's ills to *Job*. Between 1824 or 1825 and about 1835 P. produced his greatest work, a series of sketchbooks, small ink and wash landscapes and a few oil paintings, in which Blake's influence, Christian mysticism, pastoral idealism and the landscapes in the Shoreham Valley, Kent, were combined in a powerful manner. P. lived in Shoreham from 1826 to 1835, living simply and surrounded by such friends as Linnell and George Richmond; the group called themselves 'The Ancients'. In 1835 P. returned to London; his visionary intensity of observation and statement was declining. A subsequent visit to Italy and a growing reputation as an academic painter

Palmer In a Shoreham Garden c. 1829

altered his style completely. His early work was rediscovered in the 1930s and 1940s and influenced a generation of painters in Britain, the so-called Neo-romantics, e.g. J. Minton, G. Sutherland, P. Nash. Many of the Shoreham period paintings are in the Ashmolean Museum, Oxford.

Palomino Y Velasco Acisclo Antonio (1655–1726). Spanish painter and writer on art whose writing is a prime source of information on Spanish art in the 15th–16th cs.

Pamphilos (fl. 390–350 BC). Greek painter. He was the pupil of Eupompus, and possibly the master of Apelles, Melantheus and Pousias. His contemporary reputation was extremely high.

Pan(n)ini Giovanni Paolo (1691/2–1765). Italian landscape painter, noted particularly for his picturesque portrayal of ruins, and an admirer of the work of Salvator Rosa. His very large output included historical scenes in architectural settings and capriccios. Many of his large works were lost or destroyed.

Panofsky Erwin (1892–1968). German art historian, one of the most important of his generation. In 1935 he settled in the U.S.A. where he taught at Princeton Univ. With *Saxl he established the method of *iconology. His best-known works are Meaning in the Visual Arts and Early Netherlandish Painting. *iconography.

panorama. A circular life-size painting of a view which surrounds the spectator creating the illusion of reality.

Pantocrator (Gr. universal ruler). Term for the image of Christ in majesty in *Byzantine art. The P. situated in dome or apse as the focus of the pictorial scheme, portrays the bust and head of Christ with stern bearded face; the best examples are among the most awe-inspiring images of all religious art.

Pantoja de la Cruz Juan (1551–1608). Spanish painter of animals, historical subjects and portraits. He was a favourite painter of Philip II and painted many royal subjects, including Philip III. He also painted the retable for the monastery church of St Augustine, Valladolid.

Paolozzi Eduardo (1924—). Edinburgh-born sculptor; he studied at the Slade School, London (1943—7) and then worked (1947—50) in Paris. I lis *Jason* (1956) and *Large Frog* (1958) are examples of assemblages of unrelated ordinary objects — often fragments of abandoned machinery—into figures. P. has also made ceramics, drawings, prints, books and films, and he has been given commissions for civic works.

papiers collés (Fr. glued paper). Term which refers to the technique of incorporating various types of paper — newspaper, wallpaper, bustickets, etc. — into a composition. It was first used by *Braque, then by other Cubist painters such as *Picasso and *Gris. *collage.

Papworth John Buonarotti (1775–1847). British painter, architect and landscape gardener. He designed a palace for the king of Württemberg, and also painted a number of watercolour views of London.

Pareja Juan de (c. 1610–70). Spanish painter, known as 'the slave of Velazquez'. He worked under Velazquez and remained in his house even after Philip IV had made him a freeman on seeing one of his paintings. He was primarily a genre painter, but did a religious painting, *The Calling of St Matthew*.

Paris, school of. *École de Paris

Paris Psalter (10th c.; Bibliothèque Nationale, Paris). Byzantine codex of the golden age of Byzantine illumination when artists returned to classical paintings for their illustrations. The text is in Greek minuscules and it contains 14 fullpage miniatures including 1 of David with his harp. Derived from a Graeco-Roman picture of

Parler

Orpheus taming the beasts, it became very popular and was much copied.

Parler. 14th–15th–c. family of German architects and sculptors, notably Peter appointed master mason for St Vitus's cathedral, Prague, in 1353. He designed the choir vault and as sculptor probably contributed to the remarkable portrait busts (one possibly a self-portrait) in the triforium.

Parma, school of. School of Italian painting which flourished in the 15th and 16th cs under the patronage of the Farnese family. Correggio and his pupil Parmigianino were its most influential members.

Parmigianino II, (né) Girolamo Francesco Maria Mazzola (1503–40). Italian Mannerist painter and engraver named after his birthplace, Parma. He fled Parma c. 1521, was taken prisoner during the sacking of Rome (1527), sought asylum in Bologna, returned to Parma (1531), only to die in Casalmaggiore, again a refugee. Frescoes can be found in the churches of most of these cities, notably in S. Maria dell Steccata, Parma. P.'s art, influenced by Correggio, Raphael and Michelangelo, is characterized by the elongation of the figures,

Parmigianino Madonna and Child with St John the Baptist and St Jerome (detail) 1527

and influenced in its turn the school of *Fontainebleau. Typical of his altarpieces is the Madonna and Child with St John the Baptist and St Jerome, while among the warmest of Mannerist portraits, reserved yet somehow intimate, is the masterly Portrait of a Woman, probably portraying P.'s mistress, Antea 'la Bella'.

Parrhasios (fl. c. 400 BC). Classical Greek painter who was born at Ephesus. He was the pupil of Euphranor and the rival of Xeuxis. He was noted for his vanity, as well as for his ability as a figure painter; he styled himself 'the prince of painters'.

Parthenon. Doric temple on the Acropolis, Athens, built 447-432 BC and dedicated to Athena the Virgin ('parthenos'). The architects were Ictinus and Callicrates, and the master sculptor *Phidias. The sculpture (of which the largest coll., known as the 'Elgin Marbles', is in the British Mus.) consisted of (1) large freestanding figures in the pediments representing Athena, Poseidon and other gods; (2) the high reliefs of the metopes, alternating with triglyphs, showing the fight between the Lapiths and Centaurs; and (3) the continuous low-relief frieze round the top of the outside cella wall, showing the Panathenaic procession of youths and maidens bringing the sacred 'cloak' ('peplos') to the goddess. Inside the cella was the huge ivory and gold statue of Athena by Phidias. Lord Elgin removed most of the sculpture during 1801-3, but some remains in situ. There are also portions of the frieze in the Louvre.

Paschke Edward (1939—). U.S. figurative painter from the School of Chicago Art whose aggressive anti-aestheticism goes beyond *Pop art realism. His portraits of grotesque underworld figures, e.g. *Elcina* (1973), emphasize erotic sexuality and theatricality.

Pascin Jules (1885–1930). Bulgarian-born U.S. painter and decorative artist. He studied in Vienna, Berlin and Paris. He made an early reputation as a cartoonist in Germany and also ill. the works of Heine. He then turned to serious painting, working in France and the U.S.A. (becoming a citizen in 1915); his subject matter was primarily the female nude with echoes of Toulouse-Lautrec and Degas and stylistic elements from his contemporaries *Grosz and *Schiele.

Pasmore Victor (1908–98). British painter and a founder of the *Euston Road school (1937)

with *Coldstream and from 1954 to 1962 a teacher at Durham Univ. By 1945 he had earned a reputation with paintings such as The Studio of Ingres (1945-6): interiors painted with a strong sense of organization and great technical accomplishment. By 1952, possibly encouraged by a period of collaboration with B. *Nicholson, he made a total break with representation. P.'s conversion to abstraction was an important development in post-war British painting. His influence has originated in part from his championship of autonomous abstraction, from his exploitation of 3 dimensions in collages, reliefs and constructions and from his use of contemporary materials such as aluminium and laminated plastics. His abstract paintings, e.g. Abstract in White, Black, Indian Red and Lilac (1957), have been succeeded by constructions like Projective Painting in White, Black and Ochre (1963).

pastel. Drawing material consisting of artificial chalks made of ground white chalk and powder colour. A form of p. was used in the 15th c., but it was fully developed only in the 18th c., a period which found sympathetic its subtlety, charm and ability to portray light. Degas revived it and his work in the medium influenced the Impressionists.

Pasternak Leonid (1862–1945). Russian painter. Soon after the Revolution, he settled in Berlin (1921). His figurative oil paintings and drawings were influenced by the *Nabis and are often portraits of his family and friends. He was the father of Boris P. He lest Germany during the Nazi period and settled in Britain where he died.

pastiche (Fr.), *pasticcio* (It.). A work of art using borrowed styles and elements, but not necessarily a direct copy.

Patenier (Patinir or Patinier) Joachim (c. 1485–1524). Landscape painter active at Antwerp. Influenced by, and possibly the pupil of, Gérard David, he was a collaborator of Quinten Massys and a friend of Dürer. His rocky landscapes with a wide sweeping vista and figures reduced to mere compositional elements had a lasting influence on Flemish religious painting. Technical perfection, smooth finish, naïve vision combined with a rich and controlled imagination, are characteristic of his work. The 3 signed paintings Flight into Egypt, Baptism of Christ and St Jerome are certainly his; there are numerous others in his style.

Pater Jean-Baptiste François (1695–1736). French painter, pupil and follower of *Watteau. He worked with incredible industry, burning himself out at the age of 40. P. had great talent, but lacked individuality and often repeated himself to satisfy the demands of patrons. The *Toilette* illustrates his brilliant gifts as a decorator, but lacks the sensitivity and psychological penetration which marked Watteau's work.

Pater Walter Horatio (1839-94). British writer and aesthete. From 1864 to 1885 he was a fellow of Brasenose College, Oxford. He became famous on the publ. of Studies of the History of the Renaissance (1873), which presented the Renaissance as an impulse moving men to seek the beautiful in art, radiating from Italy throughout Europe. Here as elsewhere P. seeks not to evaluate, but to evoke, in controlled. rhythmical prose, the beauty of his subject. In Marius the Epicurean (1885) he recounts the philosophic quest of a young Roman in Antonine times for truth and inner peace. Other important works are Imaginary Portraits (1887), Appreciations (1889) and the autobiographical The Child in the House (1804).

patina. A thin coating, often of a carbonate of copper, green in colour, which forms on bronze sculptures, etc. after prolonged exposure to the air, or burial, or is induced artificially. The term is also used to describe the oxide that forms on the surface of other metals, and by extension to describe the surface, achieved by age, handling and polishing over the years, of furniture, silver, etc.

Pattern painting. School of post-Matisse decorative painting, often deliberately coarse in the way it uses figurative motifs, which flourished mainly in N.Y. during the second half of the 1970s. Joyce Kozloff, Kim MacConnel and Brad Davis are among the artists involved. Synonym: Dekor.

Paul Bruno (1874–1968). German painter, architect and art critic. He studied at the School of Fine Art in Dresden (1886–94) and then in Munich (1894–1907). In 1907 he became director of the School of Decorative Arts in Berlin and did cartoons for the magazine *Simplicissimus*.

Peale Charles Willson (1741–1827). U.S. portrait painter and miniaturist. He studied under *West in London, then had a successful career as a portraitist in Philadelphia. His ability

Pearce

to get a likeness made him popular in spite of a certain rigidity in his style. His brother James P. (1749–1831) was a miniaturist. Of his sons, all named after the old masters, Raphael(le) (1774–1825) was a miniaturist and Rembrandt (1778–1860) a painter of portraits and historical subjects.

Pearce (Pierce) Edward (c. 1635–95). British sculptor and wood carver; he did much work for Wren and also carved a portrait bust of him.

Pearlstein Philip (1924—). U.S. figurative painter. Since the early 1960s he has concentrated on the realistic but non-expressive depiction of nudes and, he has written, 'on the exploitation of creating the illusions of form in space'. This statement conveys that, contrary to Realist concerns about subject matter, what are important to P. are formal considerations often achieved through hard-edge handling, composition and cropping, e.g. *Two Redining Female Models* (1973). The tension with subject matter and an impersonal *trompe l'œil verisimilitude give his paintings a look of formal abstraction.

Pechstein Max (1881–1955). German painter. In Dresden he met *Heckel and *Kirchner and became a member of Die *Brücke (1906). His style at the time shows a complete if more decorative assimilation of their ideas, both in his taste for the raw and unsophisticated and in his expressive use of colour and paint – *Under the Trees* (1911). In 1910 he joined *Nolde's Neue *Sezession. His later work, like Müller's, involved a more obviously sophisticated, decorative form of primitivism. He taught at the Berlin Academy from 1923 to 1933, when he was dismissed by the Nazis, and again from 1945.

Peeters Bonaventura I. (1614–52). Flemish landscape and marine painter and satirical poet, who lived and worked in Antwerp. He was the brother of the painters Jan (1624–72), Catharina (1615–after 1676) and Gillis (1612–53). In 1639 he painted a picture of the Siege of Calloo (with his brother Gillis) for the municipal authorities at Antwerp.

Peintres cubistes, Les. *Apollinaire

Pellan Alfred (1906—). French-Canadian Surrealist painter. He worked in Paris from 1926 to 1940, and after his return to Canada exercised an invigorating influence.

Pearlstein Mr and Mrs Edmund Pillsbury 1973

Pellegrini Giovanni Antonio (1675–1741). Italian painter and decorative artist who studied under Ricci and Pagani. He worked rapidly and painted in an idiom similar to Tiepolo's. His works, all over Europe, covered biblical, historical and classical subjects. He did influential work in Britain, notably at Castle Howard.

Penck A. R., born Ralph Winkler P. (1939—). East German painter and sculptor who settled in the west in 1980. In the 1960s he shared ideas with the *Neo-Expressionist *Baselitz. In the 1970s he developed a hieroglyphic style in a series of paintings called 'Standart' in which a black stick figure represents Everyman. The overall hieroglyphic mixture of stick figures, symbols, numbers, letters and patterns allude to a mythic subconscious, but are also related to *Klee, *Miró and other primitivist modern artists, e.g. Der Jager (1985).

Penrose Roland Sir (1900–84). British artist and writer on art. He lived in France (1922–36) and became a close friend of Picasso and the *Surrealist artists and writers. He organized the 1st International Surrealist Exhibition (1936) in Britain. After World War II he was one of the founders of the Institute of Contemporary Arts, London. 1 of the most prominent British Surrealist artists, he also wrote several books including Picasso: his Life and World (1958), Portrait of Picasso (1956), Man Ray (1975), Tàpies (1978) and his autobiography, Scrap Book (1981).

pentimento. Term sometimes used in painting of figures, etc. which the artist painted over but which, through the course of time, have become visible through the superimposed layers of paint.

Performance art. Throughout the history of modern art, from 1910 on, P. a., sometimes called 'live art' has been used by modern art movements as a means of shaking up the prevailing art establishment and as a catalyst for new ideas. It is characterized by 3 factors: it is live, it takes place in front of an audience and it usually involves performing artists who also work in other media - dancers, fine artists, musicians and poets: the performer is the artist, seldom a 'character' like an actor. P. a. was used notably by exponents of *Futurism (Marinetti, Boccioni), Russian Futurists and *Constructivists (Mayakovsky, the Blue Blouse Group, etc.), *Dada (H. Ball, Richard Huelsenbeck, etc.), *Surrealism (Breton, Dali, etc.) and at the *Bauhaus under *Schlemmer, director of the theatre workshop, in accord with the Bauhaus principle of a 'total art work'. From 1952 P. a. took on even greater significance esp., to begin with, in the U.S.A. following the seminal Black Mountain College p. by John Cage and p.s often called *'Happenings' - by artists associated with *Pop art such as *Rauschenberg, *Dine, *Oldenburg and *Kaprow. More recently, *Action, *Earth and *Conceptual art have made extensive use of the medium in works by artists such as *Klein and *Manzoni; and of the younger generation, *Acconci, *Anderson, *Beuys, *Burden, *Gilbert and George, *Schneemann and R. *Wilson.

Perino del Vaga (1500–46). Also known as 'Pierino del Vaga' and 'Pietro Buonaccorsi'. An Italian painter of the Roman school. He studied under Raphael and was employed on the decoration of the Vatican where, after 1520, he took over much of Raphael's work. He also worked in Florence (1523–5) and Genoa, decorating the Palazzo Doria. He was, with Giulio Romano, the greatest successor to Raphael's Academy.

Permeke Constant (1886–1952). Belgian painter, one of the major 20th-c. realists. He studied at the academies of Bruges and Ghent, then moved to Ostend (1912–14). Wounded during World War I, he convalesced in Britain where he painted his 1st independent works; he returned to Belgium in 1918. Most of his paintings are of peasants, fishermen and rural landscape, with an Expressionist involvement in human feelings and a monumental simplicity of form, e.g. *The Harvest* (1927). His sculpture – e.g. the early bronze *Marie Lou* (1936) – is in the same vein.

Permoser Balthasar (1651–1732). German Baroque sculptor. He created sculptural decoration for Pöppelmann's Zwinger at Dresden.

Perréal Jean, or Jehan de Paris (c. 1455–c. 1530). French artist, famous for his portraits and designs for festivals and tombs. P. worked in Lyon from 1483, but visited Italy (c. 1500) and Britain (1514). Few works survive, but *Portrait of Louis XII* is almost certainly his. P. was formerly confused with the Master of Moulins.

Perronneau Jean-Baptiste (c. 1715–83). French painter who studied engraving but later turned to pastel and became known for his portraits in that medium. He was very prolific, but the successful rivalry of *Latour drove him from Paris.

perspective. In art a system for representing the 3-dimensional space of actuality on the 2dimensional space of the picture plane. The basic observations behind systems of perspective are that objects in the distance appear smaller than objects close to the spectator and that parallel lines appear to meet in the far distance. Working from such premises and the earlier system of *costruzione legittima, 15th-c. Florentine artists, Brunelleschi, Uccello, Piero della Francesca and above all L. B. Alberti, evolved the principles of linear p., dependent upon, among other things, the correct use of vanishing points (i.e. the points where parallel lines appear to converge). Aerial perspective achieves effects of distance by exploiting the changes in colour and tonal values as objects recede from the observer; the apparent blue of distant mountains is an obvious effect which can be used in aerial perspective.

Perugino (Pietro Vannucci) (c. 1445-1523). Italian painter of the Umbrian school; his work was influenced by his master Verrocchio, Signorelli and the Flemish painters. He used the novel technique of oil painting with great mastery and painted the luminous quality of the Umbrian landscape: green-brown foreground and middle distance, bluish far distance are typical of his colour scheme; his figures are gracefully elongated, with clearly articulated joints, sculpturesque draperies and dreamy expressions. P. was called to Rome by Pope Sixtus IV in 1481 to decorate the Sistine Chapel with a fresco series - the most important is Christ Giving the Keys to St Peter. A severely symmetrical composition, it shows P.'s mastery of perspective and disposition of figures in a monumental geometry. The fresco The Crucifixion

Peruzzi

Perugino Christ Giving the Keys to St Peter (detail) 1481

painted in Siena in 1496 is a masterpiece. The frescoes painted in the Cambio, Perugia (1498–1500) show his style in decline. Lack of originality results in stereotypes and genuine feeling is replaced by sentiment. These frescoes had a profound influence on the development of Italian art, as they shaped the youthful work of P.'s pupil and assistant Raphael.

Peruzzi Baldassare (1481-1536). Italian architect and painter. He was born near Siena but came to Rome in 1503 and designed the Farnesina – a simple facade with pilasters, the attic-storey made into a sculptured frieze with oval windows; inside P. painted *trompe l'æil frescoes (the ground-floor was decorated by Raphael). He was in charge of St Peter's from 1520, but his contribution has been entirely obliterated. He kept Bramante's centralized plan. In 1535 he designed the Palazzo Massimi, Rome, important as marking the development of High Renaissance into Mannerism; significant features are the curved facade, columns on the ground-floor, rusticated stonework above (instead of vice versa) and the complicated shape of the window-frames of the 1st floor.

Pesellino Francesco (1422–57). Florentine painter who studied under his father Stefano di Francesco and inherited his studio workshop. His style combined elements from Fra Filippo Lippi, Masaccio and Fra Angelico. He appears to have worked with Lippi, who completed the altarpiece *The Holy Trinity* after P.'s death. P. worked with Uccello on battle scenes for the Medici Palace, Florence, and also painted panels for *cassone* ('bridal chests').

Pesne Antoine (1683–1757). French painter of portraits and historical subjects at the court of Prussia, contributing to the French influences at the court of Frederick II. He also painted portraits at many other francophile German courts.

Peto John F. (1854–1907). U.S. painter who, under the influence of *Harnett, specialized in *trompe l'œil still-lifes. P.'s work is not derivative; it is distinguished by sensitivity and painterly finish.

Petrov-Vodkin Kuzma (1878–1930). Russian painter and an influential teacher. After studying in Moscow under Levitan and Serov he went to Africa, whose art and peculiar light and colour influenced his later work, as did the work of Matisse. He was a member of the *Blue Rose group but later adopted a Neoclassical style; Playing Boys of 1911 is a typical work.

Peysner Antoine (Noton or Anton) (1886-1062). Russian painter and sculptor. In 1011 he went to study in Paris, drawn by the new French painting shown in the colls of *Morosov and *Shchukin and the *Golden Fleece exhibitions in Moscow. There he made friends with Modigliani and Archipenko. In 1913 P. began to paint in Cubist style; Byzantine art was also fundamental to the development of his later construction-sculpture. On his return to Russia in 1917, P. was appointed professor in Moscow *Vkhutemas. With his brother *Gabo he took a stand against functionalist *Constructivism in 1920, a year later leaving Russia for Berlin where he made his 1st construction, not vet abstract, in celluloid. With Gabo he designed La Chatte in 1927 for Diaghilev. P. settled in Paris, working on progressively more abstract sculpture in bronze and other metals.

Phidias (c. 500–c. 432 BC). Greek sculptor and painter, pupil of the sculptors Hegias and Ageladas of Argos (who influenced him in the direction of Doric realism). He is reputed to have painted Pericles as Jupiter but his most important work was in sculpture for the Acropolis, including a state of Athena and the Athena Chryselephantine for the interior of the Parthenon, and much of the subsidiary sculpture. P. also carved the statue of Zeus at Olympus, whither he may have moved after being accused in Athens of embezzling the precious metals he used for his major works. This statue in gold and ivory was one of the Seven Wonders of the ancient world.

Phidias Horse head, Chariot of Selene (Parthenon pediment) 448–432 BC

Phillips Ammi (1787/8–1865). U.S. primitive artist. More than 200 portraits survive; varied yet characteristic in style they include the starkly powerful *Joseph Slade* (1816).

Phillips Peter (1939—). British *Pop art painter. He studied at the Royal College of Art (1959—61) at the same time as *Hockney, *Jones and *Kitaj, all of whose work emerged decisively at the 'Young Contemporaries' exhibition (1961). P., in his flatly painted and complex structured paintings, integrates images of cars, pin-ups, pop stars, leather jackets, comics and pinball machines (e.g. Distributor, 1962, Custom Painting No. 3, 1964—5).

Phillips Tom (1937-). British artist. He studied at St Catherine's College, Oxford primarily Anglo-Saxon literature Camberwell School of Art, London, under *Auerbach. At Oxford he came under the influence of the art historian *Wind, as had *Kitaj, whose lectures on iconography and Renaissance art he attended. His paintings and prints reflect his erudition and literary sophistication. In his work he makes use of found objects and images; it is essentially figurative, eclectic and uses collage and chance techniques. He has also used the book form, as in A Humument which combines a found text, stencilled lettering and images. He has been writing his own œuvre catalogue Work/Texts. P. has also produced his own translation of Dante's Inferno with 139 ills (1979-82) which are a visual interpretation of the text.

Philoxenos (fl. early 4th c. BC). Greek painter known for his painting of the battle of Issus, of which the *Alexander mosaic may be a copy.

photomontage. Although the manipulation of the photograph is as old as photography itself, the term was first used soon after World War I, invented by the Berlin *Dadaists *Hausmann, *Grosz, *Baader and *Höch. P. has since had a continuous history both as an art form and in graphic design. It involves the pasting together of *readymade photographic images, often of machines, together with newspaper and magazine cuttings, and typography. More recently the term has been used in connection with the manipulation of photographic processes, dark-room techniques and printing.

Photo Realism. *Super Realism

Pianta Francesco. 17th-c. Italian sculptor in wood whose most notable work was in carving the stalls in the Scuola di San Rocco in Venice.

Piazzetta Giovanni Battista (1682–1754). Venetian painter, the pupil of Antonio Molinari; he came under the influence of Guercino when working in Bologna. P. returned to Venice as director of the Venetian Academy in 1760.

Piazzetta Beach Idyll (detail) c. 1740

Picabia Edtaonisl 1913

Among his best works are *The Standard Bearer* and *The Fortune Teller*. His work formed a link between that of Caliari and Tiepolo and can be seen in the churches of SS Giovanni e Paolo and at the Santo in Padua. He also did outstanding drawings and ills.

Picabia Francis (1879–1953). Paris-born painter. After an early Post-Impressionist phase, he became involved successively with *Cubism, *Orphism and *Futurism, but is most significant as a pioneer of *Dada in Paris. Working with Duchamp, whom he met in 1910, he was also responsible for the passage of Dada to N.Y., where he ed. the Dada magazines 291 and 391. He joined *Tzara, *Arp and the Zürich Dadaists in 1918 and from 1920, in contact with *Breton, was active as a *Surrealist. His best early works are in the Cubist idiom, e.g. *Undine* (1913). Many of his Dada collages and constructions parody machinery, e.g. *Parade Amoureuse* (1917).

Picasso Pablo Ruiz (1881–1973). Spanish painter, sculptor, draughtsman, graphic and stage designer, and ceramicist, born in Málaga, Andalusia. The indisputable genius of 20th-c. art, P., like Michelangelo whom he in some ways emulated, stands as one of a handful of the most important artists in the whole history of Western art. Encouraged by his father José Ruiz Blasco, an artist and teacher of art, P. studied principally in Barcelona where he mostly lived (1896–1904). Until 1898 P. signed his pictures with his father's name, Ruiz, as well as his mother's, Picasso. In 1898–9 he began occasionally using only his mother's name and

from 1900-1 he dropped his father's name. He 1st visited Paris in 1900, then in 1901 and 1902, and 1904. He showed prodigious artistic ability from his youth, e.g. Man in a Cap (1895) and Portrait of the Artist's Sister (1899). In 1900, the year of his 1st visit to Paris, he was deeply impressed by *Toulouse-Lautrec, *Gauguin and Van *Gogh, while retaining what he had learnt in his native country from El *Greco, *Velazquez and *Goya. Le Moulin de la Galette (1900), probably his 1st painting in Paris, shows the influence of Toulouse-Lautrec, while Paris Street (1900) and On the Upper Deck (1901) demonstrate how impressed he was by Parisian life seen in its cabarets, boulevards, public gardens and racecourses. In Self Portrait (1901) and also in his paintings until early 1904, his socalled Blue Period, an element of melancholy dominates his work with subjects of vagabonds, beggars, prostitutes, poverty-stricken and deprived people, e.g. the Old Guitarist (1903), who frequented the bars of Montmartre or the streets of Barcelona where he spent the greater part of these years until he settled in Paris in 1904. The restricted ethereal blue colour and simplified, plastic forms combined to create an intense melancholy and pathos away from the atmospheric effects of Impressionism.

In Paris he took a studio at the *'Bateau Lavoir', a building inhabited by painters and poets in Montmartre. He soon met artists and writers including *Apollinaire, Max Jacob, Alfred Jarry, the art critic André Salmon and his early patrons, Gertrude and Leo Stein, the art dealer Wilhelm Uhde and the Russian collector *Shchukin. The pessimism of his earlier work gave way to the so-called Rose Period. Actors and strolling players of the boulevards and circuses are rendered in a manner lighter in mood using a palette of gentle tones of pink, ochre and grey, e.g. Boy Leading a Horse, The Boy with a Pipe, The Acrobat's Family and Family of Saltimbanques (all 1905). During this period, P. also produced a number of sculptures, e.g. Head of Fernande (1905) and a remarkable series of etchings, The Frugal Repast (1904), The Saltimbanques (15 etchings made in 1904/5 publ. by Vollard in 1913) and Salome (1905). His early work exemplifies his extraordinary power to assimilate varied influences and his uninhibited will to experiment. In 1906 P. met *Kahnweiler, *Braque, *Derain and *Matisse. Although conscious of the revolutionary violence of *Fauvism, he remained untouched by the prime importance it gave to colour alone.

Picasso Les Demoiselles d'Avignon 1907

The experimental nature of his work intensified c. 1906/7 inspired, on the one hand, by 'primitive' forms (ancient Iberian sculpture at 1st and later African and Oceanic masks and carvings), e.g. Gertrude Stein, Self Portrait and Two Nudes (all 1906) and, on the other, by *Cézanne's empirical reorganization of forms in paintings which became familiar to P. through the dealer Vollard who had given P. his 1st exhibition in Paris in 1901. In 1906 he discovered the greatness of 'Le Douanier' *Rousseau, the vitality of whose work greatly appealed to P.'s eagerness to find new forms of expression. The epoch-making Les Demoiselles d'Avignon (studies started in 1906 and the painting executed in 1907) was a conscious attempt to complete his researches and, although these were obviously still evolving during its production, this painting seen in retrospect was the vital step in liberating P. from conventional

representation, The African art which P. 1st saw c. 1906/7 was not inhibited by the representational tradition of Western art, and its forms became for P. a precedent of paramount importance. *Cubism was evolved by P. and *Braque, whom P. had met in 1907 through Apollinaire. by tempering this freedom with Cézanne's sense of structural discipline (a retrospective exhibition of Cézanne was held at the Salon d'Automne in 1907). In the same year the dealer Kahnweiler signed a contract with P. that gave him exclusive sales rights to his work. In early Analytical Cubist paintings (1909-12), e.g. Portrait of Ambroise Vollard (1909-10), the form is still clearly recognizable, although the traditional rules of linear perspective are abandoned – freely dissected, separated into its elements, penetrated and reconstructed in terms of a complex arrangement of overlapping translucent planes, executed in sepia and grey with only occasional

use of olive green and ochre, the figure and its shallow spatial background setting are homogeneously integrated. The same quality characterizes *Portrait of Uhde* (1910), but in *Portrait of Kahnweiler* (1910) likeness has been abandoned to the uncompromising organization of form into the broken facets of Analytical Cubism. In 1911 P.'s 1st venture in book ill. was a commission by Kahnweiler to do etchings for Max Jacob's *Saint Matorel*.

In Synthetic Cubism (c. 1912–13 to 1916) e.g. Still Life with Chair Canin (1911-12), The Violin, The Aficionado (both 1912), Bottle of Vieux Marc (1913), Guitar, Playing Card, Glass, Bottle of Bass (1914) - the use of *found objects, newspaper, etc. in *collages and *papiers collés on the picture surface firstly placed an outspoken emphasis on that surface and secondly declared in a revolutionary manner that painting creates its own reality rather than imitates nature. In 1912 P. began exploring the possibilities of 3dimensional constructions in relief, e.g. Still Life (1914) and in the same year (1914) in a polychrome, freestanding bronze sculpture, Le verre d'Absinthe. By 1913 the subdued colour of early Cubism had been abandoned and it now assumed a new role – it glowed from flat, evenly coloured and clearly defined areas, e.g. Woman in an Armchair (1913) and Card Player (1913-14). From 1914, when his partnership with Braque was ended by the outbreak of war, until 1921, P. continued to work in a Synthetic Cubist idiom culminating in the monumental Three Musicians (1921). By this time, however, Cubism was no longer P.'s exclusive style, although Cubist devices continued to be used even decades later. P. worked on designs for several of Diaghilev's ballets (1917-24), e.g. dropcurtain for Parade (1917) and Pulcinella (1920) and visited Rome, Naples, Pompeii, Florence and Barcelona with the co. His visits to Italy possibly inspired the classicism of his figure compositions of 1919-25. The colossal, sculptural figures, e.g. Two Seated Women (1920), Seated Nude and Three Women at the Fountain (both 1921) make references to classical subjects, but were made in parallel with Cubist paintings. The strong influence of classicism, however, gave way to the ecstatic violence and frenzy of Three Dancers (1925), the 1st to show violent distortions and a new freedom of expression.

During the following years, his freely inventive anatomies and architectures began to incorporate Surrealist elements, e.g. *Crucifixion* and *Seated Bather* (both 1930). In the late '20s he

returned to bas-reliefs and sculpture inventing new forms, e.g. Figure of a Woman (1928) and Woman in Garden (1929–30), and sometimes using painting and sculpture interchangeably, e.g. The Painter and His Model (1928), part of which was also made as a painted metal construction. P. exhibited in the 1st Surrealist exhibition (Paris, 1925) and contributed etchings and writings to Surrealist publications – although he did not sign the Surrealist manifestos. In 1931 Vollard publ. 12 etchings by P. as ills to Balzac's Le chef-d'oeuvre inconnu and Albert Skira Ovid's Métamorphoses with 30 etchings by P.

From the 1930s P. became increasingly involved with political unrest in Europe. His interest in classical mythology combined with his passion for bullfights resulted in his frequent use of the subject of the Minotaur. During 1931-5 P. made a series of 100 etchings, the socalled Vollard Suite (3 portraits of Vollard were made later in 1937). 46 of these (1933-4) were of 'The Sculptor's Studio' and 15 (1933-5?) on the theme of the Minotaur. An additional etching Minotauromachy (1935) was to be used 2 years later as the departing point for P.'s, historically, most important painting since Les Demoiselles d'Avignon, the Guernica. When the Spanish Civil War broke out in July 1936, P. associated himself with the Spanish Republican cause. In 1937 he made 2 large engravings, Dream and Lie of Franco, and the Guernica named after the Basque town destroyed by an air raid. This enormous canvas (11ft 6in. x 25ft 8in., 3.5 m. x 7.8 m.) has been called 'the most famous painting of our time'. It is a complex allegory that expresses the anguish of human tragedy; it combines violent distortion with restrained subtlety of colour. It was shown at the Spanish Pavilion at the Paris World Fair soon after it was completed. The Minotaurs of the Vollard Suite and of Minotauromachy, as well as numerous drawings and studies, e.g. Horse's Head, Woman Weeping and Woman and Dead Child (all 1937) were all fed into the painting of the Guernica. As World War II was approaching he painted a number of pictures that indicate his foreboding, e.g. Cat Devouring a Bird and Night Fishing at Antibes (both 1939). P.'s wartime output was prodigious in painting and sculpture, including the bronzes Death's Head (1943) and Man with Sheep (modelled 1st in clay, 1944). From 1944 he was a member of the French Communist Party. His final great painting expressing the horror of World War II was The

Charnel House (1945). He was, however, to return to the subject again, responding to the Korean War, in Massacre in Korea (1951) and in two enormous paintings War and Peace (both 1952). P.'s constant preoccupation with forms in space find brilliantly imaginative expression in his ground-breaking sculpture (664 catalogued) which includes Cubist bronzes (c. 1909), collage constructions (1912-16), e.g. Glass of Absinthe (1914), the wrought-iron constructions made in collaboration with J. *González (1928-32), the use of *readymades, e.g. Bull (1943), Goat (1950) and Monkey with Young (1952). P.'s post-war work included several series of extraordinarily inventive paintings after other artists (Poussin, Delacroix, Velazquez and Manet) as well as a prodigious volume of graphic work and ceramics. He was prolifically productive to the end of his life. The extraordinary versatility, energy and freedom that characterize every phase of his work were yet again manifest in the astonishing new paintings and engravings he made in the last decade of his life until the very day he died, daring and innovative in style and technique, including 347 etchings produced in 1968. A large statue in bronze, Woman Holding a Vase, made from his plaster model of 1933 and shown beside Guernica in 1937, was placed on his grave.

picturesque. Term used in late 18th-c. Britain to describe the qualities of ruggedness and irregularity – particularly of rocks, ruins, etc. – felt to enhance the aesthetic appeal of landscapes, e.g. those of Salvator Rosa and Claude Lorraine. 'The p.' was thus an element in the growth of Romanticism; theorists and controversialists about its nature include Edmund Burke, Richard Payne Knight and Sir Uvedale Price.

Piero della Francesca (1410/20 92). Italian painter and mathematician. For relatively short periods he worked in Florence, Urbino, Ferrara and Rome but most of his life he lived in Arezzo and Borgo San Sepolcro, his birthplace, where he was a town councillor in 1442. He led an uneventful provincial life and died relatively unknown.

A number of influences are fused in his work. Domenico Veneziano was his master and the intellectual ferment of Masaccio, Alberti, Uccello and the mathematicians of his time helped to form his style, which intimately joined science and art. His love and mastery of mathematics is fully expressed in his paintings, constructed within a rigid framework of

Piero della Francesca Flagellation (detail) 1455

geometry but controlled by a sensibility and genius for colour, pattern, scale and proportion. P. was overshadowed by his more fashionable contemporaries but he was hailed by the Cubists and is also seen as a central figure of the Renaissance, his influence extending through his pupils Perugino and Signorelli to the main Italian schools.

The Madonna of Mercy, a polyptych, is P.'s 1st known commissioned work. The 2 centre pieces only, the Madonna and the Crucifixion, are by P., painted against a gold background as stipulated in the contract; his awareness of abstract, solid and clearly defined forms is in conflict with the decorative treatment required of him. The conflict he was able to resolve with mastery. Masaccio's influence is clearly seen in the Crucifixion, but the drama is heightened by a lower viewpoint and more agitated stark silhouettes. The Baptism of Christ although an early work is already typical of his vision. The action takes place against a hilly landscape and blue sky, patterned by horizontal clouds and establishing a strong horizontal-vertical rhythm with the figures and tree of the foreground. P.'s powers of observation are clearly shown in one of the background figures. The composition is

Piero di Cosimo

filled with a light and brightness of unearthly quality.

His monumental commission for San Francesco in Rimini brought him into contact with the architect and theoretician Alberti in 1451. P.'s monumental style is here at its purest, intimately connected with the architecture it serves. The figures are placed in a clearly defined space which is broken by columns serving to offset or obscure the characters of the action. The sense of order pervades all.

In the Flagellation at Urbino, believed to have been painted somewhat later than the Baptism, the figures, set like chessmen on a floor of chequered tiles, are contained by an architectural framework, constructed along the principles of Renaissance architectural theory, which produces a pattern of cubes within the

picture space.

The frescoes of the Story of the True Cross, painted in the choir of San Francesco, Arezzo between 1452 and 1466, were based on a story popular at that time. The subject is represented with more emphasis on pictorial than literary values; chronological sequence is abandoned in the interest of compositional symmetry. Thus the 2 battle pieces are placed along the lowest sections of 2 opposite walls, and above them the courtly scenes are contrasted. Each scene has been conceived with complete clarity and mastery of form and is related to the unified concept of the wall and entire spatial distribution of the choir. The effect of light and colour is at its most dramatic in The Dream of Constantine.

The *Resurrection*, a further illustration of P.'s great spirituality, poetry and clarity, may have been painted at the end of this period.

The double portraits of Battista Sforza and her husband are assumed to date after 1472. Both are placed in strict profile against an ideal landscape suggesting infinity.

The unfinished *Nativity* and the *Madonna and Child with Angels* are late works. The former shows some Flemish influence in conception

and treatment, the latter that growing passion for mathematics which induced him to devote the remainder of his life to the study of mathematics and the publ. of works on harmony and perspective.

Piero di Cosimo (c. 1462-c. 1521). Italian painter. Although trained in the Florentine tradition by a long apprenticeship to Cosimo Rosselli, which probably included working with Rosselli in Florence and Rome (Sistine Chapel), and also influenced by painters such as Signorelli and Leonardo da Vinci, nevertheless P. showed a strikingly individual imagination. He lived for many years as a recluse with a reputation as an eccentric, painting scenes from allegories and classical myths difficult to decipher. Typical of his work is the mythological subject, e.g. the Death of Procris, a hauntingly evocative work, serene in comparison with the strange and violent Fight Between the Lapiths and the Centaurs. P.'s imagination found an outlet in designs for festivals, masques and processions, including the celebrated Triumph of Death of 1511.

pietà (It. pity). Painting or sculpture of the Virgin nursing the dead Christ. The idea, developed in Germany in the 14th c., is similar to that of the *imago pietatis but lays greater emphasis on the human and less on the symbolical aspects of Christ's suffering. One of the most famous of all p.s is that from Avignon (c. 1460) now in the Louvre.

Pietà of Villeneuve, The or The Avignon Pietà (Louvre). Painted c. 1460, by an anonymous artist. The austere colouring, abstract gold background and almost carved figures are used to convey a feeling of religious devotion of the highest intensity. This masterpiece has been claimed for many schools, including the Catalan and Portuguese, but it seems almost certain that the painter was French.

Pietro (Berrettini) da Cortona (1596–1669). Italian painter and architect active in Rome from 1613, a devoted follower of Raphael and

Piero di Cosimo Death of Procris c. 1510

of classical antiquity. P. was influenced by Bernini and collaborated with him on a number of buildings. His patrons were the Pope, and the Pope's family, the Barberini. He thus worked in St Peter's and painted the huge ceiling of the Great Salon of the Barberini Palace, Rome (1633–9). This ceiling was an allegorical fresco painting of *Divine Providence* exuberant and bold in conception, ingenious in its symbolism. His easel painting *Alexander's Defeat of Darius* was influential as the first of its kind, showing a battle in violent, theatrical, but ordered confusion.

Pignon Édouard (1905–93). French painter and important member of the school of *Paris since 1945.

Pilo Carl Gustav (1712–92). Swedish portrait painter and sculptor. Earning his living at first in Vienna and the German courts, he became painter to the Danish court (1748) and director of the Danish Academy (1771) and later returned to direct the Stockholm Academy.

Pil(l)on Germain (c. 1535–90). French sculptor. Early Mannerist influences on his work were displaced by a greater realism. He carved Francis I's tomb (1558–9) and Henry II's tomb (1564–83) at St-Denis, and sculptures for Fontainebleau and the Louvre and at the château d'Anet (for Diane de Poiticrs).

Piloty Karl von (1826–86). German history painter, a leading exponent of the Realist school, of great influence; professor at the Munich Academy, later director.

Pimenov Yury (1903–77). Soviet painter, like Deineka typical of the 1st post–Revolution generation of Soviet painters in his revolt against the Constructivists' tenet that easel painting was dead. His work, however, is on a monumental scale more related to wall painting than the easel; in mood it much resembles Eisenstein's early films, in technique principles of photomontage are characteristic. Give to Heavy Industry (1927) is a typical work.

Pimmer William (1816–79). British-born U.S. sculptor, painter and anatomist, author of *Art Anatomy* (1877). He established his reputation as a sculptor with the nude figure *Falling Gladiator* (1861). His important commission for a draped figure of Alexander Hamilton for Commonwealth Avenue, Boston, was not successful.

Pinturicchio (Bernardino di Betto) (c. 1454–1513). Umbrian painter. An assistant to

Perugino in the Sistine Chapel and a fertile and facile painter of Renaissance court life. Many of his compositions are based on his master's work. The lavish use of gold, brilliant colour and pattern is characteristic of his frescoes. He decorated the Borgia apartments of the Vatican (1493–4) for Alexander VI. His most important work is the fresco cycle dealing with the life of Pope Pius II, the former Aeneas Silvius Piccolomini.

Piper Adrian (1948-). African-American artist, philosopher and political confrontational activist, all in one. Since the 1960s P. has been an important *Performance and *Conceptual artist making works that deal with identity - the forms of representation of race and gender. Inspired formally by *LeWitt's *Minimalism and Conceptualism, P.'s work incorporates political content and rejects preconceptions that isolate the aesthetic from the social, form from content. Philosophically, as a follower of Kant, her position affirms the belief that moral issues can be dealt with rationally, a conviction that illuminates all her work. She has said: 'I want viewers of my work to come away from it with the understanding that racism is not an abstract, distant problem that affects all those poor, unfortunate other people out there. It begins between you and me, right here and now....' P. began a series of Performances (1970), 'Catalysis', confronting the public with extreme and 'offensive' transformations of herself to

Adrian Piper Cornered 1988

Piper

provoke, or catalyze, a reaction and thus bring people face to face with their behaviour, their feelings and thoughts about social difference, jolting them into re-examining their attitudes. P.'s work since, in different forms and media, has been based on provocation. In her multimedia *Installations and *Environments, the viewers come face to face with their social attitudes in what she calls 'meta-art', examining the artist's role in society, e.g. Aspects of the Liberal Dilemma (1978), Four Intruders Plus Alarm System (1980), Cornered (1988) and What's It Like, What It Is, No 1 (1991). Her ongoing series 'Decide Who You Are' consists of panels combining photographs, texts and drawings that pose the exhortation of the title in endless variations.

Piper John (1903–92). British painter. He worked in his father's solicitor's office until 1928, then studied at the R.C.A. and the Slade until 1930. During the 1930s P. responded to the main body of European art, coming into contact with Braque, Léger, Brancusi, also Nicholson and Hepworth. Both as painter and designer he tried to integrate Surrealism. Cubism and later movements into the British Neo-romantic topographical tradition. He was a war artist of considerable distinction, his watercolours of bombed churches being particularly fine; he designed the windows for Coventry cathedral. He did the décor for a number of operas, including Benjamin Britten's Death in Venice.

Piranesi Giovanni Battista (c. 1720–78). Italian engraver and architect, famous for his views of

Pisanello Vision of St Eustace c. 1440

Piranesi Carceri d'invenzione (2nd state, plate V) 1750

the ruins of Rome and fantastic compositions of building interiors. His profound knowledge of archaeology found full expression in imaginary studies of prisons, ruins, vaults and arcades full of highly contrasting light and dark shadows. Influenced by the landscape painting of Claude Lorraine, his own work helped to establish the pattern of the Italian Romantic landscape. Of his great output of etchings and engravings the *Imaginary Prisons (Carceri d'invenzione)*, a series of plates issued in 1750, is justly the most famous. His son Francesco (c. 1758–1810) completed and reissued a number of his plates.

Pirosmanishvili Niko (1863–1918). Russian painter. By training an artisan sign painter, he was taken up by *Larionov and invited to contribute to his exhibitions. A primitive in style, P. showed talent comparable to that of Le Douanier (Henri) Rousseau and his painting enjoyed in Russia a cult similar to Rousseau's in Paris

Pisanello Antonio Pisano, called (1395–1455). Italian court painter and medallist, the most celebrated of his time. His work is characterized by a minute and accurate observation of reality and his naturalism, though within the decorative

convention of his time, stands out in marked contrast to the more idyllic and linear expression of his great contemporary Gentile da Fabriano. He was a draughtsman of genius and his drawings became examples for the artists of the Renaissance. As a medallist he carried the craft to its highest peak. The early *Vision of St Eustace*, perhaps his greatest and most imaginative painting, is an excellent illustration of his naturalism, his rendering of the splendour of knighthood and his joy in nature both animate and inanimate. His frescoes in Rome, Venice, Pavia and Mantua have been lost; only 2 frescoes in Verona have survived.

Pisano Andrea (c. 1270-1348). Italian goldsmith, sculptor and architect. In 1330 he was commissioned to execute the 1st pair of bronze doors of the Baptistery at Florence. Completed in 1336, the doors show scenes from the life of St John the Baptist and allegoric themes of the Cardinal and Christian Virtues. P.'s style is distinguished by the clear disposition of detached and grouped figures against a simple background. His association with the Duomo at Florence continued for the rest of his life, as he was appointed in 1337 to complete Giotto's Campanile with the addition of 2 storeys and reliefs. Influenced by Giotto and G. Pisano, he himself exercised a profound influence on some of the most important Florentine sculptors, e.g. Ghiberti, Donatello and Luca della Robbia, His son Nino (c. 1315-68?) was also a sculptor.

Andrea **Pisano** Naming of the Baptist (detail from the Baptistery doors, Florence) 1336

Pisano Giovanni (c. 1245/50–c. 1314). Italian sculptor and architect, son of Nicola P. The dramatic quality of his sculpture influenced Giotto, but its form is more French and more Gothic than his father's; the forms are sinuous, the draperies graceful. P. also designed the facade of Siena cathedral.

Pisano Nicola (c. 1220/5–c. 1284). Italian sculptor who with his son Giovanni carved the pulpits in the Pisa Baptistery, in Pisa cathedral, in Siena cathedral and at Pistoia. The first 2 are mainly by Nicola, the last 2 mainly by Giovanni; but their exact shares are in dispute. Possibly trained in southern Italy which, under the Emperor Frederick II, witnessed a Roman revival in the mid-13th c., P. copied Roman reliefs, evolving a plastic style with horizontal composition in depth, new in medieval art and anticipating Renaissance methods. Other works executed jointly with his son include the reliefs on the Fontana Maggiore, Perugia (1278).

(1830-1903).Pissarro Camille *Impressionist painter, born in St Thomas, Dutch East Indies, but educated in Paris, He worked under Corot and at the Académie Suisse where he met Manet, Monet and probably Courbet and Cézanne. Corot advised him to paint small sketches before nature and above all to 'study light and tonal values: execution and colour simply add charm to the picture'. Early landscapes such as The Marne at Chennevières (1864-5) were highly praised by Zola, Castagnary and other critics but received little public recognition; P. earned his living painting decorative blinds and fans. From the late 1860s he was a major figure of the Impressionist circle: he alone exhibited at all 8 exhibitions (1874–86) which he largely organized. Despite great poverty he refused to seek Salon recognition.

Influential as a teacher – for Cézanne and for Gauguin (c. 1879–83) – he was himself open to changing influences. In the 1880s, dissatisfied with his own technique, he imitated Seurat's Divisionist manner and his series of paintings of the single motifs under changing conditions were directly inspired by Monet. Despite this, his work is remarkable for its consistency.

He was in London from 1870 to 1872 (Penge Station, 1871) where he admired Constable, Turner and Dutch painting, but lived principally at Pontoise until 1884 when he settled at Eragny. His paintings differ from those of the other Impressionists in 2 major respects. Firstly the Pontoise paintings particularly, e.g. Côte du

Pissarro

Camille Pissarro Rouen 1896

Jallais (1867) are more carefully composed with a high horizon, controlled recession and dense colour areas. These are the paintings that influenced Cézanne, who worked with P. at Pontoise at intervals (1872–7). Secondly his landscape, as well as being a direct observation of certain conditions, was always inhabited. He admired Millet and Daumier and shared their respect for the working man. There are often strong socialist undertones in his letters.

Pissarro Lucien (1863–1944). French painter, the son of Camille P. He first exhibited with the Impressionists in 1886 and at the Salon des Indépendents from 1886 to 1894. From 1893 he lived and worked in Britain and was later associated with the *New English Art Club. His style and subject matter were much influenced by those of his famous father.

Pistoletto Michelangelo (1933—). Italian painter in whose work characteristically highly polished surfaces coated with plastic varnish reflect, mirror-like, the viewers and what surrounds them. His self-portraits of the early 1960s and his reflecting paintings were followed by photographed drawings attached to polished metal surfaces and *trompe l'œil paintings with Plexiglas surfaces. In other works, he uses mirrors to repeat the motif of reflection.

Pittoni Giovanni Battista (the Younger) (1687–1767). Venetian painter and the pupil of his uncle F. P. Most of his religious pictures are small in size, but he also painted classical subjects. His works include *The Sacrifice of Polyxenes* and *Crassus Despoiling the Temple at Jerusalem*.

Pittura Metafisica. *Metaphysical painting

Plains Indian art. The art of the American Indian peoples living in the vast area between the Rocky Mountains and the Mississippi River, principally the Arapaho, Blackfoot, Cheyenne, Comanche, Dakota (Sioux) and Kiowa. Their art shares a common style. Buffalo-skin robes and buckskin shirts are embellished with quill decorations and painted designs, both abstract and realistic animal forms.

plasticity. This word is sometimes used in art criticism when discussing paintings in which the 2-dimensional figures give a strong impression of solidity.

plein air (Fr. open air). Term used of paintings which convey an open-air feeling, and particularly of those actually painted out-of-doors. Hence it is most frequently used of the work of the Impressionists.

Pleydenwurff Hans (d. 1477). German painter who was working in Nuremberg between 1450 and 1472. Little is known of this primitive painter of religious subjects. *The Crucifixion* and *The Mystical Marriage of St Catherine*, however, are characteristic of his work.

Poccetti Bernardino Barbatelli (c. 1542–1612). Florentine painter. During a period in Rome P. saw pictures by Raphael which influenced his style; he reacted against Florentine *Mannerism, painting with great realism, and became the chief representative of late Florentine 16th–c. academic style. He did many frescoes.

Pistoletto Division and multiplication of the mirror 1975–9

Poelenburgh Cornelis Van (c. 1586–1667). Dutch landscape painter who worked in Rome, Florence, Holland and Britain. His small paintings, often painted on copper, are of high finish and were very popular.

Pointillism. *Neo-Impressionism

Polack Hans (Johann) (d. 1510). German painter of frescoes and panels; he was an important master of the late Gothic style in Bavaria where he mainly worked. Altar panels by P. are in the National Museum in Munich. *The Disputation of St Stephen* and *The Entrusting of the Rule by St Benedict* are in the Museum of German Art, Munich.

Polenov Vassily (1844–1927). Russian painter chiefly of landscape and religious subjects, a member of the *Wanderers group of artists and also a leading spirit in the formation of the *Abramtsevo Colony. As a teacher in the Moscow Art School in the 1880s and 1890s he was influential on a whole generation of Russian artists such as Levitan and Konstantin Korovin (the theatrical designer to Mamontov and later Diaghilev).

Poliakoff Serge (1906–69). Russian painter; he went to Paris in 1923. After his introduction to painting (1930), his early pictures were almost exclusively academic nudes and landscapes. A visit to London in 1935 found him formulating a personal style, tending to abstraction. Encouraged by his friendship with Kandinsky and influenced by visits to the studio of Delaunay, he turned to painting abstracts of contrasting and interlocking colour shapes.

Polidoro da Caravaggio (1490/5–1543). Italian painter, pupil of Raphael and assistant on decorative works in the Vatican. After the Sack of Rome (1527) he worked in Naples and Messina. He painted monochrome imitation antique frescoes on Roman house facades and was among the earliest classical landscapists; he was admired by Poussin and Claude.

Polke Sigmar (1941–). German painter and photographer. In the early '60s he collaborated with G. *Richter and Konrad Fischer-Lueg on a project which was a version of U.S. *Pop art, called Kapitalistischer Realismus, that celebrated consumerism, e.g. Plastik-Wannen (1964). In the early '70s he adopted ideas from *Picabia using motifs of mythologized trivia. Subsequently he used a wide variety of styles and materials, including fabrics and *found objects. In the

Polke Liebespaar II 1965

early '80s he produced *psychedelic paintings, e.g. Alice in Wonderland (1983) and later in that decade large canvases filled with menacing images — barbed wire, ovens and cages, e.g. Hochstand (1984) and Lager (1983) which may parody German *Neo-Expressionist painters such as *Kiefer. Colours and their chemical reactions became prominent in subsequent large-format, semi-abstract pictures, e.g. his Althanor Installation at the 1986 Venice Biennale.

Pollaiuolo Antonio (c. 1432–98). Italian painter, sculptor, engraver and goldsmith believed to have been the pupil of Andrea del Castagno; he worked closely with his brother Piero (1443–96). Their work is strongly influenced by antiquity. Early scientist-artists of the Florentine Renaissance, according to Vasari they practised dissection in order to understand the human body. Their undoubted masterpiece is the *Martyrdom of St Sebastian*; this innovates in presenting figures with a clearly defined muscular structure, showing variations of the same movement from every side and many angles. In the engraving *Battle of the Nude Men*, influenced by Mantegna, the action is even more violent

Pollaiuolo Profile of a Woman with a Muslin Headdress

and the display of muscular structure complete. Apollo and Daphne and Hercules and Nessus set their subject in a lyrical landscape closely observed but transcending mere topographical observation. The brothers spent their last years working on the bronze tombs of Sixtus IV and Innocent VIII in Rome. The gesture of the Pope and the arrangement of figures on the

tomb of Innocent was copied on later funeral monuments.

Pollard James (1797–1859). British painter and print maker. His coaching scenes, technically unsophisticated, are valued by collectors.

Pollock Jackson (1912-56). U.S. painter. He studied under *Benton in N.Y. in 1929; he worked for the *W.P.A. Art Project (1938). His early work is characteristic of the U.S. romantic realism of the 1930s and also shows the influence of *Ryder: thickly painted, energetic, Expressionist seascapes and landscapes, small in scale. During this period P. was also attracted to the work of the Mexican muralists *Orozco. *Rivera and *Siqueiros whose large-scale works probably influenced the later enormous P. paintings. By 1936 he was influenced by *Surrealism and by Picasso, Mondrian, Miró and *Masson. He became the central figure of U.S. *Abstract Expressionism. His achievement was an important contribution to the rise of modern U.S. painting and his early death in a road accident (1956) has added a legendary character to his reputation. He contributed to the International Surrealist Exhibition, N.Y. (1942) and became associated with other N.Y. Surrealists. She Wolf (1943) shows the closeness to Masson at this point, but he developed the automatic techniques to a more instinctive, personal form, relying more fully on chance and accident. One thread that runs through P.'s work is his concern with the mythic which can

Pollock Number Twenty-eight 1950

be seen most clearly in his paintings of the 1940s, among others *Pasiphäe*, *Totem* and *Guardians of the Secret*. He painted his 1st 'drip painting' (in which the paint was allowed to fall from the brush or vessel on to a canvas laid on the floor) in 1947 and this led to *Action painting. The form of his very large images was not preconceived and only emerged during the act of execution. ('The painting has a life of its own. I try to let it come through.') His late works – *Blue Poles* (1953) – although violently executed, result in a lacework of coloured and silver lines of extraordinary delicacy.

Polycletus. The greatest Greek sculptor of the 5th c. BC, with *Phidias. His figures (e.g. *Doryphorus*) were described by ancient writers as conforming to an almost unvaried formal pattern; the few surviving copies show that P. introduced a new sense of rhythm into sculptural form.

Polygnotus (fl. 480–450 BC). Greek painter, considered as among the 1st great masters by classical writers; his work marked an advance in figure composition and expressiveness. He was established in Athens c. 463 BC, decorating one of the city gates with scenes from the Trojan War

polyptych (Gr. with many folds). Several painted panels, usually of wood, grouped as a single screen, the outer panels often being hinged so that they can fold upon the centre ones. Altarpieces were frequently in the form of p.s.

Pomodoro Arnaldo (1926–) and his brother Giò (1930-). Italian sculptors and artist jewellers whose semi-abstract work is distinguished by its high craftsmanship. The former's sculptures are monumental, spherical and columnar public works cast in bronze. The latter's works evolved from designs for jewellery and are made of cast bronze, marble, stone and other materials. Their wide references are to formal tensions of forms in space, derived from the human figure, e.g. Uno (1960), stylized primitivist symbolic representations of natural phenomena, e.g. Sole, elogio del 3 (1973) and Sole deposto II (1974-5), and primitive or pre-classical architecture, e.g. Luogo di misure (1977-80) and Hermes ariete e città solare (1984).

Pont-Aven, school of. A group of painters, with *Gauguin as their inspiration and chief figure, who worked in and around the town of Pont-Aven in Brittany. Gauguin first visited

Pontormo The Deposition 1525-8

Pont-Aven in 1886, and began to gather disciples on his 2nd visit in 1888, when he met Bernard.

Pontormo Jacopo da, born J. Carrucci (1494-1556/7). Among the earliest and most influential of the Italian *Mannerist painters, P. was named after his birthplace, a village near Empoli, but was trained in the Florentine school - certainly by Andrea del Sarto, and possibly by Leonardo da Vinci and Piero di Cosimo. In 1521 he made his reputation with his lyrical decorations for the Medici villa, Poggio a Caiano, near Florence. Another cycle of frescoes, scenes from the Passion, was painted in 1523. P.'s angular style of draughtsmanship - showing the influences of Michelangelo and Dürer's engravings, yet highly original in feeling - and his unusual colour sense are probably best seen in his masterpiece, The Deposition, while a fine example of his Mannerist portraiture is Lady with a Lap dog. Rosso Fiorentino was his rival and Bronzino his pupil and follower.

Poons Larry (1937-). U.S. artist. *Pollock's drip paintings and *Newman's *Color-field canvases affected P.'s early works. *Op art

Popova Italian Still-life 1914

works such as *Nixes Mate* (1964) have small ellipses and discs scattered over a coloured field. In 1968 he adopted a painterly idiom, e.g. *Cutting Water* (1970), and tended to return to the gestures of *Abstract Expressionism.

Pop art. Movement originating in the mid-1950s with the *Independent Group who met at the Institute of Contemporary Art, London. Prominent figures were the critic Lawrence Alloway, who coined the term, the architects P. and H. Smithson, the architectural historian Revner Banham, and the artists *Paolozzi and R. *Hamilton. The basic concept was that of mass popular urban culture as the vernacular culture shared by all, irrespective of professional skills. Films, advertising, science fiction, pop music, etc. and U.S. mass-produced consumer goods were taken as the materials of the new art and a new aesthetic of expendability proposed. Similar ideas were being explored in the U.S.A. independently at about the same time. P. a. in all its manifestations was given its greatest impetus in the U.S.A. during the 1960s, where it came as a reaction to *Abstract Expressionism and in fresh response to Dadaist notions. The most important artists in the establishment of U.S. P. a. were *Rauschenberg and *Johns. Other U.S. artists specifically associated with P. a. are *Dine, *Indiana, *Lichtenstein,

*Oldenburg, *Rosenquist, *Warhol and *Wesselmann. Artists working in Britain were P. *Blake, *Boshier, *Hockney, A. *Jones and P. *Phillips.

Popova Liubov (1889–1924). Russian painter, the most distinguished painter among Malevich's *Suprematist followers, after the Revolution also a *Constructivist abandoning painting to work as a textile designer in a factory. She also worked for Meyerhold designing sets and costumes. P. studied in Paris under Metzinger and Le Fauconnier in 1912; on her return to Moscow she began contributing Cubist works such as Seated Figure (1915) to the Knave of Diamonds exhibitions. Her 1st abstract works date from 1916; after 1917 many, entitled Architectonic Compositions, show the influence of Malevich and Tatlin.

Pordenone Giovanni Antonio (1483–1539/76). Italian painter of historical subjects, much influenced by Giorgione. Favoured by the Emperor Charles V, he was a strong, if only temporary, rival of Titian. P. painted frescoes in the cathedral at Cremona and in S. Maria di Campagna at Piacenza.

Porta Joseph (Salviati the Younger) (1520–70). Venetian painter (having followed his master, Francesco Salviati to Venice from Rome). He decorated the facade of the Palazzo Loredano and provided religious works for Venetian churches. Summoned to Rome by Pope Pius IV, he competed (unsuccessfully) with T. *Zuccaro to provide ceiling frescoes for the Papal chamber.

Porter Fairfield (1907–75). U.S. figurative painter, he was virtually ignored until the 1960s. He studied at the Arts Student League, N.Y., with *Benton after taking a degree in art history at Harvard University. He was steeped in the tradition of European painting, especially the Impressionists and Vuillard. A friend of *De Kooning, he was interested in 'the "abstraction" in figurative art'. P. painted landscapes and seascapes (Southampton, Long Island and Great Spruce Head Island, Maine, where he lived, e.g. *The Harbor – Great Spruce Head*, 1968, and *Island Farmhouse*, 1969), portraits (*Elaine de Kooning*, 1957) and interiors (*October Interior*, 1963). He was also a prominent writer on art.

Portinari Candido (1903–62). Brazilian painter; his reputation rests primarily on his large-scale murals. P.'s work, essentially a stylized realism,

is usually drawn from life in the hinterland of Rio de Janeiro.

Post (Poost) Frans (c. 1612–80). Dutch landscape painter who lived in Brazil (1637–44), painting scenes there. On his return he became a member of the Haarlem Guild of Painters (1646), and painted landscapes of the Netherlands. In the Amsterdam Mus. are several Brazilian landscapes, unusual and rare documents of life in South America at that time.

poster. Form of graphic art with antecedents in antiquity, in signboards, handbills, playbills, woodcuts, etc. but assuming its modern form and requirements (simple design, bold colours, etc.) with the invention of colour *lithography. Since *Toulouse-Lautrec's famous p.s, many artists (e.g. Chagall, Matisse, Picasso) have designed and executed them, and some (e.g. *McKnight-Kauffer) have specialized in them. The p. is the only form in which the general public have without difficulty accepted such 20th-c. artistic developments as Expressionism, Cubism and abstraction.

Post-Impressionism. Term coined in Britain by *Fry to describe the artists exhibiting in an exhibition in the Grafton Galleries in 1910; they included Cézanne, Derain, Matisse, Picasso, Rouault, Scurat, Van Gogh. The term does not imply any similarity of style, although it is true that all these artists reacted against the Impressionist preoccupation with visual appearances.

Postmodernism. Term that gained wide currency in the mid-1970s practice of art and was then also applied to developments of the previous decade in architecture and literature, and in art from *Pop to *Conceptual. Postmodernists challenged what was perceived as modernism's narrowness, dogmatic authoritarianism, its socially distanced and formalist aesthetics, the emphasis on originality and authorship, and the view that art inevitably evolved towards purely formal abstraction. *Duchamp, especially in his *readymades, came to be seen as the forefather of P. For P., reality and its representation (in images or words, as in *allegory) overlap and are not clearly defined; it is representations that are experienced as real, a view derived from the French philosopher Jean Buaudrillard's term, 'simulacrum', Distinctions between life and art are rejected and art is returned to life. Artistic originality and autonomy are considered irrelevant since images

and symbols lose their fixed meaning when put in different contexts and are *appropriated and recycled irrespective of subject matter and traditional stylistic conventions. Instead, issues of identity, marginalized by modernism, are paramount, as in art that incorporates feminist, racial, gender, sexual and environmental concerns. Revealing the process by which meaning is constructed is called 'deconstruction' and has affinities with psychoanalysis and Structuralism (as defined by the French anthropologist Claude Lévi-Strauss) but goes beyond and ultimately rejects Post-Structuralism. Deconstruction particularly challenges received ideas about the importance of creative originality and authorship, and has been most forcefully argued by the French philosopher Jacques Derrida, a contemporary of two other influential French philosophers and cultural critics whose ideas are related, Michel Foucault and the Post-Structuralist François Lyotard, as well as the psychoanalyst Jacques Lacan. Among a diverse number of P. groups and artists who emerged in the '70s and '80s are *Beuys, H. *Richter, the *Neo-Expressionists, *Installation, *Pcrformance, *Earth and *Body art, *Arte Povera, *Baldessari, *Levine, *Sherman, *Salle and *Calle.

Post-painterly abstraction. Term coined by the U.S. art critic *Greenberg in 1964 to describe the work of certain U.S. artists such as *Kelly, *Louis, *Noland and Olitski, who were then using large fields of pure colour, unmodulated by brushwork. Such work is also sometimes described as *Color-field painting, in spite of the fact that this term also includes an carlier generation of artists such as *Klein, *Newman and *Reinhardt.

Pot Heindrick Gerritsz (c. 1585–1657). Dutch painter of portraits, genre and historical subjects, and possibly the pupil of Carel van Mander; his work was much influenced by that of F. Hals. He painted members of the royal family (incl. Charles I) while visiting London (1631–3) and was director of the Haarlem Guild of Painters (1626–35).

Potter (I Ielen) Beatrix (1866–1943). Writer and ill. of children's books. P.'s tales, which numbered nearly 40, are notable for their acute observation of animal life and the countryside, even if her landscapes are suffused with a somewhat utopian innocence and happiness. With a subtle blend of fantasy and emotional experience

Potter

P. was able to identify totally with her juvenile readership. A quiet humour obviated sentimentality without caricaturing the creatures that appear in her stories. Publs include *The Tale of Peter Rabbit* (privately printed 1901; 1902), *The Tailor of Gloucester* (1903), *The Tale of Jemima Puddle-Duck* (1908).

Potter Frank Huddlestone (1845–87). British genre and landscape painter. Among his works is *The Music Lesson*.

Potter Paulus (1625–54). Dutch landscape painter noted particularly for his realism, as in showing the famous urinating cow in *The Farm*. He studied under his father Pieter P. and then under Camphuysen and Jacob de Weth of Haarlem, and he worked mainly in Amsterdam and at The Hague.

Pourbus Pieter (1510–84). Flemish painter of portraits (in an austere, naturalistic style) and religious subjects. He worked in Bruges. His son Frans P. the Elder (1545–81) painted many portraits and religious subjects and studied under his father and F. Floris. Frans P.'s son, Frans P. the Younger (1569–1622), was court painter at Mantua and painter to Marie de Médicis in Paris.

Poussin (Dughet) Gaspard (1615–75). French painter, born in Rome where in later life he settled. He was the brother-in-law and pupil of N.P., to whose influence he later added the warmth of Claude Lorraine. He became a leading landscape artist of the classical idiom, using figures and architectural features in carefully balanced settings.

Poussin Nicolas (1594–1665). The most important French painter of the 17th c. He settled in Rome after 1624 having lived in Paris in great poverty, returned in 1640 at the command of the king and Cardinal Richelieu as superintendent of the Academy but in 1642 left again for Rome. He led the life of an artist-philosopher, painting and meditating amongst the Roman ruins and hills. His work became the embodiment of French classicism. Held in great esteem by his contemporaries, when asked about his method, he once remarked in a letter 'I am forced by my nature towards the orderly.'

The greatness of P. lies in his relentless search after perfection, the seeking of solutions to problems of his own making and shunning easy success. His historical 'machines' constructed with great deliberation and after much

Nicolas Poussin Shepherds of Arcady c. 1630

experimentation with models, became the prototypes of the academic history picture. P. absorbed many influences in his work. In composition and the sculpturesque treatment of his figures Mantegna and Raphael were his masters, but even mythological subjects such as the Dresden Flora were seen and treated as part of life, seen with the eyes of modern man. A slow and gradual evolution can be traced in his work. The Massacre of the Innocents is one of the earliest still Baroque compositions of the Roman period. From 1630 onwards his preoccupation with mythological subjects became marked and he became increasingly concerned with the study of nudes, as in the Bacchanals. The discovery of Titian and the study of antique cameos had a decisive influence on these paintings.

From 1638 P. entered a highly creative and inspired phase. The classical influence is paramount and can be seen in the *Bacchanal* and the *Triumph of Pan*. Here the unity of an ideal art and the fullness of life are completely realized. After 1648 biblical subjects became the theme of a series of great history paintings. Landscape gains increasingly in importance and his brush drawings and pen and wash studies of sunsets and the morning in the Campagna are some of his greatest and most lasting achievements. The feeling of stillness of poetry lifts the subject of

Landscape with a Snake into the world of dreams constructed by a philosopher of vision. P.'s influence on most French painters from David to Cézanne has been immense.

Poussinisme. *Rubénisme

Powers Hiram (1805–73). U.S. Neoclassical sculptor. He was praised by *Thorwaldsen and his famous *The Greek Slave* (1843) was cast in numerous copies. His successful portrait busts include one of his friend the sculptor *Greenough.

Poynter Sir Edward (1836–1919). British painter of historical and genre subjects in oil and watercolour. He studied under Gleyre in Paris, exhibited at the R.A. from 1859, became an R.A. in 1876, and succeeded Millais as president in 1896.

Pozzo Fra Andrea (1642–1709). Italian painter, art historian and architect; after becoming a Jesuit he produced much decorative religious work in Genoa which was inspired by Rubens. P.'s accomplished *trompe l'æil effects can be seen in churches in Turin, Arezzo and Modena. He also built Laibach cathedral (1708) and the Univ. church in Vienna. His treatise *Perspectiva Pictorum* (1693–8) was extremely influential throughout Europe.

Prague, school of. Bohemian school of painting which flourished in the 2nd half of the 14th c. at the court of the Emperor Charles IV of Prague. He encouraged artists from Germany, France and Italy to work for him and a Realistic style of painting was developed influenced by both the soft style and the work of Giotto. Chief representatives of the school were Theodoric of Prague and the Masters of Hohenfurth and Wittingau.

Prampolini Enrico (1896–1956). Italian painter, sculptor and architect. He exhibited in Rome in 1918 at a showing of 'independent' art and became a principal painter in the *Futurist movement. Favoured by Mussolini, he held several official positions in connection with the arts.

Prassinos Mario (1916–85). Turkish-born Greek painter and print maker of the French school. Influenced by the Surrealists in the 1930s, he produced hallucinatory paintings after World War II.

Praxiteles. Greek sculptor of the mid-4th c. BC. Copies of his figures of young gods and goddesses survive, notably those of the famous

Praxiteles Hermes mid-4th c. BC

Cnidian Aphrodite (at Munich and in the Vatican). P.'s style has soft contours and supple, almost languorous treatment of the human figure; he was a forerunner of Hellenistic art. He was also an innovator in portraying Aphrodite and other divine figures in the nude.

Praz Mario (1896–1982). Italian writer on English Romantic literature, and a connoisseur of the arts. After studies in Italy and Britain he became Professor of Italian Studies at Manchester Univ., but returned to Italy in 1934 to become Professor of English Language and Literature at the Univ. of Rome, where he was Professor Emeritus from 1966 to his death. The most celebrated of his many books include *The Romantic Agony* (1930) and *The House of Life* (1st It. pub. 1958).

Precisionism. *Cubist- and *Magic Realism

Pre-Columbian art. The term refers to all forms of art (architecture, sculpture, pottery, metalwork, weaving, etc.) of all the successive Indian civilizations of Central America up to the time of the Spanish Conquest at the beginning of the 16th c., which completely destroyed them. Archaeological rediscovery of these cultures began in the 19th c. At the time of the Conquest the main civilizations were the Aztec, centred on the Valley of Mexico, the Maya in the Yucatan Peninsula, and the Inca, who held sway from the Andean Highlands down to the Peruvian coast. But the Aztec and Inca civilizations were late developments in the area compared to the antiquity of the Mayan. The

Predis

Maya were remarkable for their advanced knowledge of astronomy and their invention of a method of recording dates and the names of gods, as well as for their remarkable stone temples built on top of high pyramids. Among the earliest monuments are the enormous pyramid temples of Teotihuacán in Central Mexico. Large stone statues and stelae abound throughout the entire area. Quantities of *cire perdue gold ornaments survive, particularly in Colombia and the Andean Highlands. The range of pottery is vast; among the most famous is that of Michica and Nasca found in Peru. The many examples of weaving are the finest in the world.

Predis (Predo) Ambrogio (1450/60–*c.* 1515). Milanese painter. Most of his datable works come from the years 1494–1502. A portrait of the Emperor Maximilian was painted in 1499. He probably painted the side panels of the altar for S. Francesco, Milan, of which Leonardo's *Madonna of the Rocks*, formed the centrepiece.

Predis Cristoforo di (d. 1486). Milanese miniature painter, and probably the father of Ambrogio de Predis.

Prendergast Maurice Brazil (1859–1924). U.S. painter, the leading pioneer of Post-

Primaticcio Stucco decoration with figures at Fontainebleau (detail) 1541–4

Impressionism in the U.S.A. He was a member of The *Eight and an exhibitor at the *Armory Show. He studied in Paris where he was influenced by Impressionism, from which he developed a semi-abstract style consisting of touches of colour interwoven with decorative tapestry-like effects.

Pre-Raphaelites. A group of 7 young British painters and sculptors, D. G. Rossetti, *Millais, H. *Hunt, T. Woolner, W. M. Rossetti, J. Collinson and F. G. Stephens. They wished to revive in British painting the purity of art before Raphael and hoped to achieve their aim by clarity of colour and line, and simple not grandiose subjects. Their realistic treatment of biblical subjects provoked indignation, but they were defended by *Ruskin. They remained as a group from 1848 to the early 1850s, sometimes signing their work with the initials P.R.B. (Pre-Raphaelite Brotherhood) but despite its short life (their periodical The Germ went to only 4 numbers), the movement affected several succeeding painters, e.g. Ford Madox *Brown.

Preti Mattia (also called 'Il Calabrese') (1613–99). Italian painter and pupil of *Guercino. He gained a reputation as a decorative artist, painting religious scenes in several churches in Rome in 1657, then in the Carthusian chapel in Naples, and also frescoes for the cathedral at Valletta, Malta.

Previtali Andrea (c. 1470–1528). Italian painter and pupil of Giovanni *Bellini, whose style he followed closely. His fine colouring and good landscape compositions led to attribution of his work to Giorgione (including the works *Christ Ascending from Hell* and *The Crossing of the Red Sea*). His chef d'œuvre was the altarpiece at S. Spirito, Bergamo.

Primaticcio Francesco (1504–70). Italian artist from Bologna, often called 'Il Bologna', or, in France, 'Le Primatice'. P. was the leader of the 1st school of *Fontainebleau after the death of *Rosso Fiorentino. He worked on the Palazzo del Tè, Mantua, under Giulio Romano and developed a *Mannerist style influenced above all by Parmigianino. He was invited to Fontainebleau by Francis I in 1532 and assisted Rosso on the decorations of the Galerie François I. His greatest work, executed with Niccolò dell' *Abbate, the decorations of the Galerie d'Ulysse, was destroyed, as were most of his large decorative schemes at Fontainebleau. An exception is the Chambre de la Duchesse

d'Étampes (1541–3). Here the flamboyant decorative style of the 1st school of Fontainebleau is found in its fullest phase. P.'s talent as a draughtsman can be seen in the drawings for the decorations preserved in the Louvre. *Ulysses and Penelope* is a good example of his Mannerist style in painting. P. was also a sculptor and architect, but little of this work remains.

Primitive art. The term refers to the art of 'primitive' peoples, i.e. peoples considered to have a comparatively low standard of technological development by Western standards, and should be distinguished from the art of the *primitives. In the early 20th c., P. a., particularly from Africa and Oceania, began to have a profound influence on Western painting and sculpture (*Cubism, *Picasso) which still continued later (*Lipchitz, *Moore). *Outsider art.

primitives. Name given to certain artists, usually self-taught, whose technique is by academic standards gauche, and whose work is sometimes naïve in approach and vision. Despite these 'shortcomings' the work of such great p.s as 'Le Douanier' *Rousseau has great power and inventiveness.

Prior William Matthew (1806–73). U.S. primitive painter; he was a successful intinerant portraitist.

Procaccini Ercole (the Elder) (1515–95). Italian painter who worked extensively in the churches of Bologna. He moved to Milan and founded an academy of painting which had a high reputation. His son Giulio Cesare P. (c. 1570–1625) was a notable sculptor and decorative painter, and another son, Camillo P. (1546/51–1629), painted frescoes in Milan cathedral and also in other churches in that city.

Process art. Trend of the mid-1960s and 1970s, employing materials of all kinds – grass, felt, fat, yeast, coal, etc. Forms tend to be organic and amorphous and, unlike the stable structures of *Minimal art, often impermanent; the emphasis is on the actual *processes* of making or assembling – stacking, smearing, draping. Graphics include the multiple xeroxing of a blank sheet of paper and its subsequent images – a process which produces a growing density of texture. Whatever the process, once decided it is systematically applied to evolve works. Among the artists associated with P. a. are the Americans R. *Serra, R. *Morris and L. Wiener.

Procktor Patrick (1936–). British figurative painter and highly accomplished watercolourist of charming and unpretentious interiors, landscapes from travels to Egypt, China and Venice, and portraits. His work is lyrical, tender and witty, with deceptive simplicity rendered in light, delicate brush-strokes, especially in his watercolours.

profil perdu (Fr. lost profile). Term used to describe the head when turned so far from the spectator that the profile of the face is lost and only the outline of the cheek is seen.

Proletkult. Soviet administrative body concerned with the arts, founded in 1906 by pre-Revolutionaries and made effective in 1917 with the Bolshevik Revolution. In its early years P. was associated with the experimentalism of Russian *avant-garde* – above all, the attempts to unite art and industry. In 1932, in common with all other artistic bodies, P. was incorporated into the Union of Artists. *Vkhutemas.

Provo(o)st Jan (c. 1465–1529). Flemish painter of religious subjects, pupil of S. Marmion. He worked in Antwerp and Bruges. David and Massys were the chief influences on his style until 1521, when he met Dürer.

Prud'hon Pierre-Paul (1758–1823). French painter and designer. He admired the works of Correggio in Rome (1781–7) and, in the age of

Prud'hon The Empress Josephine 1805

Pryde

David, developed a softly modelled, emotionally Romantic style. His portraits of the Empress Josephine and those of his pupil Mlle Constance Mayer, to whom he was deeply attached, are among his most charming works. He also executed large decorative compositions, e.g. *Crime Pursued by Vengeance and Justice*. In a Neoclassical idiom he designed the furniture and décor for the bridal suite of the Empress Marie-Louise.

Pryde James (1866–1941). Scottish painter, with W. Nicholson responsible for the posters of the 'Beggarstaff Brothers'. He painted romantic architectural compositions enveloped in an aura of mystery and drama with disproportionately small figures and in many cases a large bed as the central feature.

Psychedelic art. Style of art of the mid-1960s associated with the underground sub-culture. In general it aims to represent, primarily through vivid colours in organic shapes, the hallucinatory experiences induced by drugs, or to provide objects of contemplation while under drugs. Besides painting Psychedelic artists produce light-shows and multi-media presentations.

Pueblo culture. North American Indian culture, successor of the ancient Anasazi people; its principal surviving representatives are the Hopi and Zuni peoples in the S.W. of the U.S.A. The name derives from the Spanish pueblo, 'village', and the culture is noted for remarkable multistoreyed townships, excavated from and built into lofty cliff faces, constructed c. AD 1000-1300. Adobe is the principal building material. From an early date P. c. subterranean sanctuaries, kivas, were decorated with wall paintings. Kachinas, spirits of the life forces, played a major part in ritual and were impersonated by male dancers; cottonwood kachina dolls, elaborately costumed like the dancers, were made and are still produced by Hopi craftsmen. Sand-painting is used in religious healing rites, patterns being made on the swept sand with pigments from crushed sandstone, charcoal and pollens.

Puget Pierre (1620–94). French sculptor. His essentially *Baroque style, its vigour and movement, made him unacceptable at court, where more restrained and classical work was admired.

Pugh Clifton (1924—). Australian painter of portraits and of Australian fauna.

Purism. *Ozenfant and C.-E. Jeanneret (*Le Corbusier) launched P. with a book, *Après le*

Cubisme, 1918, P. aimed to take *Cubism to its proper conclusion through clarity and objectivity and by restoring the representational nature of art. The movement, which lasted only 7 years, gained international reputation through the architecture of Le Corbusier.

Puryear Martin (1941–). African-American sculptor highly skilled with wood, who also uses various other materials, e.g. leather, concrete and rope. P.'s work combines geometric forms, craft and carpentry, with allusions to African objects, e.g. Bound Cone (1972), split oak bound by rope, and Bask (1976), the soft curvature of which is achieved without carving the wood. After ring sculptures in the late '70s and early '80s, and wire and mesh works in the mid-80s, P. produced works which suggest living and inanimate matter, e.g. Untitled (1987). Outdoor works include Box and Pole (1977) and Bodark Arc (1982).

Puryear Noblesse O. 1987

putto (It. little boy). The word is usually found in the plural *putti*, plump naked little boys as found in Renaissance and Baroque painting and sculpture.

Puvis de Chavannes Pierre-Cécile (1824–98). French painter who studied in Italy and with *Couture and *Delacroix. He worked on a monumental scale on canvases which were then fixed to the walls, resembling murals. He was bitterly attacked by contemporary critics but was supported by his friends and admirers the poets Baudelaire and Gautier, and many artists. P., though contemporary with the Impressionists, went his own way, basing his style on early Italian frescoes, Poussin, Ingres and Chassériau. He gave new vigour to 19th-c. mural painting and his flat, decorative style was decisive for the development of Gauguin and the *Nabis.

Pynacker Adam (1622–73). Dutch landscape painter; a fashionable exponent in Delft of lighthearted landscapes of Italian scenes; he studied in Italy.

Pynas Jan (1583/4–1631). Dutch painter of biblical and historical subjects. He travelled in Italy after 1605. Among his works are *The Raising of Lazarus* and *The Entombment*.

Q

Quarton or Charonton, Enguerrand (c. 1410–c. 1461). French painter, born at Laon in the north, but working at Avignon from 1447 to 1461. 2 paintings are documented:

Puvis de Chavannes Ste Geneviève Watching over Paris 1898

Virgin of Mercy and the large-scale altarpiece Coronation of the Virgin. The imaginative conception and detail of the latter show evidence of great talent.

Queen Mary's Psalter (c. 1330; B.M., London). Masterpiece of the East Anglian school of illumination; it was presented to Queen Mary in 1553. It contains 200 exquisite tinted drawings of scenes from Old Testament history, a calendar showing the signs of the zodiac and the monthly occupations, and a series of tinted marginal drawings of sports, pastimes and animal lore.

Queen Mary's Psalter St Edmund (detail) 1553

Quercia

Quercia Jacopo della (c. 1374-1438). Sienese sculptor, one of the most notable early 15thc. Italian sculptors; his work uniquely combines classical and non-classical elements. He entered the competition for the 1st bronze doors for the Florence Baptistery (won by Ghiberti) but his entry has not survived. Other early works include the tomb of Ilaria del Carretto, Lucca cathedral (c. 1406) and the Fonte Gaia, Palazzo Pubblico, Siena. He worked with Ghiberti and Donatello on reliefs for Siena Baptistery (1417-31) and from 1425 executed reliefs which ill. scenes from Genesis for the doorway of S. Petronio, Bologna and figures in the lunette. He had a strong feeling for linear design and his style evidences familiarity with N. Italian sculpture.

Quidor John (1801–81). U.S. painter of portraits and humorous scenes from the books *A History of New York* and *The Sketch-book of Geoffrey Crayon, Gent.* by Washington Irving.

R

Rackham Arthur (1867–1939). British water-colourist and imaginative book ill., especially of children's stories: those for the magazine *Little Folks* (1896–1905) being among the best of R.'s work, combining spontaneity and innocence with a feeling for humour and fantasy. But it was *Rip van Winkle* (1905) that made his reputation. Subsequent titles included *Undine* (1909), Wagner's *Ring* (1900–11), *The Tempest* (1926) and Poe's *Tales of Mystery and Imagination* (1935).

Rajasthani miniature The Churning of the Milky Ocean late 17th c.

Raeburn Sir Henry (1756–1823). Scottish portrait painter. At first a miniaturist, he turned to oil portraits about 1776. A good marriage (1778) made him financially independent. R. visited Sir Joshua Reynolds in London (1785), then went to Italy, returning to Edinburgh in 1787. He exhibited at the R.A. (London) from 1792 and became an Academician in 1815. R. was particularly successful in obtaining patrons and produced about 1000 portraits.

Raetz Markus (1941–). Swiss artist whose sculptures, drawings, paintings and constructions explore visual perception and illusion. His optical conundrums, inversions and palindromes are playful and poetic, e.g. *Heads* (1982) and *Metamorphosis II* (1991–2), with frequent references to artists such as *Holbein, Escher, *Matisse, *Arp, *Magritte, but also to contemporary *Minimalist sculpture, e.g. *Andre and R. *Morris.

Raffaellino del Garbo (d. *c.* 1527). Florentine painter, probably the pupil of Filippino Lippi.

Raffet Auguste (1804–60). French graphic artist, pupil of Gros and Charlet, famous for his Romanticized presentation of the Napoleonic era. He was among the earliest illustrators to make extensive use of lithography.

ragamala. In 16th–18th–c. Indian art, miniature 'music' paintings which interpret the poetic symbolism of the musical modes (i.e. *raga*). Notable examples were by *Rajasthani, Rajput and *Deccani artists.

Raimondi Marcantonio (c. 1480–after 1527). Italian engraver, the first to specialize in the reproduction of original paintings, etc. After studying under F. Francia at Bologna he went to Venice where he copied Dürer's engravings. In 1510 he moved to Rome and made engravings of works by Raphael. It is for these that he is remembered.

Rainer Arnulf (1929—). Austrian artist best known for his expressive photographic self-portraits which are overpainted and overdrawn with strong colours, or with black lines, to accentuate and transform his own image in what he calls 'a mixture of performing and visual art'.

Rajasthani miniature painting. Art of mid-16th—early 19th-c. *Rajput courts in Rajasthan, N.W. India; notably Mewar, Bundi, Kotah, Kishangar and Jaipur. Vivid, diverse styles evolved but *Mughal miniature painting was

Rajput miniature Sitaldās Giving a visual representation of Devagāndhairāgini 18th c.

influential from the 1600s, especially in Jaipur and Bundi. R. painters ill. religious works, e.g. the Gita Govinda pastoral of Krishna and Radha, most beautiful of the *gopis* (herdswomen), produced 'music' paintings (*ragamala) and secular works, e.g. hunting scenes.

Rajput miniature painting. Art of late 16th–18th-c. N.W. Indian Rajput courts; the 2 main traditions are *Pahari and *Rajasthani. The Rajputs, Hindu warrior princes, yielded to the Mughal empire only in the 1610s. R. m. p. combined Hindu symbolic imagery with *Mughal realism.

Ramos Mel (1935—). U.S. *Pop artist. In the early 1960s, comic book characters provided his images; subsequently he did paintings of pin-up girls of increasing eroticism.

Ramsay Allan (1713–84). Scottish portrait painter. After studying in Italy he settled in London and became painter to George III. His most notable portraits are of women; in them he could give free expression to the grace and delicacy characteristic of his style, e.g. his painting of his 2nd wife, Margaret. An important male

portrait is that of the philosopher Rousseau. In the 1760s he delegated most of his work to assistants and joined the literary group round Dr Samuel Johnson.

Raphael (1483–1520). Raffaello Sanzio, Italian painter with Michelangelo and Leonardo da Vinci one of the three masters of the High Renaissance, Born at Urbino, already a flourishing centre of the arts, and the son of a painter, R. was brought into contact with the highest artistic achievements from childhood. He was trained by Perugino, who was then at the height of his own career. R.'s precocious talent was recognized long before he was 20 and his early Vision of a Knight shows an astonishing maturity. R. was astute enough to realize that the art of Leonardo and Michelangelo was transforming the whole conception of painting and in 1504 he went to Florence to study it. Betrothal of the Virgin (1504) shows the transition between the teaching of Perugino and the assertion of the new influences. R.'s colour and the emotional qualities of his work always remained within the tradition of Central Italian painting, while his sense of composition and the dynamic power of his draughtsmanship were learned from the Florentines. Early portraits too, show how much he owed to Leonardo's Mona Lisa, e.g. Maddalena

Raphael St Catherine of Alexandria c. 1507

Rauch

Doni. In his Madonnas, e.g. La Bella Iardinière (c. 1520), the influence of Fra Bartolommeo is combined with that of Leonardo's drawings of St Anne with the Madonna and Child, e.g. Madonna with the Goldfinch and Madonna del Granduca. By 1508 R. was receiving offers from both the French court and the Pope; late in that year he went to Rome to take part in the grandiose decorative schemes of Pope Julius II for the new Papal apartments in the Vatican, R.'s response to the enormous artistic challenge his part of the scheme presented is also one of those astonishing 'leaps forward' in art history and is matched, perhaps, only by Masaccio's painting of the frescoes in the Carmine church, Florence, 100 years earlier, and the exactly contemporary (1508-12) frescoes of Michelangelo in the Sistine Chapel. When he found himself the peer and rival of Michelangelo R. was 26. Considered for their composition alone, The School of Athens, Parnassus and Disputà (Disputation concerning the Holy Sacrament) are probably supreme in art. They were immediately studied by every artist in Rome and remained an 'art school in themselves'. At the same time R. was painting portraits such as the celebrated Young Cardinal. The next 8 years were, indeed, a record of astonishing achievement: R. and his assistants continued the Vatican frescoes - in the Stanza d'Eliodoro there is a richer use of colour, esp. in The Mass of Bolsena; while in the Stanza dell' Incendio del Borgo the almost forced dramatic quality shows his study of the Michelangelo frescoes. In 1514 R. was preferred to Michelangelo by the new Pope, Leo X, as successor to Bramante, architect-in-charge of St Peter's. In 1518 he was to be made, with A. da Sangallo, 'Superintendent of the Streets of Rome', which made him responsible for town planning as well as for the day-to-day upkeep of the entire city. Before this, he had decorated the Farnesina Villa (1514). The famous Galatea is, with Botticelli's Venus and Primavera, the supreme Renaissance evocation of the classical 'Golden Age'; it is also unmatched in its interpretation of spontaneous and graceful female action. The classical themes remind one too, that R. was also responsible for the Papal colls of antiquities. In 1515-16, R. drew the cartoons for the tapestries which, woven in Flanders, were hung in the Sistine Chapel. 7 of the cartoons are preserved. Yet he also found time to paint altarpieces, e.g. The Sistine Madonna and The Transfiguration, a painting left unfinished when he died of fever. It was completed by *Giulio Romano, one of

the founders of the Mannerist school which borrowed so much from R.

Rauch Christian (1777–1857). German sculptor of monumental works and portrait busts. In Rome (1804–11) he was strongly influenced by *Thorwaldsen. His chief works include the tomb of Louise, Queen of Prussia, at Charlottenburg and the equestrian monument to Frederick the Great in Berlin.

Rauschenberg Robert (1925-). U.S. painter. He studied, in 1948 and subsequently, at Black Mountain College, N.C. (with *Albers), then at Art Students League. After travelling in Italy. Casablanca, Morocco and Paris, he then settled. in 1952, in N.Y. Since 1955 he has designed sets and costumes for the Merce Cunningham Dance Company. Influenced by the Dadaists. Surrealists, and by De Kooning, R., inspired by the composer John Cage and in association with *Johns, but independently, helped revolutionize post-*Abstract Expressionist U.S. art. He often used 'combines' - part painting, part collage, part *readymades, as in Rebus (1955), Monogram (1959) and Trophy II (1960-1). R. also used *silk-screen and photographic processes, and executed a series of drawings for Dante's Inferno. Awarded 1st prize at Venice Biennale 1964.

Rauschenberg Retroactive I 1964

Ravilious Eric (1903–42). British artist who devoted himself chiefly to wood-engraving (ills for *The Natural History of Selbome* by Gilbert White). He studied at the Design School of the R.C.A. (1919–22) under *Nash and met *Bawden. He initiated a collaboration with Bawden on a mural decoration at Morley Coll., London (1928) which continued for the next 7 years. R.'s output was prolific as a watercolourist (*Train Landscape*, 1940) and print maker, and in 1936 he was commissioned by Wedgwood to execute designs for pottery and china.

Rayonism. Art movement founded in 1911/12 by the Russian painter *Larionov, in association with his wife *Goncharova. According to Larionov, the 'subject' of Rayonist paintings should be beams of colour, parallel or crossing at an angle. Rayonist paintings are therefore quasiabstract and have links with Italian *Futurism and with experiments made by *Delaunay in their emphasis on apparent movement and lines of force.

Rayski Ferdinand von (1806–90). German painter. Under the influence of the French Romantics, late *Gros, *Delacroix and *Géricault, he painted military subjects and sketches on the theme of the murder of Thomas à Becket, with an extraordinary freedom and vigour, contrasting favourably with his other work, chiefly portraiture. His late paintings show the influence of Courbet. He gave up painting in the 1870s.

Read Sir Herbert (1893–1968). British author. A poet in the romantic tradition, he also wrote fiction (the 'romance' *The Green Child*, 1947) and autobiography (coll. as *The Contrary Experiences*); but he is most widely known as an influential critic, historian and philosopher of art (*The Meaning of Art*, 1931; *Art Now*, 1933; *Education Through Art*, 1943; histories of modern painting, 1959, and sculpture, 1964), and particularly of modern art.

readymade. In 20th–c. art, an everyday, usually mass-produced object, selected by an artist with a creative or thought-provoking purpose. *Duchamp distinguished r.s from *found objects as being concerned neither with taste nor aesthetics, the artist's mere act of selection defining them as 'art'. Later artists (*Pop art) have used r.s as elements in their works.

Realism. Term often used in a general sense, meaning fidelity to life (as opposed to idealization, caricature, etc.), but more usefully

confined to the 19th-c. movement in painting and literature. This was a reaction against the subjectivity and suggestiveness of Romanticism, insisting on the portrayal of ordinary contemporary life and current manners and problems, and in fact (as part of its anti-Romanticism) tending to emphasize the baser human motives and more squalid activities. In literature the novel became the predominant form: Balzac, Stendhal and Dickens contain realistic elements, but Flaubert and Tolstoy are considered the great masters of R. *Naturalism was an extension of the principles of R. Courbet was the 1st major Realist painter. *Impressionism may be regarded as an off-shoot of R., and a 20th-c. version was *Social Realism.

red figure style. Style of Greek vase painting where the figures are painted in red on a black ground; supposedly invented by the Andokides painter (fl. 530–520 BC), it continued until the mid-4th c, BC.

Redon Odilon (1840–1916). French painter, draughtsman, graphic artist and writer. Until about 1878 he painted landscapes in oil and pastel under the influence of Courbet and Corot; later he turned to charcoal drawing and lithography. R. was concerned with the realities of the imagination, in opposition to the visual emphasis of Impressionism. His middle

Redon Portrait 1904

Refusés

period, lasting till the turn of the c., was an expression of mysticism and the Symbolism of his friends Huysmans and Mallarmé; then he became associated with the *Nabis.

Refusés. *Salon des Refusés

Regnault Henri (1843–71). French painter best known for *Automédon and the Horses of Achilles* (1868). His violent, Romantic treatment of this subject clearly shows the influence of Delacroix. He was killed in the Franco-Prussian War before he produced any mature work.

Regnault Jean-Baptiste (1754–1829). French Neoclassical painter. He followed only the superficial features of Neoclassicism, e.g. *The Three Graces* (1799).

Rego Paula (1935–). Portuguese-born painter, ill. and print maker, who has been living in Britain since 1976. R. has said that her childhood play-room, a rich education in traditional folk and fairy-tales, and an early interest in illustrative art (e.g. *Tenniel's Alice in Wonderland and Beatrix Potter) have been her greatest influences, but it could be said that her work is similar in temperament to that of *Goya and *Balthus. She made collages in the '60s and '70s, e.g. Stray Dogs (The Dogs of Barcelona) and Regicide (both 1965), but devoted herself to

Rego The Cadet and his Sister 1988

painting and making prints from the '80s, with Red Monkey Beats His Wife and Wife Cuts Off Red Monkey's Tail (both 1981). In her narrative work, R. explores power, sexuality and the subversion of social codes; she has said that her work 'is to do with half things. To do with cheating, lying, the half-sins, the mediocre ones.' The Girl and Dog series (1986) shows a young girl with ambivalent power to both nurture and destroy a creature at her mercy, while The Cadet and his Sister (1988) and The Policeman's Daughter (1987) both present relationships between gender stereotypes.

Reinhardt Ad (1913–67). U.S. abstract painter, art critic, theoretician and teacher, and one of the pioneers of U.S. abstraction. He joined the *American Abstract Artists (1930s) and was later associated with *Abstract Expressionism. His style moved from powerful colour and bold, *Hard-edged forms of the late 1930s to 'all black' paintings from the 1950s. R.'s 'ultimate' paintings, e.g. Abstract Painting (1960–2), large canvases trisected into 3 barely distinguishable zones of black, foreshadowed *Minimal art.

relief. Sculpture executed on a surface so that the figures project but are not freestanding; the projection may be considerable (high relief) or slight (low relief or bas-relief).

Rembrandt (Harmensz van Rijn) (1606-69). Dutch painter and etcher, born in Leyden. Until 1631 he worked there and in The Hague and thereafter in Amsterdam. Son of a Calvinist miller and a baker's daughter from a Catholic family. He received a classical education at the Leyden Latin School, which he left shortly before finishing the 6-year course. R.'s 1st 2 masters both worked in Italy - firstly, Jacob Isaacsz van Swanenburgh, the black sheep of a Leyden clan of artists and civil servants and secondly, the Amsterdam Catholic *Lastman. Due to his background and training, R. began his career with a certain degree of learning, considerable familiarity with early 17th-c. developments in Italian art and a multi-sectarian perspective in a society where religious affiliation was extremely important.

R.'s earliest major recognition came from Constantijn Huygens, the secretary to the Prince of Orange, dilettante musician and medallist, and an important poet and correspondent in the Republic of Letters. Huygens saw R. as the Dutch answer to Rubens – a local artist capable of raising the reputation of Dutch

painting to the highest level. He declared the young R. to be superior even to the ancient Greeks with his ability to integrate accurate observations of emotion into themes of universal applicability. Thanks to Huygens, R. and his Leyden colleague *Lievensz achieved fame when they were still in their early twenties.

R. risked – and in the event lost – his connection at court in order to pursue a commercial career in Amsterdam. There he became the partner of the Mennonite art dealer Hendrick Uylenburgh, whose studio earned money from art through various activities. R. became the artistic director of this workshop, which supplied the 'upper' end of the portrait market. R. himself set a new standard for Amsterdam portraiture with his *Anatomy Lesson of Dr Nicolaes Tulp* (1632). The bond with Uylenburgh was consolidated when R. married his niece Saskia (a Frisian Calvinist).

Between 1632 and 1636, R. attracted numerous lucrative portrait commissions. From 1636 to 1642, after leaving Uylenburgh's studio to set up on his own, he worked at a slower pace on more ambitious compositions, such as the Danaë in St Petersburg. He moved beyond the emulation of Rubens to vie with Titian. Leonardo and Michelangelo. In 1639 he bought a luxurious house near Uylenburgh. This stage of his career culminated in 1642 with the Civic Guard Company of Frans Banning Cocq, known as The Night Watch. Saskia died this year after giving birth to their 4th child, Titus, the only one to survive infancy. Saskia left her entire fortune to Titus. Subsequently, R.'s affairs grew increasingly desperate until his bankruptcy in 1656. In 1649 his mistress, Geertge Direx, sued him for breach of promise and he had her put away in a detention house for 12 years. R. took a new mistress, the docile Hendrickje Stoffels, who became his common-law wife. The liaison led to her expulsion from the Calvinist church.

R. also experienced problems in his career. From 1642 to 1652, despite his great renown, he received no significant portrait commissions. This may have been connected with an incident in 1642. R. had painted a portrait for the very powerful Amsterdam patrician Andries de Graeff, brother-in-law of Frans Banning Cocq. De Graeff refused to accept delivery, so R. sued him, winning the case and forcing the patron to pay. This Pyrrhic victory probably cost R. the patronage that would otherwise have accrued to him in the post-*Night Watch* period. He was then forced to rely on money earned from

Rembrandt Woman Bathing (detail) 1655

teaching and from selling his own finished work. His position of financial insecurity is reflected in the subject matter of his paintings. Rather than the large-scale histories and grand mythological subjects of the 1630s, he now painted sentimental cabinet pictures of familiar biblical and household themes. The Dutch economy faltered with the outbreak of the First English War in 1651 and in 1656 R. was forced to apply for voluntary bankruptcy. He moved to a depressed quarter of Amsterdam.

R.'s artistic development in the 1650s was stimulated by a new and interesting patron, the Amsterdam rentier Jan Six, son-in-law of Nicolaes Tulp. R.'s painting of the patrician (still owned by his family) is 1 of the most outstanding achievements of European portraiture. Six, who was an amateur playwright, asked R. to produce an etching for the printed edition of his play Medea alongside other conspicuous marks of favour. As with Huygens and Uylenburgh R. lost the support of Six. Those who knew R. and wrote about him considered him tactless, arrogant and temperamental. This is borne out

Remington

by the documents, which also suggest that he was querulous and unreliable.

In the final years of his life, living modestly, R. suffered the loss 1st of Hendrickje and then of Titus. He spent his time with people considered by some to be socially inferior, e.g. the melancholy shopkeeper-poet Jeremias de Decker and other members of a circle of pietistic Calvinists. Some of R.'s work, especially the biblical etchings and paintings, seems to reflect this association. De Decker's Good Friday is reflected in the monumental etchings Ecce Homo and Three Crosses, which R. issued in successive states proceeding from an open and transparent mode to one of mysterious obscurity. The common belief that attributes to the young R. a 'Baroque' outgoingness and to the late R. an acquired innerness cannot therefore be dismissed out of hand.

R. was the 1st artist to practice self-portraiture as a speciality. In so doing, he created a medium for self-fashioning that has since inspired many artists. It is hard to perform artistic introspection without thinking of R.

If R.'s biography and his self-portraits confront us with unfathomable problems concerning the relationship between art and life, his œuvre leaves us with intractable questions of attribution. The connoisseurship of R.'s etchings was never very embattled and seems to have reached a stable condition unlike the situation regarding his drawings and paintings. R. often entered extremely intimate artistic relationships. His borrowings, lendings and partnerships were never clear-cut transactions. As a result, his work has been confused from the start with that of Lievensz, the workshop assistants in the Uylenburgh studio and some of his own later pupils. With the tempting imitability of his manner, especially the brown studies in suggestive *chiaroscuro and the legendarily economical pen sketches there are the makings of an œuvre with intrinsically indefinable boundaries. The connoisseurship of R.'s paintings and drawings has been in a permanent quandary since the 17th c., allowing wishful thinking, ignorance and unscrupulousness. A committee of Dutch art historians known as the Rembrandt Research Project, founded in 1968, took it upon itself to distinguish between authentic R. paintings and all others. In 3 vols of the Corpus of Rembrandt Paintings covering the period until 1642, the Project has pronounced categorical judgment on 95% of the paintings concerned. The results have met (as some R. specialists had predicted

they would) with less acceptance than the Project anticipated, and in 1993 it announced that in the remaining 2 vols it would give more scope to the doubts, uncertainties and complexities attendant upon its enterprise.

R. has always been considered an artist of great importance, but for what has, however, often been moot. There is his position within the tradition of high art through the nature and many-sidedness of his subject matter, his technical proficiency, the name he earned as a master observer of man and his moods, his emulation of *Rubens and the great Italians. But, he also had qualities that were long disdained by classicists his irreverent flouting of decorum, his stated preference for 'nature' above artistic tradition, his excessive use of *chiaroscuro* and his personal shortcomings. What classicists saw as faults became sterling recommendations to 19th-c. Romantics. His dedication to nature was in their eyes similar to that of Realism and they saw his social maladroitness as laudable dissension from the bourgeois norm. In the same period, Dutch nationalists adopted R. as a hero while denying that he was the rebel or misfit his Romantic admirers held him to be. The scholarly study of R. and his popular reception has been caught since 1850 in the meshes of this knot. Perhaps for the past century and a half R. has had the best of both critical worlds. This has given him enough credit to cover a multitude of sins, even those of remote imitators, and to frustrate the best efforts of conscientious biographers and cataloguers.

Remington Frederick (1861–1909). U.S. artist. His ills for Longfellow's *Hiawatha* and popular paintings (e.g. *Evening on a Canadian Lake*, 1905) and statuettes of cowboys and Indians represent a vigorous record of life in the Old West where he travelled extensively.

Renaissance. The cultural and artistic revolution which originated in the N. Italian city-states of the 14th c. It manifested a new confidence in the power and dignity of man and was inspired by an increasingly intensive study of the artists and thinkers of classical antiquity. The growing importance of the secular order in European culture was reflected in the very large part played by lay aristocratic patronage in the R.; nobles such as Lorenzo de' *Medici were, moreover, themselves artistically gifted. Nevertheless, the Church continued as a great patron and the sponsorship of such great artists as Michelangelo by Popes Alexander VI, Julius

II and Leo X not only changed the face of Rome but also the development of European art. As well as changes in the pattern of patronage, the R. brought a radical change in the position of the artist: hitherto regarded as a skilled, if respected, craftsman, he began to be admired, sometimes with awe, as a superior kind of man, an inspired creator. Besides admiring great artistic inspiration, R. society also held the ideal of 'universal' or 'many-sided' man - skilled in every art, well read in the classics and an able scientist, engineer, courtier, soldier, etc. The work of the greater and lesser humanist scholars of the R. changed the character of European literary culture. The scholar-writer, the humanist Petrarch being perhaps the first, prided himself on knowledge of the classics rather than the metaphysical edifices of St Thomas Aquinas and the schoolmen. Good Latin and Greek grammars and pedagogical imitative prose laid the essential foundations of an elegant and formed style, Cicero being the admired model. The work of men such as Erasmus provided critical eds of classical texts and the Bible, and the rediscovery of much of Plato's work gave a new impulse to thought. The revolutionary invention of printing was welcomed by the most enlightened humanists who collaborated, as literary advisers, with such printers as Froben and Amerbach in producing scholarly texts; the printer's art too, in the work of such men, achieved standards of beauty not surpassed since. In the arts of painting and sculpture such masters as *Giotto, *Masaccio, *Donatello, *Sluter, *Leonardo da Vinci and *Michelangelo originated and perfected a new visual language in which, as in classical art, the human figure and countenance became the most important vehicle of the artist's intention. Growing attention to anatomy and the formulation of the laws of perspective produced figures expressive in movement and gesture and with a bodily weighty 'presence', moving in a well-modulated and coherent picture space or standing freely and confidently in actual space.

Reni Guido (1575–1642). Bolognese painter, pupil of *Carracci. A refined colourist and sensitive draughtsman, he perfected an eclectic classicism. His melodramatic images of such diverse subjects as Christ, Lucretia and Cleopatra were much sought after, and he became the idol of the fashionable circles of Rome and Bologna. The Massacre of the Innocents at Bologna is his most dramatic and celebrated work. The

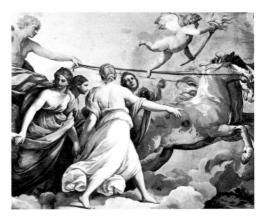

Reni Aurora (detail) 1610

composition, of great dramatic power, owes much to Raphael and the study of the antique. *Aurora*, a fresco painted for the Casino Rospigliosi in Rome in 1613, is perhaps his best-known work. Other work includes *St John the Baptist Preaching*.

Renoir (Pierre) Auguste (1841–1919). French painter born in Limoges, moved to Paris in 1845. He trained and worked with great facility as a porcelain painter (1856–9). With his earnings he entered the École des Beaux-Arts (1862–4) and became a pupil of Gleyre with Monet, Bazille

Renoir La loge 1874

and Sisley. Working with them in Paris and during summers at Fontainebleau, he emerged as one of the most naturally gifted of the future Impressionists. He exhibited in 4 of the 8 Impressionist exhibitions. *Impressionism.

The character of Impressionism emerged from the paintings of Monet and R. between 1867 and 1870. Mutually inspired, they painted directly from the subject (poppyfields, figures under trees, riverscapes) and to retain the momentariness of nature's changing appearance developed a technique of broadly painted broken brush-strokes. The living immediacy of their landscapes was further emphasized by their empirical use of complementary colour in shadows, clear scintillating colour in Monet, more sensitive subtle relationships in R., e.g. Lise (1867). The difference between them is evident in their paintings of La Grenouillère painted side by side in 1869, Monet's in aggressive clean strokes of fresh blue and ochre, R.'s in soft feathery areas of muted green, pink and violet. The climax of R.'s important contribution to Impressionism is in, e.g. The Swing and Moulin de la Galette (both 1876) in which gay Paris life flickers under a patchwork of mottled light.

Right through his career, R.'s work never reveals the introspective seriousness of Monet or Cézanne (he shocked Gleyre by saying 'if painting were not a pleasure to me I should certainly not do it') and unlike Courbet, Pissarro or Zola (of whom R. said 'he thinks he has

Repin They Did Not Expect Him 1884

portrayed the people by saying that they stink') never dwelt on any but the pleasing aspects of life. His lack of intellectual seriousness led to a disturbing fluctuation in his early work from the pure Impressionism (1869–76), to Salonconscious academicism, e.g. *Diana* (1867) and a literary anecdotal element present in *La loge* (1874). The constants in his work are his superb touch and his unfailing colour sense.

In the late 1870s he scored a great Salon success with works like the sweet and charming *Mme Charpentier and Daughters* (1878), but with the end of his Impressionist phase he felt uncertain. Such paintings as *Dance at Bougival* (1883) and *Les Parapluies* (c. 1883) show him attempting to organize his forms with a more sculptural strength. The major work of this 'manière aigre' was the *Grandes Baigneuses* (1884–7): the figures very tightly drawn and modelled against the softness of the landscape. The classical character of this period reflects his visit to Italy in 1881 and his current admiration for Raphael, Ingres and French Renaissance sculpture.

His later works are at once more freely painted and strongly coloured (oppressively hot reds and oranges), but retain this sense of monumentality, e.g. *Seated Bather* (1914). The transition to sculpture in his last years was almost predictable. The bronze *Venus Victrix* (1914) is a typical example.

Repin Ilya (1844–1930). Russian painter, the best known and probably the most brilliant of the *Wanderers group. His work is considered a model for the *Socialist Realist school in Russia. *The Volga Boatmen* (1870–3), one of his most famous works, is typical in having the poorest and most miserable Russian peasants as subject. Apart from social themes, R. was a talented portraitist and landscape painter.

replica. An exact copy of a painting either by the painter of the original or under his direction. The word is frequently used to describe identical works when it is not known which was produced first.

reproduction. Copy of a painting or drawing made by some means which renders it capable of being printed in large numbers for the purpose of popularization. From the 17th to the late 19th c. engraving was the means of r., mezzotint being the most widely used technique; this has been superseded by photographic processes.

Rethel Alfred (1816–59). German painter and graphic artist chiefly remembered for his

powerful series of woodcuts (1848) on the *Dance* of *Death* theme in the manner of Dürer and Holbein the Younger. Idealized historical paintings formed the major part of his work, e.g. frescoes illustrating the life of Charlemagne, in the town hall, Aachen.

Reymerswaele Marinus van. *Marinus van Reymerswaele

Reynolds Sir Joshua (1723–92). British painter of portraits and genre allegorical subjects, founder-member and 1st president of the R.A. (1768). R. studied with Thomas Hudson, and, under Admiral Keppel's patronage, visited Europe (1749-52). His portrait of Keppel (1753-4) led to many other portrait commissions, great wealth and influence, and he painted portraits of George III and Queen Charlotte (1779). R. himself became an art collector and also founded the R.A. schools. Friendly with and accepted in aristocratic circles, he was also friendly with Dr Johnson, Sheridan and theatrical and literary circles in London. R. also painted somewhat sentimental pictures of children, and, especially in his later years, mythological and allegorical paintings. Among his works are: Mrs Siddons as the Tragic Muse, The Infant Samuel and The Age of Innocence. R.'s views on art and paintings were publ. as Discourses Delivered to the Students of the Royal Academy by Sir Joshua Reynolds.

Ribalta Francisco (1565–1628). One of the 1st Spanish painters to use *tenebrist effects in scenes of intense religious fervour. He was trained in Madrid, probably under Navarrete, then settled in Valencia. His paintings include *The Vision of Father Simon* (1612) and *The Vision of St Francis* (c. 1620). His son Juan (c. 1596–1628) was his pupil and collaborator.

Ribemont-Dessaignes Georges (1884–1972). French painter and writer, member of the Paris *Dada group.

Ribera José (Jusepe) de (c. 1590–1652). Spanish painter and etcher. In 1616 he settled in Italy; his life was full of dramatic incidents and this is reflected in the violent subject matter of his paintings, the contrasted modelling of his figures and the theatrical lighting of his compositions. He was strongly influenced by Caravaggio and Correggio and his own powerful style we associate today with the Spanish Baroque. His uncompromising realism is demonstrated in the Boy with a Club Foot. In his last paintings he

Reynolds Self-portrait Aged about 25 c. 1748

achieved a mastery of light similar to Velazquez's.

Ricci Marco (1676–1729). Venetian landscape painter, nephew and collaborator of Sebastiano R. He was often employed to paint landscape backgrounds in his uncle's religious works. He was the originator of romantic landscape painting in 18th-c. Venice and N. Italy. R. also produced remarkable etchings.

Ribera St Peter Repentant 1628

Ricci

Ricci Sebastiano (1659–1734). Venetian painter active in Vienna, Paris and London. He painted the *Resurrection* in Chelsea Hospital chapel and left decorations in Burlington House unfinished. He was chiefly influenced by Veronese but had a looser lighter style which in turn influenced G. B. Tiepolo.

Riccio, Il Andrea Briosco called (1470–1532). Paduan sculptor influenced by Donatello's work; most of his sculpture is in bronze. A heavily ornamented Paschal candlestick for the Santo, Padua, is his most celebrated achievement. His many statuettes include *Warrior on Horseback*.

Richards Ceri (1903–71). Welsh painter trained at Swansea and the R.C.A., London. In the early 1930s, influenced by Picasso and Ernst, he was one of the 1st British artists to experiment with relief and collage constructions. After a Surrealist phase he turned to informal abstraction of ebullient lyricism. Music is the inspiration for some of his finest work, e.g. the important *La Cathédrale engloutie* series of paintings and constructions based on Debussy. He also used themes from Dylan Thomas's poems.

Richardson Jonathan (1665–1745). British portrait painter and writer, pupil of J. Riley. Though he succeeded Kneller as leading portraitist in Britain his writings are of more interest than his stereotyped paintings. He publ. essays on the theory of painting, art criticism and connoisseurship and with his son Jonathan (1694–1771) produced the 1st English guidebook to the art treasures of Italy, An Account of Some of the Statues and Bas-Reliefs, Drawings and Pictures in Italy (1722).

Richter Adrian Ludwig (1803–84). German book ill. and landscape painter, a representative of late Romanticism. He was a prolific ill. of German folk-tales and fairy-tales. His autobiography *Lebenserinnerungen eines deutschen Malers* (1885) was popular.

Richter Gerhard (1932–). German *Postmodern painter who works in a wide variety of styles. In the early 1960s, influenced by U.S. *Pop and *Fluxus, he produced black-andwhite 'photo-paintings' from ominous-looking *found photographs of World War II images in newspapers and magazines. He transferred them on to canvas and then blurred them with the use of a dry brush. The charged images were flattened and made deadpan and neutral, e.g. Act

Gerhard Richter Faltbarer Trockner 1962

Lehrnschwestern (1966). Soon after R.'s work rapidly diversified. His Farbtafeln ('Colour Charts') series (1966-74) consisted of over 4,000 canvases of flat colour samples. His Stadtbilder ('Townscapes') series (1968-73) is based on aerial photographs of cities, on which he made expressionistic brush-strokes that transform the original photographs into abstract colour patterns. In his series of 'Gray Paintings' (1967-74) and 'Colour Streaks' (1968) he produced pure, post-*Minimalist abstractions of great emotional depth. R. continued to pursue simultaneously figurative and abstract art in deliberate rejection of any distinction between the two. A notable example is the series of The Annunciation after Titian (1972) in which his faithful rendering of the Titian painting is progressively dissolved into pure abstraction. From the late 1970s he has been producing large-scale abstracts of extraordinary colour, sensuality and atmospheric depth which hint at a visionary beyond, along with work using photographs. In Achtundvierzieg Portraits (1972) and 18. Oktober 1977 (1988) R. shows the relationship between photography and painting.

Richter Hans (1888–1976). German painter and pioneer of the *avant-garde* film. He joined the *Dada group in Zürich (1916) and in 1917 painted his 1st abstracts. In 1918 he began to develop abstract themes on rolls of paper and in 1921 produced his 1st abstract film, *Rhythm 21*.

He was connected with Surrealist cinema in the late '20s. In 1941 he settled in the U.S.A. His films include *Dreams That Money Can Buy* (1947), with contributions by Calder, Duchamp, Ernst, Léger and Man Ray.

Ricketts Charles (1866–1931). British painter, ill. and designer. In 1896 he founded the Vale Press for which he designed in the tradition of W *Morris

Riegl Alois (1858–1905). Austrian art historian notable for his reassessment of late Roman art. He saw in it not a decline in technical competence and inspiration, but rather a change in artistic intention.

Riemenschneider Till (Tilman) (c. 1460–1531). German late Gothic sculptor active in Würzburg and famed for his work in wood; it includes the *Ascension of the Virgin* on the altar in the church of Our Lord, Creglingen. In stone he executed the tombs of bishops Scherenberg and Bibra in Würzburg cathedral and the memorial sarcophagus in Bamberg cathedral of its IIIh-c. founder, the Emperor Henry II, and his wife.

Riemenschneider Ascension of the Virgin c. 1505–10

Rigaud Hyacinthe (1659–1743). French portrait painter to Louis XIV and Louis XV. He reflected the temper of the age, excelling in formal portraiture where sumptuous robes and decorations took priority over characterization, e.g. *Louis XIV in Robes of State* (1701). His poses were often based on those of Van Dyck. He also painted more intimate unofficial portraits which bridge the gap between Baroque court portraiture and the naturalistic portraits of the 18th c.

Riley Bridget (1931-). British painter. She studied at Goldsmith's College of Art, London (1949-52) and at the Royal College of Art (1952-5) where her contemporaries were P. *Blake R *Smith and *Tilson. The start of a clear direction in her work came in 1956 in response to an exhibition of U.S. post-war art at the Tate Gal., and in the ideas of H. Thubron and V. Pasmore in 'The Developing Process' exhibition at the Institute of Contemporary Arts, London. In 1960 the Futurists *Boccioni and *Balla made a great impression, as did the U.S. *Color-field painters. Soon she was on her way in developing the perceptual-optical implications which have characterized her work ever since, encouraged by Anton Ehrenzweig. Her contribution to the M.O.M.A., N.Y., exhibition 'The Responsive Eve' attracted international recognition, and in 1968 she won the International Prize for Painting at the Venice Biennale. Unlike other *Op artists, she employs variations in tone and colour in repeated units and varied measures, tempi and widths.

Riley (Ryley) John (1646–91). British portrait painter, pupil of G. Soest. With Kneller he was appointed chief painter to William and Mary although some of his best portraits are of less exalted people, e.g. *Bridget Holmes, Housemaid* (1686).

Rimmer William (1816–79). U.S. painter, graphic artist, teacher of anatomy and the most powerful sculptor of his age. His paintings include the evocative *Evening*, his sculptures the heroic bronze *Dying Centaur* (1871).

Rinehart William Henry (1835–74). U.S. sculptor who settled in Rome in 1855 and joined the group of Neoclassical sculptors there.

Ringgold Faith (1930–). African-American feminist painter, soft sculptor and *Performance artist. Her initial exploration of black—white relations, e.g. the 'American People' series of paintings (1963–7), developed into a more expressive militancy in tandem with the

Riopelle

Ringgold Die 1967

growing black movement in the U.S.A., e.g. US Postage Stamp Commemorating the Advent of Black Power (1967). In 1971 R. painted a feminist mural at the Women's House of Detention outside Manhattan, which prompted her to abandon 'inflexible canvases' and explore new media, e.g. watercolours ('Political Landscapes'), acrylic on cloth ('Feminist Landscapes') and collaborations with her mother on soft sculptures made out of beads, bits of material and raffia, which was to develop her interest in craft as a medium for collective expression. Since the late '70s, R. has predominantly focused on making quilts which in many ways echo her earlier political works, e.g. The Purple Quilt (1986), inspired by Alice Walker's novel

Rivera The Agrarian Leader Zapata 1931

The Color Purple. Her quilt, Change: Faith Ringgold's Over 100 Pounds Weight Loss Story Quilt (1986), whose first presentation was accompanied by a performance, is an autobiographical exploration of female identity.

Riopelle Jean-Paul (1923—). French-Canadian painter, in Paris since 1948, associated with *Surrealism, later turning to *Action painting.

Rippl-Ronai József (1861–1927). Hungarian painter who went to Paris in 1887 and worked for 2 years under *Munkácsy but subsequently joined the *Nabis group. He developed a flat *cloisonniste style and produced some notable paintings predominantly in black and grey. On his return to Hungary (1900) he specialized in interiors which have similarities with those of his friend *Vuillard.

Rivera Diego (1886–1957). Mexican painter. He came under Cubist influence while working in Paris (1911–20) and on a visit to Italy (1920–1) was deeply impressed by Renaissance frescoes. He returned to Mexico in 1921 and painted several monumental mural decorations for the new socialist government's public buildings. In the U.S.A. (1930–3), he decorated the California Stock Exchange and Detroit Institute of Arts. His *Social Realism was responsible for the modern revival of Mexican art and was an important influence, through artists like Shahn, on the realist development in U.S. art in the 1920s and 1930s.

Rivers Larry (1923—). U.S. artist of the N.Y. school; he studied music at the Juillard school, N.Y., and became a jazz saxophonist; he began painting in 1947, studying with *Hofmann. Much of his early work is in an idiom related to *De Kooning and the *Abstract Expressionists, but he developed a basically figurative manner close to *Pop art, following his

Washington Crossing the Delaware (1953), e.g. Dying and Dead Veteran, 1961.

Robbia Luca della (1400–82). Florentine sculptor regarded by his contemporaries as the equal of Ghiberti and Donatello. An important figure of the Early Renaissance, he used classical Greek and Roman models but his work reflects a warm personality and lacks dramatic grandeur. Among his works are the Cantoria and the Sacristy doors for Florence cathedral. R. evolved a technique for applying pottery glazes, in various colours, to terracotta figures and established a factory continued by his nephew Andrea (1435–1525) and Giovanni (1469–after 1529) and Girolamo (1488–1566) the sons of Andrea.

Robert Hubert (1733–1808). French painter called 'Robert des Ruines'. He went to Rome (1754) where the example of *Pannini led him to devote himself to painting ruins. He also became a close friend of *Fragonard with whom he visited Paestum and Naples. On his return to Paris (1765) he painted imaginary landscapes with 18th-c. figures in settings of classical ruins. He was imprisoned during the Revolution but saved by the fall of Robespierre.

Roberti Ercole d'Antonio de' (d. 1496). Ferrarese painter, probably assistant to Cossa in Ferrara and later in Bologna before he displaced Tura as painter to the Este court in Ferrara in 1486. His major works are an altarpiece (1480) and *Pietà*. Until 1933 some of his paintings were attributed to Ercole de' Grandi, said to have been a painter who worked in Bologna and died in 1531. There is no evidence for this.

Roberts William (1895–1980). British painter in a Cubist idiom applied to scenes of working-class life; associated with the *Vorticist movement, member of the *London Group and an official war artist in World Wars I and II.

Robinson Theodore (1852–96). U.S. Impressionist painter who became a friend of Monet at Giverny.

Rockburne Dorothea (1935-). U.S.-Canadian post-*Minimalist painter whose mathematical exploration of theories of form and colour, and her interest in art history as a source relevant to the present, is seen to convey an unusual emotive spirituality; she once said, 'I feel that an object is really an emotional experience.' Drawing Which Makes Itself (1973) are folds of paper marked by carbon paper in which her purpose was to erradicate external signifiers with the images created through the interrelation of one surface and another: the Golden Section Paintings (1974), based on the mathematical formula for harmony of shape, are folds of natural linen stiffened with gesso and varnish, alluding to Renaissance and Byzantine

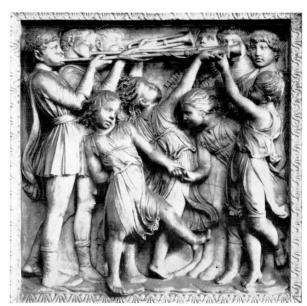

Luca della **Robbia** *Trumpeters* (detail from the Cantoria) 1431–8

rocker

art, while the sensual 'Robe Series' (1976), signalling an increasing use of vivid colour, refers more directly to *Duccio's Maestà altarpiece. Extasie (1983–4) and Exsultate (1985–6) were inspired respectively by Ben Jonson's poem and Mozart's 'Exsultate Jubilate'.

rocker. Tool used in mezzotint (*engraving) to roughen the plate.

Rockwell Norman (1894–1978). U.S. popular painter and ill. for the *Saturday Evening Post* (1916–63). His acutely observed paintings of the U.S. scene in a bold semi-photographic style, include *Norman Rockwell Visits a Country Editor* (1946) and *After the Prom* (1957).

Rococo (Fr. rocaille: shell-work). 18th-c. style, essentially French, a reaction against the ponderous and formal atmosphere of Louis XIV's court, and therefore adapted to the decoration of intimate interiors, using soft colours and delicate curves to produce gay, elegant and charming effects. The painting of the period (*Watteau, *Boucher, *Fragonard) has the same qualities. In the 2nd half of the 18th c. R. gave way to *Neoclassicism. The other main centre (notably of R. churches, e.g. of Dominikus Zimmermann) was S. Germany and Austria; elsewhere R. produced important individual works (e.g. by Tiepolo, Goya) but was never the dominant movement.

Rodchenko Alexander (1891–1956). Russian painter, photographer and designer who, settling

Rodchenko Drawing (compass and ruler) 1915

in Mexico in 1914, came under the influence of *Tatlin and *Suprematism. In 1915 he began doing abstract compositions with a ruler and compass. In 1918 he exhibited his *Black on Black* series of paintings in answer to *Malevich's *White on White* and from this period R. became a leader of a group of 'non-objectivist' artists who in 1922 decided to leave easel painting and 'speculative activity' for industrial design, calling themselves *Constructivists. R. began working as a typographer, photographer and furniture designer, applying his principles of abstract design to create a modern system of design, since become universal

Rodin Auguste (1840–1917). French sculptor who until 1882 worked as a craftsman in porcelain factories and workshops. His 1st sculptures, bronze portrait busts which he made in the evenings, were rejected by the Salon. Working in Brussels (1871–7), he paid his 1st visit to Italy (1874–5) and was overwhelmed by Michelangelo's spiritual intensity and his vigorous modelling of the figure. R.'s 1st Salon success, *Age of Bronze* (1875–7), reflects this rippling lifelike vitality and was such a sensational contrast to academic conventions that he was accused of using life-casts. He made *St John the Baptist* (1878–80) larger than life to disprove this. His mature work, either in bronze or marble (often

Rodin The Kiss 1886

deliberately left in a Michelangelesque half-finished state), developed an intense emotional expressiveness and the tragic *Burghers of Calais* (1884–6) illustrates his identification of composition with psychological content. The *Gate of Hell*, a doorway commissioned for the Musée des Arts Décoratifs, Paris (1880–1917) was unfinished, but several motifs from it – *The Thinker* (1880), *The Kiss* (1886), etc. – were developed separately. *Balzac* (1893–4) was his outstanding portrait, but was only cast in 1939.

R.'s great influence lay in his fusion of the Realist and Symbolist streams of the late 19th c. and in works such as *Le Jongleur* (1909) he foreshadowed the 20th-c. preoccupation with space.

Roelas Juan de (1588/90–1625). Spanish painter of religious subjects, master of Zurbarán. His style is close to that of Veronese and he may have studied in Italy. He worked in Seville where almost all his paintings are to be found.

Roerich Nikolay (1874–1947). Russian landscape painter, archaeologist and stage designer, an important member of the St Petersburg *World of Art group. His archaeological excavations influenced both his painting and his sets for Diaghilev's Paris production of *Prince Igor* (1909). In 1918 he left Russia for the U.S.A. and India

Rogers John (1829–1904). U.S. sculptor of narrative statuette groups such as the anti-slavery *Fugitive's Story*. He marketed thousands of casts and these are still collected.

Rohlfs Christian (1849–1938). German painter and graphic artist chiefly associated with *Expressionism. He turned from Realism to Impressionism in the early 1890s, to Post-Impressionism in the early 1900s and was an Expressionist by 1912, influenced by Nolde. His late work verged on abstraction. He produced some very fine hand-coloured woodcuts.

Rollins Tim (1955—) and K.O.S. (Kids of Survival). U.S. artist and teacher who studied at N.Y.'s School of Visual Arts where *graffiti was promoted. In 1982 he began working in the depressed South Bronx in N.Y.C. with promising 'learning-disabled' black and Hispanic teenagers who showed interest in the arts, and founded K.O.S. and the Art and Knowledge Workshop, Inc., for a small group of girls and boys. In 1985 R. devoted himself full time to collaborations with K.O.S. There they study

classic works of literature or music together, e.g. Kafka's *Amerika*, and then collectively 're-create' them visually, e.g. *Amerika IV* (1986) and paintings based on Flaubert's *The Temptation of Saint Anthony*, often on the book pages themselves, using gold lacquer. Other works are *The Autobiography of Malcolm X* and the *X-Men* series, using comics (1990).

Romanesque. In W. European architecture, sculpture, painting and the minor arts the style which evolved in the mid-10th c. following Charlemagne's revival of the arts and lasted until the late 12th c. Its architectural characteristics are: round arches, thick columns or composite piers, thick walls, heavy proportions, small windows and tunnel-vaults. There are great regional variations within R. Italy remained close to classical models: France was divided into different schools, e.g. Aquitaine favoured domes. Provence low single-storey naves (Avignon), Auvergne a heightening of the transepts next to the crossing (Issoire), etc.: Britain followed Normandy with very long basilican churches, mostly with square E. ends and 2-tower W. fronts (Durham); Germany went on developing R, after other countries had turned to Gothic. In the late 12th c. (beginning in the Île-de-France) the development of

Romanesque Carving (Oloron-Sainte-Marie) 12th c.

Romanino

vaulting techniques and the desire for more light led to the evolution of Gothic. Relief sculpture was used extensively in R. churches, especially on the capitals of the interior columns and the tympana; free-standing sculpture appeared only at the end of the period. Many mural paintings have survived in churches in France, Italy and Spain. As in architecture there is great stylistic variety within R. painting and sculpture which combines elements from the early Christian-Byzantine tradition and, particularly in N. Europe, barbarian art. Common features are distorted elongated figures, stylized vegetation, geometric and interlaced patterning and strong rhythmic movement. Similar characteristics appear in the jewellery, metalwork and ms. illumination which flourished during the period.

Romanino Girolamo Romani called (1484/7–after 1562). Italian painter influenced by the Venetian school. He lived in Brescia, near Milan, but travelled extensively in N. Italy. He painted mainly religious subjects which include a *Pietà* (1510), his earliest dated work, and a polyptych *Nativity with Saints* in the N.G., London.

Romanist. Name used to describe Northern artists of the early 16th c. whose style was influenced by Italian Renaissance painting, usually as a result of a visit to Italy. Mabuse, B. van Orley, M. van Heemskerk, Q. Massys and M. van Reymerswaele are important R.s.

Romano Giulio. *Giulio Romano

Romanticism. A profound revolution in the human spirit gathering momentum in the 18th c. and in full flood in the 19th. The movement in the arts was at its height during the 50 years c. 1790–c. 1840. The most important elements in R. were: feeling for nature (foreshadowed by the *picturesque); emphasis on subjective sensibility and emotion and on imagination, as opposed to reason; and interest in the past, the mysterious and the exotic.

R. in painting began in Britain in the works of *Constable and *Turner, which show a new awareness of landscape; later the paintings of *Palmer (a disciple of W. *Blake) reveal an essential Romantic genius. In Germany, the medieval townscapes of *Shinkel and *Schwind and the mysterious landscapes of *Friedrich are typical manifestations of R. *Goya in Spain is uniquely R. In France, *Géricault and *Delacroix.

Romney Emma, Lady Hamilton

Rombouts Theodor (1597–1637). Antwerp painter. He studied under A. Janssens, then spent several years in Rome where he came under the influence of Caravaggio's followers. His work is of 2 kinds: Caravaggesque genre scenes and religious subjects after the manner of Rubens.

Rome, school of. School of Italian painting of importance from the mid-15th to the late 19th c. Both Michelangelo and Raphael worked in Rome, making it the centre of the High Renaissance; in the 17th c. it was the centre of the Baroque movement represented by Bernini and Pietro da Cortona. From the 17th c. the presence of classical remains drew artists from all over Europe including Poussin, Claude, Piranesi, Pannini and Mengs.

Romney George (1734–1802). British painter of portraits and historical subjects. Beginning as a portrait painter in Westmorland, he moved to London in 1762, where his *Death of Wolfe* (1763) attracted attention, but led to a quarrel with *Reynolds, whose style, together with that of *Gainsborough, influenced R. He became a fashionable portrait painter. A visit to Italy (1773–5) and the study of Raphael, Titian and Correggio brought new maturity to his art. He greatly admired Emma, Lady Hamilton and painted over 50 works in which she appeared, usually in a historical role. His clientele declined in the 1790s, and in 1798 he retired to Kendal, where he died.

Rooker Michael called 'Michael Angelo' (1743–1801). British landscape painter and engraver remembered for his watercolours of

architectural ruins made on a series of tours of English counties. He was a pupil of *Sandby.

Rops Félicien (1833–98). Belgian graphic artist, a master of etching techniques. He settled in Paris in the mid-1870s and acquired a reputation for satanism and decadence.

Rosa Salvator(e) (1615–73). Italian painter, engraver, poet, musician and actor, noted chiefly for a flamboyant and dramatic style of landscape painting in opposition to the classicism of Claude and Poussin. He was probably a pupil of Jusepe da Ribera. Apart from turbulent battle scenes, R.'s fame lies mainly in his somewhat theatrical landscapes, peopled by saints and banditti. The subjects, the dramatic lighting and the wild natural settings of these works started a vogue in the 18th c. for 'sublime' and 'picturesque' landscape.

Rosenberg Harold (1906–78). U.S. art and literary critic; many of his influential and controversial essays, coll. in *Artworks and Packages* (1969), first appeared in *The New Yorker*. His books include: *The Tradition of the New* (1959), *Arshile Gorky* (1962), *The Anxious Object* (1964), *Art on the Edge* (1975). R. coined the phrase *'Action painting'.

Rosenquist James (1933—). U.S. painter. He Ist worked as a billboard painter in and around N.Y., 1953—8, which influenced his work. With his 1962 I-man show— in the same year as *Lichtenstein, *Warhol, *Wesselmann and *Indiana also exhibited—R. emerged as one of the leading U.S. *Pop artists, e.g. F-111 (1965).

Rosicrucians. A loose grouping of *Symbolist artists led by the Sai (Josephin) Peladan, a prolific writer who was a believer in the occult doctrines of the supposed 15th-c. visionary Christian Rosenkreuz. His followers exhibited their work in the Salons of the Rose-Croix held in Paris, 1892–7. Among the more typical Rosicrucian painters were Charles Filiger (also associated with Gauguin and the school of Pont-Aven), Armand Point, Edgard Maxence and Marcellin Desboutin. The chief role of the solons, however, was to draw attention to the work of important Symbolist painters who were not French, such as the Swiss *Hodler and the Dutchman *Toorop.

Roslin Alexander (1718–93). Swedish Rococo portrait painter in the style of J.-M. Nattier. R. worked mainly in Paris but visited St Petersburg, Warsaw and Vienna.

Rosselli Cosimo (1439–1507). Florentine painter who had an important share in the decoration of the Sistine Chapel for Sixtus IV. In Florence his paintings include frescoes in S. Annunziata and S. Ambrogio. He worked in a severe static manner. Fra Bartolommeo and Piero di Cosimo were his pupils.

Rossellino the brothers Bernardo (1409–64) and Antonio (1427-79). Florentine sculptors. Bernardo, the more gifted, also worked as an architect for the Vatican, which he proposed to rebuild in imitation of classical architecture. His most important buildings are in Pienza, near Montepulciano. In 1444 Bernardo completed the funeral monument for the humanist Leonardo Bruni, erected in the church of S. Croce, Florence. The figure lies prostrate on a bier over a sarcophagus and is flanked by ornamented pilasters; this became the prototype of the Renaissance monument. Antonio R. was mainly active as a funeral sculptor; one of his best-known works, the tomb of the cardinal of Portugal (1459), shows realism and some originality in composition.

Rossetti Dante Gabriel (1828–82). British poet and painter, son of Gabriele R. With *Millais and H. *Hunt he was a founder of the *Pre-Raphaelite Brotherhood. As a painter R.'s Romantic imagination was out of sympathy with the Realism and moral earnestness of Millais and Hunt and their early association was brief. The most famous painting of his early period is *Ecce Ancilla Domini* (1850). Between 1850 and 1860 R. worked chiefly in water-colour; also important are his drawings of his wife Elizabeth Siddal and the idealized portrait of her, *Beata Beatrix*. She and Mrs William Morris provided R. with an ideal of feminine

Rossetti Beata Beatrix 1863

Rosso

beauty which is recurrent in his work. His late paintings were chiefly on Arthurian and Dantesque themes.

Rosso Medardo (1858–1928). Italian sculptor. R. studied at the Brera Academy in Milan, but was expelled after one year; from then on he worked on his own. He went to Paris (1884) and met *Rodin. He had an income from making funerary monuments, exhibiting new work at the Paris Salon (1886-9) and the Salon des Indépendants. In 1889 he decided to settle permanently in Paris and was helped by the collector Rouart and by Rodin with whom R. developed an uneasy relationship and whom he accused of stealing his ideas. R. liked to see his coloured wax sculptures, combining visual Impressionism with symbolic abstractions, displayed among paintings. In 1904 he had a 1-man show at the Salon d'Automne which attracted the attention of the Italian writer and critic Ardengo Soffici who became his propagandist in Italy. 1-man shows followed in Vienna (1905) and London (1906). In 1910 Soffici organized in Florence a large exhibition on R. and Impressionism. In 1915 a R. room was opened in the Galleria d'Arte Moderna in Venice. Apollinaire considered R. to be 'the greatest living sculptor' (1917), and the Futurist hailed R. as a predecessor and great pioneer.

Medardo Rosso Ecce Puer 1906

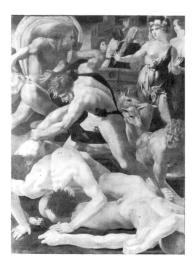

Rosso Fiorentino Moses Defending the Daughters of Jethro c. 1523

Rosso Fiorentino (né) Giovanni Battista di Jacopo di Gasparre (1494–1540). Florentine artist, one of the founders of the school of Fontainebleau and a leading *Mannerist painter. R. was trained, briefly under Andrea del Sarto and was influenced by Michelangelo and Dürer's engravings. He painted in Florence and Rome and in 1530 he was invited to the French court by Francis I. R.'s major surviving work is the cycle of pagan subjects.

Rotella Mimmo (1918—). Italian artist, one of the *Nouveaux Réalistes, best known for his *décollages, starting in the mid-1950s, and as an affichiste—an artist using torn street posters as a medium. The *found torn posters offered their potential as abstract designs, textures, patterns and colours, e.g. Scotch Brand (1960). In the mid-1960s he turned to 'photo-reportages'—direct, restrained and sombre photographic or found, mechanically reproducible, images, e.g. of a Vietnam soldier, portraits of artists and advertisement still-lifes.

Roth Dieter (1930–98). German artist, living in Hanover and Reykjavik. His works include 'mould pictures', graphics, films and Dada events and typographic poems. He uses *décollage (*Vostell, with whom R. has worked) techniques to break down consumer product images and to expose their own aesthetic aspects.

Rothenberg Susan (1945–). U.S. painter and print maker who fused an early interest in abstraction with figuration in the '70s when she introduced images of horses into her work – mostly monochrome canvases, using precise geometrical methods. R. explored the symbolism of the equine form, beginning with oblique representations which developed into near-human images, e.g. *Tuning Fork* (1980). This led in the early '80s to her introduction of often disturbing fragmentations of the human form and the use of freer brushwork. Her recent large-scale dynamic works show the whole human form depicted with an increasing use of colour, e.g. *Vertical Spin* (1986–7).

Rothko Mark (1903-70). Russian-born U.S. painter; one of the leading figures of *Abstract Expressionism. He studied painting under *Weber; R. also worked on the *W.P.A. Art Project (1936-7) and founded an art school, 'Subjects of the Artist' (1948) with *Baziotes, *Motherwell and *Newman in N.Y. He was initially inspired by the freedom of expression of Miró, Ernst and U.S. Surrealists but his mature work developed, from c. 1948, as single abstract images or symbols presented through colour, line and shape: floating horizontal rectangles with blurred edges, the background colour subtly and dramatically related to the colour of the rectangles, e.g. Number 2 (1962). With *Still, *Newman and *Reinhardt, R.'s painting devel-

Rothko Light Red over Black 1957

Rothenberg United States 1975

oped a non-geometric, clean and simple style of great, deep evocative power. R. said: 'The progression of a painter's work ... will be toward clarity; toward the elimination of all obstacles between the painter and the idea, and between the idea and the observer. ... To achieve this clarity is, inevitably, to be understood.'

Rottenhammer Hans (1564–1625). German painter of religious mythological subjects who spent many years in Venice and Rome. He was strongly influenced by Venetian painting.

Rottmann Carl (1797–1850). German painter best known for his Greek and Latin landscapes commissioned by Ludwig I of Bavaria and painted in fresco on the walls of the Hofgarten cloisters in Munich.

Rouart Henri Stanislas (1833–1912). French amateur painter who exhibited with the Impressionists and was an early collector of Impressionist paintings.

Rouault Georges (1871–1958). French painter, born in Paris; apprenticed as a ciassman in stained glass. He studied painting in G. *Moreau's studio (1892-8) and on Moreau's death (1898) became curator of the Mus. Moreau, a post he held until his own death. His early religious paintings reflect both the jewellike character of Moreau's art and his own taste for medieval art. His intense religiosity was heightened by his contacts with Huysmans and with Léon Bloy whose passionate Catholic novels of sordid Parisian life prompted the Prostitute series of 1903-7: e.g. At the Mirror (1906). Superficially close to Lautrec in subject and technique, these were the crudely painted images that linked R.'s name with the *Fauves at the 1905 Salon d'Automne. But in fact these pictures were conceived as moralities of sin and redemption foreshadowing the intensely

Roubil(1)iac

Rouault Guerre et Miserere (detail) 1917-27

religious character of his mature style. This placed, in common with contemporary German *Expressionist painting, great emphasis on the direct expression of emotion.

He concentrated on graphic work (1916–29), and these prints – particularly the *Guerre et Miserere* etchings – are his most Expressionist works. His paintings, laboriously painted and with a heavy black outline reminiscent of the lead in stained glass, are the more profound hieratic images which made him the foremost religious artist of the c. He designed stained-glass windows for a church at Assy (1948).

Roubiliac Handel c. 1735

Roubil(I)iac Louis-François (1705–62). French sculptor, one of the most important sculptors working in Britain in the 18th c. He was a pupil of the Baroque sculptor Permoser, then of Nicolas Coustou. He settled in Britain (c. 1732) and made his reputation with a statue of Handel for Vauxhall Gardens. His many works include the statue of Sir Isaac Newton at Trinity College, Cambridge, the Argyll monument in Westminster Abbey and a statue and the 'Davenant' bust of Shakespeare.

Rousseau Henri called 'Le Douanier' (1844-1910). French primitive painter. He served in the army (1870-1) and then as a minor customs official in Paris. He began to paint c. 1880 and when he retired in 1885, painted full time, becoming the greatest of the self-taught *primitives. His only tuition was the advice of Canabel and the copies he made in the Louvre. The naïve directness of his work ranged from the simplicity and hieratic scale of his Self-portrait (1890) to the intense visionary quality of War (1894). He was acclaimed by Jarry, Apollinaire, Delaunay and Picasso, all of whom he met c. 1906. The child-like simplicity of form and the uninhibited imaginativeness of subject in such works as The Sleeping Gypsy (1897) came as a revelation to artists seeking new means of expression. Contact with such people fostered the more conscious, exotic sophistication of late works such as The Snake Charmer (1907). The 'legendary banquet' in his honour was organized in 1908 by Apollinaire and Picasso, whom he told: 'We are the two greatest artists of our age - you in the Egyptian manner, I in the modern.

Rousseau (Étienne-Pierre) Théodore (1812–67). French landscape painter, leader of the *Barbizon school. He was strongly influenced by Constable and the 17th-c. Dutch landscapists. He stayed several times at Barbizon before settling there in 1848 after continued refusals in the Salon. His work combines objective observation of nature with melancholy Romanticism.

Roussel Ker-Xavier (1867–1944). French painter, one of the *Nabis but unusual in his frequent choice of mythological subjects. With his brother-in-law É. Vuillard he executed decorative paintings and stage designs.

Rowlandson Thomas (1756–1827). British painter and social caricaturist, working mainly in ink and watercolour wash. He studied at the R.A. Schools and in Paris. His exuberant,

Henri Rousseau The Dream 1910

robust, exaggerated and sometimes savage caricatures of English life show consummate draughtsmanship. R.'s success began with his Academy picture *Vauxhall Gardens* (1784); besides caricatures he painted watercolour landscapes and ill. a series of books: *Tour of Dr Syntax in Search of the Picturesque* (1812), *Dr Syntax in Search of Consolation* (1820), *Dance of Death* (1814–16), and the works of Goldsmith, Smollett and Sterne

Rozanova Olga Vladimirovna (1886–1918). Russian artist and ill., one of the most active members of the *avant-garde* movement in St Petersburg. She ill. numerous Russian Futurist publications. She exhibited in all the major *Suprematist and *avant-garde* exhibitions of non-figurative art and was a member of Proletkult and Svomas (*Vkhutemas).

Rubénisme. Late 17th-c. movement in French painting opposed in the French Academy by Poussinism. The Rubénistes, admirers of Titian and Rubens, whose great life cycle Life of Marie de Médicis was in Paris, claimed that colour was the most important element in painting because it enabled the artist to achieve a more perfect semblance of reality. Led by Lebrun, the Poussinists, followers of the Carracci and Poussin, maintained that colour was only of decorative value and was of less significance than the more formal elements of drawing and design which gave intellectual instead of sensual satisfaction. By the end of the 17th c. the Rubénistes had won, opening the way for Watteau and *Rococo.

Rubens Peter Paul (1577–1640). Flemish painter, draughtsman, etcher and diplomat. R.

had a classical education. He studied under the Dutch Mannerist, *Veen, in Antwerp, where he became a member of the Guild of St Luke (1508). His journey to Italy in 1600 greatly influenced his future development; it gave him an opportunity to study Titian, and later the Carracci and Caravaggio in Rome. In 1603 he undertook his first diplomatic misson to the court of Spain, sent by his patron Duke Vincenzo Gonzaga of Mantua. Here he came into further contact with the paintings of Titian. R returned to Rome in 1605, where he studied Graeco-Roman antiquity and met the painter *Elsheimer, who taught him the art of etching. On his mother's death in 1608 R, returned to Antwerp and became the favourite of the Spanish governor, Albert, and his wife, Isabella. He married and settled in Antwerp, where he won increasing admiration from his patrons and fellow-artists. The famous double portrait with Isabella Brant, his wife (c. 1609), dates from this period. R. established himself in a sumptuous palace, where his paintings were displayed and sold to the nobility and crowned heads of Europe. Artists eager to learn the secrets of his art flocked to his studio, which produced many copies and variations; R. often retouched and sold them as originals. The most important paintings of this period are religious and mythological compositions and hunting scenes, including The Last Judgement, The Battle of the Amazons and The Lionhunt (1616-17). The pressure of work increased and R. employed Anthony van Dyck as his chief assistant. In 1621 he worked for Charles I of England and in the following year was ordered to Paris by Marie de Médicis to plan large-scale decorations for the Luxembourg Palace. These were completed

Rubley

Rubens Le Chapeau de paille c. 1625

within 3 years and comprised 22 large canvases and a number of portraits. In 1625 further diplomatic missions took him to Spain, where he met Velazquez, and to Britain. He was knighted by Charles I, who commissioned decorations for the Whitehall Palace. In 1630 he married Hélène Fourment, who was the subject of many of his later works; the famous portrait *Le Chapeau de paille (The Straw Hat* — not in fact of straw), once thought to be of Hélène, is now believed to be of her elder sister Susanna. He retired to the Château de Steen where, though beset by illness, he painted a number of splendid landscapes and compositions of rustic life.

The work of R. shows continuous development and can be divided roughly into periods. The 1st covers his formative years, his stay in Italy and early, eclectic work in Antwerp. Colours were laid on broadly, the paintings were strong in contrast with harsh modelling of the figures and academic drawing. The influence of Tintoretto, Veronese and Titian is very evident. From c. 1612 a gradual change took place. The paint became more luminous, though still opaque, and the chiaroscuro less violent. Fluency and facility combined and formed an exuberant style suitable to workshop practice and the mass production of paintings. This was the start of the Antwerp school. During the last

phase from about 1625 he achieved complete mastery with his vital, free and expressive brushwork, the brilliance and luminosity of colour and an exuberantly sensual feeling for the tactile human flesh and materials – which has not been paralleled since. Contemporary taste and criticism finds this aspect of R.'s least acceptable, but it was in fact his greatest achievement. His influence on Flemish, French and English painting has been enormous. Both Watteau and Delacroix learnt a great deal from the subtle colour relationship of his paintings, and the portrait painters of the 18th-c. English school, Reynolds, Gainsborough and later Ward and Constable, owed their freedom in the handling of paint to him. Other famous paintings by R. are The Three Graces and Peace and War (1629).

Rublev Andrey (1370?–c. 1430). The greatest Russian religious painter, a monk working at Andronnikov where he painted 3 icons for the cathedral of the Annunciation, Moscow, murals in the cathedral of the Assumption, Vladmir (with his friend Daniel Chorny), and icons for the church of the Savvino-Storozhevsk monastery; he also worked at Zagorsk, where he decorated the walls of the cathedral of the Trinity and painted his most famous work, the icon *The Old Testament Trinity*. His painting departs from the Byzantine tradition and is characterized by delicacy of line and full, subdued and harmonious colours.

Rublev The Old Testament Trinity early 15th c.

Rückriem Ulrich (1938-). German sculptor, who lives mostly in Ireland and Normandy, of wall reliefs and free-standing toughly abstract sculptures, often of very large blocks of split granite and porous German dolomite stone left in its rough state except for occasional discreet incisions and polishing of small areas. After early experience as stone mason at Cologne Cathedral, R.'s main concern has been with 'handling materials, and understanding the process of what's done to them'. In a specially constructed small museum of his work in Clonegal, Ireland, sculptures of characteristic simplicity and subtle beauty emphasizing the colouring of the stones are displayed, demonstrating R.'s devotion to the geometry of the square and the recurring theme of the standing stone which carries associations with archaic standing stones.

Rudé François (1784–1855). French sculptor who abandoned Neoclassicism for a more Naturalistic and Romantic approach. The statue of Marshal Ney in the Place de l'Observation, Paris, and the striking relief *La Marseillaise* on the Arc de Triomphe are notable.

Ruisdael Jacob Isaac(k)z van (1628/9–82). Dutch landscape painter, born in Haarlem; also a practising physician. R. was probably the pupil of his father and uncle (Salomon van Ruysdael). I lis painting reinvigorated the realistic landscape and was a major influence on later painting in the genre; his predilection was for melancholy scenes, usually with some elements suggesting decay – heavy and oppressive, as in *The Great Forest*, or tranquil, as in *The Water-Mill*. *Hobbema was his pupil.

Runge Philipp Otto (1777–1810). German painter, etcher and writer, with *Friedrich the

Runge The Hülsenbeck Children 1805

leading artist of the German Romantic school. He was mainly active in Hamburg, famous for his portraits painted with a melancholy symbolism. He went to study in Denmark, attracted by the then prevalent interest in the legendary epics and mythology of Scandinavia. The mystical spirit of R.'s historical, biblical and mural compositions foreshadowed Wagner and the Pre-Raphaelites.

Ruscha Edward (1937—). U.S. painter and photographer, born in Omaha, Nebraska. He attended the Chouinard Art Institute, Los Angeles, 1956–60, and remained on the West Coast, emerging in the 1960s as one of the most interesting *Pop artists. He has also made prints (e.g. Hollywood, 1968) and books of his photographs, e.g. Sunset Strip, Nine Swimming Pools, 26 Gasoline Stations, etc.

Rush William (1756–1833). An early American-born sculptor famous for his ship-figureheads; all examples are now lost. Among his surviving works are a life-size statue of

Ruscha Large Trademark with Eight Spotlights 1962

Ruskin

Washington, Nymph with Bittern and a self-portrait.

Ruskin John (1819–1900). British writer on art, economics and social reform; with Carlyle, and others, one of the 'prophets' of the Victorian age. The work of Turner, which he began to collect when young, triggered his meditations on art, eloquently paraded in Modern Painters (1843-60), Seven Lamps of Architecture (1849) and The Stones of Venice (1851-3), valuable less for judgments ad hoc than for his recognition that 'the whole function of the artist ... is to be a seeing and feeling creature' (Stones of Venice), and that the excellence of art, though reached through nature is independent of representation. At its best his prose (Proust's favourite reading) is of unsurpassed magnificence, though in earlier work sometimes losing relevance, especially in his descriptions of nature. In his social and economic writings, of world-wide influence, e.g. Unto This Last (1862) - the essays of which Thackeray refused to continue printing in The Cornhill - Fors Clavigera (1871-84) and Munera Pulveris (1872), he stated the case against capitalism. He left a classic autobiography in Praeterita (1886-9).

Russell Morgan (1886–1953). U.S. painter, with S. MacDonald-Wright founder of *Synchromism. He 1st studied under *Henri in N.Y., then went to Paris, where he began to paint 'Synchromies' in 1912 – Four Part Synchromy, Number 7 (1914). After World War I he returned to representational painting.

Russolo Luigi (1885–1947). Italian painter and composer, a signatory of the *Futurist Manifesto (1910). His paintings were not outstanding but his music (Bruitism) and his noise-making instruments ('intonarumon') made a significant contribution to the Futurist movement. He expounded his principles in L'Arte dei rumori (1916).

Ruysch Rachel (1664–1750). Dutch still-life and flower painter, pupil of W. van Aelst. In 1708 she was appointed painter to the Elector Palatine.

Ruysdael Salomon van (c. 1602–70). Dutch landscape painter who worked in Haarlem; uncle of *Ruisdael. His early work resembles the work of J. van Goyen. He was later influenced by the Italianate landscapes of *Both.

Ryder Albert Pinkham (1847–1917). U.S. painter of visionary and poetic imagination.

Ryder Death on a Pale Horse 1890-1910

Living a solitary life in a N.Y. attic he painted small Romantic landscapes and scenes of the sea by night as well as symbolic and literary subjects. *Death on a Pale Horse* is a famous and characteristic work. His paintings have deteriorated as a result of his constant repainting.

Ryman Robert (1930—). U.S. artist, sometimes considered a *Minimalist. The quality of paint itself, whiteness, squareness, flatness, concern with materials (unstretched canvas and linen, hand-made rag paper, plastic, matt paint on steel, baked enamel on copper), the exploitation of the whole visual field, e.g. the sides of a stretched canvas, are characteristic of his work. R.'s paintings include the *Windsor* series (1965–6), *Standard* (1967), the *Surface Veil* paintings and *General* (1970), *Empire* (1973).

Rysbrack John Michael (1694–1770). Antwerp sculptor who settled in Britain and was chief rival to *Roubiliac. His work, in a more restrained style than that of most of his contemporaries, includes the Marlborough family tomb at Blenheim, the equestrian statue of William III at Bristol and fine portrait busts.

S

Saar Betye (1929—). African-American artist whose interest in African folk culture and mythology has led to her awareness of the occult and spiritual. In her *assemblages and *collages S. uses found and natural materials (wood, cloth,

straw and leather) which are often of personal significance, e.g. her late Aunt Hattie's handkerchief was the base of her collage *Dat Ol' Black Magic* (1981). She subverts stereotyped images of blacks by *appropriation and reinvention of these impressions in her work.

Sacchi Andrea (1599–1661). Roman painter, a leading representative of the classical tradition of Poussin and Algardi during the high Baroque period. He was a pupil of Albani and influenced by the Carracci. His paintings include *Divine Wisdom* (Barberini Palace, Rome) and *Vision of St Romuald.* *Maratta was his pupil.

sacra conversazione (It. holy conversation). Painting of the Madonna and Child with Saints in which the figures are together on a single panel and are involved with one another. Developed in the 15th c. in the work of Fra *Angelico, *Lippi and *Domenico Veneziano, this type of representation replaced that of the Gothic polyptych in which the Madonna and Child group occupied the central panel and each of the Saints a separate side panel.

Saenredam Pieter (1597–1665). Dutch painter of churches and town halls, working at Haarlem. He was a painstaking worker, correcting the perspective of his site plans with elaborate construction drawings, which he would transfer to panel. This gives his paintings an air of complete reliability despite their departures from reality. He had an independent income and produced only about 50 paintings in 35 years. S. was an avid collector of books, prints and drawings. Prized in the 19th c. mainly as topographical documents, his works are now among the most highly valued Dutch museum pieces from the 17th c.

Saftleven (Sachtleven) Cornelis (1607–81). Dutch painter best known for his peasant genre scenes in the manner of *Brouwer. He also painted interiors, landscapes and historical subjects.

Saftleven Herman (1609–85). Dutch painter of landscapes and religious subjects, pupil of *Goyen and brother of Cornelis S. In the early 1640s his work was influenced by the Italianate manner of *Both and later by the detailed study of Jan *Bruegel the Elder.

Sage Kay (1898–1963). U.S. painter and poet. In 1937 following the exhibition of one of her paintings at the Salon des Surindépendants, Paris, she was discovered by the Surrealists. Her

Sage All Surroundings Are Referred to High Water 1947

work was distinguished by its austerity, spareness of form and its great attention to detail, e.g. Danger and Construction Ahead (both 1940). S.'s paintings were frequently abstract and nearabstract based on architectural motifs, e.g. Afterwards (1937) and All Surroundings Are Referred to High Water (1947). In 1940 she married *Tanguy and her first U.S. exhibition opened in N.Y. A joint exhibition of S.'s and Tanguy's work was held in Connecticut in 1954. She committed suicide.

Saint Gaudens Augustus (1848–1907). Irishborn U.S. sculptor who, after study in France and Italy, became a leading sculptor in the U.S.A. His work is clearly influenced by Renaissance and Neoclassical ideals but has an individual vigour and plasticity marred occasionally by sentimentality. His works include: the Farragut Monument and the General Sherman Monument.

St Ives artists (St Ives school of painting). In 1939 *Stokes invited B. *Nicholson and *Hepworth to move from London to St Ives in Cornwall. Soon St Ives became a lively visual cultural centre which included A. *Wallis, on the one hand, and *Gabo on the other. Stimulated by the presence of Nicholson, Hepworth and Gabo, younger artists began to

gather: *Lanyon and, after the war, *Davie, *Frost, *Heron, *Hilton and W. *Scott.

Saint-Phalle Niki de (1930–). French sculptor who has used ideas from her early *assemblages and *collages of *found objects – ornaments, statues, toys, etc. – in developing her 'Nanas', large-scale female figures consisting of interwoven fabric stretched over frames made of chicken wire. Hon (1966) playfully challenges popular objectified images of the female body: 'spectators' entered between her legs into a huge arcade of amusements, including a milk-bar in one breast, a 'lovers' nest', an aquarium and a cinema playing an early Greta Garbo film.

Salish. North American Indian people of the *North-west Coast group, occupying an area of N.W. Washington, S.W. British Columbia and Vancouver Island. They were noted for their split plank communal houses, up to 500 ft (152 m.) long, and carved wooden 'spirit canoe' figures, used as markers in religious ceremonial to delineate the outline of imaginary canoes.

Salle David (1952-). U.S. *Postmodernist painter, photographer, stage designer and sculptor of the same generation as *Schnabel and *Fischl. He studied under *Baldessari. A *collage or *assemblage artist of unconnected, *appropriated images, styles and techniques from high art of the past, or modernism, and from popular and consumer cultures, which he juxtaposes and superimposes. Since the late 1970s S. has been making his controversial layered works which, in their characteristic combination of deadpan anonymity and shocking expressiveness, derive from the deadening quality of TV but are also closely related to *Polke and through him to *Picabia esp. in his use of overlapping drawings on top of recycled images, e.g. the diptychs Brother Animal and B.A.M.F.V. (both 1983) and Miner (1985). S.'s paintings suggest narrative and meaning which they then frustrate. His often pornographic representations of naked women on all fours taken from hard-core magazines have made him a target of some feminists. In 1992 he produced a series of seemingly abstract works, 'Ghost', which were in fact based on photographs projected on to photosensitized canvas and were related to *Warhol's Shadow paintings. His series 'Pre-Fab' (1993) consists of large canvases with overlapping images reminiscent of *Rosenquist's 1963 paintings, 'on top of which are painted my paintings'.

Saint-Phalle Black Nana 1968-9

Salon. A number of friends, forming a more-or-less stable group, who meet regularly at a private house; the lady of the house usually presides. The intellectual S. originated in 17th-c. France and has since always played an important role in the literary and artistic life of the country. The Hôtel de Rambouillet was the most famous of the early S.s. Founded in 1667, the S. provided the opportunity for annual exhibitions to members of the French Royal Academy of Painting and Sculpture.

Salon des Indépendants. Founded, in Paris, in 1884, in opposition to the official annual Salon, by artists who disagreed with academic art.

Salon des Refusés. Special exhibition held in Paris in 1863 of the works refused by the Salon of that year. The exhibition was ordered by Napoleon III after the outcry caused by the number of rejections; nevertheless, the paintings exhibited were attacked by critics and public alike. One of the principal exhibits was *Manet's Le Déjeuner sur l'herbe while other artists exhibiting were *Boudin, *Cézanne, *Fantin-Latour, *Jongkind, *Pissarro and *Whistler

Salviati Francesco de' Rossi, called (1510–63). Florentine *Mannerist painter and designer, pupil of Andrea del Sarto and friend of Vasari.

He worked in Florence, Venice and Rome and from 1554 to 1556 in Paris. His paintings include *Justice* and *Story of Psyche*.

Samaras Lucas (1936—). Greek-born U.S. artist. He studied at Rutgers Univ. and Columbia Univ. under *Schapiro. His works include assemblages, constructions, Box 54 (1966), disturbing environments, Mirrored Rooms (1960), figure/portrait photography, pieced-fabric compositions and pastels, October 17, 1974.

Sandby Paul (1725–1809). British landscape painter and engraver. He did some of his best work in and around Windsor Great Park and discovered the artistic potentialities of Welsh scenery. Besides watercolour he worked in gouache and was also the first to use aquatint engraving creatively. He gave an unidealized though sometimes over-detailed rendering of his subject.

Sand painting. A technique of making designs in different colours of sand, practised by the Navajos and other North American Indians (and also in Tibet, in Japan, and among the Australian Aborigines) in connection with religious ceremonies. They are ephemeral and must be done anew on every occasion.

Sandrart Joachim von (1606-88). German painter and art historian widely travelled in Germany and Italy. He is important as the author of *Teutsche Academie* ... (1675–79), a valuable source of information on 17th–c. art and artists.

Sandys Frederick (1829–1904). British ill., subject painter and portraitist associated with later Pre-Raphaelitism.

Sano di Pietro (1406–81). Sienese painter, pupil and follower of *Sassetta. He painted many scenes from the life of St Bernard, including *St Bernard Preaching* in Siena cathedral.

Sansovino II (Andrea Contucci) (1460–1529). Italian sculptor. He was trained in Florence but worked mainly in Portugal (Lisbon and Coimbra) and Rome. His style is that of the High Renaissance, though the early influence from Donatello always remained strong. Works include the tomb of Cardinal Sforza, Rome; *The Baptism*, over the door of the Baptistery, Florence; and a *Madonna* for Genoa cathedral.

Santi Giovanni (d. 1494). Italian painter of the Umbrian school, father of Raphael and author

Sargent Coventry Patmore 1894

of a rhymed chronicle which refers to various 15th-c. artists. His paintings include frescoes in S. Domenico, Cagli and *Virgin and Child*.

Santomaso Giuseppe (1907—). Italian painter, a founder of the *Fronte nuova delle arti. He developed his own colouristic style of abstraction after World War II.

Sargent John Singer (1856–1925). Painter of the English school, but of U.S. origin. S. studied in Paris, arriving in London (1884) as an 'Impressionist', although influenced by the work of Frans Hals and Velazquez. Famous after the acquisition by the Chantrey Trustees of Camation, Lily, Lily, Rose, S. became a prolific and fashionable portrait painter. His technical dexterity and ability to flatter the sitter were offset by a bravura brushwork, sometimes degenerating into the slipshod, which earned him and his followers the nickname of 'the Slashing School'.

Sarrazin Jacques (1592–1660). Influential French sculptor. He worked in Rome with *Domenichino and *Vouet and developed a classicizing style that preceded the *Baroque and French sculptural classicism.

Saryan Martiros (1880–?). Armenian painter. He studied at Moscow School of Art under Leonid Pasternak and Serov. He was a prominent member of the *Blue Rose group, and his work is closely related to that of Kusnetsov in his interest in Middle Eastern traditions, particularly Kirghiz Mongol painting, which together with the work of Matisse played an important part in forming his style.

Sassetta The Whim of the Young St Francis to Become a Soldier 1437–44

Sassetta Stefano di Giovanni (c. 1392–1450). Sienese painter of great power and invention; he combined naïvety with the courtly sophistication of the International Gothic style. His most important work consists of a series of 8 panels dealing with the life of St Francis, painted for the town of Borgo San Sepolcro (1437–44).

Sassoferrato Giovanni Battista Salvi, called (1605–85). Italian painter of Raphaelesque Madonnas. He worked mainly in Urbino and was probably a pupil of Domenichino.

Saunders Raymond (1934—). African-American *abstract artist who has borrowed techniques and ideas from *graffiti art and modified them into brightly coloured, textured paintings expressing through symbols and letters urban life in the U.S.A., e.g. *Red Star* (1970). S. wrote in 1968, in a pamphlet entitled *Black is a Color*, that 'the indiscriminate association of race with art, on any level — social or imaginative — is destructive'. S. thought artists should resist racial identification and strive to express individual experience and identity.

Savery Roelandt (1576?–1639). Flemish painter of landscapes, animals and flowers, trained in Amsterdam. He worked in Prague and Vienna in the service of the Emperors Rudolf II and

Mathias, but later settled in Utrecht. Favourite subjects were the Garden of Eden and Orpheus enchanting the wild beasts.

Savinio Alberto. The pseud. of Andrea de Chirico (1891–1952). Italian writer, painter and concert pianist, brother of the painter De *Chirico.

Savoldo Giovanni Girolamo (c. 1480–c. 1550). Italian painter of religious subjects and portraits influenced by the Venetian school and Leonardo da Vinci. He anticipated Caravaggio in his realism and Elsheimer in his use of strange lighting effects.

Saxl Fritz (1890–1948). Viennese art historian. In 1929 he became Director of the Warburg Institute, which he had helped to found in Hamburg, and which, in 1944, was incorporated in the University of London, where he held the Chair of the History of the Classical Tradition. His books and papers in learned journals include Antike Götter in der Spätrenaissance, Mithras, Classical Mythology in Medieval Art (with Erwin Panofsky), Rembrandt's Sacrifice of Manoah, British Art and the Mediterranean (with Rudolf Wittkower), Pagan Sacrifice in the Italian Renaissance, The Classical Inscription in Renaissance Art and Politics and A Spiritual Encyclopaedia of the Later Middle Ages.

Scarpazza Vittore. Vittore *Carpaccio

Schack Adolf Friedrich, Graf von (1815–94). German art patron who built up an important coll. of paintings. S. was also a poet and novelist; his house was a literary centre in Munich.

Schad Christian (1884–1982). German artist, a member of Die *Neue Sachlichkeit movement as a painter. Around 1918 he experimented with photography and produced 'photograms' to which he returned in 1960 when he developed what *Tzara termed Schadographs – a method that, without the use of the camera, incorporated interferences with the development process. *Dada.

Schadow Johann Gottfried (1764–1850). German sculptor and art theorist, one of the leading exponents of Neoclassicism in Germany. He studied in Rome (1785–7). His works include the Quadriga of the Brandenburg Gate, Berlin and monuments to Frederick the Great (Stettin) and Luther (Wittenberg). His group of the princesses Louise and Frederike of Prussia (Berlin) is a good example of his earlier work.

Schadow Two Princesses 1795-7

IIis son Friedrich Wilhelm von Schadow-Godenhaus (1788–1862), a painter and writer, joined the *Nazarenes group in Rome (1811). He was director of the Düsseldorf Academy (1826–59).

Schaffner Martin (late 15th-early 16th c.). German late Gothic/early Renaissance painter of religious subjects and portraits, active in Ulm. His masterpiece is the *Wettenhausen altarpiece*.

Schalcken Godfried (1643–1706). Dutch genre and portrait painter best known for his genre scenes by candlelight. He studied under Van Hoogstraten, then under Dou, whom he imitated closely in his earlier works.

Schapiro Meyer (1904–96). Highly influential Lithuanian-born U.S. writer and teacher on art, whose ideas have had a profound influence on a large number of artists, art historians and critics.

such as D. Judd, R. E. Matta, R. Motherwell, L. Samaras, J. Ackerman, F. Hartt, R. Rosenblum, L. Steinberg. His publications include *Van Gogh* (1950), *Gézanne* (1952) and *Selected Papers* in 3 vols, and numerous articles in journals, incl. *Art Bulletin, Gazette des Beaux-Arts* and *Journal of Warburg and Courtauld Institutes*.

Schapiro Miriam (1923—). U.S. artist whose early works of the '50s were abstract paintings, but whose commitment to feminism in the '70s led her to explore *collage as a medium expressive of 'a responsibility to history to repair the sense of omission'. Her *appropriation of objects (e.g. buttons, cottons and silk) and crafts (e.g. embroidery and patchwork) traditionally exclusive to women and her re-presentation of them in *assemblages and *photomontages have often been collaborative and coined by her as 'femmages'. Through a meticulous geometrical

Scharff

layering that encompasses familiar female symbolism, S. has worked to challenge the stereotypical male–female dichotomy of intellect vs. emotion and to re-introduce the possibility of both.

Scharff Erwin (1887–1955). German sculptor. He ist studied painting but later took up sculpture while in France (1911–13). He was a founder-member of the Neue *Sezession group and his work shows the influence of Rodin and Maillol.

Schauffel(e)in Hans Leonhard (c. 1480–1538/40). German painter of portraits and religious subjects, and a woodcut designer, pupil and follower of *Dürer.

Scheemakers Henry (d. 1748). Flemish sculptor, brother of Peter S. He worked in Britain (c. 1720–33) sometimes as assistant to his brother.

Scheemakers Peter (1691–1781). Flemish sculptor. After studying in Rome he worked in Britain almost continuously from c. 1716 to 1771, first assisting Francis Bird, then in partnership with Laurent Delvaux. He executed the Shakespeare monument in Westminster Abbey and many tombs in the Abbey and in country churches. His work is highly competent but lacking in character. His son Thomas (1740–1808) was also a sculptor and worked in Britain.

Scheffer Ary (1795–1858). German-born Dutch painter, ill. and engraver. In France from 1811 on, S. gained great popularity with history and genre paintings and portraits.

Schelling Friedrich Wilhelm Joseph von (1775–1854). German philosopher who gave art the most important place in human activity; he exercised an important influence on Romantic writers.

Schiavone Andrea Meldolla (1522–82). Dalmatian painter and engraver who worked in Venice in a style derived from Parmigianino and Titian and influencing Tintoretto.

Schiele Egon (1890–1918). Austrian painter and graphic artist; with Klimt, who influenced him, and Kokoschka, one of the great *Expressionist artists of early 20th-c. Vienna. S.'s most powerful work is in his male and female nudes in pencil, gouache, watercolour, etc.; the figures express in their postures emotions from despair to passion — and the female nudes are often

Schiele Paris von Gütersloh, the Painter's Biographer (detail) 1918

unashamedly erotic. S. was primarily a draughtsman, and the angularities of his line and its nervous precision pervade all his work. His 1st real success came in the last year of his life, but full recognition was not accorded his work until the 1950s.

Schinkel Karl Friedrich (1781–1841). German architect. S. began as a painter and designer of theatre sets, with a special fondness for vast imaginary Gothic buildings. S. was also a noted painter of Romantic landscapes.

Schlemmer Oskar (1888–1943). German sculptor who studied at the Stuttgart Academy under Hölzel (1909–14, 1918–19). He exhibited at the Sturm Gallery, Berlin, in 1919 and from 1920 to 1928 was at the Weimar *Bauhaus teaching sculpture. His paintings, mural reliefs and sculpture run through a wide range of media in reducing the figure to a rhythmic play between convex, concave and flat surfaces. At the Dessau Bauhaus he directed the Bauhaus stage and taught the course 'Man'. His Triadic Ballet produced at the Landestheater, Stuttgart (1922), was performed at the Weimar Bauhaus in 1923; in it he extended the concepts of his sculpture by the introduction of time, movement and changing light. Under Nazi suppression he virtually retired in 1937.

Schlüter Andreas (c. 1664–1714). German sculptor and architect. In 1694 he was appointed court sculptor at Berlin (producing, e.g. an equestrian statue of Friedrich Wilhelm). He visited Rome and his chief work, the Royal Palace, Berlin (1698–1706) shows the influence

of Bernini. In 1713 he became chief architect to the Russian court; he died at St Petersburg.

Schmidt-Rottluff Karl (1884–1976). German artist born at Rottluff, near Chemnitz. He, *Heckel and *Kirchner founded Die *Brücke group in Dresden in 1906 and were joined by *Nolde and *Pechstein. He stayed with the group until its dissolution in 1913. S.-R. was one of the most brutally violent of the German *Expressionists, aggressively stark in drawing and raw in colour, e.g. *Two Women* (1912). In Berlin (from 1910) he was deeply influenced by Negro sculpture and produced several carvings, often brightly coloured, e.g. *Head* (1917) and woodcuts, e.g. *The Way to Emmaus* (1918).

Schnabel Julian (1951—). U.S. *Neo-Expressionist painter who came to notice in the late 1970s along with the Italians *Chia and M. Palladino, and the Germans *Kiefer and *Basclitz.

Schneemann Carolee (1939–). U.S. painter, *Performance artist, film maker and writer. Her work is known for its controversial themes: feminist history, sexuality and what she calls 'the body as a source of knowledge'.

Schnorr von Carolsfeld Julius (1794–1872). German painter who joined the *Nazarenes in Rome, 1817–25. He became head of the Dresden Academy in 1846 and exercised great influence in Germany.

Schöffer Nicolas (1912—). Hungarian-born French artist. From the late 1940s he has built 'spatio-dynamic' towers and *Kinetic art constructions, tall, outdoor metal skeleton frames which carry Plexiglas sheets, lighting units and mobile sections and broadcast randomly programmed taped music.

Schonbroeck Pieter (c. 1570–1607). Landscape painter born at Frankenthal, Germany, where his Flemish Protestant parents fled to escape religious persecution. There he was a pupil of *Coninxloo. He later worked in Nuremberg. Characteristic paintings are of mountain scenery with small figures.

Schongauer Martin (c. 1430–91). German painter, influenced by R. van der Weyden, and engraver. He worked mainly in Colmar and his only authenticated work, *Madonna of the Rose Bower* (1473), is in St Martin's church, Colmar. A number of other paintings, mainly of Madonnas and Nativity scenes, are attributed to

Schongauer Madonna of the Rose Bower 1473

him. His engravings exercised a powerful influence on *Dürer and on the development of the medium in Germany. H. Burgkmair was his pupil.

Schwind Moritz von (1804–71). Austrian painter and graphic artist, a representative of late German Romanticism; pupil of Cornelius. He attempted monumental murals but was more successful with smaller paintings such as *Das Knaben Wunderhorn* and *The Morning Hour* and book ill.

Schwitters Kurt (1887–1948). German painter, sculptor, writer, architect, typographer and publisher. He started painting in a Cubist idiom, but after World War I he became associated with the German *Dadaists. In 1918 he was the founder of the Dada group in Hanover. He lived in Norway from 1930 to 1937 and then in Britain. His 2 principal media were constructions and collage in which he used broken and idiscarded rubbish to create works of remarkable sensitivity, e.g. Opened by Customs (1937–9). He extended these ideas in what he called 'merz'

Scopas

Schwitters Merz 1003 - Peacock's Tail 1924

pictures, e.g. the 3 *Merzbaue*: Hanover (1920–2; destroyed 1943), Oslo (1930–7; burnt 1953) and Langdale, Westmorland (1947–8), constructions which filled a whole building.

Scopas (mid-4th c. BC). Greek sculptor of the early *Hellenistic period. The tendency towards violent action and pathos in his work became typical of much Hellenistic sculpture. He worked on the famous Mausoleum at Halicarnassus.

Scully Red Way 1992

Scorel Jan van (1495–1562). The first Dutch painter of importance to study in Italy and responsible for introducing the Italian High Renaissance to the Netherlands. He was widely travelled and was appointed by Pope Hadrian VI superintendent of the Vatican Coll. In Rome he was influenced by Michelangelo and Raphael, particularly the latter. He returned to the Netherlands in 1524. His works include *Pilgrims to Jerusalem, St Mary Magdalene* and *Holy Kinship*.

scorper. A small chisel or gouging instrument used in wood- or metal-engraving for clearing large areas of a block or for engraving broad lines.

Scott Samuel (c. 1702–72). British marine and topographical painter. In his early work he followed W. van de *Velde the Elder and the Younger but later, inspired by *Canaletto's success in London, turned to views of the City and the river Thames.

Scott William (1913–89). Scottish painter. S. first won reputation with simplified still-lifes; since the late 1960s these have been reduced to arrangements of basic, coloured forms.

Scott William Bell (1811–90). Scottish poet and painter, friend of D. G. Rossetti and Swinburne. His *Autobiographical Notes* ... (1892) gives an idea of 19th–c. literary and artistic circles. It has now been revealed that an unsatisfied love for S. motivated the intensely sad love–poems of Christina Rossetti.

Scully Sean (1945—). Irish abstract painter working in N.Y. and London. His multipanelled, textured works of rich and muted colours in oils are characteristically striped and chequered. His almost ritualistic method of working — familiarizing himself with the 'feeling' of painting, sometimes substituting one panel for another — confers the 'immediacy' and 'associational power' he sees in figurative art. S.'s titles suggest his inspirations — admired writers and painters, places, emotions and, lately, women — e.g. Barra, Spirit and Lucia (all 1992).

scumbling. In oil painting, the technique of working a layer of opaque colour over an existing colour in such a way that the latter is only partially obliterated and a broken effect obtained.

Sebastiano del Piombo (1485–1547). Venetian painter of religious subjects and portraits, born Sebastiano Luciani but known as 'del

Sebastiano del Piombo Flagellation 1517-24

Piombo' (It. seal) after his appointment as keeper of the Papal seal. His early style was in the manner of Giorgione, some of whose work he completed. In 1511 he went to Rome to work at the Villa Farnesina, where he met and was influenced by Raphael. Later he became a friend and follower of Michelangelo, who supplied the drawings for some of S.'s paintings such as the *Flagellation* in S. Pietro in Montorio, Rome. S.'s late work forms a link between the Venetian school and the High Renaissance in Rome.

Sebree Charles (1914–85). African-American painter, ill. and writer active in the 1930s Chicago art scene. Boy in a Blue Jacket (1938) displays both the influence on him of *Post-Impressionism and his stylistic interest in *Expressionism. Some of his works were exhibited at the Art Institute of Chicago. S. moved to N.Y. in 1940 where he also designed sets for the theatre.

Segal George (1924—). U.S. sculptor who began his career as a painter. S. studied at Cooper Union, N.Y., Pratt Institute of Design and N.Y. University. S. exhibited regularly from 1956 but won special acclaim in the 1962 N.Y. exhibition 'New Realists'. He is noted for life-sized white plaster figures cast from life, frozen in a gesture or pose and often juxtaposed with colourful, real everyday environments. Examples include *The Gas Station* (1963—4), *The*

Diner (1964–6), The Bowery (1970) and The Curtain (1974).

Segantini Giovanni (1858–99). Italian painter noted for his landscapes of Alpine scenery and who, in later life, painted strangely symbolic pictures, e.g. *The Bad Mothers*. There is an S. museum at St Moritz.

Seghers Daniel (1590–1661). Early Flemish flower painter, pupil of Jan Bruegel the Elder. He specialized in floral garlands surrounding religious paintings and portraits often by another artist

Seghers Hercules Pietersz (1589/90–after 1633). Dutch landscape painter and etcher, a pupil of *Coninxloo; he may have visited Italy and come into contact with *Elsheimer there. His rocky landscapes with dramatic lighting effects were expressive of awe at the sublimity of nature; they considerably influenced Rembrandt's landscapes. S. produced powerfully imaginative experimental etchings using inks of different colours and printing on coloured paper and canvas.

Segonzac André Dunoyer de (1884–1974). French landscape, still-life and figure painter in a personal style influenced by Cézanne and the *Fauves, graphic artist and theatrical designer. Many of his paintings are in watercolour. Among the books he ill. are Colette's *La Treille Muscate* and Virgil's *Georgics*.

Seligmann Kurt (1900–62). Swiss painter, graphic artist and theatrical designer in the *Surrealist tradition. In 1939 he settled in the U.S.A.

Sellaio Jacopo del (c. 1441–93). Florentine painter, pupil of Fra Filippo Lippi and strongly influenced by Botticelli. His only fully authenticated work is a *Pietà* (Berlin) from S. Frediano, Florence.

sepia. A brown pigment prepared from the inky secretion of the cuttle-fish and used in watercolour and ink, often in monochrome. It was not much used until the 19th c. and should not be confused with *bistre.

serial imagery. The same image repeated several times, sometimes with slight variations, in a contemporary painting or sculpture. The image chosen can be figurative (*Warhol) or abstract (Judd and other *Minimal sculptors).

serigraphy. A print making technique based on stencilling. Ink or paint is brushed through a fine

Serov

screen made of silk, and masks are used to produce the design. These can be made of paper, or from varnish applied to the silk itself. Also called silk-screen printing.

Serov Valentin (1865–1911). Russian painter, teacher at the Moscow School of Art (1897–1909) and a contributor to *The *World of Art* magazine and exhibitions. S. was brought up on *Mamontov's estate and taught at the *Abramtsevo Colony. He painted the famous men of his day, but 1 of his best-known works is *Girl with Peaches* (1887), depicting Mamontov's daughter. He was also a talented landscape painter.

Serra Jaime (d. before 1395) and Pedro (d. after 1405). The most important Catalonian painters of the late 14th c. They continued the Sienese tradition introduced by Ferrer Bassa. Pedro's altarpiece *The Holy Spirit* in Manresa cathedral is a fine example of their work.

Serra Richard (1939—). U.S. Minimalist sculptor who, like *Judd or *Andre, used as ways of composition repetition, regularity of units and intervals between them; for S., like R. *Morris and *Smithson, transience of structure (e.g. One-Ton Prop [House of Cards], 1969), ordering, allowing weight to determine where a composition ends (e.g. Stacked Steel Slabs, 1969), are also important considerations.

Sérusier Paul (1865–1927). French painter, founder of the *Nabis group in 1889 under the influence of *Gauguin.

Sesshu (1420–1506). Japanese *sumi-e painter of the *Muromachi period. He excelled in a conventional academic style which influenced the *Kano family as well as an intense individual calligraphic technique derived from the Chinese *Sung and *Yüan masters, e.g. the renowned landscape scroll (1486).

Settignano Desiderio da. *Desiderio da Settignano

Seurat Georges (1859–91). French painter born in Paris. S. studied at the École des Beaux-Arts (1878–9) where he was a model academic student. Early drawings show a complete absorption of *Ingres's classical discipline and his careful preparation in sketches and colour studies for each of his 7 large paintings was thoroughly traditional. His successive investigations of form, colour and line were part of a lifelong search for a sense of order in painting.

Most of his early independent works were *conté* drawings reflecting *Millet in subject, in which a monumentality of form was realized by gradual tonal gradation.

His Baignade (1883-4) shows the simplicity of his early works enforced by the carefully calcu-

Seurat Baignade 1883-4

lated composition and by a palette of primary colours. His study of colour was based not on the empirical observation of the *Impressionists, but on research into the writings of Chevreul, Blanc, Superville and Delacroix. In his theory of *Divisionism (later called *Neo-Impressionism) each local colour is composed of tiny particles of pure colour which not only represent the colour of the object, but also the colour of light, reflected local colours and complementaries. These are blended at a distance by the eye. The purest example of this is *Un Dimanche d'été à l'Île de la Grande Jatte* (1884–6).

His later works – Poseuses (1886–7), Parade (1887–8), La Poudreuse (1889), Le Chahut (1889–90) and Le Cirque (1890) – become increasingly linear and decorative, reflecting both the curvilinear arabesques of Art Nouveau and his own life-long interest in popular art (posters, prints, etc.). The widespread use of his Divisionist technique illustrates his superficial influence on almost all painters. Of a more long-term significance were his liberation of pure colour and his reaction against Impressionism's formlessness, which – like Cézanne – foreshadows the structural discipline of later abstract art.

Seven. *Group of Seven

Seven and Five Society. Group of 7 British figurative painters and 5 sculptors founded (1920) and subject to annual re-election. By 1935, when the group, renamed the '7 and 5' Abstract Group, mounted Britain's 1st allabstract exhibition, leading members were *Hepworth, H. *Moore and B. *Nicholson.

Severini Gino (1883–1966). Italian painter who signed the Futurist Manifesto (1910) and was one of the most significant members of *Futurism; from 1906 he lived chiefly in Paris. His Futurist paintings include Dance of Pan-Pan (1911) and Dynamic Hieroglyph of the Bal Tabarin (1912). He later allied himself with the Cubists and as a result of his theoretical studies publ. Du Cubisme au Classicsme (1921). This was followed by a period of representational, almost academic painting; later he returned to a non-figurative idiom. His works include murals and mosaics.

Severn Joseph (1793–1879). British portrait and subject painter, a friend of Keats. He accompanied the poet to Italy in 1820 and was with him at his death. He painted many portraits of Keats.

Seymour James (1702–52). British painter, with *Wootton a pioneer of sporting art in Britain.

He specialized in hunting and racing subjects and was noted for his horse portraiture.

Seymour Robert (1798–1836). British ill., caricaturist, engraver and painter whose fame rests on his ills for *The Pickwick Papers* by Dickens, one of his last commissions before he committed suicide.

Sezession (Ger. secession). Term for the groups of German and Austrian artists who in the 1890s resigned from the recognized academic organizations in order to further the modern (mainly *Impressionist and *Art Nouveau) movement. The most important were the S.s of Munich (1892), Vienna (1897) and Berlin (1899). The most avant-garde, the Berlin S., evolved from the rejection of Munch's paintings in the Berlin Artists' Association (1892). In 1910 the Berlin S. split and the Neue *Sezession was formed; its members included Nolde, Pechstein and other artists who later formed Die *Brücke, as well as Kandinsky and Jawlensky.

sfumato (It. evaporated). The rendering of form by means of subtle tonal gradations so as to eliminate any sharply defined contours. The work of Leonardo is an example.

Shahn Ben (1898–1969). Russian-born U.S. painter. After study in N.Y. he travelled in Europe and Africa (1927–9). He collaborated with *Rivera on the Rockefeller Center murals (1933) and became one of the major figures in the wave of U.S. realist painting in the 1930s. His tightly drawn, slightly caricatured realism often has a satirical element reminiscent of late German *Expressionism (Dix, Grosz, etc.). He painted several public murals under the *W.P.A. Art Project.

Shapiro Joel (1941-). U.S. sculptor who first showed *Minimal works in N.Y. in 1970. He soon allowed (from 1975) toy-like, miniature representations of familiar objects into his work. They were there for their purely formal qualities, e.g. a table, bridge, ladder and most commonly houses cast in iron or lead, exhibited sparsely on the floor or on shelves, in disproportionately vast spaces. In the '80s, S.'s works, in squared-off blocks of wood, or wood cast in patinated bronze, were on a larger scale and made abstracted, or reduced, reference to the human figure in a *Constructivist-like manner, but also showed how closely the artist considered the grand tradition of modernist sculpture, from *Brancusi to *Giacometti and D. *Smith.

Shchukin

Since the mid-80s he has made box-like sculptures which, as in his previous work, address the fundamental issues of sculpture as form in space.

Shchukin Sergei (1851–1936). With the *Morosovs, the Shchukin family, esp. Peter (1852-1912) and Sergei, became great and distinguished patrons and collectors. Peter collected prints, drawings and rare books, as well as Russian and Eastern art and decorative arts. His brother Dimitri collected Old Masters, esp. Dutch School, Flemish masters and French pictures including *Watteau, *Boucher and *Fragonard. It was Sergei, however, who became most famous outside Russia. From the end of the 19th c. to the year of the Revolution his collection of modern French art parallels its development, and it attracted the attention of students and lovers of art. His collection was visited in Moscow to be studied, and it exerted a revolutionary influence on contemporary Russian art; S. had a lively personal contact with the young artists who flocked to his house to look at the 'new' art. He assembled a rich collection of works - many through the Durand-Ruel Gal. - by Braque, Cézanne, Degas, Derain, Gauguin (over 15 of Gauguin's paintings were displayed in his dining room), Manet, Monet, Matisse (so many of his works - over 20 paintings in the Grand Salon of his house - that his collection was dubbed 'the apotheosis of Matisse'), and Picasso (through the art dealer *Kahnweiler) of whose work he was the 1st collector.

Sheeler Charles R. Jr (1883–1965). U.S. painter of industrial architecture and machinery, a leading exponent of *Cubist-Realism (or Precisionism) exemplified in *New England Irrelevancy*. In the 1930s, beginning with scenes of the River Rouge Plant for Ford, he worked in a style of straight realism, influenced by his work as a photographer. *Magic Realism.

Shepard E(rnest) H(oward) (1879–1976). British ill. renowned especially for his ills to A. A. Milne's Winnie the Pooh books and K. Grahame's *The Wind in the Willows* (1931). S. also worked many years for *Punch*; his publs included the autobiographical *Drawn from Memory* (1957).

Sherman Cindy (1954–). U.S. *Postmodern artist using black-and-white and colour photographs. Her works, usually in series, in which she is exclusively the subject, are not self-portraits: the many stereotype 'characters' she simulates, 'plays' and photographs are depicted

Sherman from Untitled Film Stills 1979

in ways that are often rife with narrative ambiguity. Her disguises range from stereotypes of women on TV, in films, girlie magazines and advertisements, to subjects from fairy-tales, myths, operas and Old Master paintings. S.'s 'Untitled Film Stills' series (c. 75 in total), begun in 1977, is made up of small, documentary-like black-and-white photographs based on '40s and '50s film noir B-movies, taken in her studio and around Manhattan, which hint at narrative. In the early '80s S. produced a series of 'horizontal' (2 ft [0.6 m.] by 12 ft [3.7 m.]) Playboy-type photographs which focus on the mood and individuality of the 'model' - 'the part the photographer doesn't want to take pictures of'. She subsequently used different techniques and formats, including Cibachrome colour and 6 ft (1.8 m.) large prints. In a new series, started in the '90s S. disguised herself as either a male or female subject from famous Old Master portraits, e.g. Untitled (1990), in which she is a Bacchus by Caravaggio. S. has said that her purpose is 'to go blank': through this effacement of her own 'self', she addresses the issue of identity in images that might in other contexts remain unquestioned.

Shields Frederic James (1833–1911). British painter and ill. influenced by Rossetti.

Shinn Everett (1876–1953). U.S. painter, member of The *Eight. Influenced by Degas, he abandoned urban realism for subjects from the theatre and theatrical decoration.

Shunga-Kanva. Cultural period in N. India (c. 184 BC–AD 17) named after its 2 dominant dynasties. The most famous Shunga monument is the stone *stupa* railing from Bharhut, imitative of split-log wooden prototypes, on the inscribed uprights of which are carved nature spirits assimilated to Buddhism. Other sites include Besnagar and important sculptures at Bodhgaya which are probably Kanva.

Siberechts Jan (1627–c. 1700). Antwerp land-scape painter who settled in Britain and was one of the earliest interpreters of the British land-scape and country-houses.

Sickert Walter (1860-1942). British artist, the leading British Impressionist painter. S. studied under Whistler and was much influenced by his friend Degas, whose wit and meticulous draughtsmanship he appreciated fully. He employed Impressionist techniques to portray interiors, often of the theatre, using, however, sombre tones to express the nuances of colour rather than light. S. also painted landscapes and townscapes in London, Dieppe and Venice. In 1911 he helped to found the *Camden Town Group and was also a member of the *New English Art Club and the *London Group. In London, after 1905, he was associated with *Gore, L. *Pissarro and *Gilman. The coll. A Free House! (1947) reveals that S. was a fluent writer on artistic subjects.

Sickert The Old Bedford c. 1890

Siena, school of. School of Italian painting which flourished between the 13th and 15th cs and for a time rivalled Florence, though it was more conservative, being inclined towards the decorative beauty and elegant grace of late Gothic art. Its most important representatives include *Duccio, whose work shows Byzantine influence; his pupil *Martini; Pietro and Ambrogio *Lorenzetti; Domenico and *Taddeo di Bartolo; *Sassetta; and *Matteo di Giovanni. In the 16th c. the Mannerists *Beccafumi and *Sodoma worked there.

Signac Paul (1863–1935). French painter who joined Seurat and with him worked out the theoretical principles of *Neo-Impressionism which he defined in *D'Eugène Delacroix au néo-impressionnisme* (1899). He was the most rigid exponent of *Divisionism.

significant form. Term used by the British art critic C. *Bell in 1913 to describe the essence of works of art, which he saw in terms of forms, and relationships of forms. Form itself is, according to Bell the true content of the work of art, and other kinds of content (e.g. narrative and symbolic elements) are secondary.

Signorelli Luca (1441–1523). Italian painter, pupil of Piero della Francesca. S. anticipated Michelangelo in his interest in nude figures in

Signorelli Study for the Martyrdom of a Saint

silhouette

action, though he was not entirely successful in his attempts to depict movement. His work finds its most complete expression in the famous fresco cycle at Orvieto cathedral (1499–1503), a series of semicircular compositions conveying his vision of life, death, damnation and resurrection. The story is told in a harsh, brutal manner which emphasizes the solemnity and horror of the subject. S.'s interest in the formal qualities of dramatic action pervades his religious compositions and portraits. S. worked on the frescoes in the Sistine Chapel in the 1480s.

silhouette. A profile outline, sometimes a head, cut out of black paper or painted or drawn from shadow. The medium was at its most popular in the 18th c. and early 19th c. and derives its name from Étienne de Silhouette (1709–67), an unpopular French finance minister, whose hobby was cut-out portraiture.

silk-screen printing. *serigraphy

silver point. 15th–16th–c. drawing technique; Dürer was a master of the medium. A silver pointed pencil (sometimes gold or lead) was used on paper, often tinted, prepared with an abrasive compound. Although heightened effects were obtained with opaque white, s. p. depended fundamentally on line; shading for example was possible only by *hatching. The s.-p. line was indelible.

Singler Gustave (1909–). Belgian-born French painter, of the school of *Paris.

Siqueiros David Alfaro (1896–1974). Mexican painter; with *Rivera and *Orozco, one of the great contemporary Mexican muralists. He

Sisley The Flood 1876

Siqueiros Echo of a Scream 1937

fought in the Mexican Revolutionary army and his left-wing political and trade union activities led to frequent periods of imprisonment and exile; his large-scale paintings are full of energy and violence, mirroring his rebellious spirit (e.g. Flowers, 1962). In Europe (1919) he and Rivera formulated principles for creating a public art derived from the *Pre-Columbian tradition. From 1922 S. painted many huge, turbulent, crowded murals, e.g. The Mexican Revolution. He used a variety of mediums and styles evolved from *Surrealism.

Sisley Alfred (1839/40–99). Painter born in Paris of British parents. While a student under Gleyre (1863–4) he met Monet, Renoir and Bazille and painted with them near Fontaine-bleau. He made 4 visits to Britain (1871–97); from 1880 he lived at Moret-sur-Loing. Influenced at 1st by Corot, he became a central figure of the *Impressionist group, exhibiting with them (1874, 1876, 1877, 1883). The paintings of the floods at Marly are paramount examples of Impressionism, freshly painted in clear colour; his landscapes are mostly of the Îlede-France.

Sistine Chapel. A private chapel of the Pope, also used for Papal elections. It is a long plain room covered with a tunnel-vault pierced by windows. Built in 1473 for Sixtus IV (whence the name) it was decorated (1481–3) with large frescoes by *Botticelli, *Ghirlandaio, *Perugino, *Pinturicchio and *Rosselli. Between 1508 and 1512 the ceiling was painted by *Michelangelo in 9 main scenes (from the Creation to Noah) surrounded by Prophets, Sybils and nude youths. In 1536–41

Michelangelo returned to paint *The Last Judgement* on the E. wall behind the altar.

Situation artists. 18 British painters, e.g. *Denny, *Hoyland and R. *Smith, who mounted an exhibition in London in 1960 of large abstract pictures at least 30 ft (9.14 m.) square. The aim was to fill the spectator's field of vision and so make him participant in a situation created by the artwork.

Six Dynasties, the. Period in Chinese history (265–581) marked by political disunion and the ascendance of Buddhism in the arts. Outstanding painters were the 4th-c. *Ku K'ai-chih and the 6th-c. theorist *Hsieh Ho and Chang Sengyu at the 6th-c. court of Nanking. In sculpture a gilt bronze Sakayamuni Buddha (338) reveals the influence of *Gandhara. Shrines and colossal figures of Buddhas and attendant figures were hewn out of the cliffs at Ping-ling-ssu and Maichi-shan, Kansu (begun 4th c.), Tun-huang, W. Chinese Turkestan (366 onwards), Yunkang, Shansi (5th c.) and Lung-men, Honan (late 5th-6th c.). Remarkable wall paintings also survive at the 1st 3 sites, notably Tun-huang.

sketch. Quick drawing or painting made as an aid to memory or a rough draught of a painting made to give the artist some idea of what the completed work will look like. Some of the s.s of artists such as Constable have a spontaneity which is lost in their finished paintings. In the case of Rubens, the full-scale compositions were frequently the work of pupils whereas his s.s were his own.

Slevogt Max (1868–1932). German *Impressionist painter, ill. and theatrical designer trained in Munich (1885–9) and Paris (1889).

Sloan John (1871–1951). U.S. realist painter, ill. for newspapers in Philadelphia and N.Y., and cartoonist, one of the most important members of The Eight. His city scenes include *Greenwich Village Backyards* (1914). His later studies of nudes show an interest in formal problems.

Sluter Claus (d. c. 1405). Netherlands sculptor in the service of Philip the Bold of Burgundy. He assisted Jean de Marville in constructing the portal of the Carthusian monastery at Champmol, completing it in 1400 with the addition of 4 figures. The duke's tomb (Dijon Mus.), begun in 1384, was only completed in 1411 after S.'s death. Carved in black-and-white marble, the duke's effigy was placed on a slab surmounting a rectangular base flanked by figures in different

attitudes of grief. This tomb and the well-head, *The Well of Moses* (1395–1406), with its powerful figures of the Prophets, anticipating Michelangelo, were influential well into the 16th c. S. was a great innovator in the expressive handling of drapery, realism of gesture and rendering of character type. Regarded as the founder of the Burgundian school.

Sluyters Jan (Johannes Carolus Bernardus) (1881–1957). Dutch Post-Impressionist painter of portraits, still-lifes and nudes in a personal expressionistic style.

Smart John (1741–1811). British portrait painter and miniaturist, friend of *Cosway. He worked in India from 1784 to 1797.

Smet Gustave de (1877–1943). Belgian *Expressionist painter. During World War I he stayed with Van den Breghe in Holland, where he came into contact with German Expressionism. After the war he worked with Permeke and other Expressionists at Laethem-Saint-Martin. He painted many scenes of rural life, stylized in a manner reminiscent of child art.

Smibert John (1688–1751?). Scottish portrait painter, a follower of Kneller, who worked in Italy and London before going to America in 1728 and settling in Boston. He established the New England tradition of portrait painting.

Smith David (1906–65). U.S. sculptor, a pioneer in the field of metal sculpture. Originally a painter, he studied at the Art Students League; he turned to reliefs and free-standing structures in the mid-1930s, deriving from the Surrealist work of *Picasso and *Gonzalez; he held his 1st 1-man exhibition in 1938. His work ranges from the semi-representational (e.g. Sentinel IV, 1957) to monumental geometric constructions in his last years (e.g. Cuhi XVIII, 1964).

Smith Sir Matthew (1879–1959). British painter who studied at Manchester School of Art (1900–4) and the Slade School, London (1905–7), worked at Pont-Aven, Brittany (1908) and studied in Matisse's studio (1910). Fitzroy Street Nude No. 1 (1916) in its strong colour and simplified forms, shows the extent of S.'s absorption of *Fauvism, which was also brilliantly expressed in his early Cornish landscapes. In his later nudes, landscapes and flower paintings form suffered from an expressive flamboyance of paint and colour.

Smith Richard (1931-). British painter who has worked much in the U.S.A., influenced by

Smithson

F. *Stella, *Poons and R. *Morris; he exhibited (1960) with the London *Situation artists. He has exploited pictorial elements from advertising and commercial packaging of consumer products, and his concern with colour and space has led to work with 3-dimensional shaped canvases. Later work includes *multiples and kite-like cloth hangings.

Smithson Robert (1928–73). U.S. artist, one of the most prominent practitioners of *Earth art. Originally a *Minimal art sculptor of 'primary structures', S. developed his concept of 'sites and nonsites', a notion which affected greatly the development of 'site sculpture' (art made in specific outdoor locations) in the late '60s and in the '70s. His 2 major earthworks were *Spiral Jetty* (1970), a mud and rock coil in Great Salt Lake, 1500 ft (457.2 m.) long and 15 ft (4.57 m.) wide, and *Broken Circle/Spiral Hill* (1971). *Long.

Snyders Frans (1579–1657). Flemish painter of still-life subjects, animals and hunting scenes, pupil of P. *Bruegel the Younger and H. van Balen. He worked in Antwerp, often collaborating with Rubens, in whose pictures he painted the flowers and fruit. One of his best-known paintings is *The Kitchen Table*.

Socialist Realism. Pronounced as a dogma for all Soviet artists in all fields of art in 1934. It aimed to produce art comprehensible to the masses, and inspire the people with admiration for the dignity of the working man and his task of building Communism. Heroic idealization of work and the worker was the required theme, and the guiding hand of the Communist party and its discipline was to mould and prune artists, in order to create, in Stalin's words, worthy 'engineers of souls'. The approved techniques were derived from the realistic and naturalistic traditions.

Social Realism. A term used to describe paintings of the life and environment of the lower middle and working classes in the 20th c. The 2 main groups generally identified as S.-r. painters are The *Eight, painting after 1900 in the U.S.A., and a British group (*Kitchen Sink school), working in the 1950s, among them John Bratby, Derrick Greaves, Edward Middleditch and Jack Smith.

Sodoma Giovanni Antonio Bazzi, called Il (1477–1549). Italian painter who worked chiefly in Siena in an elegant mannered style. According to Vasari, who disliked him, he got

his nickname on account of his homosexuality. However, he used it himself in his signature. In 1498 he went to Milan, where he was strongly influenced by Leonardo da Vinci, and in 1501 to Siena. His work there included the completion of a series of frescoes begun by Signorelli in the monastery of Monte Oliveto and the notable *Vision of St Catherine* in S. Domenico. He was employed in the Vatican and the Villa Farnesina, Rome.

Soest Gerard (d. 1681). Portrait painter, either from Germany or the Netherlands, who worked in Britain from 1656. He painted fine male portraits but never rivalled *Lely as a fashionable portraitist because his rough manners made women dislike sitting for him.

Soffici Ardengo (1879–1964). Italian artist and writer. After taking part in the Cubist movement in Paris S. became one of the most vociferous members of Marinetti's *Futurist group and wrote violent but brilliant polemics and poems.

Solano Susana (1946-). Spanish sculptor living in Barcelona. Her sensuous, handwrought works in bronze and iron from the early to mid-80s, made with unsophisticated tools and referring often to domestic and natural spaces, embrace a variety of ambiguities, e.g. the relationship between interior and exterior space, which the critic Barbara Rose has described as 'our experience that these volumes are hollow'. Since the mid-80s, S. has produced works with sleeker lines and suggestions of colour, e.g. Thermal Station No. 1 (1987), using sheet iron, plate glass, marble and wire mesh, and photographs to explore effects of light and dark. Works include Dos Nones (1988), You Shall Not Pass (1989) and Here Lies the Paradox (1990-1).

Solari(o) Andrea (d. c. 1520). Milanese painter who was influenced by the work of Antonello da Messina on a visit to Venice and by Leonardo da Vinci in Milan. One of his finest paintings is *Madonna with the Green Cushion*. His brother Cristoforo (d. 1527), called 'Il Gobbo', was an architect and sculptor.

Solari(o) Antonio da (fl. 1502–18). Italian painter nicknamed 'Lo Zingaro' ('The Gypsy'). He was a follower of Giovanni Bellini and Carpaccio and worked mainly in Naples. He is best known for his frescoes of the life of St Benedict in S. Severino, Naples.

South-west Indian cultures

Soldati Atanasio (1887–1953). Italian painter who developed a purely abstract style after World War II and gathered round him in Milan the 1st group of Italian abstractionists.

Solimena Francesco (1657–1747). Italian painter who worked mainly in Naples; one of the most famous exponents of late Baroque decorative painting. The chief formative influence on S.'s style was that of Giordano but tempered with elements borrowed from Maratta's classicism. Representative paintings are in the churches of S. Paolo Maggiore and Gesù Nuovo, both Naples. His many pupils included *Conca and *Ramsay.

Solomon Simeon (1840–1905). British painter and ill. Talented early *Pre-Raphaelite works earned S. a wide reputation but his arrest for homosexuality (1871) ended his career and he died a destitute alcoholic. S. did ills for Swinburne's poems and, later, insipid drawings and pastels of mythological and biblical subjects.

Somer Paul van (1577/8–1621/2). Flemish portrait painter, possibly trained in Italy, who worked in the Netherlands and from 1616 in London where he was patronized by the court. His most important painting is a full-length portrait of Queen Anne of Denmark (1617).

Sonfist Alan (1946–). U.S. artist whose work is exclusively related to nature and its processes, as in wet canvases enclosed in sealed Plexiglas boxes, which gradually become mildewed. In other works, a colony of ants, warren tunnels, twigs, etc. reveal the organic processes, and therefore the essential component of time, which S. uses as his subject matter.

Sonnier Keith (1941). U.S. sculptor, writer and *video artist whose primary concern with communication and the use of technology fuses pictorial and verbal language. The apparatuses he sets up in his works using neon lighting, microphones, telephones, TV sets, videos and satellites are effectively self-contained communication systems, e.g. Expanded Set, Send Receive (both 1979) and Aesthesipol (1982).

Soto Jesús-Rafael (1923—). Venezuelan artist who settled in Paris in 1950. He soon became engaged in *Op(tical) research and in 1954, together with other practitioners of *Kinetic art, joined the Galerie Denise René which became the forum for their experiments in perception, illusion, movement and change. The kinetic

effect in his work (e.g. *Petite Double Face*, 1967) is obtained by the superimposition of a grille (wires or nylon cords, etc.) on a painted panel, sometimes 3-dimensional, or mobile.

sotto in sù (It. from below upward). Term applied to foreshortening in a ceiling painting so that from below the figures have the appearance of floating in space. It was used by *Mantegna (Camera degli Sposi frescoes, Mantua) and reached its highest point of development in the *Baroque period.

Soulages Pierre (1919—). French painter principally self-taught under the inspiration of prehistoric and medieval art. His mature style did not fully develop until, after his military service (1940–5), he emerged as one of the leading members of the post-war school of *Paris. He made a reputation partly as a theatrical designer. He 1st exhibited in 1947.

Southern school. *Chinese art

South-west Indian cultures (North American). *Hohokam, *Mogollon, *Pueblo

Soutine Flayed Ox 1925

Soutine

Soutine Chaim (1894-1943). Russian painter. He moved to Paris (1913), living in desperate there he met *Chagall *Modigliani. Like theirs, his work was only tenuously connected with the current Parisian mainstream. S.'s art is closer to other isolated such *Nolde *Expressionists as *Kokoschka. Under the influence of the *Fauves and Van *Gogh, the haunted melancholy of his early work gave way to the volcanic violence of colour and technique in the landscapes painted at Céret (1919-22), e.g. Gnarled Trees whose crude brushwork witnesses furiously expended energy. These are some of the most extreme examples of Expressionism.

With a growing patronage from 1923 (most of his works are still in private colls) his financial hardship was over, but the disturbing images persisted, painted in the colour and texture of raw flesh, e.g. the Rembrandt-inspired *Carcass of Beef.* Only in his last works, e.g. *Windy Day, Auxerres* (1939), does a lyrical decorative quality appear.

Spada Leonello (1576–1622). Bolognese painter of religious and genre subjects who studied at the Carracci Academy before entering *Caravaggio's studio in Rome. He accompanied Caravaggio to Naples and Malta and became a close follower of his style. He ended his career in Parma, softening his style under the influence of *Correggio.

Spagna Giovanni di Pietro called lo (d. 1528). Spanish painter who worked in and around Perugia. He was a follower of *Perugino and *Raphael.

Spero Codex Artaud (detail) 1971

Spencer Double Nude Portrait: the Artist and his Second Wife 1937

Spencer Sir Stanley (1891–1959). British painter born in Cookham, Berkshire, where he spent most of his life. He studied at the Slade School, London (1908–12). Untouched by modern art and a meticulously dry craftsman, he was an isolated eccentric of British 20th-c. art. He was gifted with an extraordinary visual imagination; most of his paintings were of religious subjects poetically interpreted in the context of Cookham Village, e.g. Resurrection Cookham (1923-7). After 1932 he felt that his visionary power had left him and that all subsequent works were uncertain and incomplete. He decorated the Burghclere chapel (Soldiers Resurrecting, 1926-32) and was an official war artist (1940-1).

Spero Nancy (1926–). U.S. artist who, since the mid-60s, has worked on paper and whose preoccupation with abuse against women has been the principal concern of her often disturbing work, e.g. *The Torture of Women* (1976). Her large collage-like works on paper scrolls encompass female figures of differing scales (present, past and mythological), combined with textual fragments, e.g. from the media, demonstrating a political and historical sensibility keen to document but which offers no solutions. S.'s works include *Codex Artaud* (1971), *Tortured in Chile* (1974) and *The First Language* (1981).

Spillaert Leon (1881–1946). Belgian painter. His works include gouaches, watercolours and ink drawings of his native Ostende and also ills

for poetry by his friend M. Maeterlinck. These combine Symbolist and Expressionist elements with Surrealist-like dream motifs.

Spinello Aretino (fl. 1371–1410). Italian painter of the early Florentine school who anticipated Masaccio in reviving the tradition of Giotto. He worked in Arezzo, Florence, Pisa and Siena, painting frescoes and altarpieces.

Spitzweg Carl (1808–85). German painter of delicate Romantic landscapes and anecdotal pictures of eccentric small-town characters such as *The Poor Poet* (1839).

Spoerri Daniel (1930–). Swiss artist, one of the members of the *Nouveau réalisme movement which was founded in 1960. He makes assemblages of objects from everyday life, reflecting the Dada and Surrealist obsession with the fantasy of the commonplace object. In 1959 he founded Multiplication d'Art Transformable (Μ.Λ.Τ.). *décollage, *Rotella, *Villeglé, *Hains and *Vostell.

Spranger Bartholomeus (1546–c. 1611). Flemish painter of religious and allegorical subjects who worked in Rome, Vienna and Prague. He followed the rhetorical style of late Italian *Mannerism derived from Correggio and Parmigianino.

Spraycan art. Comic-strip style murals rooted in, and expressive of, inner-city life, which originated in the *graffiti art of the N.Y. subways in the '70s and '80s and which has spread throughout the cities of the Western world. In the U.S.A., S. a. is commonly employed in the creation of memorials to victims of city life.

Squarcione Francesco (1397–1468). Italian painter, teacher and antiquarian, founder of the school of *Padua. He travelled in Greece and Italy coll. antique works. These influenced his own work and that of his pupils who included *Mantegna, *Tura and *Crivelli.

Stael Nicholas de (1914–55). Russian painter who studied at the Académie des Beaux-Arts in Brussels, and settled in Paris in 1932; he was influenced by *Braque, whom he met in 1940, and also by the spirit generated by the *Bauhaus. His abstract and lyrical style is characterized by use of boldly defined masses, painted in rich contrasting tones. He slowly gravitated towards representational paintings, with his colour becoming more subdued and neutral. He committed suicide.

Staffage. French term used in English for the figures, human and animal, in a landscape. Often landscape painters, particularly Dutch 17th– and 18th–c. masters, employed a second painter to add the S.

stained glass. Pieces of glass stained with metal oxides are joined together with leading, and details can be painted on. Unique among the visual arts, s. g. is illuminated by diaphanous rather than reflected light. It probably originated in the Near East with coloured glass set in a plaster framework; in Europe it was used for representational art. The finest examples are in the churches of France, Britain and Germany. The successful use of s. g. depends not only on the manipulation of the richly coloured glass pieces but also on the use of the heavy leads to create a satisfactory pattern. From the 17th c. onwards a facile technique of enamel painting on clear glass was gradually substituted for

Stained glass *The Prophet Hosea* (Augsburg cathedral) early 12th c.

grisaille painting on s. g. In the 20th c. s. g. has been used by Expressionist artists and a new technique has been developed in Denmark, involving thick glass pieces joined by reinforced concrete. In recent years the medieval techniques have been revived in Britain, notably for the cathedral at Coventry.

Stamos Theodoros (1922–97). U.S. *Colorfield painter who has consistently explored the limits of abstraction in works of radiant and lyrical colour.

Stämpfli Peter (1937-). Swiss painter, living in France since 1960. In the early '60s he isolated images from mass culture, e.g. Machine à Laver (1963), decontextualizing them firstly against a background of colour, then against white, and finally shaping the canvas to the single image, e.g. Rouge Baiser (1966), where the lips alone are suspended. Since 1969 S. has focused on the image of the tire, his reiteration of which has freed the object of any signification other than a formal one, e.g. SS 396 no 2 (1969) - 3 concentric circles cut from canvas, presented frontally - and his 1970 Venice Biennale *assemblage of rectangular canvases with elliptical images of tires over shaped canvases on the floor, M301 (1970) and Royal (1971). Since the '80s, S.'s work has become bolder in patterning and colour.

Stanfield Clarkson (1793–1867). British marine painter admired by *Ruskin.

state. Used as a technical term to describe the various stages through which an *engraving or etching may pass. The 1st s. is the 1st proof pulled from the plate. The artist may decide on some improvement and alter lines on the plate; the proof from the altered plate is the 2nd s. This process may be repeated a number of times until the artist is fully satisfied with the work.

steel engraving. Copper, the metal generally used in *engraving, was too soft to allow a large number of reprints. In the 19th c. some workers began to engrave on steel, which was durable but also hard to work; a further refinement was steel facing in which a fine steel film was laid on the copper plate by electrolysis.

Steell Sir John (1804–91). Leading Scottish sculptor of the statue of Sir Walter Scott in the Scott Monument, Edinburgh.

Steen Jan Havicksz (1625/6–79). Dutch genre painter, pupil of A. van Ostade and J. van

Goyen. He worked at Leyden, The Hague, Delft and Haarlem, producing a great number of paintings, often of tavern scenes and social gatherings. There is a wide range of humour and anecdotal interest in his work. He is noted for his rich colour harmonies and sense of composition.

Steer Philip Wilson (1860–1942). British painter who studied in Paris under Bouguereau and Cabanel. S.'s work was strongly influenced by Neo-Impressionism, but in the 1890s he turned to a style derived from Turner and Constable. He became widely known only when the Tate accepted *Chepstow Castle*, an oil painting, in 1909. S.'s fresh, light, breezy landscapes in oil were matched by watercolours of great liquidity and economy of statement, with large skies and a strong sense of atmosphere.

Stefano da Zevio (or da Verona) (c. 1375–1451). Veronese painter in the International Gothic style. Antonio Pisanello was probably his pupil.

Steinbach Haim (1944—). U.S. Neo-*Conceptualist artist born in Israel whose *assemblages of mixed media — as with those of *Koons and *Bickerton, often of simulated and reconstituted commodity mass-produced goods — refer obliquely to *Pop and *Minimalism. His usually brightly coloured, ambiguous works prompt a variety of formal and associational interpretations, e.g. Fantastic Arrangement (1985), comprising 5 clocks — 4 digital and 1 in the shape of a soccer ball — on a red and green formica shelf setting off the different colours of the clocks and Security and Serenity (1986).

Steinberg Saul (1914—). Rumanian-born U.S. artist who, especially since 1959, has been living in the U.S.A. after years of travelling. He 1st studied and worked as an architect but soon turned to drawing, watercolour and sculpture. His drawings are sophisticated and witty, and abound in visual and verbal puns. He has been publishing regularly in *The New Yorker* since 1941. In 1978 he had a retrospective exhibition at the Whitney Museum of American Art. N.Y.

Steinlen Théophile-Alexandre (1859–1923). Swiss-born French painter and graphic artist, a vigorous impassioned critic of social misery and human exploitation. His poster designs

of the 1890s were executed in the bold, flat style, influenced by the Japanese print, which is best exemplified in the work of Toulouse-Lautrec.

Stella Frank (1936-). U.S. painter of great prominence among the artists of his generation. Nurtured on the *Abstract Expressionism of *Kelly and *Newman, S., struck by *Johns's use of repetition and flat colour, moved, by 1960, to what he called 'non-relational' painting and what was to be labelled *'Post-painterly abstraction' and *Hard-edge flat painting (1964) and *'Systemic painting' (1966). In 1960 S. attracted controversy and recognition for his black paintings included in the M.O.M.A. exhibition, 'Sixteen Americans' (e.g. Die Fahne Hoch!, 1959). These were large, vertical rectangles with a symmetrical pattern of balanced bands of black paint separated by thin stripes of bare canvas, forming regular, spaced rectangles radiating inward from the canvas edge to a cruciform centre. Later, using copper or aluminium paint (e.g. Creede, 1961), S. explored different shapes for the canvas, suggested by the rectilinear repeated pattern. This developed into U- and L-shaped canvases using heavy framing edges. From 1967 S. turned to brilliantly coloured shaped works interrelating semi-circles with rectangular or diamond shapes (e.g. Lac La Rouge II, 1968). These led to the 'exotic Birds' series, begun in 1975: colourful and expressive paintings which are freer, shaped structures and which play on the dichotomy between real space and the 2-dimensional picture plane. A late work is S at Bh āi (1978).

Stella Joseph (1877–1946) Italian-born U.S. painter. Closely associated with the contemporary artistic developments of Europe, his Futurist paintings of 1910 to 1923, notably Battle of Lights, Coney Island, and Brooklyn Bridge, show his sense of excitement and urgency that he was to find and paint in the U.S.A. and are the finest of his career; they were of seminal importance to U.S. modernists. During the 1920s S. exhibited with *Duchamp and *Man Ray in the Société Anonyme; later works include Still Life (1944).

stencil (Fr. *pochoir*). Method of duplicating designs by cutting required shapes out of card or thin metal which are then sprayed or brushed with ink or paint, reproducing the shapes on the paper beneath. S.s have been traditionally used for reproducing simple fabric designs and have

Joseph Stella Brooklyn Bridge 1917-18

also been used to great effect in book ill. *silk-screen printing.

stencil wallpaper. Late 18th–19th–c. U.S. domestic folk art. Travelling painters toured remote country districts, equipped with paints and simple stencil patterns. With these they decorated the plain–papered walls, lodging with the family until the job was complete.

Stepanova Varvara Fedorovna (1894–1958). Russian artist and designer, wife of *Rodchenko. She collaborated with the Russian Futurists producing collages and ills for publications. She also produced designs for the stage and for textiles. A member of the Productivist group including Rodchenko, *Popova and *Tatlin, she used *Constructivist principles in her designs; she taught in the textile department of *Vkhutemas. She also did typographical and poster designs and worked in films.

Stephens Frederick George (1828–1907). British painter and writer on art, a member of the *Pre-Raphaelite Brotherhood.

Stevens Alfred (1818–85). British sculptor and painter. He studied in Italy and worked with *Thorwaldsen. He designed the vases and lions on the railings of the British Museum and the Wellington Monument at St Paul's Cathedral.

Stieglitz

Stieglitz Alfred (1864-1946). U.S. photographer who has been called the father of modern photography. In 1905 he established the 1st of his N.Y. galleries known as the Photo-Secession or '291' which showed not only the pioneering work of photographers but became an influential centre of avant-garde painting and sculpture. He showed *Rodin for the 1st time in the U.S.A. and among others, *Matisse; the 1st exhibition of *Toulouse-Lautrec's lithographs; H. *Rousseau; *Cézanne; *Picasso; *Picabia; *Brancusi, and the U.S. artists *Dove, *Marin, A. Maurer, *Hartley, *O'Keeffe and *Man Ray. From 1925 to 1929 S. ran the Intimate Gallery, after which he opened An American Place. His influence on U.S. art was seminal. His collection, which included 450 U.S. works, was presented to the Metropolitan Museum of Art in 1949.

Still Clyfford (1904–80). U.S. painter. His style, which is highly individualistic, owes little or nothing to contemporary European movements. He was, however, a central figure among the *'Color-field' or 'abstract-imagist' wing of *Abstract Expressionism and was influential as a teacher at the California School of Fine Arts, 1946–50. He employs large monochrome masses and predominant colours are black, red and yellow. His paintings are lyrical and passionate, merging space and figure into a powerful unity, e.g. 1947-M, 1947.

still-life. Painting containing only objects (most often domestic - tableware, flowers, books - but sometimes skulls, dead game, etc.) viewed close up. S.-l. was of early importance in oriental art, and is approached in Greek and Roman mosaics; but it emerged as an independent subject in the West only in the 16th c., e.g. practised by *Caravaggio, and flowering in 17th-c. Flanders. It was often used symbolically and allusively. *Chardin was the 1st notable French s.-l. painter. Since the 18th c. it has been widely used, receiving impetus from the 19th-c. discovery of the Japanese colour print; with *Cézanne and others the s.-l. has been a stage in a development towards nonrepresentational art.

stippling. In drawing or painting, modelling form by means of small dots or short strokes instead of lines or areas of colour.

Stokes Adrian (1902–72). British writer on art and psychoanalysis, painter and poet. In 1936 he started painting with the *Euston Road school

and the following year completed 8 years of psychoanalysis with Melanie Klein, which had a profound effect on his art theory and painting. His most important and influential works include his 1st 2 books on art and architecture, Quattro Cento (1932) and Stones of Rimini (1934), as well as Smooth and Rough (1951) and Michelangelo (1955), and the essays Reflections on the Nude (1967). The complete critical writings were published in 3 vols in 1978. His paintings, mostly still-lifes and landscapes, are luminous and quiet, sometimes reminiscent of *Morandi.

Stomer Matthias (17th c.). Dutch Caravaggesque painter of religious subjects who settled in Italy; pupil of Honthorst.

Stone Marcus C. (1840–1921). British painter and ill. Son of Frank (1800–59). His genre paintings were much admired at the turn of the c., e.g. *In Love, Rejected, A Stolen Kiss*, pictures of sentimental narrative. He was a member of the R.A. (1886).

Stone Nicholas (1586–1647). British mason-sculptor and architect, trained under Hendrick de Keyser in Amsterdam (1606–13) and appointed master mason to James I (1619). He worked on the Banqueting House, Whitehall, where he began an association with Inigo Jones. He is best known for his tombs, which include that of Francis Holles (Westminster Abbey), based on Michelangelo's tomb of Giuliano de' Medici. His son Nicholas (d. 1647) was a sculptor who worked under Bernini in Italy, and another son Henry (d. 1653) was noted as copyist of Van Dyck.

Stoss Veit (d. 1533). German late Gothic sculptor, painter and engraver active in Cracow and Nuremberg. His masterpiece is the huge high altar in carved and painted wood in the church of Our Lady, Cracow. Other important works include the tomb of King Casimir IV, *Annunciation* and the high altar of Bamberg cathedral.

Stothard Thomas (1755–1834). British painter, and a book ill. and embellisher of considerable charm. His best-known painting is *Canterbury Pilgrims* which caused a quarrel between him and *Blake, who was already working on the same subject.

Strange Sir Robert (1721–92). Scottish engraver, noted for line engravings after Van Dyck; rival of *Bartolozzi.

Straub Johann Baptist (1704–84). Bavarian Rococo sculptor, from 1737 court sculptor in Munich. His works include the high altar, St Michael's church, Berg-am-Laim, Munich, and altars in the monastic churches of Ettal and Schäftlarn. *Günther was his pupil.

Streeter (Streater) Robert (1624–80). British decorative painter, best known for the ceiling (1669) of the Sheldonian Theatre, Oxford, the nearest approach to Baroque decoration by an Englishman before Sir J. Thornhill.

stretcher. The wooden frame on which canvas is stretched for painting.

Strozzi Bernardo (1581–1644) called 'Il Cappuccino'. Genoese painter of religious subjects who was for a time a Franciscan friar. From 1630 he worked in Venice. His painting was influenced by Rubens, later by the Venetian school.

Stuart Gilbert (1755–1828). Outstanding U.S. portrait painter. He studied in London under *West although the development of his style owed more to *Gainsborough and *Reynolds. He worked in London and Dublin before returning to the U.S.A., acquiring a great reputation for the honesty and psychological insight of his work. He painted the best-known portraits of Washington including the unfinished 'Athenaeum' head.

Stubbs George (1724–1806). British painter. He studied anatomy at York and then made a

Stubbs Anatomy of the Horse 1766

perfunctory visit to Italy in 1754. S. lived and worked in Lincolnshire and London, making anatomical drawings, esp. of horses, publ. the *Anatomy of the Horse* (1766). He became a popular painter of racehorses for the aristocracy, but his animal paintings are not mere records; they are elegant and dignified in design. He is a master of composition who also painted brilliant conversation pieces and portraits, genre paintings of rural life and some enamelled earthenware panels for Josiah Wedgwood.

stucco. Originally the lime-plaster used as a ground in fresco painting and in the decoration of buildings; the term is now used loosely to describe any plaster or cement used on exteriors.

Sturm, Der. The magazine (inaugurated in 1910) and art gallery in Berlin, of the German *Expressionist movement. In its pages appeared ills by members of the *Brücke and *Blaue Reiter groups and articles expounding the new aesthetic.

style. Term for the manner of execution in writing, painting, etc. as opposed to subject matter or its organization (i.e. *form); (2) the common characteristics of the arts in a given period – e.g. Louis XIV s. – or of a school or movement.

Sully Thomas (1783–1872). U.S. portrait painter. He studied under *West in London. There he was influenced by *Lawrence, particularly in his portrayal of women and children. He settled in Philadelphia, where he had no rivals after the deaths of *Peale and *Stuart. He also produced a large number of subject paintings.

Sultan Donald (1951-). U.S. painter and graphic artist who uses innovative materials such as tar, vinyl tiles, plaster and latex paint in the creation of isolated, recognizable images, e.g. his 'puzzle pictures' series of the mid-70s. His landand seascapes of the late '70s are multilayered, suggesting both physical and illusory dimensions. In the mid-80s he began to create his well-known images of lemons in yellow and black, e.g. Four Lemons (1984) and the 'Black Lemon' series on paper (1985-6). Throughout the '80s he produced 'event pictures' which were inspired by current issues, e.g. environmental and industrial concerns, e.g. Pumps (1984) and Early Morning (1988), in which the effect of fire is achieved by the application of turpentine to yellow latex paint.

sumi-e

sumi-e. *Japanese art-term for monochrome ink painting.

Sunday painter. Someone who paints for pleasure in their spare time. The term is often used in a derogatory sense but is also associated with modern primitive painters who usually began as self-taught amateurs.

Sung. Chinese dynastic era divided into N. Sung (960–1126) and S. Sung (1126–1279) by invasions which occupied most of N. China and drove the emperors from their capital at K aifeng to Hang-chou. It witnessed the classical epoch of *Chinese art. Confucianism and Taoism were strong influences: the most famous treatise in the N. Sung period was Kuo Jo-hsü's Experiences in Painting (1074) which analyses the work of a series of prominent painters from the late T'ang down to the 1070s. The division between courtly and scholarly traditions became marked (*wen-jen and *Chinese art). Leading N. Sung courtly painters were Fan Kuan (fl. 990–1020), Travelling amid Mountains and Gorges;

Sung Wild Geese

Hsu Tao-ning, Fishing in the Mountain Stream (c. 1000); Kuo Hsi (mid-11th c.), Early Spring; and the late 11th-12th-c. Chang Tse-tuan, River Life on the ... Ch'ing-ming Festival. The S. wen-jen affected an unacademic clumsiness, working in ink on paper rather than the courtly colour on silk. They included Su Tung-p'o (1036–1101), Wen T'ung (d. 1079), his teacher in bamboo painting, Mi Fu (1051–1107), and the calligrapher Huang T'ing-chien (1045–1105). Li Kung-lin (1040–1106) copied many old masterpieces in the archaizing fashion of the period; his panoramic scroll of his country estate, Lung mien, followed the T'ang painter *Wang Wei.

The N. Sung emperor, Hui-tsung (reigned 1101–25), a dictatorial patron of the imperial academy, was a painter of exquisite delicacy and an elegant calligrapher. The principal artist of the academy, Li T'ang, noted for his 'axe-cut' brushstroke, linked the grandeur of N. Sung with the S. Sung interest in atmospheric perspective and the representation of space personified by the 'Ma-Hsia' school of *Ma Yüan (fl. 1190–1225) and *Hsia Kuei (fl. 1200–30). This in part influenced the mid-13th c. school of *Ch'an Buddhist artists, e.g. Liang K'ai, Mu-ch'i and the noted dragon painter Ch'en Jung.

Super Realism. Art of extreme verisimilitude, associated with the U.S.A. in the 1970s but to a lesser extent popular also in Western Europe. In painting it is usually, though not always, based on the direct copying of photographs (Photo Realism); in sculpture it makes much use of direct casts from the human figure. Also called Hyper Realism.

Suprematism. The 1st system of purely abstract pictorial composition, based on geometric figures. Its founder was the Russian artist *Malevich whose 1st Suprematist work was a black square on a white ground painted in 1913; he himself described this as 'no empty square, but rather the experience of non-objectivity ... the supremacy of pure feeling ...' Malevich's early Suprematist works were 2-dimensional simple geometric studies using chiefly primary colours; from *ε*. 1915 greater complexity appears, 2 or more interrelated groups of shapes overlapping or in receding succession, introducing the 3rd dimension.

Surikov Vassily (1848–1916). Russian painter, a member of the *Wanderers. His subjects, however, were chiefly historical: one of the most famous is the colossal canvas *The Boyarina*

Morosova (1887). He was fascinated by Russian medieval art and architecture; Veronese, Titian and other monumental Italian painters played a part in forming his style which was the earliest attempt to marry the ideals of the Wanderers with parional artistic traditions.

Surrealism. Movement begun in 1924 (when the *Dada movement split) with a manifesto written by *Breton, in which it is described as 'pure automatism'. This fitted Surrealist literature better than Surrealist painting, but Surrealist art has become better known than Surrealist writing, especially in the works of *Arp, M. *Ernst *Dali and *Miró. The dominant vehicle of S. ideas and work. literary and visual, was the magazines. La Révolution Surréaliste, the 1st official S. magazine, 1st appeared in Paris. December 1024, instigated by Breton, Aragon, Eluard and others, with contributors including Robert Desnos, De *Chirico, *Man Ray, Ernst. *Picasso and *Masson 12 issues came out and it ceased publication in 1020. Le Surréalisme au service de la Révolution, considered by Breton as the best S. magazine, came out in Paris in 6 numbers between 1930 and 1933. It was succeeded by the eclectic review Minotaure (1933-9), publ. in Paris. Other important S. magazines publ. outside France were the Bulletin Internationale du Surréalisme (1935 and 1940), publ. by the S. group in Belgium, London Bulletin (1938-40), and in N.Y. View (1940-7) and VVV (1942-4).

S. paintings are of 2 main sorts: Dali has called the one 'hand-painted dream objects' - conventional techniques are used to depict a fantastic image like De Chirico's enigmatic townscapes or the soft watches in Dali's Persistence of Memory; the other is inventive in technique, as in rubbings ('frottage') by Ernst, the *decalcomania (a sort of monotype) invented by Dominguez, and the informal abstract painting of such an artist as Masson. In both sorts of painting the Surrealists aimed to mingle reason with unreason, using dreams, chance effects, the automatism uncontrolled by aesthetic or moral consideration, to create a new reality. Surrealist poetry by writers such as Paul Éluard and René Crevel had the same aim, and so had the 2 important Surrealist films Un Chien Andalou and L'Âge d'Or. The zenith of the movement was in the 1930s, Surrealist groups having been formed in Britain, the U.S.A., Japan, Scandinavia and elsewhere. During the war many Surrealists were in the U.S.A. (e.g. *Duchamp), where their art and ideas had a liberating influence on U.S. art.

There has been some Surrealist activity in Paris since 1945, but the major Surrealist artists have worked and developed independently. The term S. is more loosely used of fantastic, weird or horrific imagery in the art of any period. The word was coined in 1917 by Apollinaire for the work of certain artists, in particular Marc Chagall.

Survage Léopold (1879–1968). Finnish-born painter and theatrical designer who settled in Paris (1908) and joined the *Cubists.

Susterman(s) or Sutterman, Justus (1597–1681). Flemish portrait painter in the tradition of Van Dyck. He was court painter for a time in Florence. One of his finest portraits is that of Galileo.

Sutherland Graham (1903–80). British painter; he studied graphic art at Goldsmiths' College (1921–6). S. started painting in earnest in 1935

Sutherland Somerset Maugham 1949

Syomas

and contributed to the 1936 Surrealist Exhibition, London. His pre-war landscapes, e.g. Entrance to Lane (1939), moved from Palmer's formalizations towards a freer organic language. As a war artist (1940–5) S. withdrew, like Piper, Vaughan and others, into the English romantic tradition, e.g. Tapping a Steel Fumace (1941); but following an important visit to the Mediterranean seaboard (1947) he developed a spiky language of expressive abstract forms, Surrealist in mood, e.g. Head III (1953). He also painted a series of portraits and in 1957 completed the design for the altar tapestry for Coventry cathedral.

Svomas. *Vkhutemas

Swan John Macallan (1847–1910). British painter and sculptor, chiefly of animals. He was a considerable draughtsman and worked in the London Zoo and Jardin des Plantes, Paris, producing fine unsentimental work.

Sweerts Michiel (1624–64). Flemish genre and portrait painter, in Rome from 1642 to 1652/4. He went to India as a missionary and died in Goa.

Symbolism. A movement in European literature and the visual arts c. 1885–c. 1910, based on the notion that the prime concern of art was not to depict, but that ideas were to be suggested by symbols, thus rejecting objectivity in favour of the subjective. It combined religious mysticism with an interest in the decadent and the erotic. Among the artists associated with the movement were *Redon, G. *Moreau and *Puvis de Chavannes in France, F. Khnopff in Belgium, *Toorop in Holland, *Hodler in Switzerland, *Klimt in Austria and *Segantini in Italy.

Synchromism. U.S. art movement, originated in Paris (1912) by S. Macdonald-Wright and *Russell and joined by P. Bruce and A. Frost. They developed a brilliant chromatic idiom, clearly related to Orphism, and exhibited at the Armory Show (1913).

Synthetism. A style of painting in the 1890s by *Gauguin, *Bernard and other artists at *Pont-Aven in Brittany. Flat areas of colour are surrounded with black lines. The group around Gauguin believed that an artist must synthesize his impressions and paint from memory, rather than depict directly. The Pont-Aven artists organized an exhibition under the title 'Synthétisme', during the Universal Exhibition of 1889. In 1891 a group was formed including

Gauguin, Bernard, Charles Laval and Louis Anquetin. *cloissonism.

Systemic painting. Abstract painting which is based on a logical system; often the repetition and sometimes progressive variation of a single element, either in one work or in a series of related canvases, e.g. F. *Stella.

T

Taaffe Philip (1955-). U.S. painter whose consciously derivative works, e.g. Defiance (1986) - a version of *Riley's painting - with their thickly textured surfaces and different use of colour, negate what he sees as the impersonality of much *Op art. He *appropriates other artists' works, treating them as subjects and reworking them, e.g. Homo Fortissimus Excelsius (1986), almost a replica in size and colour of *Newman's Vir Heroicus Sublimus (1951) - in which he uses rope imagery for the zips of Newman's work - and Green Blue (1987), a silkscreen collage in homage to E. *Kelly. More recent works, e.g. Ahmed Mohammed (1989). show an increasing focus on historical cultures and their styles.

Tachibana. Shrine in the Horyu-ji temple, Japan. It presents the Buddha Amitabha flanked by two Bodhisattvas on lotus blossoms. The small, high-relief bronze is one of the finest achievements of Japanese Buddhist sculpture.

Tachisme. *Action painting

Taddeo di Bartolo (Taddeo Bartoli) 14th–15th-c. Sienese painter, follower of the Lorenzetti brothers.

Taeuber-Arp Sophie (1889–1943). Swiss painter and designer, member of the Zürich *Dada group and the Cercle et Carré and *Abstraction-Création groups; wife of *Arp. Some of her earliest paintings (1916) were geometric abstractions. In 1928 she collaborated with Van Doesburg and Arp on the interior decoration of the Aubette Café, Strassburg (since destroyed).

Taine Hippolyte (1828–93). French philosopher of art (e.g. *Philosophie de l'art*, 1881) and vivid exponent of positivist and scientific experimental method as applied to art and art history.

Tait Arthur Fitzwilliam (1819–1905). Britishborn U.S. painter; he settled permanently in N.Y. in 1850 after 1st working at Thomas Agnew's print store, and then doing extensive sketches and lithographs of the British countryside. In the U.S.A. he became commercially successful especially with his pictures of animals and landscapes in the Adirondacks.

Takis (Vassilakis) (1925—). Greek *Kinetic sculptor, working in Paris from 1954. Signals (late 1950s) were standing steel wires with top weights which caused constant vibration. From 1959 weights were replaced by electromagnets which strengthen the vibrations, sometimes acoustically amplified.

Talashkino. A centre for artists and a school for children, founded for the encouragement of Russian arts and crafts by the Princess Tenisheva on her estate near Smolensk in the 1890s. In many ways it was based on a continuation of Mamontov's *Abramtsevo Colony. Artists such as Vrubel and Roerich, and the theatre designer Alexander Golovin worked there. These centres created the 'Russian style' of interior design and were influential also in theatre design.

Tamayo Rufino (1899–1991). Mexican painter. His style remained distinctively Mexican in character, inspired by folklore and primitive art, despite influences by contemporary Europeans, notably Picasso and Braque. His works include *Photogenic Venus* (1930), *Women in the Night* (1962) and numerous important murals for public buildings in Mexico City and the U.S.A. Chief among these are murals for the art gal. and mus. in Mexico City, for the UNESCO building, Paris, and for the Montreal Expo '67.

Tanagra. Town in the province of Boeotia in Greece where a series of 3rd-c. BC terracotta figurines were excavated. Made from moulds, they are mostly of elegant young women and were decorated in coloured paint over a white slip-like coating. Many forgeries were produced in the 19th c.

T'ang. Chinese dynasty (618–906). Artistic development, formative for later Chinese and Japanese art, shows sinification of foreign influences. Up to the persecution of Buddhism in the 840s, Indian Buddhist influence was strong in painting and sculpture. Temple wall paintings, e.g. at Loyang and *Ch'ang-an, the T. capital, and after 845 at such provincial centres as Tun

T'ang Horse

huang, embodied Indian formal ideals. These were fused with the traditional Chinese brush style by such masters as *Wu Tao-tzu. Courtly painting is represented by Yen Li-pen (d. 673) in a handscroll of Thirteen Emperors, a monumental embodiment of Confucian ideals of dignity and order, and by Court Ladies in the tomb of Princess Yung t'ai (c. 706), near Ch'ang-an. Masters at the brilliant court of Ming Huang (713-56) included Chou Fang, Chang Hsuan and the great painter of horses, Han Kan. A courtly 'green and blue' style of landscape painting of precise line and decorative colour evolved under such masters as Li Ssuhsun (651-716) and Li Chao tao (d. c. 735). A scholarly tradition (*wen-jen) of monochrome landscapists, e.g. *Wang Wei, began to emerge. Some later T. painters, inspired perhaps by Ch'an Buddhism, experimented with techniques reminiscent of *Action painting. Such mid-10th-c. artists as Ku Hung-chung at Nanking revived T. glories. In sculpture, Indian *Gupta-period statues brought back (AD 645) by the famous Buddhist pilgrim Hsuan Tsang (Monkey) stimulated the climax of Chinese Buddhist achievement. Majestic T. Buddhist sculptures survive at the caves of Lungmen, e.g. the massive 7th-c. Vairocana Buddha, and in Japan at Nara. In pottery the semi-naturalistic floral motifs from Sassanid Persian metalwork

T'ang Scenes from the life of Buddha (silk banner)

and the shapes of Syrian and Seine–Rhine Roman glassware are evident in some T. pottery. The grey-green T. Yüeh porcelain is a forerunner of Sung dynasty (960–1279) celadons. The famous T. statuettes of horses, court dancers, Middle Eastern merchants, represent the culmination of a Han dynasty (206 BC–AD 220) tradition.

Tanguy Yves (1900–55). French painter living in the U.S.A. from 1939. He began to paint in 1922 and was influenced at first by De *Chirico's *Metaphysical painting. In 1925 he joined the *Surrealists. In 1930 he contributed to *Le Surréalisme au service de la révolution*. The barren landscapes of his paintings shared with

Surrealist imagery a hallucinatory stillness; the amorphous organisms which inhabit them echoing similar forms in Miró's paintings. *Jours de Lenteur* (1937) is a typical example of his work.

Tanner Henry Ossawa (1859-1937). Most acclaimed African-American artist of the late 19th c. T.'s father was an African Methodist minister and his mother was a former slave. He studied at the Pennsylvania Academy of the Fine Arts under *Eakins who greatly influenced him. Subjected to racial discrimination, T. moved to Europe, settling in Paris where he enrolled at the Académie Julian. His early works are mainly paintings of animals, and land- and seascapes, but, prompted by a brief return to Philadelphia in 1893, where he faced undiminished racism, T. began to paint genre scenes of African-American life. His aim was to restore the reality of the lives depicted as opposed to prevailing caricatural stereotypes: he wrote, 'Many of the artists who have represented Negro life have only seen the comic, the ludicrous side of it'. His handling of brushwork, dramatic use of light in interior scenes (an effect he was to continue in his later religious works) and emphasis on the central figure(s) are modelled on *Rembrandt, e.g. The Banjo Lesson (1893). Other works similar in technique depict inhabitants of rural France, e.g. The Bagpipe Lesson and The Young Sabot Maker (both 1894). From 1895, having visited the Holy Land, T. began religious paintings which show influences of French *Symbolism and *Impressionism, e.g. Salome (1900) and Mary (1914). T. found, like E. *Lewis, a greater freedom in Europe than in his native country. He exhibited at the Paris salons and was eventually awarded the Legion d'honneur. While he forged no formal link with an African-American movement, he has been an inspiration to subsequent generations of black artists.

Tanning Dorothea (1912–). U.S. painter and writer associated with *Surrealist circles (she married *Ernst in 1946) whose work is illustrative of female Surrealist painters' psychological exploration of sexuality in contrast to their male counterparts' more explicit representational language. The imagery in *Guardian Angels* (1946) and *Palaestra* (1947) demonstrates T.'s fascination with the psychic forces that inform the tangible world.

Tàpies Antonio (1923–). Catalan painter; he took up painting with no formal training after

studying law. Co-founder of the group and review 'Dau al set' in Barcelona. Influenced by *Miró and *Dubuffet, he has developed a profoundly dramatic style with austere imagery and earthy colour and texture. Characteristic are canvases with thickly impastoed, scratched or scraped paint, reminiscent of arid Spanish landscapes.

Tassel Richard (1583–1666/8). French painter who worked at Langres in an eclectic style derived from contemporary Italian painting. He was a pupil of Reni at Bologna and was later in Rome. His masterpiece is a portrait in the Ursuline convent at Dijon.

Tatlin Vladimir (1885–1953). Soviet painter, born in Kharkov, T. studied at the Penza School of Art (1902-9) and the College of Painting, Sculpture and Architecture at Moscow (1909-11). He became the pupil and protégé of *Larionov and *Goncharova. In 1911 his 1st designs for the theatre were used in a production in Moscow. He visited Paris (1913) where he was much impressed by Picasso's work; he produced his 1st semi-abstract 'Relief Construction' in Moscow in the winter of 1913-14. He continued to make reliefs from such materials as glass, iron, wood, now entirely abstract; by 1915 these had developed into freehanging 'Corner Constructions'. In 1917 T. was invited by Georgy Yakulov to help him to decorate the Café Pittoresque in Moscow with constructions – their first practical application and generally regarded as the beginning of *Constructivism. After the Bolshevik Revolution T. emerged as an important figure in the artistic reorganization of the country undertaken by the former *Futurist, now 'leftist' artists; he was appointed head of the Moscow Department of Fine Arts. His growing group of followers gradually became known as Constructivists. He lived in Petrograd (1920–5), building his Monument to the Third International and working on practical projects, designing stoves, workers' clothes, etc. with economy and sensitivity to the nature of the materials used. T. called this system of design 'culture of materials'. He directed the ceramic faculty in the reorganized Moscow Art School, Vkhutein, continuing to develop 'culture of materials'. He also became known as a glider designer. Between 1933 and 1952 he worked as theatrical designer, continuing to paint, mostly still-life subjects and nudes, using icon preparation on wooden panels.

Tatlin Monument to the Third International (model) 1919–20

Taylor Sir Robert (1714–88). British architect and monumental sculptor. Apprenticed to Henry Cheere, T. set up on his own as a sculptor in 1743 after a brief visit to Rome. Although gaining some important commissions, notably the pediment of the Mansion House, London, T. turned to architecture after 10 years.

Tchelitchew Pavel (1898–1957). Russian Neoromantic painter and stage designer; he worked in Berlin and Paris before settling in the U.S.A. He made use of perspective distortion and multiple images in the late 1920s, and at that time he also began to develop his interest in metamorphic forms; the Surrealist practice of *Automatism played a significant part in his metamorphic compositions, of which the most famous is *Hide and Seek* (1942).

Teerlinc Levina (1510/20–1576). Born Benninck, in Ghent, in a prominent family of Ghent/Bruges illuminators, she was recruited into the service of Henry VIII, and was a

gentlewoman to Mary I and Elizabeth I, as a painter of miniatures and designer of royal seals and other official printed images.

tempera. Painting technique in which powder colour is mixed with a binder, normally the yolk of an egg or both white and yolk together, thinned with water and applied to a *gesso ground. It is opaque, permanent and fast drying, though the colours dry lighter than they appear when wet. Modelling is achieved by *hatching. T. was the usual technique for panel painting until the 15th c. From the early 14th c. and lasting into the 16th c. a mixed technique was also common, i.e. an oil glaze applied over t. From this the technique of oil painting developed and superseded t. because of its greater range of possibilities, particularly *impasto. T. has been considerably revived in the 20th c.

Ten, The. Group of U.S. artists who studied in Paris (Académie Julian) and whose work (1895) showed influence of Impressionism. They included F. W. Benson (1862–1951), T. W. Dening (1851–1938), Childe Hassam (1859–1935) and J. H. Twachtman (1853–1902).

tenebrist (pl. Tenebristi) (It. tenebroso: dark). Name given to 17th-c. painters in Naples, the Netherlands and Spain who painted in a low key and emphasized light-shade contrasts in imitation of *Caravaggio.

Teniers the Elder, David (1582–1649). Antwerp painter who studied under *Rubens and in Rome under *Elsheimer. He painted mainly religious subjects but his reputation rests on such landscapes and genre scenes as *Playing at Bowls*.

Teniers the Younger, David (1610–90). Flemish painter, chiefly of peasant genre scenes. He was taught by his father (the above) but in the development of his style owed more to Brouwer. He became court painter to the Archduke Leopold Wilhelm in Brussels and keeper of his art coll., which included works by Titian, Giorgione and Veronese. T.'s copies of these pictures (engraved *Theatrum Pictorium*, 1660) and his paintings of the interior of the gal. provide valuable evidence for art historians. His peasant scenes were immensely popular and gained T. his fashionable reputation.

Tenniel Sir John (1820–1914). British artist and draughtsman; best remembered for his political cartoons for *Punch* (1850–1901) and his ills for Lewis Carroll's *Alice* books (1866 and 1870).

Teotihuacán. Ancient city of Mexico, c. 30 miles (48 km) N.E. of Mexico City. The site, some 7 square miles (11.2 sq. km), comprises: pyramids, notably the Pyramid of the Sun; temples, e.g. the so-called Temple of Quetzalcoatl; and extensive residential complexes. The site was occupied by 1000 BC and the city was perhaps the major Mexican cultural centre for c. 1000 years from c. 300 BC. The art and culture of T. show strong links with those of the Maya, Mixtec, Olmec, Toltec and Zapotec. *Pre-Columbian art.

Ter Borch (Terborch, Terburg) Gerard (1617–81). Dutch genre and portrait painter. He travelled widely as a young man, making his reputation with the group portrait *Signing of the Peace of Munster, May 15, 1648* (1648). His early paintings were guardroom scenes similar to those of *Codde and *Duyster but he later specialized in a distinctive type of interior genre, elegant and serene. Examples include *The Letter, Singing Lesson* and *Woman Writing*.

Terbrugghen Hendrick (1588–1629). Dutch painter of religious and genre subjects, a leading member of the Utrecht school. After studying under Bloemaert he went to Italy (1604–14), then settled in Utrecht. He was a follower of Caravaggio and Manfredi; the influence of the latter in particular is apparent in his half-lengths of figures playing musical instruments, singing, drinking, etc. In his later works, e.g. *Jacob, Laban and Leah* (1627), T. came closer to Vermeer.

terracotta (It. baked earth). A hard baked clay used for statuary or decoratively in architecture.

terribilità (It. terribleness). The effect or expression of awesome grandeur in art, used by contemporaries of the work of *Michelangelo.

Theodoric of Prague. 14th-c. Bohemian painter whose naturalistic style influenced later German painting. He worked at the court of the Emperor Charles IV and executed religious paintings in the royal chapel at Burg Karlstein.

Theophanes the Greek (fl. late 14th c.). Greek icon and fresco painter in the Byzantine tradition who worked in Russia in Novgorod and Moscow. His surviving paintings include frescoes in the church of the Transfiguration, Novgorod.

Thiebaud Wayne (1920–). U.S. painter, working in California, of works of great

Thiebaud Four Sundaes 1963

complexity and distinction, which appear deceptively simple in terms of subject matter and in their presentation. In fact, T: is part of the grand tradition of representational art from *Chardin and *Manet to the American Realist masters such as *Eakins and *Hopper. Simple, ordinary subjects - cigar boxes, iced cakes and other food - often depicted repetitively, giving an overall abstract impression, are treated as elementary shapes – cubes, cylinders and circles - rather than because of their vernacular character. They are richly rendered in oils, sometimes in combination with acrylic. T.'s use of shadows and modelling results in surprising illusions of volume and depth, e.g. Pies, Pies, Pies, Five Hot Dogs (both 1961), Bakery Counter (1961-2) and Salads, Sandwiches and Deserts (1962). His urban landscapes, e.g. San Francisco Landscape (1976) and Study for Apartment (1980), related to those of *Diebenkorn in their simplification and flatness, as well as to his figurative compositions, may be perceived as tending towards abstraction. Diebenkorn, however, challenges any opposition between representation and abstraction. T. has said that it is characteristic of the Realist idiom that 'You take away by simplification, by leaving out detail. But you also put in selective bits of other experience, or perceptual nuances that enforce it, giving it more of a multidimension than if it were done directly as a visual recording.'

Thoma Hans (1839–1924). German painter in the tradition of late German Romanticism modified by the influence of Courbet. His work is very uneven in quality; his most successful paintings are landscapes and portraits of his family and friends.

Thomas Alma (1891–1978). African-American *Abstract painter, the first graduate in art from Howard University, Washington. After a long career as an art teacher T. became a professional artist at the age of 69 and started with still-lifes and realistic paintings. Inspired by the shifting effects of light on her garden - her natural environment was to continue to influence her - T.'s work ranged in style from *Expressionist to *Abstract to non-objective, working with both watercolours and acrylic paint. Her best-known works are her large, mosaic-like canvases - consisting of vertical lines and concentric circles in which colour predominates. Her 'Earth' series (late 1960s) hints at a floral landscape with her application of dazzling shades of green, blue, red and orange. Her later series, 'Space' or 'Snoopy', influenced by the recent explorations of space, achieve a sense of dynamism through bright, fragmented shapes on a white background, e.g. Snoopy Sees a Sunrise (1970).

Thomson Tom (Thomas John) (1877–1917). Canadian painter, closely associated with the group of painters who in 1919 formed the *Group of Seven.

Thorwaldsen Shepherd Boy 1817

Thornhill Sir James (1675–1734). British painter of portraits and, more notably, the 1st British fresco painter in the Baroque manner. Master of the Painters' Co. (1720), he was also a fellow of the Royal Society (1723), M.P. (1722–34) and history painter to George I and George II. T. decorated the dome of St Paul's cathedral (1716–19) and the Painted Hall at Greenwich (1708–27). He also worked on ceilings at Hampton Court, Blenheim Palace and Chatsworth. Apart from portraits of notable people such as Steele and Newton, he painted altarpieces for several Oxford colleges.

Thorwaldsen Bertel (1768–1844). Danish Neoclassical sculptor who worked much in Italy. He was greatly admired by his contemporaries and became the most influential sculptor of his time, second only to *Canova. He established his fame with the frieze *Alexander the Great Entering Babylon* (1812). There is a Thorwaldsen Mus. in Copenhagen including one version of *The Three Graces* (1817–19).

Tibaldi Pellegrino (1527–96). Italian painter and architect. From 1547 to 1550 he lived in Rome, coming mainly under the influence of Michelangelo and Daniele da Volterra. He later worked at Bologna (his home town), Milan, Ferrara and in Spain (for Philip II). His style is

typically Mannerist – characterized in his painting by violent gestures, strained poses and sharp contrast of light and shade (e.g. *Adoration of the Shepherds*), and in his architecture by arbitrarily combined classical motifs, multiplication of planes and awkward proportions (e.g. facade of S. Fedele, Milan). He is an important figure in the spread of *Mannerism outside Rome.

Tiepolo Giovanni Battista (Giambattista Chiepoletto) (1692–1770). Venetian mural, genre and historical painter, draughtsman and etcher. An artist of immense industry and invention, he travelled to many parts of Europe to carry out his numerous commissions. His sons Domenico and Lorenzo worked as his assistants on many of his mural decorations. In 1737 he was active near Vienna, 3 years later in Milan, and from 1750 to 1753 he painted his most important works in the palace of the archbishop at Würzburg. He was called by Charles III to Madrid in 1761 to decorate the new royal palace and died whilst working on this monumental commission.

A typical example of T.'s work carried out for the merchant princes of Venice are the frescoes on the ceilings of Ca' Rezzonico Palace. These decorations convey a feeling of luxury and splendour transporting the spectator into a world of heightened energy. T. was a draughtsman of genius and he introduced into his drawings and etchings a light touch which foreshadowed the achievements of the Impressionists.

T. liberated Venetian art from the academic Baroque style into which it had degenerated. He was strongly influenced by Paolo Veronese, but his colours were more brilliant, the foreshortening bolder, the compositions more dramatic yet ordered with tonal clarity and the effect of atmosphere. Life is portrayed with humour, sympathy and heroic exaggeration and his influence on 18th- and 19th-c. painters was inevitable and decisive.

Tilson Joe (1928—). British sculptor, painter and print maker, apprenticed as a carpenter. Associated with the British *Pop art movement, T. produced painted wood and metal reliefs, sometimes on a huge scale, of ordinary objects—a keyhole, a wristwatch, etc. Later he produced multiples and prints incorporating philosophical, ethnographic and alchemical ideas, as well as wooden sculptures of word-ladders and spheres on the same principles, inspired by pre-classical Greek literature and philosophy.

Tiepolo The Institution of the Rosary (detail) 1737-9

Timomachos of Byzantium (1st c. BC). Greek painter. Copies of his *Medea* were found at Pompeii and Herculaneum.

Tinguely Jean (1925–91). French-born Swiss sculptor working in Paris from 1952 with *Kinetic 'metamécanique' sculpture, e.g. Homage to New York (1960) which autodestructed during a happening. T.'s spastically operating, amateur machines are Dadaist and Surrealist in character: humorous and ironic mechanical constructions which satirize the technological world.

Tino di (da) Camaino (c. 1285–1337). Sienese sculptor, pupil of Giovanni Pisano. He worked in Pisa cathedral, then in Siena and Florence. In 1323 he settled in Naples, where he executed the series of tombs (for the Angevin rulers) for which he is chiefly remembered.

Tintoretto Jacopo Robusti (1518–94). Venetian painter. Though accounts of his life and work were written in his lifetime, little is known of the man. His origins and training are obscure; the 1st document (1539) refers to T. as a master. He married in 1550 and had a daughter, Marietta, and 2 sons, Domenico and Marco; all 3 were active as painters. After T.'s death Domenico carried on in charge of the workshop. In 1565 T. became a member of the charitable Brotherhood of St. Rochus and

eventually its official painter. He seems to have led the life of a prosperous Venetian, outwardly unadventurous but of tremendous industry and an iron will to succeed. This is clear from contemporary evidence. In his relations with his patrons he used any means to secure a commission; for example, during a competition for one of the ceiling decorations of the Scuola di S. Rocco (1564) he broke the rules by finishing the painting and displaying it on the ceiling. These practices made him unpopular with many of his contemporaries.

T.'s creative development was more complex than his alleged statement about his own work, 'Michelangelo's drawing, the colour of Titian', implies. In his youth he seems to have worked briefly with *Titian, for whom he professed a life-long admiration, though Titian never concealed his aversion to T. Not only did he assimilate the gigantic forms of Michelangelo, but his starting-point could have been Paris *Bordone, and all his life he remained sensitive to outside influences to enrich his art. T. had a highly organized workshop capable of dealing with the most varied commissions, from cassoni panels to portraits, monumental compositions on canvas for official commissions and private patrons. He kept the best work for his native Venice, whilst studio productions found their way abroad. To keep up with the demand he developed a method of work which was swift, energetic and sure, based on study, observation and analysis.

Tintoretto Self-portrait 1588

Tischbein

He often worked from models of his own, so as to be able to experiment with effects of light, then returned to the human figure for detailed action studies. The final, full-scale painting was made on the site when and if its relationship with the prevailing architecture and light was satisfactory. Thus he achieved a seeming spontaneity and blended the subject with its environment with much labour. A number of his action studies, drawn with a nervous, summary line, have been preserved. From one of the earliest signed and dated paintings, The Last Supper (1547) to The Last Supper of 1592-4 his work constantly gained greater depth of feeling, mastery of form and, above all, effective use of light. His influence is most apparent in El Greco's work.

T.'s gift for dramatic story-telling is brought to its height in his vast painting cycle at the Scuola di S. Rocco. Here, unhampered by the exigencies of patrons, he composed a series of deeply tragic visual meditations on the life of Christ. The *Crucifixion* is perhaps the most powerful and moving composition. Painted with bold brush-strokes in a low tonal scale, it has the freedom and pathos of an elemental statement of faith. His *Last Supper* (1592) transformed an earthly scene into a superhuman vision.

Tischbein. Family of German artists including the following: Johann Friedrich August (1750–1812), portrait painter influenced by Gainsborough and other British portraitists, nephew of J. H. T. the Elder and cousin of J. H. W. T.; Johann Heinrich the Elder (1722–89), Rococo painter of portraits, historical and mythological subjects; Johann Heinrich Wilhelm, called 'Goethe' T. (1751–1829), nephew of J. H. T. the Elder and painter of the famous portrait of Goethe in the Campagna. This shows the poet unnaturally posed among classical remains and typifies the Romantic element in Neoclassicism.

Tissot James (1836–1902). French painter and ill. While working in London he painted delightful genre scenes from fashionable life, e.g. *The Picnic* and *The Ball on Shipboard*, influenced by Manet and A. Stevens. Later he concentrated on biblical subjects, staying for a time in Palestine.

Titian (Tiziano Vecelli) (c. 1487–1576). Venetian painter, the most important of the 16th c. He was born in the region of the Dolomites and brought with him to Venice,

Titian Charles V 1533

where he was apprenticed to Giovanni and Gentile *Bellini, the elemental vitality and the toughness of his childhood. For some years he worked with *Giorgione, a few years his senior. In 1510 he worked in Padua and returned to Venice in 1512. He became the painter of the wealthy Venetian intellectual circles and the close friend of Pietro Aretino, the writer and publicist, who did much towards establishing T.'s fame during his lifetime. The kings and princes of Europe competed for his services and his stature was as great as Michelangelo's. In 1516, after Bellini's death, he was appointed painter to the Venetian Republic. In the same year he was commissioned to paint a series of mythological subjects, the Bacchanals, for the duke of Ferrara, Alfonso d'Este, and in 1523 painted the portraits of the Gonzagas at Mantua. His wife died in 1523, an event which affected T. deeply. At this time Charles V commanded him to paint his portrait and in 1533 he ennobled T. as Count Palatine. In 1543 he painted the portrait of Pope Paul III and 2 years after was called to the Vatican and

received with great splendour. In Rome he met Michelangelo. After 1553 he began his paintings for Philip II of Spain. T. died at the age of 99 during a plague epidemic in Venice.

T.'s creative development was as meteoric as his life. From the poetic style of Giorgione he developed an unparalleled expressiveness. The feelings of the courtier, the cosmic powers of the universe, the mystery of life and death, the joys of sacred and profane love, were themes which occupied him during his long creative life. He had developed a technique which became more complex and free with maturity and foreshadowed in his last years the achievements of the Impressionists. Over an underpainting, often on coarse-textured canvas, he applied a great many glazes and brilliant colours. T.'s use of colour was an achievement both of an emotional and intellectual nature: he influenced generations of painters of all schools.

T.'s vast work is often discussed from the point of view of his subject matter: religious paintings, mythological and historical subjects and portraits. In each field his contribution was original and decisive for the future development of art. The portraits temper a searching realism with lyricism and compassion, and they range from the famous men of his time to the beauties of Venice. The portrait of Charles V (1548) is typical in showing the tragedy of a lonely man beneath the trappings of power, the *Flora* (c. 1515) the ideal beauty of a satiated society.

His mythological paintings, e.g. the *Bacchanal* (1518) and the later *Venus* paintings, are in praise of the ideal, celebrating the beauty and richness of life. T.'s religious paintings vary from the sensuality of the *Mary Magdalene* (c. 1530) to the horror and tragedy of the unfinished *Pietà*.

Tobey Mark (1890–1976). U.S. painter; in 1960 he settled in Switzerland. The main formative influence upon his painting was his visit (1934–5), with the British potter Bernard Leach, to China and Japan, where he spent some time in a Zen monastery. His technique in the 1940s (sometimes called 'white writing') bore a formal resemblance to oriental calligraphy, but more important was his intention to create, like *Rothko, abstract images for meditation. One of the most subtle of U.S. abstractionists, T. compounded a delicate style out of Klee's discoveries and Chinese calligraphy.

Tocqué Louis (1696–1772). French portrait painter of the Rococo period, pupil and son-in-law of *Nattier.

Tokugawa. *Edo

Tom(m)aso da Modena (14th–15th c.). Italian painter, son of the painter Barisino dei Barisini (d. 1343). His paintings include 40 figures of monks of the Dominican order for the Chapter–House, S. Nicolò, Treviso, painted in a flat linear style with interesting individual characterization, and an altarpiece, *Madonna with SS Wenceslaus and Dalmasius* and panels in Burg Karlstein, Bohemia, where he worked with Theodoric of Prague. He had many followers among minor Bohemian painters.

Tomlin Bradley Walker (1899–1953). U.S. painter, for a long time of Cubist still-lifes and, in the last few years of his life, of Abstract Expressionist canvases filled with symbols (geometrical forms, letters, etc.).

Tonks Henry (1862–1937). British figure painter, notably of conversation pieces, Slade Professor of Fine Art, Univ. of London (1918–30) and a leading member of the *N.E.A.C.

Toorop Jan Theodoor (1858–1928). Dutch *Symbolist and *Art Nouveau painter, ill. and graphic designer. He exhibited at the Groupe des Artistes Indépendants in Paris in 1884 and also with Les XX (Les *Vingt) in Brussels, and its successor La Libre Esthétique whose shows became increasingly dominated by the Neo-Impressionists and the *Nabis. The 2 phases of his work are illustrated by After the Strike (1887) and the later decorative linear art which was influenced by oriental art, e.g. The Three Brides (1893).

Torelli Giacomo (1608–78). Italian scenc painter and designer, the 1st professional designer and one of the most expert in devising machinery and effects. He worked in Venice and then Paris, where he introduced many innovations.

Torrès-Garcia Joaquin (1874–1949). Uruguayan painter; he worked in Paris (1924–34), where he was influenced by abstract art, though his work has always retained figurative elements – owing much formally to Pre-Columbian art.

Torrigiano Pietro (1472–1528). Florentine sculptor, the most important Italian Renaissance artist to work in Britain. He studied under Bertoldo di Giovanni in Florence but was exiled after a fight in which he broke Michelangelo's nose. He died in Spain while imprisoned by the

Inquisition. His masterpiece is the joint tomb of Henry VII and Elizabeth of York (1512–18). Of his work in Spain only the statues *St Jerome* and *Virgin and Child* have been preserved.

torso. The trunk of the human body and hence a statue which by accident or design is without head, arms and legs. Modern sculptors often used this depersonalized human form to express abstract concepts of line and pose.

Tosa. Family of Japanese artists of the *Edo period. Rivals of the *Kano family, the T. tended to more traditional, small-scale style and subject matter, e.g. ills of the literary classics.

Toulouse-Lautrec Henri de (1864-1901). French painter born at Albi into an aristocratic family. Physically frail, he broke both legs in accidents of 1878-9, after which he remained crippled. He studied in Paris (1882-5) under Bonnat and Cormon, was a student with Bernard and met Van Gogh in 1886. He was aware of Impressionism, but his 1st important work Le Cirque Fernando (1888) is formally closer to Manet, Degas and the poster artist Jules Cheret. In studying the same aspects of contemporary life as Degas - racecourses. music- and dance-halls, cabarets, etc. - T.-L. foreshadowed Seurat and the Nabis in his flat treatment of forms enlivened by curvilinear contours. This interest in exotic silhouettes predominates in his studies of the Moulin Rouge

Toulouse-Lautrec Poster (lithograph) 1893

and the Cabaret Aristide Bruant of the late 1880s. and early 1890s. Iane Avril Entering the Moulin Rouge (1892) is typical in its strident colour, theatrical lighting and strong contours. A personal friend of the singers and dancers, T.-L. was a central figure of the society he depicted and the intimacy of a painting such as Les Deux Amies (1894) is characteristic. Like Degas he worked in a wide range of media often freely mixed: his reputation as a graphic artist was established with his earliest posters and lithographs (1891-2). His prolific output shrank with his deteriorating health (c. 1896) and his last painting, the Examination Board (1901), an uncomfortable attempt to reorientate his art, betravs his spiritual and physical exhaustion. His work inspired Rouault, Seurat, Van Gogh and others and his brief career was an important manifestation of the fin de siècle intensity and exoticism (he admired Wilde enormously) which swept Europe and which can be seen for example in the early work of Picasso.

Tournier Nicolas (late 16th–17th c.). French painter, chiefly of religious subjects, in a Caravaggesque style, pupil of Valentin in Rome. He worked in Toulouse and many of his paintings are there.

Towne Francis (1740–1816). British water-colourist chiefly inspired by the mountainous districts of Italy, Switzerland and the Lake District. His best work is notable for its bold simplification of natural forms, e.g. *The Source of the Arveiron*.

Traini Francesco (fl. early 14th c.). Italian painter, follower of the *Lorenzetti brothers and the Sienese school and known principally for his fresco *Triumph of Death* (c. 1350; destroyed in World War II) for the Campo Santo, Pisa.

Trans-avantgarde. Name coined in Italy for the Expressionist revival of the late 1970s and the 1980s, involving German, Italian and U.S. artists. Among those associated with the movement are *Baselitz, *Chia, *Clemente, *Kiefer, Lupertz, Penck and *Schnabel. *Neo-Expressionism.

Traylor Bill (1854–1947). African-American artist who began drawing at the age of 85, having spent most of his life as a plantation worker. He used pencil and crayon on scraps of card or paper and from simple geometric shapes created often humorous, *primitive figures which, 40 years after his death, were seen as paradigms of *Outsider art.

triptych. 3 painted panels, usually of wood, hinged together; the 2 outer wings can be closed over the central panel and may be decorated on the reverse side. Altarpieces were frequently in the form of a t., the central panel showing the Virgin and Child, the Crucifixion or some similar subject, the outer panels showing figures of Saints or the donor of the painting, etc.

triumphal arch. Roman monument erected in honour of victorious emperors, normally with either I large opening, or I large plus 2 smaller ones, I on each side; it carried reliefs and inscriptions of the emperor's campaigns. The best known are those of Constantine (AD 312), which contains sculpture from a variety of earlier monuments; of Titus (AD 82), with reliefs of the taking of Jerusalem; and of Septimius Severus (AD 203); all are at Rome.

Trockel Rosemarie (1952−). German artist whose work is neither strictly abstract nor figurative. T. posits a discourse of the 'feminine' in her art through the *appropriation of materials traditionally associated with women, e.g. stretching patterned woven fabric over a frame, canvas-like. Influenced by, though often parodying, the prevalence of abstract painting in the '80s, T.'s repeated geometrical re-presentation of certain representative images, e.g. the Cowboy and the Hammer and Sickle, is intended to subvert − through this 'purified' reiteration − their ideological symbolism, allowing for the possibility of non-conformity.

trompe l'œil (Fr. deceive the eye). In painting a type of illusionism designed to trick the onlooker into accepting what is painted as real.

Troy François de (1645–1730). French portrait painter influenced by the portraiture of Rubens and Van Dyck,

Troy Jean-François de (1679–1752). French *Rococo painter and designer for Gobelins tapestries, pupil of his father François de T. He specialized in light, charming genre scenes of upper-class life and large decorative compositions.

Troyon Constant (1810–65). French landscape and animal painter, at first associated with the *Barbizon school but later influenced by A. Cuyp and P. Potter. His mature work consists chiefly of very large paintings of cattle. His attempt to treat animals in the grand manner was developed in later 19th–c. animal painting.

Trubetskoi Pavel (1866–1938). Russian Symbolist sculptor, known as the 'Russian Rodin'. Of aristocratic family, he grew up in Milan, where he studied sculpture with Bazarro. He made likenesses of many celebrities of his day, e.g. Leo Tolstoy (1899), Tsar Alexander III (1909), and also taught in the Moscow College; *Goncharova was among his pupils.

Trumbull John (1756–1843). U.S. painter, the pictorial chronicler of the American Revolution in which he took part, for a time as aide-de-camp to Washington. He later studied under *West in London. He executed 4 large panels (completed 1824) – Declaration of Independence, Surrender of Burgoyne, Surrender of Cornwallis and Resignation of Washington at Annapolis – for the rotunda of the Capitol, Washington, based on small earlier versions.

Tucker William (1935—). British sculptor. He studied history at Oxford University and sculpture with *Caro at St Martin's School of Art. His works include abstracts in steel, and in fibreglass, plastics and wood. He has also written numerous articles and an influential book, *The Language of Sculpture*, 1974.

Tuke Henry (1858–1929). British marine painter noted for his fresh and vivid feeling for sea and sunlight. Among his best-known works are pictures of naked boys bathing from sunlit beaches or boats.

T'ung Ch' i-ch' ang (1555–1636). Chinese Ming scholar-painter, calligrapher and critic whose classification of *Chinese art into a 'northern school' and a 'southern school' dominated later Chinese art theory.

Tunhuang caves. The *Six Dynasties

Tunnard John (1900–71). British painter particularly well known in the late 1940s and early 1950s for rather spiky semi-abstract landscapes and figure paintings.

Tura Cosimo (c. 1430–95). Court painter to the d'Este family at Ferrara and founder of the Ferrarese school; he was eventually eclipsed by Ercole Roberti. He is best known for his series of wall paintings commissioned by Duke Borso d'Este for the Palazzo Schifanoia at Ferrara to record the splendour of court life. A more dramatic aspect of his talent is revealed in *St Jerome* where the influence of Mantegna is apparent in the sculpturesque treatment of the figure.

Turkish art. *Islamic art

Turnbull

Turner Petworth: A Stag Drinking c. 1830

Turnbull William (1922—). Scottish artist and poet, trained in London and Paris. A leading *Situation artist, he developed towards *Minimal art styles. His sculptures include totem-like, wood or stone, balanced cylinders (1960s) and painted steel abstracts.

Turner Joseph Mallord William (1775–1851). British painter in oils and watercolour, mainly of landscape, historical and seascape subjects; he was born in London, the son of a barber. He was taught by Thomas Malton but his precocious talent took him to the R.A. Schools (1789) and he exhibited at the R.A. for the first time in 1790; he became a full Academician in 1802. Contact with Dr Monro's circle led him to be influenced by J. T. *Cozens, Richard *Wilson and *Girtin, and his work gained greatly in imagination and technical expertise. The death of Girtin (1802) left T. master of the architectural and topographical field, but already his interests had broadened. In 1802 he made studies in the Louvre and was showing the influence of the Dutch marine artists and the Venetian painters. A journey to Switzerland, via Lyon, returning through Schaffhausen and Strassburg, resulted in 400 sketches, many later worked up into pictures. This was a culmination of earlier sketching tours to North Wales, Yorkshire and Scotland. After 1802 T. produced a large number of historical works such as Hannibal Crossing the Alps (1812). Influence of Claude Lorraine is seen in several idyllic landscapes, including Dido Building Carthage (1815). Between 1810 and 1835, the 'middle period', T. produced many large-scale works for rich or aristocratic patrons. He also did engravings for a number of books, including the Liber Studiorum (1807–19), a series of landscapes and intended to rival *Claude's liber veritatis. After a visit to Italy

(1819). Italian and especially Venetian scenes formed the subject matter of many hundreds of works. T.'s late period, beginning in the early 1830s, was concerned with the painting of light, to which the ostensible subject matter was almost secondary. Forms and details were suggested and painted on previously prepared broad areas of yellows, whites, pinks and reds, or cool greys and blues. Petworth, the home of T.'s friend and patron Lord Egremont, figured in many of these works. Among major late paintings were The Fighting Téméraire, A Fire at Sea, Interior at Petworth, and Rain, Steam and Speed, and Rockets and Blue Lights. Although T. had become successful as a painter by 1801, the case also for many of his formal Academy paintings, the advocacy of *Ruskin in Modern Painters (vol. 1, 1843) helped greatly in the public appreciation of his later works. His painting of light influenced the *Impressionists, especially Monet and Pissarro, who saw his work in London in 1870. After the T. exhibition at the Venice Biennale (1948) there was a second wave of influence, on non-figurative painters. There was a major retrospective at the R.A., London, 1977.

Turrell James (1943—). U.S. artist whose works — site-specific, depending on the neutrality of the site where they are installed—use as the artist's material light, colour and space ('I'm interested in the weights, pressures, and feeling of the light inhabiting space itself and in seeing this atmosphere rather than the walls.') In the late '60s T. was one of a group of artists in Los Angeles including L. *Bell, R. Irwin and D. Wheeler. In 1967 he made *Afrum-Proto* using projected light. Since then he has consistently explored visual perception and the use of light, whether projected or natural, as physical

material in creating space and volume ('... the light is used to make a realm that's of the mind'). His light projections and large-scale *installations that use natural light, as in his monumental work-in-progress, which he has been engaged in since 1974 - the Roden Crater project, near Flagstaff, Arizona – fuse an aesthetic impulse with scientific calculation, the laws of human perception and cognition, man's relationship with his environment and the mutability of light as material in time. They ultimately direct the viewer's experience inwards. As Robert Hughes has written, '... one is confronted ... with the reflection of one's own mind creating its illusions and orientations and this becomes the "subject" of the work. The art, it transpires, is not in front of your eyes. It is behind them.' The volcanic Roden Crater provides the setting within which 'I am making spaces that will engage celestial events. Several spaces will be sensitive to starlight and will be literally empowered by the light of stars millions of light years away. The gathered starlight will inhabit that space, and you will be able to feel the physical presence of that light.'

Tutankhamūn (d. c. 1350 BC). A young Pharaoh whose tomb, with its original magnificent contents astonishingly almost intact, was discovered in the Valley of the Kings at Thebes by Howard Carter, in an expedition financed by the Earl of Carnarvon, 1922. Carnarvon gave the treasures to the Cairo mus. The sensational find inspired neo-Egyptian design styles in art deco.

Twombly Cy (1929—). U.S. painter living abroad almost continuously since 1951, settling in Rome in 1957. T. evolved an abstract style of 'writings'; in the late 1950s allover *graffiti-like figurations developed along with a fresh interest in the surface on which they are placed, e.g. *School of Athens* (1961), while 'figure' and 'landscape' lines began to merge. Pencil marks with fragments of rectangles, numbers and words are drawn, scratched and crayoned over the canvas, reminiscent of works by *Abstract Expressionists, or complete words suggest layers of association and meaning.

Tworkov Jack (1900–82). Polish-born U.S. painter and teacher. Cézanne influenced his early figures, landscapes and still-lifes. After 1950, T.'s paintings lost specific figurative references and his style moved closer to *Abstract Expressionism. His abstraction developed

suggestive and atmospheric action of brushstroke and vigorous colour, e.g. *Watergame* (1955). T. used verticals recurrently, sometimes in a more linear style and in an allover pattern. In the 1960s he experimented with pure colours in grid-like compositions, as in *West 23rd*, 1963. He was chairman, Art Department, Yale School of Art and Architecture, 1963–9.

Tzara Tristan (1896–1963). Rumanian poet who founded the *Dada group in Zürich (1916) and ed. the periodical *Dada*. He later became leader of the Paris group. In addition to numerous writings on the Dada movement, his own Dada works include *Vingt-Cinq poèmes* (1918) and the play *La Cœur à Gaz* (1923).

\mathbf{U}

Uccello Paolo (c. 1396–1475). Florentine painter apprenticed to *Ghiberti. At first successful, he fell out of favour with his patrons, due, it is believed, to his uncompromising interest in the problems of perspective. Vasari relates how according to his daughter, '... Paolo would stand the whole night through

Uccello Battle of San Romano (detail) 1450-9

Udine

beside his writing-desk seeking new terms for the expression of his rules in perspective. ...' Vasari also refers to the reason for his nickname 'Uccello' (It. bird). As he was very fond of animals but could not afford to keep any, he surrounded himself with paintings of birds and other animals in his house.

Belonging to Donatello's threw himself wholeheartedly into the new scientific-painterly problems of representing 3dimensional reality on a 2-dimensional surface by means of perspective. After his death he was forgotten, but 20th-c. concern with formal problems caused a revival of interest in his work. It is interesting to compare 2 early paintings, versions of St George and the Dragon, the first flat and decorative, the second with a passionate concern for space and form. The pattern of circles on the dragon's wings becomes an excuse for showing them in perspective; the treatment of the prancing horse and knight's armour is identical. The upright figure of the princess is composed with severity. The lines of central perspective are accentuated by the diagonals of the knight's lance and the dragon's leg. All the essential elements of U.'s later paintings are here clearly and uncompromisingly stated. His bestknown works are the fresco The Flood and the 3 panels of The Rout of San Romano (1454-7). painted decorations for the Medici Palace in Florence. They are further examples of his highly original and imaginative approach. Scientific perspective is blended with a poetical interpretation of reality. The trappings of horses and armour are turned into fantastic forms and the colour scheme is rich and unexpected. His last important work, The Hunt (1468), is a night scene. Perspective is used here to create a superb, varied pattern of diminishing forms.

Utamaro Wood-block colour print, late 18th c.

Udine Giovanni da (Giovanni Nanni) (1487–1546). Italian painter, one of the foremost decorative artists of his time, notable for his grotesque ornamentation and responsible for reviving and popularizing stucco as a form of decoration. He studied under Giorgione in Venice, then entered Raphael's workshop in Rome; on the sacking of Rome (1527) he fled to Florence.

Ugly Realism. The work produced by a number of artists working in Berlin from the late 1970s, among them J. Grutzke, M. Koeppel, and W. Petrick. It was essentially a revival of the *New Objectivity of the 1920s.

Ugolino di Nerio (da Siena) (fl. 1317–27). Italian painter of the Sienese school, follower of Duccio. His only authenticated painting was the high altar of S. Croce, Florence, a polyptych, only fragments of which now exist. Many other paintings are attributed to him.

Ukiyo-e. *Japanese prints

Umbria, school of. Central Italian school of painting of the 15th–16th cs based on Perugia and represented by *Perugino, *Pinturicchio and *Raphael.

underpainting. Painting of a composition in monochrome before the addition of colour glazes, which was the initial stage in the traditional method of oil painting. The word can also be applied to a layer of colour which is to be glazed or scumbled.

Unit One. Group of British artists formed in 1933 and including H. *Moore, B. *Nicholson, *Hepworth and *Nash; *Read was its spokesman.

Utamaro (1753–1806). Japanese master of the wood-block colour print, the 1st Japanese artist to become well known in the West.

Utrecht Psalter (9th c.; University Library, Utrecht). Carolingian Psalter from the Rheims school, almost certainly a copy of a much older codex. Each psalm has an illustrative ink drawing in a sketchy, agitated freehand style totally unlike the usual Carolingian style. The Psalter was brought to England in the late 10th c. and strongly influenced the English school.

Utrecht school. Group of Dutch painters including *Terbrugghen, *Honthorst and *Baburen who were influenced in Rome (c. 1610–20) by the realism of *Caravaggio and

his follower Manfredi, and later worked in Utrecht painting religious and genre subjects. Frans Hals, Rembrandt and Vermeer, as well as lesser artists, were all to some extent affected.

Utrillo Maurice (1883–1955). French painter, son of the painter *Valadon. A habitual drinker from his youth, he reputedly began to paint as a therapeutic distraction between sanatorium confinements, often copying his views of Paris streets from picture postcards, e.g. *Place du Tertre* (1912). Influenced by Impressionism at first, he developed a more personal style of freely impastoed paint and very high-keyed pale colours, which by the 1920s enjoyed a popular success. His poetic interpretation of the streets and squares of Montmartre helped to create the locality's popular romantic image.

Vaillant Wallerant (1623–77). Portrait and genre painter of the Dutch school and an early practitioner of mezzotint engraving.

Valadon Suzanne (Marie-Clémentine Valadon) (1867–1938). French painter and mother of *Utrillo. She began as a model posing for Puvis de Chavannes, Renoir and Toulouse-Lautrec, who encouraged her to draw. She took up painting in 1909 but her interpretation of still-life and figure subjects remained strongly linear. Both her drawings and paintings, particularly

Valadon Nue à la couverture rayée

Utrillo L'impasse Cottin c. 1910

of the female nude, are characterized by a merciless objectivity.

Valckenborch Lucas (d. 1597) and Marten (1535–1612). Flemish landscape painters who settled in Frankfurt to avoid religious persecution. They both painted panoramic views with small figures. Lucas imposed an atmospheric unity on his work by his use of subtly graded shades of grey, green and blue.

Valdés-Leal Juan de (1622–90). Spanish Baroque painter and engraver of Portuguese origin who worked in Seville from 1656. He was a pupil of A. del Castillo. His most famous paintings are those on *vanitas* themes such as *Finis Gloriae Mundi* and *Triumph of Death*.

Valentin, Le (Moise) (c. 1591–1632). French painter of religious and genre subjects who spent most of his working life in Rome where he came under the influence of Manfredi and through him of Caravaggio. Various paintings in a Caravaggesque style such as Brawling Soldiers and Tavern are attributed to him. His only documented work, Martyrdom of SS Processus and Martinian, shows the influence of his friend N. *Poussin.

Vallotton Félix (1865–1925). Swiss painter, woodcut artist and writer who became a naturalized French subject in 1900. He went to Paris in 1882 and joined the Nabis but later adopted a more detailed and objective style reminiscent of the German and Swiss schools. His use of

Valori Plastici

the woodcut was influential in reviving that medium.

Valori Plastici (It. *Plastic Values*). The name of a magazine founded in Rome in 1918 by Broglio, *Carrà, *Severini and De *Chirico. It advocated a return to classicism and the revival of traditional academic methods of art teaching and gave its name to a Neoclassical tendency in the Italian art of the time.

Vanderlyn John (1775–1852). U.S. *Neoclassical history and portrait painter. From 1796 to 1815 he lived chiefly in Paris, where he built up a considerable reputation with *Marius amid the Ruins of Carthage* (1807) and *Ariadne* (1812). On his return to the U.S.A. his work met with little success.

Van Loo Charles-André called Carle (1705–65). French painter of religious and mythological subjects and portraits, brother and pupil of Jean-Baptiste V. L. He lived in Italy (1727–34), then settled in Paris and later became court painter to Louis XV. His work was elegant and superficial, typical of its age. His son Jules César (1743–1821) was a landscape painter.

Van Loo Jean-Baptiste (1684–1745). French portrait and decorative painter. He worked in Britain (1737–42) where he became the leading portraitist in succession to Jonathan Richardson the Elder and Dahl. He acquired an inflated contemporary reputation because he brought a certain elegance to British portraiture. His sons Charles-Amédée (1719–95) and Louis-Michel (1707–71) were also painters.

Vanni Andrea (fl. 1350–75). Sienese painter, follower of Simone Martini.

Vantongerloo Georges (1886–1965). Belgian sculptor, painter and writer on art theory, one of the most important members of the *De Stijl group and co-founder of the *Abstraction-Création group. He was one of the earliest abstract sculptors, following in his sculpture as well as his painting the horizontal-vertical principle of De Stijl. He began to make use of the curve in the mid-1930s.

Vargas Luis de (1502–68). Spanish painter who spent many years in Italy, where he was influenced by the followers of Raphael. He worked in Seville, where his greatest achievement is the altarpiece of the Nativity in the cathedral. He is credited with introducing the art of fresco to Seville.

Varley F(rederick) H(orsman) (1881–1969). British-born Canadian painter; he settled in Canada in 1912. V. was known mainly for his portrait and figure painting, and his powerful work as a war artist (1918); he was also a member of the *Group of Seven.

Varley John (1778–1842). British water-colourist. He worked with an architectural draughtsman before being taken up by Dr Monro, in whose house he met Turner and Girtin; he was also a friend of Blake. Much of his work was hasty and inferior, but he was popular as a teacher, his pupils including David Cox, Palmer, Linnell, Mulready and Holman Hunt. He wrote treatises on drawing, composition and perspective.

varnish. Resinous transparent substance applied by painters to their works in order to preserve them – as distinct from glazing.

Varo Remedios (1908-63). Spanish painter involved in *Surrealist circles who settled permanently in Mexico in 1942, closely associated with *Carrington. The two artists shared an interest in legends, fairy-tales and alchemy with the artistic and biological creativity of woman at the centre of their work. V. focused on alchemy as a positive process of transformation – a search for spiritual enlightenment through materiality - but Alchemy or the Useless Science (1958), in which she employed *decalcomania, begs its futility. Her work is more often characterized by a meticulous application of paint, achieving through formal precision a fluid and dream-like result. Solar Music (1955) and Harmony (1956), though different in character, show a concern for a spiritually redemptive order, which she was to develop further in works such as Born Again and Ascension to Mount Analogue (both 1960).

Vasarély Victor de (1908–97). Hungarian painter. He was tutored by Moholy-Nagy, and through him was introduced to the work of Kandinsky, Gropius, Le Corbusier and Mondrian. Since 1930 he has lived in Paris. He was profoundly influenced by the functionalism of the *Bauhaus. His *Op(tical) abstractions, painted often in contrasting colours, are composed of clean-cut geometric forms.

Vasari Giorgio (1511–74). Italian *Mannerist painter and architect of the Uffizi Gal., important as an art historian. His *Le vite de' più eccellenti architetti, pittori, et scultori Italiani*, a coll. of nearly 200 biographies dedicated to Cosimo de' Medici

was first publ. in 1550 and carefully revised and enlarged in 1568. V.'s appreciation of Venetian art is coloured by his great love for all things Florentine and his worship of Michelangelo blinds him to the ability of others. But in spite of some inaccuracies V.'s book is an all-important source of information relating to the history of Renaissance art. The 1st complete English trs. appeared in 1850.

Vatican Rome. Works of art in the Vatican Palace, in addition to the works by Raphael, artists of the Venetian school and of the 17th-c. Roman school contained in the picture gallery founded by Pius VII, include the paintings by Michelangelo and other artists in the Sistine Chapel, the paintings by Raphael and his assistants and pupils in the Stanze and Loggie, the paintings by Pinturicchio in the Borgia Apartments and the Raphael tapestries. The chapel of Nicholas V contains frescoes by Fra Angelico.

Vaughan Keith (1912–77). British painter specializing in studies of the male nude.

Vecchietta Lorenzo di Pietro called II (1412–80). Sienese painter and sculptor probably trained as a painter by *Sassetta; his masterpiece is *Assumption of the Virgin*. His sculptural work, which shows Florentine influence, includes the statue *Risen Christ* and the bronze ciborium on the high altar of Siena cathedral.

Vedder Elihu (1836–1923). U.S. painter of imaginative subjects famous for his series of over 50 ills to Edward Fitzgerald's *Rubáiyát of Omar Khayyám*.

Vedova Emilio (1919—). Italian abstract painter. He joined the *Fronte nuovo delle arte in 1946. His work combines *Cubist, carly *Futurist and expressive, informal gestural styles in paintings of great dramatic potency, e.g. Image of Time (Barricade) (1951).

Veen (Vaenius) Otto van (1556–1629). Dutch painter of portraits and religious subjects who worked mainly in Antwerp and Brussels but also in Italy under Zuccaro. He adopted an Italianate style.

Velazquez Diego Rodriguez de Silva (1599–1660). Spanish painter, pupil of Francisco de Herrera and Don Francisco Pacheco. In 1617 he graduated from Pacheco's workshop-academy as a master painter and married his daughter in 1618. 4 years later V. left his native Seville for Madrid; his hope of admission to the royal court

was disappointed, but the following year his portrait of his friend the courtier Juan de Fonseca was seen by the king, and this secured V. the commission to paint the king's own portrait. V. became Philip IV's close companion at the Alcazar Palace and remained in his service until his death Rubens visited the court in 1628 and on his advice V. obtained the king's consent to travel. He left for Italy in 1629 and studied the Italian masters. 20 years passed before he was able to visit Italy again, when he not only studied but also bought paintings by Tintoretto, Veronese and Titian for the Royal College. In 1650 he painted the portrait of Pope Innocent X in Rome. In 1659 he was ennobled as a Knight of the Order of Santiago.

V.'s greatest achievement is seen not in his splendid representations of Spanish court life but in the profound feeling for humanity which underlies all his work. In the midst of the glitter and artificiality of his daily life he was keenly concerned with human tragedy and suffering: the deformed, the dwarfs and the poor were of as much interest as a pope, king or courtier. As an artist he preferred Titian to Raphael. The art of V., like that of Titian, was concerned with movement, the movement of light over objects, dissolving static forms into a summary statement of a visual impression. The paintings of V. show a development in their means - but the end, painting life as it appeared to him, remained constant. His earliest paintings such as The Water Carrier of Seville (c. 1618) show a deep concern for everyday reality, uncompromising in subject matter and unpretentious in presentation. The jar in the foreground is just as important as the figures. Material existence is shown here as essence, the trivial becomes eternal.

The royal portraits needed to be treated dif ferently. Form is here partly monumental, partly psychologically conditioned, as in the King Philip IV. The psychological interest increases, as in the later portrait. The famous Las Meninas (1656) – which inspired a series of reworkings of its themes by *Picasso - contains a number of figures, puppet-like and including the artist at his easel, ladies' maids and a dwarf, and reveals the atmosphere of life at the court as seen by a detached and critical man. Forms are suggested with the minimum amount of brushwork and controlled with a superb economy of means. During his life V. continued to be intrigued by the depth of the human mind and in his paintings of dwarfs and court jesters he created a series of tragic and revealing documents,

Velazquez The Rokeby Venus

meditations on fate painted in sombre colours. The *Pope Innocent X* portrait (1650) is one of V.'s greatest.

Two landscapes, views of the Villa Medici. Rome, date from about the same time. V. here foreshadows Impressionism in his glimpse of the fleeting atmosphere of day and dusk. The Surrender of Breda (c. 1634) turns the 'historical' into a composition with light, where the human drama becomes an element of nature. The Rokeby Venus (1658), painted with superb restraint, is the only surviving nude by V.; at the time the subject was virtually forbidden in Spain. V.'s fame suffered an eclipse after his death, but during the 2nd half of the 19th c. he was hailed as the 'greatest painter'. In 20th-c. art his work has been of particular relevance for his mastery over formal problems of colour and relationship.

Velde Adriaen van de (1636–72). Dutch painter of landscapes with figures and animals, portraits and genre and religious subjects. He studied under his father, Willem van de V. the Elder, and J. Wynants. He was influenced by the Italianate manner of Berchem. He frequently painted the animals in landscapes by other artists such as Jacob van Ruisdael and Wynants.

Velde Esaias van de (c. 1590–1630). Dutch landscape and genre painter who contributed to the development of Realism in Dutch landscape painting. He was influenced by Buytewech and worked in Haarlem and The Hague. His most notable paintings are small landscapes with figures. J. van Goyen was his pupil.

Velde Geer van (1898–1977). Dutch painter of the school of *Paris; brother of Bram van V. His compositions, which are of great colouristic sensitivity, relate to exterior reality but transform it spatially within a geometrical framework.

Velde the Elder, Willem van de (1611–93). Dutch marine painter, brother of Esaias van de V. He settled in Britain (1672) with his son Willem the Younger and together they entered the service of Charles II. He is known for his grisaille drawings, though he probably also painted in oils. He collaborated with his son.

Velde the Younger, Willem van de (1633–1707). Dutch marine painter, son of Willem the Elder. He studied under his father and De *Vlieger. Early paintings were seascapes influenced by De Vlieger, but after settling in Britain he concentrated on shipping and naval events. In the work which he produced with his father he is reputed to have been responsible for the colouring, his father for the draughtsmanship. He had many British imitators.

Veneziano Domenico. *Domenico Veneziano

Venice, school of. School of Italian painting which flourished in the 16th and 18th cs. In the 16th c. it developed under the influences of the school of Padua and Antonello da Messina, who introduced the oil-painting technique of the Van Eycks. Rich and painterly use of colour characterized Venetian painting. Early masters were the Bellini and Vivarini families, followed by Giorgione and Titian, then Tintoretto and Veronese. In the 18th c. the decorative art of

Tiepolo and the views of Canaletto and Guardi revived Venetian painting.

Verelst Simon (1644–1721). Dutch flower and portrait painter who settled in London (1669) where his highly finished naturalistic flower pieces became very popular. He started a vogue for portraits with floral surrounds. His brother Harmen (1643?–1700?), also a painter, worked in London from 1683.

Vereshchagin Vasilevich (1843–1904). Russian painter who enjoyed an international reputation based chiefly on his military paintings, which exposed the grim reality of war as he had seen it as a war correspondent. His historical paintings of Napoleon's invasion of Russia in 1812 were popular as illustrations to Tolstoy's *War and Peace*.

Vergós. Family of Spanish painters of the 15th c. who worked in Barcelona.

Vermeer Jan, of Delft (Joannes van der Meer) (1632-75). Dutch painter mainly active as an art dealer; a member and eventual president of the Painters' Guild at Delft. It is thought that he did not sell one of his own paintings; there survive few contemporary references to his work and he seems to have died in poverty; over half the paintings attributed to him were noted at the time in his house and studio. A contemporary of the painter *Fabritius, a pupil of *Rembrandt, it is likely that he came under both his and *Caravaggio's influence. After the death of Fabritius, V.'s own style began to develop: classical, timeless and monumental - reality in its everyday aspect observed by a passionate and detached intelligence. Domestic life is raised to the level of poetry. V. is acknowledged in our time as one of the great masters and his influence on the 'tonal' painter has been enormous.

V.'s surving towards the fullest possible representation of reality was achieved through mechanical and pictorial means: the *camera obscura, mirrors, smooth and thin paint whose texture does not destroy the illusion of the counterfeit, sculpturesque modelling, the tonal and geometric organization of pictorial space, all these were used ruthlessly to emphasize the visual process. This is now recognized as V.'s unique achievement. A tentative chronology, the result of 50 years' scholarship, permits the following outline of V.'s development.

The *Girl Asleep at a Table (c.* 1656) shows a growing realization of creative problems and points towards possible solutions. The conven-

Vermeer The Love Letter c. 1670

tional genre subject is treated quite differently from the average stage-like representation by his contemporaries. As in a landscape, the eye is compelled to travel over a number of clearly defined forms of the foreground, such as a table and chair, before it can reach the figure of the middle distance and see into the room at the far end of the interior. This visual intent is reinforced by cutting into the visual field of the foreground and projecting beyond the picture frame part of the table and the chair, so that the space of the painting is extended into the real space of the spectator. The Maidservant Pouring Milk (c. 1658) carries the intensification of the visual a stage further. Objects are seen as eternal forms placed in an ideal space; a silvery light plays over objects and figures with the same cool detachment. The Love Letter (c. 1670) is the most profound example of V.'s visual philosophy. Other famous paintings by V. are View of Delft and The Head of a Young Girl, The Artist's Studio and Christ in the House of Martha and Mary.

Vermeer van Haarlem Jan (1628–91). Dutch landscape painter. His son Jan (1656–1705) painted Italianate landscapes and his younger son Barent (1659–*c.* 1700) still-life subjects.

Vermeyen Jan Cornelisz (c. 1500–59). Dutch painter, mainly of portraits, influenced by Mabuse and J. van Scorel. Travels in Spain and Tunis gave him themes for some historical paintings and a series of tapestries designed for Mary of Hungary.

Vernet

Vernet Carle (1758–1836). French painter of horses and Napoleonic battle scenes; son of Claude-Joseph V. Carle's son, Horace (1789–1863), also a painter and ill., decorated the Gallery of Battles at Versailles.

Vernet Claude-Joseph (1714–89). French painter who spent many years in Italy. He painted chiefly classical landscapes after the manner of *Claude Lorraine and overdramatized marine subjects. For Louis XV he completed the 16 paintings the *Ports of France*.

Veronese. The name used by Paolo Caliari (c. 1528-88). One of the greatest painters of the 16th-c. Venetian school, named after his birthplace, Verona, then within the Venetian cultural and political orbit. Although the son of a stonebreaker and trained by minor Mannerist painters, V. shows an extraordinary assurance of style from the beginning, from which he hardly developed or varied. His first frescoes in the Doge's Palace (c. 1553) and the St Mark's Library, Venice, won him acclaim in Venice and the respect of *Titian. After Titian's semiretirement V. shared with *Tintoretto the most important commissions, and his chief patrons were the religious foundations in Venice. In 1573, however, V. was in serious trouble with the Inquisition for his manner of representing traditional religious scenes in the spirit of highfestival, e.g. Marriage at Cana, Feast in the House

Veronese Feast in the House of Levi (detail) 1573

of Levi. Although he was censured, his reputation did not suffer permanently. Tintoretto's, V.'s art was enormously influential throughout the 17th and even 18th c., especially with the artists of Spain and Flanders and with Tiepolo and other painters of large-scale decorative schemes. V.'s style shows his delight in elegance, opulence and the splendour of surfaces. This is saved from appearing simply mundane or too facile by high technical skill and a superb colour sense. It would be impossible to list more than a fraction of the paintings of this prolific and consistently fine artist, but nowhere is his colour sense better ill. than in the painting of the golden hair of St Barbara cascading down a dress of gold and black thread in Holy Family with St Barbara. V.'s very personal conception of aristocratic grandeur appears in The Family of Darius before Alexander. Other fine works are: Feast in the House of Simon, The Finding of Moses and Rebecca at the Well. That V. could, on occasion, bring a note of tragedy into his painting is shown in the figures on their high crosses against the dark storm-torn sky in the Crucifixion.

Verrio Antonio (d. 1707). Neapolitan decorative painter who settled in Britain in 1671 and was appointed court painter in 1684. In spite of his mediocrity he achieved great success because of the comparative novelty of his late *Baroque style in Britain. He worked at Windsor Castle, Hampton Court and elsewhere.

Verrocchio Andrea del (c. 1435–88). Florentine goldsmith, sculptor and painter. Very little is known of V.'s life, none of his works as a goldsmith have survived and few sculptures can be definitely attributed to him. He worked in Florence at the court of Lorenzo de' Medici. V. is regarded as the most influential Florentine painter of the 2nd half of the 15th c. The achievement of V. and his relationship with his young apprentice Leonardo da Vinci have been debated; his profound influence on Leonardo, Lorenzo da Credi and others of the Florentine school is indisputable.

In the bronze statue *David* (c. 1476) V.'s style is clearly expressive of the new trends in Florentine art. In the quest for naturalism, the mastery of the figure is extended into an understanding of the psychological; the youthful, victorious David is seen as an adolescent full of conceit and self-confidence. This striving after psychological truth expressed by plastic means is carried further in the group on the outside of Or San Michele, Florence (1476–83) representing

Verrocchio David

The Unbelief of St Thomas. The Colleoni monument in Venice, begun in 1479 and only completed after his death, is perhaps his best-known work. Compared with Donatello's carlier Gattamelata, it shows the individuality of V.'s achievement at its height. The condottiere and his horse have become the embodiment of will-power, a purposeful and ruthless machine.

Of V.'s painting only the much-disputed *The Baptism of Christ* remains. On the suggestion of Vasari, the head of one of the kneeling angels is attributed to the young Leonardo da Vinci

Verspronck Jan Cornelisz (1597–1662). Dutch portrait painter noted for his portraits of children. He was a pupil of *Hals and worked in Haarlem.

Vertue George (1684–1756). British engraver and antiquary whose notebooks on British art from about 1700 to 1750, although disorderly and mainly unreflective, are the principal source for the period. On them H. Walpole based his *Anecdotes of Painting in England* (1763).

Viani Albert (1906—). Italian sculptor, a pupil of A. Martini and a member of the *Fronte nuovo delle arte* group. His style followed that of Arp but is less purely abstract. The female form is usually the basis of his work.

video art. Television and video-recording technology used in works of art (e.g. *Paik).

Vieira da Silva Maria Elena (1908–92). French painter born in Portugal who emigrated to France in 1928. Her paintings are elaborate, patterned, architectural explorations of perspective.

Vien Joseph (1716–1809). French painter working at Rome for a period and influenced by the *Neoclassicism of the later 18th c. He achieved a great contemporary reputation both as artist and teacher. J.-L. *David was a pupil.

Vigée-Lebrun Marie-Elisabeth-Louise (1755–1842). French portraitist of the *Rococo period, pupil of her father the pastellist Louis V.-L. (1715–67) and wife of Jean-Baptiste-Pierre Lebrun (1748–1813), painter and art dealer. She painted attractive, flattering portraits which brought her the patronage of Queen Marie-Antoinette and, during the years of the Revolution, of royalty elsewhere in Europe. Her memoirs were publ. under the title Souvenirs (1835–7: Souvenirs ..., 1870).

Vigeland Gustav (1869–1943). Norwegian sculptor. He studied in Oslo and Copenhagen, and then in Paris under Rodin (1892). His major work, begun c. 1906, is the group of sculptures in the Frognerpark, Oslo, conceived as an open air chapel and culminating in a massive column of interwoven nude figures which is medieval in spirit and complexity.

vignette. Term originally applied to the decorative borders of medieval mss, later to the small decorative motifs appearing at the ends of the chapters of 18th- and 19th-c. books.

Vignon Claude (1593–1670). French painter and etcher who worked for Louis XIII and Richelieu. He studied in Rome (c. 1616–24), where he was influenced by the followers of Caravaggio and Elsheimer, developing a style strikingly similar to that of the young Rembrandt. The two artists were acquainted with one another and V. sold some works by Rembrandt in Paris.

Vijayanagar. Ancient S. Indian city and capital of a vigorous Hindu kingdom (c. 1336–1565). It built enormous temple cities with technically brilliant but highly stylized and often ferocious sculptures. The chief cities were V. itself, sacked by Muslim armies (1565), Shrirangam and Vellore.

Villeglé Jacques (Mahé) de la (1926–). French affichiste artist who, with *Hains, *Rotella and

others, belonged to a branch of the *Nouveaux réalistes. In 1947 he started collecting found objects and from 1949 he made *décollage his exclusive medium, tearing off street posters to reveal underlying ones, then removing selected sections and mounting them on canvas, e.g. Angers, 21 septembre 1959 (1959), 14 juillet, décembre 1960 (1960) and Rue Vieille du Temple (1980).

Villon Jacques, real name Gaston Duchamp (1875–1963). French painter, half-brother of *Duchamp and R. Duchamp-Villon. In 1911 he became a *Cubist, for a time the leader of a faction including Léger, Gleyre and Gleizes. In 1919 he began painting abstracts, and his work passed through several phases, all however marked by command of proportion and line.

Vingt, Les (Fr. The Twenty) – also often written 'Les XX'. A group of twenty avant-garde Belgian painters and sculptors which began a series of annual exhibitions in 1883 lasting until its dissolution in 1893. These exhibitions included numerous leading foreign painters and sculptors then at the beginning of international careers, such as *Cézanne, *Gauguin, *Manet, *Seurat, *Toorop, *Toulouse-Lautrec and Van *Gogh. It was influential in spreading the international reputation of Neo-Impressionism and Post-Impressionism.

Viola Bill (1951-). U.S. *video and *installation artist, considered to be one of the most influential video artists of our time. His evocative works assemble sounds and images, often of the body, which are manipulated and recombined, creating new meanings and environments. His video installations are presented in dark, enclosed spaces, e.g. the highly poetic Room for St John of the Cross (1983) and the deeply moving autobiographical Nantes Triptych (1992) which presents on 3 screens his wife giving birth, the artist's dying mother and the artist, himself, shrouded and weightless in water as if suspended in space between birth and death. To Play without Ceasing (1992) contains whispered extracts from Walt Whitman's Song of Myself accompanying the images and is 'a compendium of everything I have ever done.

The real place the work exists is not on the screen or within the walls of the room, but in the mind and heart of the person who has seen it. This is where all images live.' V.'s aim is to awaken these images within us: 'To see the unseen is an essential skill to be developed at the close of the twentieth century.'

Vischer. Family of German sculptors and metal-founders (fl. mid-15th-mid-16th c.). The family workshop in Nuremberg was established by Hermann (d. 1488) and taken over by his son Peter the Elder (d. 1529) and his sons Peter the Younger (1487–1528), Hermann the Younger (1486–1517) and Hans (d. 1550). They were responsible for the tomb of Archbishop Ernst of Saxony (Magdeburg cathedral), the statues of Theodoric and Artus for the tomb of the Emperor Maximilian and the tomb of St Sebald, a fine example of German Renaissance art.

Vischer Friedrich Theodor (1807–87). German writer, an important theorist on aesthetics and author of the satirical novel *Auch Einer* (1879).

Vitale da Bologna Vitale d'Aimo de'Cavalli, known as (fl. 1334–59). Italian painter, founder of the Bolognese school. His early work, in which there is a strong decorative element, shows Sienese influence; he later adopted a broader, more simplified treatment. His paintings include *Madonnas* in Bologna Gal. and the Vatican Mus., and a polyptych in S. Salvatore, Bologna.

Viti Timoteo (1469/70–1523) called 'Timoteo da Urbino'. Italian painter trained as a goldsmith, then as a painter under *Francia in Bologna. He worked in Urbino where he was Raphael's master.

Vivarini. Family of Venetian painters who contributed to the development of the Venetian school. Antonio (fl. 1440–76) worked until 1450 with his brother-in-law Giovanni d'Alemagna in a Gothic style chiefly derived from G. da Fabriano. He later collaborated with his brother Bartolommeo (fl. 1450–99) who in the 1460s developed a style strongly influenced by Mantegna. His work makes the transition from Gothic to Renaissance. Alvise (d. 1503/5), son of Antonio, was strongly influenced by Antonella da Messina and Giovanni Bellini. He painted altarpieces and portraits.

Vivin Louis (1861–1936). French 'primitive' painter, a Post Office employee and 'Sunday painter' until his retirement in 1922, when he was able to spend all his time painting. He is best known for his paintings of the buildings of Paris.

Vkhutemas. 'Higher State Technical-Artistic Studios' set up by the Soviet government in Moscow (1920) and Petrograd and Vitebsk (1921); they ran their own affairs and were

important and more or less open experimental and avant-garde centres of teaching, theoretical development (especially of *Constructivism) and discussion, for *Malevich, *Kandinsky, *Pevsner and *Tatlin. The Moscow V. of 1920 was in fact the re-named former Institute of Painting, Sculpture and Architecture; it received financial support from the semi-autonomous trade unions and not directly from the State. Other institutions which supported experimental art were: Inkhuk (Institute of Painterly Culture) founded in Moscow, 1920, and headed initially by Kandinsky; the Svomas (Free Art Studios) in Petrograd, which replaced for a short while the Academy of Arts (re-established in 1920); the Proletkult (Proletarian Culture) movement. With the formation of AKhRR (Association of Artists of Revolutionary Russia) in 1922, the tolerance and support of the avantgarde declined. The anti-art call of the Constructivists associated with the journal LEF (Left Front of the Arts) led to the avant-garde turn towards industrial design, c. 1922-4.

Vlaminck Maurice de (1876–1958). Painter, born in Paris of Flemish parents. He was untrained and claimed never to have been inside the Louvre; the only debt he acknowledged was to Van Gogh, whose expressive use of colour

Vlaminck Self-portrait 1922

and execution was the foundation of V.'s *Fauvism. With Derain, he was one of the 1st painters to collect African masks (c. 1905) and his Fauve paintings have a more savage intensity than those of his Parisian contemporaries, e.g. Paysage aux Arbres Rouges (1906). He believed that 'instinct is the foundation of art. I try to paint with my heart and my loins.' He was influenced by Cézanne in 1907 and his later works, though often wildly painted, are more subdued in colour.

Vlieger Simon de (c. 1600–53). Dutch painter, principally of marine subjects, and etcher whose style was based on that of Porcellis. Willem van de Velde the Younger was his pupil and he also influenced Van de Capelle.

Volterra Daniele Ricciarelli called Daniele da (1509–66). Italian Mannerist painter, follower of Michelangelo. He is sometimes known as 'the breeches painter' because in obedience to an order from Pope Paul IV he painted draperies to cover the nudity of some of the figures in Michelangelo's Last Judgement. Descent from the Cross is the most famous of his paintings.

Vorticism. A British art movement which developed in reaction to *Cubism and primarily *Futurism. The name was invented by Ezra Pound in 1913, but in 1912 W. *Lewis had already made what could be described as Vorticist drawings. The group's only exhibition took place in 1915, and included works by *Roberts, *Wadsworth, *Nevinson and *Gaudier-Brzeska. Two numbers of their magazine BLAST appeared in 1914 edited by Lewis. Due to wartime conditions, V. did not survive as a movement although an unsuccessful attempt was made to revive it in 1920 renamed Group X.

Vos Cornelis de (1584–1651). Flemish painter of portraits and historical, allegorical and religious subjects; also an art dealer. He worked in Antwerp. His style of portraiture follows Rubens and Van Dyck and his paintings have sometimes been confused with theirs. *Portrait of the Artist and his Family* (1621) is a good example of his work.

Vos Marten de (1531/2–1603). Flemish Mannerist painter who studied under Floris, then went to Italy and worked in Venice under Tintoretto. On his return to the Netherlands the novelty of his style made him popular as a painter of religious subjects and portraits.

Vos Paul de (1596–1678). Flemish painter of hunting scenes, animals and still-life subjects, brother of Cornelis de V. He collaborated with Rubens and Snyders.

Voss Jan (1936—). German artist living in Paris whose linear paintings are pictograms, invented 'writing' made of painterly gestures, e.g. *Reading for Everyone* (1968), and, from the '70s, 'imaginary signs'. His work was influenced by the '60s French theory and critique of language, esp. the writings of Michel Foucault.

Vostell Wolf (1932–). German artist, contriver of *Happenings and publ. of a magazine, *Décollage* (1962). V. has torn, overpainted and singed posters since 1956. *décollage.

Vouet Simon (1590–1649). Leading French *Baroque painter and an arbiter of taste for almost 20 years. The son of an artist, V. settled in Italy (1613), living chiefly in Rome, with periods in Genoa, Venice and Naples. His style shows an individual talent and a profound study of Italian painters, especially Veronese. V. soon enjoyed high favour, including the patronage of Pope Urban VIII. In 1627 he was invited back to France, where he became First Painter, a

Vouet Wealth (detail) 1630-5

position challenged only once, in 1640–2, when he was brought into an artificial rivalry with *Poussin. V. taught or collaborated with almost all the painters of the next generation in France, notably *Lebrun, Le Sueur and Mignard. His portraits of the court of Louis XIII and most of his large–scale decorative schemes for Parisian houses and country châteaux have been destroyed. Among surviving pictures are: Wealth, Time Vanquished and Ceres.

Vranckz (Vranx) Sebastian (1573–1647). Flemish painter of lively episodic scenes depicting genre subjects or military skirmishes. He was influenced by contemporary Italian painting and the work of Pieter Bruegel the Elder.

Vrubel Mikhail (1856–1910). Russian painter, theatrical designer and craftsman. He suffered from schizophrenia and ended his life in a mental asylum. Before graduating he was commissioned to work on the restoration of Byzantine frescoes in Kiev. This work prompted the artist to begin his important and persistent researches into pictorial analysis; many of his drawings, such as those for *Demon* (1890), anticipate Cubist and Futurist work. He was connected with the *Abramtsevo and *Talashkino colonies and the World of Art.

Vuillard Édouard (1868–1940). French painter, V. studied at the Lycée Condorcet, the École des Beaux-Arts, Paris, and the Académie Julian where he met the other future *Nabis, including *Bonnard, with whom he shared a studio. Au Lit (1891), evenly painted in flat

Vuillard Interior at l'Étang-la-Ville 1893

areas, shows his current proximity to *Denis's ideas. He usually painted homely interior scenes – *The Mantelpiece* (1905) – richly coloured but often low-toned and creating a strong surface pattern. Their form and content influenced Sickert and thence the *Camden Town Group in London. V. lived a withdrawn life and seldom exhibited after 1914.

Wadsworth Edward (1889–1949). British painter. He exhibited Post-Impressionist works (1912), was briefly associated with the *Omega Workshops and then the *Vorticists (1915), and in 1933 with *Unit One.

Walker Frederick (1840–75). British painter and graphic artist. His works included watercolours and monumental oil paintings on rural themes and the outstanding poster design, *The Woman in White* (1871).

Walker John (1939—). British painter whose preoccupation with ambiguities of surface, structure, space and form, and a search to place himself art-historically, has meant his denial of an emphatic distinction between abstraction and figuration. His early works, e.g. images of World War I, inspired by *Goya, and a growing fascination with abstraction culminated in

'Studies for Anguish' (1964–6), a series of paintings in which he sought 'to resolve shapes that were meaningful for a particular kind of angst'. The ephemerality of his large chalk works, 'Blackboard Pieces' (1973) led to the 'Juggernaut' series (1973–4), in which he combined chalk and dry pigment, creating a constructed, multilayered effect. His work increasingly alludes technically (using oil, wax, *sfumato and *impasto) and associatively to past painters, e.g. Picnic (1978–9) recalling Manet's Le Déjeuner sur l'herbe. The 'Oceania' series (1979–84) displays W.'s concern with the West's effect on the East.

Walker Robert (d. 1656/8). British portrait painter famous for his portraits of Oliver Cromwell and other important Parliamentarians.

Wallis Alfred (1855–1942). British primitive painter. He worked as a fisherman in St Ives, Cornwall, from 1892, starting to paint (St Ives and the sea) only in 1928. B. *Nicholson and the painter Christopher Wood were chiefly responsible for discovering him.

Wallis Henry (1830–1916). British painter and authority on Persian ceramics, known for his *Death of Chatterton* (1856), for which the model was George Meredith. Other works, including *The Stonebreaker* (1858), are at Birmingham.

Walton Henry (1746–1813). British painter remembered for his rare genre scenes such as Girl Plucking a Turkey (c. 1776). These scenes are strongly influenced by *Greuze's treatment of

Henry **Wallis** The Death of Chatterton 1856

Wanderers, The

similar themes but they also show (unusual in Britain) the influence of Chardin.

Wanderers, The. Group of Russian artists founded in 1870 to promote travelling exhibitions with the idea of discovering new sources of patronage outside the normal centres of St Petersburg and Moscow. Its leaders were Miasoedov, Perov and Ge. The subject matter of their pictures presented common life realistically.

Wang Wei (699–759). Chinese *T'ang scholar, musician, poet and painter. His monochrome landscapes, e.g. of his country estate, were considered by the Ming theorist *Tung Ch'i-ch'ang to be the origin of the 'southern school'. *Chinese art.

Warburg Aby (1866–1929). German art historian. His art library founded in Hamburg was moved to Britain in 1933 and became, eventually, the Warburg Institute, University of London. W. encouraged the understanding of works of art in the context of their religious, astrological and hence psychological and superstitious traditions, and their modifications and transformations at any one moment.

Ward James (1769–1859). British Romantic painter and engraver. His early paintings were genre subjects influenced by his brother-in-law George Morland. But he was a far more robust artist and developed into a Romantic Realist of considerable power, much influenced by Rubens's landscapes. He painted the combat of powerful animals, portraits (including portraits of madmen), wild allegories and sporting subjects. His masterpiece is the huge sombre landscape *Gordale Scar*. Géricault admired and was influenced by his work.

Warhol Andy (1928-87). U.S. painter, print and film maker, one of the main exponents of U.S. *Pop art. W. became a cult figure in the 1960s. He began his career as a commercial artist (1949-60) and used such techniques and images in his work. His early paintings were stylized comic strips or advertisements; later he produced works of repeated images using rubber and wooden stamps and stencils which eventually led him to reproductions made with silkscreen on canvas. His work consists mainly of portraits (Elvis Presley, 1962, Marilyn Monroe, 1962, Liz Taylor, 1962-5, etc.), documentary images (car crashes, 1962-3, electric chairs, 1963-7, etc.), consumer goods (Campbell's soup cans, 1962-5, Coca-Cola bottles, 1962, dollar

Warhol The Six Marilyns 1962

bills, 1962–3) and flowers, 1964–7. From 1963 on he made, or collaborated in, films produced in his 'factory': e.g. *Sleep* (1963), *Empire* (1964), *Chelsea Girls* (1966), *Lonesome Cowboys* (1968), *Trash* (1970).

Waring Laura Wheeler (1887–1948). African-American painter whose portraits and still-lifes show the influence of the French *Impressionists, consolidated by a period spent in France. Her *Still Life* (1928) shows a movement towards European modernism in its use of bold brushstrokes and colour.

Washington Color Painters. U.S. group launched by an exhibition of this name at the Washington, D.C., Gal. of Mod. A. in 1965. Principal members were *Louis, *Noland and Gene Davis. The group generally employed acrylic paints – on unprimed canvas – in their exploration of colour qualities and relationships.

watercolour. Painting in colours which are soluble in water (bound with gum-arabic or similar substances) on white or tinted paper. W.s were known in 2nd-c. AD Egypt, but became an important art with Dürer; a tradition of w. painting was created by British painters from the 19th c.

Watteau Jean-Antoine (1684–1721). French painter, draughtsman and etcher. His life is well documented since both his dealer, Gersaint, and his friends wrote his biography. From his provincial home in Valenciennes and an apprenticeship to obscure master painters, W. made his way to Paris, where he at first worked as a hack copyist. From 1703 for 5 years he was assistant to Gillot, the leading painter of fashionable Italian theatrical scenes, painter of the commedia dell'arte. W. now joined Audran the court painter, who was charged with decorations of the royal châteaux. His artistic training was now complete and his social ascendancy just beginning. He became a recorder of the social life of his times, a celebrated painter whose patrons were the richest men of France. He was invited to join the French Academy and in 1717 became a full member.

W's work was 'the deification of the ideals of the 18th c., the spirit of the period. ...' His world of reality was the reality of the fairy-story, where women became goddesses and men satyrs in fashionable clothes. He transformed the coarse and earthly into dreams and fantasy.

W. was deeply imbued with the spirit of the great colourists of the past. He had ample opportunity to study the paintings of the mas ters in the colls of his patrons, and he copied avidly. Rubens and the painters of the Venetian school were the greatest influences on his development. The Harlequin and Columbine (c. 1715) shows this influence clearly, but the exquisite delicacy of the draughtsmanship and the dreamlike sentiment is that of the mature W. His Academy presentation piece, and perhaps his most famous painting, the Embarkation for Cythera, was painted in 1717. Here the spirit of the French *Rococo found its 1st full expression. Elegant courtiers wend their way to a landing-stage, where cherubs wait to conduct them to the island. One of the last and greatest paintings is the sign of the picture dealer Gersaint. Painted in 1720, it is said in a matter of 8 days, it was a triumph of observation, composition and draughtsmanship. The execution

Watteau Mezzetino with a Guitar

and treatment of colour foreshadows the Impressionists.

Watts George Frederick (1817–1904). British painter. He supported himself by painting portraits now considered among his best works, though W. thought them unimportant compared with his allegorical compositions; in these, e.g. *Hope*, he aimed to deliver a timeless and universal message based on his own vague moral idealism. W. was also a sculptor, e.g. the huge equestrian statue *Physical Energy* in Kensington Gardens.

Webb Boyd (1947–). New Zealand-born artist living in Britain, whose medium is photography. From the late '70s he made staged photographic set-ups, which are elaborate, dream-like pseudo-narratives. Since the late '80s, always using photographs often with brightly coloured backgrounds, the human presence in W.'s work has often been replaced by toys, deflated inflatable animals, etc. which enact elaborate allegorical fictions that encourage different readings as debased mythologies, encounters between culture and nature, and environmental commentaries, e.g. Eyeless (1989).

Weber Max (1881–1961). Russian-born U.S. painter who studied in Paris (1905–8), for a time under Matisse, and was a pioneer of avant-garde European art movements in the U.S.A. before World War I. From *Fauvism he turned to *Cubism and in The Geranium (1911) began to evolve a style which combined Cubism and *Expressionism. He attained complete Cubist abstraction in Chinese Restaurant (1915). From 1918 he painted in a representational Expressionist idiom.

Webster Thomas (1800–86). British painter of scenes of school and village life, e.g. *A Village Choir*.

Weenix Jan (d. 1719). Dutch still-life and landscape painter, son and pupil of Jan Baptist W. He worked in Amsterdam and at the court of the Elector Palatine, for whom he executed a series of paintings of live and dead game.

Weenix Jan Baptist (1621–60). Dutch painter who studied under A. Bloemaert, then in Italy. In addition to Italianate landscapes he painted still-life subjects and portraits.

Wegman William (1942-). U.S. *video and *Performance artist, photographer and writer, whose work has centred on himself and his pet Weimaraner, Man Ray – his 'collaborator'. W. exploits with humour the illusory identification of the public with the animal, presenting the dog in various guises that will be at once totally incongruous and recognized, e.g. Contemplating Art, Life, and Photography (1975-9) - Man Ray the philosopher sitting on water; Ray Bat (1980) - the dog as a bat - and Brooke (1980) - the dog 'impersonating' the actress Brooke Shields. W. has said, 'As soon as I got funny I killed any majestic intentions in my work' which the U.S. critic Craig Owens saw as his having deliberately 'jettisoned the whole ideology of achievement'.

Weiner Lawrence (1942—). U.S. leading *Conceptual artist whose art uses mainly words, with texts, statements or proposals in Letraset or stencilled directly on to the walls of the exhibition space, often surrounding the viewer, or in published notebooks. W. has said that 'without language, there is no art.' The meaning of words or phrases is left deliberately ambiguous even when they seem familiar. The recognition of references in his works may vary from one person to another, all of whom can 'possess' them once they know them.

Wells James Lesesne (1902—). African-American painter and print maker of predominantly religious subjects (his father was a Baptist minister). His work fuses the influence of African sculptors and German *Expressionists, e.g. Escape of the Spies from Canaan (c. 1933), which attested through the 'modern' treatment of his subject the growing public consciousness of black Americans.

wen-jen. Chinese scholar-painters of landscapes working in a monochrome tradition of ink on silk (later paper, *Sung). According to the 16th-c. wen-jen *Tung Ch' i-ch' ang, the tradition began with the 7th-c. painter *Wang Wei.

Wentworth Richard (1947—). British artist born in Samoa, one of the leading artists of the generation of post-*Minimalist British sculptors, including *Cragg and *Deacon, who came to international prominence from the late '70s with anti-representational work which assimilated and synthesized the legacies of *Surrealism, *Duchamp's *readymades, the *Pop art attention to ordinary consumer products, industrially manufactured detritus, and the rigour of Minimalism. W.'s work thrives on playfulness, paradox, double meaning and wit, as in his *Toy* (1983), *Profit and Loss* (1987) and *Lips and Fingertips* (for Simon Rodia) (1992).

Werff Adriaen van der (1659–1722). Dutch painter of portraits and religious, mythological and genre subjects; also an architect. In his early paintings he followed the style of his master, Van der Neer, but he was later influenced by contemporary French classicism. His mature work has an exceptionally high finish.

Werff Pieter van der (1665–1722). Dutch painter of portraits and biblical and mythological subjects, brother and imitator of the above.

Wesselmann Tom (1931–). U.S. *Pop artist; studied at Cooper Union, N.Y., 1956–9; included in 'The New Realists' exhibition at the Sidney Janis Gallery, N.Y., 1962; Matisse was one important influence. His works, often assemblages combining oil, enamel, collage, found images and readymades, include the Great American Nudes series of variations on the theme, which began in 1962, Still Life Painting, 30 (1963) and Tit Box (1970).

West Benjamin (1738–1820). American portrait and history painter who settled in London, having studied in Italy, where he was influenced

West Death of Wolfe

by the *Neoclassicism of *Mengs. He was much favoured by George III, was a founder-member of the R.A. and became its president on the death of Reynolds. His history picture *Death of Wolfe* is a typical and well-known work.

Westmacott Sir Richard (1775–1856). British *Neoclassical sculptor. He studied under his father, Richard (1747–1808) and in Rome under *Canova. His work includes the bronze *Achilles* (1822) in Hyde Park, the memorial to Charles James Fox (1810) in Westminster Abbey and the figures on the pediment of the British Museum. His son Richard (1799–1872) was also a sculptor.

Weyden Rogier van der, or Rogier de la Pasture (c. 1400–64). The most important early Netherlands painter after the death of Van Eyck. The identity of his work is disputed and he may be identical with Rogelet, Roger of Bruges and others. No signed paintings have survived and very little is known about his life. He is believed to have been apprenticed to Roger Campin and is known to have lived in Brussels from 1435 to 1449, when he was appointed painter to the city. A probable visit to Italy in 1450 resulted in the Entombment which shows Italian influence, and the Madonna with Four Saints which carries the Medici arms and patron saints. He painted for several members of the Burgundian

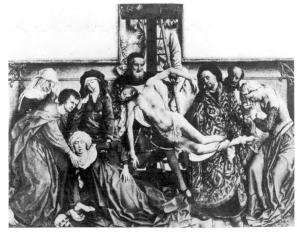

Weyden Descent from the Cross c. 1438

Whistler

court including Chancellor Rolin, for whose foundation he painted the Last Judgement. The Descent from the Cross is stylistically his most important work. The action has the quality of a relief set against a flat background, and conveys the deep pathos of suffering. His works show a feeling for the significance of the action rather than realistic representation. A fine example of this is the Adoration of the Magi, known as the St Columba altarpiece, and such portraits as Portrait of a Lady and Le Grand Bâtard, which skilfully capture the subjects' emotions.

Whistler James Abbott McNeill (1834–1903). U.S. painter, a notable dandy and wit. W. was a cadet at West Point (1851–4), failed to qualify for the army and came to Europe, studying painting in Paris under Gleyre. He settled in London (1859), introducing the cult of the Japanese, which had already arrived in Paris. The famous libel action against Ruskin (1878) ruined W. and he lived abroad for some years. His painting theories and doctrine of 'Art for Art's sake' found expression in the witty and vitriolic Ten O'Clock Lecture (1885) and The Gentle Art of Making Enemies (1890).

The early influence of Courbet was later modified by a greater emphasis on surface

Whistler The Little White Girl: Symphony in White No. 2 1864

arrangement, abstract harmonies, and close colour and tonal relationships. In the 1860s W. sought greater delicacy of colour and form, e.g. 'The white girl' (*Symphony in White Number 2*, 1864); in the 1870s the influence of Velazquez led to greater robustness, as in the *Portrait of the Artist's Mother* (1872) and *Thomas Carlyle*. The *Noctumes* depicting the blurred atmosphere of London fuse Japanese decorative qualities with the ideas of the French Impressionists. W. was also a fine engraver.

White Charles (1918–79). African-American painter and graphic artist whose persistent use of the image and figure against contemporary movements of *Abstract Expressionism, *Conceptualism and *Minimalism was a cultural, racial and spiritual assertion of black life in the U.S.A., e.g. Sounds of Silence (1978).

White John (fl. 1585–93). British painter who sailed to N. America with Sir Richard Grenville and was one of the 1st settlers in Virginia. His were the 1st watercolours of N. American subjects, the native inhabitants, the flora and fauna; the large coll. in the British Museum reveals a delicate and observant artist.

Whiteley Brett (1939–92). Australian painter. Semi-abstract figure compositions were followed by freer and more explicitly figurative works verging on illustration.

Whiteread Rachel (1963–). British sculptor who came to great international prominence in the '90s. Starting in 1988 she made several works by taking plaster casts of domestic features which carry 'the residue of years and years of use':

Whiteread Ghost 1990

objects, doors, floors, tables, sinks, baths, beds, mattresses and a whole room in *Ghost* (1990). *House* (1993) was the cast of an entire house on its original site in East London, which was then demolished by the local authorities. These are not replicas of their originals, but positive renderings of the space in or around them. W. works in plaster, rubber, wax and cement. In 1993 she was awarded the prestigious Turner Prize in Britain.

Whittredge Worthington (1820–1910). U.S. painter particularly noted for his landscape paintings in the *Hudson River school tradition. While in Rome, 1854–60, he worked closely with *Bierstadt.

Wiertz Antoine-Joseph (1806–65). Belgian painter of melodramatic compositions such as *Triumph of Christ* (1848) in which he aimed to combine the characteristics of Michelangelo and Rubens. He also painted portraits and morbid scenes depicting premature burial, suicide, madness, etc. After his death his studio in Brussels was turned into a mus, of his work.

Wilding Alison (1948–). British sculptor of the same generation as *Deacon and *Wentworth who, like them, came to prominence from the late '70s, with her first solo show in 1976. Following early multi-media *installations, she soon evolved her personal, quiet, simple and clear abstract idiom in works that use stone. patinated copper, lead, brass, bronze, galvanized steel, wood, wax, silk, linen and pigments, sometimes in unexpected combinations of such heterogeneous materials and textures, e.g. Stormy Weather (1987) where oil, pigment and beeswax are rubbed into galvanized steel and Assembly (1991) which is made up of PVC slats and a steel tunnel. W.'s work is frequently about the relationship between an outer 'skin' and an inner 'core' and space, e.g. Vestal and Into the Light (both 1985), Her Furnace (1986-7), Into the Brass (1987) and Temple (1991-2).

Wilke Hannah (1940–93). U.S. artist whose work addressed issues of sexual politics and mortality with humour, innovative materials and lyricism. Her *Conceptual work of the early '70s included *performances and photo-works of her own nude body. W. is best known for petal-like sculptures made of latex, laundry-lint, chewing gum and ceramic, suggestive of female genitalia, arrayed singly or in groups on the floor, the wall, or on her own body. In the '80s she began the documentation of her mother's

battle with cancer through photographs. When she herself developed cancer in 1987, she began a series of evocative watercolour self-portraits.

Wilkie Sir David (1785–1841). Scottish painter. He made his reputation with scenes of village life in the style of Teniers the Younger and Van Ostade, e.g. Blind Man's Buff; influenced by Spanish painting (he visited Italy and Spain) he developed a looser technique and turned to historical subjects such as Sir David Baird Discovering the Body of Tippoo Sahib.

Wilson Richard (1714–82). Landscape painter of the English school, born in Wales. In 1729 he was a pupil of Thomas Wright in London and from 1735 was working on his own. He had turned to landscape before going to Italy (1750–ε. 1757) where he was influenced by the work of Poussin and Claude, and the picturesque landscapes of Vernet and Zuccarelli. He later painted landscapes in England and Wales, and reminiscences of Italian scenes, works full of serenity, light and the nuances of popular, he had considerable influence on Turner, Cotman, Constable and Crome, and started the cult for Welsh mountain landscapes.

Wilson R.obert (1941—). U.S. Performance artist, sculptor, painter, writer, designer, architect, film maker and theatre director. From painting, sculpture and *Performance art he moved to stage works, or 'operas', as he calls them, of extraordinary dramatic and visual originality and complexity, which are unique as examples of 20th-c. gesamtkunstwerke, and which often 'unfold' over many hours, e.g. The Life and Times of Sigmund Freud (1969), lasting 12 hours. These works have a loose, free-associational, cinematic structure, with dreamlike series of events, dances, visually stunning tableaux, sound and words.

Wilton Joseph (1722–1803). British sculptor, founder-member of the R.A. He studied in the Netherlands, Paris, Rome and Florence. His monumental works include General Wolfe's tomb in Westminster Abbey. He is also known for his portrait busts and decorative carving.

Wilton diptych (N.G., London). Formerly attributed to the Parisian school, it appears likely now that this charming work, a major example of *International Gothic art, was painted in England *c.* 1395−9. The theme is the presentation of King Richard II to the Virgin and Child

Winckelmann

Wilton diptych (one panel) c. 1395-9

by his patron saints, Edmund, Edward the Confessor and John the Baptist.

Winckelmann Johann Joachim (1717–68). German writer on art and archaeology, in which his attempt to classify and interpret styles of antique art was extremely important. His Gedanken über die Nachahmung der griechischen Werke ... (1755) formulated a long unchallenged intepretation of Greek art which stressed its 'noble simplicity' and 'tranquil grandeur'; these ideas, expanded in W.'s major work, the Geschichte der Kunst des Alterthums (1764; History of Ancient Art among the Greeks, 1850), were extremely influential in the development of *Neoclassicism.

Wind Edgar (1900–71). German-born British art historian who became deputy director, Warburg Institute, and honorary lecturer in philosophy, University College, London, 1934–42. After a number of years teaching in the U.S.A., he returned to Britain in 1955 as professor of history of art, University of Oxford, until 1967. His influential publications include Pagan Mysteries in the Renaissance (1958) and Art and Anarchy (1963).

Winterhalter Franz Xaver (1806–73). German portrait painter famous as the portrayer of

European royalty, including Queen Victoria, Prince Albert and their children.

Witte Emanuel de (1617–92). Dutch painter, chiefly of church interiors such as *Interior of the Oudekerk*, *Amsterdam*, *during a Sermon*.

Witten Hans. 15th–16th-c. German sculptor in wood and stone. His works include the statue *St Helen*, the tulip pulpit in Freiburg cathedral and a *Scourging of Christ* group.

Wittkower Rudolf (1901–71). German-born U.S. art historian whose *Art and Architecture in Italy 1600–1750* became the standard work on the *Baroque. The architecture of the Italian Baroque was his particular domain, but he also wrote extensively on art, e.g. *Bernini*.

Witz Konrad. 15th-c. painter mainly active in Basel. Rediscovered in 1901, his paintings were until then attributed to various painters. His work is characterized by great strength and simplicity and a searching realism. His paintings include the *St Bartholomew*, a monumental freestanding figure, and the *Draught of Fishes* (1444) at Geneva.

Wölfflin Heinrich (1864–1945). Important German art historian, considered as one of the founders of the art historical discipline. His highly influential publications include *Die Klassische Kunst* (1898), *Die Kunst Albrecht Dürer* (1905) and *Principles of Art History* (1915).

Wolgemut Michael (1434–1519). German painter and master of Dürer. He was head of a workshop in Nuremberg which produced painted and carved altarpieces and designer of the woodcut ills to the famous 15th-c. books, the *Schatzbehalter* and Hartmann Schedel's *Weltchronik* (known as the *Nuremberg Chronicle*, 1493).

Wollaston John. 18th-c. British portrait painter who went to work in the American colonies.

Wols Alfred Otto Wolfgang Schulze called (1913–51). German painter and poet who studied at the Dessau *Bauhaus under Mies van der Rohe and Moholy-Nagy; moved to Paris in 1932. He ill. with engravings works by Kafka and Sartre.

Wood Grant (1892–1942). U.S. regionalist painter of Iowa. His development was influenced on visits to Europe in the 1920s, by 15th- and 16th-c. Flemish and German painting and the *New Objectivity movement. The

technical precision and stylization which characterize his work are also reminiscent of U.S. folk-art. His best-known paintings are *American Gothic* and *Daughters of the Revolution* in which there is a strong element of satire.

woodcut. Relief printing technique in which the design is drawn on the plank surface of the wood (usually pear or alder) and that part of it which is to be white is cut away with a gouge or knife, leaving the remainder to print black. The w. came into use in the late 14th c. for the printing of playing-cards and block-books and had become an artistic medium by the mid-15th c., culminating in the work of Dürer. Displaced by the line engraving, it was revived in the 19th c. by William Morris and others. The medium is ideally suited to subjective expression and was widely exploited in the 1st quarter of the 20th c. by the German Expressionists, e.g. Kirchner and Heckel, who used it with a power and originality not attained since Dürer.

wood engraving. Relief technique of printing which differs from the woodcut in that the working surface of the block uses the end-grain of the boxwood section, and a burin instead of a gouge is used for cutting. This makes very fine lines possible, so that effects similar to those of line engraving can be achieved. W. e. was developed in the mid-18th c. and was beautifully handled by *Bewick (1753-1828). In the mid-19th c. it was used as a reproduction technique by the Dalziel brothers and others but was revived as a medium for original work just after World War I. The major exponents of w. e., including Bewick and Gwen Raverat, have used the white-line method, i.e. the lines are cut into the block and therefore print white in contrast with both the woodcut and the line engraving.

Woodrow Bill (1948—). British sculptor, of the same generation as *Cragg and *Deacon, who uses a wide range of *found objects in often ironic works suggestive of a narrative. His 'Breakdown' series (1974), presenting household appliances and objects — e.g. TV sets, toasters, etc. — dismantled and juxtaposed with reproductions of them in painted wood, shows a fascination with the post-industrial world and effects of mass production. W. travels to each place where he is to exhibit and collects objects from there, e.g. his 'Natural Produce: An Armed Response' exhibition in San Diego (1985). One of these works, *Trivial Pursuits* (1985), consists of a damaged Porsche door,

which is growing 'flowers' in the form of a jewel box, a handgun and a padlock at which a hummingbird picks.

Woodruff Hale A. (1900–80). African-American painter whose early work was influenced by *Cézanne, *Matisse and by a period spent studying frescoes with *Rivera. His association with artists such as *Rothko, *Motherwell and *Pollock in N.Y. during the 1940s and 1950s led him to abandon figurative painting in favour of abstraction. In 1963 he and *Bearden set up 'Spiral', a group dedicated to the cultural experiences of African-Americans in the U.S.A. W.'s works include Georgia Landscape (1934–5), Afro Emblems (1950) and Caprice (1962).

Woodville Richard Caton (1825–55). U.S. painter of portraits and sophisticated genre scenes, influenced by *Mount. From 1845 he studied at the Düsseldorf Academy for 6 years, where he produced his best work, often compared to *Wilkie. He died in London of an overdose of morphine.

Wootton John (c. 1686–1765). British painter of hunting and racing scenes, pupil of J. Wyck and the 1st important sporting artist in Britain. He was also one of the 1st British artists to follow the landscape style of Claude and G. Poussin.

World of Art, The (Mir Iskusstva). The name for a society, exhibiting organization and a magazine, founded in St Petersburg in 1898 similar to the *Nabis group. It brought together artists chiefly, but also poets and musicians; prominent members were Benois, Diaghilev and Bakst. They were in revolt against the 'provincial nationalism' of the *Wanderers and in contrast declared for 'Art for Art's sake' and close ties with Western European ideas. The magazine was ed. (1899–1904) by Diaghilev, and his Ballet Russe is the group's most notable production, to which most of its members contributed.

Worringer Wilhelm (1881–1965). German writer on aesthetics. His Abstraktion und Einfühlung (1908; Abstraction and Empathy, 1953) recognized the role of abstraction in the history of art; and Formprobleme der Gothik (1912; Form in Gothic, 1927) – arguing the existence and continuity of a non-classical Northern tradition of spiritual unrest expressing itself by distorting reality – profoundly influenced the development of *Expressionism.

Wotruba

Wotruba Fritz (1907–75). Austrian sculptor, trained as a stonemason. His first exhibition was in Vienna in 1930. From 1945 he was director of the sculpture school at the Vienna Academy. Most of W.'s works from 1928 were directly carved in stone. They are mostly figure-images, but their character is determined largely by the nature of the stone's mass, shape and texture, as in *Standing Figure* (1949–50) or *Figure* (1959).

Wouters Frans (1612–59). Flemish painter of landscapes with figures and religious and allegorical subjects, pupil of Rubens. He worked in Britain (1637–c. 1641).

Wouwerman(s) Philips (1619–68). Dutch painter of landscapes with battle and hunting scenes and genre scenes of soldiers in camp reminiscent of the work of P. van Laer. His canvases usually contain a white horse and often large numbers of tiny figures. His brother Jan (1629–66) worked in a similar style.

W.P.A. The Works Progress (later called Projects) Administration, an agency set up by the U.S. government in 1934–5. It organized a great number of projects which provided employment during the Depression. More than 5000 artists of all kinds were among those employed, the emphasis being on public service (writers produced the 'American Guides', painters decorated public buildings, there was a Federal Theater, etc.); but from 1939 the artistic projects were wound up. Abstract monumental murals were made by, among others, *Gorky, *De Kooning.

Wright John Michael (d. 1700). British portrait painter, a lesser contemporary of *Lely. He studied under George Jamesone in Edinburgh, then spent several years in Italy. He worked as antiquary to the Archduke Leopold Wilhelm in Brussels before settling in Britain.

Wright Joseph ('Wright of Derby') (1734–97). British painter, almost the earliest to take his subjects from the Industrial Revolution. He visited Italy (1773–5), tried his fortune at Bath but, failing to oust Gainsborough as a portrait painter there, returned to Derby, where he spent most of the rest of his life. Apart from a few portraits and night landscapes, his main work was in depicting the domestic and workshop interiors at the time of the Industrial Revolution, where, by the light of a candle or furnace, the figures are thrown into relief and dramatically presented.

Wunderlich Paul (1927–). German painter, sculptor, ill. and print maker whose work is distinguished by traditional high craftsmanship and emulates *Dürer. W. also surprisingly used spray guns in his paintings from the '60s. His subject matter is often political or erotic with a degree of surrealistic artificiality and literariness.

Wu Tao-tzu (8th c. AD). Major Chinese artist of the T'ang dynasty. He did 300 wall paintings for temples in Loyang and Ch'ang-an. None survive, but contemporary descriptions speak of their monumental conception and vivid realism and of W.'s fiery energy.

Wyant Alexander Helwig (1836–92). U.S. landscape painter. His early work was in the *Hudson River school tradition, but influenced by Inness and by the work of Constable and Turner, which he studied on a visit to Britain, he developed a more atmospheric interpretation of nature. Much of his work was done in the Catskill Mountains

Wyck Jan (c. 1640–c. 1700). Dutch painter who worked mainly in Britain. His hunting scenes foreshadowed those of J. Wootton. He also painted battle scenes, landscapes and small military equestrian portraits of a type which gained popularity in the 18th c.

Wyeth Andrew (Newell) (1917—). U.S. painter of genre subjects; studied under his father, the celebrated ill. N. C. Wyeth. A most accomplished naturalistic artist, he works in a meticulously detailed style but invests his paintings with an enigmatic visionary quality which raises them above photographic naturalism.

Wynants (Wijnants) Jan (d. 1684). Dutch landscape painter who worked in Haarlem and later Amsterdam. Most of his pictures are similar, showing a sandy track winding through dune scenery with small figures often painted by P. Wouwerman or A. van de Velde.

Yamato-e. *Japanese art

Yeats Jack Butler (1871–1957). Irish painter, graphic artist and writer, brother of W. B. Y.; he studied at the Westminster School of Art. Y. sought to capture the Irish scene in pen,

watercolour and, late in life (from the 1930s), oil painting; he always tried to convey mood rather than describe in detail, and the increasing violence of his colours brought his style close to *Expressionism. He was recognized as a great national painter only after World War II.

Yellow Book, The (1894–7). Ill. periodical to which many distinguished writers and artists – e.g. Henry James and Max Beerbohm – contributed, but particularly associated with the 'decadents' and 'aesthetes' of the period, e.g. *Beardsley, Oscar Wilde and Rolfe.

Yoakum Joseph (1886–1972). African-American artist, recognition of whom came after his death. His delicate works, in contrast to the bolder folk-art of his contemporaries, are mostly 'naive' panoramic landscapes, e.g. *Mt. Cortezo; in Hureto Province near Mexico City Mexico* (c. 1960–70).

Yoruba. Tribal people of S.W. Nigeria; the largest and one of the most artistically prolific in W. Africa. They are noted for wood carving, e.g. the masks of secret societies and religious cult objects, notably of the thunder god Shango. The classical tradition of Y. art was that of *Ife.

Yoseki-tsukuri. *Japanese art

Yüan. The Mongol dynasty of China (1260–1368), a major epoch of *Chinese art. The painter Ch'ien I Isuan (c. 1235–after 1300) pioneered the return to archaic styles (e.g. of the T'ang period). *Chao Meng-fu's landscapes combined respect for the antique, using brush techniques of neglected *Sung masters, with an original use of colour and spontaneity. He was followed by the 'Four Masters': Huang Kung Wang (1269–1354) whose magnificent Living in the Fu du'un Mountains survives; Ni Tsan (1301–74), whose noble and austere manner was much copied; Wu Chen (1280–1354) and Wang Mend (d. 1385).

Z

Zadkine Ossip (1890–1967). Sculptor born in Smolensk, studied in Sunderland, London and in 1909 at the École des Beaux-Arts, Paris. In Paris he formed a deep admiration for Rodin, but the most immediate impact upon him was

that of *Cubism. For a few years he experimented – like *Lipchitz, *Laurens and *Archipenko – with a disciplined analysis of the figure into an austere geometric arrangement of solids. In the 1920s his forms took on an essentially expressive significance, e.g. *Prometheus*, a fusion of figure and flame, and the torso of *Orpheus* (1949) and *The Destroyed City* (1951–3).

Zapotec. Mexican pre-Columbian culture with its ceremonial centre at Monte Alban, near Oaxaca. The Z. fl. c. AD 300–900 and were succeeded apparently by the Mixtec. Among the most outstanding examples of their art are pottery urns in the shape of human figures wearing elaborate ornaments and fantastic headdresses.

Zenale Bernardino (d. 1526). Italian painter and architect, pupil of Foppa in Milan. He was a friend of Leonardo da Vinci and to some extent influenced by him. He frequently collaborated with *Butinone.

Zeuxis (fl. late 5th c. BC). Greek painter, pupil of Apollodoros and particularly renowned for a painting of Helen for the city of Crotona in which he combined the best features of several young girls. He was reputed to have painted a bunch of grapes with such naturalism that the birds flew to peck at it.

Zick Januarius Johann Rasso (1730–97). German painter and architect who studied under his father Johann Z. (1702–62), a painter of religious subjects, and in Rome under Mengs. He produced many large-scale frescoes. He also painted portraits and genre scenes which showed the combined influences of *Mengs and Rembrandt.

Zingaro, Lo. Antonio da *Solario

Zoffany John (Johann Zoffani) (1733–1810). German painter who studied in Rome before he settled in Britain c. 1760. One of the foundermembers of the R.A., his patrons were Garrick's circle and the Royal Family. Some of his best paintings deal with the theatre, but he also painted a number of hack portraits and domestic scenes. During a stay in India (1783–90) Z. produced a great deal of work. Queen Charlotte with the Prince of Wales and Duke of York is one of his typical paintings.

Zoppo Marco (c. 1432–c. 1478). Italian painter, pupil of Squarcione at Padua but more strongly influenced by Cosimo Tura. He worked mainly in Venice.

Zorach

Zorach William (1887–1966). Lithuanian-born U.S. sculptor and painter. He began as a painter, studying in the U.S.A. and in Paris where he came under the influence of *Cubism. On his return to the U.S.A. he exhibited at the *Armory Show, 1913. He devoted himself to sculpture in the early 1920s. As a sculptor he was a traditionalist both in his choice of subjects and his mode of expression.

Zorn Anders Leonard (1860–1920). Swedish genre and portrait painter in a vigorous impressionistic style, and etcher. He worked in Britain, France and the U.S.A. before settling in Mora, his birthplace.

Zuccarelli Francesco (1702–88). Italian painter of light pastoral, chiefly riverside, scenes after the manner of M. *Ricci. He worked mainly in Venice but made 2 visits to Britain where he received court patronage and became a foundermember of the R.A.

Zuccaro (Zuccari, Zuccheri) Federico (1543–1609). Italian painter in the *Mannerist tradition; brother of Taddeo Z. He visited Britain (1574–5) where he made chalk drawings of Queen Elizabeth I and the Earl of Leicester and possibly painted some of the many portraits attributed to him. On his return to Italy he finished Vasari's frescoes in the dome of Florence cathedral. He later worked in the Escorial, Madrid, for Philip II. He was a founder of the Academy of St Luke, Rome, and in 1607 publ. the theoretical work *L'Idea de' Pittori, Scultori et Architetti*.

Zuccaro (Zuccari, Zuccheri) Taddeo (1529–66). Italian *Mannerist painter active chiefly in Rome. His most important works were decorative frescoes in the Palazzo Farnese at Caprarola and in the Sala Regia in the Vatican.

Zucchi Antonio (1726–95). Venetian decorative painter who worked in Britain for R. Adam. In 1781 he married *Kauffmann and settled with her in Rome.

Zuloaga (y Zabaleta) Ignacio (1870–1945). Spanish portrait and genre painter.

Zurbarán Francisco de (1598–1664). Spanish painter of portraits and religious subjects. At the request of Seville, then one of the most important art centres in Spain, he moved to the city as official painter. The commission to decorate the new royal palace, Buen Retiro in Madrid, with a series of paintings, *The Labours of*

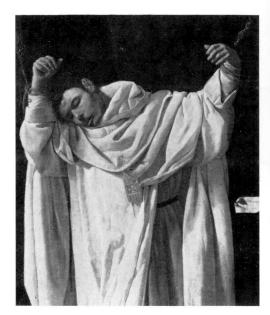

Zurbarán St Serapion 1628

Hercules (1624), probably came through his good friend *Velazquez. From 1628 to 1640 he was working on a great many paintings for the Jeronymite monastery at Guadalupe. From 1640 onwards his fortunes changed and he died in poverty and obscurity.

A characteristic feature of his paintings is flat areas of pure colour and clashing dissonances of yellow, crimson and blue. A change took place, however, towards the end of his life, as his colours became less harsh and their tonal relationship more subtle. This could have been partly due to the necessity of pleasing his patrons the religious orders. Living a life close to theirs, he came to produce work which was the embodiment of mysticism and spiritual composition. He influenced the work of Spanish painters and the artists of the Spanish South American colonies. The Realists in 19th-c. France owed him a great deal.

ACKNOWLEDGMENTS

The publishers are grateful to the following institutions and individuals for permission to reproduce the illustrations on the pages mentioned.

The following abbreviations have been used: a, above; b, below; c, centre; l, left; r, right.

Royal Collection Enterprises: 221b, 264, Alabama: Museum Tuxhegee Institute Amsterdam: Riiksmuseum 365: Stedeliik Museum 79, 337, Assisi: St Francis 221a, Athens: Acropolis Museum 204: National Museum 1011. Baltimore: Museum of Art 1994, 200h (gift of Mr and Mrs Albert Lion). Barcelona: S. Miguel Pedralloes 32a. Basel: Öffentliche Kunstsammlung 59. Bayeux: Episcopal Museum 36 (photo Giraudon), Berlin: Staatliche Museen Preußischer Kulturbesitz 50r. 84, 325. Birmingham: City Museum and Art Gallery 65, 284a. Bruges: City Museum 104a (photo ACL Brussels): Hôpital St Jean 237. Brussels: Musées Royaux des Beaux-Arts 104b, 233. The Duke of Buccleuch and Oueensberry KT 91a, Buffalo (N.Y.): Albright-Knox Gallery 58r, 110a, 244, Chantilly: Musée Condé 216 (photo Giraudon). Chatsworth: The Devonshire Collection, reproduced by permission of the Trustees of the Chatsworth Settlement 290. Chicago: The Art Institute of Chicago 32b, 246b (The Joseph Winterbotham Collection), 276; Oriental Institute 238. Cleveland (Ohio): Museum of Art 320. Collection the artist (Luciano Fabro) 130, Colmar: St. Martin's church 327; Unterlindenmuseum 162. Cologne: Museum Ludwig 21, 194, 322; Stadtmuseum 197a; Wallraf-Richartz Museum 112b, 275b. Copenhagen: Nationalmuseet 17 (drawn by Jon D. Wilsher); Statens Museum for Kunst 235. Creglingen church. 30%. Dallas. Museum of Art, Central Acquisitions Fund and a gift of The 500, Inc. 204. Darmstadt: Hessisches Landesmuseum 131. Detroit: Institute of Arts 45ar. Dewar and Sons Ltd: 205a. Dresden: Gemäldegalerie 29b, 147; Gemäldegalerie Neue Meister, Staatliche Kunstsammlungen 136. Dublin: Trinity College Library 195a. Duisberg: Städelsches Kunstmuseum 20bl. Düsseldorf: 44 (photo Ute Klophaus), Mrs Eva Beuys, Seibu Museum (photo Eileen Tweedy) 267b; Konrad Fischer Gallery 257. Edinburgh: National Gallery of Scotland 51a, 160a. Florence: Baptistery 145l, 283; Bargello 114b, 367; Convent of S. Apollonia 75a; Loggia della Signoria 77; Museo dell'Opera del Duomo 309; Museo di S. Marco 16b (photo Alinari); Palazzo Pitti 14; S. Annunziata 28; Sta Croce 101r; S. Felicità 287; Galleria degli Uffizi 16a, 55, 71, 85, 142, 151r (photo Alinari), 314a, 333r. Fort Worth (Texas): Private collection 272. Glasgow: Art Gallery and

Museum 305b. Grenoble: Musée de Grenoble 179al. Haarlem: Frans Hals Museum 166. The Hague: Collection Haags Gemeentemuseum 246h (on loan from S. B. Sliiper). Halifax: Henry Moore Sculpture Studio 202. Hamburg: Kunsthalle 38, 211al, 319a. Collection the Estate of Keith Haring 168a. Hartford (Conn.): Wadsworth Athenaeum 88, 208 (gift of Susan Morse Hilles), 382. Heraklion (Crete): Museum 243. Houston: The Menil Collection 284b. Kvoto: Daikaku-ii 246a. Indianapolis: © 1994 Indianapolis Museum of Art, Delayan Smith Fund 46. Kungälv (Sweden): Bo Boustedt 31. Liège: Musée des Beaux-Arts 1251. Liverpool: Walker Art Gallery 138, London: British Museum 41, 185, 2034. 217l, 242, 254a, 275a, 295b, 297a, 344, 348; Courtesy Chisenhale Gallery 376r: Courtauld Institute Galleries 30b, 127a, 141, 152, 211b, 245, 303b, 356; Marlborough Fine Art (London) Ltd 197b, 300; Reproduced by courtesy of the Trustees. The National Gallery 7, 33, 40, 86a, 97b, 98, 113, 128b, 139b, 176, 177al, 179ar, 211c, 218a, 220b, 228, 251. 268, 270, 280, 282b, 297b, 301, 318a, 324, 330, 359, 364, 378; By courtesy of the National Portrait Gallery 167, 305a, 312, 323; Royal Academy of Arts 194, 343: Saatchi Collection 23: Courtesy Serpentine Gallery 49; Photo Gift of South Bank Centre 151b; Tate Gallery 30a, 52b, 91b, 111, 139a, 145br, 161a, 188a, 188b, 108, 211ar, 215a, 225, 241a, 249a, 249b, 260, 310r, 313, 315b, 333l, 338u, 345, 371, 376l; Courtesy of the Board of Trustees of the V & A 51b. 90, 173l, 316b; Wallace Collection 56, 69, 96a, 135, 163; Westminster Abbey 133. Louvain: S. Pierre 581 (photo ACL Brussels). Lyons: Musée des Beaux-Arts 144a (photo Giraudon). Madrid: Prado 156, 375b. Manchester: Whitworth Art Gallery, University of Manchester 47, 96b. Mannheim: Kunsthalle 27. Mantua: Palazzo del Tè 150 (photo Edwin Smith). Mexico City: Collection of Dolores Olmedo 191. Middletown (Conn.): Collection of the Davison Art Center, Wesleyan University 321. Milan: Galleria Schwarz 174: Poldi Pezzoli Museum 286a. Minneapolis: Institute of Arts 326. Moscow: State Tretyakov Gallery 54a, 182, 288, 304. Munich: Alte Pinakothek 15, 126, 129, 255, 354; Neue Pinakothek 266a. Naples: Galleria Nazionale 13 (photo Alinari); Pinacoteca 232 (photo Alinari). Nara: Museum Yamato Bunkakan 123b. Nenningen (Württemberg): Freidhofkapelle 164b. New Haven (Conn.): Yale University Art Gallery 218b, 328a (Collection Société Anonyme). New York: Harry N. Abrams Family Collection 175; Courtesy Josh Baer Gallery and Rhona Hoffman, Chicago 338b; Courtesy Mary Boone Gallery 203b, 328b; Leo Castelli Gallery 319b; The Frick Collection 60; Courtesy Gagosian Gallery

285; Courtesy of Barbara Gladstone Gallery 177ar; The Solomon R. Guggenheim Museum 259, 266a; The Joseph Hirshhorn Foundation 200a; Collection Pierre Matisse 74; Courtesy of Metro Pictures 332; The Metropolitan Museum of Art 19, 75b, 107b, 209a, 234; The Museum of Modern Art 29a, 50 (Lillie P. Bliss Bequest), 102, 105, 108, 126, 140, 154, 210, 215b (Gift of Original Editions), 277 (Lillie P. Bliss Bequest), 308b (Abby Aldrich Rockefeller Fund), 317, 334a; Courtesy of the Pace Gallery 86b (photo by Kenneth Lester); Sonnabend Collection 18; Bernice Steinbaum Gallery 308; Courtesy John Weber Gallery 281; Whitney Museum of American Art 179b, 258 (Gift of Timothy Collins), 341. Northampton (Mass.): Smith College 370r. Norwich: Castle Museum 94. Olympia: Museum 291. Oslo: Nasjonalgalleriet 254b. Ottawa: National Gallery of Canada 263b, 375a. Paris: Courtesy Galerie Crousel-Robelin/BAMA 68, 97a; Courtesy The Artist, Galerie Ghislaine Hussenot 52a; Nina Kandinsky Collection 193; Musée du Louvre 24 (photo Hirmer), 26, 37bl, 80 (photo Giraudon), 81, 87 (photo Giraudon), 92, 95 (photo Bulloz), 106 (© photo R.M.N.), 107a (photo Giraudon), 121 (photo Bulloz), 143br (photo Giraudon), 145a, 149, 161b, 184, 212 (photo Giraudon), 219, 241b, 229b (photo Giraudon), 250r, 250l, 293, 299 (© photo R.M.N.), 334b, 353b, 370l (photo Giraudon); Luxembourg 144b (photo Giraudon); Musée d'Orsay 227 (photo Giraudon); Documentation du Musée National d'Art Moderne - Centre Georges Pompidou 57, 110b (© photo R.M.N.), 119a, 119b (© photo R.M.N.), 208, 361a; Musée du XX^e siècle 53 (© photo R.M.N.); Panthéon 295a; Petit Palais 361b. Parma: Cathedral 93. Pedralbes: S. Miguel 34a. Petworth House (National Trust): 358. Philadelphia: Museum of Art 118, 122 (given by Mrs Thomas Eakins and Miss Mary A. Williams), 178, 200b. Pommersfelden: Schonborn Collection 143a. Port Sunlight: Lady Lever Art Gallery 99a, 181. Private collection 172a.

Ravenna: S. Vitale 66 (photo Alinari). Rimini: Tempio Malatestiano 11 (photo Gabinetto Fotografico Nazionale, Rome). Rome: Borghese Gallery 70; Casino Rospigliosi 303a; Galleria Doria 73; S. Maria della Vittoria 42; S. Pietro in Montorio 329; Villa Ludovisi 164a. Roswell (New Mexico): Museum and Art Center 263a (Gift of Mr and Mrs Donald Winston, Mr and Mrs Samuel H. Marshall and Mr and Mrs Frederick Winston). Rouen: Musée départment des antiquités de la Seine-Maritime 252 (photo Ellebé). St Petersburg: Staatliches Russisches Museum 349. St Wolfgang (Austria): St Wolfgang church 267a. San Francisco: Courtesy John Berggruen Gallery 351; San Francisco Museum of Modern Art 112. Santa Monica: The Eli Broad Family Foundation 153. Seattle: Art Museum 347. Siena: Opera del Duomo 117; Palazzo Pubblico 220a, 231b. Southampton: Art Gallery 231a. Stuttgart: Sammlung J W Frölich 306. Toledo: Church of San Tomé 159. Toronto: Art Gallery of Ontario 67b. Urbino: Galleria Nazionale 279. Valladolid: Museo Nacional de Escultura 43. Vatican: Museums and Galleries 128a (photo Hirmer), 205b; Sistine Chapel 239 (photo Alinari), 274. Venice: Accademia 366; Gesuati Church 353a; Museo Correr 72 (photo Alinari). Versailles: 148r (photo Giraudon). Vienna: Akademie der Bildenden Künste 54b; Kunsthistorisches Museum 20br, 62, 63; Museum für Volkerkunde 127b; Österreichische Galerie 199b; Österreichisches Museum für Angewandte Kunst 173r. Washington, D.C.: National Gallery of Art 115, 143bl; Phillips Collection 103; National Musuem of American Art, Smithsonian Institution 37a (Evans-Tibbs Collection), 76a, 123a (Gift of Elizabeth Gibbons-Hanson), 160b, 190. Zagorsk: Cathedral of the Trinity 318b. Zürich: Kunsthaus 217r.

Photographs: Akademie der Künste, Berlin 169; © Douglas Mazonowicz 206b, Photo Scott Bowron Photography 351.